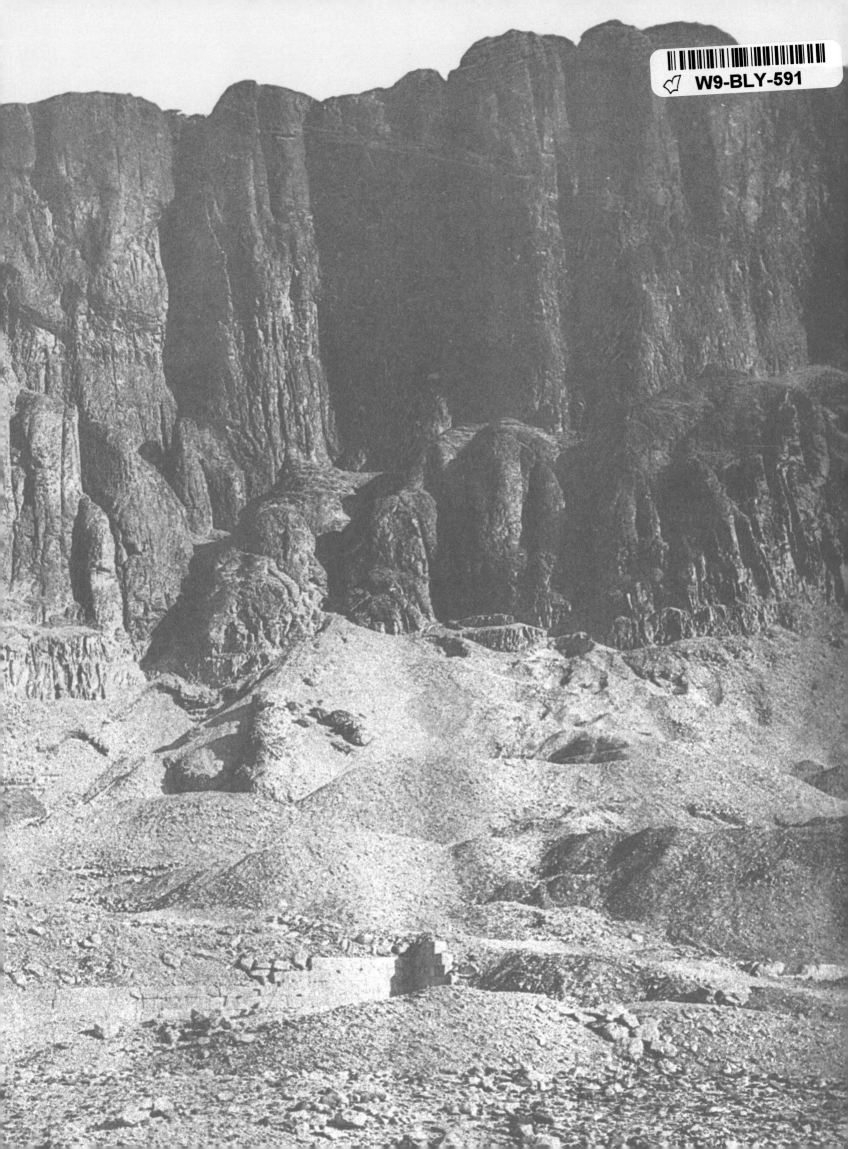

W9-BLY-591

HATSHEPSUT

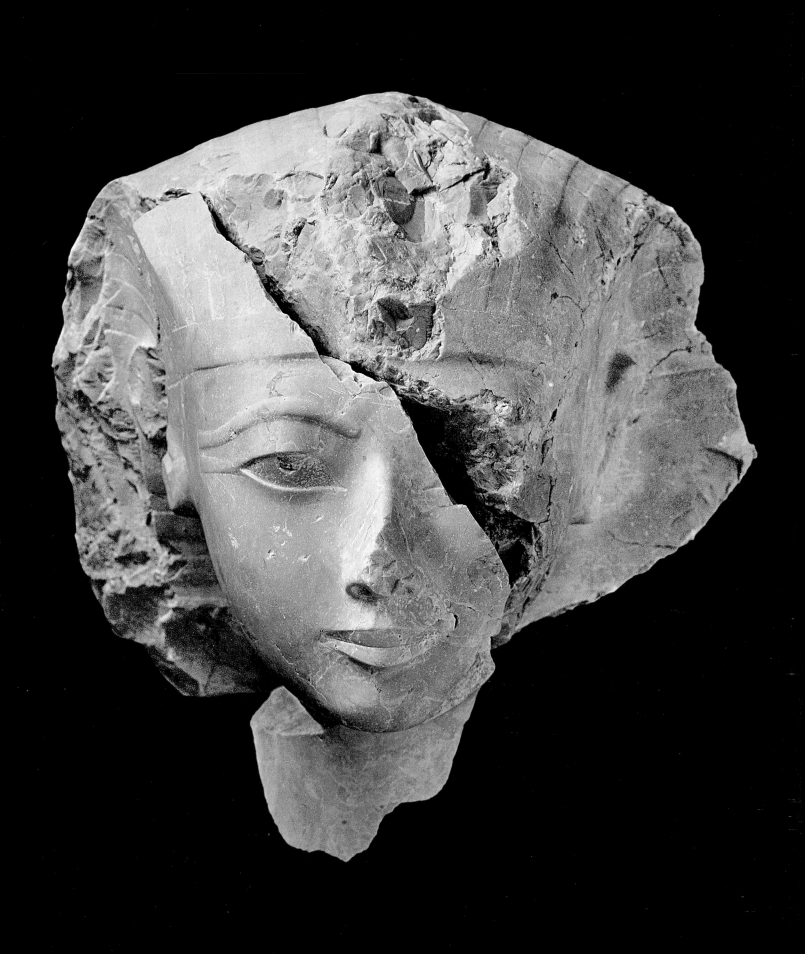

HATSHEPSUT
FROM QUEEN TO PHARAOH

Edited by Catharine H. Roehrig

with Renée Dreyfus and Cathleen A. Keller

THE METROPOLITAN MUSEUM OF ART, NEW YORK

YALE UNIVERSITY PRESS, NEW HAVEN AND LONDON

L. E. SMOOT MEMORIAL LIBRARY
9533 KINGS HIGHWAY
KING GEORGE, VA 22485

This volume is published in conjunction with the exhibition "Hatshepsut: From Queen to Pharaoh," held at the Fine Arts Museums of San Francisco /de Young from October 15, 2005, to February 5, 2006; at The Metropolitan Museum of Art, New York, from March 28 to July 9, 2006; and at the Kimbell Art Museum, Fort Worth, from August 27 to December 31, 2006.

The exhibition is supported in part by the National Endowment for the Humanities, a federal agency.

The exhibition at the Fine Arts Museums of San Francisco /de Young is made possible in part by the National Endowment for the Arts, a federal agency.

The exhibition at The Metropolitan Museum of Art is made possible by Dorothy and Lewis B. Cullman.

The exhibition catalogue is made possible by The Adelaide Milton de Groot Fund at the Metropolitan Museum, in memory of the de Groot and Hawley families.

The exhibition was organized by The Metropolitan Museum of Art, New York, and the Fine Arts Museums of San Francisco.

The exhibition is supported by an indemnity from the Federal Council on the Arts and the Humanities.

Published by The Metropolitan Museum of Art, New York

John P. O'Neill, Editor in Chief
Jane Bobko and Ruth Lurie Kozodoy, Editors
Bruce Campbell, Designer
Anandaroop Roy, Maps and Genealogy Designer
Peter Antony, Chief Production Manager
Douglas J. Malicki, Production Manager
Minjee Cho, Desktop Publishing
Jane S. Tai, Picture Coordinator
Jayne Kuchna, Bibliographic Editor

Copyright © 2005 The Metropolitan Museum of Art, New York

All rights reserved. No part of this publication may be reproduced or transmitted in any form or by any means, electronic or mechanical, including photocopying, recording, or any information storage or retrieval system, without permission in writing from the publishers.

New photography of works in the Metropolitan Museum collection by Bruce Schwarz, the Photograph Studio, The Metropolitan Museum of Art, New York

Typeset in Fournier
Printed on 130 gsm R-400
Separations by Professional Graphics, Inc., Rockford, Illinois
Printed and bound by CS Graphics PTE, LTD, Singapore

Jacket/cover illustrations: (Front) detail, statue of Hatshepsut as female king (cat. no. 95); (back) the temples of Mentuhotep II and Hatshepsut at Deir el-Bahri in 1953, before restoration

Frontispiece: Head of a statue of Hatshepsut as reassembled from fragments discovered in western Thebes, 1928 (see cat. no. 96)

On page xvi: Detail, relief depicting running soldiers (cat. no. 82a)

Library of Congress Cataloging-in-Publication Data

Hatshepsut: from Queen to Pharaoh /edited by Catharine H. Roehrig, with Renée Dreyfus and Cathleen A. Keller.
 p. cm.
 Catalogue to an exhibition at the MH de Young Memorial Museum, San Francisco, from October 15, 2005, to February 5, 2006; at The Metropolitan Museum of Art, New York, from March 28 to July 9, 2006; and at the Kimbell Art Museum, Fort Worth, August 27 to December 31, 2006.
 Includes bibliographical references and index.
 ISBN 1-58839-172-8 (hardcover)—ISBN 1-58839-173-6 (pbk.)—ISBN 0-300-11139-8 (Yale University Press)
 1. Hatshepsut, Queen of Egypt—Exhibitions. 2. Hatshepsut, Queen of Egypt—Art—Exhibitions. 3. Pharaohs—Exhibitions. I. Roehrig, Catharine H. II. Dreyfus, Renée. III. Keller, Cathleen A. IV. M.H. De Young Memorial Museum. V. Metropolitan Museum of Art (New York, N.Y.) VI. Kimbell Art Museum.
 DT87.15.H378 2005
 932'.014'092—dc22 2005020286

Contents

Directors' Foreword

While modern Europe has had a number of extraordinary ruling women who shaped the history of their times—one thinks of England's Elizabeth I and Victoria, and Russia's Catherine the Great—their counterparts in antiquity are rare. In the ancient Near East, such figures are conspicuously absent (the adventures of the fabled Assyrian queen Semiramus, although based on a real individual, were primarily a product of Herodotus's fertile imagination). Egypt's Cleopatra looms large more for her romantic exploits than her historical legacy. One Egyptian queen stands apart, however: Hatshepsut, who ruled Egypt for some two decades at the beginning of the fifteenth century B.C. A strong and effective pharaoh, she oversaw a cultural renaissance that influenced the arts in Egypt for more than a millennium.

"Hatshepsut: From Queen to Pharaoh" is the first major exhibition to trace the story and impact of this remarkable woman, bringing together the most important sculptures and other works of art that have survived from her reign. Complex circumstances, colored by the intricate rules of royal inheritance and intermarriage, brought Hatshepsut to power on the death of her husband—first as co-regent with her young stepson-nephew Thutmose III, and then as co-ruler. Having achieved kingship, she was officially acknowledged as a female pharaoh, although in conformity with the Egyptian ideology of rulership she was often represented in art as a man. After her death, Hatshepsut's monuments were destroyed and her name omitted from subsequent Egyptian king lists. All memory of her reign was lost until the mid-nineteenth century, when Hatshepsut was rediscovered by Egyptologists and her place in history restored. While the obliteration of her memory was once explained as an act of retribution on the part of her successor, and more current theories propose that the motive was safeguarding the royal succession, the reasons for this extraordinary *damnatio memoriae* are still not entirely clear.

Recent archaeological finds and scholarship indicate that Hatshepsut's largely peaceful and prosperous reign provided the impetus for a period of great artistic innovation and creativity and laid the groundwork for the "golden age" of the New Kingdom that was to follow. Hatshepsut's most magnificent surviving monument is her mortuary temple at Deir el-Bahri near the Valley of the Kings in western Thebes. Its terraced architecture, sculpture, and landscape combine to form one of the world's greatest architectural masterpieces. Within a few decades of Hatshepsut's death, however, the statues that made up the temple's rich array had been removed and hacked to pieces. In the 1920s and 1930s, thousands of fragments were uncovered during excavations carried out by the Metropolitan Museum's Egyptian Expedition; a number of the statues reconstructed from these fragments form the core of this exhibition. They are accompanied by reliefs from the temple, statues representing members of Hatshepsut's court, and works in a wide range of other media, among them paintings, jewelry, furniture, stoneware, and pottery, that exemplify the exceptional artistic achievement of this important period in Egypt's history.

The exhibition marks a double celebration for the organizing institutions: in San Francisco, the opening of "Hatshepsut" in October 2005 coincides with the inauguration, by the Fine Arts Museums of San Francisco, of the new de Young museum in Golden Gate Park; and in New York, the opening in March 2006 celebrates the hundredth anniversary of the Metropolitan Museum's Department of Egyptian Art, whose earliest curators and excavators brought to light many of the works on display in the exhibition.

We wish to express our admiration and gratitude to the curators who conceived and organized this exhibition: Renée Dreyfus at the Fine Arts Museums of San Francisco, Catharine H. Roehrig at the Metropolitan Museum, and Cathleen A. Keller of the University of California, Berkeley. We extend our profound and heartfelt thanks to the many museums in Europe and America, and to Dr. Zahi Hawass and the Supreme Council of Antiquities of Egypt, who generously agreed to lend key works to the exhibition.

No major exhibition is possible without significant financial support, and we are most grateful to those whose important contributions have allowed this project to come to fruition. A grant from the National Endowment for the Humanities, a federal agency, supports, in part, the exhibition at the Fine Arts Museums of San Francisco and the Metropolitan Museum. At the Fine Arts Museums of San Francisco, the exhibition is supported by a grant from the National Endowment for the Arts, a federal agency. At the Metropolitan Museum, the exhibition is made possible by Dorothy and Lewis B. Cullman. The exhibition is supported by an indemnity from the Federal Council on the Arts and the Humanities. The publication of this exhibition catalogue was made possible by the Metropolitan Museum's Adelaide Milton de Groot Fund, in memory of the de Groot and Hawley families.

Harry S. Parker III
Director, Fine Arts Museums of San Francisco

Philippe de Montebello
Director, The Metropolitan Museum of Art

Timothy Potts
Director, Kimbell Art Museum

Acknowledgments

An exhibition of this scope inevitably involves the efforts of a great number of people. We would like to extend our gratitude to the museum directors, administrators, and department chiefs who have approved loans from their collections, and to the curators, conservators, and innumerable support staff who have facilitated these loans.

Our thanks go first to the directors of the museums that organized the exhibition: Philippe de Montebello of The Metropolitan Museum of Art, New York, and Harry S. Parker III of the Fine Arts Museums of San Francisco. Without their support this enterprise could not have been realized. We also wish to thank Timothy Potts, Director of the Kimbell Art Museum, Fort Worth, whose interest in the project dates almost from its inception.

Special thanks go to our colleagues at the following European and American museums whose assistance in this undertaking was essential: Bancroft Library, University of California, Berkeley: Charles Faulhaber, Anthony Bliss, and Todd Hickey; Phoebe Apperson Hearst Museum of Anthropology, University of California, Berkeley: Douglas Sharon and Joan Knudsen; Ägyptisches Museum und Papyrussammlung, Staatliche Museen zu Berlin: Dietrich Wildung and Karla Kroeper; Museo Civico Archeologico, Bologna: Cristiana Morigi Govi and Daniela Picchi; Museum of Fine Arts, Boston: Malcolm Rogers, Rita E. Freed, Lawrence Berman, and Yvonne Markowitz; Brooklyn Museum: Arnold Lehman, Richard Fazzini, Edna R. Russmann, Madeleine Cody, and Kathy Zurek; Musées Royaux d'Art et d'Histoire, Brussels: Anne Cahen-Delhaye and Luc Limme; the Fitzwilliam Museum, Cambridge: Duncan Robinson, David Scrase, Lucilla Burn, Sally-Ann Ashton, and Thyrza Smith; the Field Museum, Chicago: Dorren Martin-Ross, Bennet Bronson, and Chapurukha Kusimba; the National Museums of Scotland, Edinburgh: David Caldwell, Elizabeth Goring, Lesley-Ann Liddiard, Katherine Eremin, and Michelle Foster-Davies; Kestner-Museum, Hannover (Germany): Wolfgang Schepers, Rosemarie Drenkhahn (retired), and Christian Loeben; Roemer- und Pelizaeus-Museum, Hildesheim: Katja Lembke, Eleni Vassilika (former director), Bettina Schmitz; Rijksmuseum van Oudheden, Leiden: J. R. Magendans, Maarten Raven, Marianne Stauthamer; Ägyptisches Museum der Universität Leipzig: Hans-Wolfgang Fischer-Elfert, Friederike Kampp-Seyfried; the British Museum, London: Neil MacGregor, W. Vivian Davies, Nigel Strudwick, Neal Spencer, and Claire Messenger; the Ashmolean Museum, Oxford: Christopher Brown, Helen V. Whitehouse, Chezzy Brownen, and Julie Clements; Musée du Louvre, Paris: Henri Loyrette, Christiane Ziegler, and Christophe Barbotin; the University of Pennsylvania Museum of Archaeology and Anthropology, Philadelphia: Jeremy A. Sabloff, David P. Silverman, Jennifer Houser Wegner, and Juana Dahlan; Museo Barracco, Rome: Anna Mura Sommella, Eugenio La Rocca, and Marisita Nota; Ägyptische Sammlung der Universität Tübingen: Karola Zibelius-Chen (retired) and Christian Leitz; Museo delle Antichità Egizie, Turin: Marina Sapelli Ragni, Anna Maria Donadoni Roveri (retired), Eleni Vassilika, and Elvira d'Amicone.

Loans from Egypt could not have been secured without the cooperation of Zahi Hawass, Director General of the Supreme Council of Antiquities of Egypt; Mahmoud Mabrouk, Director General of Egyptian Museums; and Wafaa El-Saddik, Director of the Egyptian Museum, Cairo. Our appreciation is extended to the members of the Permanent Committee of the Supreme Council of Antiquities and the High Committee for Exhibitions. We would also like to thank the many staff members at the Egyptian Museum and in Luxor who have helped facilitate the loans.

We would like to thank Dietrich Wildung in Berlin, Richard Fazzini in Brooklyn, Wafaa El-Saddik in Cairo, and Sylvia Schoske of the Staatliche Sammlung Ägyptischer Kunst, Munich, for allowing us to include in the catalogue a number of important works that could not travel to the three exhibition venues owing to their fragility or importance to their home collections. Other colleagues who deserve our thanks are Joanna Aksamit, Marc Étienne, Janusz Karkowski, Nanette Kelekian, Arielle Kozloff, Jaromír Málek, Geneviève Pierrat-Bonnefois, Stephen G. J. Quirke, Marie-Françoise de Rosières, Patricia A. Spencer, Paul Stanwick, Zbigniew Szafrański, and Giuseppina Capriotti Vittozzi.

The photographs of objects in the Metropolitan Museum's collection were taken by Bruce Schwarz of the Museum's Photograph Studio; he was also allowed to photograph objects belonging to the Louvre, in Paris, and five works from the British Museum that were shown in a traveling exhibition in Montreal. In Paris we were greatly assisted by Christophe Barbotin, Catherine Bridonneau, and Marie-Françoise de Rosières, and in Canada by Paul Tellier of the Musée des Beaux-Arts de Montréal; Neal Spencer, Nic Lee, and John Hayman of the British Museum; and Dotty Canady of the American Federation of Arts. Special thanks also go to Barbara Bridgers, Susan Melick Bresnan, Robert Goldman, and Teresa Christiansen of the Metropolitan's Photograph Studio, and to Julie Zeftel,

Deanna D. Cross, and Carol E. Lekarew in the Photograph and Slide Library.

We are also grateful for the cooperation of the photography departments and photographers of the lending institutions, many of which provided specific views of the objects at our request. Our special thanks go to the following people: Museum of Fine Arts, Boston: Lisbeth Dion, Erin M. A. Sleigh; Brooklyn Museum: Ruth Janson; Musées Royaux d'Art et d'Histoire, Brussels: Florence Branquart; the Fitzwilliam Museum, Cambridge: Diane Hudson, Andrew Morris, and the Photography Department; the Field Museum, Chicago: Jerice Barrios; the National Museums of Scotland, Edinburgh: Helen Osmani and Leslie Florence; Kestner-Museum, Hannover: Christian Tepper; Rijksmuseum van Oudheden, Leiden: Peter Jan Bomhof and Anneke de Kemp; the British Museum, London: Sandra Marshall; the Ashmolean Museum, Oxford: the Photographic Department; the University of Pennsylvania Museum of Archaeology and Anthropology, Philadelphia: Sharon Aponte Misdea; Museo delle Antichità Egizie, Turin: Elvira d'Amicone.

In San Francisco many people contributed their enthusiasm and expertise to this cooperative venture, and we are pleased to recognize them. Louise Chu, Associate Curator of Ancient Art, ably assisted with numerous facets of the exhibition's development, and Jane Nelson, Assistant Curator, carried on much of the ongoing work of the Ancient Art Department. We also thank Elisabeth Cornu, Head Objects Conservator, for her assistance with conservation and mount making. Krista Brugnara Davis, Director of Exhibitions, assisted by Allison Satre, and Therese Chen, Stephen Lockwood, and Doug DeFors in the Registration Department assumed critical roles in the organization, transportation, insurance, and presentation of the exhibition. The fine efforts of exhibition designer William White and his team of technicians; lighting designer William Huggins; graphic designer Juliana Pennington; Ann Heath Karlstrom, Elisa Urbanelli, and Suzy Peterson of the Publications Department; and Sheila Pressley, Renée Baldocchi, and the Education Department were indispensable in the presentation of the exhibition in California. Gratitude goes also to Barbara Traisman, Senior Media Relations Officer, Linda Katona, Director of Advertising and Promotion, and Gerry Chow, Senior Grants Officer. We would be remiss if we did not mention Abderahman Salaheldin, the Consul General of Egypt in San Francisco, whose efforts in support of the exhibition have been invaluable. We are grateful to the University of California, Berkeley, for allowing us to use its library resources.

Finally, our thanks go to our colleagues at The Metropolitan Museum of Art. We express our appreciation for the support, in the Director's Office, of Mahrukh Tarapor, Associate Director for Exhibitions/Director for International Affairs, Geneva Office; Martha Deese, Senior Administrator for Exhibitions; and Heather Woodward, Assistant for Exhibitions.

This handsome catalogue was produced by the Editorial Department of the Metropolitan Museum. John P. O'Neill, Editor in Chief and General Manager of Publications, provided essential guidance throughout the writing and production of the book. Jane Bobko and Ruth Lurie Kozodoy shouldered the bulk of the editing, with considerable assistance from Carol Fuerstein as well as the collaboration of Margaret Aspinwall and Emily Walter. Jayne Kuchna edited the formidable bibliography, and Robert Palmer prepared the index. Bruce Campbell designed the catalogue; Peter Antony and Douglas J. Malicki oversaw the production and printing; Minjee Cho served as desktop-publishing specialist; and Jane S. Tai tracked the images for the publication. Margaret Rennolds Chace, Managing Editor, solved emergencies large and small. This catalogue could not have been completed without the extraordinary dedication, patience, meticulous attention to detail, and tireless work of the editorial team.

We would like to acknowledge the efforts of Nina McN. Diefenbach, Andrea Kann, Claire Gylphé, Eti Bonn-Muller, Thomas Reynolds, and Christine Scornavacca in the Development Office; Rebecca Noonan Murray in the Office of the Vice President, Secretary and General Counsel; Lawrence Becker, Deborah Schorsch, Jeffrey Perhacs, Frederick J. Sager, and Jenna Wainwright in the Sherman Fairchild Center for Objects Conservation, and in particular Ann Heywood and Alexandra Walcott, who meticulously prepared the Metropolitan's objects for travel to San Francisco and Fort Worth; Mark T. Wypyski in the Department of Scientific Research; Herbert M. Moskowitz, Willa M. Cox, Nestor R. Montilla, Frances Redding Wallace, Minora Collins, Joo Yun Isabel Kim, Gerald P. Lunney, Wayne Morales, and Amanda Thompson in the Registrar's Office; Harold Holzer, Elyse Topalian, and Egle Žygas in Communications; Jeanie M. James in Archives; and Elizabeth Hammer, Christopher Noey, Stella Paul, Nicholas Ruocco, Teresa Russo, Nancy Thompson, Edith Watts, Paul H. Caro, Jessica Glass, and Vivian Wick in Education.

For the exhibition installation at the Metropolitan Museum our thanks go to Philip T. Venturino, Thomas Scally, and the workshops in Facilities Management. Their efforts behind the scene,

and those of the Design Department's production staff, have allowed the work of exhibition designers Daniel Kershaw, Sue Koch, Clint Coller, and Rich Lichte to be realized. Linda M. Sylling, Manager for Special Exhibitions and Gallery Installations, coordinated all aspects of the installation; without her the exhibition would have been impossible. We also thank Franz J. Schmidt and William Brautigam, both retired from the Buildings Department, for their invaluable advice on moving the large Hatshepsut statues in the Museum's collection.

The entire Department of Egyptian Art—James P. Allen, Susan J. Allen, Dieter Arnold, Dorothea Arnold, William Barrette, Miriam Blieka, Claudia Farias, Donald Fortenberry, Marsha Hill, Julia Jarrett, Dennis Kelly, Adela Oppenheim, Diana Craig Patch, and Isidoro Salerno—contributed to the exhibition and the catalogue. Our special acknowledgment and thanks are given for their unstinting hard work in studying, photographing, documenting, transporting, and organizing the Metropolitan's loan of more than 150 objects to the exhibition.

Catharine H. Roehrig
Curator, Department of Egyptian Art
The Metropolitan Museum of Art, New York

Renée Dreyfus
Curator of Ancient Art and Interpretation
Fine Arts Museums of San Francisco

Cathleen A. Keller
Professor, Department of Near Eastern Studies
University of California, Berkeley

Lenders to the Exhibition

Contributors to the Catalogue

JAMES P. ALLEN
Curator, Department of Egyptian Art
The Metropolitan Museum of Art, New York

SJA SUSAN J. ALLEN
Research Associate, Department of Egyptian Art
The Metropolitan Museum of Art, New York

DIETER ARNOLD
Curator, Department of Egyptian Art
The Metropolitan Museum of Art, New York

DoA DOROTHEA ARNOLD
Lila Acheson Wallace Chairman, Department of
Egyptian Art
The Metropolitan Museum of Art, New York

MANFRED BIETAK
Professor
Institut für Ägyptologie der Universität Wien,
Vienna

BETSY M. BRYAN
Alexander Badawy Professor of Egyptian Art and
Archaeology, Department of Near Eastern Studies
Johns Hopkins University, Baltimore

W. VIVIAN DAVIES
Keeper, Department of Egyptian Antiquities
British Museum, London

PFD PETER F. DORMAN
Chairman and Associate Professor in Egyptology,
Department of Near Eastern Languages and Civilizations
Oriental Institute
University of Chicago

RD RENÉE DREYFUS
Curator of Ancient Art and Interpretation
Fine Arts Museums of San Francisco

KE KATHERINE EREMIN
Principal Scientist Emerita, Inorganic Analysis
National Museums of Scotland, Edinburgh

EG ELIZABETH GORING
Principal Curator, Mediterranean Archaeology
National Museums of Scotland, Edinburgh

AH ANN HEYWOOD
Conservator, Sherman Fairchild Center for
Objects Conservation
The Metropolitan Museum of Art, New York

CAK CATHLEEN A. KELLER
 Professor, Department of Near Eastern Studies
 University of California, Berkeley

AK ANDREW KITCHENER
 Principal Curator, Birds and Mammals
 National Museums of Scotland, Edinburgh

 CHRISTINE LILYQUIST
 Wallace Research Curator in Egyptology, Department
 of Egyptian Art
 The Metropolitan Museum of Art, New York

 JADWIGA LIPIŃSKA
 Professor and Curator Emerita
 Muzeum Narodowe, Warsaw

BM BRIAN MELVILLE
 Ethnographic and Historical Artefacts Conservator
 National Museums of Scotland, Edinburgh

DCP DIANA CRAIG PATCH
 Assistant Curator, Department of Egyptian Art
 The Metropolitan Museum of Art, New York

AlQ ALEX QUINN
 Loans Conservator
 National Museums of Scotland, Edinburgh

AnQ ANITA QUYE
 Principal Scientist, Organic Analysis
 National Museums of Scotland, Edinburgh

CHR CATHARINE H. ROEHRIG
 Curator, Department of Egyptian Art
 The Metropolitan Museum of Art, New York

AMR ANN MACY ROTH
 Clinical Associate Professor of Egyptology
 New York University

ERR EDNA R. RUSSMANN
 Curator, Department of Egyptian, Classical, and
 Ancient Middle Eastern Art
 Brooklyn Museum

JT JIM TATE
 Head of Conservation and Analytical Research
 National Museums of Scotland, Edinburgh

List of Maps and Plans

Note to the Reader

Historians are not in agreement on many matters of Egyptian chronology. The chronology on page 6 gives the framework of dating employed in this volume. While throughout the book dates are given without the modification of "about" or "circa," all dates should be understood as approximations.

In translations of ancient Egyptian texts, brackets enclose material that is missing from the original but can be restored. Parentheses enclose modern interpolations made for clarity.

Full translations of certain inscriptions associated with the vizier Senenmut can be found in the appendix.

In the headings of catalogue entries, dimensions are abbreviated as follows: H., height; W., width; D., depth; L., length; Diam., diameter.

All source references are cited in abbreviated form. Complete citations will be found in the bibliography.

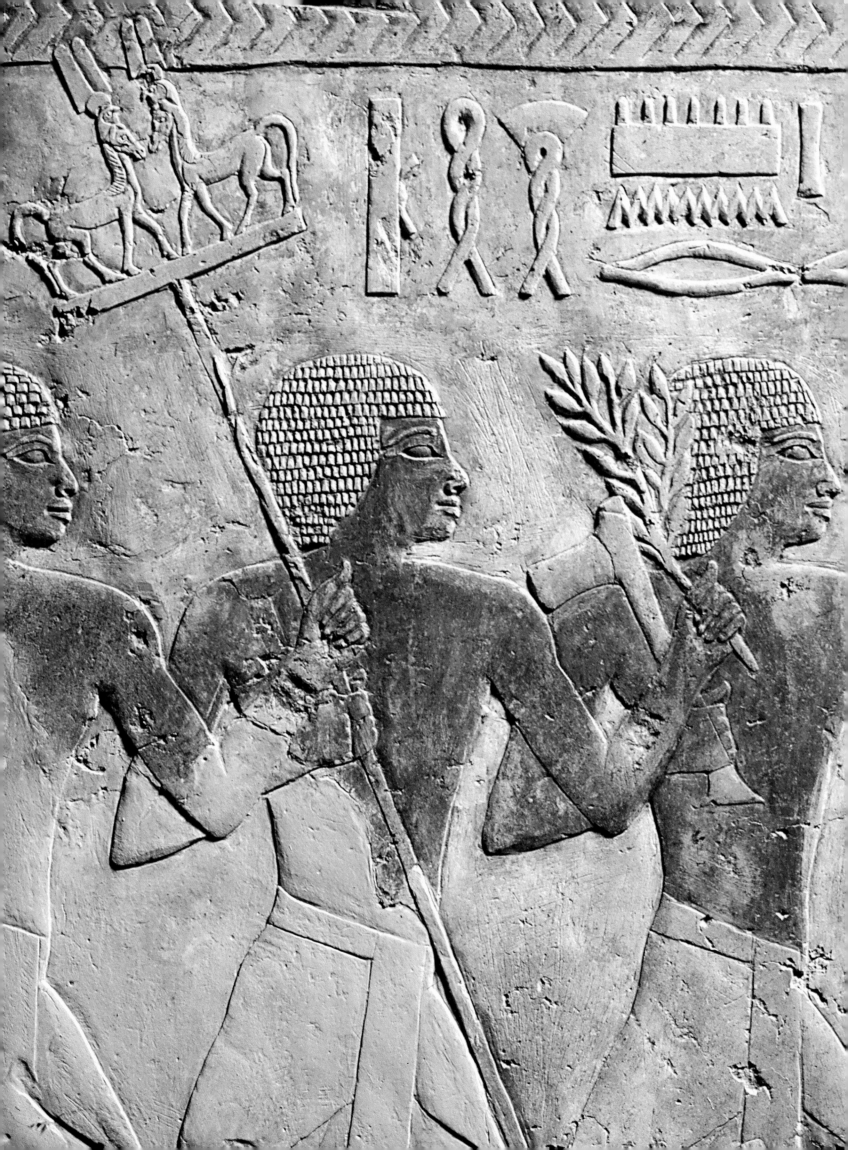

HATSHEPSUT

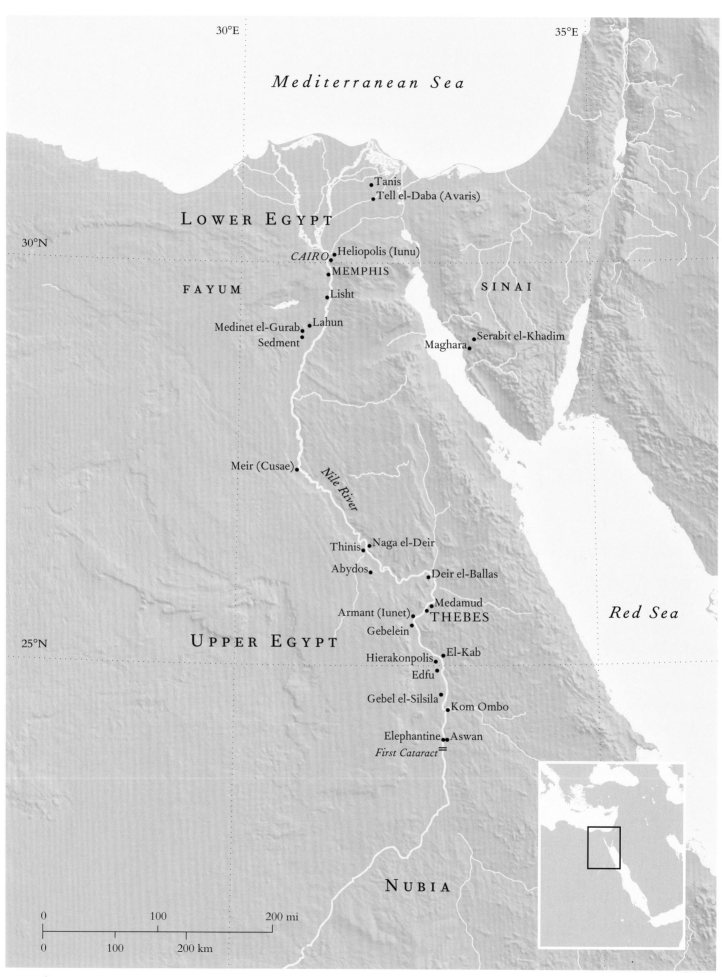

Mediterranean Sea

30°E

35°E

Red Sea

LOWER EGYPT

• Tanis
• Tell el-Daba (Avaris)

30°N

CAIRO• • Heliopolis (Iunu)
• MEMPHIS

FAYUM

• Lisht

Medinet el-Gurab • • Lahun
Sedment •

SINAI

Maghara • • Serabit el-Khadim

Meir (Cusae) •

Nile River

Thinis • • Naga el-Deir

Abydos • • Deir el-Ballas

• Medamud
Armant (Iunet) • • THEBES
Gebelein •

UPPER EGYPT

Hierakonpolis • • El-Kab
Edfu •
Gebel el-Silsila • • Kom Ombo

Elephantine • • Aswan
First Cataract

25°N

NUBIA

0 100 200 mi
0 100 200 km

Map of Ancient Egypt

Introduction

By the time Hatshepsut ascended the throne of Egypt in about 1473 B.C., the pyramids at Giza were over a thousand years old, and more than seventeen centuries had passed since the country was first united by the legendary king Menes in approximately 3100 B.C. In ancient times, as now, the habitable land of Egypt was created by the Nile River, which runs roughly south to north, cutting through the desert and creating a narrow valley that opens into a wide delta before emptying into the Mediterranean Sea. Even after the unification of these two geographic areas—Upper Egypt (upriver), the valley in the south, and Lower Egypt, the expanse of delta in the north—the distinctions between them remained a defining element in Egyptian culture. The ruler was called King of Upper and Lower Egypt, and Lord of the Two Lands. Each region had a tutelary deity: Nekhbet, the vulture goddess of Upper Egypt, and Wadjet, the cobra goddess of Lower Egypt. These goddesses became the protectors of the king, and their joint epithet "Two Ladies" preceded one of the five names in the royal titulary. Upper and Lower Egypt were also represented by the lotus and the papyrus, which are often shown tied together to symbolize the union of the Two Lands. The white crown of the south (see cat. no. 93) and the red crown of the north could be combined into the double crown of the united kingdom (see cat. no. 74).

In the history of ancient Egypt, eras when the two lands were united were times of prosperity that produced great cultural achievement. At these times the country was ruled by successive dynasties, which usually represented distinct families. This stability was interrupted by "intermediate periods" when the central power of the state disintegrated and competing dynasties controlled different areas of the country. Before Hatshepsut's time, Egypt had already experienced two extended eras of union. The Old Kingdom (ca. 2649–2100 B.C.), best known as the age of the pyramids, was a time of unparalleled artistic endeavor that became a source of inspiration for generations of artists to come. The Middle Kingdom (ca. 2030–1650 B.C.) saw a second flowering of the arts and is also known as the classical period of Egyptian literature. The Middle Kingdom ended when people from western

Opposite: In ancient times, Egypt's southern border was at Aswan, just north of the first cataract of the Nile. Upper Egypt was the name given to the Nile valley extending upriver (south) from Memphis; Lower Egypt spread north from Memphis, through the Delta. Memphis was the capital of Lower Egypt and in the Eighteenth Dynasty also served as the administrative capital of all Egypt. Thebes, the capital of Upper Egypt, was the ancestral home of the dynasty and the cult center of the god Amun-Re. South of Egypt lay Nubia, which the Egyptians often controlled.

Asia who had gradually moved into the eastern delta rose to power, becoming the Fourteenth and Fifteenth Dynasties. Called the Hyksos, "rulers of foreign lands," they ruled the northern part of Egypt during the Second Intermediate Period (ca. 1650–1550 B.C.).

While the Hyksos reigned in the north, a family from Thebes, the Seventeenth Dynasty, controlled the south. Toward the end of this time the Thebans made a concerted effort to drive the Hyksos out of Egypt, and Ahmose I finally succeeded in about 1550 B.C. By reuniting the Two Lands Ahmose established himself as one of the greatest of Egyptian kings, to be placed alongside the mythical Menes and Mentuhotep II, another Theban ruler, whose reunification of the country had begun the Middle Kingdom. Ahmose is known to historians as the first king of the Eighteenth Dynasty and the founder of the New Kingdom.

The family relationships that connected early Eighteenth Dynasty rulers are not always well documented. We know that Ahmose I was a descendant of the Seventeenth Dynasty kings and that he had a son, Amenhotep I, who succeeded him. However, Amenhotep's successor, Thutmose I, never used the title King's Son, and his relationship to the ruling family is unclear. Many scholars believe that Thutmose's wife, Ahmose (see cat. no. 80), was Amenhotep's sister, creating a link with the original royal family (see the genealogy, page 7). Another possibility is that Amenhotep I, having no surviving male heirs, chose one of his generals, Thutmose, as his successor. Whatever the case, the transition from Amenhotep I to Thutmose I was smooth, but additional dynastic problems ensued. Thutmose had no surviving sons with his principal wife Ahmose, only a daughter, Hatshepsut. His son and heir, Thutmose II, was born to a secondary wife, Mutnofret (see cat. no. 9). It was considered expedient to marry this boy to his half-sister, Hatshepsut. After the death of their father, Thutmose II reigned only a few years (see "Models of Authority" by Ann Macy Roth in chapter 1). During his short life Thutmose II had fathered a daughter with Hatshepsut, but his son and heir, Thutmose III, was born to a secondary wife, Isis. The untimely death of Thutmose II when his heir was only a small child set in motion the events that led Hatshepsut first to act as regent for her nephew and then to take the extraordinary step of becoming his co-ruler. Thus she became the Horus *Wosretkaw*, Golden Horus *Netjeret-khau*, Two Ladies *Wadjet-renput*, Daughter of Re *Maatkare*, Lady of the Two Lands, King of Upper and Lower Egypt, Hatshepsut-united-with-Amun.

The ancient Egyptians understood kingship as the link between the gods and mankind, achieved through the person of Pharaoh,

who was seen as the physical child of the sun-god Re. The primary function of the king was to uphold *maat*, the cosmic order that had come into being with creation. By the early Eighteenth Dynasty, Amun of Thebes had become the principal god of the Egyptian pantheon. Amun was seen as the creator of the universe and, joined with Re as Amun-Re, was regarded as the ultimate source of the sun's life-giving power (see "The Role of Amun" by James P. Allen, chapter 1). For this reason, Hatshepsut, who was Daughter of Re, also styled herself the physical child of Amun (see Ann Macy Roth's essay on architecture as political statement, chapter 3).

As in most cultures, the Egyptian throne traditionally passed from father to son, and the symbolism of kingship was profoundly masculine—a fact that informs all representations of Hatshepsut as ruler, many of which depict her in the guise of a male king (discussed by Cathleen A. Keller in chapter 3). Hatshepsut was not the first woman in Egypt's history to take on the role of king, nor is she the best known to modern readers—a distinction that indisputably belongs to the Ptolemaic queen Cleopatra VII (r. 51–30 B.C.). She is undoubtedly the most important, however, in terms of the influence of her reign on the culture of ancient Egypt.

The early kings of the Eighteenth Dynasty are known for their military exploits, in which they reestablished Egyptian control over Nubia to the south and led campaigns as far as the Euphrates River in western Asia. By contrast, Hatshepsut's twenty-year reign, though not without military campaigns (one of which she may have led herself), saw an explosion of artistic creativity. During this period Egyptian artists reinterpreted the traditional forms of art and architecture with an originality that is exemplified in Hatshepsut's temple at Deir el-Bahri in western Thebes, one of the great architectural wonders of the ancient world (see chapter 3). Lively experimentation introduced new forms of statuary that became prototypes for later generations of artists, as is particularly notable in the unprecedented corpus of statues depicting Senenmut, one of Hatshepsut's principal courtiers (discussed by Cathleen Keller in chapter 2). Ties with the cultures of Nubia, the eastern Mediterranean, and the Aegean also led to the introduction of new resources and artistic motifs that Egyptian artists incorporated into their repertoire (see the essays by Vivian Davies, Christine Lilyquist, and Manfred Bietak in chapter 1).

After more than two decades as principal ruler of Egypt, Hatshepsut quite literally disappeared from history. Sometime after her death, her co-ruler, Thutmose III, ordered her name and images destroyed. Although the process of eliminating Hatshepsut's memory did not begin immediately after her reign, it was a deliberate act carried out with great efficiency. As a result, only a vague idea persisted of a great female ruler. In the history written in the early Ptolemaic Period by the Egyptian priest Manetho, she was recorded as "Amessis." In 1828–29, the French Egyptologist Jean-François Champollion visited the site of Deir el-Bahri in western Thebes and saw an unfamiliar cartouche, which he read as "Amenenthe" and equated with Manetho's Amessis (see "Hatshepsut's Reputation in History" by Cathleen Keller, chapter 6). Since that time scholarly opinions regarding Hatshepsut have fluctuated considerably. Nineteenth- and early twentieth-century Egyptologists often demonized her as a usurper who transgressed traditional Egyptian cultural and religious boundaries, a scheming, manipulative woman who lusted after power and suppressed her nephew for the first twenty years of his reign. Others saw her as a passive figure under the influence of her male courtiers and relying on them to remain in power. In the 1920s and 1930s, when two great pits filled with smashed statues from Hatshepsut's temple were discovered by The Metropolitan Museum of Art, it was easy for scholars to interpret the destruction as an act of revenge by Thutmose III, a result of his resentment and hatred of the aunt/stepmother who had usurped his throne. In the past half-century, significant new evidence and the gradual shift in cultural attitudes toward women in power have produced further interpretations of Hatshepsut's reign.

Today, debate continues over what circumstances allowed or compelled Hatshepsut to become king, what relationship existed between Hatshepsut and Thutmose III during their joint reign, and what motivated him to destroy her memory some twenty years after her death. This catalogue is designed to present recent research into these issues and varying interpretations of them, alongside wide-ranging scholarly discussion of the rich artistic output that marks Hatshepsut's reign.

Catharine H. Roehrig
Renée Dreyfus
Cathleen A. Keller

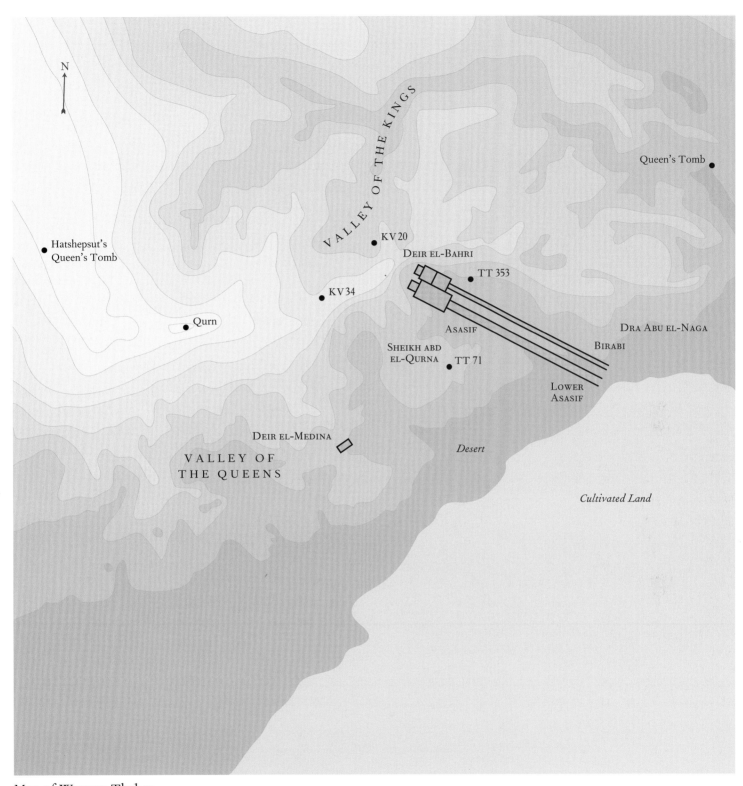

Map of Western Thebes

The ancient Egyptian city of Thebes (modern Luxor) was located on the east bank of the Nile (see the map of Thebes, fig. 63). The ancestral home of the Eighteenth Dynasty kings, Thebes was also the seat of Amun-Re, and his cult center, the temple of Karnak, was at the north end of the city. Across the river in western Thebes, the cultivated land of the flood plain extends about two and one-half miles before coming to the edge of the desert and a spectacular expanse of limestone cliffs. This area was used as a necropolis by generations of Thebans. Theban rulers of the Middle and New Kingdoms built their tombs and temples at the edge of the cliffs and in the desert valleys beyond.

Located on this map are a number of the places and monuments mentioned in the following pages. They include Hatshepsut's queen's tomb, made for her before she became king; the Qurn, a high point that resembles a pyramid when seen from the Valley of the Kings or Deir el-Bahri (see fig. 56, p. 134); KV 20, Hatshepsut's king's tomb, and KV 34, the tomb of her nephew Thutmose III, both located in the Valley of the Kings; TT 353 and TT 71, the two tombs of Hatshepsut's courtier Senenmut; Deir el-Bahri, the site of Hatshepsut's temple and that of her much earlier predecessor Mentuhotep II; Deir el-Medina, a village of workmen who built the royal tombs; Sheikh Abd el-Qurna, a hill with a large cemetery of nobles' tombs; Dra Abu el-Naga, the ancestral cemetery of the Seventeenth Dynasty kings; Asasif, the valley stretching from Deir el-Bahri to the flood plain; and Lower Asasif and Birabi, two excavation sites at the end of the temple causeways. The queen's tomb at the upper right belonged to a royal woman and child of the Seventeenth Dynasty.

Chronology: Kingdom, Dynastic, and Regnal Dates

From the unification of the land by the mythical king Menes in about 3100 B.C., the history of ancient Egypt is split into a succession of thirty-one dynasties, usually representing separate ruling families. The outline presented here is based on ancient sources, especially a history of the Egyptian kings compiled by Manetho, an Egyptian priest of the third century B.C. This era of nearly three thousand years was marked by long periods of great prosperity when Egypt was united under a single king—the Old Kingdom, Middle Kingdom, New Kingdom, and Late Period—interspersed by three intermediate periods, when central power collapsed and the land was ruled by competing regional dynasties or foreign invaders. The lengths of the intermediate periods are not known with certainty. The Egyptians reckoned their year

dates anew with each king's reign (e.g., year 22, month 4 of the Growing season, day 25 of Thutmose III).

Most ancient Egyptian dates cannot be exactly equated with ones in our modern dating system. The chronology of ancient Egypt is constantly being debated and revised as scholarly understanding of the ancient sources changes and as new information becomes available. The following chronology is the one currently used by The Metropolitan Museum of Art, but the dates in it do not necessarily reflect the opinions of all the scholars who have contributed to this catalogue. While it is understood that all dates are approximate, for the sake of simplicity "about" and "circa" (ca.) have generally been omitted in this catalogue.

ca. 4400–3100 B.C.	PREDYNASTIC PERIOD
ca. 3100–2649 B.C.	ARCHAIC PERIOD *First and Second Dynasties*
ca. 2649–2100 B.C.	OLD KINGDOM *Third–Eighth Dynasty*
ca. 2100–2030 B.C.	FIRST INTERMEDIATE PERIOD *Ninth–Early Eleventh Dynasty*
ca. 2030–1650 B.C.	MIDDLE KINGDOM *Late Eleventh–Thirteenth Dynasty*
ca. 1650–1550 B.C.	SECOND INTERMEDIATE PERIOD *Fourteenth–Seventeenth Dynasty*
ca. 1550–1070 B.C.	NEW KINGDOM *Eighteenth–Twentieth Dynasty*
ca. 1070–743 B.C.	THIRD INTERMEDIATE PERIOD *Twenty-first–Early Twenty-fifth Dynasty*
743–332 B.C.	LATE PERIOD *Late Twenty-fifth–Thirty-first Dynasty*
332–30 B.C.	PTOLEMAIC PERIOD
30 B.C.–A.D. 476	ROMAN PERIOD

LATE SEVENTEENTH DYNASTY

ca. 1557–1556 B.C.	Senakhtenre (Tao I)
ca. 1556–1552 B.C.	Seqenenre (Tao II)
ca. 1552–1550 B.C.	Kamose

EIGHTEENTH DYNASTY

ca. 1550–1525 B.C.	Ahmose I
ca. 1525–1504 B.C.	Amenhotep I
ca. 1504–1492 B.C.	Thutmose I
ca. 1492–1479 B.C.	Thutmose II
ca. 1479–1425 B.C.	Thutmose III
ca. 1479–1473 B.C.	*Hatshepsut as regent to Thutmose III*
ca. 1473–1458 B.C.	*Joint reign of Hatshepsut and Thutmose III*
ca. 1458–1425 B.C.	*Sole reign of Thutmose III*
ca. 1427–1400 B.C.	Amenhotep II
ca. 1400–1390 B.C.	Thutmose IV
ca. 1390–1352 B.C.	Amenhotep III
ca. 1352–1349 B.C.	Amenhotep IV
ca. 1349–1336 B.C.	Amenhotep IV as Akhenaten; Amarna Period
ca. 1338–1336 B.C.	Neferneferuaten
ca. 1336–1336 B.C.	Smenkhkare
ca. 1336–1327 B.C.	Tutankhamun
ca. 1327–1323 B.C.	Aya
ca. 1323–1295 B.C.	Haremhab

EARLY NINETEENTH DYNASTY

ca. 1295–1294 B.C.	Ramesses I
ca. 1294–1279 B.C.	Seti I
ca. 1279–1213 B.C.	Ramesses II

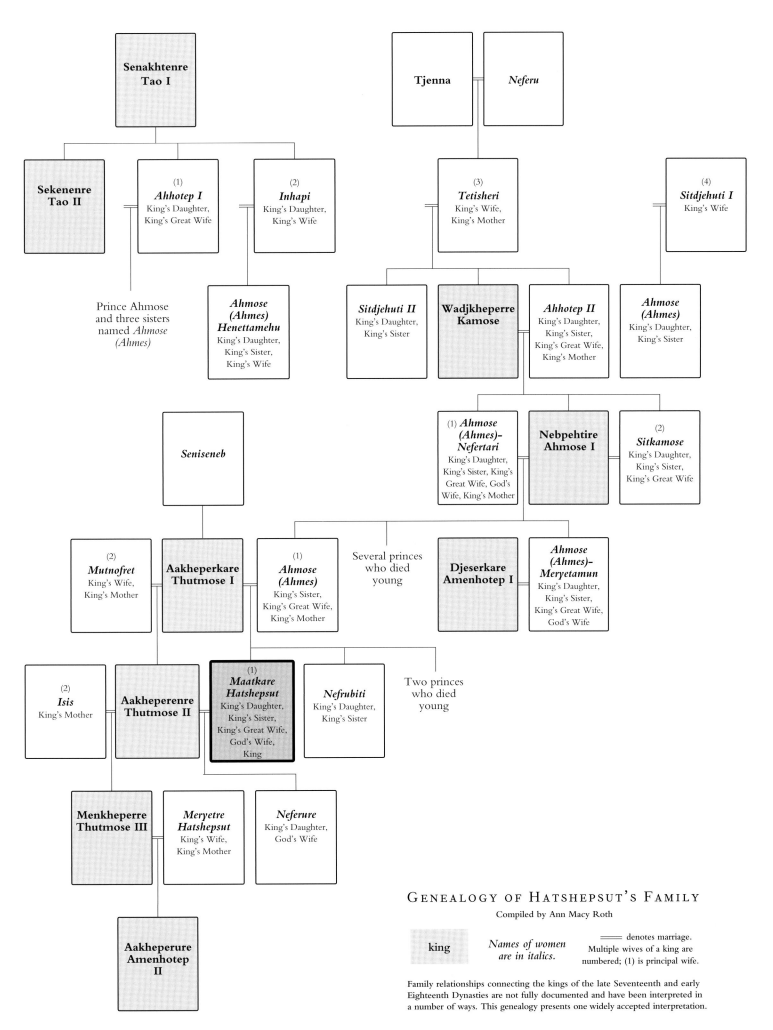

Senakhtenre
Tao I

Sekenenre
Tao II

(1)
Ahhotep I
King's Daughter,
King's Great Wife

(2)
Inhapi
King's Daughter,
King's Wife

Tjenna

Neferu

(3)
Tetisheri
King's Wife,
King's Mother

(4)
Sitdjehuti I
King's Wife

Prince Ahmose
and three sisters
named *Ahmose
(Ahmes)*

*Ahmose
(Ahmes)
Henettamehu*
King's Daughter,
King's Sister,
King's Wife

Sitdjehuti II
King's Daughter,
King's Sister

Wadjkheperre
Kamose

Ahhotep II
King's Daughter,
King's Sister,
King's Great Wife,
King's Mother

*Ahmose
(Ahmes)*
King's Daughter,
King's Sister

Seniseneb

(1) *Ahmose
(Ahmes)-
Nefertari*
King's Daughter,
King's Sister, King's
Great Wife, God's
Wife, King's Mother

Nebpehtire
Ahmose I

(2)
Sitkamose
King's Daughter,
King's Sister,
King's Great Wife

(2)
Mutnofret
King's Wife,
King's Mother

Aakheperkare
Thutmose I

(1)
*Ahmose
(Ahmes)*
King's Sister,
King's Great Wife,
King's Mother

Several princes
who died
young

Djeserkare
Amenhotep I

*Ahmose
(Ahmes)-
Meryetamun*
King's Daughter,
King's Sister,
King's Great Wife,
God's Wife

(2)
Isis
King's Mother

Aakheperenre
Thutmose II

(1)
*Maatkare
Hatshepsut*
King's Daughter,
King's Sister,
King's Great Wife,
God's Wife,
King

Nefrubiti
King's Daughter,
King's Sister

Two princes
who died
young

Menkheperre
Thutmose III

*Meryetre
Hatshepsut*
King's Wife,
King's Mother

Neferure
King's Daughter,
God's Wife

Aakheperure
Amenhotep
II

GENEALOGY OF HATSHEPSUT'S FAMILY

Compiled by Ann Macy Roth

king *Names of women
are in italics.*

══ denotes marriage.
Multiple wives of a king are
numbered; (1) is principal wife.

Family relationships connecting the kings of the late Seventeenth and early
Eighteenth Dynasties are not fully documented and have been interpreted in
a number of ways. This genealogy presents one widely accepted interpretation.

7

I. SETTING THE SCENE

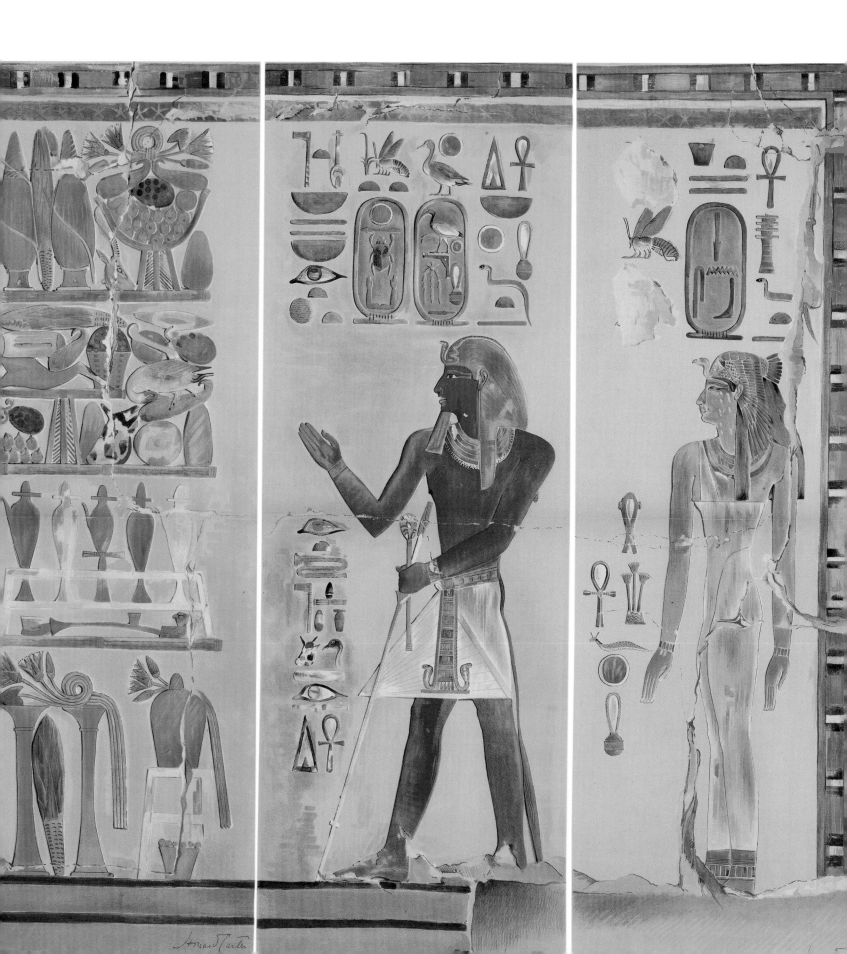

MODELS OF AUTHORITY
Hatshepsut's Predecessors in Power

Ann Macy Roth

Sometime before the seventh regnal year of her young nephew King Thutmose III, Queen Hatshepsut, the daughter, wife, and probably granddaughter of kings, was herself crowned king, assuming explicitly the power that she had been wielding unofficially since his accession.[1] In conceiving her kingly role and presenting herself to her people, she took three groups as models: male kings, Kings' Mothers, and queens regnant. From her association with each of these groups, Hatshepsut derived her legitimacy as a female pharaoh. These models illuminate the nature of her kingship and the reasons for her apparently unorthodox coronation.

KINGS

When Hatshepsut took the throne in the early fifteenth century B.C., the institution of the Egyptian kingship was over a millennium and a half old. Its ideology, iconography, and social conventions were well established. Hatshepsut bolstered her legitimacy by adopting them.

Traditionally, a king was male, identified as a manifestation of a male god, the falcon-headed Horus. Publicly, therefore, Hatshepsut was most often depicted as a male king in the prime of life. She rarely appears as a woman in either statuary or relief carving.[2] Some of the early representations seem to have been changed from female to male later in her reign (see fig. 2).[3] Wearing the traditional kilts of a king and a variety of crowns, she is shown in her reliefs striding forward and reaching out, where a female figure would have stood passively, feet held close together by an ankle-length dress, usually with her arms at her sides or bent back toward her body.[4] In representing herself as male, Hatshepsut was not being deceitful; she was simply conforming to the conventions of royal representation. Thutmose III was represented the same way, despite the fact that he was a young child;

and older male kings surely also had physiques markedly different from the trim, youthful bodies represented in their reliefs. Egyptian relief representations of kings in essence functioned as hieroglyphic determinatives, the pictures that occur at the end of a word to indicate the category to which the word belongs—in this case that of a generic (and therefore adult male) king.[5]

Relief scenes of Hatshepsut show her undertaking the ritual duties that kings had fulfilled for centuries: celebrating festivals, making offerings to the gods, spearing fish in the marshes, and bashing in the heads of foreign captives or, in the form of a sphinx, trampling on them. The venerable royal form of the sphinx may have appealed to Hatshepsut because it had been adopted by queens during the Middle Kingdom. Hatshepsut's sphinxes are kingly, however, showing her face framed by the striped *nemes* headcloth or a lion's mane, not the feminine tripartite wig (see cat. nos. 88a, 88b, 89). Historical associations may have made this image of a powerful feline especially appropriate to a woman claiming royal power.[6]

Kingship in Egypt entailed more than simply looking and acting like a king, however. The Egyptian king was a god on earth, the communicating link between Egyptians and their gods. Representations of the king functioned magically as stand-ins, ensuring the perpetuation of that link. It was thus important for images of Hatshepsut to identify her correctly. Her femininity was an essential part of her identity, and images that showed a fictional, nonexistent man named Hatshepsut would not be effective.

To attach her own female identity to the generic depictions of a male king, Hatshepsut used the hieroglyphic labels that were normally placed adjacent to relief images or on the sides and back of statues. Here the traditional male royal names, titles, and epithets were replaced by feminine variants, liberally sprinkled with feminine endings (see cat. nos. 91–96). This rather schizophrenic projection of her gender has been interpreted as an assertion of androgyny, a characteristic of fertility gods and creator gods.[7] But it was also a way of insuring that both kingly identity and feminine gender were attached to the images, allowing them to function as intermediaries with the gods, just as Hatshepsut herself did.

Opposite: Fig. 1. Thutmose I and his mother. Wall painting from the upper Anubis chapel of Hatshepsut's temple at Deir el-Bahri, early 18th Dynasty. In the inscription, Thutmose is said to be acting "so that she may be given life" and is called the "Good Goddess" (*ntrt nfr*). Facsimilies by Howard Carter

Fig. 2. Drawing of decoration from the temple at Buhen, 1479–1458 B.C. At left, traces of erased forms indicate that Hatshepsut was initially represented as female, with a relatively narrow stride and wearing a dress, of which the hemline remains visible. Possibly in her later reign, the stride was widened and the hemline erased to make the image male. In the second scene, the line at the front of the kilt worn by Hatshepsut (the figure at the left) was moved; originally she may have been depicted wearing both a kilt and a dress, as was done by an earlier female ruler, Nefrusobek. Drawings by Ricardo Caminos

Of the two genders associated with representations of Hatshepsut, the generic male was clearly the more obvious. Like modern museum visitors who assume that an image of Hatshepsut represents a male king until they read the label, illiterate Egyptians entering the temple would have seen a male king and missed the radical implications of the accompanying inscriptions. Even for the literate elite, dealing with the contradictory gender information must have been a challenge. It is at just this period that the grammatically male term *pr-ʿ3*, "great house" (which has come down to us in the term "pharaoh"), is first attested as a periphrastic way to refer to the king.[8]

Oddly, the use of a feminine royal titulary seems to have become so standard that even Hatshepsut's father, husband, and stepson were sometimes associated with feminine epithets and feminine pronouns (see fig. 1).[9] These might be explained as accidental results of confusion with Hatshepsut's own inscriptions, but their frequency suggests that they were intentional.[10]

As one of two kings existing at the same time, Hatshepsut was a senior co-regent to her nephew Thutmose III.[11] For a reigning king to take a younger co-regent was a well-established tradition, dating back at least to the Middle Kingdom. Hatshepsut's case was unusual, however, in that the younger king had held the throne prior to the older king's accession. Nonetheless, Hatshepsut adopted the standard iconography of joint kingship, aggressively including representations of Thutmose III in her monuments throughout Egypt and Nubia, and even at her own mortuary temple at Deir el-Bahri. His position is secondary, as was traditional for younger co-regents. The iconography is consistent with the supposition that Hatshepsut intended to bolster the legitimacy of Thutmose III's kingship and allow a smooth transition to his sole rule after her death. However, by depicting herself in the familiar role of the older of two simultaneously reigning kings, she reinforced not only her nephew's legitimacy but her own.

KINGS' MOTHERS

A number of women had ruled Egypt before Hatshepsut. Most of them ruled as *mwt nswt*, "King's Mother," an important title from the very beginning of Egyptian history. Kings often died young, leaving very young sons as successors,[12] and because an adult serving as regent might be tempted to seize power for himself

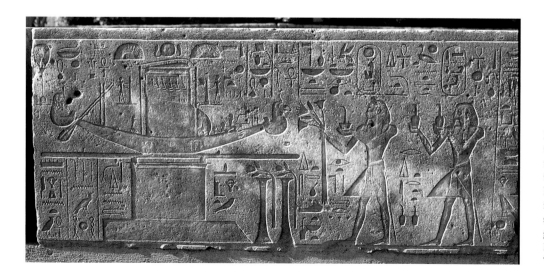

Fig. 3. Hatshepsut as a male king (shown twice, at the right) presenting offerings before the barque of Amun. The cartouche above the first figure contains her throne name, Maatkare; the one above the second figure reads "Hatshepsut united with Amun." The semicircular t hieroglyph, denoting feminine gender, has been inserted in many of her titles. Block from the Chapelle Rouge, Karnak, Thebes, early 18th Dynasty. Quartzite

before the child came of age, tradition soon assigned the role to the young king's mother, who would presumably gladly yield power to her own son.[13] There is no separate Egyptian title that can be translated as "regent,"[14] but the title King's Mother apparently allowed the holders of this title to act as regents for their young sons.

Clearly these women were important and powerful. The first attested King's Mother, Merneith, had a tomb comparable in size and position to those of the other First Dynasty rulers, all of whom were male. Two Old Kingdom queens, both named Khentkawes, bore the same enigmatic double title that suggests that their roles as regents entitled them to call themselves kings (see fig. 4).[15] Pepi II, who ascended the throne at age five, is even shown at a smaller scale than his mother, seated on her lap.[16] Kings' Mothers of the Old Kingdom were listed in the royal annals preserved on the Palermo Stone.[17]

In the Middle Kingdom, a King's Mother was accorded a tomb near her son's pyramid, often one larger than that of his principal wife.[18] However, the status of royal women declined during this period, paralleling an overall decline in the autonomy and power of women generally.[19] Queens may also have become less powerful because of the peace and stability of the period, which allowed kings to reign long enough for their heirs to become adults.

In no other period, however, did the role of King's Mother take on the importance it assumed in Hatshepsut's family in the late Seventeenth and early Eighteenth Dynasties. (For one possible reconstruction of the royal genealogy, see the introduction, above.) A number of princes of this period seem to have ascended the throne at a young age, and Kings' Mothers may also have ruled the country during the military forays of their adult sons against the Hyksos occupiers. The conqueror of the Hyksos, Ahmose I (r. 1550–1525 B.C.), honored his grandmother, the King's Mother Tetisheri, with a cenotaph at Abydos, presumably because of her role in

the war. Ahmose memorialized the regency of his own mother, Ahhotep II, in a stela at Karnak in which she is described as "one who pulled Egypt together, having cared for its army, having guarded it, having brought back those who fled it, gathering up its deserters, having quieted the South, subduing those who defy her."[20] Other queens may have also taken on this role: another older relative, the Great King's Wife Ahhotep I, was buried with several fly-pendant necklaces, which are decorations for military valor. Ahmose himself died in his mid-twenties, and his wife Ahmes-Nefertari,[21] as King's Mother, became regent for their young son Amenhotep I (r. 1525–1504 B.C.). She, too, received a special temple at Abydos. Amenhotep I had no surviving sons, and the throne passed to Thutmose I (r. 1504–1492 B.C.), who had married Amenhotep's sister Ahmes and who was probably himself a distant relative of his predecessor.[22]

It has been argued that Ahmes, Hatshepsut's mother, was not a daughter of King Ahmose I because she did not hold the title King's Daughter. However, New Kingdom princesses apparently forfeited that title upon marriage to a man who was not a king.[23] Ahmes seems to have done so when she married Thutmose, who was not a King's Son. When her husband subsequently took the throne, she stressed the secondary title King's Sister, underlining her connection to Amenhotep I and the royal family.

Hatshepsut herself was probably born before her father's accession.[24] Her half brother and eventual husband, Thutmose II (r. 1492–1479 B.C.), was born to a secondary queen, Mutnofret. Normally, only kings could have more than one wife at a time, so Thutmose II was probably born after his father became king and thus still quite young at his own accession. On early stelae, Thutmose II and Hatshepsut are shown with Ahmes, who was Thutmose's stepmother and mother-in-law.[25] Although Mutnofret may have nominally been regent for her son, apparently Queen Ahmes truly held the power, which may have been ceded to Hatshepsut herself, as she grew older. Thutmose II probably took the reins only a few years before his own death.

Thus, of the early kings of the Eighteenth Dynasty, probably only Thutmose I came to the throne as an adult. Ahmose, Amenhotep I, and Thutmose II seem to have been quite young at their accessions, perhaps averaging five years old, which means that their mothers or other female relatives ruled for ten to twelve years before they came of age. As a result, women effectively ruled Egypt for almost half of the approximately seventy years preceding Hatshepsut's accession. The acceptance of these women's rule and their veneration after death surely helped legitimize Hatshepsut's kingship. Her courtiers were accustomed to dealing with powerful women, and the Egyptian populace had long accepted their role as effective rulers of the country.

Hatshepsut's support of Thutmose III mimicked the tradition in which a mother ruled in the name of her young son. However,

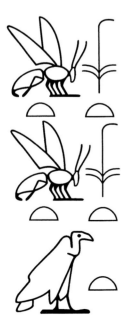

Fig. 4. These hieroglyphs read, literally, "King of Upper and Lower Egypt, King of Upper and Lower Egypt, Mother [of]." (In Egyptian writing, the king's title is given precedence as a sign of respect.) This enigmatic titulary was held by two Old Kingdom queens. It is not clear whether each woman was the mother of two kings, or whether each was acting as regent (Mother of the King of Upper and Lower Egypt) for her son and thus could add the king's title (King of Upper and Lower Egypt) to her own titulary. Drawing by Ann Macy Roth

like her mother, Queen Ahmes, Hatshepsut was not the mother of the young king for whom she ruled. Unlike the other powerful regents, going back to the time of the First Dynasty, neither Ahmes nor Hatshepsut held the important title of King's Mother.[26] Ahmes managed to rule without it, but Hatshepsut apparently could not, making the assumption of another role necessary.

WOMEN WHO RULED AS KING

In the history of Egypt, only a few women ruled as king, taking on the divinity of kingship and grappling, as Hatshepsut did, with a gender role in conflict with their own identities. There are three possible examples of such women known before Hatshepsut and two after her; all six female kings will here be considered briefly to determine the commonalities in their circumstances that impelled them to assume the kingship.

The first of these queens regnant was the wife of Djedkare-Izezi of the Fifth Dynasty, who is known from her unusually large pyramid next to his. Her mortuary temple was excavated by Ahmed Fakhry in the 1950s, but never published. Klaus Baer, who assisted Fakhry, described the scenes as having been "secondarily altered: stereotyped texts above the queen's figure had been erased and replaced by vultures and other royal insignia."[27] The temple was "badly destroyed," he noted, so the excavators were unable to determine her name. Elements from her monument were apparently incorporated into the monument of Unis, her successor. She seems to have had no young son for whom she might have been King's Mother. The royal insignia and the violence with which her monument was attacked after her death suggest that this queen ruled as a female king and was thus Hatshepsut's earliest predecessor.

The second such queen regnant may have been Queen Neith-Iqerti (in Greek, Nitocris), who seems to have ruled at the end of the Sixth Dynasty, although there is no mention of her in the sources for that period. Her name is recorded in later histories, however, both Egyptian and Greek.[28] Herodotus wrote that she succeeded her brother, avenging his death in an elaborate underwater suicide that drowned all his traitorous officials. If this queen existed (and serious doubts have been raised),[29] her position at the end of her dynasty, a position shared by the later queens regnant Nefrusobek and Tawosret, supports the assumption that she took the throne in the absence of a male heir.[30]

Queen Nefrusobek, a daughter of Amenemhat III, was apparently married to her brother Amenemhat IV, whose reign was very brief. After his death, she assumed the throne as the final king of the Twelfth Dynasty. She may have served as a direct model for Hatshepsut in her claims of co-regency with her father[31] and her combination of female dress with that of a male king. Again, she seems to have had no son for whom she acted as regent and no monuments that have survived undamaged.

Tawosret, who ruled after Hatshepsut at the end of the Nineteenth Dynasty, continued the patterns associated with female kings.[32] Tawosret was not a King's Mother; her husband was succeeded by Siptah, the young son of a secondary wife. Her reign was less successful than Hatshepsut's, probably because Siptah did not live to succeed her. Tawosret outlived him by about four years, and her reign was followed by a new dynasty. Her monuments, in which she was invariably shown as female, were usurped by her successor, Sethnakht, who sometimes changed her image into a table of offerings, just as images of Hatshepsut had been changed earlier.

Cleopatra VII, the last queen of the Ptolemaic Dynasty, took the throne following a different model, the Ptolemaic tradition of strong king's wives. Like the earlier queens regnant, she had no young son at the time of her coronation, and she did not abandon the throne later, even for her own sons.

Egyptian queens regnant had a thankless role. Their common characteristic was apparently the lack of a young son for whom to rule as King's Mother. Their rule in all cases marked the end of a line of kings in direct father-son succession (though not always the end of a dynasty). Most had very short reigns. In contrast to Kings' Mothers, who were honored for generations afterward, queens regnant were persecuted after death: their names obliterated, their monuments reinscribed for other rulers, and their images destroyed. This was not necessarily because the Egyptians found it inappropriate for a woman to hold power—Kings' Mothers ruled successfully and with honor for long periods. The destruction more probably resulted because these women were succeeded not by sons but by kings of less legitimacy, whose ties to the preceding royal line were tenuous or nonexistent and whose position would be strengthened by the obliteration of its memory.[33]

HATSHEPSUT'S CORONATION AND REIGN

Upon the death of her husband, Hatshepsut quickly installed his son on the throne as Thutmose III. To judge from the inscription of the vizier Ineni,[34] she exercised her authority openly from the beginning, initially citing only her title God's Wife, which referred to her important function in the temple of Amun-Re and may have assured her the political support of that god's priests. Indeed, given her husband's probable youth, it is not unlikely that she had already been ruling Egypt in his name for some years.

It is not clear at exactly what point Hatshepsut was crowned king (see n. 1 below). While apparently her initial instinct was to rule in the name of Thutmose III, she could not do this officially because she was not his mother. That title belonged to a woman named Isis, a secondary wife who did not have independent ties to the royal family as Hatshepsut did.

At some point it must have become imperative for Hatshepsut to take on titles that officially justified her rule—perhaps to safeguard the throne for Thutmose III. A precipitating factor for her coronation might have been the death of Isis, whose position as King's Mother perhaps gave cover for Hatshepsut's regency; the date of her death is not known. A threat to Hatshepsut's legitimacy might also have arisen from the death of her own mother, Ahmes. Although not a King's Mother until Hatshepsut's coronation, Ahmes had some authority through her role of Queen's Mother and her own ties to the main line of the royal family. The importance of that authority is shown by the fact that she was depicted standing behind Thutmose II and Hatshepsut in the same way that Kings' Mothers such as Ahhotep I and Ahmes-Nefertari had been shown behind their royal sons. Hatshepsut herself would perhaps have acquired similar power through the marriage of her own daughter Neferure to Thutmose III; however, there is no evidence this marriage ever occurred.[35] Perhaps Neferure and Thutmose III were too young to contract such a marriage when it was needed to bolster Hatshepsut's authority. Whatever the reason, Hatshepsut took on the role of king.

That she did not step down after her co-regent was of age has been taken as a sign of Hatshepsut's ambition, but in fact it is hard to imagine how she could have done so. She was not a King's Mother but a king, and once crowned, no known king ever ceased to be a king. A coronation in ancient Egypt was no mere ceremonial occasion:[36] its rituals literally transformed the new king into a god. Once Hatshepsut took the steps to make herself a king, and hence also a god, both she and Thutmose III were committed to joint rule until her death. Indeed, the prospect of this lifelong commitment may explain Hatshepsut's hesitation to take on the burden of kingship during the early years of Thutmose III's reign.[37]

While Hatshepsut used the roles of male kings and of Kings' Mothers as models for her own expression and exercise of political power, as a queen regnant she belonged to neither category. She belonged instead to a very elite minority of Egyptian women who ruled Egypt in their own right—as Daughters of Re, Ladies of the Two Lands.

1. The date of Hatshepsut's coronation remains a subject of debate. It is clear that she was not yet a king in year 2 of Thutmose III's reign and that she was crowned before the end of his year 7. She did not date her reign independently, instead dating her own reign from the beginning of Thutmose III's, so her year dates give no clue to the date of her accession. The year 7 terminus was argued by Lansing and Hayes 1937. See also Tefnin 1973.

2. The few exceptions to this rule mostly occur early in her reign. A block at Karnak shows her as a woman with an *atef* crown and the titles King of Upper and Lower Egypt, Lord (Lady?) of the Ritual (see fig. 38, below, and Chevrier 1934, pl. IV), and Luc Gabolde and Vincent Rondot (1996, p. 182) suggest that a masculine depiction of Hatshepsut on a dismantled building of her early reign at Karnak was originally female. Reliefs in which she is shown with a feminized male body, with clear breasts and narrow, rounded shoulders, are found only in the most sacred areas at Deir el-Bahri, the sanctuaries of Amun-Re and of Hathor (Gilbert 1953).

3. Scenes on the walls of the temple of Horus at Buhen were clearly altered. Traces underneath the final version suggest that Hatshepsut originally attempted a compromise. She appeared as a woman in a dress that reached her lower calf, but her feet were separated, not together as a woman's would be, in all but two examples. Her stride was less wide than that of the male figures (presumably Thutmose III) accompanying these altered representations, and in the revision her feet have been separated further. See Ricardo Caminos 1974, vol. 2, pls. 74, 82 (narrow stride and skirt), pls. 49, 61, 77 (narrow stride only), pls. 65, 68 (feet together). Caminos stresses that the identification of these early figures as Hatshepsut is conjectural. In one case (pl. 49) where the reliefs are preserved to a greater height than elsewhere, the shoulders were also widened, and the kilt was extended out farther in front. In these reliefs it is possible that Hatshepsut, like her predecessor Nefrusobek (discussed later in this essay), wore a male king's kilt over a dress, since it is unlikely that the upper part of her female body was shown nude.

4. For an example of this distinction from an earlier period, see A. M. Roth 2002.

5. A former King's Wife with a markedly female name (meaning "foremost of noblewomen"), Hatshepsut was clearly known by her people to be female. It is thus unlikely that she presented herself as male in her public appearances, although the many reliefs depicting her processions invariably show her as a male king.

6. During the Middle Kingdom, the catlike and lionlike qualities of princesses and queens were emphasized, as shown by the cat-claw anklets and the use of the sphinx form in the statues of queens. While one might speculate that this was the result of the domestication of cats during the course of the First Intermediate Period, even in the Old Kingdom queens and princesses had been associated with lions, which appear on sedan chairs and thrones—for example, the sedan chairs of Princess Watetkhethor (Wreszinski 1936, pl. 11) and Queen Meresankh III (Dunham and Simpson 1974, fig. 8). (Female cats and lionesses were associated mythologically with goddesses, the "eye of Re," while male cats were sometimes linked with the sun god Re himself.)

7. See Troy 1986, pp. 139–44, for a discussion of the way several queens regnant combined male and female iconography to create an androgynous kingship that replaced the traditional kingship defined by a king and a queen. In Troy's view, Hatshepsut assumed both roles herself.

8. Catharine H. Roehrig has suggested to me that the use of the term when Hatshepsut and Thutmose III were reigning together would have the additional advantage of obscuring which of the two kings was acting.

9. Examples at Deir el-Bahri in which the male officiant is said to act "that she may be given life" are the most common. Representations of male kings that were part of Hatshepsut's original decoration occasionally have feminine titles and epithets; these include representations of Thutmose I in the upper Anubis chapel (*ntrt nfr; jr.s dj ʿnh* in Naville 1894–1908, pt. 1, pl. XIV; fig. 1 above) and of Thutmose III (Amun calls him *ʒt.j,* in Naville 1894–1908, pt. 4, pl. CLXIV).

10. It may be that Hatshepsut saw the pattern of representation with a male body and female titles as a new model for kings of either sex and had it applied to Thutmose III and, retrospectively, to her husband and father. It has been suggested that Hatshepsut was paving the way for a line of female pharaohs that would continue with her daughter Neferure (Redford 1967, pp. 84–85). The suggestion is based on an inscription in Sinai in year 11 (see fig. 46) that shows Neferure making offerings to Hathor (a kingly prerogative) and also gives her kingly epithets. The application of female gender markers to male kings could support this theory.

11. Murnane 1977, pp. 32–44.

12. A different system, followed in the southern kingdom of Nubia in later periods, called for a king's brothers to precede his sons on the throne. The claims the god Seth makes for his brother's throne in the Osiris myth may allude to this pattern of succession.

13. Such women may have also had religious authority. By virtue of their sons' accession, they held, in the Old Kingdom period, the title *ʒt ntr,* "Daughter of the God," indicating that they were the source of some of the king's divinity. S. Roth (2001) has argued that this retroactive status reinforced the legitimacy of their sons' kingship.

14. The question of an Egyptian equivalent for "regent" was raised by P. Kyle McCarter Jr. at a study day devoted to Hatshepsut held at the National Gallery of Art, Washington, D.C., in fall 2002 in connection with the exhibition "Quest for Immortality." Participants agreed that the only title that could be so translated is *mwt nswt*, "King's Mother." I believe that this issue is crucial to understanding Hatshepsut's actions, and I am very grateful to Professor McCarter for raising it.

The title *jrjt-pˁt*, "Hereditary Princess," has sometimes been translated "regent" when it occurs in the titles of Tawosret (Altenmüller 1983b, p. 21; Callender 2004, p. 88); however, as this title was given in earlier periods to women who clearly were not regents, it seems more likely to indicate a status conveyed by Tawosret's birth than her function as regent.

15. The title has three elements, (1) "King of Upper and Lower Egypt," (2) "King of Upper and Lower Egypt," and (3) "Mother of." Because the title of king would precede everything else in the conventions of Egyptian writing (a phenomenon called "honorific transposition"), this title can be read either as "King of Upper and Lower Egypt and Mother of the King of Upper and Lower Egypt" or as "Mother of two Kings of Upper and Lower Egypt."

16. Brooklyn Museum, 39.119; Fazzini et al. 1989, no. 15.

17. Schäfer 1902.

18. See Lehner 1997, pp. 168–83, for a summary treatment of the queen's tombs of this period. The architectural differentiation and the comparative ranking of tombs of royal women are discussed in Dieter Arnold 2002, pp. 55–87, 117–18, 1200–22.

19. Marianne Galvin (1981) first proposed that women's roles in temple hierarchies decreased in status during this period; however, the point has been argued more generally by, for example, Fischer 2000, p. 45. In the Middle Kingdom, queens cease to be depicted alongside kings in statues and in the relief decoration of tombs and temples. Most royal women of the period are known only from their own tombs.

20. *Urkunden* 4, p. 21, ll. 10–16.

21. While the spellings of Ahmose and Ahmes are identical in Egyptian (in which vowels are not written), in this essay I have transcribed female names as Ahmes and male names as Ahmose to add some clarity to discussions of this family.

22. The name Thutmose (a modern compromise between the Greek transcription of the name and the Egyptian form, Djehutimes) makes reference to a moon deity, Thoth (Egyptian Djehuti). Two queens of the Seventeenth Dynasty also have names based upon Djehuti, and the god Iah honored by the name Ahmose/Ahmes (Iahmes) is also a moon god. It seems likely that Thutmose I, a high official under his brother-in-law Amenhotep I, was related to the royal family.

23. Many Kings' Daughters are known in this family and in royal families in later periods. (The genealogy in the introduction omits several.) However, among all the known tombs of high officials, none depicts a wife who holds the title. This is in striking contrast to Old Kingdom officials' tombs, particularly those of viziers, which often depict wives who were Kings' Daughters. The sons of these women inherited their rank, and they were given the title King's Son even though their fathers were not kings.

Stripping Kings' Daughters of their titles would have made sense in both the political and the theological contexts of the late Seventeenth and early Eighteenth Dynasties. The frequency of brother-sister marriage in the royal family can be seen both as a political attempt to ensure the purity of royal blood by preventing more distant relatives from claiming the throne, and as an imitation of the brother-sister marriages of important divinities like Geb and Nut or Osiris and Isis. If Kings' Daughters who did not marry kings had to abandon that title, their husbands could not use their status to challenge the ruling king, and their sons would not be Kings' Sons who might challenge the designated heir. Thus, the state avoided the creation of rivals to the king like that brought about by the Seth-Nephthys pairing of mythology, which created a dangerous, illegitimate alternative to Osiris and Isis.

A slightly later example of the abandonment of the title of King's Daughter can be seen with Tia, the sister of Ramesses II, who was presumably also the daughter of Seti I. Like Ahmes, however, she used only the title King's Sister. (See Martin 1997, passim; the single shawabti fragment, his no. 105, where the *sʒt nswt* is said to be present, seems to me very problematic.) The rule would

also explain why some kings of this period married their own daughters, which would have allowed specially favored daughters to retain the title.

24. In Hatshepsut's account of her own birth, Anubis tells Amun that Thutmose I is an *jnpw* (*Urkunden* 4, p. 219, l. 4). This title seems to describe a king during the period before his coronation and thus is normally used in retrospect. Erika Feucht (1995, pp. 503–12) has argued that it could also be used of a young king, but the assumptions underlying her argument are questionable. For example, she claims that Thutmose I's throne name would not be used if he were not yet king (although the inscription is clearly much later); that a tablet identifying a house as that of Thutmose IV when he was an *jnpw* must predate when the house was built (although it might have been inserted later); that an Amarna scene referring to Akhenaton as an *jnpw* cannot represent a pre-Amarna state; and that Tutankhamun would not have used a razor before his coronation at age nine (although Egyptian princes had shaved heads). By describing Thutmose I as an *jnpw* at the time that Amun-Re took Thutmose's form and visited his wife, Hatshepsut implies that she was born (or at least conceived) prior to his accession.

25. Ahmes is called "King's Mother" in the stela in the Ägyptisches Museum, Berlin (15699; Wildung 1974, pl. 34), but this title seems to have been altered from King's Sister after Hatshepsut became king. The depiction of Ahmes behind the young couple is reminiscent of the manner that Ahhotep II was sometimes shown with her son Ahmose and her daughter Ahmes-Nefertari, or Ahmes-Nefertari with her son Amenhotep I and his wives.

26. In addition to her title God's Wife, before her coronation Hatshepsut often used her mother's title, King's Sister. While she was clearly the (half) sister of Thutmose II, one wonders whether this might not also mean "King's Aunt," given the generational elasticity of Egyptian kingship terms, in a reference to her relationship to the ruling king, Thutmose III. After her coronation, Hatshepsut's inscriptions occasionally call Thutmose III her "brother." For example, *Urkunden* 4, p. 464, ll. 7–8.

27. Baer 1960, pp. 298–99.

28. Newberry 1943 cites references in the Turin papyrus, Manetho, and Herodotus.

29. Ryholt 2000.

30. It is also conceivable that Nitocris was actually Djedkare's queen, erroneously moved to a later dynasty in the temple records.

31. Murnane 1977, pp. 115–16.

32. For a recent compilation of the evidence for the reign of Tawosret, see Callender 2004.

33. Nefertiti, Akhenaton's queen, may have ruled as king in her own right, at the end of the Eighteenth Dynasty. Her situation mirrors that of Hatshepsut, Tawosret, and perhaps other queens regnant, in that she had no son. While her monuments, too, were attacked after her death, it is impossible to determine whether this was because she was a queen regnant or because of her association with Akhenaten's religious innovations. Her situation probably most closely paralleled that of Ahmes, Hatshepsut's mother, who played an important political role as the mother of the King's Wife, and it is possible that Nefertiti, like Ahmes, was able to use this authority and never required to take on a more kingly role.

34. *Urkunden* 4, pp. 59–60.

35. It is often assumed that Thutmose III was married to Neferure (see, for example, Dorman 1988, p. 79), but there is no clear evidence for this marriage.

36. Several writers have assumed that Hatshepsut's assumption of the kingly role was an incremental process, based on her apparently gradual adoption of male iconography. Gabolde and Rondot (1996, p. 214) describe the coronation as "progressif"; Peter Dorman (2005) speaks of "[t]he gradual increments in which Hatshepsut assumed her kingship," stating that hence "the question of her precise accession or coronation date is to some extent moot." This seems to me highly unlikely. An ancient Egyptian ruler was either king or not king; the role could not be played in a limited way.

37. According to Dorman 2005, "[no one could] have had foreknowledge of the many years that she would yet share the throne with her young nephew." On the contrary, Hatshepsut and her court seem likely to have been well aware that once she was crowned, the kingship would be shared for the remainder of her life.

1. Grips from a Dagger Handle of Thutmose I

Early 18th Dynasty, reign of Thutmose I
(r. 1504–1492 B.C.)
Wood
L. 12.1 cm (4¾ in.) and 6.3 cm (2½ in.)
The Metropolitan Museum of Art, New York,
Rogers Fund and Edward S. Harkness Gift, 1922
22.3.75a, b

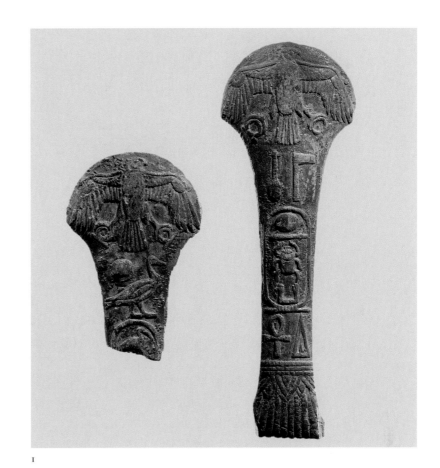

1

Inscribed for Hatshepsut's father, Thutmose I, these two wood grips were fixed to either side of the handle of a dagger. In the case of earlier Egyptian knives, a blade was hafted to a handle of a different material, but knives of the early Eighteenth Dynasty were sometimes made using a technique known from the Levant: the bronze knife blade and handle were made in a single piece, and wood grips were crimped in place on either side of the flat handle by raised rims. The wood inserts made the dagger handle rounder and easier to hold, and the contours of the relief inscription prevented the handle from slipping in the owner's hand.

The decoration on both of these grips faces to the right, the dominant orientation for Egyptian writing and art. The end of each is carved with a depiction of a falcon, its wings bent to fit the curve of the pommel and its claws grasping *shen* hieroglyphs, which symbolize eternity. The falcon represents Horus, a god personified on earth by the king; here, Horus may be seen as holding eternity himself and perhaps also extending it to the king named below.

The more complete of the two grips is inscribed with Thutmose's prenomen "The Good God, Aakheperkare, given life." The part of the grip adjacent to the blade is decorated with a stylized plant motif. The other grip is broken at the halfway point. Only the title Son of Re and the beginning of the king's nomen, Thutmose, are preserved.

AMR

PROVENANCE: Western Thebes, "Sankhkare" cemetery, found in debris near pit tomb 1013; Metropolitan Museum of Art excavations, 1921–22, acquired in the division of finds

BIBLIOGRAPHY: Wainwright 1925, p. 136; Hayes 1959, pp. 76–77

THE BURIAL OF A ROYAL WOMAN AND CHILD OF THE LATE SEVENTEENTH DYNASTY

In December 1908, the British Egyptologist W. M. Flinders Petrie discovered the intact burial of a woman and child while excavating in western Thebes, opposite the modern city of Luxor.[1] Petrie had been systematically exploring a small valley north of the road that leads to the Valley of the Kings (see map of western Thebes in the introduction).[2] The grave was not elaborate, just a shallow trench cut into the rock below an overhang and masked from view by a group of boulders.

Considering the simplicity of the burial place, the contents were of unexpected richness and quality. The woman's mummy was enclosed in a coffin decorated with a wing pattern (a *rishi* coffin), a type common at Thebes in the Seventeenth and very early Eighteenth Dynasties.[3] This example is unusual both for its size[4] and for its decoration, in which gold foil was generously used over the face and chest, in the stripes of the headcloth, and in the feather pattern. The coffin was found surrounded by pottery, including bowls containing food offerings of bread and dried fruit, and closed jars for liquid. Many of the small jars were enclosed in remarkably well-preserved pot slings and string bags, which had been used to suspend them from a long pole for transport to the grave.[5]

Among the pots were Egyptian forms that suggest a date late in the Seventeenth Dynasty[6] and six beakers of Kerma ware, an exceptionally fine type of Nubian pottery (cat. no. 5).

The woman was also provided with three stools, a wood box of linens, and a basket that held, among other things, an unusually fine horn container (cat. no. 2) and an anhydrite bowl decorated with monkeys (cat. no. 4). An exquisite inlaid headrest (cat. no. 6) was inside the coffin.

The woman's body had been decked out in a rich array of gold jewelry that included earrings, a necklace made of four strands of small ring beads (cat. no. 3), and four bracelets. A girdle of pocket beads and barrel beads, similar in style to catalogue number 119, is of electrum.[7]

The assemblage is significant for the variety of objects brought together in the same tomb. Found on its own, the girdle of pocket and barrel beads would probably be dated to the mid-Eighteenth Dynasty, while the anhydrite bowl is more in keeping with the late Thirteenth Dynasty. The Kerma beakers were certainly manufactured in Nubia, and some of the other objects have counterparts in the cemeteries at Kerma; however, most of the grave goods appear to be of Egyptian manufacture and conform to Egyptian taste and custom. Recent examination of the skeletal remains and determination of their mineral content have demonstrated that the woman spent her childhood in Egypt, whatever her connection to Nubia may have been.[8]

The richness of the burial indicates a level of wealth that would be notable in any period and suggests that the woman and child had a close link with the ruling family of Thebes.[9] Taken as a whole, this exceptional group of objects belies the conventional wisdom about Thebes in the Second Intermediate Period that was accepted by many Egyptologists until relatively recently. They believed that an almost constant state of conflict at that time with its neighbors to the south and north made Thebes into a relatively isolated provincial center, cut off from the trade and resources needed to acquire or manufacture luxury items of the type that this burial reveals.

CHR

1. Petrie 1909, pp. 6–10. Examination of the skeletal remains indicates that the woman was in her late teens or early twenties and the child was a toddler (Eremin et al. 2000, p. 35). Though the child was far too young for its sex to be determined from the skeletal remains, the type and distribution of the jewelry, which included spiral earrings and a bead girdle, suggest a girl.
2. Petrie's description and map are detailed enough to identify the general area of the grave but not its exact location.
3. The word *rishi* is Arabic for "feather." Feather-design coffins are peculiar to Thebes.
4. Eremin et al. (2000) record the length of the coffin as 2.3 meters (ca. 7½ feet). By contrast, the largest of the Metropolitan Museum's *rishi* coffins measures just under 1.95 meters (ca. 6½ feet).
5. Slings for much larger pots have been found in Egyptian tombs (Lansing and Hayes 1937, p. 33, fig. 39; Roehrig 2002, p. 37, fig. 49) and are depicted in wall paintings (Newberry 1893, pl. XII), but the best-preserved pot slings and string bags were found at Kerma (Reisner 1923, pp. 301–3, pls. 64, 65, 67), where only one or two were present in a single grave.
6. See Bourriau 1981a, p. 35.
7. Analysis of the jewelry is being conducted by the National Museums of Scotland Mummy Project. Preliminary results were published in Eremin et al. 2000, pp. 37–39.
8. Reported in "A Mummy Island," May 14, 2005, an episode of *Mummy Autopsy*, a Discovery Channel series.
9. Eremin et al. (2000) suggest that the woman was a queen of the Seventeenth Dynasty, an idea supported by the fact that a number of royal women of the late Seventeenth and early Eighteenth Dynasties seem to have been buried in isolated tombs in the hills and desert wadis of western Thebes.

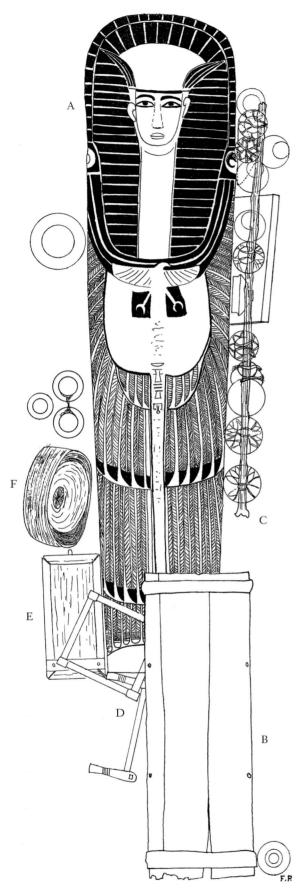

Fig. 5. The burial of a royal woman, 17th Dynasty. Included are her *rishi* coffin (A), the coffin of a child (B), numerous pots suspended from a long carrying pole (C), several stools (D), a box of linen (E), and a basket (F) holding a horn container (cat. no. 2) and a stone bowl decorated with monkeys (cat. no. 4). Drawing by W. M. Flinders Petrie

2

2. Horn Container

Late 17th Dynasty (before 1550 B.C.)
Cow's horn, wood, ivory
L. 20 cm (7⅞ in.)
The Trustees of the National Museums of Scotland,
Edinburgh A.1909.527.32

Most Egyptian horn containers are quite simple, with the pointed end carved into a spout or fitted with a wood spout and the large end plugged with a wood disk (fig. 6). The Edinburgh example is much more elaborate. The tip has an ivory fitting carved in the shape of a bird's head topped with a spoon. A small hole allowed the contents to flow into the spoon when the horn was tipped. An ivory disk decorated with an incised and inlaid rosette plugs the large end of the horn.[1]

Seven other horn containers or their remains have been found in Theban tombs dating from the late Seventeenth to the early Eighteenth Dynasty.[2] Another example was uncovered in an early Eighteenth Dynasty tomb at Saqqara.[3] Of these eight, five had been almost entirely destroyed by dampness or insects,[4] a circumstance that may explain the rarity of this type of vessel. At least five other horns are known: one from Thebes;[5] one from Saqqara;[6] and three without provenance.[7] Two bone or ivory spoon stoppers that were probably made for horn containers have also been recorded, one found at Thebes,[8] the other unprovenanced.[9]

There are pottery figure vases of the early Eighteenth Dynasty (cat. nos. 164, 165) that represent a kneeling woman holding an unadorned

horn similar to the one in figure 6. It has been suggested that the vessels contained medication used for gynecological purposes (see the discussion of figure vases in chapter 4). However, the evidence of actual horns does not support this hypothesis. The ten horns with documented provenance are associated with four men, four women, and a child.[10] Three horns appear to have contained oil,[11] and two others held a powder thought to be kohl.[12] Five horns were found inside coffins that also contained various combinations of pottery and stone jars, weapons, and a lute. One horn was in a basket of carpenter's tools; another was in a basket of cosmetic jars and sewing implements; a third was in a basket of jars, jewelry, and writing supplies; and one was set out with small jars containing wax, honey, and some fatty substance. The Edinburgh horn was found in a basket with an anhydrite bowl, a bronze cutting tool or razor, a whetstone, two flints, and a ball of thread. The motley grouping of objects might suggest that this horn was part

2, detail

Fig. 6. Horn container with a wood disk stopper, probably early 18th Dynasty. Excavated from burial R2 E3 in Lower Asasif, western Thebes, by the Metropolitan Museum. Egyptian Museum, Cairo (JE 45701)

of a kit belonging to an apothecary or a mid-wife; on the other hand, the basket may simply have been a convenient place to store unrelated objects. This rather disparate evidence suggests that horn containers were used for a variety of purposes, depending on the whim or profession of the owner.

Egyptian horn containers have been likened to vessels from western Asia that are depicted in Eighteenth Dynasty Theban tombs from the time of Thutmose III onward (fig. 22),[13] the theory being that Egyptian horns derived from Near Eastern prototypes.[14] However, the Asian vessels are of tusk, not horn, are more elaborate than most Egyptian horn vessels, and first appear in wall paintings made eighty to one hundred years later than the Edinburgh horn. In fact, this horn belongs to a time when Thebes seems to have had little access to Near Eastern luxury items.[15] It is possible, then, that Egyptian horn containers developed independently from the Asian variety.

CHR

1. The identification of the material as cow's horn was made by Andrew Kitchener, Curator of Mammals and Birds at the Royal Museum, Edinburgh. He has provisionally identified the ivory as from a hippopotamus.

2. A horn container (fig. 6; Egyptian Museum, Cairo, JE 45701) was found in the coffin of a woman in the Lower Asasif (burial R2 E3) by the Metropolitan Museum, and evidence of three more were found in MMA tomb 729; two were in the coffin of Baki (male), and one may have been in a basket associated with the burial of Neferkhawat (male). Three others were discovered in the eastern cemetery at Deir el-Medina by the French Institute. They were a fragmentary horn stored in a basket that probably belonged to a woman named Madja (tomb 1370); a complete horn (Cairo, JE 63753) with a wood stopper carved in the shape of a right hand holding a disk-shaped spoon, which was in the coffin of a woman (tomb 1382); and a horn (Musée du Louvre, Paris, E 14469) similar to the one in figure 6 that was in the tomb of a man (tomb 1389). For these three examples, see Bruyère 1937, pp. 84–86, fig. 42.

3. In this case a human-headed stopper with a disk-shaped spoon on the top (Cairo, JE 47783) was found in a child's coffin with traces of the horn container. See Firth and Gunn 1926, p. 68, pl. 45, F.

4. They were the three horns found in MMA tomb 729, the horn in Deir el-Medina tomb 1389, and the horn found in the child's tomb at Saqqara.

5. Now in the British Museum, London (EA 6037): British Museum 1975, p. 213, fig. 79. According to J. G. Wilkinson 1878, vol. 1, p. 401, this horn was in a basket of carpenter's tools found in the tomb of a man in western Thebes.

6. This horn has an ivory stopper carved into a cow's head with a disk-shaped spoon at the top. It is said to have come from the Serapeum at

Saqqara and is now in Cairo (CG 45201); see Bénédite 1920, pl. 1, 2.

7. A simple horn vessel similar to that in figure 6 is in the Petrie Museum, London: Petrie 1927, p. 37, pl. XXXIII, 17. Two similar vessels are in the Louvre: 1485 (Bénédite 1920, p. 82, pl. 1, 1) and AF 6611 (Brunner-Traut 1970a, pl. 7, c).

8. Found by Bruyère at Deir el-Medina (Cairo, JE 54893), this stopper is carved in the shape of a head wearing a *nemes* headcloth with a disk-shaped spoon on top.

9. This stopper is carved in the shape of a woman's head with a disk-shaped spoon on top and closely resembles the one excavated at Saqqara (Cairo, JE 47783). It is now in the Merseyside County Museums, Liverpool (1977.109.20): Susan K. Doll in *Eypgt's Golden Age* 1982, p. 293, no. 403. This listing of examples is limited to actual horn vessels and does not include a horn-shaped vessel made of faience that was found by Petrie at Kahun in a multiple burial dating from the Eighteenth Dynasty (Petrie 1891, pl. XXVI, 50).

10. These include the British Museum horn (see n. 5 above). The horn found by the Metropolitan Museum was in a coffin that also contained a lute, some cosmetic equipment, and two throw sticks, the latter seeming more in keeping with the burial of a man. However, the very cursory excavation notes on the burial identify the mummy as female.

11. Bruyère 1937, pp. 84–86.

12. Bénédite 1920, p. 81; but results published in Hassanein and Iskander 2003, p. 224, suggest that one of these in Cairo (CG 45201) contained oil rather than kohl.

13. They occur in Theban tombs 42, 84, 86, 90, and 100. The most elaborate example is in a fragment of wall painting in the British Museum: Nina de G. Davies 1936, vol. 1, pl. XLII.

14. Amiran 1962 in particular makes this connection.

15. A pottery horn-shaped vessel with a cow's head found in a Predynastic grave at Gerza (Petrie, Wainwright, and Mackay 1912, p. 23, pl. VII) and a horn associated with the Middle Kingdom burial goods of Henui from Gebelein (Steindorff 1901, p. 28 and n. 2, where Steindorff suggests that the horn may be modern, ill. on p. 29) indicate that the type had a long history in Egypt.

PROVENANCE: Western Thebes; W. M. Flinders Petrie excavations for the British School of Archaeology in Egypt, December 9, 1908–February 8, 1909

BIBLIOGRAPHY: Petrie 1909, p. 7, no. 15, pl. XXV; Bruyère 1937, p. 86; Eremin et al. 2000, p. 39

TECHNICAL STUDY

Among the rich grave goods of the burial is the horn (cat. no. 2) that W. M. Flinders Petrie found in a basket together with an anhydrite bowl (cat. no. 4), a bronze cutting tool, a whetstone, two flints, and a ball of thread. He noted that the horn's broader end was "covered with a plate of ivory . . . cemented on, and . . . therefore permanently closed."[1]

He also noted that the bird's neck had been cracked in antiquity and bound with a strip of red leather (the leather no longer survives).

The horn itself probably came from a domesticated bovine native to Egypt. The mountings are almost certainly made from hippopotamus ivory.

X-radiography shows that the horn was fairly roughly cleaned out and that there is a continuous passage to the opening in the "spoon." The opening has several deep scratches, as if a plug had been pushed in. These are different in appearance from marks where the hole was bored. The spoon itself and the decorated bird's head are finely carved and finished. The beak appears to be made of horn, as noted by Petrie. It is set into a deeply carved socket that does not connect with the passageway. Several areas at the end of the horn have a different X-ray density; some of these are modern repairs.

The round ivory end-plate was mounted on a block of wood shaped to fit as a socket into the horn. The ivory is decorated with inlays that have been partially restored in recent times. One ancient segment is wood, probably ebony; some areas are filled with a black waxy material and the remaining sections with a light brown substance. Samples of the organic material from these areas were found by analysis[2] to most probably come from a wax source. Black-colored wax was also used for decoration around the eye. There are traces of various colored oil or wax residues within the horn, but these have not yet been fully identified.

The sides of the wood socket retain clear impressions of a textile, which was found to be cellulosic and probably baste fibers (for example, hemp or flax) rather than cotton, impregnated with an organic material. Resinous material was detected on the edge of the end-plate. Two small pegs on the wood-and-ivory plate fit into holes in the end of the horn. The presence of the resin, fabric, and pegs confirms Petrie's observation that the horn was intended to be sealed. The contents were presumably decanted when a (now missing) plug was removed from the spoon end.

EG, JT, ANQ, AK, ALQ

1. Petrie 1909, p. 7.
2. By Fourier transform infrared microspectroscopy. Additional analysis by a technique such as gas-chromatography-mass spectrometry is necessary for more specific identification.

3. Ring-Bead Necklace

Late 17th Dynasty (before 1550 B.C.)
Gold
L. 38 cm (15 in.)
The Trustees of the National Museums of Scotland,
Edinburgh A.1909.527.19

This necklace, which was found in the burial described above, is made of four strands of gold ring beads, strung with an ingeniously fashioned clasp that is described in the technical study below. Chokers of similar ring beads date as far back as the Eleventh Dynasty at Thebes; one example was discovered in the tomb of Mayet, a young girl who was buried in the temple complex of Mentuhotep II (r. 2051–2000 B.C.).[1]

Two chokers (see cat. no. 121) and a double-strand necklace, all made of gold ring beads similar in size to those in the Edinburgh necklace and dating from the late Seventeenth or early Eighteenth Dynasty, were excavated by the Metropolitan Museum in the Lower Asasif section of the Theban necropolis.[2] The necklaces were found in the graves of three women, none of whom was buried with many grave goods or any inscriptions identifying her.[3] While these women were certainly not members of the royal family, the presence of gold jewelry in their burials suggests a certain level of prosperity.

The Edinburgh necklace has often been described as the earliest *shebiu* collar, a type of jewelry that the king gave to his officials as a reward (see cat. nos. 52, 54).[4] However, a *shebiu* collar was made of large, thick, lentoid beads and was tied around the neck, whereas the Edinburgh example is of narrow ring beads and its strands are brought together in a clasp. Both lentoid-bead chokers made of faience (similar in design to later gold *shebiu* collars) and gold ring-bead chokers were found in tombs of the late Seventeenth and early Eighteenth Dynasties in Asasif, suggesting that these are two different types that existed simultaneously.[5]

The same two types of beaded necklace remained in use for more than five centuries. Both varieties were found among the rich jewelry of the Twenty-first Dynasty king Psusennes I (r. 1040–992 B.C.) that was discovered at Tanis in the early twentieth century,[6] a further indication that they represent two distinct types of necklace. While both may well have been used as reward jewelry, only one should be given the precise name *shebiu*.

CHR, DCP

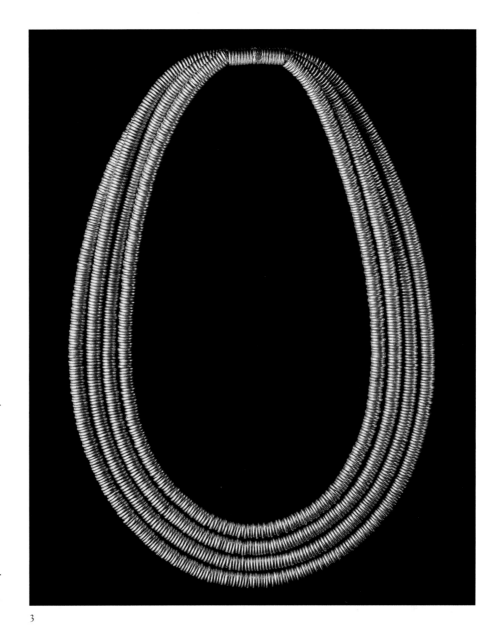

3

1. The tomb of Mayet was excavated by the Metropolitan Museum of Art (Winlock 1921, pp. 52–53, fig. 30); the necklace (22.3.322) came to New York in the division of finds.
2. In the division of finds, one choker (cat. no. 121) went to the Metropolitan Museum. The second choker (JE 45691) and the double-strand necklace (JE 45661) went to the Egyptian Museum, Cairo.
3. Each woman's burial also contained a pair of gold earrings.
4. For a discussion of the *shebiu* collar, see the section on jewelry in chapter 4, especially the entry for catalogue no. 109.
5. The Metropolitan Museum found two faience lentoid-bead necklaces in the tomb of a woman during its 1916 excavation season at Asasif. One of these is in the Metropolitan Museum (16.10.272); the other is in the Egyptian Museum, Cairo (JE 45676).
6. Psusennes's *shebiu* collar (Egyptian Museum, Cairo, JE 85753; Montet 1951, no. 482) is made of five strands of large lentoid beads. Two other necklaces have, respectively, five strands of large ring beads (Cairo, JE 85751; Montet 1951, no. 483) and seven strands of large ring beads (Cairo, JE 85752; Montet 1951, no. 484).

PROVENANCE: Western Thebes; W. M. Flinders Petrie excavations for the British School of Archaeology in Egypt, December 9, 1908–February 8, 1909

BIBLIOGRAPHY: Petrie 1909, p. 9; Aldred 1971, pp. 197–98, pl. 48; Andrews 1990, pp. 23, fig. 14b, 181–82; Eremin et al. 2000, p. 37; Adel Mahmoud in Ziegler 2002a, p. 431, no. 109

TECHNICAL STUDY

The necklace (cat. no. 3) was found in situ around the neck of a mummified woman. W. M. Flinders Petrie unwrapped the mummy at the time of its excavation, carefully recording everything he found.[1] He measured and weighed all the necklace elements and described its construction in detail. He counted 1,653 ring beads, strung in four rows. The rows are linked by a pair of terminals, each terminal consisting of four tubes made of eight rings soldered together. Each terminal has four cups, to hold

the knotted ends of the strings, and four horizontal wire loops. When juxtaposed, the loops from the two sides interweave and are held together by a locking pin. Petrie found that the pin had been erroneously inserted from below and thus the necklace was not closed properly.

Ring beads are usually made from wire rings soldered closed, but very few of the beads on this necklace have a visible join. The quality of the workmanship is remarkable; even under optical and scanning electron microscopy (SEM), joins are not detected on the outer surface. However, close examination of individual ring beads removed from the string for conservation has revealed that some have traces of a soldered join on the inner surface. Detailed study of two ring beads showed that they are very regular, with a diameter between 4.2 and 4.5 mm and a central hole 3.5 mm across. One weighs 55 mg,

3, clasp

the other 60 mg. Analysis[2] gives an approximate composition of 87 percent gold, 11 percent silver, and 2 percent copper. The locking pin is made of a harder alloy (72 percent gold, 22 percent silver, and 6 percent copper).

The outer, beveled faces of the ring beads are polished, while the flat sides and inner surfaces are rougher, as if cast and worked. Under magnification, various tool marks can be seen on the surfaces where after being formed into rings the metal was shaped and burnished. The method by which the ring beads were constructed is the subject of a current technical study. The smaller ring beads of a necklace found with the accompanying burial of a child[3] have very obvious joins and are much less uniform in size and surface finish.

EG, JT, KE, BM

1. Petrie 1909, pp. 8–10.
2. Energy Dispersive X-ray analysis (EDX) during SEM examination. The surface was cleaned and lightly abraded but not polished. Approximate compositions are from standardless analysis.
3. Petrie 1909, p. 10.

4. Bowl Decorated with Monkeys

13th Dynasty, reign of Sebekhotep IV–late 17th Dynasty (1731–1550 B.C.)
Anhydrite
H. 4 cm (1⅛ in.), Diam. 12.8 cm (5 in.)
The Trustees of the National Museums of Scotland, Edinburgh A.1909.527.33

The beautiful pale blue stone known as anhydrite was a popular material for cosmetic vessels in the Twelfth and Thirteenth Dynasties of the Middle Kingdom. Hundreds of examples have been found in the graves of both women and men.[1] However, anhydrite vessels carved

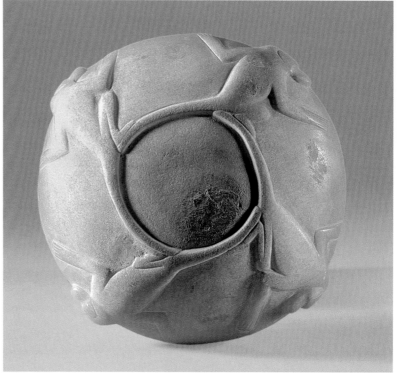

4, base

4

in animal form or decorated with animals, like the present example, are quite rare. Fewer than three dozen have been published,[2] and hardly any of these come from well-documented archaeological contexts.[3] Dated to the Middle Kingdom until the 1980s, the animal vases are now assigned a date range of the Thirteenth to the Seventeenth Dynasty (1802–1550 B.C.),[4] but this distinctive group of luxury vessels is so small and so homogeneous in style that they were probably all made in one location during a very brief time period.[5] An anhydrite vase inscribed with the name of the Thirteenth Dynasty king Sebekhotep IV (r. 1731–1719 B.C.) was found at Dendera,[6] and the animal vessels of known provenance come from Abydos and

Thebes.[7] It may well be, therefore, that the source of anhydrite was somewhere in this part of Upper Egypt. Sebekhotep's vase, though not in animal form, is elaborately carved and fits well with the type. Since the preponderance of anhydrite cosmetic vessels dates from the Twelfth and Thirteenth Dynasties, it seems likely that the animal vases come from late in this period, about the time of Sebekhotep, and that the example now in Edinburgh is, in fact, an heirloom from this period.[8]

The surface of the Edinburgh bowl is decorated with four monkeys or baboons carved in relief.[9] The animals squat, facing right, with their arms raised and their tails forming a ring base on which the bowl balances. A similar, slightly smaller bowl, decorated with two monkeys, was excavated at El-Arabah, near Abydos,[10] and a third bowl, also decorated with two monkeys and probably from the same general area, is in the Metropolitan Museum.

CHR

1. Bourriau 1988, p. 142.
2. Terrace 1966 and Fay 1998a together list thirty-four examples of vessels with animal decoration or of zoomorphic form.
3. The present bowl, now in Edinburgh, is the only excavated example known to come from an undisturbed tomb. The context is clearly late Seventeenth Dynasty, but one must remember that it provides only the date when the bowl was buried, not the date of its manufacture. According to Bourriau 1988, p. 141, only one of the duck vases (the most common variety of zoomorphic vessel) has a published archaeological context, and this is from a disturbed tomb, albeit one containing pottery consistent with the Seventeenth Dynasty.
4. In Fay 1998a, pp. 29–33, after a long discussion the author ultimately dates the anhydrite duck flasks to the Seventeenth Dynasty, but a number of her examples, notably the Metropolitan Museum's Girga group (see n. 7) and the so-called Terrace Group, do not come from archaeological contexts. She cites the Edinburgh monkey bowl but makes no mention of an excavated monkey bowl from El-Arabah that dates to the Middle Kingdom (see n. 10 below). At least two anhydrite kohl jars decorated with monkeys have also been dated to the Middle Kingdom (Bourriau 1988, p. 142).
5. As is also pointed out in Fay 1998a, pp. 29–30.
6. Weigall 1908, p. 107; Fay 1998a, p. 28.
7. A group of anhydrite vessels at the Metropolitan Museum was purchased in Cairo in 1910. This group is said to have come from a Twelfth Dynasty cemetery at Girga, a town about ten miles north of Abydos. However, Diana Craig Patch has pointed out to me that there is no cemetery of that date at Girga, which is in the flood plain near the river. The ancient cemeteries are across the river at Naga ed-Deir. There is no evidence of a royal workshop in the area, nor was Girga a noted pilgrimage site, and the cemeteries from pharaonic times have never produced anything

as luxurious as the anhydrite vessels. In 1910, Girga was the largest town near Abydos, and Patch suggests that objects found at Abydos would probably have been taken to Girga for sale. She also observes that this group (which includes vessels in the forms of a seated baboon and a fish—both animals sacred to Abydos) seems like a temple hoard, although that does not preclude some pieces being found in tombs.
8. For a contrary view, see Fay 1998a.
9. The animals have been described as monkeys, but their long snouts are more suggestive of baboons.
10. The bowl is now in the Egyptian Museum, Cairo (JE 46403): Garstang 1901, pp. 7–8, pl. IX, top right, E 237; Terrace 1966, p. 59, pl. XXVII. John Garstang, who was an expert on Middle Kingdom material, described the associated objects as being of "known types," but he illustrated nothing except the bowl and he did not state that the tomb was undisturbed. Tomb E 237 is near tombs that Garstang dated from the Thirteenth to the Seventeenth Dynasty, so a later date is possible.

PROVENANCE: Western Thebes; W. M. Flinders Petrie excavations for the British School of Archaeology in Egypt, December 9, 1908–February 8, 1909

BIBLIOGRAPHY: Petrie 1909, p. 7, pls. XXII, XXV; Terrace 1966, p. 59, sect. A, pt. 1, no. 9, pl. XVIII; Fay 1998a, p. 31, fig. 25

5. Kerma Beaker

Late 17th Dynasty (before 1550 B.C.)
Pottery
H. 10.2 cm (4 in.), Diam. 12.7 cm (5 in.)
The Trustees of the National Museums of Scotland, Edinburgh A.1909.527.8

Six Kerma beakers were found in the burial, stacked in twos in the first three pot slings at one end of the carrying pole. While the rest of the pottery from the tomb is recognizably Egyptian[1] and was probably made locally, these beakers must have been manufactured around Kerma, the capital of the kingdom of Kush, which lay just south of the Third Cataract in what is now Sudan (see map, fig. 15). They belong to the Classic Kerma Period (1750–1550 B.C.), which roughly corresponds to the Second Intermediate Period and the very early New Kingdom in Egypt.[2] The presence in this grave of Kerma pottery has led to the suggestion that the woman was a Nubian who had been largely acculturated into a high level of Theban society. However, in the light of current knowledge of Nubian and Egyptian relations during the Second Intermediate Period (see "Egypt and Nubia" by W. Vivian Davies in this volume), it seems equally possible that she was from an Upper Egyptian family that through connections

5

6

with Nubia, either as traders or in military serv-
ice, had developed a taste for Nubian crafts.

Classic Kerma beakers, a form of black-
topped red ceramic, were made by hand with-
out use of a wheel. They have thin walls with
sharp rims and are very lightweight, although
quite resilient. Egyptians too made a type of
black-topped red ware, but they never devel-
oped a mastery of firing techniques equal to that
of the Kerma potters. Producing the lustrous
black and deep red surfaces of the Classic
Kerma pots seems to have required more than
one firing.[3] A light-colored, variegated band
separating the black and red zones is specific to
this phase of Kerma pottery. Taken together,
the form, delicacy, and surface treatment of
Classic Kerma beakers place them among the
finest ceramic art forms ever created.

CHR

1. Bourriau 1981a, p. 35.
2. Though the vast majority of Classic Kerma beakers
 have been found in tombs, a few examples have also
 been found in habitation sites at Kerma and Sai
 (Gratien 1978, p. 204).
3. Ibid., pp. 210–11.

PROVENANCE: Western Thebes; W. M. Flinders
Petrie excavations for the British School of Archaeology
in Egypt, December 9, 1908–February 8, 1909

BIBLIOGRAPHY: Petrie 1909, p. 6; Eremin et al.
2000, p. 39

6. Headrest

Late 17th Dynasty (before 1550 B.C.)
Acacia wood inlaid with ivory and East African
ebony
H. 14 cm (5½ in.), L. 30.5 cm (12 in.)
The Trustees of the National Museums of Scotland,
Edinburgh A.1909.527.3

This headrest was made in three pieces fastened
together with tenons. The graceful design, with
an octagonal neck and long, narrow base, is
typical of the period bridging the late
Seventeenth and early Eighteenth Dynasties.
The headrest was carved from acacia, a local
wood. Its inlaid decoration is of ivory, either
local hippopotamus tusk or imported elephant
tusk, and ebony, which was imported into
Egypt from areas farther south.[1] Headrests of
similar type and date have been found else-
where in western Thebes, though none com-
pares in beauty with this example.[2]

CHR

1. Modern analysis of the materials was published in
 Eremin et al. 2000.
2. This headrest and another from Thebes are pub-
 lished in the typology in Reisner 1923, p. 233,
 fig. 221, nos. 19, 20; another of this type was found
 in Lower Asasif by Lord Carnarvon and is now in
 the Metropolitan Museum, New York (14.10.9). At
 Kerma, Reisner found headrests of a similar type
 but with with even longer bases (Reisner 1923,
 pp. 236–39).

PROVENANCE: Western Thebes; W. M. Flinders
Petrie excavations for the British School of Archaeology
in Egypt, December 9, 1908–February 8, 1909

BIBLIOGRAPHY: Petrie 1909, p. 8, pls. XXII, XXV;
Reisner 1923, pp. 232–33, fig. 221, no. 19; Eremin et al.
2000, p. 39

ART IN TRANSITION

The Rise of the Eighteenth Dynasty and the Emergence of the Thutmoside Style in Sculpture and Relief

Edna R. Russmann

In all the history of pharaonic Egypt, no artistic style was more influential than the Thutmoside style of the early Eighteenth Dynasty in which Hatshepsut, Thutmose III, and their immediate kingly predecessors and successors were represented in sculpture and relief. The style's appeal lay perhaps in the generic quality of the elegant, impersonal features with which these rulers were depicted; perhaps it was owing to the prominence of their monuments, many of which stood for generations at Karnak and other major temples. Certainly, a desire among later kings to present themselves in the guise of the great Thutmose III played a role in perpetuating the Thutmoside style. It was emulated by Seti I and Ramesses II of the Nineteenth Dynasty,[1] by the kings of the Third Intermediate Period,[2] and, later still, by the kings of the Twenty-sixth Dynasty. The statues and reliefs of these pharaohs formed the basis for the royal style of the Thirtieth Dynasty, which was subsequently adopted by the Ptolemaic rulers.[3] In its many manifestations over the centuries, the Thutmoside style came to be regarded by many foreigners as the quintessential Egyptian style, and to some extent it remains so today. It seems particularly ironic, therefore, that we know so little about the origins of this style.

Archaism—the emulation or imitation of works from earlier periods—was an important component of ancient Egypt's conservative culture,[4] particularly at the beginning of a new dynasty or political era. It is not surprising, therefore, that most of the surviving representations of the first two kings of the Eighteenth Dynasty, Ahmose I (r. 1550–1525 B.C.) and Amenhotep I (r. 1525–1504 B.C.), were strongly influenced by monuments of the past, in particular by works of the early Middle Kingdom at Thebes.[5] We should be cautious, however, when trying to identify specific instances of borrowing.[6] Artists could imitate only what they could see, so only visible monuments could serve as prototypes. It has often been observed that the reliefs at Karnak of the Twelfth Dynasty king Senwosret I (r. 1961–1917 B.C.) were the principal sources for representations of Ahmose I and Amenhotep I. It is

seldom noted, however, that the influence of Senwosret I's images is not found in the reliefs of Ahmose I and Amenhotep I at Abydos, where little was to be seen of the earlier king's works, or that the images of the late Twelfth Dynasty king Senwosret III (r. 1878–1840 B.C.), whose reliefs and statues were plentiful at temples near Thebes,[7] were not emulated by the early Eighteenth Dynasty kings, perhaps because they looked so somber. Generalizations based on a failure to consider all such available evidence can lead to unsound conclusions.[8]

Although much has been written about archaism, relatively little attention has been given to evidence of the uninterrupted continuation in the early Eighteenth Dynasty of artistic traditions from the immediate past, perhaps because the evidence is harder to recognize and evaluate. W. Vivian Davies established that a statue of a seated royal figure in the British Museum, long identified as a depiction of the Thirteenth Dynasty king Sebekhotep III (r. 1748–1741 B.C.), in fact represents King Sebekemsaf I (r. 1632–1616 B.C.), of the Seventeenth Dynasty.[9] This discovery is of considerable significance, not only because it adds to our short list of statues of Seventeenth Dynasty kings,[10] but also because it indicates that this Thirteenth Dynasty type of important royal temple statue—large, carved in dark stone, showing the king seated and wearing a *nemes* headcloth and *shendyt* kilt, his face and form distinctively idealized—persisted into the Seventeenth Dynasty.

A chronological examination of the surviving statues of seated kings reveals a progressive exaggeration of the idealized royal features. The earliest known example, a figure of the Thirteenth Dynasty king Amenemhat V (r. 1795–1792 B.C.),[11] is fairly naturalistic: the long, smiling face tapers to a rounded chin, and the long-limbed, small-waisted body is quite athletic. In succeeding statues, the king's face tapers more and more, his smile becomes less pronounced, and his waist continues to narrow. By the time of Sebekemsaf I, the royal face, seen from the front, resembles an inverted triangle. The expression is neutral. The king's figure is still long of limb, but a markedly pinched waist makes it seem

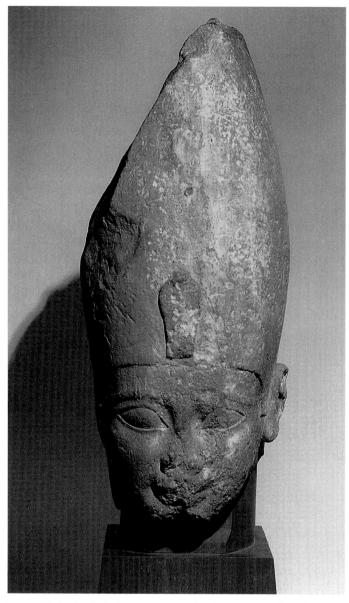

Fig. 7. Lifesize head of Ahmose I wearing the white crown, early 18th Dynasty. Limestone. Private collection

broader, rounder faces characteristic of depictions of women (see cat. no. 11), but with rather pointed chins. Features similar to those of the large statues of seated kings are also found on limestone statuettes, predominantly of women, from this period at Thebes. Most represent nonroyal persons.[16] The bodies are usually slender, with little anatomical detail. The heads are somewhat overlarge and emphasized by heavy wigs that frame smiling faces with large, bright-looking eyes. These attractive little figures, sometimes dismissed as dry or naive,[17] are historically significant, as the only surviving link between sculptural style at the end of the Seventeenth Dynasty and the shawabti of Ahmose I, the first royal forerunner of true Thutmoside style. It is unfortunate that almost none of the statuettes can be dated with any precision, either by inscription or by archaeological context.[18]

The most remarkable feature of Ahmose's shawabti (cat. no. 12) is the small face, carved rather summarily yet expertly, which begins to taper just below eye level and ends in a very pointed chin. The lips turn up a bit. The eyes are slightly slanted, with elongated corners and arched upper lids, under rounded brow ridges. Most of these characteristics can be related to those of the limestone statuettes discussed above. In the shape of the face, the shawabti of Ahmose recalls the large statue in the British Museum of Sebekemsaf I seated. All the facial features of the shawabti approximate those of later depictions of kings in the Thutmoside style.

The sole identifiable fragment of a large statue of Ahmose I found in Egypt is a slightly over-lifesize limestone head of the king wearing the white crown of Upper Egypt (fig. 7).[19] The face is broad, with flat, unmodulated planes and a taut, smiling mouth. The misleading naive quality of this finely worked head suggests that its features derive probably from representations of the Eleventh Dynasty king Mentuhotep II (r. 2051–2000 B.C.), such as those in his funerary temple at Deir el-Bahri, or possibly from certain statues of Senwosret I at Karnak. However, no statue of Mentuhotep II or Senwosret I has such large, protuberant eyes, nor do any have both irises and pupils delineated as incised circles, as on this head. In raised or incised reliefs, the iris began to be indicated as early as the Middle Kingdom. Even in reliefs, however, the detail was unusual, and it was extremely rare on sculpture.[20]

The figures on a stela of Ahmose I honoring his grandmother Queen Tetisheri (cat. no. 10) have large, bulging eyes similar to those on the limestone head of Ahmose, though without the incised details.[21] In size and shape, they resemble the eyes in relief representations of the Seventeenth Dynasty king Sebekemsaf I at Medamud, near Thebes.[22] Both the Sebekemsaf reliefs and the Ahmose stela adhere closely to Twelfth Dynasty models, except for the exaggeration of the figures' eyes. This shared departure from precedent may suggest that the reliefs and the stela are somehow related.

rather willowy.[12] Though the statue of Sebekemsaf I in the British Museum does not at all resemble Thutmoside sculpture, it exhibits many core features of the Thutmoside style.

We have no evidence whether this type of statue continued to be produced throughout the Seventeenth Dynasty and into the early Eighteenth. The next surviving examples date from the time of Hatshepsut and Thutmose III, when the Thutmoside style was fully developed.[13] The persistence of "proto-Thutmoside" facial features at Thebes during this period can be inferred, nonetheless, from the long, tapering jaws of some male faces, many of them quite crude, depicted on Seventeenth Dynasty royal coffins.[14] Two female faces, one on the gilded coffin of a princess or queen who seems to have lived at the start of the Eighteenth Dynasty and the other the gilded mummy mask of a lady-in-waiting at the court of Ahmose I,[15] have the

The single complete large statue of Ahmose I known is a seated figure in painted sandstone, found at a temple that he established on the island of Sai in Nubia (now Sudan). The king wears the white crown with the uraeus, the artificial royal beard, and a short Sed-festival cloak, and holds a crook and flail.[23] A similar representation of Amenhotep I was later erected at the same site (fig. 16). Describing the two figures, W. Vivian Davies stressed the quality of their modeling and the differences between the very battered faces.[24] Unfortunately, one can discern little in the published photographs of the statues. The round heads and bodies appear so blocky that one is reminded of the seated figure of Mentuhotep II in Sed-festival garb found at Deir el-Bahri,[25] though it is more probable, as Davies suggested, that the figures were made by local, Nubian sculptors, in whose work exaggerated forms of this kind were typical.

The only other known representations of Ahmose I in three dimensions are the heads of two little gold sphinxes flanking his cartouche on a bracelet from the burial of Queen Ahhotep.[26] The modeling of the tiny heads is summary, but the large eyes, plump cheeks, and upturned lips are in keeping with the features of the limestone head of Ahmose discussed above (fig. 7).

So few surviving representations are inscribed with Ahmose's name that attempting to recognize "his" features in works that are not otherwise identifiable seems foolhardy. One uninscribed statue, however, merits consideration: a sphinx in yellow limestone that was found not far from Ahmose's cult center at Abydos (fig. 8).[27] The style of the broad, smiling face indicates that this is

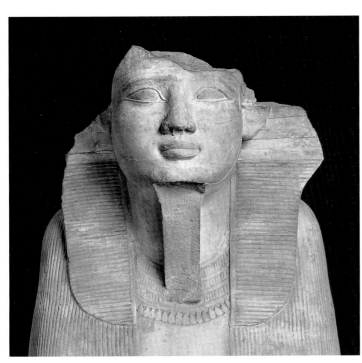

Fig. 8. Head of a small sphinx, possibly representing Ahmose I, early 18th Dynasty. Limestone. The Trustees of the National Museums of Scotland, Edinburgh (A.1900.212.10)

probably a work of the early Eighteenth Dynasty, but one hesitates to identify either Ahmose I or Amenhotep I, who continued the work on his late father's monument at Abydos and who is represented there, as the subject.[28] The breadth of the face and the slight smile may relate the sphinx to the limestone head of Ahmose discussed above (fig. 7). However, the detailed articulation of the face—the full cheeks, the folds beside the nostrils, and the round, fleshy chin—is quite unlike both the summary modeling of these details on the head of Ahmose and the modeling of heads of Amenhotep I, discussed below (cat. no. 13; figs. 9, 11). The sphinx's long eyebrow strips and cosmetic lines, rendered in raised relief, are also absent from surviving statues of both kings. One feature, nonetheless, suggests that the sphinx does indeed represent Ahmose: the large, protuberant eyes, which resemble those on the limestone head and on the large stela from Ahmose's Abydos complex (cat. no. 10). Another statue has these big bulging eyes, a seated figure, in limestone, of a certain Prince Ahmose.[29] The identity of the prince has been debated, but the available evidence suggests that he lived no later than King Ahmose I. These three representations, few as they are, support a provisional identification of the sphinx as Ahmose.

A stela from Karnak in raised relief shows Ahmose I with his queen, Ahmose-Nefertari, and a small prince before the god Amun-Re.[30] Both the bodies and the faces of the figures follow those on the numerous reliefs of Senwosret I at Karnak. The reliefs of Amenhotep I on structures that he had erected at Karnak also imitated those of Senwosret I. Amenhotep's reliefs, numerous examples of which are today both at Karnak and (as fragments) in many museums, are remarkable not only for their overall fidelity to their models but also for the way in which the carved facial features of Senwosret were adapted to create a quite different visage, which, with its long, slightly retroussé nose, flared nostril, short philtrum, and slightly pursed lips, is instantly recognizable as that of Amenhotep I.[31] This group of representations of Amenhotep often has other distinctive details as well, such as thick, elongated eyebrows and cosmetic lines in raised relief and an indication of the indentation in the philtrum—a detail seldom depicted in Egyptian reliefs. As on the limestone statue head of Ahmose (fig. 7), the iris of the eye (but not the pupil) is indicated plastically.[32] Another group of reliefs at Karnak shows Amenhotep with similar but fleshier, older-looking features. The eyes in these representations[33] have natural, rounded brow ridges in most cases and lack cosmetic lines.

The existence of such distinctive features in depictions of Amenhotep—at different stages of his life, it seems—raises the question whether these depictions are portrait likenesses of the king. In yet another set of reliefs at Karnak, on Amenhotep's alabaster chapel, the king is again shown as an aging man with a sagging chin. The rest of his profile, however, is quite different

from that on other images of him: the forehead bulges and the nose, though still long, has a decided downward curve.[34] Since Thutmose I seems to have overseen the completion of the alabaster chapel, these images of Amenhotep may have been carved late in his life, or even posthumously.[35] Moreover, only the alabaster reliefs, not the more numerous limestone examples, bear any resemblance to the only statues securely identifiable as depictions of Amenhotep I: the series of Osiride statues that Amenhotep had erected at Deir el-Bahri (see figs. 9, 11)[36] and a small sphinx from Karnak.[37]

The kingship of the third and fourth rulers of the Eighteenth Dynasty, Thutmose I (r. 1504–1492 B.C.) and Thutmose II (r. 1492–1479 B.C.), was central to the claims of legitimacy and strategies to gain power of both Hatshepsut and Thutmose III. As instruments in the political maneuvering of Hatshepsut and her successor, many images of Thutmose I and Thutmose II were made posthumously. There are few representations of either king that we know to have been produced during their lifetimes, and almost no such examples in sculpture.

A well-preserved statue of a seated figure, today in Turin, has long been considered the primary representation of Thutmose I,[38] even though the inscription on the statue indicates that it was dedicated by a successor and, thus, was made posthumously. Moreover, a recent reexamination of the inscription, which was altered at least once, suggested that the statue may in fact represent Thutmose II.[39] In any case, it is not a contemporary representation of Thutmose I.

The only statues of Thutmose I that we know to have been made for him are the sandstone Osiride statues he had erected at Karnak, between the Fourth and Fifth Pylons (fig. 12).[40] Those still in situ are badly mutilated, but the well-preserved face of one was found nearby.[41] Although the face is somewhat broader and rounder than that in most representations of Hatshepsut or Thutmose III, the elegantly contoured eyes, the sweeping brows in raised relief, and the pleasant expression of the well-shaped mouth are stylistically close to the features on statues of his successors. This may be the earliest surviving example of the true Thutmoside style. A head now in Turin (cat. no. 14) may also be from this Osiride group.

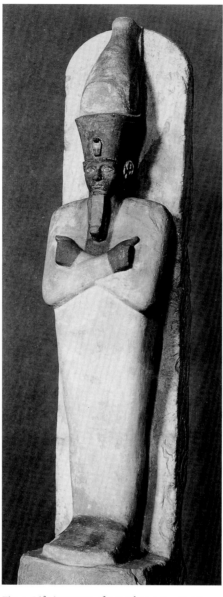

Fig. 9. Lifesize statue of Amenhotep I as Osiris, early 18th Dynasty. Limestone. Excavated at Deir el-Bahri, western Thebes, by the Egypt Exploration Fund. The Trustees of the British Museum, London (EA 683)

It was long believed that no contemporary statues of the short-lived Thutmose II had survived. In 1984, however, Günter Dreyer reported finding the inscribed base of a lifesize statue of a seated man carved in rose granite, pieces of which had been turning up at Elephantine for years.[42] The figure, wearing the white crown with the uraeus, is clad in a short Sed-festival robe and holds the crook and flail in the Osiride manner. The inscription identifies the subject as Thutmose II. As on other early Thutmoside monuments, the text has been altered; a small but crucial part is lost. Nonetheless, Dreyer believed that the original dedicator of the statue could be identified as Hatshepsut, while she was regent. In that case, the statue would still be posthumous, but only slightly so. While Dreyer's argument is not conclusive, it seems to be supported by the old-fashioned look of the face, which is rounder and shorter than the Osiride head of Thutmose I, and which has broad, artificial-looking eyebrow strips and cosmetic lines in raised relief, like those on the pre-Thutmoside sphinx from Abydos (fig. 8).[43]

The small tomb statues made for nonroyal people of the late Seventeenth and early Eighteenth Dynasties have been cited above as precursors of the Thutmoside style.[44] It is noteworthy how the statuettes of women among them prefigured the poses of women in New Kingdom sculpture. They were the first depictions of women standing with the left foot advanced (see cat. no. 18) and of women standing or sitting with one arm bent across the chest and the hand either fisted (see cat. no. 17) or holding a flower (see cat. no. 18). In contrast to the traditional female pose—women were portrayed as utterly passive, with feet together, arms at their sides, and hands open and flat (cat. no. 7)—the poses of statuettes made at the beginning of the Eighteenth Dynasty suggest movement, activity, and even, perhaps, a degree of control. Both the number of these statues and the changes they incorporated may reflect increasingly prominent roles for Egyptian women at the beginning of the New Kingdom, analogous to, and possibly connected with, the enhanced status of Egyptian queens. They were to become standard for statues of women throughout the New Kingdom.

Throughout Egyptian history, periods of major political change had a direct influence on art, permitting and perhaps even

encouraging innovations that would largely have been unthinkable in more settled times. Surviving statues and reliefs that can be attributed to the Seventeenth and early Eighteenth Dynasties are, regrettably, few in number, and, partly for that reason, they raise many questions to which we still have no answers. Yet in much of this art—in the representation of kings' facial features, for example, in manners ranging from the schematic, for the seated statue of Sebekemsaf I in the British Museum and the head of Ahmose I, to the distinctively detailed, as on the heads of Osiride statues of Amenhotep I—we can sense an interest in experiment and change that we seldom detect in the formal images of Egyptian kings and nobles. In the introduction of new, less passive poses for women, we seem to see artistic conventions in the process of being adapted to the realities of a changing society. It was from these varied beginnings that the Thutmoside style emerged, in all its elegant strength and impersonal beauty.

1. See Sourouzian 1998, pls. 40, 41, 46, 47.

2. Myśliwiec 1988, pls. 15–25.

3. For the evolution of this style from the Twenty-sixth to the Thirtieth and the Ptolemaic Dynasties, see Edna R. Russmann in Russmann et al. 2001, pp. 43–44. Examples are illustrated in Aldred et al. 1980, pp. 143–45, figs. 125–27, p. 285, fig. 287 (Twenty-sixth Dynasty), and in Russmann et al. 2001, pp. 246–47, no. 135 (Thirtieth Dynasty), pp. 250–51, nos. 138, 139 (Ptolemaic).

4. For a brief discussion of archaism, see Russmann in Russmann et al. 2001, pp. 40–44.

5. Romano 1976; Russmann in Russmann et al. 2001, p. 42.

6. For a masterly discussion of some of the problems involved, see Romano 1976.

7. See, for example, statues of this king from Medamud (and today in the Louvre, Paris) in Delange 1987, pp. 24–29.

8. See, for example, Baines 1989, p. 142: "In modelling itself on [the art of] the 12th dynasty, the early 18th evaded [sic] the 11th, the previous reuniters of the country whose rule did not last." Baines not only disregards the likelihood that representations of Ahmose were indeed influenced by statues of the Eleventh Dynasty king Mentuhotep II; his assertion is also contradicted by the homage paid to Mentuhotep II by Amenhotep I, who, like Senwosret III, had statues of himself erected at the site of the funerary temple of Mentuhotep, the "previous reuniter."

9. W. V. Davies 1981. The statue (EA 871), of red granite and slightly larger than life, probably comes from Karnak; it was acquired by the British Museum in 1907.

10. Ibid., pp. 29–31, nos. 44–53.

11. See the chronological list of statues (including other types) in ibid., pp. 21–31; this statue is on p. 22, no. 3. For the join of the base (Aswan Museum, 1318) to the bust (Kunsthistorisches Museum, Vienna, ÄS 37), see Fay 1988; for more recent bibliography, see Wildung 2000, pp. 138, 184, no. 63.

12. W. V. Davies 1981, pls. 1, 7–14.

13. Museo Egizio, Turin, 1374. This statue of a seated figure, inscribed for Thutmose I, is posthumous; see n. 38 below.

14. See the remarks of Vandier 1958, pp. 291–92, fig. 14.

15. The former (Staatliche Sammlung Ägyptischer Kunst, Munich, ÄS, 7163) is the principal subject of Grimm and Schoske 1999b. For the mask (British Museum, London, EA 29770), see Russmann in Russmann et al. 2001, pp. 204–6, no. 106. The face on the coffin of Queen Ahhotep, however, is rather long and has a rounded chin (Egyptian Museum, Cairo, CG 61006; Daressy 1909, pls. VIII, IX).

16. For the limestone bust of a queen in the collection of Nanette Kelekian, see Russmann forthcoming.

17. See, for example, Matthias Seidel and Dietrich Wildung in Vandersleyen 1975, p. 240.

18. Nonroyal tomb statuettes are discussed further below. See also the entries for cat. nos. 17–20.

19. Published in Romano 1976, pp. 103–5, pls. 28, 29. Ahmose's name is partially preserved in an inscription on the back pillar of the statue.

20. For plastically delineated irises on a face from an extremely fine, large nonroyal statue of the early Nineteenth Dynasty, see Sotheby's 2004, lot 306. For a summary of occurrences of this detail, see Fazzini 1997, pp. 116–17, nn. 32–39; indications of both iris and pupil are discussed in Fazzini forthcoming, n. 12.

21. The bulging eyes are clearly visible in details of the stela published by Myśliwiec 1976, figs. 1, 2 (with incorrect identification; see the entry for cat. no. 10).

22. Bisson de la Roque 1930, pls. 6, 2 and 7, 2; recently discussed by Eder 2002, pp. 110–11.

23. Welsby and Anderson 2004b, p. 103, fig. 79 (upper half only).

24. Ibid., pp. 102–3 (with bibliography). The statue of Amenhotep I, no. 76 in the catalogue, is illustrated on p. 102. I have not had the opportunity to see these statues.

25. Egyptian Museum, Cairo, JE 36195; Saleh and Sourouzian 1987, no. 67.

26. Egyptian Museum, Cairo, CG 52642; H. W. Müller 1989, pp. 1–4 (with bibliography), pl. 1; detail of one head on pl. 1c; see also Lindblad 1984, p. 16.

27. Royal Museum, Edinburgh, 1900.212.10; Lindblad 1984, pp. 23–24, pl. 10, a–d (with bibliography); on the provenance, see Harvey 1998, p. 408.

28. Harvey's current reexcavation of the cult complex will, one hopes, expand our knowledge of the history and art of both kings; Harvey 2004, pp. 5–6.

29. Musée du Louvre, Paris, E 15682; Vandier 1958, pl. XCVI, 3, 5. Large eyes are also found on a statue of Princess Ahhotep (cat. no. 7), which may be a little earlier than the statues discussed here.

30. Porter and Moss 1972, p. 73; well illustrated in Vandersleyen 1971, pl. 1.

31. Myśliwiec 1976, figs. 8–11, 14, 15.

32. Ibid., figs. 11, 22, 23. On this detail, see n. 20 above.

33. Ibid., figs. 7, 12, 13.

34. Ibid., figs. 5, 21; very well illustrated in K. Lange and Hirmer 1961, pls. 116, 117.

35. Romano 1976, p. 102.

36. For further discussion of these statues, see the entry for cat. no. 13.

37. Egyptian Museum, Cairo, CG 42033; Lindblad 1984, pp. 37–38, pl. 20, a–d; Russmann 1989, pp. 81–82, 217, no. 36. The same features, slightly feminized, appear in a depiction of Amenhotep's wife and sister, Ahmose Meryetamun, on her wood coffin: Egyptian Museum, Cairo, JE 53140 (fig. 72); Lindblad 1984, pp. 30–31, pl. 15, a–c; Saleh and Sourouzian 1987, no. 127.

38. Museo Egizio, Turin, 1374; Lindblad 1984, pp. 56–57, pls. 35, 36, a–c (with bibliography); Elisa Fiore Marocchetti in Ziegler 2002a, p. 395, no. 24 (with bibliography).

39. Tefnin 1979, pp. 62–65, pl. XV, b. Despite introducing this doubt about the identity of the subject, Tefnin seems to believe that the statue probably represents Thutmose I.

40. Lindblad 1984, pp. 49–50, pl. 29.

41. Egyptian Museum, Cairo, CG 42051; ibid., p. 50, pl. 30, a–c.

42. Aswan Museum, 1086; Dreyer 1984. Cartouches of the Nineteenth Dynasty king Merneptah were later incised on the figure's lap.

43. These observations should not be construed to support the thesis of Lindblad 1988 that the statue was made for Ahmose and usurped under Hatshepsut. Lindblad's use of the stela of Ahmose (cat. no. 10) as a comparative representation of Ahmose is not valid, and the identity of her other comparative representations is supposition. Moreover, the usurpations and other changes made by Hatshepsut and Thutmose III were limited to depictions of their immediate predecessors, Thutmose I and Thutmose II.

44. These statues, and the small funerary stelae of the same period, deserve further consideration for their impact on the art of the New Kingdom. The stelae borrowed extensively from Middle Kingdom prototypes and in so doing (see cat. no. 15) transmitted such mannerisms as the extremely attenuated figures that are so striking a feature of the Chapelle Rouge at Karnak (compare fig. 3).

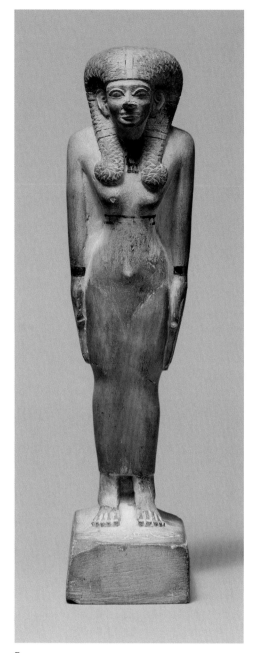

7

7. Princess Ahhotep

Late 17th–early 18th Dynasty, reign of Tao II–
reign of Ahmose I (1560–1525 B.C.)
Painted limestone
H. 27.5 cm (10⅞ in.), W. 6 cm (2⅜ in.), D. 10.5 cm
(4⅛ in.)
Musée du Louvre, Paris N 446 (formerly AE 2958)

Few works of the late Seventeenth or incipient
Eighteenth Dynasty seem as archaic as this stiff,
square-shouldered female figure.[1] It must have
been made no later than the reign of Ahmose I,
who in several representations has similarly
large, prominent eyes (cat. no. 10; fig. 7).

Unlike statuettes of women made only slightly
later (cat. nos. 17, 18), this figure is posed with

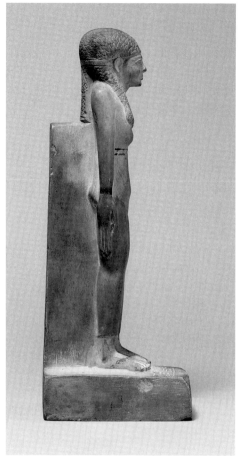

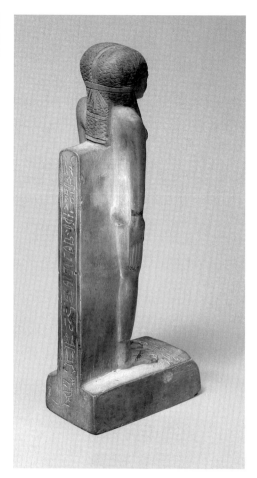

feet together and hands open against the sides
and has a small-waisted, full-hipped body—
exaggerations of the passive stance and anatom-
ical traits that characterize statues of women in
the Middle Kingdom. In some examples, such as
an Eleventh Dynasty wood statuette of Aashit
from Thebes, the figure wears a similar high-
waisted skirt and rather ostentatious jewelry
(fig. 10).[2]

Although she was a King's Daughter,
Ahhotep bears no obvious signs of royal sta-
tus. This is in the tradition of the Old and
Middle Kingdoms, when only queens were
shown wearing the uraeus or a royal headdress.[3]
A Middle Kingdom princess might be repre-
sented as a sphinx, but she wore no royal
regalia—at best, only a modest wig clip.[4]
However, Ahhotep's royalty may here be dis-
creetly alluded to by the elaborate binding of
her "Hathor wig."[5] This headdress, which orig-
inated in the Middle Kingdom, was worn by
royal and common women alike. Although
Middle Kingdom representations of the wig
could be quite elaborate, detailing the texture of
the hair and jeweled decorations, it is only on
those worn by queens that ribbonlike bindings
appear.[6] Ahhotep's hair binding, with its back

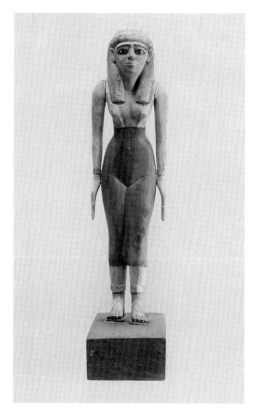

Fig. 10. Queen Aashit. Wood statuette, 11th Dynasty.
Excavated in the temple complex of Mentuhotep II at
Deir el-Bahri, western Thebes, by the Metropolitan
Museum. Egyptian Museum, Cairo (JE 36538)

tie, is not only more conspicuous than those of Middle Kingdom queens but also was painted yellow, undoubtedly to simulate gold. Modest in artistry as this figure may seem, it was clearly intended to portray a great lady.

ERR

1. See the works cited in the bibliography; for early features in the inscription, see Christophe Barbotin in *Pharaonen und Fremde* 1994, p. 266.
2. Egyptian Museum, Cairo, JE 36538. Vandier 1958, pl. xcv, 2; Dorothea Arnold 1991, p. 27, fig. 36.
3. For royal women in the Old Kingdom, see Fay 1998b.
4. Respectively, Musée du Louvre, Paris, AO 13075, and Brooklyn Museum, 56.85. Fay 1996, pp. 28–32, nos. 3, 4, pls. 55–60.
5. A misnomer; see Sourouzian 1981, p. 446, n. 8.
6. Ibid., pp. 449–50, figs. 6–8, pl. 71b. On Eighteenth Dynasty queens, the tresses were no longer rendered as vertical (or zigzag, as here) incisions; rather, the hair was divided into horizontal sections that Sourouzian (ibid., p. 451) considers remnants of the Middle Kingdom bindings.

PROVENANCE: Unknown, presumably from the unlocated tomb of Ahhotep at Thebes; formerly Salt collection; purchased in 1826

BIBLIOGRAPHY: Vandier 1958, pp. 294, 636, pl. xcvi, 2; Matthias Seidel and Dietrich Wildung in Vandersleyen 1975, p. 243, no. 172; Christophe Barbotin in *Pharaonen und Fremde* 1994, p. 266, no. 368, color ill. on p. 78; Winterhalter 1998, no. 33, pp. 299–300; Málek 1999, p. 479, no. 801-557-000

8. Bust of a Queen (Ahmose-Nefertari?)

Early 18th Dynasty, probably reign of Ahmose I (r. 1550–1525 B.C.)
Indurated limestone with traces of paint
H. 28 cm (11 in.), W. 17.8 cm (7 in.), D. 10 cm (4 in.)
The Metropolitan Museum of Art, New York, Rogers Fund, 1916 16.10.224

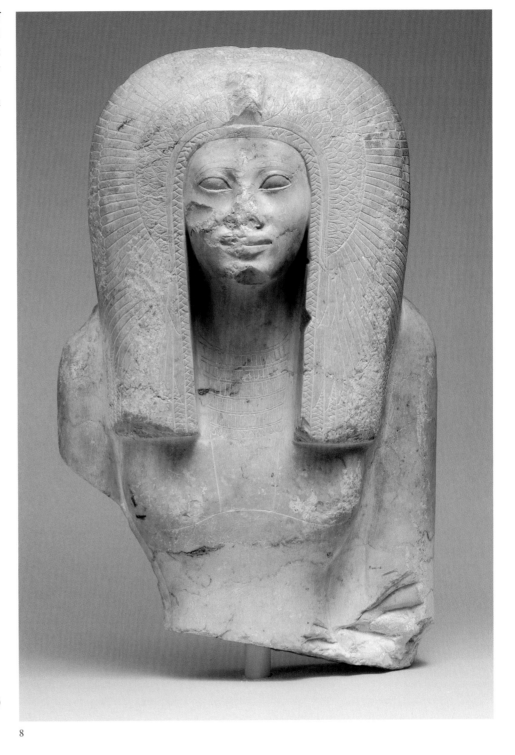

8

This arresting female image, carved in hard, marblelike limestone, probably comes from a statue of a royal couple seated against a broad back slab. The queen's bent left arm rested on her lap; her right arm may have been raised to embrace her husband. The entire back of the sculpture was chiseled away when the slab was removed, perhaps for reuse.

The vulture headdress of a queen, worn over a heavy braided wig,[1] frames a broad face with strong features. The queen's wide, slightly slanted eyes and the taut curve of her mouth resemble those on an archaizing head of King Ahmose I that emulates Middle Kingdom sculpture (fig. 7). On the bust of the queen, however, crisp outlines around the eye rims and eyebrows and pronounced modeling of the low-set cheekbones, slightly everted lips, and small, round chin indicate that the sculptor, while similarly borrowing from Middle Kingdom statues, based his work on more sophisticated examples from that era.[2] Details of style show that the bust was made very early in the Eighteenth Dynasty. Two statues that may represent Ahmose display comparable features.[3]

Unfortunately, the name of this queen has been lost, and when the bust was excavated in the Asasif in western Thebes, by the Metropolitan Museum, it was not in its original location.[4] In the much-disturbed ground of this area in the Theban necropolis, which was continually reused for centuries, the only surviving structure known to date from the early Eighteenth Dynasty is a chapel erected by Amenhotep I. Many years later it became a shrine to that king, who had been deified, and also, especially, to his mother, the deified Queen Ahmose-Nefertari.[5] The introduction of her cult was probably due to her original prominence in the area, since her

L. E. SMOOT MEMORIAL LIBRARY
9533 KINGS HIGHWAY
KING GEORGE, VA 22485

tomb was almost certainly nearby,[6] together with related structures now lost.

Although later statues of the deified Ahmose-Nefertari exist, no contemporary figures of the great queen are known. While there is a good possibility that this bust represented her and was made in her lifetime or shortly thereafter, we are unlikely ever to know for sure.

ERR

1. This type of wig is more often shown on nonroyal women: see cat. nos. 17, 18.
2. Such as the royal head of the late Eleventh or very early Twelfth Dynasty, The Metropolitan Museum of Art, New York, 66.99.3: Dorothea Arnold 1991, p. 30, fig. 42.
3. One is a sphinx from Abydos (fig. 8) with even more strongly modeled features, as well as thick, plastic brows and cosmetic lines like those on the head of Ahmose discussed above; see figure 7. Also very similar to this queen's features are the facial modeling and the shapes of eyes and mouth on a colossal sandstone head of unknown provenance, which Lindblad believes is Ahmose (Egyptian Museum, Cairo, CG 1224; Lindblad 1984, pp. 19–20, pl. 6, a–c).
4. Lansing 1917, pp. 7–8, fig. 2.
5. Porter and Moss 1972, pp. 422–23. The sparse results of several early excavations are collected and analyzed in Van Siclen 1980. Of Amenhotep's

original decoration, only fragments of a doorway survive; the votive statuettes and reliefs are Ramesside, the latest dating to Ramesses IX.

6. For the tomb tentatively assigned to her and associated finds, see Porter and Moss 1964, pp. 599–600. The most recent discussion of the tomb's owner(s), in Reeves 2003, pp. 71–72, is inconclusive.

PROVENANCE: Western Thebes, Asasif; Metropolitan Museum of Art excavations, 1915–16, acquired in the division of finds

BIBLIOGRAPHY: Porter and Moss 1964, p. 622; Seipel 1992, pp. 226–28, no. 76 (with bibliography); Catharine Roehrig in *Pharaonen und Fremde* 1994, pp. 266–67, no. 369; Winterhalter 1998, p. 307, no. 46 (with bibliography); Grimm and Schoske 1999b, frontis. and p. 109, no. 48 (with bibliography)

TECHNICAL STUDY

Minute traces of pigments are visible on the surface of the bust (cat. no. 8) when it is viewed under magnification. Of special interest are remains of a blue pigment found within the recesses of the necklace, which was found to be natural ultramarine (ground lapis lazuli). The initial identification by polarizing light microscopy was confirmed using X-ray diffraction. Lapis lazuli, a semiprecious stone, was exported from Afghanistan to Egypt as early as the Predynastic Period and there fashioned into beads, inlays, amulets, and small statuary; however, this is the first reported occurrence of its use as a pigment in ancient Egypt, or elsewhere in the Mediterranean world, before the sixth century A.D. Except for a cobalt-based pigment used for postfired painting on pottery that briefly appeared during the New Kingdom, Egyptian blue, a synthetic copper-calcium silicate, is the only blue pigment thought to have been used in ancient Egypt. Analyses of blue paint on other provenanced Egyptian antiquities known to be in as-excavated condition might help to establish whether this occurrence represents an isolated experiment or is evidence of an ongoing, but still unrecognized, tradition.

AH

9

9. Queen Mutnofret Seated

Early 18th Dynasty, reign of Thutmose II (r. 1492–1479 B.C.)
Painted sandstone
H. 165 cm (65 in.)
Egyptian Museum, Cairo CG 572

This statue of the King's Wife and King's Mother Mutnofret was dedicated by her son, Thutmose II. It was found in the chapel of Prince Wadjmose, one of two sons born to the king's principal wife, Ahmose, who predeceased him. Mutnofret must have begun her queenly career as a junior wife or successor to Queen Ahmose, but when her son became the reigning king, she rose to a rank above all the other royal women. She wears a queen's vulture headdress; the vulture's wings are spread over her wig, and its damaged head (or perhaps the hood of a uraeus cobra) is at her brow.

Mutnofret's facial features, enormous ears, simple three-part wig, youthful-looking bosom,

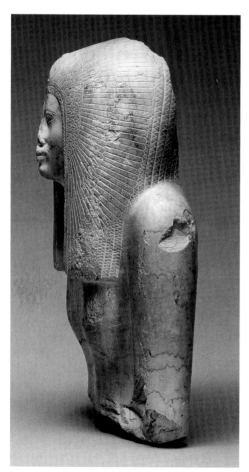

8, profile

and narrow white dress are very similar to corresponding features on a statue from the early Middle Kingdom that represents a princess or minor queen of Mentuhotep II.[1] The statue was found among the remains of that king's funerary temple at Deir el-Bahri, not far from the findspot of Mutnofret's statue. The resemblance between the two works, widely separated in time, is almost disconcertingly close. It is interesting that so faithful an imitation of the Middle Kingdom royal style was produced as late as the reign of Thutmose II, since by that time the Thutmoside style was well developed.[2] Later on in the New Kingdom, however, parents were sometimes portrayed as looking more old-fashioned than their children;[3] perhaps this young-looking image of the dowager queen was fashioned in the archaizing style that prevailed in her youth. ERR

10

1. The statue is now in the Musée d'Art et d'Histoire, Geneva, 4766; best illustration in Evers 1929, pl. 11. For a comparison of the two statues, see Lindblad 1984, p. 62, with reference. The woman's junior rank is indicated by her lack of queenly regalia.
2. Thutmose I is depicted in the Thutmoside style in catalogue no. 14.
3. An example is the statue of Sennefer and his family (Egyptian Museum, Cairo, CG 42126), in which his wife, Senay, wears a very old-fashioned wig, while their daughter, Mutnofret, sports the latest style. See Saleh and Sourouzian 1987, no. 140.

PROVENANCE: Western Thebes, chapel of Prince Wadjmose, 1887

BIBLIOGRAPHY: Lindblad 1984, pp. 62–63 (with bibliography), pl. 38

10. Stela of Ahmose I Honoring Tetisheri

Early 18th Dynasty, late reign of Ahmose I (year 17 or later, 1534–1525 B.C.)
Limestone
H. 2.25 m (7 ft. 4⅛ in.), W. 1.06 m (41¼ in.), D. 23 cm (9 in.)
Egyptian Museum, Cairo CG 34002
Not in exhibition

Beneath a winged sun disk with two pendant cobras are two scenes back to back, each depicting King Ahmose I presenting offerings to his grandmother Queen Tetisheri. Her vulture headdress, tall plumed crown, and elegant fly whisk are all queenly regalia. The king, who stands facing her, wears a short kilt with a decorated front panel and a bull's tail attached behind. A dagger is stuck in his belt, and he grasps a staff and a mace in one hand. In the scene on the left he wears the white crown, in that on the right the double crown.

The long hieroglyphic text below purports to record a conversation between Ahmose and his queen, Ahmose-Nefertari, in which he declared his intention to build a shrine for Tetisheri in his own cult center at Abydos. It is there that the stela was found in 1902, in two pieces but almost complete.[1]

When Ahmose commissioned this stela, late in his reign,[2] he knew that he had inaugurated both a new dynasty and a new era. By emphasizing his descent (on both his mother's and his father's sides!) from Tetisheri, the matriarch of the Seventeenth Dynasty, he proclaimed his own right to the throne.

The prototypes for the double scene were Middle Kingdom royal reliefs, but the figures' large, prominent eyes may derive from Seventeenth Dynasty versions of those earlier compositions.[3] The two scenes are not mirror images; different foods are heaped on and under the offering tables, and on both sides the figures hold their implements in their left hand.[4] The contours of the figures were carved in sunk relief with fine precision, but they lack details, and smooth surfaces, such as skin, are unpolished.[5] In Egyptian carving such defects were often hidden by paint, but this stela was apparently never painted.[6] ERR

1. Harvey 1998, pp. 106–10, 425–26. Harvey is currently reexcavating this structure: Harvey 2004, pp. 1 (with a photo of the stela in situ), 5–6.
2. Vandersleyen 1971, p. 194.
3. For the eyes, see Myśliwiec 1976, figs. 1, 2 (the number is mistakenly given as CG 34001 and the

provenance as Karnak). For similar eyes on reliefs of Sebekemsaf I in the temple at Medamud, near Thebes, see Bisson de la Roque 1930, pls. 6, 2 and 7, 2; recently discussed by Eder 2002, pp. 110–11. The eyes on this stela also resemble those on a head from a statue of Ahmose (fig. 7).

4. Traditionally, on the other hand, two-dimensional figures were shown holding large implements or gesturing with the limb farther from the viewer, so as not to obscure a view of the body.

5. As noted by Myśliwiec 1976, p. 25, and visible in his figs. 1, 2 (incorrectly identified; see n. 3 above).

6. There are, however, traces of preliminary drawing in red: Klug 2002, p. 15.

PROVENANCE: Abydos, in the Tetisheri shrine built by Ahmose I, 1902

BIBLIOGRAPHY: Saleh and Sourouzian 1987, no. 118 (with bibliography); Klug 2002, pp. 15–21

11. Sphinx of a Queen of Thutmose III

Early 18th Dynasty, reign of Thutmose III (r. 1479–1429 B.C.)
Gray granite
H. 54 cm (21¼ in.), W. 29.5 cm (11⅝ in.), D. 77 cm (30⅛ in.)
Museo Barracco, Rome 13

The only major damage to this sphinx is the loss of its forelegs and the front of its base and, unfortunately, the name of the owner as well. Her "Hathor wig"[1] shows that she was a woman, and the vulture headdress indicates that she was a queen.[2] (Queens and princesses had been represented in sphinx form during the Old and Middle Kingdoms, but, as was also true in the Eighteenth Dynasty, most sphinxes were male and depicted the king; see also cat. nos. 88–90.) There have been attempts to identify this queen as Hatshepsut, but they are incorrect. Since the name Thutmose III appears in the surviving inscription on the chest, the now-anonymous queen must have been one of his wives.[3]

The queen's stylized features closely resemble those on statues of her husband, but with a winsome expression due mostly to the fact that her face is rounder and fuller than his is generally portrayed. The convention of depicting the faces of women as similar to those of their menfolk, but broader or plumper, was established at least as early as the Fourth Dynasty.[4] On other representations of Thutmose III's female relatives,

11

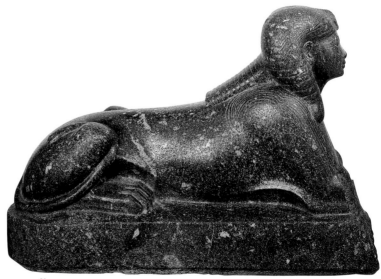

11, profile

the custom is even more noticeable. A statue of his mother, Isis, shows her with a moon face,[5] and the cheeks on a queenly head in quartzite are so plump that they appear almost dimpled.[6] Compared with the narrower visage of Hatshepsut as shown on most of her statues, the faces on statues of Thutmose's queens, perhaps deliberately, emphasize their traditional womanly roles.

After the Romans conquered Egypt, this sphinx was taken to Rome, where a copy was made. The two were installed as a pair at the Roman temple of Isis, near the place where they were found, still together, in 1856.[7] ERR

1. See cat. no. 7, n. 5.
2. Representations of this wig and headdress on queens of the Eighteenth Dynasty are discussed by Sourouzian 1981, pp. 450–54, and the head of this sphinx is illustrated, pl. 73, c, d.
3. Arguments that she represents Hatshepsut are summarized and conclusively refuted by Tefnin 1979, pp. 153–55 (with bibliography).
4. The practice is notable on statues of Mycerinus with a queen and with goddesses (*Age of the Pyramids* 1999, pp. 268–73, nos. 67, 68) and, from the beginning of the dynasty, the companion statues of Rahotep and his wife Nofret (Saleh and Sourouzian 1987, no. 27).
5. Egyptian Museum, Cairo, CG 42072: Saleh and Sourouzian 1987, no. 137.
6. Brooklyn Museum, 65.134.3, previously dated to the Middle Kingdom; the reasons for its reattribution will be published by Biri Fay. For further examples, see Sourouzian 1981, pls. 72–74.
7. Roullet 1972, p. 133, no. 278, fig. 290 (with bibliography). The Roman copy is on pp. 132–33, no. 277, fig. 289.

PROVENANCE: Found in Rome in 1856

BIBLIOGRAPHY: Lollio Barberi, Parola, and Toti 1995, pp. 156–57, no. 17 (with bibliography); Sist 1996, pp. 48–50

12. Shawabti of Ahmose I

Early 18th Dynasty, reign of Ahmose I (r. 1550–1525 B.C.)
Limestone
H. 28.7 cm (11¼ in.), W. 8.3 cm (3¼ in.),
D. 5.8 cm (2¼ in.)
The Trustees of the British Museum, London
EA 32191

A shawabti is a funerary figurine that was intended to serve as a substitute for the deceased owner and perform certain types of labor for

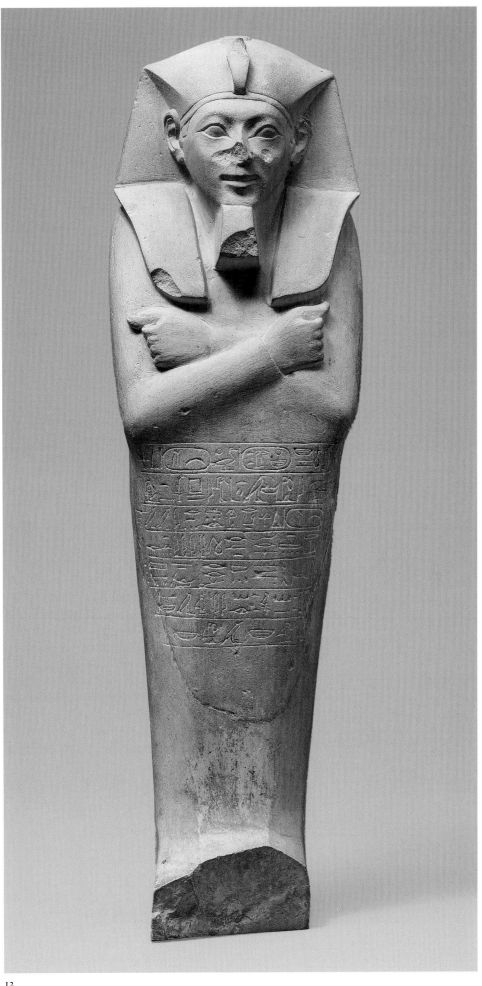

12

him in the afterlife. Shawabtis are found in graves from the Middle Kingdom on.

This remarkably well-preserved figure of King Ahmose I is the oldest known royal shawabti.[1] The text inscribed on the front gives the so-called shawabti spell in its early, Middle Kingdom version rather than the later formulation found on many New Kingdom shawabtis and in the Book of the Dead. Otherwise the statuette resembles the royal shawabtis that will follow it, being mummiform, with arms crossed in the pose of Osiris, and wearing a royal head-dress and uraeus. Unlike many but not all later examples, this one shows the king with a rec-tangular royal beard and his closed hands empty of symbolic objects such as the Osiride crook and flail. The statuette was probably deposited in Ahmose's tomb, which is believed to have been in western Thebes but has not been located.

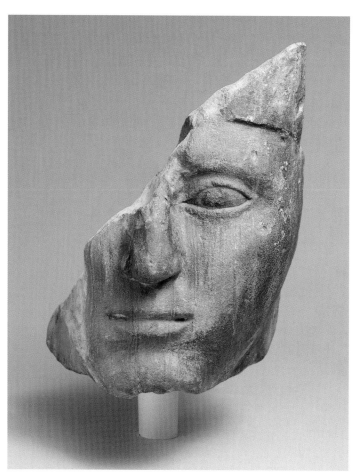

13

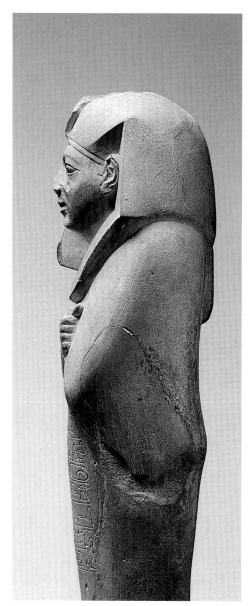

12, profile detail

The figure's most striking feature is the face, which, although small in scale and with a mini-mum of detail, conveys a vivid impression of alertness and intensity.[2] Even more remarkable, perhaps, is the way the tapering shape of the face, the almost hieroglyphic contours of the small but rather prominent eyes, and the arched lines of the brows above herald features of the Thutmoside style that otherwise seem not to have emerged for at least another generation. Even if this shawabti was made not during the reign of Ahmose but under Amenhotep I (r. 1525–1504 B.C.), as has been suggested,[3] it would still be our earliest evidence of the emerging royal style that was to transform Egyptian sculpture.

ERR

1. J.-F. Aubert and L. Aubert 1974, p. 32.
2. As noted by Vandersleyen 1971, p. 204, among others.
3. By Vandersleyen 1995, p. 232 (he provides no evidence).

PROVENANCE: Unknown, presumably from Thebes; acquired in 1899

BIBLIOGRAPHY: Edna R. Russmann in Russmann et al. 2001, pp. 210–11, no. 110 (with bibliography)

13. Fragmentary Head of Amenhotep I

Early 18th Dynasty, reign of Amenhotep I (r. 1525–1504 B.C.)
Painted sandstone
H. 20 cm (7⅞ in.), W. 14 cm (5½ in.), D. 25 cm (9⅞ in.)
The Metropolitan Museum of Art, New York, Rogers Fund, 1926 26.3.30a

This fragmentary face may not at first glance seem distinctive. The features it presents appear naturalistic: puffy cheeks, a very round chin, and thin, unsmiling lips; a fleshy nose with nar-row nostrils and a downturned tip; an eye bare of makeup, set close under the brow bone. In all of Egyptian sculpture, however, this particular combination of features occurs only here and on a few other royal heads.

In 1905, archaeologists excavating the mor-tuary temple of the Eleventh Dynasty king Mentuhotep II, at Deir el-Bahri, first encoun-tered these features, on a statue of painted sand-stone that bears the name Amenhotep I and depicts him standing in the pose of Osiris (fig. 11).[1] Later, at the same site, Metropolitan Museum excavators found the present head and part of another. Eight such heads are now

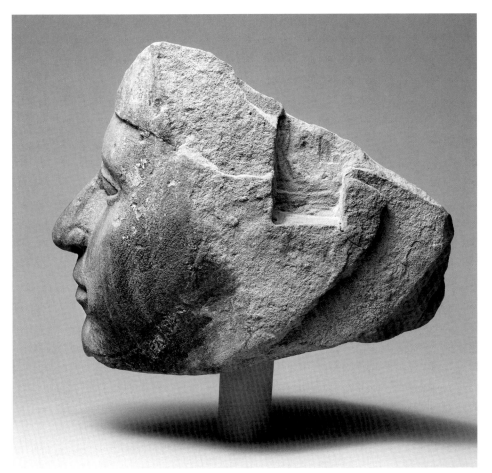

13, profile

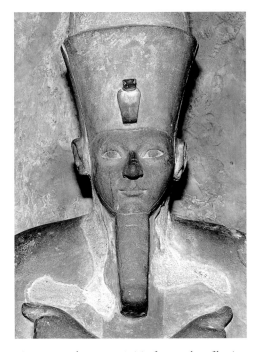

Fig. 11. Amenhotep I as Osiris, front and profile views of the head of a lifesize statue, early 18th Dynasty (see fig. 9). The Trustees of the British Museum, London (EA 683)

relief representations of him.⁶ Even more curious is the use of such individual-looking features as these on Osiride statues, which, being images of the ruler in the guise of the god, were normally among the most formal and stylized royal works in any reign (see, for example, cat. nos. 14, 74). It may therefore be significant that some of these statues and statue fragments show unusual signs of alteration. The face had been entirely removed from another full-length statue in the series and has not been found.⁷ The present head and at least two others retain the marks of ancient repairs.⁸

ERR

1. British Museum, London, EA 683: Romano 1976, pp. 97–98; Lindblad 1984, pp. 16–27.
2. Seven are discussed by Romano 1976, pp. 98–100, pls. 26, 27; followed by Lindblad 1984, pp. 34–37, pls. 17–19. For an eighth head, formerly in the Bastis collection, see Bernard V. Bothmer in *Collection of Christos G. Bastis* 1987, frontis. and pp. 7–13, no. 3.
3. For the most recent addition to the series, which lacks its face, see n. 7 below.
4. Karnak Cachette is the name given in modern times to a space beneath a courtyard in the temple of Amun at Karnak, where, in antiquity, many statues and obsolete temple implements were buried. The sphinx, now in the Egyptian Museum, Cairo (CG 42003), is generally accepted as a representation of Amenhotep I: Lindblad 1984, pp. 37–38, pl. 20; Russmann 1989, pp. 81–82, 217, no. 36.
5. Cairo, JE 53140: Saleh and Sourouzian 1987, no. 127; also Lindblad 1984, pp. 30–31, pl. 15.
6. Some resemblance to Amenhotep's reliefs on his alabaster chapel was noted by Romano 1976, p. 102.
7. The statue was found in 1982: Szafrański 1985. The inscription on the back pillar naming Amenhotep I is almost identical to that on the British Museum example seen in figure 9, above. The excavator suggests (pp. 261–62) that this statue was buried during construction by Hatshepsut or, more probably, Thutmose III, but does not speculate about the date of the mutilation or the reason for it.
8. The partially preserved rectangular hole on the left side of this face may have been cut, as has been suggested, so that a separately made ear could be attached. The sides of two of the heads in Cairo have large cramp holes indicating major repairs, such as attachment of the face, and on one of these, CG 966, there are two such holes, one on either side: Romano 1976, p. 99.

PROVENANCE: Western Thebes, Deir el-Bahri; Metropolitan Museum of Art excavations, 1925–26, acquired in the division of finds

BIBLIOGRAPHY: Lindblad 1984, pp. 36–37, pl. 19 (with bibliography); Catharine Roehrig in *Pharaonen und Fremde* 1994, p. 267, no. 370 (with bibliography); Grimm and Schoske 1999b, p. 108, no. 49, color ill. on p. 77

known,² all belonging to Osiride statues that Amenhotep erected at Deir el-Bahri.³ The same face can be seen on an alabaster sphinx from the Karnak Cachette⁴ and, in a softer, more feminine version, on a coffin lid of his queen, Ahmose Meryetamun.⁵

If this was Amenhotep's actual appearance, it is curious that it does not resemble the numerous

14. Colossal Head of a King, Probably Thutmose I

Early 18th Dynasty, reign of Thutmose I (r. 1504–
1492 B.C.)
Painted sandstone
H. 144 cm (56¾ in.)
Museo Egizio, Turin 1387

This colossal head has plausibly been identified
as a representation of Thutmose I from a statue
depicting him as Osiris.[1] The only statues
known to have been made during Thutmose I's
lifetime[2] are a series of colossal standing Osiride
figures that lined the walls of a colonnaded hall
at Karnak.[3] Many of them are still in situ, but all
have had their faces mutilated or destroyed.[4]
Fortunately, a well-preserved head from one of
them was found nearby (fig. 12).[5] It too is
painted sandstone, and it is almost exactly the
same size as this one.

A detailed comparison of the two pieces is
hampered by differences in their present condi-
tion. On the head found at Karnak, such carved
elements as the tip of the nose and the rendering

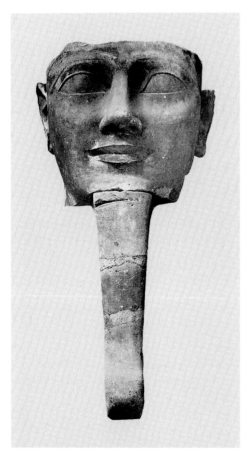

Fig. 12. Colossal head of Thutmose I. Sandstone,
early 18th Dynasty. Excavated at Karnak temple by
the Egyptian Antiquities Service. Egyptian Museum,
Cairo (CG 42051)

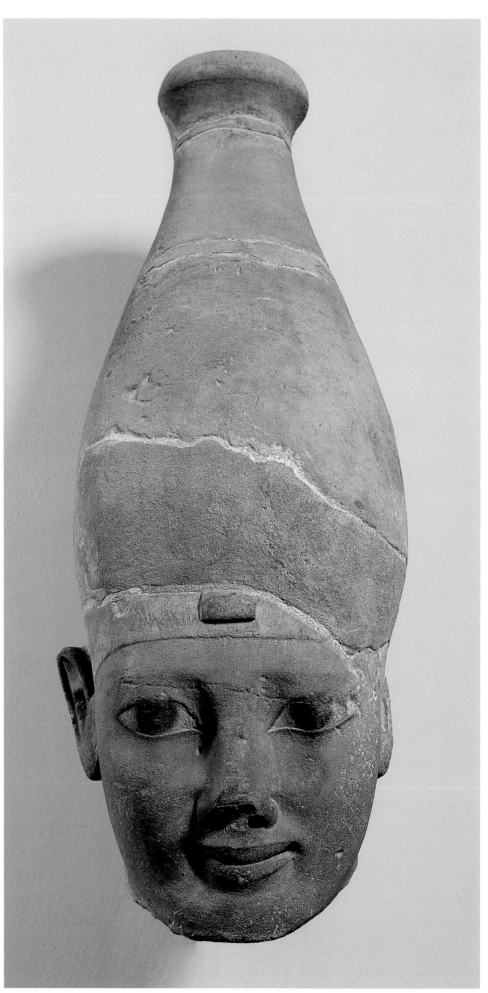

14

of the eyebrows in relief are well preserved, but the paint, apparently bright when it was first found, is now so faded as to be unnoticeable. This head, in contrast, is still enlivened by its original color, especially on and around the eyes. However, the original surface on the brows and upper eyelids has been abraded, and although the loss is small, it has subtly altered the expression, imparting qualities of softness and openness not present in the other work.[6]

Lindblad, who published the Karnak series, pointed to other differences between these two heads, which led her to conclude that the present work is not from the Karnak series, although she accepted its identification as Thutmose I.[7] But the differences she noted are so minor that they fall well within the range of variation to be expected when several sculptors work on one large project, as they would have for the Osiride statues. It is in fact probable that this head was part of that series, especially since nothing suggests that Thutmose I erected other statues of the same type and size.

ERR

1. For the history of this attribution, see Lindblad 1984, p. 53.
2. The seated statue inscribed for Thutmose I (Museo Egizio, Turin, 1374) is a posthumous work; see my essay "Art in Transition" in this volume, n. 38.
3. Porter and Moss 1972, p. 80; for a description and texts, see Lindblad 1984, p. 49.
4. Photographs are in Lindblad 1984, pl. 29.
5. Now in the Egyptian Museum, Cairo, CG 42051. See Lindblad 1984, p. 50, pl. 30, a, c.
6. The face is very well described by Maya Müller 1979, pp. 28–29.
7. Lindblad 1984, p. 53.

PROVENANCE: Unknown

BIBLIOGRAPHY: Lindblad 1984, pp. 52–53, pl. 31; Málek 1999, pp. 108–9, no. 800-732-400 (with bibliography)

15. Stela of Senres and Hormose

Early 18th Dynasty, reign of Ahmose I or Amenhotep I (1550–1504 B.C.)
Limestone
H. 42.9 cm (16⅞ in.), W. 21.1 cm (8¼ in.), D. 4.2 cm (1⅝ in.), originally 8.2 cm (3¼ in.)
Brooklyn Museum, Museum Collection Fund 07.420

15

As early as the First Dynasty, some funerary stelae were made with a rounded top symbolizing the course of the sun through the sky, in that way connecting the deceased with the eternal cycle of sunrise and rebirth. On Middle Kingdom stelae this upper space was often filled with additional cosmic symbols, such as the round sign signifying solar encirclement and, singly or in pairs, the *wedjat* eye, which was also believed to have powerful protective qualities.[1] This type of Middle Kingdom stela was revived in the early Eighteenth Dynasty. On the present example, carved in sunk relief, many details, such as the texture of the man's kilt and wig, the jewelry worn by the figures, and the fleshy planes of their faces, derive from elaborately detailed reliefs of the early Middle Kingdom.

Senres and his wife, Hormose, sit side by side on a broad seat with legs shaped like those of a lion and a low, cloth-draped back. Their feet are supported by a rectangular footrest. Senres holds to his nose a large blossom of the fragrant blue lotus, a symbol of rebirth into the afterlife. Hormose embraces her husband with both hands in a conventional gesture of wifely affection and support. An offering stand before the couple holds different kinds of breads and a bundle of green onions.

Various commodities needed in the afterlife, including other foods, drink, and linen cloth, were to be magically provided for the deceased Senres by the prayer inscribed on the lower part of the stela. Also inscribed is the information that Hormose commissioned the stela for Senres. As the carved image makes clear, she expected to share this eternal bounty in their joint tomb.

ERR

1. The fundamental work on round-topped stelae and their decoration is still Westendorf 1966, chaps. 3 and 4 (and see pl. 8, fig. 15, for a drawing of a First Dynasty stela in the Louvre).

PROVENANCE: Unknown

BIBLIOGRAPHY: James 1974, pp. 70–71, no. 164, pl. XLIV; Fazzini, Romano, and Cody 1999, pp. 22, 27, 78, no. 34

16. Shawabti of Seniu

Early 18th Dynasty, reign of Amenhotep I (r. 1525–1504 B.C.) or later
Glazed steatite
H. 28 cm (11 in.), W. 7 cm (2¾ in.), D. 6.5 cm (2½ in.)
The Metropolitan Museum of Art, New York, Rogers Fund, 1919 19.3.206

Seniu's high-quality, unusually large shawabti has been described as "spectacular."[1] It represents a continuation of the Middle Kingdom tradition in which a burial was provided with a single finely fashioned shawabti statuette. In fact, so much care and labor had been invested in making this figure that when it broke in two during manufacture, the pieces were painstakingly rejoined with three steatite dowels.[2] Like most Eighteenth Dynasty shawabti figures, this one presents its subject in the form of a mummy and in the pose of Osiris, with crossed arms and closed hands. Like King Ahmose I in his shawabti (cat. no. 12) and other, nonroyal individuals early in the dynasty, Seniu is shown with his hands empty.[3]

The inscription on his shawabti says that Seniu was a scribe and a Chief Steward. The latter title, also held by Senenmut and other powerful officials of the Eighteenth Dynasty, was often amplified by adding the name of the royal person or god whose estates the steward administered.[4] Seniu's tomb has not been located and was probably destroyed. The shawabti was found in a section of the necropolis in western Thebes not far from the site of the famous Deir el-Bahri cache where priests of the Twenty-first Dynasty had hidden the plundered mummies of many New Kingdom kings and queens, rehousing most of them in nonroyal coffins.[5] One of these reused coffins, according to its inscription, had originally been made early in the Eighteenth Dynasty for a scribe named Seniu whose other office was Chief Steward of the God's Wife (the queen).[6] This shawabti would have been suitable for a royal official of that high rank.

ERR

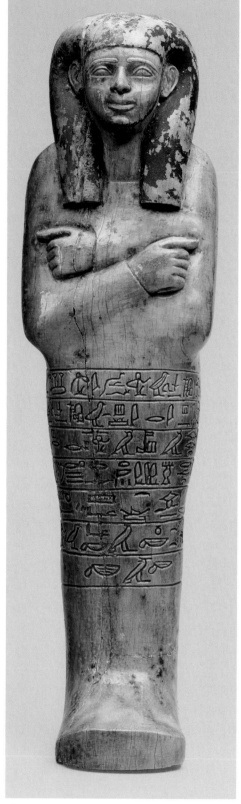

5. The find is also called the Royal Cache. The story of its discovery, in 1881, has often been told; for a recent account, see Reeves and R. H. Wilkinson 1996, pp. 194–97.
6. Egyptian Museum, Cairo, CG 61010: Porter and Moss 1964, p. 659, no. 8 (with bibliography). The coffin contained the badly damaged mummy of a woman, perhaps Princess Meryetamun, which is CG 61052: G. E. Smith 1912, pp. 6–8, pl. IV.

PROVENANCE: Western Thebes; Metropolitan Museum of Art excavations, 1918–19, acquired in the division of finds

BIBLIOGRAPHY: Lansing 1920, pp. 6, fig. 2, 8; Hayes 1959, pp. 58–59, fig. 29

16

1. J.-F. Aubert and L. Aubert 1974, p. 45.
2. Lansing 1920, p. 8.
3. J.-F. Aubert and L. Aubert 1974, p. 46.
4. Senenmut, for example, in addition to being Chief Steward, had the titles of Chief Steward "of Amun," "of the God's Wife, Hatshepsut," "of the King," and "of the King's Daughter, Neferure," among numerous others.

17. Tetiseneb Seated

Early 18th Dynasty, reign of Ahmose I or
Amenhotep I (1550–1504 B.C.)
Painted limestone
H. 30.8 cm (12⅛ in.), W. 8.5 cm (3⅜ in.), D. 22.2 cm
(8¾ in.)
Kestner-Museum, Hannover 1935.200.106

This tomb statuette, which was commissioned
by the son of Tetiseneb, shows her sitting with
her right hand flat on her lap and her closed left
hand held against her torso. The depiction of
women with a bent arm and a fisted hand was a
New Kingdom innovation and represents a sig-
nificant departure from the far more passive poses
of earlier female statues (see also cat. no. 18).

The braided hairdo that frames Tetiseneb's
face is set off by two short, asymmetrical tresses
descending from the temples that may be meant
as locks of her own hair, teased out from under
her wig.[1] The same attention to small but
rather sophisticated details may be seen on the
round face. Despite its sprightly, almost ingen-
uous expression, there are subtle cosmetic
lines extending the large eyes, and the eye-
brows are elegantly arched. Similar features on
the mummy mask of a noblewoman at the court
of Ahmose I[2] suggest that the two images,
although differing in material and size, were
made at about the same time, and thus that the
present statue is one of the earliest products of
New Kingdom sculptors.

ERR

1. A less organic handling of the same hairdo on the
statuette of Taweret (cat. no. 18) suggests that
Taweret's statue may be slightly earlier than
Tetiseneb's.

2. British Museum, London, EA 29770: Edna R.
Russmann in Russmann et al. 2001, pp. 204–6,
no. 106 (with bibliography).

PROVENANCE: Unknown, presumably from Thebes;
acquired in 1935 from the collection of Baron von
Bissing

BIBLIOGRAPHY: *Das Menschenbild im alten
Ägypten* 1982, pp. 42–43, no. 11 (with bibliography);
Rosemarie Drenkhahn in *Ägyptens Aufstieg* 1987,
p. 110, no. 9; Winterhalter 1998, p. 307, no. 47;
Grimm and Schoske 1999b, p. 111, no. 58, color ill.
on p. 85

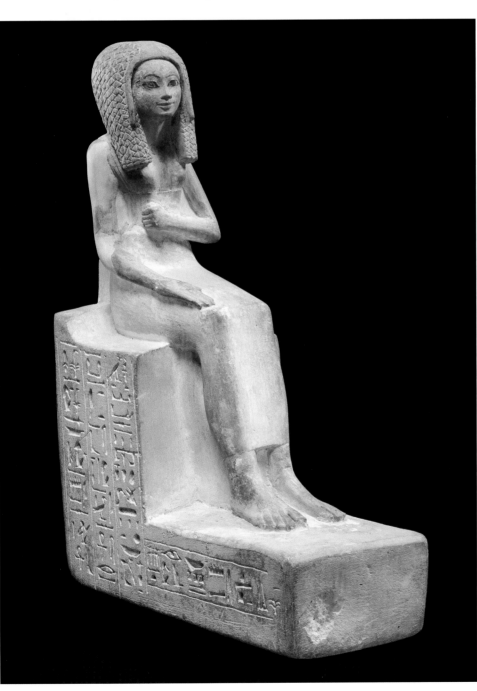

17

18. Taweret

Early 18th Dynasty, reign of Ahmose I or
Amenhotep I (1550–1504 B.C.)
Painted limestone
H. 17.3 cm (6⅞ in.), W. 4.6 cm (1¾ in.), D. 7.5 cm
(3 in.)
The Metropolitan Museum of Art, New York,
Purchase, Edward S. Harkness Gift, 1926 26.7.1404

Taweret stands with her left foot very slightly
forward, her right hand open at her side. In her
left hand she clasps a lotus bud between her
breasts.[1] Her rather stocky form is clad in the

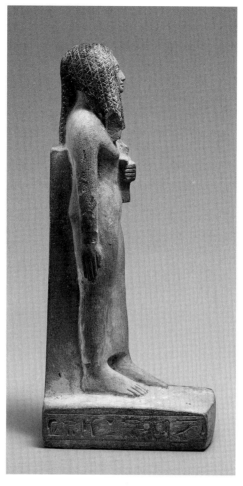
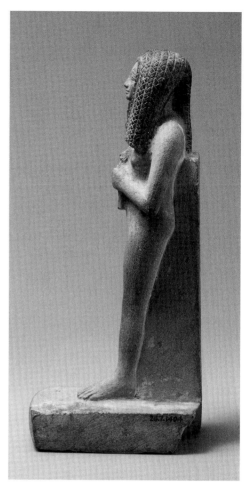
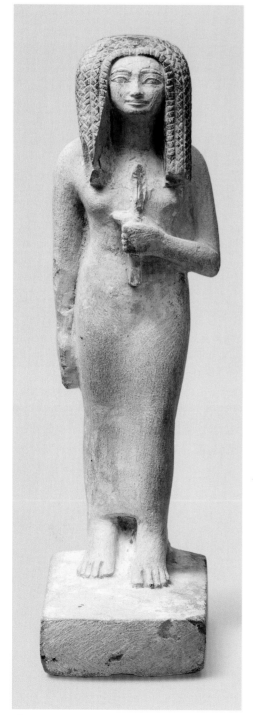
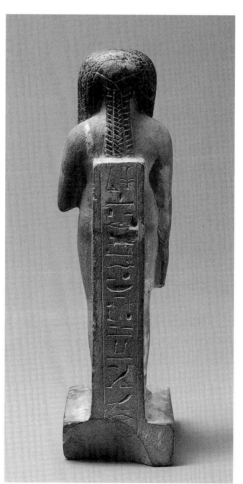

usual narrow white dress, the shoulder straps of
which were indicated in paint.

The front part of Taweret's hairdo is a mass
of braids. Brought forward over her shoulders
and embellished by a twisted tress along either
side of the face, they form a heavy frame for
her plump, pleasant features. We see here for
almost the first time a hairstyle that was to
remain extremely popular for four generations
or more.[2] The arrangement of Taweret's back
hair resembles that of an earlier style: it has
been divided into three thick plaits that are
drawn together, exposing parts of her neck
and scalp. Versions of this skin-baring hairdo
first appeared on nude fertility figures of the
Middle Kingdom, but by the beginning of the
Eighteenth Dynasty it was considered appro-
priate for the clothed tomb image of a woman.
In both cases, presumably, the hairdo identified
its wearer as an unmarried young woman of
childbearing age.[3]

The inscription on this statue states that it
was dedicated by Taweret's mother,[4] suggesting
that Taweret still lived at home. Her hairdo
seems to indicate that she was unmarried, and
the lotus bud held to her breast may refer even
more poignantly to her youth. So rarely is this
unopened flower found on statues that one can

18

only guess at its symbolism, but here, as on the statuette of Amenemhab (cat. no. 19), it seems to be one of several indications of a life ended young.

<div align="right">ERR</div>

1. Both these features are early instances of New Kingdom innovations in the sculptural representation of women. Previously, women were depicted with their feet together and both hands open.
2. In one work made during the reign of Amenhotep II (Egyptian Museum, Cairo, CG 42126), a mother wears this hairstyle in contrast to her daughter's more modish hairdo: Saleh and Sourouzian 1987, no. 140.
3. For the history and meaning of this hairdo, see Russmann forthcoming.
4. Others, including Seipel 1992, p. 306, concur; but as translated by Hayes 1959, p. 61, and Porter and Moss 1964, p. 619, the dedication is by her daughter.

PROVENANCE: Western Thebes, Asasif, Pit tomb 51; Carnarvon excavations, acquired by Lord Carnarvon in the division of finds; formerly Carnarvon collection, purchased in 1926

BIBLIOGRAPHY: Vandier 1958, pp. 438, 488–89, 500, 504, 678, pl. CXLI, 4; Hayes 1959, pp. 61, 62, fig. 31; Porter and Moss 1964, p. 619; Seipel 1992, pp. 306–7, no. 117

19. The Child Amenemhab Nude

Early 18th Dynasty, reign of Ahmose I–reign of Thutmose II (1550–1479 B.C.)
Copper-silver alloy, silver; wood base
H. 13 cm (5⅛ in.), W. 4.9 cm (1⅞ in.), D. 9 cm (3½ in.)
The Metropolitan Museum of Art, New York, Purchase, Edward S. Harkness Gift, 1926 26.7.1413

It is often said that the Egyptians portrayed children as miniature adults, but this small figure of a boy effectively conveys the soft tummy and gangly limbs of a young child who still ran about naked.[1] Plump cheeks and a snub nose make the tiny face look almost babyish. As was customary for children in ancient Egypt, Amenemhab's head was shaved. Standing with his left leg forward and right hand open at his side, he clasps to his chest in his left hand a long-stemmed lotus bud.

The figure was cast in copper alloyed with enough silver to give it a silvery color, surely the intended effect. The lotus was made separately of a purer silver.[2] The lotus flower, a fragrant water lily, symbolized rebirth; from the Old Kingdom on, funerary reliefs conventionally

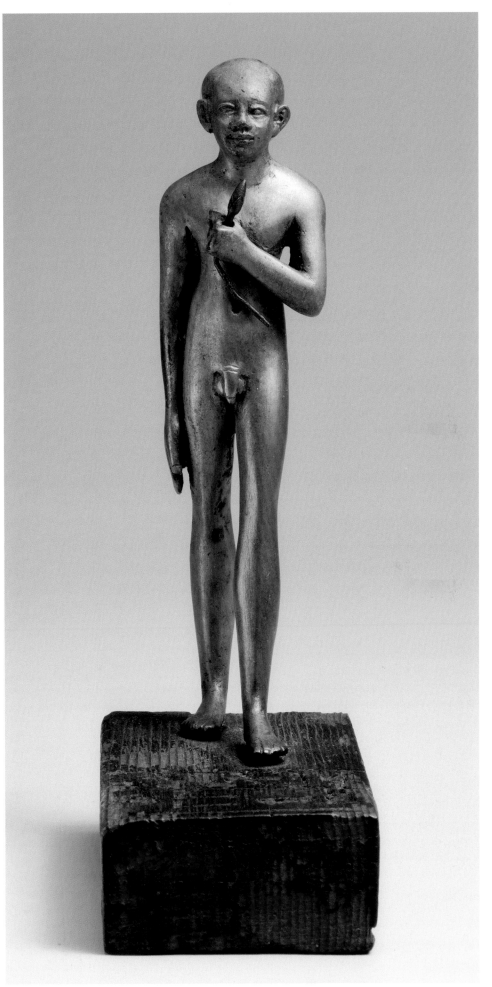

19

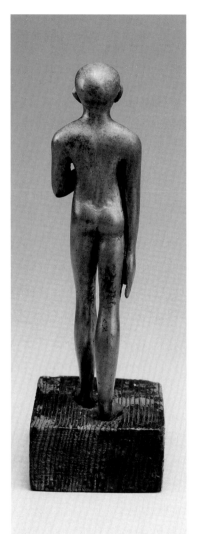

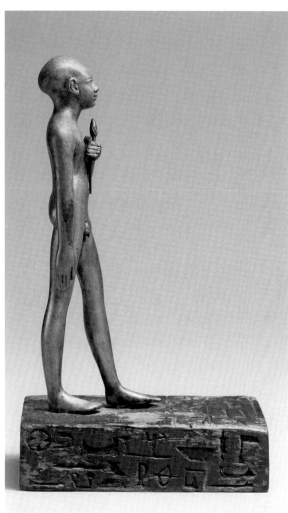

19, back and profile

20. The Youth Huwebenef

Early 18th Dynasty, reign of Ahmose I–reign of
Thutmose II (1550–1479 B.C.)
Painted wood
H. 35 cm (13¾ in.), W. 6.6 cm (2⅝ in.),
D. 19.2 cm (7½ in.)
The Metropolitan Museum of Art, New York,
Purchase, Edward S. Harkness Gift, 1926 26.7.1414

Like the little naked figure of the boy Amen-
emhab with which it was found, this wood stat-
uette has a separate, "somewhat crude"[1] wood
base with a funerary inscription by their father,
Djehuti, who presumably placed the statuettes
in the coffin of their mother, where they were
found (see fig. 13). The youth seen here, named
Huwebenef, is shown at an older age than his
brother. Not only is he clothed, in a pleated
kilt,[2] but also his formal, square-shouldered
stance is that of an adult. However, his shaven
head[3] and the lack of any reference to a profes-
sion indicate that he had not yet entered the
adult world. It may well be, as some have sur-
mised,[4] that the presence of these two youth-
ful funerary figures is evidence of an ancient
family tragedy.

This statue lacks the artistry so apparent in
the metal figure of Amenemhab, but it is
undoubtedly the work of a competent sculptor.
Since the great majority of nonroyal tomb stat-
uettes from Thebes that can be attributed to the
early Eighteenth Dynasty represent women, it
is interesting to observe that this male figure,
like them, is slender, lacks anatomical details,
and has a somewhat oversized head with deli-
cate facial features and large eyes.

ERR

1. Hayes 1959, p. 61, describing both bases.
2. Instead of the usual allover pleating, the pleats on
 this kilt are grouped in vertical bands separated by
 bands of unpleated cloth. This unusual pattern is
 paralleled on a granite statue of a grandee of the
 mid-Twelfth Dynasty (Museo Egizio, Turin, suppl.
 4267): Evers 1929, p. 30, fig. 6.
3. The new growth of hair is indicated in black paint.
4. For example, Hayes 1959, p. 61.

PROVENANCE: Western Thebes, Lower Asasif; exca-
vations of Lord Carnarvon and Howard Carter, 1910
or 1911, formerly Carnarvon collection, acquired in
the division of finds

BIBLIOGRAPHY: Carnarvon and Carter 1912, pp. 74–
75, pl. LXVII, 2, 3; Hayes 1959, pp. 60–61, fig. 30;
Porter and Moss 1964, p. 616 (with bibliography)

show the deceased sniffing an open lotus blos-
som (see cat. no. 15). Unopened buds were also
depicted, in bouquets and other floral composi-
tions. However, a single bud is a very unusual
accessory for a freestanding statue, so much so
that its appearance here and on another statue in
this exhibition (cat. no. 18), both representing
young people, suggests that the symbolism was
thought especially appropriate for a young life
that had never flowered.

The wood base carries an inscription nam-
ing the boy as Amenemhab. It matches the base
of the larger wood figure of his brother, with
which it was found (cat. no. 20). The two stat-
uettes are so different that one may wonder
whether they were originally made for the same
purpose or even at the same time. The exquisite
modeling of this figure makes it likely that it
was produced in a royal workshop, perhaps as
an image of a deceased prince, before somehow
finding its way to a more modest resting place.

ERR

1. As was observed in Carnarvon and Carter 1912,
 p. 75, "The statuette at first may seem attenuated,
 but anyone who knows the youth of modern Egypt
 will at once recognize its truth."
2. Like gold, silver had symbolic meanings, which
 have not been fully explained. It may not be a coin-
 cidence, therefore, that Nefertem, a god associated
 both with youth and with the fragrant lotus, was
 frequently represented in silver: Becker, Pilosi, and
 Schorsch 1994, pp. 54–55, n. 46; see also p. 48,
 fig. 22. However, all known figures of Nefertem in
 silver postdate the New Kingdom.

PROVENANCE: Western Thebes, Lower Asasif; excava-
tions of Lord Carnarvon and Howard Carter, 1910
or 1911, formerly Carnarvon collection, acquired in
the division of finds

BIBLIOGRAPHY: Carnarvon and Carter 1912,
frontis., pp. 74–75, pl. LXVII, 1, 2; Vandier 1958,
pp. 436, 481, 489, 678, pl. CXXXIX, 1; Hayes 1959,
pp. 60–61, fig. 30; Porter and Moss 1964, p. 616
(with bibliography)

ERR

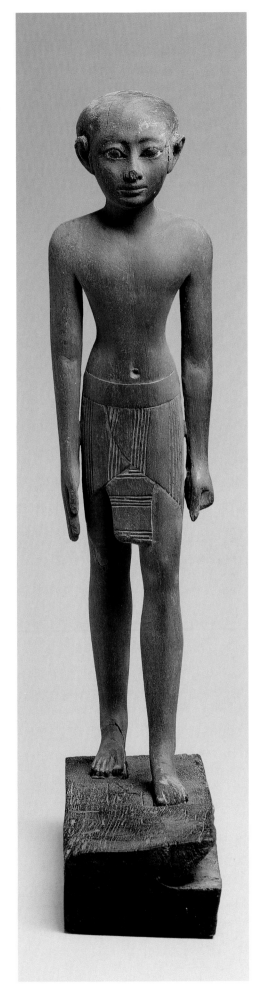

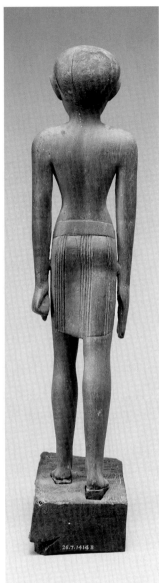

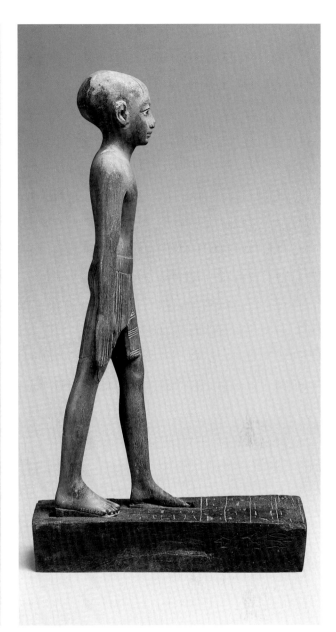

Fig. 13. Statuettes of Amenemhab and Huwebenef (cat. nos. 19, 20) as they were found in the coffin of a woman excavated in Lower Asasif (Birabi), western Thebes, by Lord Carnarvon and Howard Carter

20

21. Scarab

Early 18th Dynasty, reign of Ahmose I–reign of
Thutmose II (1550–1479 B.C.)
Egyptian blue, gold
L. 2.5 cm (1 in.), W. 1.7 cm (⅝ in.), H. 1 cm (⅜ in.),
The Metropolitan Museum of Art, New York,
Purchase, Edward S. Harkness Gift, 1926 26.7.575

21

21, base

This scarab was found in the same coffin that
contained the statuettes of Amenemhab and
Huwebenef (cat. nos. 19, 20). Its interesting
mixture of designs indicates the lively individu-
ality of artworks made during this transitional
period. The back, which has no indication of
the beetle's wing cases, is typical of Second
Intermediate Period scarabs found in the Nile
Delta, and the rope pattern framing the design
on the base had been used since the Middle
Kingdom; both of these designs continued to be
employed into the early Eighteenth Dynasty. The
winged scarab on the base is new and becomes
more common in the reigns of Hatshepsut and
Thutmose III. The notches on the beetle's care-
fully delineated wing cases are a characteristic
feature on the backs of scarabs dating from the
joint reign (see cat. nos. 75c, e, g, m).

The scarab was skillfully mold-made, with
some of the detail apparently carved before the
scarab was fired. The material appears to be
Egyptian blue, a synthetic frit closely related
to glass.[1] The overall green color (rather than
the more common blue) appears to be due to
a relatively low copper content. A hole was
drilled through the scarab, and a gold tube was
passed through the hole. A wire would have
been threaded through the tube and attached
to a ring.

CHR, DCP

1. The material was identified at the Metropolitan
Museum by Mark T. Wypiski, Research Scientist,
Department of Scientific Research, and Ann
Heywood, Conservator, Sherman Fairchild Center
for Objects Conservation.

PROVENANCE: Western Thebes, Lower
Asasif, Tomb 37, burial 24; excavations of Lord
Carnarvon and Howard Carter, 1910 or 1911,
formerly Carnarvon collection, acquired in the
division of finds

BIBLIOGRAPHY: Carnarvon and Carter 1912, p. 69,
pl. LXXII, 24

PAINTING IN THE EARLY EIGHTEENTH DYNASTY

The best-known Egyptian paintings that can be dated to the period from
the accession of King Ahmose I through the reign of Hatshesput are
found in the nobles' tombs of the Theban necropolis. Unfortunately,
because of the fragility of the medium—painted plaster on what is some-
times a very unstable wall surface—the decoration in these tombs is
often in extremely poor condition, with large sections missing and the
colors badly faded. Fortunately for us, Egyptian painters did not restrict
themselves to the decoration of tomb walls. One can find superb exam-
ples of their art on beautifully decorated furniture (see cat. no. 25), on
votive offerings (see cat. no. 24), and on the ubiquitous limestone chips
that were a by-product of carving tombs into bedrock (see cat. nos. 22,
23). These chips, called ostraca, provided a smooth surface that could be

used to create templates, to practice drawing hieroglyphs, to write
accounts, or simply for amusement. Ostraca were often discarded soon
after they were used, and they were quickly buried under layers of
debris, a circumstance that has preserved many of them in almost perfect
condition.

Three of the four objects that follow were excavated in western
Thebes and almost certainly date from the early Eighteenth Dynasty,
perhaps even from the time of Hatshepsut. The exquisite wood chest
may date a bit later, from the end of the reign of Hatshepsut's co-ruler
and successor, Thutmose III, but the painting style is in keeping with
examples that date from her reign and earlier.

CHR

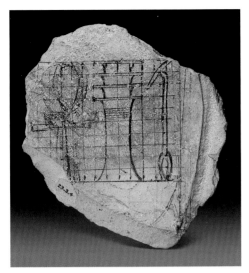

22

22. Ostracon with a Scaled Drawing of Hieroglyphs

Early 18th Dynasty, joint reign of Hatshepsut and
Thutmose III (1479–1458 B.C.)
Painted limestone
H. 14 cm (5½ in.), W. 16 cm (6¼ in.)
The Metropolitan Museum of Art, New York,
Rogers Fund, 1923 23.3.4

A grid was drawn on this limestone flake, or
ostracon, and three hieroglyphs, representing
the words "life," "stability," and "dominion,"
were drawn in red within the grid. They were
then finished in black ink. The ostracon may
have been used to teach a young scribe the
proper proportions of the hieroglyphs, and the
gridded sketch could then have allowed the stu-
dent to transfer the images to a larger surface.
These hieroglyphs occur frequently in royal
texts, following the pharaoh's name as a for-
mula to ensure his (or her) well-being.

This ostracon was found during the
Metropolitan Museum's excavations at Deir
el-Bahri, in a large depression dubbed the
Hatshepsut Hole by the excavators. Hundreds of
other ostraca were found here, mixed with frag-
ments of statues from Hatshepsut's temple (see
"The Destruction of the Statues of Hatshepsut
from Deir el-Bahri" by Dorothea Arnold in this
publication). CHR

PROVENANCE: Western Thebes, Deir el-Bahri,
Hatshepsut Hole; Metropolitan Museum of Art exca-
vations, 1922–23, acquired in the division of finds

BIBLIOGRAPHY: Winlock 1923, p. 34, fig. 32; Hayes
1959, p. 174, fig. 96

23. Ostracon with a Painting of a Hippopotamus

Early 18th Dynasty, joint reign of Hatshepsut and
Thutmose III (1479–1458 B.C.)
Painted limestone
H. 12 cm (4¾ in.), W. 10.5 cm (4⅛ in.)
The Metropolitan Museum of Art, New York,
Rogers Fund, 1923 23.3.6

This painting of a hippopotamus is less formal
than the scaled drawing of hieroglyphs dis-
cussed above (cat. no. 22). The animal was
painted with the sure hand of a skilled artist
who had no need of a grid.

Broadly speaking, the Egyptians viewed the
world in terms of the opposing forces of order
and chaos, and they recognized these forces in
the creatures around them. In its benign aspect,
the hippo, standing upright, was used to repre-
sent the goddess Taweret (see cat. no. 197), the
protector of children and pregnant women. But
the hippo could also be a dangerous, destructive
beast, and the Egyptians had great respect for
its power. In its destructive aspect, the hippo
was a stand-in for Seth, the god of chaos, and
scenes of the king, or the god Horus, or even a
deceased tomb owner harpooning a hippopota-
mus can be read as depictions of the triumph of
order over chaos. In this small painting, how-
ever, the animal, which seems to be on land, not
in the water, is not shown in an aggressive pose.
In this case the image may simply be what meets
the eye: a representation of a hippopotamus.[1]

 CHR

1. For other interpretations, see the bibliography
 below.

PROVENANCE: Western Thebes, Deir el-Bahri,
Hatshepsut Hole; Metropolitan Museum of Art exca-
vations, 1922–23, acquired in the division of finds

BIBLIOGRAPHY: Winlock 1923, p. 34, fig. 29; Hayes
1959, p. 174, fig. 95; Dorothea Arnold 1995, p. 33

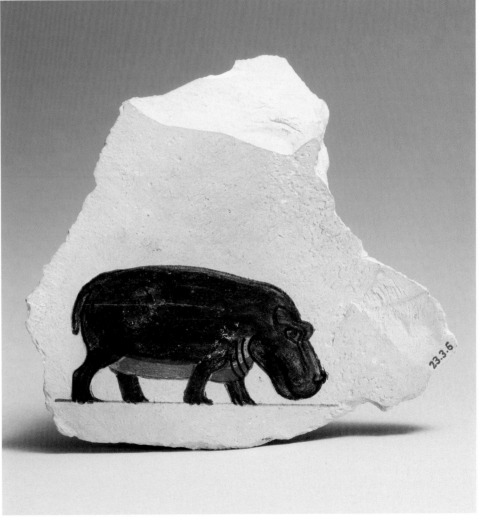

23

24. Hanging (?)

Early 18th Dynasty, reign of Ahmose I–joint reign
of Hatshepsut and Thutmose III (1550–1458 B.C.)
Painted leather
H. 16 cm (6¼ in.), W. 18 cm (7⅛ in.)
The Metropolitan Museum of Art, New York,
Rogers Fund, 1931 (31.3.98)

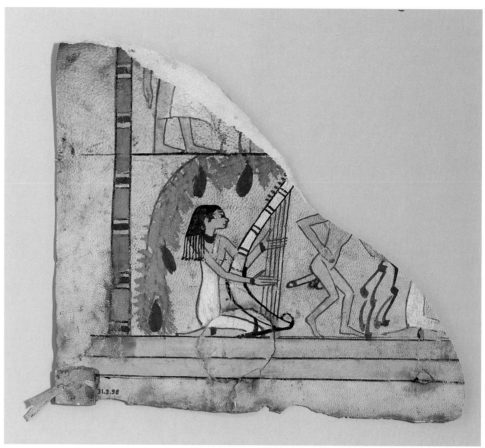

24

This fragment of painted leather was found in
debris during the clearance of a Middle King-
dom tomb some two hundred yards east of
Hatshepsut's temple at Deir el-Bahri. No other
New Kingdom material was found in this tomb,
but the hairstyle of the harpist,[1] her clothing
and jewelry,[2] and her willowy, long-waisted
figure date the piece to the early part of the
Eighteenth Dynasty.

The erotic nature of the scene, with its
naked male dancer, suggests that this piece was
intended for the shrine of the goddess Hathor at
Deir el-Bahri.[3] In her aspect as a fertility god-
dess, Hathor was associated with Bes, a fertility
god who was depicted as part human, part lion
(on Bes, see cat. no. 190). The nude figure may
be either a priest or a mummer who would have
worn a mask and played the part of Bes at a fes-
tival honoring the goddess.[4] The dancer and the
partially preserved man in the register above
both carry an object with multiple brown
strands. These have been described as scourges,
but they could as easily be some sort of percus-
sion instrument used to accompany the music
and to placate the goddess.

The material is probably goat hide.[5] Two
holes in the leather were patched before the sur-
face was painted. The lower left corner has been
reinforced with a patch of red-dyed leather that
holds a leather tie. This suggests that the piece
was attached to an item of furniture or tied to
a pole.

CHR

1. Similar braided locks can be seen on a female
harpist depicted in a wall painting in the tomb of
Amenemhat (TT 82, Nina de G. Davies and
Gardiner 1915, pl. XVII). A stela painted on a wall
in the back of the tomb is dated to year 28 of
Thutmose III, only a few years after the disappear-
ance of Hatshepsut.
2. Her anklets are particularly noteworthy, for they
were not worn by women after the very early
Eighteenth Dynasty. See Diana Craig Patch's essay
on jewelry in chapter 4.
3. In the 1930s the subject matter was considered too
erotic for public display, and the phallus was painted
out. This doctoring was reversed in 1970, and the
piece is currently displayed in its original form.
4. Pinch 1993, pp. 240–41, discusses the possible inter-
pretation of this piece.

5. The material was identified by Ann Heywood,
Conservator, in the Sherman Fairchild Center
for Objects Conservation at The Metropolitan
Museum of Art.

PROVENANCE: Western Thebes, Asasif, found
in debris during clearance of MMA tomb 815;
Metropolitan Museum of Art excavations, 1930–31,
acquired in the division of finds

BIBLIOGRAPHY: Fischer 1974, p. 10, fig. 8; Hayes
1959, p. 167, fig. 92; Pinch 1993, pp. 240–41, pl. 54

TECHNICAL STUDY

Despite the fragmentary condition of this
painted leather object (cat. no. 24), the pigments
on it are well preserved and unadulterated. The
bright white was found to be huntite, the yellow
skin color is orpiment, the red pigment outlining
the figures is red ocher, and the corner tab is
dyed pink with madder. Most significant, the
blue-green pigment used for the grapes and the
decoration on the vertical column was found to
be azurite, a natural pigment derived from the
copper-carbonate mineral of the same name. The
pale blue-green of the leaves is azurite mixed
with huntite. The initial identification by Raman
spectroscopy[1] was confirmed by polarizing light

microscopy. Although azurite was an important
pigment of ancient wall paintings of the Sung
and Ming Dynasties in China, there are few
confirmed occurrences of azurite on ancient
Egyptian objects. Its absence from the Egyptian
palette has been a mystery, considering the
availability of azurite sources both in the Sinai
and in the Eastern Desert, as well as the use of
malachite, a green copper carbonate often
found associated with azurite in geological con-
texts, as a green pigment on Egyptian objects.
The use of azurite appears to have been super-
seded by the employment of Egyptian blue, a
synthetic copper-calcium silicate and the most
commonly identified blue both in Egypt and
throughout the ancient Mediterranean world.

AH

1. Raman spectroscopy analysis was performed by
Silvia Centeno, Associate Research Scientist,
Department of Scientific Research, at the
Metropolitan Museum.

25. Linen Chest of Perpauti

Probably 1st half of the 18th Dynasty (1550–1425 B.C.)

Painted wood

H. 37 cm (14⅝ in.), W. 32.5 cm (12¼ in.), D. 48 cm (18⅞ in.)

Museo Civico Archeologico, Bologna KS 1970

This chest and a number of other objects belonging to a man named Perpauti have been known since the early nineteenth century.[1] These pieces were probably among the furnishings of his tomb, which is thought to have been located somewhere in the Theban necropolis.[2] Chests of similar size and shape, filled with linen sheets and clothing, have been found in Theban tombs dating from the Eighteenth Dynasty. Many of these are undecorated, some are painted with geometric patterns, and a few have scenes on one side that depict the owner and his family.[3] Perpauti's chest is exceptional both for the quality of the painting and for the quantity of decoration, which covers every surface with either scenes or geometric patterns.

The principal scene shows Perpauti and his wife seated at the left, facing three of their children. An offering text begins in the column of hieroglyphs above the son's head and reads from right to left:

> A royal offering of Amun-Re, king of the gods; a royal offering of Osiris, the great god, who rules forever, may he give all good and pure things to the ka of the uniquely accomplished one, a singer of his god, Perpauti, his bodily beloved wife, the housemistress Iadi.

The six columns of text at the right identify the children as "his bodily beloved son, Niwenenef; his daughter Takhat; his daughter Tay-tay."[4] Although most of the names are uncommon, they are all Egyptian, not foreign in form.[5] Perpauti is a theophoric name that can be translated "the primeval god has emerged"; his son's name, Niwenenef, can be interpreted as "he takes his time" (an appropriate name for a child who is born late); and Tay-tay, which is perhaps a nickname for the youngest in the family, might be translated as "this one's mine."[6]

The long-waisted, slim form of the figures in this scene is typical of the first half of the Eighteenth Dynasty. The braided hairstyle of two of the women is documented in the mid-reign of Thutmose III, and the simple style of the clothing is also in keeping with the early part of the dynasty.[7]

On the back of the box, the couple are shown facing two of their daughters, who are identified in the last four columns of text as "his bodily and beloved daughter Tjaua; his bodily and beloved daughter Qedut." The inscription on this side invokes the goddess Mut, whose temple, Isheru, lies just south of Karnak, and Hathor, who had long been associated with the area around Deir el-Bahri (the Valley):

> A royal offering of Mut, lady of Isheru, and Hathor, lady of the Valley, a royal offering of Osiris, the Great God, giving all that comes from their offering table as the daily need for the ka of the singer of Amun-Re, Perpauti, and the housemistress Iadi.

The ends of the chest are decorated with almost identical scenes depicting two mother gazelles rearing up to nibble the leaves of a composite plant while suckling their fawns. The plant is made up of elements that betray the influence of the art of western Asia (see

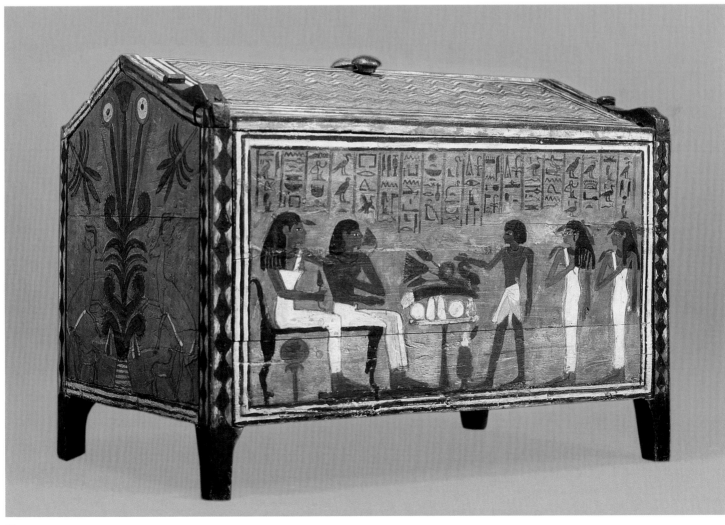

25

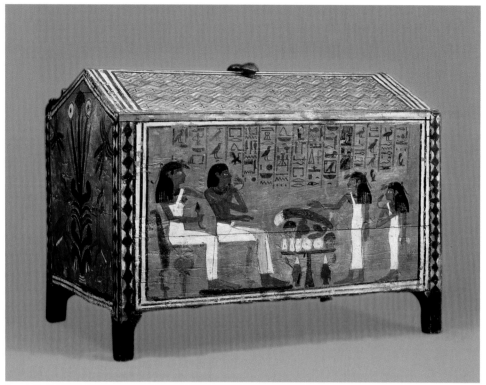

25, back

surprising that many Near Eastern motifs had already found their way into Egyptian art, though they may not yet have been common.

9. The pattern is illustrated in Dziobek 1994, pl. 2d.

10. A second box inscribed with Perpauti's name (Oriental Museum, University of Durham [United Kingdom], N. 1460) seems to be a copy of this one. The style of the painting on this second box is more in keeping with that of the second half of the Eighteenth Dynasty. As Arielle Kozloff has suggested (Kozloff and Bryan 1992, pp. 286–87), one chest may have been made early in Perpauti's life, and one at the end. She would date the Bologna box to the reign of Amenhotep II and the Durham box to the reign of Amenhotep III. I would date them slightly earlier, to the reign of Thutmose III and between the reigns of Amenhotep II and Thutmose IV, respectively.

PROVENANCE: Unknown, probably from Thebes; formerly Palagi collection (Nizzoli 1827); acquired by the Comune di Bologna in 1861

BIBLIOGRAPHY: Maria Cristina Guidotti in *Arte nell'antico Egitto* 1990, pp. 94–95, no. 43; Museo Civico Archeologico di Bologna 1994, p. 71

Christine Lilyquist's essay "Egypt and the Near East" in this publication), but the plant has been adapted by the Egyptian artist through the addition of a papyrus umbel at the center top. Though it originated and is more common in ancient Near Eastern art, the motif of animals flanking a tree had been present in Egyptian art since Predynastic times, and it was used in Theban tomb paintings from the early Middle Kingdom (see fig. 14).

This type of composite plant, particularly with inward-turning volutes and with pendant buds on the lily element at the bottom, becomes quite common in the second half of the Eighteenth Dynasty, especially in the reign of Amenhotep III (r. 1390–1352 B.C.). For this reason, Perpauti's box has generally been dated to Amenhotep's reign. However, all of the elements of the composite plant had been integrated into Egyptian art by late in the reign of Thutmose III, and related designs appear on scarabs dating from early in the reign of Hatshepsut.[8] The lily with pendant buds occurs even earlier, on the dagger of King Ahmose I (Egyptian Museum, Cairo, CG 52658-9), from the beginning of the dynasty. The pattern on the sloping lid of the box is similar to decoration found on the ceilings of Theban tombs, such as that of Useramun (TT 61),[9] who was vizier early in Thutmose III's sole reign. All this evidence supports a date in the reign of this king for Perpauti's box in Bologna.[10]

CHR

1. Other objects belonging to this man are now in the Durham University Oriental Museum (Kozloff and Bryan 1992, pp. 285–87) and the British Museum, London (Porter and Moss 1964, pp. 838, 842, 843).

2. Museo Civico Archeologico di Bologna 1994, p. 71.

3. A number of gable-topped boxes were found in the tomb of a man named Kha, which dates from early in the reign of Amenhotep III (Schiaparelli 1927, pp. 123–28).

4. The inscription is unusual both in its wording and in the orientation of the hieroglyphs. The word "bodily" (literally, "of his body") is usually used to identify only a man's biological children, not his wife. The six columns of text that identify the children are written in retrograde hieroglyphs (in other words, the order of signs is the opposite of the normal order—these signs read in the same direction that they face, from left to right, rather than the reverse).

5. Arielle Kozloff suggests otherwise in Kozloff and Bryan 1992, p. 286.

6. Tay-tay is depicted last in line, implying that she is junior to the others. The name translations are by James P. Allen.

7. For this hairstyle, see also the entry for catalogue no. 24, n. 1.

8. The in-turned volutes are also present in a scene in the tomb of Rekhmire (TT 100), who was vizier of Thutmose III and lived into the reign of his son Amenhotep II. In a section of wall decoration depicting Rekhmire's boat in port and again under sail, the boat is decorated with composite plants similar to the ones on Perpauti's box (Norman de G. Davies 1943, pls. LXVIII, LXIX). The motif is fully developed and has been executed with great ease, suggesting that it had become a well-established element in the artist's decorative repertoire. By the joint reign of Hatshepsut and Thutmose III, the Egyptians had been visiting western Asia for three generations, and it is not

Fig. 14. Men gathering sycamore figs from a tree flanked by two spotted goats. Detail of a scene in the Theban tomb of Djari (TT 366), 11th Dynasty. Drawing by Linsley F. Hall

EGYPT AND NUBIA
Conflict with the Kingdom of Kush

W. Vivian Davies

Toward the end of the Thirteenth Dynasty (1640 B.C.), internal political weakness, exacerbated by external pressures, led to the collapse of the central government in Egypt and a new political and territorial disposition in the Nile valley.[1] Only Upper (southern) Egypt remained under native Egyptian control, that of a dynasty of kings from Thebes (the Seventeenth Dynasty, 1635–1550 B.C.).[2] Lower (northern) Egypt was ruled in the same period by the Fifteenth Dynasty, a dynasty of Canaanite origin—the so-called Hyksos—based at Avaris (modern Tell el-Daba) in the eastern Delta; their control eventually extended as far as Cusae in Middle Egypt. To the south, the gold-rich land of Wawat (Lower Nubia), long part of Egypt's fiefdom, fell into the hands of the powerful kings of Kush, who were based at Kerma in Upper Nubia, just south of the Third Nile Cataract (now in northern Sudan). The situation, which lasted for a century and more, is famously summed up in the complaint of Kamose (r. 1552–1550 B.C.), last king of the Seventeenth Dynasty, whose words to his council are recorded in a commemorative monument, the so-called first Kamose stela, erected in the temple of Karnak: "To what purpose do I contemplate it, this my strength, when there is one chief in Avaris and another in Kush, and I sit here united with an Asiatic and a Nubian, each possessing his slice of Egypt, dividing the land with me?"[3] Presaging the end of Egypt's period of humiliation, these bitter words mark (in retrospect) the beginning of an extraordinarily determined drive by the Thebans not only to recover what had been lost but also, in due course, to expand and conquer—to extend the boundaries of Egypt on a previously unparalleled scale.[4]

Taking their cue from the surviving Egyptian texts—among them the well-known inscription of Queen Hatshepsut from the temple of Speos Artemidos, with its reference to the destructive time of "the Asiatics in the midst of the Delta (in) Avaris"[5]—most commentators on this period have tended to concentrate on the Thebans' power struggle with the Hyksos to the north, regarding them as the dominant threat. The Kushites have been viewed as potential allies of the Hyksos but essentially secondary players content simply to hold the territory as far as Egypt's southern border at Elephantine. In fact, however, evidence for Hyksos penetration of the Theban realm remains slight and inconclusive,[6] while testimony to hostility from the Kushites on a significant scale has now come to light (see below).

THE KINGDOM OF KUSH

"Wretched Kush" had for centuries been a thorn in Egypt's side, a trading partner but also competitor, contesting Egypt's control of both territory and resources.[7] Especially at issue was access to the luxury goods of sub-Saharan Africa[8] and the gold mines of the Nubian Desert.[9] The relationship became increasingly fraught during Egypt's Middle Kingdom, when the kings of the Twelfth Dynasty annexed Wawat and established a new southern boundary at the Second Cataract, defending their conquest with a chain of massive fortresses.[10] With the subsequent collapse of Egypt as a unified state and the Egyptian withdrawal from Wawat, the fortresses were ceded to the Kushites, who kept on to run them the personnel who had served the previous administration—Egyptians in origin but no doubt long acculturated to their Nubian context through marriage and other contacts.[11] At Buhen, one of the most important fortresses, a group of private stelae records five generations of one family who served as senior officials first for the Egyptians and then for the Kushites.[12] A royal stela from the same site appears to depict a king of Kush with both Egyptian and Nubian accoutrements (white crown, uraeus, mace on the one hand, bow and arrows on the other),[13] possibly to signify Kushite hegemony over a territory that had recently been part of Egypt.

Kush was at its zenith during this period, the so-called Classic Kerma Period. The power and prosperity it enjoyed then are still manifest today in the impressive remains of its fortified capital at Kerma—the earliest and largest city in Africa outside Egypt—and the associated cemetery containing over twenty thousand burials, including gigantic royal tumulus-tombs.[14] Here the kings of Kush were buried, accompanied by hundreds of sacrificed retainers, and with substantial quantities of luxury goods including

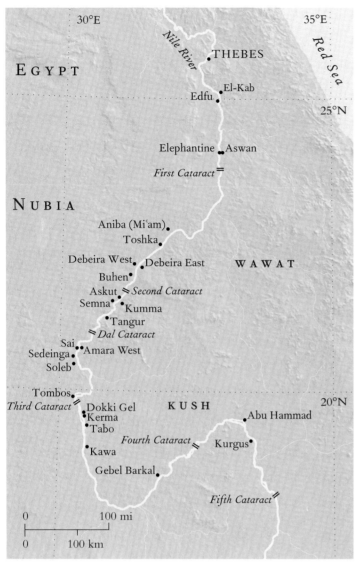

Fig. 15. Map of Nubia showing New Kingdom sites

vulnerable Egypt. The primary purpose of the attack appears to have been pillage, on a large scale. In the inscription the Kushite forces are referred to as "looters," who, it is reported, were eventually driven away through a counterattack led by the Egyptian king.

The results of such pillage are surely to be seen among the Egyptian material deposited in the royal tumuli and cult chapels at Kerma. This mass of fine objects (now mostly fragmentary) includes statues both royal and private, stone vessels, and stelae, many of them inscribed and a proportion clearly originating from tombs and temples in Upper Egypt.[18] The Kushite kings may have had the statues buried with them to symbolize their own domination over Egypt (if so, this would represent a remarkable appropriation and reversal of the traditional Egyptian worldview). The great tumuli at Kerma span several generations, and all, including the earliest, contain Egyptian trophies. It seems possible, therefore, that the Egyptians were subjected to periodic raids throughout the period and that the attack described in the El-Kab tomb, although perhaps unusually large, was not the only one.[19]

EGYPT RESURGENT

By the end of the Seventeenth Dynasty the tide had clearly begun to turn, with the Thebans successfully engaging their enemies in both the south and the north. There is evidence that by Kamose's third regnal year the Egyptians had recovered most of Wawat, penetrating as far as Buhen, and had ranged even farther, creating a buffer zone in the south, before they turned north to harass the Hyksos.[20] Kamose's achievements are commemorated in at least three great stelae set up in Karnak.[21] The first is quoted on the preceding page (and see n. 3 below). The second records the contents of a letter addressed to the ruler of Kush from the Hyksos overlord Ipepi that was intercepted by Kamose's agents. In it Ipepi refers to the unprovoked violence perpetrated against both their lands by Kamose and urges his Kushite "brother" to attack Kamose from the south while he himself distracts him in the north. In this way, Ipepi says, "we shall share the towns of this Egypt."[22] One can only speculate about what such a coordinated response might have achieved—if it had been successful, probably the end of the Theban dynasty and a course of Egyptian history very different from the one we know. But no such response materialized, and events proved fatal for the Hyksos and eventually for the kingdom of Kush.

The Hyksos dynasty was finally brought to an end by Kamose's younger brother and successor, Ahmose I (r. 1550–1525 B.C.), first king of the Eighteenth Dynasty and founder of the New Kingdom.[23] Capturing Avaris sometime during or after his year 11, Ahmose expelled the Hyksos rulers, pursued them, and defeated them in Palestine, thus securing his northern front, before turning his attention southward to Nubia. Here the

high-prestige Egyptian objects. Even before its occupation of Wawat, the kingdom had encompassed a huge territory. Recent archaeological work has uncovered hundreds of so-called Kerma-culture sites in an area stretching southward through the Dongola Reach along the Nile valley and adjacent deserts to the Fourth Cataract and well beyond.[15]

The extent of the kingdom's influence is evident from the military coalition it was able to direct against Upper Egypt, as reported in an Egyptian inscription recently discovered in the tomb of the governor Sebeknakht at El-Kab that probably dates from the first half of the Seventeenth Dynasty.[16] The force is described as of unparalleled size and consisting of troops drawn not only from the tribes of Wawat and riverine Upper Nubia but also from the Medja bedouin of the desert and even the exotic land of Punt[17] (one day to be visited by a famous expedition sent by Queen Hatshepsut), all perhaps seizing their chance against a

imperial strategy, designed from the outset to meet goals both economic and flowing from the Egyptian ideology of kingship, was one of military advance and consolidation, together with the assimilation and acculturation of the native population and the ruthless suppression of opposition.[24] Ahmose's conquests, along with those of his successors Amenhotep I (r. 1525–1504 B.C.) and Thutmose I (r. 1504–1492 B.C.), are chronicled in a long biographical inscription in another tomb at El-Kab, that of the soldier Ahmose son of Ibana, who served in the army of all three kings: "After his majesty (Ahmose) had slain the nomads of Asia (i.e., the Hyksos), he went south to Nubia to destroy the Nubian tribesmen. His majesty made a great slaughter among them. . . . His majesty journeyed northward joyful, in strength and victory, for he had taken the southerners and the northerners."[25] Building rapidly on his predecessor's achievements, Ahmose extended Egypt's southern border beyond Buhen to Sai Island, north of the Third Cataract, where he built a fortress and a temple in which he erected a lifesize statue of himself.[26] His successor Amenhotep I also set up a statue of himself there (fig. 16);[27] both works carry dedications to the chief god of the Egyptian state, Amun-Re. The military and cultural reappropriation of Nubia was by now well under way and set to advance, with Sai fortress serving as a bridgehead into Kush proper and a secure launching pad for further campaigns.

THUTMOSE I AND HATSHEPSUT

Beyond the Third Cataract lay the ultimate military goal: Kerma, the capital of "Wretched Kush" and source of much of Egypt's recent humiliation. The decisive move against it was made by Thutmose I, the father of Queen Hatshepsut, in year 2 of his reign. After ordering his boats to be dragged around the Third Cataract to reach the city, he won a major battle, slaying a Kushite chief, whose body, according to the account of Ahmose son of Ibana, was displayed hanging upside down from the prow of the royal boat as it sailed back to Thebes, a gruesome act of revenge and warning to all potential enemies.[28] The victory was marked by five large stelae carved into the rocks at Tombos (fig. 17)[29] at the southern end of the Third Cataract, not far north of Kerma; the principal one, inscribed on a huge boulder, records the massacre of the Kushites in vivid detail.[30] That the Kushites suffered a serious defeat appears confirmed by archaeological evidence of destruction within Kerma itself at that time, strongly suggesting that the Egyptians succeeded in storming the city.[31] It is known that following his victory Thutmose I built at least two fortresses to deter rebellions. Their location has yet to be identified,[32] although it is now clear from recent excavations that by the reign of Amenhotep II (r. 1427–1400 B.C.), if not before, Tombos had become the site of a major colonial settlement.[33]

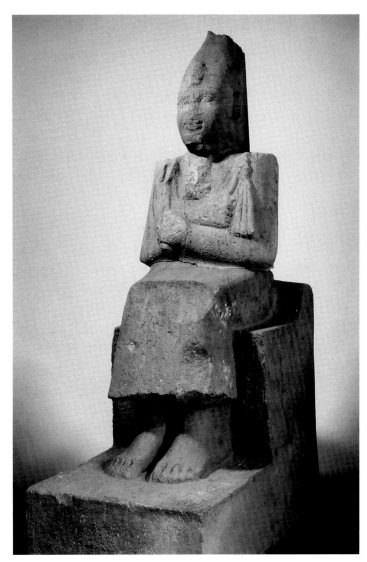

Fig. 16. Amenhotep I. Statue from Sai Island, early 18th Dynasty. Sudan National Museum, Khartoum (63/4/5)

Bent on encompassing Kush ideologically as well as territorially, the Egyptians now struck deep into Upper Nubia, to a remote point beyond the Abu Hammad bend of the Nile at modern-day Kurgus. The target was an enormous quartz rock (known today as the Hagr el-Merwa; fig. 18), a conspicuous landmark then embellished with native rock drawings and probably of great spiritual significance for the indigenous population. Here Thutmose I had an impressive stela carved, obliterating much of the native matter and marking the site as both the new southern boundary of the Egyptian empire and one end of the ordered cosmos as ordained by Amun-Re; the inscription threatened dire consequences for any Nubian who violated the monument.[34] In due course, Thutmose set up a corresponding stela marking the empire's northern end, in the country of Naharin in Syro-Palestine. Some fifty years later his grandson Thutmose III (r. 1479–1425 B.C.) renewed the northern and southern boundaries established by his great predecessor.

Fig. 17. A rock stela of Thutmose I at Tombos, early 18th Dynasty

Other inscriptions on the Hagr el-Merwa show that Thutmose I traveled to Kurgus with a large entourage of followers.[35] It comprised not only military personnel but priests, scribes, and even elite members of the court, including, remarkably, the king's chief wife, Queen Ahmose, his crown prince, Amenmose, and, intriguingly, a princess.[36] Although her name, rather clumsily carved and now somewhat effaced, is of uncertain reading,[37] the traces are perhaps more compatible with "Hatshepsut" than with "Nefrubiti" (the two daughters currently documented for Thutmose I and Ahmose). If Hatshepsut participated as a young princess in the Kurgus expedition, the experience would have stood her in excellent stead for her own future campaigning in Kush.

After a campaign in Nubia of at least seven months' duration, Thutmose I returned to Egypt in his third regnal year,[38] having

achieved unprecedented success. Nevertheless, Egyptian control of Upper Nubia (as opposed to Wawat) was by no means totally secure. The Kushites proved to be both uncooperative and resilient. They rebuilt Kerma, raising its great central temple (the eastern "deffufa") to a height of over sixty feet, and the city may well have continued to serve as a node of resistance. According to an inscription of Thutmose II (r. 1492–1479 B.C.),[39] Thutmose I divided Kush into three parts, two of which were placed under the rule of native princes, sons of the slain ruler, who had escaped the slaughter commemorated at Tombos. Shortly after the accession of Thutmose II they joined forces with "a chief in the north of wretched Kush" (probably based at Kerma) and attacked fortresses that had been erected by Thutmose I, killing Egyptians and plundering cattle. The response was uncompromising. A punitive expedition was sent to Kush and crushed the uprising. On the orders of the king, no male was left alive among the enemy except for one son of the Kushite chief, who was brought to Egypt with his family—possibly for "reeducation" and eventual return,[40] a policy of enforced assimilation already successfully deployed in Wawat (see below). Nevertheless, rebellions continued to occur. Kerma's final abandonment now appears to have coincided with the foundation of a new pharaonic complex to the north at nearby Dokki Gel,[41] possibly under Thutmose III—the first settled Egyptian presence in the area.

The old idea that Hatshepsut's reign was deliberately peaceful and conciliatory, as opposed, for example, to that of the "warlike" Thutmose III, is well wide of the mark.[42] Confronted with the forces of disorder, as she was on several occasions, she acted appropriately. At least two southern campaigns are attested during the period of her co-regency with Thutmose III. One, dated to year 12, was directed against Kush and is recorded in a rock inscription at Tangur.[43] The other, undated but probably the earlier of the two, was led by Hatshepsut herself. It is described in a

Fig. 18. Colossal quartz rock known as the Hagr el-Merwa, Kurgus

biographical inscription at Sehel belonging to the royal chancellor Ty, who bears witness to the active role played by the queen/king in slaying the Nubian tribesmen and ravaging the land of Nubia.[44] It may be this expedition that is commemorated in an important but fragmentary inscription from Deir el-Bahri in which the great victory campaign of her father, Thutmose I, is presented as the inspiration for a successful Nubian campaign by Hatshepsut.[45] A reference, probably generic, to her defeat of enemies is also preserved in the new (southern) temple of Horus at Buhen, where an important scene, now incomplete, shows her coronation at the hands of the god, while the inscription proclaims her universal rule.[46] The special significance the queen attached to this temple, one of a number built in Wawat during her reign, is reflected in the high standard of workmanship in the main building (the part for which she was largely responsible). The quality of the painted relief, which is particularly well preserved in the inner sanctum (fig. 19), is quite remarkable.[47]

COLONIAL NUBIA

Following its conquest, Wawat was administered as a province of Egypt, with a centrally controlled bureaucracy manned at the very highest level by Egyptians but otherwise largely by local personnel based in important population centers (mainly the old military strongholds, now fortified settlements).[48] They were given Egyptian titles and sometimes assumed Egyptian names. The system was gradually extended to cover Kush, where a number of new colonial centers were established.[49] However, it is doubtful that the level of close control that obtained in Wawat was ever achieved or even attempted in Kush, where, it is thought, native chiefs, particularly those operating in more remote areas, continued to enjoy a degree of autonomy and independence.[50] The colonial regime, which appears not to have been unduly exploitative, proved pragmatic and effective, sending the desired products back to the king and maintaining a viable government (albeit with intermittent setbacks) for nearly five hundred years.

The senior official of the administration was initially designated King's Son, or viceroy, and later, beginning in the reign of Thutmose IV, King's Son of Kush.[51] He was not an actual son of the king but a close confidant and direct royal appointee, who also held the title Overseer of the Southern Foreign Lands or a variant of it. The viceroy's authority extended south from Hierakonpolis in Upper Egypt to the outermost boundary of Egyptian ambition in Upper Nubia (as far as Kurgus in the early Eighteenth Dynasty; pulled back to Gebel Barkal later on).[52] The duties of his administration were to carry out the king's appointed building program, manage the tax regime and trade in exotic goods, and organize the extraction and delivery of gold from Nubia's eastern desert. The viceroy was also responsible for security, and, if the

Fig. 19. Painted relief decoration in Hatshepsut's temple of Horus, Buhen, 1479–1458 B.C.

situation were serious enough, he might accompany the king on military or punitive expeditions or lead such expeditions himself. Exactly when the office was instituted is not known. Two Kings' Sons, Teti and Djehuti, dating from the reigns of Kamose and Ahmose I, respectively, may have been the first two viceroys; but the earliest attested bearer of the full titulary King's Son, Overseer of the Southern Foreign Lands was a certain Ahmose-Satayt, who perhaps straddled the reigns of Ahmose I and Amenhotep I. He is known to have been succeeded by his son, the well-known Ahmose-Turi, who was viceroy from at least year 7 of Amenhotep I to year 3 of Thutmose I. He in turn was replaced by Seni, who served through the reign of Thutmose II and possibly into the early years of Hatshepsut.[53]

There has been considerable debate over the number and identity of Hatshepsut's viceroys.[54] In fact, only one viceroy, Amenemnekhu, is attested with certainty for the period of the co-regency. He is well documented from a number of Nubian rock inscriptions, at Sehel, Shalfak, Kumma, Tangur, Dal, and possibly

also Tombos.[55] At least one context at Tangur is dated to year 12, the one at Shalfak to year 18, and that at Tombos to year 20. With the advent of Thutmose III's sole reign in year 22, a new viceroy, Nehi, was appointed.[56] In due course, Amenemnekhu's name, like that of his mistress, was officially excised. It has been suggested that one of the co-regency's senior military officials, the King's Son, Troop-Commander, Overseer of Weaponry, Inebni, known from a fine statue in the British Museum (cat. no. 26), was also a viceroy at some time during the period,[57] but the title King's Son is not conclusive in this case and the evidence is open to differing interpretations.[58]

The routine governance of the province was delegated to an official deputy whose full title was Deputy of the King's Son. By the later Eighteenth Dynasty there was one deputy for Wawat (based at Aniba) and one for Kush (based initially at Soleb, later at Amara West). The first holder of the full title was the Deputy of the King's Son, Ruiu, also identified as First Royal Confidant of the King's Son, possibly pointing to a connection with the Egyptian court. A native Nubian, as indicated by his name, Ruiu was buried in a fine Egyptian-style tomb at Toshka, near Aniba.[59] In the tomb were found two remarkable statues, also Egyptian in form if a little provincial in style, one showing Ruiu seated, the other squatting (cat. no. 27); both are decorated with Egyptian hieroglyphs giving his name and titles.[60] The viceroy under whom he served is nowhere named, but the statues have been dated on stylistic grounds to the reign of Hatshepsut.

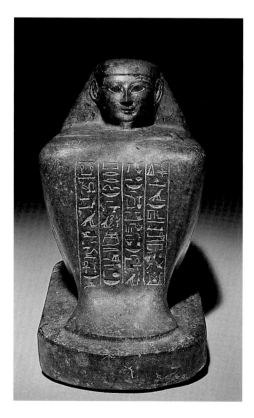

Fig. 20. Statuette of Amenemhat from Buhen, 1479–1458 B.C. Sudan National Museum, Khartoum (92)

NUBIAN ACCULTURATION

The case of Ruiu highlights an important element in Egypt's colonial policy already referred to above and particularly well documented during Queen Hatshepsut's floruit: pacification through the assimilation of Nubian elite families, in part by educating their young in Egypt, and subsequently incorporating them into the governance of the province.[61] The policy, which held clear benefits for both parties, appears to have been especially successful among the elite of Wawat—not surprisingly, perhaps, given the region's long history of acculturation and mixed ethnicity.[62] A conspicuous example is provided by the family of another Ruiu, the hereditary chief of the region of Teh-khet (covering modern Debeira-Serra), which is traceable in the Egyptian record over several generations during the early Eighteenth Dynasty,[63] most prominently during Hatshepsut's ascendancy. Especially well documented are Ruiu's two sons, both of whom had Egyptian names: Djehutihotep, the elder son (also called by his Nubian name Paitsi), and Amenemhat, whose wife was called Hatshepsut. Each son inherited the chiefdom in turn, and both served during the period of the co-regency, running their region as part of the colonial administration.

Djehutihotep is famous for his tomb at Debeira East, which is decorated with scenes of daily life clearly painted by Egyptian artists[64] (perhaps recruited from the work on Hatshepsut's temple at Buhen not far to the south, a site with which the family appears to have had a strong connection). Amenemhat's tomb at Debeira West was left undecorated,[65] but he is otherwise attested from a large number of monuments again wholly Egyptian in appearance and execution, including a very fine tomb stela[66] and an important group of statues (cat. no. 28; fig. 20) and stelae from Buhen (cat. no. 29),[67] where he appears to have been posted, very possibly after education and training at the Egyptian court (one of his titles is True Royal Confidant). These Buhen pieces help to document the earlier stages in his career, from his first posting as a scribe, probably under Thutmose I, through subsequent promotions under Thutmose II and Hatshepsut herself.

Amenemhat is directly associated with Hatshepsut through a series of titles, Vigilant Agent of the King's Daughter, Vigilant Agent of the God's Wife, and Vigilant Agent of the Lady of the Two Lands—a sequence that mirrors Hatshepsut's own gradual rise to power. He is also entitled Valiant Agent ("of the King" or "in Wawat"), as was his brother before him (Valiant Agent of the Lady of the Two Lands), a title that hints at military duties, probably including the policing of the routes and mines of Nubia's eastern desert.[68] Childless and lacking an heir, Amenemhat was the last chief of Teh-khet of his line. He probably died toward the end of Hatshepsut's reign, after which the family, if not the chiefdom, disappears from the archaeological record.

1. This period is often called the Second Intermediate Period (1640–1550 B.C.). For a recent overview with previous bibliography, see Bourriau 2000; on the early New Kingdom, see Bryan 2000. References cited below are selective and weighted toward recent literature.

2. The chronological scheme followed in this catalogue appears in the introduction. Various alternative chronologies for the Seventeenth Dynasty period are listed and discussed in Bennett 2002. See also Polz and Seiler 2003, pp. 44–47, 65–68. On the Fifteenth Dynasty, see T. Schneider 1998, pp. 57–98.

3. First Kamose stela, line 3 (= Carnarvon Tablet, line 3); see Gardiner 1916, pp. 99–109; Lacau 1939, pp. 251–52, pls. XXXVII, XXXVIII; Habachi 1972, pp. 46, fig. 29, 48; Helck 1975b, pp. 83–84; H. S. Smith and A. Smith 1976, pp. 54, 59; S. T. Smith 1995, pp. 179–80; Redford 1997, p. 13, no. 68; Bietak 2004a, p. 142, fig. 1; T. Schneider 2004.

4. The major military events and campaigns in Nubia are usefully summarized in Morkot 1987; Zibelius-Chen 1988, pp. 192–97; Säve-Söderbergh and Troy 1991, pp. 1–6. On the Theban/Egyptian expansion in the north, see Redford 2003, pp. 185ff.; Bietak 2004a; Marcus Müller 2004; T. Schneider 2004.

5. *Urkunden* 4, p. 390, ll. 6–8; Gardiner 1946, pp. 47–48, pl. VI, l. 3; Redford 1997, p. 17.

6. O'Connor 1997, pp. 56–57; Polz 1998; Bennett 2002, pp. 146–47; Darnell 2002a, p. 151; Darnell 2002b, pp. 42–43, 115, 118–19.

7. Zibelius-Chen 1988; Török 1997, pp. 92ff.; Valbelle 2004; Vogel 2004; Zibelius-Chen 2004.

8. Zibelius-Chen 1988, pp. 91–114; Morkot 1995, pp. 181–82; S. T. Smith 1995, p. 170; Manzo 1999, pp. 6–8; S. T. Smith 2003, pp. 8, 73, 79.

9. Zibelius-Chen 1988, pp. 73–80; S. T. Smith 1995, pp. 22–28; Manzo 1999, pp. 8–9. On the gold mines of Egypt's and Nubia's eastern deserts, see D. D. Klemm, R. Klemm, and Murr 2001; D. D. Klemm, R. Klemm, and Muir 2002; Angelo Castiglioni and Alfredo Castiglioni 2004.

10. S. T. Smith 1995, pp. 22–28, fig. 1.6, 39–50; S. T. Smith 2003, pp. 56–57, 74–76; Vogel 2004, pp. 164–67.

11. S. T. Smith 2003, pp. 78–83, 114; Vogel 2004, p. 167.

12. H. S. Smith 1976, p. 41; S. T. Smith 1995, p. 110; S. T. Smith 2003, p. 80; Valbelle 2004, p. 94; Vogel 2004, p. 167; W. V. Davies in Welsby and Anderson 2004b, p. 100, no. 73. For evidence of similar continuity of occupation in other fortresses, such as the one at Askut, see S. T. Smith 1995, pp. 90–106, 109ff., 176–78.

13. H. S. Smith 1976, pp. 1–12, no. 691, 84, 246, pls. III, 2, LVIII, 4; Anderson 2004, p. 28, no. 19; W. V. Davies in Welsby and Anderson 2004b, p. 101, no. 74.

14. S. T. Smith 2003, pp. 76–77, 82–83; Bonnet 2004a; Bonnet 2004b; D. N. Edwards 2004, pp. 4–7.

15. Welsby 2001, pp. 572–89; Kołosowska, el-Tayeb, and Paner 2003; Paner 2003, pp. 16–18; S. T. Smith 2003, pp. 87–94; Welsby 2003, pp. 30–32; Welsby 2004.

16. W. V. Davies 2003b; W. V. Davies 2003d, pp. 52–54, fig. 2; W. V. Davies 2003e, pp. 5–6; Anderson 2004, p. 28, no. 20; W. V. Davies in Welsby and Anderson 2004b, p. 101, no. 75.

17. On the Medja bedouin, see el-Sayed 2004, p. 361, n. 68; see also T. Schneider 2003a, pp. 92ff. For the latest discussion of much-debated Punt, see Kitchen 2004, which argues for a location "on balance . . . in eastern Africa, well south of Egypt, conveniently accessible from the Red Sea's western shores"; see also T. Schneider 2003a, pp. 100–104; Dixon 2004, pp. 33–34.

18. For the inscriptions, see Reisner 1923, pp. 505–31. On the origin of the objects, see W. V. Davies 2003b, pp. 43–44, n. 11; W. V. Davies 2003d, pp. 53–54, n. 11; Anderson 2004, p. 28, no. 20; Redford 2004, p. 34; Valbelle 2004, p. 94; Verbovsek 2004; W. V. Davies in Welsby and Anderson 2004b, p. 101, no. 75.

19. The demise of certain local cults during the Seventeenth Dynasty (those of Heqaib at Elephantine, Isi at Edfu; see Franke 1994, p. 86) may perhaps be related to such assaults, as may, at least in part, the ruination of Egyptian monuments described on the "Tempest Stela" of Ahmose I (Ryholt 1997, pp. 144–47; Wiener and J. P. Allen 1998, p. 20; Beylage 2002, pp. 85, 609; Klug 2002, p. 45; W. V. Davies 2003b, p. 44, n. 14; W. V Davies 2003d, p. 54, n. 14) and later in the Speos Artemidos inscription of Hatshepsut (see n. 5 above).

20. On the recovery of Wawat, see H. S. Smith 1976, pp. 8–9, 206, pls. II, 1, LVIII, 1; S. T. Smith 1995, pp. 138–39; Valbelle 2004, p. 94. The Egyptians reached as far south as the land of Miu, according to the inscription of the drummer Emhab, lines 12–13 (Černý 1969, pp. 88–89, 91, pl. XIII; Helck 1975b, pp. 97–98, no. 20; Baines 1986, pp. 42–43; O'Connor 1997, p. 45; Redford 1997, p. 12, no. 6; Ryholt 1997, pp. 182–83; Baines 2004, pp. 38–39). That land can be at least partly located in the Nile Reach upstream of Abu Hammad, including the area of Kurgus (W. V. Davies 2001, p. 52).

21. Two of the stelae are well known; see references in notes 3 and 22. A third has recently been identified by C. Van Siclen III in a paper entitled "Preliminary Report on the Third Kamose Stela from Karnak," delivered at a British Museum conference on the Second Intermediate Period (July 2004), to be published in forthcoming conference proceedings.

22. Habachi 1972, pp. 39–40; Helck 1975b, p. 94; H. S. Smith and A. Smith 1976, p. 61; Redford 1997, pp. 14–15, no. 69. On the archaeological evidence (or lack of it) for contacts between Avaris and Kerma, see Hein 2001.

23. Valbelle 2004, pp. 94–99.

24. On the much-debated nature of Egyptian imperialism and colonial policy in Nubia, see Kemp 1978a, pp. 21–43; Morkot 1987; Zibelius-Chen 1988, pp. xi–xxii; Morkot 1991; Säve-Söderbergh 1991; Säve-Söderbergh and Troy 1991, pp. 6–7; S. T. Smith 1995; Kemp 1997; Török 1997, p. 95; S. T. Smith 2003, pp. 8, 56ff.; Redford 2004, pp. 44–45, 49–53.

25. *Urkunden* 4, p. 5, ll. 4–14. For a photograph of the inscription, see W. V. Davies and R. F. Friedman 1998, pp. 120–21.

26. Valbelle 2004, pp. 94–95, fig. 69; Geus 2004; W. V. Davies in Welsby and Anderson 2004b, p. 103, fig. 79.

27. W. V. Davies in Welsby and Anderson 2004b, pp. 102–3, no. 76; Welsby and Anderson 2004a, p. 17; see also Klug 2002, pp. 53–54.

28. *Urkunden* 4, p. 9, ll. 3–5; W. V. Davies and R. F. Friedman 1998, p. 131, right.

29. *Urkunden* 4, pp. 82–88; S. T. Smith 2003, pp. 84–85, fig. 4.10.

30. *Urkunden* 4, pp. 82–86; W. V. Davies and R. F. Friedman 1998, p. 131, left; Beylage 2002, pp. 209–19, 679–83; Klug 2002, pp. 71–78, pl. 7; Redford 2004, pp. 37, 170–71, n. 61.

31. Bonnet 2004c, p. 115; Valbelle 2004, p. 96.

32. *Urkunden* 4, p. 138, ll. 16–17; Klug 2002, p. 76; Valbelle 2004, p. 96.

33. S. T. Smith 2003, pp. 136–38; D. N. Edwards 2004, p. 103.

34. W. V. Davies 2001, pp. 46–53; W. V. Davies 2003a, pp. 24–29; W. V. Davies 2003c; Baines 2004, pp. 39–41, fig. 15; W. V. Davies 2004; Valbelle 2004, pp. 94–95.

35. W. V. Davies 2001, pp. 53–57; W. V. Davies 2003a, pp. 32–37; W. V. Davies 2003c; W. V. Davies 2004, pp. 154–57, 160. On the importance of the king's physical presence in defining the cosmic frontiers and the symbolic function of such stelae, see Liverani 2001, pp. 34–37.

36. See Thutmose IV's "official tours, accompanied by court and family" (including his wife and young princes), as recorded in rock inscriptions at Konosso (Bryan 1991, pp. 50–51, 111, 198, 335–36; see also Klug 2002, pp. 345–56).

37. W. V. Davies 2001, pp. 53–57; W. V. Davies 2003a, pp. 35–36, fig. 17.

38. Gasse and Rondot 2003, p. 41, pl. 3; see also Gabolde 2004, p. 137.

39. *Urkunden* 4, p. 139, ll. 6–7; Klug 2002, p. 85; Gabolde 2004, pp. 131–34 (ll. 5–15), 139–43, 148.

40. Morkot 1987, p. 32.

41. Bonnet and Valbelle 2004; Valbelle 2004, pp. 96–97.

42. Redford 1967, pp. 57–63; Redford 2003, p. 190, n. 28; Redford 2004, p. 38.

43. Hintze and Reineke 1989, p. 172, no. 562, pl. 239.

44. Habachi 1957, pp. 99–104, fig. 6; Gasse and Rondot 2003, pp. 41–43, fig. 3.

45. Naville 1894–1908, pt. 6, pl. CLXV; Redford 1967, pp. 58–59; Klug 2002, p. 75, n. 593; Redford 2003, p. 190, n. 28; Redford 2004, p. 38.

46. Caminos 1974, vol. 2, pp. 44–50, pl. 46.

47. The quality of the work is commented upon by Caminos (ibid., pp. 87, 93), who notes its superiority to the later repainting carried out under Thutmose III.

48. S. T. Smith 1995, pp. 8–10, 18–24, 166–74; Török 1997, p. 96; S. T. Smith 2003, pp. 85–87, 98–99.

49. These were, in the Eighteenth Dynasty, Sai, Sedeinga, Soleb, Sesebi, Tombos, Dokki Gel, Tabo (?), Kawa, and Gebel Barkal; in the Nineteenth Dynasty, Amara West.

50. Morkot 1987, pp. 40, 42; Morkot 1991, pp. 295, 299; O'Connor 1993, p. 65; S. T. Smith 1995, pp. 9–10; Török 1997, p. 103; Morkot 2000, pp. 135–36; S. T. Smith 2003, pp. 60–61, 86–87, 94–96, 170, 195; D. N. Edwards 2004, pp. 105, 111. On the considerable potential for resistance offered by such chiefs, see Török 1997, pp. 102–3.

51. Habachi 1980; Bryan 1991, pp. 250ff.; Säve-Söderbergh and Troy 1991, pp. 6–7; Török 1997, pp. 95–96; Bács 2002; Gasse and Rondot 2003; Redford 2004, pp. 40–43; Valbelle 2004, p. 95.

52. Säve-Söderbergh and Troy 1991, p. 6; S. T. Smith 1995, pp. 180–83. For the Semna inscription of the viceroy Nehi, see Caminos 1998, pp. 62, 64, pls. 30–31, col. 12, confirming that as early as the sole reign of Thutmose III if not before, the viceroy's authority extended from the nome of Nekhen (the third Upper Egyptian nome) southward. Nehi's name is attested at Kurgus (W. V. Davies 2003a, p. 34, fig. 15; W. V. Davies 2003c, p. 56, fig. 4). The viceroy's jurisdiction over the area between Hierakonpolis and Aswan may be regarded as indicative of a significant Nubian population, possibly long settled, in the region. Note the recent, important discovery of a Nubian C-Group cemetery at Hierakonpolis, the northernmost known attestation of the C-Group in Egypt (R. F. Friedman 2001, 2004a, and 2004b; see also T. Schneider 2003a, p. 180).

53. Bács 2002, pp. 53, 56–58.

54. Pamminger 1992; el-Sabbahy 1992; Dziobek 1993; Bács 2002, pp. 57–58.

55. For Sehel, Gasse and Rondot 2003, p. 43, fig. 4; for Shelfak, Hintze and Reineke 1989, pp. 90–91, nos. 365, 366, pl. 122; for Kumma, Hintze and Reineke 1989, p. 116, no. 419, pl. 154; for Tangur, Hintze and Reineke 1989, p. 171, no. 558, pl. 237, and p. 173, no. 564, pl. 240; for Dal, Hintze and Reineke 1989, pp. 182–83, no. 609, pl. 264; for Tombos, *Urkunden* 4, p. 1375, no. 416, Säve-Söderbergh 1941, pp. 207–9, Pamminger 1992, p. 100; and see most recently D. N. Edwards 2004, pp. 103–4, fig. 4.11.

56. Or perhaps (somewhat improbably) re-appointed, if Caminos is correct in identifying his name (only a small vestige remains) in the year 2 Semna inscription

(Caminos 1998, pp. 43–44, n. 2, pls. 23, 25, col. 2; Bács 2002, pp. 57–58, n. 30).

57. Bryan 1991, pp. 6–9; Säve-Söderbergh and Troy 1991, p. 6; el-Sabbahy 1992; Redford 2004, pp. 38, 171, n. 8.

58. Pamminger 1992; Dziobek 1993; Bács 2002, pp. 57–58.

59. Porter and Moss 1951, p. 79; S. T. Smith 1995, pp. 166–67.

60. Schulz 1992, pp. 357–58, pl. 92c; Renate Krauspe in Krauspe 1997a, pp. 81–83, pls. 66–67; Krauspe 1997b, pp. 64–67, nos. 117–18, pls. 58–59; Dietrich Wildung in Wildung 1997c, pp. 128–29.

61. Morkot 1987, p. 33; Morkot 1991, pp. 298–99; Säve-Söderbergh 1991, p. 188; O'Connor 1993, pp. 61–65; S. T. Smith 1995, pp. 18–24, 175–88; Török 1997, pp. 97–101; Morkot 2000, pp. 81–83; S. T. Smith 2003, pp. 84–86; Redford 2004, pp. 44–45; W. V. Davies in Welsby and Anderson 2004b, p. 105.

62. S. T. Smith 1995, pp. 148ff., 173, 176–78; S. T. Smith 2003, p. 85. On issues of ethnicity and acculturation in relation to foreigners within Egypt, see T. Schneider 2003a, pp. 316ff.

63. Säve-Söderbergh and Troy 1991, pp. 190–207; S. T. Smith 1995, pp. 152–53; Török 1997, p. 100; S. T. Smith 2003, pp. 85–86, 173; D. N. Edwards 2004, p. 108.

64. Säve-Söderbergh 1960.

65. Säve-Söderbergh and Troy 1991, pp. 182–90.

66. Anderson 2004, pp. 30–31, no. 22; W. V. Davies in Welsby and Anderson 2004b, pp. 104–5, no. 78.

67. H. S. Smith 1976, pp. 208–9; W. V. Davies in Welsby and Anderson 2004b, p. 104, no. 77.

68. That such activity was part of a chiefdom's official brief is now confirmed by rock inscriptions discovered along the Korosko road in the eastern desert that record the presence there of the "chief of Tehkhet, Paitsi" (Alfredo Castiglioni and Angelo Castiglioni 2003, p. 48, pls. 1, 2). Other inscriptions similarly record the presence there of the famous "chief of Miᶜam (Aniba), Heqanefer," who served under Huy, Tutankhamun's viceroy (Alfredo Castiglioni, Angelo Castiglioni, and Vercoutter 1995, pp. 26, 118–19; Damiano-Appia 1999, pp. 513–17, fig. 1, no. 1; Alfredo Castiglioni and Angelo Castiglioni 2003, pp. 50–51, fig. 2; D. N. Edwards 2004, p. 108).

26. Block Statue of Inebni

Early 18th Dynasty, joint reign of Hatshepsut and Thutmose III (1479–1458 B.C.)
Painted limestone
H. 52 cm (20½ in.), W. 28.5 cm (11¼ in.), D. 44.5 cm (17½ in.)
The Trustees of the British Museum, London
EA 1131

This block statue, dedicated to a military officer named Inebni, was probably a temple sculpture made to allow its owner to benefit from temple festivals and receive offerings in perpetuity in the afterlife. The block statue, a form that dates from the Middle Kingdom, represents a squatting man enveloped in a cloak. The pose conveys humility, making it appropriate for a temple setting, and the shape offers large surfaces for inscription.

Inebni's statue is striking for its use of color, which draws attention to its two most important elements: the inscription, filled in with blue, and the head, on which the hair, eyes, and brows are painted black. The treatment of the eyes is

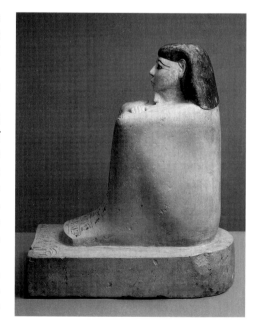

particularly noteworthy because they appear as brown rather than the usual black. This effect was achieved by applying an initial layer of red paint that was then covered with black. The triangular shape of the face, with its wide-open eyes and arching brows, is typical of the period.

Inebni served as a troop commander and overseer of weaponry during the joint reign of Hatshepsut and Thutmose III. He also had the title King's Son, which has led to the suggestion that he served as viceroy of Kush, but this cannot be verified.[1] He certainly campaigned in Nubia, however, for his inscription states that he "followed his lord" on expeditions into the foreign lands both south and north of Egypt.

The statue was dedicated to Inebni by both Hatshepsut and Thutmose III, whose names appear in the first and second lines of the inscription. In the text, Hatshepsut's royal epithets are given feminine gender, "the Good Goddess, Lady of the Two Lands, Maatkare," and Thutmose is called "her brother, the Good God, Lord of Action, Menkheperre." As one would expect, at some later time the cartouche of Hatshepsut was erased by the agents of

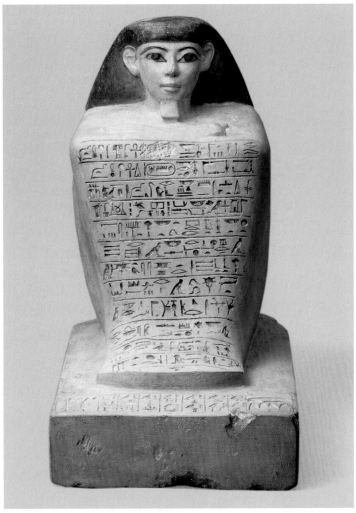

26

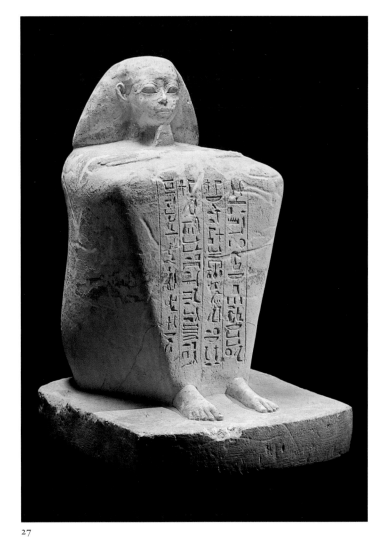

27

Thutmose III; however, the feminine epithets were left.[2] The fact that the statue itself survives unharmed suggests that Inebni had done nothing to incur the wrath of Thutmose, unlike some of Hatshepsut's officials, whose monuments were destroyed.[3]

CHR

1. See "Egypt and Nubia" by W. Vivian Davies in this volume.
2. Interestingly, the name of the god Amun, in the third line of the text, was not erased during the Amarna period.
3. It is also possible that Inebni was not of sufficient rank to prompt such destruction, or that he had no children who were perceived as a threat to the king and his heirs.

PROVENANCE: From Thebes, according to Athanasi 1836, p. 247; formerly Salt collection; acquired in 1835

BIBLIOGRAPHY: Porter and Moss 1964, p. 788 (with bibliography); Schulz 1992, pp. 379–80, no. 219, pl. 98c, d; Edna R. Russmann in Russmann et al. 2001, pp. 121–22, no. 45

27. Block Statue of Ruiu

Early 18th Dynasty, joint reign of Hatshepsut and Thutmose III (1479–1458 B.C.)
Limestone
H. 47.8 cm (18⅞ in.), W. 30 cm (11⅞ in.), D. 39 cm (15⅛ in.)
Ägyptisches Museum der Universität Leipzig 6020

Ruiu was one of the large number of Nubians who had become Egyptianized over generations of close contact with their Egyptian overlords. He lived at Miᶜam (modern Aniba), the administrative center of Lower Nubia (known to the Egyptians as Wawat), and he served as deputy to the Egyptian viceroy, or King's Son.

Like his Egyptian contemporary Inebni (cat. no. 26), Ruiu chose to be represented in the form of a block statue, but in this example his feet project beneath the edge of the cloak. Although the proportions of Ruiu's statue give it a provincial aspect, the shape of the face, the wide-open eyes, and the arching brows compare well with other sculpture dating from the time of Hatshepsut and Thutmose III.

This statue and another depicting Ruiu in the standard seated pose[1] were found in his tomb during Georg Steindorff's excavations at Aniba.

CHR

1. For multiple views of the seated statue, see Krauspe 1997b, pp. 66–67, pl. 59.

PROVENANCE: Aniba, Tomb S66; Ernst von Sieglin expedition, 1912

BIBLIOGRAPHY: Steindorff 1935–37, vol. 2, pp. 70, 189, pl. XXXVII, c, d; Porter and Moss 1951, p. 79; Renate Krauspe in *Ägyptens Aufstieg* 1987, pp. 208–9, no. 131; Schulz 1992, pp. 357–58, 575, no. 205, pl. 92c; Renate Krauspe in Krauspe 1997a, pp. 81–83, no. 66; Krauspe 1997b, pp. 64–66, pl. 58 (with bibliography); Jean Leclant in Wildung 1997b, pp. 128–29, no. 129, and frontis.

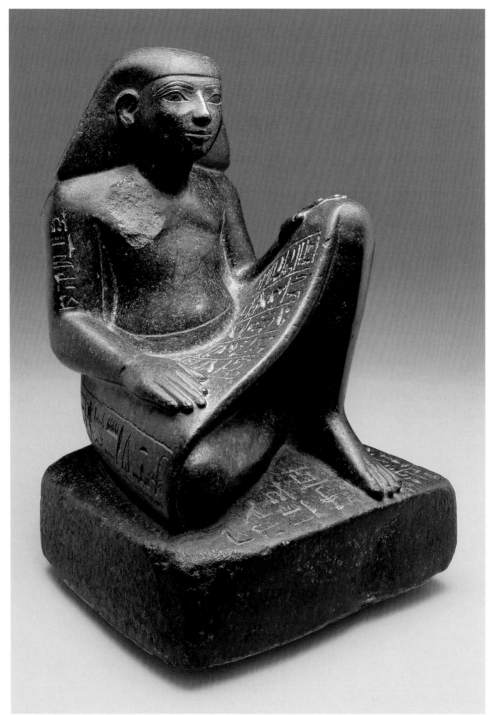

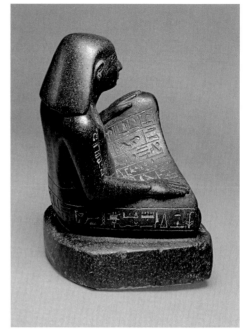

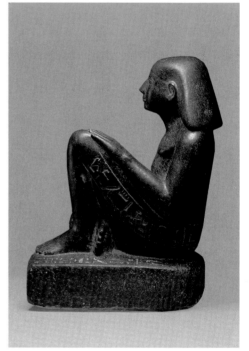

28

28. Amenemhat

Early 18th Dynasty, joint reign of Hatshepsut and
Thutmose III, period of Hatshepsut's regency
(1479–1473 B.C.)
Diorite
H. 37 cm (14⅛ in.), W. 23 cm (9⅛ in.)
The University of Pennsylvania Museum of
Archaeology and Anthropology, Philadelphia
E 10980

Amenemhat, whose name is Egyptian, was a
son of the prince of Teh-khet,[1] an area just

south of Miᶜam. He was a scribe and is here
given the epithet "Valiant Agent of the King."
From other monuments (such as cat. no. 29), we
know that Amenemhat served into the time
after Hatshepsut had taken on the titles of king.[2]
However, in this inscription she is referred to as
"God's Wife," a title she ceded to her daughter
Neferure after becoming king. This suggests
that the statue was made while Hatshepsut was
still regent for her nephew, and that "King"
refers here to the child Thutmose III.

Amenemhat, like his contemporary Ruiu,
was a Nubian who served the Egyptian king.

Unlike the block statue of Ruiu (cat. no. 27),
which is distinctly provincial in style, this piece
looks entirely Egyptian. The asymmetrical
seated pose, first used by Egyptian sculptors at
the end of the Old Kingdom, is not common; its
use in this context suggests that it was made by
an Egyptian sculptor who was resident in
Nubia. This is quite possible, since the statue
was excavated at Buhen, the site of a large
Egyptian fortress, which probably included a
number of artists among its Egyptian residents.

Judging from the inscription, which has a
dedication to Horus, Lord of Buhen, this image

of Amenemhat probably was placed in that god's temple. It was discovered with two other statues (one inscribed for the same Amenemhat; see fig. 20)[3] outside the fortifications of the inner city. The findplace has led to a suggestion that the statues were removed from the temple during the destruction of Hatshepsut's monuments by Thutmose III.[4] The statues of Amenemhat are in perfect condition, however, and the feminine royal epithets of Hatsheput have not been defaced. It is possible that the absence of Hatshepsut's cartouche helped save Amenemhat's monuments from damage at the hands of Thutmose's agents.[5]

CHR

1. For more information on this family, see "Egypt and Nubia" by W. Vivian Davies in this volume.
2. A large sandstone stela, now in the Egyptian Museum, Cairo (CG 20775), describes Amenemhat as the "True Royal Acquaintance of His Lord," "Vigilant Agent for the Lady of the Two Lands," and "Valiant Agent in Wawat"; see H. O. Lange and Schäfer 1908, pp. 403–5; Säve-Söderbergh and Troy 1991, pp. 194–96, no. B4.
3. Randall-MacIver and Woolley 1911, p. 110, pl. 37, left. This statue is now no. 92 in the National Museum, Khartoum.
4. Ranke 1940.
5. It is also possible that the statues were removed from the temple for a reason entirely unrelated to Hatshepsut.

PROVENANCE: Buhen; Coxe expedition, 1909–10

BIBLIOGRAPHY: Randall-MacIver 1910, pp. 27–28; Randall-MacIver and Woolley 1911, pp. 108–9, pl. 36; Ranke 1940; Porter and Moss 1951; Vandier 1958, pp. 450, 679; Säve-Söderbergh and Troy 1991, pp. 193–94, no. B2; Donald B. Redford in Silverman 1997, pp. 134–35, no. 39; Gerry D. Scott III in N. Thomas 1995, p. 181, no. 82

29. Stela of Amenemhat

Early 18th Dynasty, joint reign of Hatshepsut and Thutmose III, period of Hatshepsut's regency (1479–1473 B.C.)
Limestone
H. 63.5 cm (25 in.), W. 66 cm (26 in.), D. 16.5 cm (6 ½ in.)
The University of Pennsylvania Museum of Archaeology and Anthropology, Philadelphia E 10982

Like the preceding statue (cat. no. 28), this stela was dedicated by Amenemhat to Horus, Lord of Buhen. In its inscription Amenemhat offers a thousand portions of incense, cattle and fowl, choice cuts of meat, all good and pure things, and everything fresh "to the ka of all the gods of Nubia." In return he asks for "good life, favor, love, wisdom in all work." The epithets that precede his name describe him as "the one who is steadfast of heart, who listens to what is said, who does what satisfies the officials, accurate of heart and without libel, who is much admired among the subjects," and, most interesting for us, "the Vigilant Agent of the King's Daughter," a phrase that must refer to Hatshepsut before she became king.[1]

On the remaining surface of the stela, Amenemhat is depicted at the right, presenting burnt offerings of birds and pouring a libation.

An image of the god Horus, Lord of Buhen, probably appeared at the far left. Over his short kilt Amenemhat wears a long, translucent, fringed skirt that reveals his legs beneath. Although the man's figure has been carved with assurance, the proportions are awkward, with the limbs becoming absurdly narrow where they are carved entirely in sunk relief.

Sometime in the reign of Amenhotep II, son and successor of Thutmose III, Amenemhat's stela was cut into a roughly circular shape and reused as a column base in a private house.[2] This was probably done for expediency rather than as a personal attack on Amenemhat, since his name and epithets were not erased and his figure is largely preserved.

CHR

1. Randall-MacIver and Woolley 1911, p. 112, pl. 34; Säve-Söderbergh and Troy 1991, pp. 193–94, no. B3.
2. Randall-MacIver and Woolley 1911, p. 112; Ranke 1940, p. 29.

PROVENANCE: Buhen; Coxe expedition, 1909–10

BIBLIOGRAPHY: Randall-MacIver and Woolley 1911, p. 112, pl. 34 (bottom)

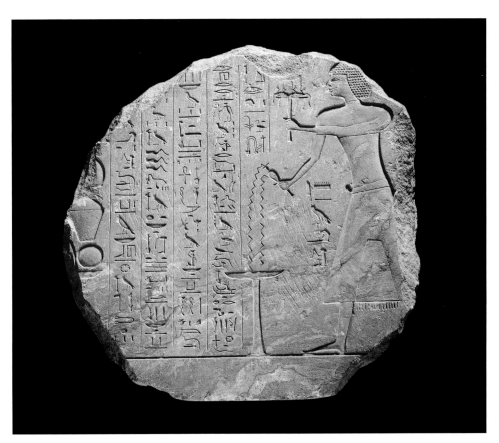

29

EGYPT AND THE NEAR EAST
Evidence of Contact in the Material Record

Christine Lilyquist

Egypt had a long and extensive relationship with its Near Eastern neighbors that was evident even in Predynastic times, before 3000 B.C. In the New Kingdom, beginning with the Eighteenth Dynasty about 1550 B.C., this relationship reached a new level.

The increase in contact built on interchange that had occurred in the late Middle Kingdom and Second Intermediate Period (1800–1550 B.C.), when central authority declined in Egypt and her borders were no longer maintained. That breakdown allowed peoples speaking primarily West Semitic languages from the Eastern Desert, the Sinai, and areas north of it (see map, fig. 21) to move into Egypt in far greater numbers than heretofore. Among them were "rulers of foreign lands" (Hyksos) who controlled Egypt from the Nile Delta southward to Cusae in Middle Egypt from about 1650 to 1550 B.C. Borders and domination of areas to the south also gave way; a Kushite kingdom in the Sudan extended its authority northward to Elephantine, thus depriving Egypt of its traditional influence in Nubia (see "Egypt and Nubia" by W. Vivian Davis in this volume). Eventually, the Theban leader Ahmose I (r. 1550–1525 B.C.) both chased the Hyksos from their Delta capital Avaris (Tell el-Daba) and regained control of Nubia, thereby reestablishing united rule in Egypt. Ahmose also marched north to capture Sharuhen, near Gaza, perhaps the last stronghold of the Hyksos. His successor two reigns later—Hatshepsut's father, Thutmose I—went north into Syria and set an inscription within Naharin (Mitanni).

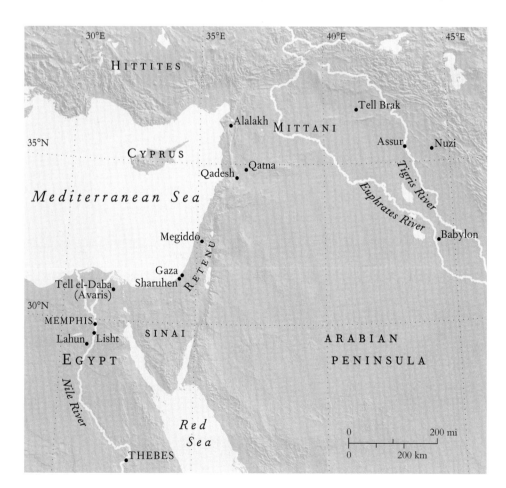

Fig. 21. Map of Egypt and the Near East, early New Kingdom

Hatshepsut did not undertake campaigns to the northeast when she came to power, although she complained in an inscription that she needed to rebuild temples in Middle Egypt because Hyksos rulers had not followed Re and had allowed wanderers to destroy "what had been made."[1] When the ruler of Qadesh in northwestern Syria convened Levantine leaders at Megiddo about the time of the queen's death, her nephew Thutmose III perceived a new threat to Egypt, as well as a chance for glory and reward. He marched northward in year 23 with a newly professional and equipped army, and for the rest of his fifty-four-year reign he dominated Palestine and coastal Syria, penetrating even the Mitannian territory of central Syria. Winning control of Nubia and the Sudan at the same time, this vigorous pharaoh created the Egyptian empire.[2]

As the result of Egypt's New Kingdom expansion into western Asia, large quantities of goods and people began to flow into the country through booty, taxes, and "benevolences," a donor's expected fulfillment of obligation (fig. 22). According to temple inscriptions, for example, the Megiddo campaign yielded the following: [3]

340 prisoners of war;

2,500 people, including 3 chiefs, more than 43 maryannu (elite Asiatic warriors), various women and 87 children, and 1,796 male and female servants servicing their children;

gems and gold;

much raw silver;

a statue of silver and another with head of gold;

a statue of ebony and gold, its head of lapis;

much clothing;

a large mixing cauldron of Hurrian workmanship;

various drinking vessels and great cauldrons;

ivory and wood chairs and footstools;

a wood and gold bed in the form of a krkr . . . worked in gold all over;

924 chariots, including two wrought in gold;

202 bronze suits of mail;

502 bows;

7 poles of mry-wood and silver, for tents;

staves with human heads;

2,041 mares, 191 foals, and 6 stallions;

1,929 cattle;

2,000 goats;

20,500 sheep

How did the presence of such goods and people affect Egypt? And, conversely, did Egyptian goods and culture penetrate the eastern Mediterranean, Cyprus, and inland Syria? Answering these questions is not easy, partly because information from texts and material culture is not only incomplete but often contradictory.[4] Further, the authoritative voice of Egypt's texts, the monumentality

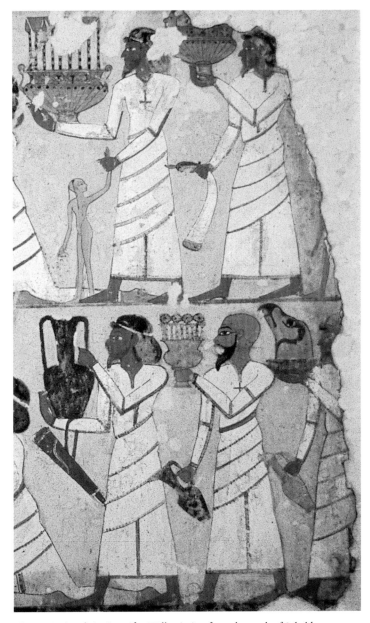

Fig. 22. Syrians bringing gifts. Wall painting from the tomb of Sebekhotep, Thebes, mid-18th Dynasty. The man at the top right holds a tusk container in his right hand. The Trustees of the British Museum, London (EA 37991)

of its stone structures, and the sheer sweep of time that the civilization endured may prejudice our judgment. We know that Egyptian officials of the New Kingdom were sent to the Levant.[5] For instance, a fragmentary statue of the "Royal Scribe, Overseer of Northern Foreign Lands, Djehuti," with an inscription invoking Hathor, Lady of Byblos, was purchased in Beirut.[6] But it does not follow that everything of Egyptian style found in the Near East was made in Egypt.[7] In fact, even scholars of the very earliest, Predynastic Period of contact between Egypt and the eastern Mediterranean disagree on the characterization and meaning of "Egyptian" material found north of the Sinai.[8]

As for the question of western Asiatic influence on the culture of Egypt during the New Kingdom, much work needs to be done from the material record.[9] Currently, scholars are scrutinizing the Hyksos period to determine the true nature of relations between

Egyptians on the one hand and Semites and Hurrians on the other.[10] Likewise, they are beginning to assess the interchange of Egyptian, Nubian, and Kushite cultures in the early New Kingdom,[11] and the role of Aegean peoples in the same period (see "Egypt and the Aegean" by Manfred Bietak in this volume). But, although textual and pictorial material reveal Near Eastern contributions in language, music, warfare, and religion during the New Kingdom,[12] there are still questions to be asked of the material record. If Thutmose III brought back thousands of people who became mercenaries, domestics, quarry workers, artisans, and builders,[13] where are they in the cemeteries? And among the many small objects that have come to light, do not some that we have assumed to be "Egyptian" reflect Near Eastern workmanship and inspiration?

To be sure, there are difficulties when trying to parse answers from noninscribed material. Skeletal remains resist apportionment to ethnic groups;[14] standards by which archaeologists can assess the completeness of a tomb's assemblage are lacking; differentiating between a true import and a locally made version is a formidable challenge;[15] determining the date of a type is problematic, partly because the life span of a style or form is variable;[16] the date of an object's manufacture may not at all be the date of its deposition; the Near East, due to the vagaries of climate and population change, often lacks relevant comparative material; and the equipment and expertise of those undertaking technological studies are not uniform.

Nevertheless, the time has come to look more closely for specific Asiatic contributions to the cultural record of Egypt in the New Kingdom. In this essay, drawing on many years of observation, I wish to call attention to three groups of small objects that provide evidence about Egypt's contact with her northeastern neighbors.

MAIHERPERI'S QUIVERS AND FLASK

Maiherperi was a Child of the Nursery and royal Fanbearer on the King's Right[17] (see "The Tomb of Maiherperi in the Valley of the Kings" by Catharine H. Roehrig below). Genetically he belonged with the sub-Saharan populations rather than the Nilotic Egyptian and Nubian ones, and he died in his mid-twenties.[18] He was given a rich burial in the Valley of the Kings, a necropolis normally reserved for royalty; his gold sandals and Osiris bed were royal prerogatives.[19] In essence, Maiherperi's tomb illustrates the permeability of Egypt's culture to outsiders.

The date of Maiherperi's tomb has been widely discussed. His canopic jars and at least one coffin (Egyptian Museum, Cairo, CG 24003) favor an early date; recently Roehrig has called attention to a sheet in the tomb carrying the name of Hatshepsut.[20] Roehrig argues that Maiherperi's burial must have taken place before Thutmose III began destroying his aunt's monuments about year 42, and she also observes that the tomb's location connects Maiherperi to Thutmose III more plausibly than to any

other king. However, a number of Maiherperi's possessions—leather quivers, decorated arms, stone and glass vessels, the Osiris bed—are similar to objects found in the tomb of Amenhotep II,[21] and specialists have dated other significant belongings of Maiherperi to that era: pottery to the late reign of Thutmose III or the reign of Amenhotep II;[22] the Book of the Dead to the reign of Amenhotep II;[23] and the various coffins to the late reign of Amenhotep II.[24] The earring CG 24066 is also of a mid- to late Eighteenth Dynasty form. Were a greater number of luxury items from Thutmose III's tomb preserved, the dating of Maiherperi's tomb would no doubt be clearer.[25] Without that information, the best solution seems to be to place the tomb late in Thutmose III's reign, just prior to the proscription of Hatshepsut. The young man's titles and his tomb show that he was favored. He probably grew up with the king's children and, as a hunter and likely a warrior, could have accompanied the king in the late campaigns.

Several of Maiherperi's royal gifts are Asiatic in style, if not in workmanship; that is, they have a closer affinity, over a longer history, with Near Eastern objects and technology than they do with Egyptian ones. Of two pink leather quivers with embossed patterns, the more elaborate example is illustrated in figure 25 (the quiver itself is an Asiatic form).[26] The papyrus and sedge chain depicted on it has some relation to motifs on items in Egypt of the late Hyksos period and early Eighteenth Dynasty,[27] although this form is fancier. The band of spirals, here a series of individual units one next to the other, occurs throughout the eastern Mediterranean at this time. But the two palmettes—composed of fronds and a sedge with pendant buds—are a motif new to Egypt. The fronds occur on a headdress believed to come from the tomb of Thutmose III's foreign wives,[28] and the entire motif is common on Mitannian seals contemporary with the Thutmoside period (see below).

Most telling is the large "volute tree" that appears in three places on the quiver and its cap. It is made up of two sedges with pendant buds that alternate with two heart-shaped volutes to form a multi-branched tree; three papyrus stalks spring from the top. While a simple volute with pointed inner petals occurred in Egypt during the Hyksos period and the early Eighteenth Dynasty,[29] and a crude version of the volute tree was depicted about the time of Amenhotep II (cat. no. 25),[30] it is in the Near East that tree motifs have a long iconographical history (the tree is often referred to as "sacred"). Even though exact parallels have not been found in the Near East for Maiherperi's palmettes and volute trees, Mitannian seals and wall paintings at Nuzi, Alalakh, and elsewhere show that the inspiration for the motifs on his quiver came from the east (fig. 23).[31] By the time of Tutankhamun over a century later, depictions of the volute tree were very elaborate, in Egypt as well as Syria.[32]

Maiherperi's quiver may have been made in either western Asia or Egypt, but, except for the papyri, its basic iconography is Asiatic. The design's formality and the papyrus motif speak for

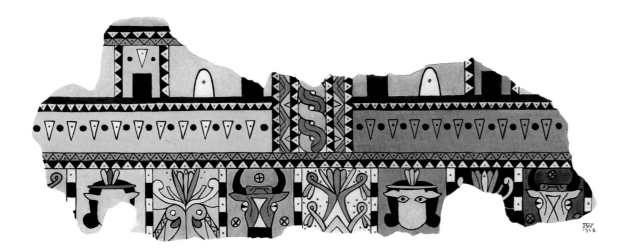

Fig. 23. Restoration of a
Mitannian wall painting.
From the Level II palace,
Nuzi, late 15th–early
14th century B.C.

Egypt,[33] while the tree's many volutes and branches speak for a late rather than an earlier date.

Another object of Maiherperi's, a glass flask with trailed pattern, is probably an actual import. This vessel was previously compared to a bottle from Middle Assyrian Assur,[34] but a closer parallel is now known from the Mitannian period at Tell Brak.[35] Although found there in a destruction layer of about 1300 B.C., this bottle was with tablets of Tushratta and his older brother, whose family members were wives of Thutmose IV, Amenhotep III, and Akhenaten (r. 1400–1336 B.C.).[36] The Brak bottle could thus be almost forty years later than Thutmose III's year 42; on the other hand, it could be an heirloom, as there were certainly sophisticated glass vessels in fifteenth-century levels at Brak—as shown by David Oates et al.—and also at Nuzi[37] and the Mitannian-dominated Alalakh.[38] Another glass object of Maiherperi's, a polychrome "eye" bead (Egyptian Museum, Cairo, CG 24068 bis E), is, like Maiherperi's flask, quite advanced in comparison with products of Egypt's glass industry dating late in the reign of Thutmose III (see cat. no. 33).[39] It is clear that vitreous vessels were making their way to Egypt from the Near East at the time of Thutmose III. A button-base goblet believed to come from the tomb of his foreign wives early in the king's reign (cat. no. 32) is in shape, pattern, and ware similar to items found at Nuzi; furthermore, the isotopic ratio of its lead falls within the range of Near Eastern samples of ore rather than Egyptian ones.[40]

By what means and in what year Maiherperi's glass flask reached Egypt is not known. It could have been obtained in the course of a campaign—not necessarily at the place of manufacture—or it could have arrived in some other manner.[41]

POSSESSIONS IN THEBAN BURIALS

The second instance where Egyptian contact with Near Eastern material culture is manifest is in graves of middle-class inhabitants excavated at Thebes by The Metropolitan Museum of Art. According to present research, these span from the end of the Seventeenth Dynasty to late in the reign of Thutmose III.

Of interest in the earliest tombs (Ambrose Lansing's Asasif burials)[42] are a lyre, an ivory pyxis with a compass-drawn design (cat. no. 144),[43] a cow horn equipped with a spoon and a compass-decorated plug,[44] a wood kohl container with a hinged lid,[45] an incised ivory game board,[46] an oryx-shaped pottery vessel,[47] a painted pottery jug and jar (cat. nos. 160a, b), handled metal vessels,[48] a glass pin,[49] rectangular combs, a massive cast mirror, and impressive weapons. All of these objects of daily life are new in Egypt, and all but the mirror are of Levantine or Cypriot type.

Noteworthy in slightly later tombs (those of Senenmut's family)[50] are a lute, a tambourine, the body of a horse with a multicolored woven saddle, and arrows and javelins.

The latest burial group (tomb 729)[51] contained horns with a scoop at one end and a decorated plug at the other, a stool with incised legs,[52] a lyre, a wood pyxis with a compass-drawn design, metal juglets, quantities of ointment in various containers, and, also, weapons.

Who were the people buried in these tombs? The earliest group of burials contained virtually no canopic jars or shawabties, and few inscriptions. At the same time, some objects found in them have associations with Kerma and Nubian culture: pottery, coffins and a mask of *rishi* type, a heart scarab with a face, and a *shebiu* collar (cat. no. 3). Donald Redford stated some years ago, "It is not unlikely, in view of the heavy influx of Nubians into Upper Egypt, that the [royal] family of the Seventeenth Dynasty could boast of a large admixture of Nubian blood."[53] Could some of the individuals in this first burial group have been people from the south? Or had Nubian and Kushite objects become part of Egyptian culture?[54] With the kingdom of Kerma now thought to have lasted into the Eighteenth Dynasty,[55] it is time to look for contributions that people to the south might have made to early New Kingdom Egypt.

Indeed, there is much we do not know about population groups in Egypt. Three women from the Levant were taken into the harem of Thutmose III;[56] their ethnic identity would not have been learned had their West Semitic names not been written on their funerary goods. However, immigrants often took Egyptian names, or their names were not recorded at all, leaving us only their bodies, possessions, and possibly grave types to tell their story. What are we to make, for instance, of the women with braided hair buried quite simply in the tomb of Senenmut's parents?[57]

Particularly intriguing in the Theban burials are the small objects that reflect Near Eastern culture. Where did they originate and how did they come to be deposited in graves of Upper Egypt? Were they booty from the sack of Avaris, imports from informal trade, or items made by Asiatics living in Egypt? Hatshepsut might rail against the Hyksos for neglecting temples and Thutmose III feel threatened by chieftains of the Levant, but an integration of Egyptian and Near Eastern cultures was taking place in Egypt on the ground.

Sculptured Pottery Vessels

Figurative pottery vases are a third area where Near Eastern elements in Egypt's material culture are evident. These vessels are generally dated to the era extending from Hatshepsut's reign to Amenhotep III's, although one example is as late as the Third Intermediate Period.[58] Their most common subjects are women: a seated woman in a shawl who usually holds a child and/or a horn (cat. nos. 161–165);[59] a standing woman who holds a lute, vessels, or an animal (cat. nos. 166, 167, 169); a kneeling woman with elaborate hairstyle and jewelry, her hands held flat on her thighs;[60] a standing woman similarly attired, carrying a bird or basket.[61]

But there are other types: a standing fat woman (dwarf or Nubian) wearing jewelry, in one case holding a wine service;[62] a nude male (dwarf or Nubian) carrying a vessel;[63] a head of the dwarf god Bes;[64] fauna (cat. nos. 171–174); a flask, with or without a human head at the spout (cat. no. 158);[65] a ring-shaped vessel;[66] and perhaps fruit.[67] For some years the vessels shaped as seated women have been considered receptacles for mother's milk, to be used as medicine (especially when the women wear a shawl and hold one breast);[68] all other types have generally been considered oil containers.[69]

The vessels are either of a silt clay with a burnished red surface or of a light pink desert (marl) clay, also polished. Many are well made, although some are summary. Those representing kneeling women with flowing hair, who appear to be of a lower class, are often of silt ware; those that show women with more formal hairstyles, who appear to be more elite, are often of marl clay and continue to a later date.

The provenance of these unusual vessels has long been discussed, with some authors favoring foreign manufacture.[70] Unfortunately, the size of sample needed for investigating clay provenance by neu-

tron activation analysis or petrography is comparatively large. Janine Bourriau believes that the silt ware of some vessels is Nile clay and that the pink ware of others is Marl A2 in the Vienna system of Egyptian pottery classification. She points out that polished red silt wares and anthropomorphic vessels existed in Egypt from earliest times, and that there are no exact parallels for the vases outside Egypt.[71] She considers the vessels wholly Egyptian and focuses on manufacture as a means of grouping them.[72]

To the present author, however, both the wares and the personal character of the best of these vessels are unusual among Egyptian products. Clay was not a medium often used by Egyptian sculptors, and a fine canopic jar head of Senenmut, made of red-burnished ware, seems similarly unusual.[73] That the vases were frequently found in Egypt in association with imported pottery is noteworthy, as is the visual similarity of the silt examples to Red Lustrous wheel-made pottery, a contemporary ware with very specific shapes that is thought to originate in northern Cyprus.[74] Also notable is the fact that in the first millennium B.C., figure vases of kneeling women with children and horned animals were very popular in the eastern Mediterranean.[75]

The most interesting characteristic of these New Kingdom sculptural pottery vessels, however, is the presence of foreign elements in their subject matter. Some show a connection with areas south of Egypt, such as a pink clay vessel now in the Louvre that depicts a standing Nubian woman with a basket. Many more, however, have features that refer to the Near East. The fringed shawl and dress are of Asiatic type, and horn-shaped receptacles of this sort apparently originated in the Levant. Further, the figures of women with a child or a horn most often have an unusual hairstyle, with the hair pulled to the back except for a lock falling forward on each side of the neck. One such figure has a necklace of disks framing a crescent (fig. 24),[76] while on other vases crescent and disk are combined.[77] Emma Brunner-Traut believed that the hairstyle and crescent identified the women represented as mothers or nurses whose lives were governed by monthly cycles.[78] However, hair tied back and long frontal locks occur on a nude female figure that forms the handle of a mirror where there is no feature suggesting a mother or a nurse.[79] Georges Bénédite raised the question of a foreign origin for the hairstyle in 1920,[80] and, in fact, Asiatic women are represented in the Thutmoside and later periods with curl(s) down the back and locks falling forward.[81] Even more specifically Asiatic are the disk and crescent pendants, which have a long history in the Near East.[82] In tomb decorations they are depicted on Asiatics brought back from the campaigns of Thutmose III to be temple personnel,[83] and on visiting Levantine chiefs.[84] As for the more elite women represented who do not hold children, they have elaborate hairstyles and unusual markings on the body (jewelry? dress?). Although we may recognize these females as "Egyptian," their

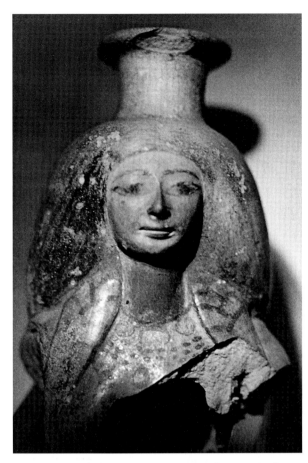

Fig. 24. Figure vase representing a woman, early New Kingdom. She wears a Near Eastern fringed shawl, a cord necklace with crescent pendant, and rows of beads with disk pendants; her hair is pulled back, with a large braid falling forward on each side of the neck. Egyptian Museum, Cairo (JdE 28554)

created by immigrants in Egypt responding to their interaction with Egyptians. Less likely to the author is the possibility that the vases were made by Egyptian potters who were stimulated by the goods and practices they observed entering Egypt in the early Eighteenth Dynasty. The Mitannian seals and wall paintings cited above in connection with Maiherperi's quiver contain ankh signs and "Hathor" heads, as well as bucrania (bulls' heads) that must have originated in the Aegean; the presence of these motifs in Mitannian art does show that artists could be inspired by foreign goods that reached them.

The sculptured vases of Egypt deserve further study. Zero radiography could be helpful in determining provenance,[94] as could residue analyses. More importantly, the purposes of these vessels and their subject matter need new scrutiny. Other authors have suggested that the contents had healing or rejuvenating powers.[95] This author sees many foreign elements in the vessels, and these could reveal information about their contents, their makers, and the way foreigners were perceived in Egypt.[96]

All of the objects surveyed above date to the beginning of Egypt's period of empire and demonstrate an intermingling of western Asiatic and Egyptian cultures. Goods, motifs, and materials were imported into Egypt; Egypt undoubtedly sent objects and cultural information abroad at the same time. The culture of each area changed through contact with the other's.

Anthony Leahy and John Baines have recently stressed the importance of ethnic contributions to Egypt's health and long-term stability.[97] Thomas Schneider has further suggested that Egypt "promoted and enhanced cultural contact as a stimulus to the progress of its civilization" and that in this way Egypt continually refigured itself.[98] The broad analyses of these scholars fit with the material record of Eighteenth Dynasty Egypt discussed here. Texts reveal that an Asiatic god was introduced into the Egyptian pantheon during the reign of Thutmose III's son Amenhotep II.[99] The small objects described above show that material culture penetrated Egypt as well.

attributes do not comply with the Egyptian canon.[85] They are intentionally shown as "other."

The sculptured vessels have additional Near Eastern associations in their subject matter or forms. A highly interesting group of four in the Antikenmuseum Basel includes a bearded male with a pointed head or helmet.[86] A round flask in the Ägyptisches Museum, Berlin, has relief figures of one if not two male Asiatics.[87] A vessel in the National Archaeological Museum, Athens, shows a bearded kneeling man with his hands tied behind his back, clearly a foreigner.[88] Fish-shaped spouted flasks, although understood to represent Nile perch, first appeared in Egypt as a form in Tell el-Yahudiyeh ware,[89] a type of pottery that originated in the Levant. Further, sculptured vases have often been found in Egypt with foreign or foreign-based pottery, ring-shaped flasks were present in the Levant during the Middle Bronze Age,[90] and anthropomorphic vessels were consistently used in the Near East and Cyprus.[91]

If many of these vases, then, contain references to the Near East, one must ask whether their makers in Egypt could have been Cypriot or Asiatic.[92] Carol Redmount and John Holladay believe that a hybrid West Semitic culture formed in the Delta during the Hyksos period;[93] similarly, the sculpted vases could have been

1. Redford 1997, p. 17.
2. Redford 1992, pp. 118–58; Redford 1997, pp. 21–22; Bryan 2000; Redford 2003, pp. 185–94; A. Spalinger 2005, pp. 1–159.
3. This list is extracted from passages translated in Redford 2003, pp. 34–38.
4. Compare S. T. Smith 2003, pp. 202–6.
5. Lilyquist 1988. Through the time of Thutmose III, however, their presence was not great: see Redford 2003, pp. 256–57.
6. British Museum 69863; incrustations on the stone could be the result of seawater. Catalogue no. 149 also belongs to this man.
7. Scandone Matthiae 1995 and 1997; Bietak 1998; Yon 2003, pp. 45–46. For an alternate view, see Lilyquist 1993a, 1994, 1996, 1998, and 1999; Barbieri, Lilyquist, and Testa 2002.
8. Van den Brink and Levy 2002.
9. Pierre Montet did basic work (1937), and William Stevenson Smith presented a mass of material that asks for chronological scrutiny (1965b).

10. T. Schneider 2003a; London, British Museum 2004. See also James 1973, pp. 295–96, 302; Baines 1996, p. 376; Bourriau 1997; Holladay 1997, pp. 187–209; Bourriau 2000.

11. Merrillees 1970; Bourriau 1981a and 1991; Säve-Söderbergh and Troy 1991, pp. 7–10, 205–211; Bourriau 1999 and 2000; S. T. Smith 2003. Often it has been by the absence of "Egyptian" goods that ethnicity has been determined.

12. Helck 1971; T. Schneider 1992; Hoch 1994. Representations of Near Easterners or their goods coming to Egypt start very early in the Eighteenth Dynasty: see Porter and Moss 1960, Theban tombs 39, 42, 81, 84, 86, 100, 119; Lilyquist 1997. Among the items brought back to Egypt from central Syria in Amenhotep II's year 7 campaign were 272 female singers and their instruments: see A. Spalinger 2005, pp. 140–41.

13. See, for example, Leahy 1995, p. 234; Redford 2003, p. 139.

14. See Rösing 1990, pp. 176–214, 226; Winkler and Wilfing 1991. Even if a sample exists, it may give little information due to damage or incompleteness. Karl Grossschmidt is presently studying the question (personal communication, November 8, 2004).

15. Recent studies of pottery from a late-fourth-millennium B.C. royal cemetery at Abydos come to different conclusions, one side pointing to an Asiatic origin (Hartung 2002, pp. 62–63), the other to an Egyptian (Hartung 2002, p. 63; Porat and Goren 2002a and 2002b).

16. For this problem in studying pre–New Kingdom objects, see Lilyquist 1979, pp. 102–42, and Lilyquist 1993b.

17. Feucht 1985, p. 40.

18. Personal communication, James E. Harris, March 4, 2005. Harris X-rayed the skull of the mummy in February 1984, when he was studying mummies in the Egyptian Museum, Cairo. His judgment is based on a study of ancient and modern Nubian populations as well as Americans of African and European ancestry; compare Shehata 1982, Richardson 1991, and G. R. Scott and Turner 1997.

19. Lilyquist 2003, p. 133.

20. "The Tomb of Maiherperi in the Valley of the Kings." Lecture at the Institute of Fine Arts, New York University, March 5, 2004.

21. Compare, in Daressy 1902, pp. 1–61, with pp. 63–279.

22. Personal communication from Anne Seiler, January 6, 2005.

23. Munro 1988, pp. 51, 278.

24. Dodson 1998, p. 334.

25. On the tomb's date, see also S. T. Smith 1992, p. 223.

26. A. Spalinger 2005, pp. 15–16. Gaston Maspero suggested that this quiver had been made from a Syrian model (Maspero 1910, p. 445); George A. Reisner considered the leatherwork in the tomb to be of Nubian manufacture (Reisner 1923, p. 19).

27. Lilyquist 1993a, p. 54, and Lilyquist 1995, no. 37.

28. Lilyquist 2003, pp. 164–67.

29. Von Bissing 1900, pl. 2; Lilyquist 1993a, p. 46, for a Middle Bronze Age ring from Ebla that has pendant buds but no stalks at the top.

30. See also the representation of a gold bowl in the tomb of Kenamun, an official of Amenhotep II's: Norman de G. Davies 1930, pp. 23–24, pl. XIV.

31. See Woolley 1955, p. 264, no. 69, pl. 63; Porada 1947, nos. 370, 474, 477, 651, 653, 743, 794, 865, 910, and passim, p. 11 on date, pls. 51–53 with drawings; Salje 1990, pl. 19, nos. 322, 327, 329, pl. 22, no. 383. For the paintings, see Starr 1939, pp. 143–44, pls. 128, 129.

32. *Treasures of Tutankhamun* 1976, pl. 14; Vogelsang-Eastwood 1995, pp. 98–100; Vogelsang-Eastwood 1999, pp. 80–86.

33. Compare the horse blinkers of Amenhotep II, particularly CG 24144 in the Egyptian Museum, Cairo, and the design on a wood model, CG 24124 (Daressy 1902).

34. Barag 1962, pp. 15–16.

35. D. Oates, J. Oates, and McDonald 1997, pp. 3, 81–82, 237–38 (bottle 1).

36. Ibid., pp. 28, 35, 143–54, and personal communication from Joan Oates, November 24, 2004.

37. Lilyquist 1993a, pp. 56–57. I date the Mitannian period as ca. 1500–1350 B.C.; Alalakh V as Late Bronze I (corresponding to Mitannian levels at Tell Brak); and Alalakh IV and Nuzi II as contemporary in part with Thutmose III, himself a contemporary of Alalakh's ruler Niqmepa.

38. Lilyquist 1993a, p. 56; personal communication from Marie-Henriette Gates, November 18, 2004.

39. Lilyquist and Brill 1993, pp. 24–28.

40. Ibid., pp. 13–15, 61–62; Lilyquist 2003, pp. 149–51.

41. The record of the year 38 campaign mentions "vessels of all sorts of Djah[i] workmanship" and a "benevolence [expected gift] of the chief of Alalakh" (Redford 2003, pp. 87–89).

42. Lansing 1917; Lilyquist 1997.

43. See Miron 1990, no. 88; Lilyquist 1994, p. 215. Wood boxes from Middle Bronze Age Jericho could be precursors: Kenyon 1965, pp. 272, 311, 365. Paul Donnelly recently observed that a compass was used to draw circles on a Chocolate-on-White ware bowl at Pella, which he dates to Late Bronze Age I (Annual Meeting of the American Schools of Oriental Research, November 18, 2004, San Antonio; personal communication, December 1, 2004). Compass work can also be seen on wood cases for balance scales found in New Kingdom Egypt (Susan K. Doll in *Egypt's Golden Age* 1982, p. 61, no. 32). Balances would have been useful items for traders; see the painting of Syrians and Egyptians trading in Theban tomb 162, and note also the disk pendants worn by various Syrian males (Norman de G. Davies and Faulkner 1947, p. 46).

44. Amiran 1962.

45. See Killen 1980, p. 11.

46. Miron 1990, no. 520.

47. Woolley 1955, pl. 101, f; see also pp. 350–52.

48. Merrillees 1982.

49. Lilyquist and Brill 1993, p. 24.

50. Lansing and Hayes 1937.

51. Hayes 1935b.

52. Kenyon 1965, pp. 405, 457. See also Killen 1980, pp. 48–49, and Der Manuelian 1981.

53. Redford 1967, p. 68. See also Lilyquist 1997, p. 342.

54. See the burial of a woman at Qurna, discussed in Lilyquist 2003, pp. 137–38, and by Catharine H. Roehrig in this volume ("The Burial of a Royal Woman and Child of the Late Seventeenth Century" and entries for cat. nos. 2–6).

55. London, British Museum 2004, papers by Daniel Polz and Charles Bonnet and Dominique Valbelle.

56. See the entries for catalogue nos. 30–32, 50b, 106a, 109, 110a, 113–118, 120d, 132a, 132b, 133–136, 143a–d, 147, 150, 151a–d, 153–155, and 175.

57. See n. 50 above.

58. Glenn E. Markoe in Capel and Markoe 1996, pp. 145–47, no. 72.

59. British Museum, London, 66711 and 30724 (Bourriau 1987, pl. XXIX, 2, 3).

60. Ashmolean Museum, Oxford, E 2432 (ibid., pl. XXIX, 1).

61. Ashmolean Museum, Oxford, E 2431 (Janine Bourriau in *Egypt's Golden Age* 1982, pp. 105–6, no. 90).

62. Egyptian Museum, Cairo, JdE 34403 (*La femme dans l'Égypte des pharaons* 1985, no. 7); Ashmolean Museum, Oxford, E 2427, wearing a bead girdle and fly(?) necklace (Bourriau 1987, pl. XXX, 2).

63. British Museum, London, 29935 (Bourriau 1987, pl. XXIX, 4).

64. Egyptian Museum, Cairo, JdE 46996 (Bourriau 1982, p. 101, fig. 31).

65. Ägyptisches Museum, Berlin, 13156 (Janine Bourriau in *Egypt's Golden Age* 1982, p. 102, no. 84) and 14422 (Bourriau 1987, pl. XXVIII); British Museum, London, 29936 and 29937 (Bourriau 1987, pl. XXVIII, 3, 4).

66. University Museum, Philadelphia, E. 6761 (Janine Bourriau in *Egypt's Golden Age* 1982, pp. 104–5, no. 88).

67. Fitzwilliam Museum, Cambridge, E.29.1982 (Bourriau 1987, pl. XXX, 3). See also Patch 1990, no. 37.

68. Garnot 1949; Desroches-Noblecourt 1952; Brunner-Traut 1970b, 1971, and 1972. Hornblower (1929, p. 46) thought the vase figures were mother-goddesses.

69. Bourriau 1982, p. 101, suggests they contained cosmetics for everyday use.

70. Von Bissing 1898a and 1898b; J. L. Myres in Randall-MacIver and Mace 1902, pp. 72–75; Murray 1911, pp. 41–42.

71. Bourriau 1981b, pp. 34–37; Bourriau 1982; Bourriau in *Egypt's Golden Age* 1982, p. 261, no. 366; Bourriau 1987. Kayser 1969 also sees the vessels as Egyptian.

72. Bourriau 1987, p. 84; see also Dorothea Arnold 1993, pp. 23–26.

73. Dorman 2002, no. 73.

74. See Eriksson 1993, where several interesting points are made: that "the introduction of new forms, into what had been a very traditional local [Egyptian pottery] industry, culminated in the reign of Thutmosis III when the Egyptian potters were at their most inventive"; that Red Lustrous ware in Egypt is mostly found in simple graves; and that the occurrence of Red Lustrous ware outside Cyprus suggests that the vessels found in Egypt arrived by sea route (pp. 59, 67, 97–98). These ideas are developed further in Eriksson 2004.

75. Lagarce and Leclant 1976.

76. Egyptian Museum, Cairo, JdE 28554, CG 2776 (volume unpublished; see Borchardt 1937); height 10.7 cm (4¼ in.) and of unknown provenance, according to von Bissing 1898b.

77. Crescent pendants have been recorded on three other vases: one in the British Museum, London, 54694; a vase formerly at auction (Christie's 2001, lot 291), which shows the crescent on a cord and four disk pendants suspended on a second cord below it, while the woman wears a fringed shawl and has long frontal locks; and a vessel in the Brooklyn Museum, 61.9 (Hornemann 1966, no. 1268a). On other vases, the crescent and disk are suspended one above the other: Musée du Louvre, Paris, AF6.643; British Museum, London, 24652; Ashmolean Museum, Oxford, 1921.1291c and o; and perhaps others. A crescent may also be worn by the child on the vessel in the Ägyptisches Museum, Berlin, 14476 (Settgast 1989, pp. 58–59).

78. Brunner-Traut 1970b.

79. Berlin 2775 (Hornemann 1966, no. 960). See also Hornemann 1966, no. 944 (Berlin 14526). I have also seen an unpublished mirror handle with a female figure wearing an echeloned Egyptian wig with its left lappet pushed back and a curled lock falling forward from under it.

80. Bénédite 1920, p. 84.

81. Säve-Söderbergh 1957, p. 26, pl. XXIII (time of Thutmose III); Norman de G. Davies 1908, p. 20, pl. XXVIII (Amarna period). See also Wiese 2001, p. 104, no. 64.

82. Boehmer 1972, pp. 19–30, 30–34; McGovern 1985, pp. 68–70, 97, 101.

83. Norman de G. Davies 1943, p. 30, pl. XXIII, and p. 48, pl. LVII. In these representations the disk is worn by a young Syrian girl and disks and crescents by children.

84. Norman de G. Davies 1922–23, vol. 1, frontis, and pls. XXXI, XXXVI.

85. See Hornemann 1966, no. 1018. Other figure vases in Hornemann's series are her nos. 903, 1019, 1266, 1268a, 1269–70.

86. Wiese 2001, pp. 106–7, no. 66.

87. Berlin 13155 (Bourriau 1987, pl. XXVII, 1–3).

88. Naville 1899, pp. 215–16; *World of Egypt* 1995, pp. 119, 121. It appears that a vessel from the same collection and representing a kneeling female figure with open hands against the thighs is a mate to this vessel.

89. Irmgard Hein in *Pharaonen und Fremde* 1994, p. 234, no. 289, "13. Dynastie."

90. Bietak 1996, p. 34.

91. Compare the jug with human head from Middle Bronze Age Jericho (Jacqueline Balensi in *Der Königsweg* 1987, pp. 44, 98–99, no. 87) and the head from a vessel excavated in levels dating from the last phase of Hyksos domination at Tell el-Daba (Hein and Jánosi 2004, frontis. and pp. 65, 80–83).

92. The genesis of a Middle Kingdom clay canopic jar lid from Lisht may also be questioned (Dorman 2002, p. 72). Asiatics are known to have been at Lahun and Lisht; could the expressive face on this lid represent, or be the product of, an Asiatic?

93. Redmount 1995, p. 188; Holladay 1997. Note, as an example, the Syrian-style cylinder seal excavated in the Delta at Tell el-Daba for which Edith Porada could find no exact parallel in Syria (Porada 1984).

94. As Vandiver 1986. Spectrographic analyses were performed on four figure vases at the Ashmolean in the 1960s (Payne 1966). Comparison with other pottery vessels having foreign characteristics, but apparently made locally, could also be useful; see a painted marl group from Abydos (Patch 1990, p. 45, no. 30) and a red burnished vessel from Sedment (Philadelphia, University of Pennsylvania Museum of Archaeology and Anthropology, 14327) in this volume (cat. no. 157).

95. Jan Quaegebeur saw an association between the ibex and gazelles on several sculptured vessels and the concept of rejuvenation: Quaegebeur 1999, pp. 121–23. Note also certain ivory containers in the form of an ibex: Petrie 1927, p. 43, §92, nos. 38, 39.

96. Particularly intriguing are the vessels depicting kneeling and standing women with elaborate hairstyles and jewelry. Two interesting examples in the Antikenmuseum Basel were acquired with a bull vessel and the male figure vessel cited in n. 86 above. Judging by the character of the four, they are from a single provenance. One of them (4790) has not only holes through the nipples but, in the middle of the back, "a kind of spout (similar to that on the head)"; personal communication, André Wiese, February 7, 2005.

97. Leahy 1995, p. 234; Baines 1997, p. 217.

98. T. Schneider 2003b, pp. 157, 161.

99. Ibid., pp. 160–61.

GLASS

By the beginning of the Eighteenth Dynasty, Egyptians had long since perfected the use of glazes and were experts at manufacturing bowls, cosmetic containers, small sculpture, and jewelry elements from faience and a related material called Egyptian blue.[1] The technology for producing these materials is similar to that for glassmaking. Slight changes in the chemical composition or heat level can produce a substance that is more or less vitrified, or glasslike, without being true glass.

The art of making true glass vessels seems to have first been perfected in western Asia. Objects of glass were probably imported into Egypt in the early New Kingdom, and presumably the manufacture of glass was established in Egypt through the importation of glassmakers from whom Egyptian craftsmen learned the art.[2] It seems that some sort of glass manufacture had begun in Egypt at least by the reign of Hatshepsut.[3] Fragments of glass vessels were found in the tombs of Thutmose III (cat. no. 33) and his son Amenhotep II.[4] Two glass fragments were also found in the tomb of Thutmose I.[5] Although it is possible that these date from the reinterment of Thutmose I by his grandson, Thutmose III, it is equally possible that Thutmose I acquired glass objects as booty on his campaigns into western Asia, or as trade goods, gifts, or tribute from the same area. He might also have been the first king to import foreign glassmakers into Egypt.[6]

CHR

1. The Egyptians used glazes and faience in the Predynastic Period in the fifth and fourth millennia B.C.; they had developed Egyptian blue by the Fourth Dynasty (ca. 2400 B.C.). See Lilyquist and Brill 1993, p. 5.

2. For discussions of early glass manufacture, see Nolte 1968; Goldstein 1982; Shaw and Nicholson 1995, pp. 112–13.

3. For example, two glass beads are inscribed with the names of Hatshepsut and Senenmut (Marianne Eaton-Krauss in *Egypt's Golden Age* 1982, p. 169, no. 193; Lilyquist and Brill 1993, MMA 26.7.746). See the entry for catalogue no. 59.

4. The fragments are in the Egyptian Museum, Cairo, and were published in Daressy 1902. Those from the tomb of Thutmose III are CG 24959–24961 (pp. 292–93); those from the tomb of Amenhotep II are CG 24753–24843 (pp. 191–209, pls. XLIII–XLV).

5. CG 24981; ibid., p. 301.

6. Glass beads were excavated by the Metropolitan Museum in early Eighteenth Dynasty tombs at Thebes that are dated between the reigns of Ahmose and of Thutmose II (see cat. no. 127b).

30. Wide-Necked Cosmetic Jar with Lid

Early 18th Dynasty, reign of Thutmose III (r. 1479–1425 B.C.)
Vitreous material, gold
H. 8.5 cm (3⅜ in.), Diam. 6.7 cm (2⅝ in.)
The Metropolitan Museum of Art, New York, Fletcher Fund, 1926 26.8.34a, b

The shape of this lidded jar is typical for cosmetic jars in the mid-Eighteenth Dynasty. The inscription on it is longer than most:

> *Live! The Horus, Mighty bull arising in Thebes, the Good God, Lord of the Two Lands, King of Upper and Lower Egypt, Menkheperre, Son of Re, Thutmose-Neferkheperu, given life, stability, and dominion like Re, forever and ever.*

The inscription on the lid reads simply: "The Good God, Menkheperre, given life."

CHR

PROVENANCE: Western Thebes, Gabbanat el-Qurud, Wadi D, Tomb 1

BIBLIOGRAPHY: Lilyquist and Brill 1993, pp. 13, no. 8, 16, fig. 10 (left), and cover (left); Lilyquist 2003, pp. 147, 148, no. 93, fig. 138

31. Upper Part of a Lotiform Cup

Early 18th Dynasty, reign of Thutmose III (r. 1479–1425 B.C.)
Turquoise glass, gold
H. 7.5 cm (3 in.), Diam. 8.5 cm (3⅜ in.)
The Metropolitan Museum of Art, New York, Bequest of the Earl of Carnarvon, 1923 23.9

The shape of this cup imitates that of a lotus bud and is typically Egyptian, suggesting that it was made in Egypt. The outer surface is incised with a pattern of lotus petals, one of which is inscribed with the words "The Good God, Menkheperre, given life."

CHR

PROVENANCE: Western Thebes, Gabbanat el-Qurud, Wadi D, Tomb 1; formerly Carnarvon collection

BIBLIOGRAPHY: Winlock 1948, p. 61, pl. xxx, b; Lilyquist and Brill 1993, p. 34, no. 11, fig. 34, and cover (center); Lilyquist 2003, pp. 150, 151, no. 103, figs. 144, 145

32. Drinking Cup

Early 18th Dynasty, reign of Thutmose III (r. 1479–1425 B.C.)
Glassy faience, gold
H. 10.2 cm (4 in.), Diam. 7 cm (2¾ in.)
The Metropolitan Museum of Art, New York, Purchase, Edward S. Harkness Gift, 1926 26.7.1175

This jar was probably imported from western Asia and may have been brought to Egypt by one of the foreign wives of Thutmose III as part of her dowry. The form, which has a button-shaped base now masked by gold leaf over plaster restoration, has a long history in Mesopotamia. Fragments of glassy faience vessels with a similar variegated pattern have been found at the site of Nuzi (modern Yorgan Tepe, Iraq), which flourished in the kingdom of Mitanni during the fifteenth and fourteenth centuries B.C.[1]

CHR

1. Lilyquist 2003, p. 150.

PROVENANCE: Western Thebes, Gabbanat el-Qurud, Wadi D, Tomb 1; formerly Carnarvon collection

BIBLIOGRAPHY: Lilyquist and Brill 1993, pp. 13–14, no. 9, 16, fig. 10 (right), and cover (right); Lilyquist 2003, pp. 150, 151, no. 104, fig. 148a

30, 31, 32

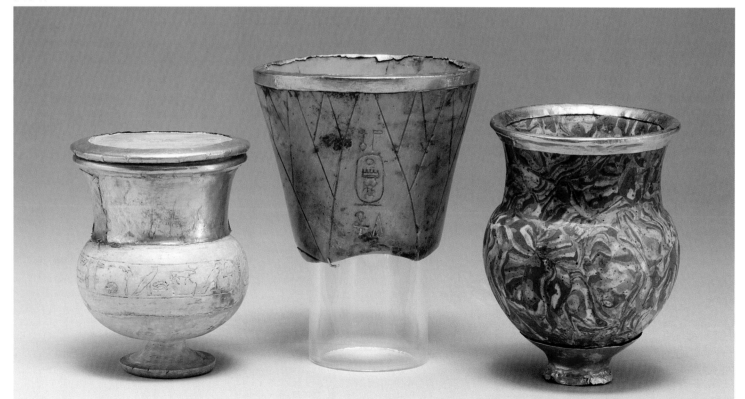

33

33. Vessel Fragment

Early 18th Dynasty, probably reign of Thutmose III
(r. 1479–1425 B.C.)
Glass
H. 4.8 cm (1⅞ in.)
Brooklyn Museum, Anonymous Gift 53.176.4

This fragment is from the shoulder of a glass
vessel, perhaps an amphoriskos (a small
amphora-shaped bottle). A glass fragment of
similar color and pattern was found in the tomb
of Thutmose III, in the Valley of the Kings, and
it is possible that these two fragments belonged
to the same vessel.

CHR

PROVENANCE: Possibly from Thebes

BIBLIOGRAPHY: Lilyquist and Brill 1993, pp. 33–34,
nos. 2–4, figs. 19, 31

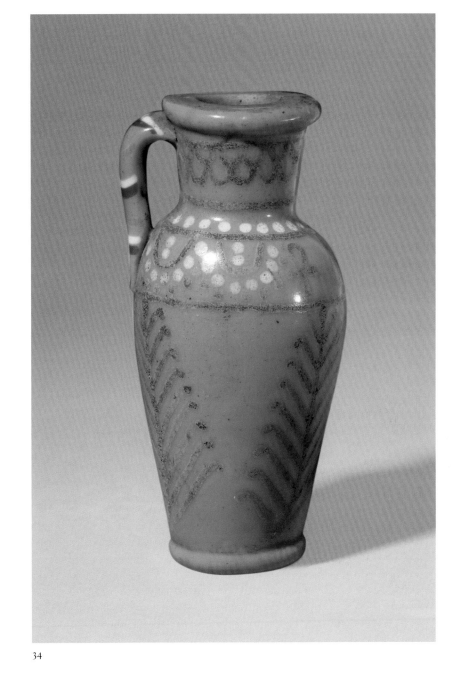

34

34. One-Handled Jug

Early 18th Dynasty, reign of Thutmose III (r. 1479–
1425 B.C.)
Glass
H. 8.7 cm (3⅜ in.), Diam. 4.1 cm (1⅝ in.)
The Trustees of the British Museum, London
EA 47620

This jug of core-formed glass is decorated with
a conventional scale or feather pattern around
the neck, a stylized plant motif on the body, and
a band of hieroglyphs at the shoulder that reads:
"The Good God, Menkheperre, given life."
The decoration, which appears to have been
painted on, is made of crushed glass that was
fired after application. It has been described by
John Cooney as the first known example of
enamel decoration.[1]

Fragments of glass vessels were found in the
tomb of Thutmose III, in the Valley of the
Kings (see "Glass," n. 4, above), and Sir E. A.
Wallis Budge suggested that the jug might orig-
inally have come from this tomb.[2] Cooney
agreed with this suggestion.[3]

The jug combines western Asian and Egyp-
tian influences, and it is impossible to tell where
it was manufactured. The shape has close paral-
lels among vessels produced in the Levant, but
similarly shaped jugs can also be found in
Egypt. The stylized plants and the pattern of
dots are more common in the Near East, but
the scale pattern is well known in Egypt, and
the hieroglyphs are competently formed and
legible, though the king's name is not enclosed
in a cartouche.

CHR

1. Cooney 1976, pp. 70–71.
2. Budge 1925, p. 391.
3. Cooney 1976, p. 71.

PROVENANCE: Unknown

BIBLIOGRAPHY: Harden 1968, p. 17; Nolte 1968,
p. 50, pl. 1, 5; Cooney 1976, pp. 70–71, pl. VI; Lilyquist
and Brill 1993, pp. 26–27, fig. 43; Shaw and Nicholson
1995, ill. on p. 112

THE TOMB OF MAIHERPERI IN THE VALLEY OF THE KINGS

The cemetery in western Thebes now known as the Valley of the Kings was the principal burial ground of New Kingdom pharaohs. Like all royal cemeteries in Egypt, the Valley of the Kings also contained numerous tombs of nonroyal individuals who had close ties to the royal family.[1] Among the earliest of these was the tomb of a man named Maiherperi, Fanbearer on the King's Right[2] and Child of the Nursery, the latter title indicating that he had been brought up with the royal children. Maiherperi's tomb, KV 36 (fig. 26), was discovered in March 1899 by Victor Loret, a French Egyptologist and director of the Egyptian Antiquities Service.[3] Although the tomb's single chamber had been robbed in antiquity, the many objects remaining were remarkably rich and well preserved.[4]

When it was unearthed, Maiherperi's small burial chamber contained a set of nesting coffins along the north wall. At the foot of the outermost coffin was a canopic jar, next to which lay a papyrus scroll that when unrolled revealed a beautifully illustrated Book of the Dead (cat. no. 35).[5] Boxes of preserved meat, storage jars, and a ritual object known as an Osiris bed were also found in the tomb. Among Maiherperi's more personal possessions were a number of luxury items including an exquisite glass bottle, an imitation Cypriot juglet of Egyptian blue, a faience bowl, and a game box made of acacia and ebony with gold foil decoration (cat. nos. 100–105, 156, and 189 are similar). In addition to these more durable objects, Maiherperi owned two exceptional leather quivers and two leather dog collars (fig. 25).[6] In 1903, while clearing the area around KV 36, the British Egyptologist Howard Carter discovered a wood box inscribed with Maiherperi's name that contained two leather loincloths (cat. no. 36).[7]

Burial in the Valley of the Kings was a privilege granted by the ruler, and many of Maiherperi's tomb furnishings were undoubtedly royal gifts. The objects assembled show the wide range of Egypt's contacts with other cultures. The glass bottle, for example, was probably imported from the Near East,[8] and the decoration on one of the quivers (fig. 25) presents a mixture of Egyptian, Near Eastern, and Aegean decorative motifs.[9] Maiherperi himself was probably a transplant from Nubia, perhaps brought to Egypt as a child to be indoctrinated at court and later returned to his home to serve as a member of Egypt's administrative bureaucracy (see "Egypt and Nubia" by W. Vivian Davies in this volume).[10]

Much attention has been given to the question of when Maiherperi lived and died. The only object in the tomb inscribed with a king's name was a sheet found on the mummy.[11] It is embroidered in one corner with a royal device depicting the "two ladies," Nekhbet, vulture goddess of Upper Egypt, and Wadjet, cobra goddess of Lower Egypt. Written in ink

Fig. 25. Quiver of Maiherperi, mid-18th Dynasty. Leather. Discovered in his tomb (KV 36) in the Valley of the Kings, western Thebes, by Victor Loret. Egyptian Museum, Cairo (CG 24071)

next to this emblem is Hatshepsut's throne name, Maatkare. Initially dated to the reign of Hatshepsut on the basis of this cartouche, the tomb has since been assigned new dates anywhere from the reign of Amenhotep II to that of Amenhotep III, but the arguments for these redatings are not compelling.[12]

Most scholars who have written on the subject in recent years begin with Birgit Nolte's study of glass vessels from ancient Egypt, in which she gives several reasons for dating Maiherperi's tomb later than the reign of Hatshepsut.[13] The first concerns the leather loincloths mentioned above, which Nolte would date to the time of Amenhotep II because such loincloths are most frequently represented in tombs from the reigns of Amenhotep II or Thutmose IV. Nolte herself points out, however, that similar garments are illustrated in the reliefs on Hatshepsut's temple (cat. no. 82c), so there is little force to her reasoning here.

Nolte's second argument has to do with the style of Maiherperi's funerary papyrus (cat. no. 35), which is discussed in its catalogue entry below. Her third assertion is that Maiherperi's title Fanbearer on the King's Right is documented for the first time "in its full form" in the reign of Amenhotep II.[14] This argument requires her to exclude the possibility that Maiherperi was the first holder of the full title and omits the important fact that the simple title Fanbearer is documented in the reign of Thutmose III.[15]

Nolte's final point concerns the pierced ears of Maiherperi's mummy. It is well known that the first royal mummy to have pierced ears is Amenhotep II's, and the wearing of earrings by Egyptian men is therefore commonly dated to his reign. However, earrings have been found in men's tombs that date from the time of Hatshepsut and Thutmose III (see the discussion of jewelry by Diana Craig Patch in chapter 4). There are also representations of Nubian men wearing large earrings in the reliefs on Hatshepsut's temple. Maiherperi was a Nubian and may well have practiced certain Nubian customs despite having been raised at the Egyptian court.

The objects preserved in the tomb show many affinities with works of the early Eighteenth Dynasty. The cartonnage mask[16] on Maiherperi's mummy, which completely covers the shoulders, is of the same type as that of Hatnefer (fig. 40), Senenmut's mother, who was buried before year 7 of Thutmose III (and Hatshepsut). Maiherperi's inner coffin has the simple form and shows the long wig lappets of the early Eighteenth Dynasty, and on the lid of his unused coffin is the same broad, wide-eyed face with a slightly pointed nose that one sees in some representations of Hatshesput. Maiherperi's objects are certainly more elegant than those found in nonroyal cemeteries of the early Eighteenth Dynasty, but this is to be expected in a burial that must have been provided by the king.

In a consideration of dating, the presence in Maiherperi's tomb of the name Maatkare cannot be dismissed lightly. An object bearing the name of any other king might be explained as an heirloom. It is highly unlikely, however, that the cartouche of Hatshepsut, which was so meticulously excised on monuments throughout Egypt and Nubia after her death, would have found its way into a tomb in, of all places, the Valley of the Kings. We know from archaeological evidence that the inscribed corners of sheets used in mummification were routinely ripped out,[17] making it particularly unlikely that Hatshesput's cartouche would have been left in place after the destruction of her monuments.

Certainly, a sheet from the royal storerooms bearing Hatshepsut's name might have been distributed for funerary use some years after her death. Therefore the presence of her cartouche does not necessarily date Maiherperi's tomb to her reign, but it does strongly suggest that he was buried no later than the destruction of Hatshepsut's name and images, which seems to have begun some twenty years after her death. Maiherperi's tomb is set in a somewhat isolated spot in the Valley of the Kings, but its location at the outlet of the subsidiary valley chosen by Thutmose III supports a closer association with his tomb than with that of Hatshepsut (see fig. 75). The most obvious conclusion is that his burial in the royal valley was ordered by Thutmose.[18]

The glass bottle found in Maiherperi's tomb also supports a dating of the burial to the time between Hatshepsut's death and the destruction of her monuments. Glass vessels were probably not common in Egypt until the reign of Amenhotep II, whose tomb has yielded many fragments of large glass vases. Both imported from abroad and manufactured in Egypt, glass vessels were highly prized, and it should come as no surprise that only fragments of them have been found in early Eighteenth Dynasty contexts: a complete glass bottle, whether or not its contents were still usable, would have been carefully handled and removed by tomb robbers. Maiherperi's glass vase, being broken, was left in the tomb. The remains of small glass vessels similar in size to the one found in KV 36 were discovered in the tomb of Thutmose III (see cat. nos. 33, 34). Two glass fragments were also found in the tomb of Thutmose I (KV 38), although these may date from his reburial by his grandson Thutmose III—probably sometime between the death of Hatshepsut and the destruction of her monuments.[19] The presence in KV 36 of Hatshepsut's cartouche and the glass vessel, and the types and styles of the other contents, make it likely that Maiherperi's burial took place during this period as well.

CHR

Fig. 26. Plan and elevation, tomb of Maiherperi (KV 36), Thebes. Drawing by Julia Jarrett

1. Almost half of the individuals buried in the valley were not royal. The earliest datable nonroyal tomb in the valley, KV 60, is that of Hatshepsut's wet nurse. On the Valley of the Kings, see my essay "The Two Tombs of Hatshepsut" in chapter 3.

2. This full form of the title appears at least once in Maiherperi's funerary papyrus (Daressy 1902, p. 52), but the title's short form, Fanbearer, is more frequently used there (Daressy 1902, pp. 38–56, for the complete text). The short version is the one that appears in other inscriptions found in the tomb.

3. For Maiherperi's tomb, see Daressy 1902; Reeves 1990b, pp. 140–47; Reeves and R. H. Wilkinson 1996, pp. 179–81.

4. The robbers had sliced through the wrappings on the mummy and removed most of the jewelry, then had re-covered the mummy with large pieces of folded linen. The rather considerable care with which this was done, and the surprisingly good preservation of other objects in the tomb, suggest that the theft represented an official "recycling" of valuable resources rather than a random robbery.

5. Until recently, any attempted reconstruction of the position of the objects in the tomb was either based on a description published by Georg Schweinfurth (1900), who visited the tomb during its excavation, or gleaned from George

Daressy's publication of the objects (see Daressy 1902; Reeves 1990b, p. 142). Loret never published a description of the tomb, but his notes were acquired by the Università degli Studi di Milano and have now been published. For KV 36, see Piacentini and Orsenigo 2004, pp. 271–81.

6. The faience bowl, the glass bottle, and one dog collar have recently been published in Wiese and Brodbeck 2004, pp. 168–73.

7. Carter 1903, pp. 46–47.

8. See, in this volume, Christine Lilyquist's essay "Egypt and the Near East," in which she cites fragments of glass vessels with similar decorative patterns found at Near Eastern sites. On one fragment, from Tell Brak in Syria, part of the decoration on the shoulder is left in relief (D. Oates, J. Oates, and McDonald 1997, frontis. and p. 82); on another, from Assur, in what is now Iraq, all of the decoration is marvered into the surface of the vessel, as on Maiherperi's example (Barag 1962, pp. 14, fig. 5, 15, 16).

9. For a discussion of the quiver, see Lilyquist's essay (n. 8 above). Elements of the Near Eastern motifs are already present on early Eighteenth Dynasty scarabs (see cat. no. 25). The running spiral motif, an Aegean import, is also used to decorate Egyptian faience bowls in this period (see the discussion of faience bowls in chapter 3, as well as Lilyquist's essay).

10. On Maiherperi's ethnicity, see note 18 in Lilyquist's essay (n. 8 above). He died young, at the age of about twenty (Daressy 1902, p. 60).

11. The sheet is in the Egyptian Museum, Cairo (CG 24099); it was published in Daressy 1902, p. 58, pl. XII.

12. Daressy (ibid., p. 58) dated the tomb to the time of Hatshepsut based on the cartouche but thought that the style of the coffins was more like that of Amenhotep II or III. For the views of other early Egyptologists, see Reeves 1990b, p. 146. Birgit Nolte (1968, pp. 50–51) dates the tomb to the reign of Amenhotep II, Carl Nicholas Reeves (1990b, p. 147) to that of Amenhhotep II or Thutmose IV. Irmtraut Munro (1988, p. 279) dates Maiherperi's Book of the Dead papyrus to the time of Amenhotep II. Aidan Dodson (1998, p. 334) dates

Maiherperi's coffins to the end of Amenhotep II's reign, but to do so he must argue away the "primitive" technique and "archaic" appearance that relate the coffins to the reign of Thutmose III.

13. Nolte 1968, pp. 50–51.

14. Nolte (1968) cites a personal communication from J. R. Harris as her source for this information. Wolfgang Helck (1958, pp. 201–2), who may have been Harris's source, similarly states that the full form of the title appeared for the first time in the reign of Amenhotep II, but he seems to be unaware that the scroll belonging to Maiherperi, whom he places in the reign of Hatshepsut, also records the full form of the title.

15. According to George Reisner (1920, p. 81), there were three holders of the title Fanbearer or Fanbearer on the King's Right during the reign of Thutmose III.

16. Egyptian Museum, Cairo, CG 24026; Daressy 1902, pl. XVI, where it is misnumbered 24027.

17. Winlock 1940; Roehrig 2002.

18. Although on a map KV 36 appears closer to the tomb of Thutmose's son, Amenhotep II, a ridge separates it from Amenhotep's tomb. Moreover, a number of pit tombs lie near the entrance to the tomb of Amenhotep II, and one of these (KV 48) contained the burial equipment of his vizier, Amenemopet. If Maiherperi had been associated with Amenhotep II, his tomb would properly have been among the subsidiary burials near that king's tomb.

19. Hatshepsut had arranged for Thutmose I to be moved to her own tomb, KV 20. Presumably, Thutmose III did not restore Thutmose I to his original tomb until after Hatshepsut's death. Tomb KV 20 lies in a very unstable stratum of expansive shale, a circumstance that might have caused Thutmose to remove his grandfather's burial quite soon after Hatshepsut's demise. Or he might have carried out the reburial of Thutmose I as one of the first stages of his attack on Hatshepsut's memory. Since it is unlikely that he would have left his grandfather in Hatshepsut's tomb once he began destroying her monuments, this terminus ante quem can be assumed for the reburial.

35. Section of a Book of the Dead belonging to Maiherperi

Early 18th Dynasty, reign of Thutmose III (r. 1479–1425 B.C.)
Painted papyrus
H. 33.5 cm (13¼ in.)
Egyptian Museum, Cairo CG 24095

The papyrus found in Maiherperi's grave is among the finest and earliest illustrated examples of the Book of the Dead. Spells from this collection of magical funerary texts, more correctly called the Book of Coming Forth by Day, began to appear on linen shrouds and coffins of the royal family in the Seventeenth Dynasty.[1] By the time of the joint reign of Hatshepsut and Thutmose III, the texts were also being included in the tombs of nonroyal individuals, written on shrouds and on rolls of papyrus and leather.[2]

This vignette from the papyrus depicts Maiherperi standing before seven celestial cows and their bull; the illustration accompanies an abbreviated version of spell 148 (see also cat. no. 73), which asks for daily provisions for the deceased. Maiherperi is shown with the dark skin of a Nubian rather than the red color conventionally used for Egyptian men. His hairstyle consists of tight curls and is similar to the wig found on his mummy. He wears a choker and another necklace of amulets rather than the broad collar necklace that one would expect in this context. His bracelets and armlets are of types quite commonly seen in representations of men in Egyptian art.

The slim, long-waisted human figures in this papyrus are painted in a style consistent with the early Eighteenth Dynasty, and the costumes and hairstyles agree with findings in the tombs of this period.[3]

One vignette shows a funerary procession with a pair of oxen dragging a sledge on which is a boat carrying the coffin of the deceased,[4] and the inclusion of the boat has been used to date the papyrus to the reign of Amenhotep II or later.[5] But in fact, two coffins carrying a similar boat image can be dated to the joint reign of Hatshepsut and Thutmose III.[6]

CHR

1. Quirke and Spencer 1992, p. 98.

2. The burial of Hatnefer, the mother of Senenmut, contained a linen shroud, a papyrus, and a roll of leather, all of them inscribed with texts from the Book of the Dead. The shroud has no illustrations (Lansing and Hayes 1937, p. 28), the papyrus shows a few simple vignettes, and the leather roll, which is inscribed with spell 100, has one simple vignette (Roehrig 2002, p. 35). Thutmose III also had a shroud inscribed with Book of the Dead texts but no illustrations (Nagel 1949).

3. For example, in the tombs of User (TT 21), Ineni (TT81), and Useramun (TT 61 and 131).

4. Corteggiani 1987, p. 92.

5. Munro 1988, pp. 16–18.

6. One of Irmtraut Munro's examples comes from a cemetery that was sealed by the causeway of Hatshepsut's temple and therefore must predate the causeway; and on a second coffin from this cemetery (Hayes 1959, p. 31, fig. 14) the coffin of the deceased is also depicted on a boat.

PROVENANCE: Western Thebes, Valley of the Kings, tomb of Maiherperi (KV 36); excavated by Victor Loret on behalf of the Egyptian Antiquities Service, 1899

BIBLIOGRAPHY: Daressy 1902, pp. 38–57, pls. XIII–XV; Corteggiani 1987, pp. 92–95; Saleh and Sourouzian 1987, no. 142; Munro 1988, pp. 278, 360 (index, under pM3j-ḥr-prj), pl. XI

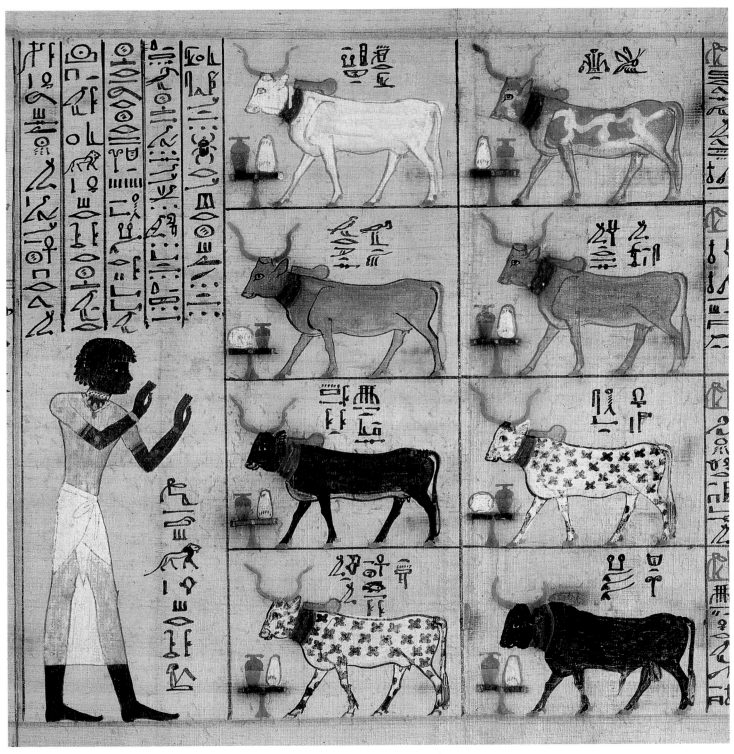

36. Box

Early 18th Dynasty, reign of Thutmose III (r. 1479–1425 B.C.)
Painted wood
H. 13.3 cm (5¼ in.), W. 12.6 cm (5 in.), D. 19.7 cm (7¾ in.)
Museum of Fine Arts, Boston, Gift of Theodore M. Davis 03.1036ab
Not in exhibition

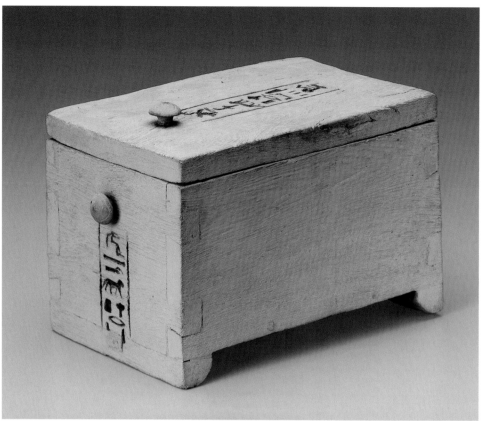

36

Howard Carter discovered this small box near the tomb of Maiherperi on February 26, 1903.[1] The box is inscribed with Maiherperi's name and his titles, Fanbearer and Child of the Nursery. It had presumably been removed from the tomb by robbers, who stashed it in a depression in an outcropping of rock but never retrieved it. Inside the box were two leather loincloths, one of them of leather cut into a very fine mesh (fig. 27). Similar leather garments are depicted being worn by soldiers in the reliefs on Hatshepsut's temple (cat. no. 82c).

Carter described the skins as very soft and "dexterously mended anciently."[2] In fact, the sewn areas of the loincloth shown here are symmetrically located on both sides, indicating that to make the garment the skin was carefully shaped, with some areas being cut and re-sewn while others were spliced to allow for a better fit. Gaston Maspero, the director of the Egyptian Antiquities Service when Carter's discovery was made, thought that the loincloths were probably of Syrian manufacture;[3] however, pierced leather garments (though not of exactly the same type) were also manufactured in Nubia.[4] The Egyptians were certainly using leather loincloths as early as the reign of Hatshepsut, and the garments were probably already being manufactured in Egypt.

CHR

1. At the time, Carter was working for Theodore M. Davis, an American who held the concession to excavate in the Valley of the Kings.
2. Carter 1903, p. 47.
3. Ibid., p. 47, n. 1.
4. Wainwright 1920, p. 29; Reisner 1923, pp. 303–5, pl. 65, 3.

PROVENANCE: Western Thebes, Valley of the Kings, found near the tomb of Maiherperi (KV 36); excavations of Theodore M. Davis, 1903

BIBLIOGRAPHY: Carter 1903, pp. 46–47, fig. 1, pl. II; Peter Der Manuelian in *Egypt's Golden Age* 1982, pp. 176–77, no. 200

Fig. 27. Leather loincloth, 18th Dynasty. Discovered in a box belonging to Maiherperi (cat. no. 36) near his tomb, by Theodore M. Davis and Howard Carter. Museum of Fine Arts, Boston, Gift of Theodore M. Davis (03.1037)

EGYPT AND THE AEGEAN
Cultural Convergence in a Thutmoside Palace at Avaris

Manfred Bietak

An unexpected discovery was made in the last decade at ʿEzbet Helmy, west of Tell el-Daba in the eastern Nile Delta. At the foot of a ramp leading to a palace of moderate size, dumps containing thousands of fragments of Minoan wall paintings were revealed.[1] As the fieldwork continued it became clear that the fragments had come from this building, called Palace F. It was one of three palaces of the Thutmoside period erected within a huge precinct at this site, on the eastern bank of the easternmost branch of the Delta (fig. 28). Once the site was Avaris, the capital of the ephemeral Hyksos ("rulers of the foreign countries"), a foreign dynasty of Near Eastern origin that ruled Egypt between about 1640 and 1530 B.C. After Ahmose I, founder of the Eighteenth Dynasty and creator of the New Kingdom, finally succeeded in conquering Avaris, he expelled the inhabitants of the city and established a major military stronghold for conducting operations in the Levant against the last remaining Hyksos.

The first pharaohs of the New Kingdom built large military installations in the western part of Avaris. Hundreds of grain silos were constructed, probably for stockpiling provisions for troops and for future campaigns. A substantial enclosure wall surrounded the core of this new site, which also had a small palace. In another stratum (D/1.1), excavators found remains of campfires and huts and the pit graves of soldiers, most of them young men between eighteen and twenty-five years of age. Physical anthropologists determined that some of them were Nubians, an identification confirmed by fragments of cooking pots, beakers (cat. no. 5), and other containers representative of the Nubian Kerma culture found in the camp remains and in succeeding strata. These were soldiers from the Sudan, employed by the Egyptian army of the early Eighteenth Dynasty. At that time Egypt was grappling with the formidable kingdom of Kush in the south, which it finally destroyed under Thutmose III. It seems that Ahmose and his successors recruited former prisoners of war as archers for their military campaigns in Canaan.

During the early Thutmoside period the site became more developed. Within a fourteen-acre area a palatial precinct was built containing three palaces (fig. 29). Each was constructed on a podium of mud brick—a characteristic building material for palaces in the ancient Near East—and accessible via a ramp with a landing. All had a dazzling coating of whitewashed plaster. The largest, Palace G, measuring 518 by 260 feet (305 by 150 ancient Egyptian cubits), and the medium-sized Palace F, 221 by 153 feet (130 by 90 cubits), stand on either side of a large courtyard. To the south of Palace F were found storehouses with faience objects and pottery,[2] evidence of this household's far-reaching trading connections with Cyprus and the Levant. A third small palace, J, lay south of Palace G. An enclosure wall surrounded the whole precinct, with a pylon at the halfway point on a north-south axis through the courtyard. East of Palace G was a large public building more than 17,000 square feet in area, which is currently being

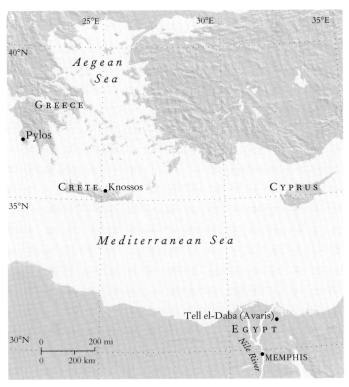

Fig 28. Map showing sites of contact between Egypt and the Aegean, early New Kingdom

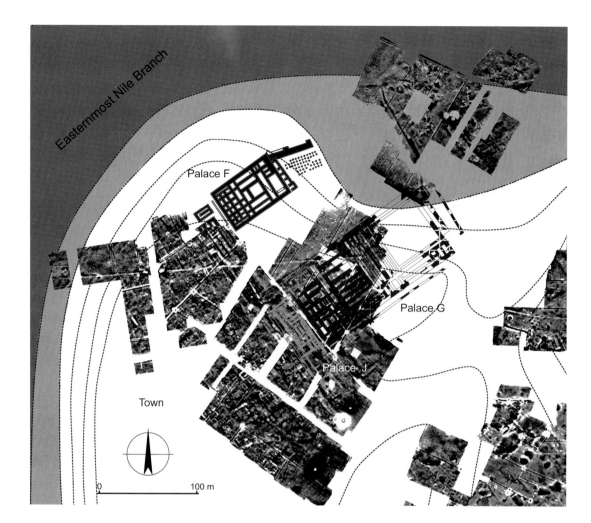

Fig. 29. The palace precinct at ʿEzbet Helmy, early Thutmoside period, early 18th Dynasty. After an unpublished survey map by T. Herbich, C. Schweitzer, J. Dorner, I. Forstner-Müller, and W. Müller

excavated. It probably was the seat of an official of very high rank. South of the palatial precinct lay a whole town, as can be seen on the geophysical survey map (fig. 29); north of it one can see enclosures, probably for military camps. Farther north the river shows an indentation that in all likelihood was the mooring place.

Although only the substructures of the palaces are preserved, it is possible to reconstruct the plans on the basis of what we know about Egyptian palatial and domestic architecture. The large Palace G (fig. 30) had a square courtyard that was open to the north and lined on two sides with colonnades, whose substructures remain. Adjacent was a portico of three rows of columns. On the other side of a thick wall one entered a wide vestibule that led into the building, which was divided in two. The left wing can easily be identified as a square throne room, with four rows of columns and niches at the rear indicating the positions of doors or thrones. The right wing looks like a tripartite sanctuary with a hidden holy of holies in back—a typical feature in temples of the Thutmoside period. Left and right have symbolic meanings in Egyptian architecture, and the right-hand location of this room, giving it preference over the throne room, can only be explained if it was a residence of a dynastic god, who at that time would most likely have been Amun; the local god Seth of Avaris cannot, however, be entirely ruled out. The front

of this wing of the palace is reinforced by a parallel attached wall reminiscent of a temple pylon. As the geophysical survey map reveals, it also supported a staircase, a feature often found in pylons.[3] Behind this official part of the palace lies the private section, where the identification of rooms is more difficult. After a vestibule one entered a square room with foundation walls that supported four columns. Thereafter the area seems to have been divided into at least two apartments, each with a sleeping room and a reception room. The eastern apartment has a stairway leading down to a cellar. Of special interest are latrines, which can be identified by sediments and a toilet basin made of two stone slabs. One slab broke through the floor and fell into the sediment during an early phase of use. One can only hope that this was not connected to a royal misfortune.

Palace G had two entrances, a main entrance by way of the ramp, and a side entrance along the eastern side, which led via a narrow stair with a landing to the residential quarters. At both entrances baths with stone basins were installed, seemingly making it imperative to wash and shower before entering the building.

The plan of Palace J was similar, but simpler, with only one apartment in the living section. Palace F, however, had a different plan (fig. 31). From the ramp the entrance led into a rectangular courtyard that gave access to a square yard situated in the center

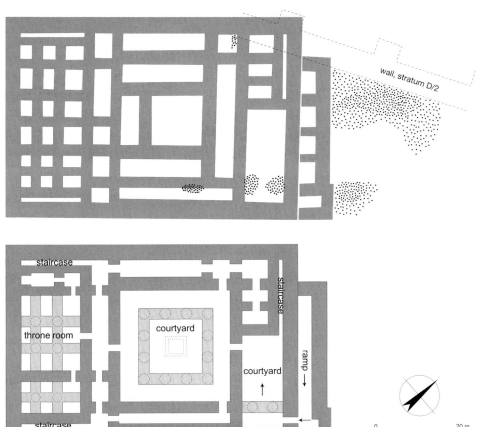

Fig. 30. Palace G at ʿEzbet Helmy. Reconstructed plan by Manfred Bietak and Nicola Math

of the building. This yard was apparently surrounded on all sides with colonnades. The southern colonnade led into a system of rooms that can be reconstructed as consisting of a four-columned reception room, flanked on its eastern side by a two-columned side room and on its western side by perhaps a bathroom or a ceremonial sleeping room. What is missing is the private area, and this identifies it as an entirely ceremonial palace.

Palace F was also extraordinary in other respects. At the foot of its ramp and landing were dumps containing thousands of fragments of wall plaster painted in an entirely Minoan style and technique. Unfortunately they represent only about ten percent of the original wall decoration; the rest was lost in the construction of later building projects and modern brick pits in this area. The fragments were not found near the wall's original location. This

Fig. 31. Palace F at ʿEzbet Helmy, reconstructed. Dotted areas show where the fragments of Minoan wall painting were found. The foundation level appears above, the main level below (top after Jánosi 1995, p. 65; bottom Manfred Bietak)

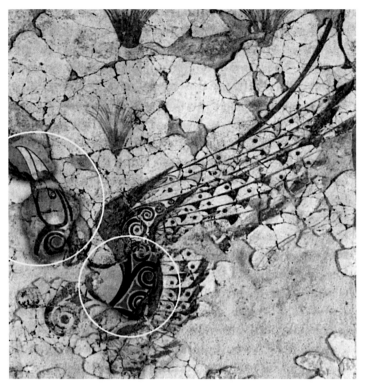

Fig. 32. Fragments of a griffin in a wall painting from the throne room of Palace F, ʿEzbet Helmy. The circles highlight the griffin's head and the spirals on its wings

plaster coating seems to have fallen off the walls soon after it was applied. The hard lime plaster typically used in the Aegean area does not adhere well to soft building material such as walls of Egyptian mud brick built on alluvial ground; moreover, a wall of this type may continue to shrink for more than fifteen years. This must have happened at Palace F, causing the painted plaster to fall off—after which the fragments were collected and dumped in the nearest convenient spot, the end of the ramp and the landing. This relocation of the fragments in antiquity makes the reconstruction of the original friezes a most difficult task. Nevertheless, the fragments recovered point to the presence of well-known Minoan compositions.

About the arrangement of the decoration, a good deal may be hypothesized on the basis of the fragments and what is known about Minoan painting. We can be rather sure that large, emblematic images of griffins and lions occupied the back wall of the throne room (fig. 32), as is the case in the throne rooms at Knossos, on Crete, and Pylos, on the coast of Greece. A floor painting with a maze pattern and multiple borders should also be assigned to the throne room. It is very likely that the paintings treating central Minoan themes such as bull-grappling, bull-leaping,

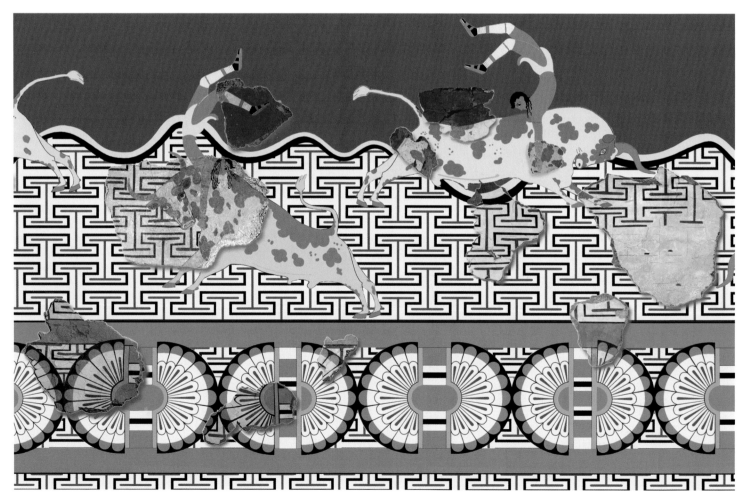

Fig. 33. Bull-leaping and maze pattern. Wall painting from Palace F, ʿEzbet Helmy. Reconstruction © Manfred Bietak, Nanno Marinatos, and Clairy Palyvou

and other acrobatic feats were located in the throne room as well (fig. 33). Other friezes with lions or leopards chasing hoofed animals could also have had a place in this room. There were, however, many additional representations, such as a hunting frieze, lifesize figures, and a plaster relief with representations of bulls; these perhaps adorned the colonnade surrounding the central courtyard or the entrance area.

Parts of Palace G too were decorated with paintings and plaster relief. Pieces of ornamental paintings and a lifesize figure of a woman in a flounced skirt were retrieved from a side entrance in the enclosure wall leading to the foot of the ramp. Fragments of plaster relief depicting a large-scale white figure wearing jewelry[4] were found in dumps east of this building near a side entrance, together with a fragment showing a yellow horn, probably that of a goat. Also found scattered around the landing of Palace G were pieces of paintings on mud coating (rather than plaster) with motifs that are partly Minoan, partly Egyptian.

The technique of making a very compressed lime plaster containing crushed murex shells, which was then highly polished, is purely Minoan.[5] The basins for mixing this paste were found near Palace F, on the banks of what was formerly the easternmost branch of the Nile.[6] Other techniques evident from the fragments—of laying out the design of the paintings with impressions of a cord and applying the first colors on the still-damp surface—were known at that time only in the Minoan world. The color conventions, especially the use of blue for gray and green and of red for the background, are also Minoan, as are the above-mentioned motifs, the composition of them, and the undulating horizons, maze patterns, ornamental frieze designs such as the running spiral, and various other patterns.

In iconography and style as well, the paintings are typically Minoan. Characteristic features include the partly shaved scalp, painted in blue (for gray), that signals an acrobat's young age;[7] the flounced skirt worn by a lady or goddess; the Minoan kilt of an acrobat, cushion-shaped seal at his wrist, and an armlet decorated with a running spiral decoration. Absolutely Minoan is the minute rendering of the cushion-shaped seal stone, which even shows, at the point where the leather strap enters the perforation, the typical indentations caused by wear and tear. The running spiral decoration in the wings of griffins (fig. 32), with red fillers between the spirals, is a combination of motifs typical of Late Minoan IA.[8] And the Minoan style is clearly recognizable in the paintings' depiction of movement, such as the high swing of acrobats and the flying gallop of felines and ungulates.

How can we explain the fact that an Egyptian ceremonial palace and parts of another, major palace were painted with Minoan works of mural art by Minoan artists? There are some other instances of Minoan painting occurring in unexpected places. Minoan paintings dating from the Middle Bronze Age (six-

Fig. 34. A Keftiu delegation. Wall painting from Theban tomb 71 of Senenmut, early 18th Dynasty

teenth century B.C.) have been found at Alalakh and Kabri, in the Levant,[9] and paintings most likely dating from the Late Bronze Age that show the influence of Minoan art appeared in the royal palace at Qatna, Syria. One suggested explanation is that the Knossian palatial style was exported, by sending artists to befriended courts, as an expression of Knossos's prestige.[10]

But in Tell el-Daba a different explanation seems likely, since these paintings can be firmly fixed later, in the early Thutmoside period, in the first half of the fifteenth century B.C. Beneath the palace that held the paintings, stratum D/1 yielded pottery of the early Eighteenth Dynasty. The later phase of the palace (C/2) can be dated by a scarab of Amenhotep II (r. 1427–1400 B.C.) and a seal impression from the time of his reign;[11] however, the chronological range of pottery found at the site indicates that the palace was not in use beyond this date. Thus the principal functioning period of the palace falls between the reigns of the two Amenhoteps, probably in the time of Thutmose III (r. 1479–1425 B.C.), and the earlier phase, with the paintings, must belong to the early Thutmoside period. While the works could be as early as Thutmose I, it is during the joint reign of Thutmose III and Hatshepsut, 1479–1457 B.C., that delegations of Keftiu (inhabitants of Crete) are first represented, in the tombs of Senenmut (fig. 34) and Useramun.[12] This speaks in favor of a date for the paintings contemporary with Hatshepsut. At that time, it seems, a special relationship with the Knossian court began that periodically

Fig. 35. Minoan-style decoration from Theban tomb 71 of Senenmut, early 18th Dynasty

brought delegations from Crete to Egypt. This is the very time when Minoan influence can be seen in the decoration in Theban tombs[13]—beginning in the tombs of Senenmut, who was the favorite of Queen Hatshepsut (figs. 34, 35), and of Useramun and culminating with the hunting scene in the tomb of Qenamun,[14] chief steward under Amenhotep II.

In this palace decoration there are no representations of Egyptian royal emblems, only motifs and symbols typically associated with the palace of Knossos, such as bull acrobatics and the maze pattern. At no other site of that time, except Knossos, were there maze and bull representations. Moreover, the bull-and-maze frieze in Palace F has at its bottom a half-rosette frieze, a royal Minoan emblem from the palace of Knossos[15] not to be found at any other site with Minoan paintings (fig. 33). In all likelihood this signifies a direct relationship between the courts of Knossos and Egypt. Who was responsible from the Egyptian side, Hatshepsut or Thutmose III? And what was the basis of this relationship? To reach an answer we first must clarify the function of this site before, during, and after their joint reign.

After its conquest, we know, Avaris became a military stronghold and a place for stockpiling grain and other food, most likely for military purposes. The big palatial precinct only makes sense if it was the residence for the king or some other royal figure. The fact that the palace's period of use was during the reigns of Thutmose III and Amenhotep II argues for associating it with Perunefer,[16] known from texts as the major military and naval stronghold of the Thutmosides. As far back as the 1920s, Georges Daressy,[17] and following him Labib Habachi,[18] proposed to locate Perunefer not at Memphis, as the majority of Egyptologists

believe,[19] but at the site of Avaris and nearby Piramesse, the Delta residence of the Ramesside kings. Until now there was no proof of an Eighteenth Dynasty stronghold there, but now everything falls into place. The previous function of Avaris as a harbor is well established by the inscription on the Seventeenth Dynasty Kamose stela,[20] and it was still known in the time of the Nineteenth and Twentieth Dynasties as the harbor of Piramesse.[21] Therefore it is plausible that Avaris remained a formidable harbor between those times, during the reigns of Thutmose III and Amenhotep II, just when Perunefer was in full operation.

Also speaking for Perunefer's possible identification with Avaris is the fact that there were Canaanite cults and Canaanite ship carpenters[22] there, as documented in papyrus 1116A in the Hermitage, Saint Petersburg.[23] The Canaanites could be explained as survivors from the period of Hyksos control in Avaris. Indeed, excavations in the temple of Seth in Avaris show that the city continued to be occupied beyond the time of its conquest by Ahmose I.

Moreover, in the dockyard records of Perunefer written during the reign of Thutmose III or Amenhotep II (British Museum, London, papyrus 10056), Keftiu ships are mentioned.[24] Until now one would explain them not as Cretan ships but as vessels bound for Crete (like the China clipper in the nineteenth century) or as ships of a type that originated in Crete.[25] Now, with the evidence of Minoan paintings at the site, it makes perfect sense to suppose that the ships did indeed come from Crete. The special relationship between the Egyptian and Minoan courts was in all likelihood linked to maritime traffic and the ship facilities available in this biggest Egyptian dockyard. For its part, the Minoan thalassocracy provided Egypt with maritime know-how and security in the eastern Mediterranean. It is perfectly possible that this relationship stimulated Egyptian enterprises by sea such as the voyage to the mythical land of Punt—a notable achievement of Queen Hatshepsut.

This reciprocity seems to have lasted until the reign of Amenhotep II. Keftiu delegations were still represented in Theban tombs (see n. 13 below) in his time, although not necessarily in a realistic fashion. One can recognize Minoan influence in several tombs in Thebes, especially that of Qenamun, where a hunting scene includes inverted landscape representations in the Minoan manner.[26] This is no coincidence, for in the course of his career Qenamun seems to have been in charge of Perunefer. This would explain why paintings in his tomb show the impact of Minoan composition more markedly than any other examples of Egyptian art. It seems that the artists working in the palaces of ʿEzbet Helmy developed a new program for wall painting in Egyptian palaces. That model continued to be followed through the time of Amenhotep III, when it is seen in the bucrania and running spiral decoration in the palaces of Malqatta in western Thebes. The palaces that Akhenaten built in Amarna later in the

fourteenth century B.C. carry decorations that drew on the same source, with blue papyrus plants arranged asymmetrically and scenes shown against a red background.

Who lived in the palaces at Tell el-Daba/ᶜEzbet Helmy? Was it Hatshepsut or young Thutmose III? It seems more likely that the occupant was the young Thutmose III. Is it thinkable that the queen placed him there so that he would be quite far from the official court in Thebes?[27] When Amenhotep II, as crown prince, made use of the residence in Perunefer, it seems plausible that he was taking over a tradition from his father.

After Amenhotep II the site fell into disrepair. Already late in his reign, the goal of Egyptian foreign policy had changed to pursuing a rapprochement with the other superpower in the eastern Mediterranean area, the Near Eastern kingdom of Mitanni; Thutmose IV married a Mitannian princess. Under Amenhotep III, Egypt's policy of peaceful coexistence reached its peak. The friendly relationship between Egypt and Mitanni was again sealed with marriages, the pharaoh taking two Mitanni princesses as wives. Was there no longer any need for the naval and military stronghold of Perunefer? Its palaces fell into ruin and were taken over by shepherds.

Perhaps we should search for another, more cogent reason for the abandonment of so important a base. Is it possible that the city was struck by an epidemic of a disease such as the plague, which is known to have roamed through the eastern Mediterranean in the fourteenth century B.C.? Harbor towns were particularly vulnerable to devastation from such diseases.

It was only during the Amarna period, when a new superpower, the Hittites, threateningly appeared in the political arena, that the site became important once again, and large buildings of unknown purpose were constructed. Later, Haremhab, who after a long military career became the Eighteenth Dynasty's last king, strengthened the site with an impressive fortress.[28] At the same time he restored the old temple of Seth in Avaris,[29] where Seth had been the *interpretatio aegyptiaca* (that is, the Egyptianized version) of the Canaanite storm god Baal Zephon[30]—a survivor from the Hyksos period. This makes it clear that the Canaanite cults lived on during the Eighteenth Dynasty and were disbanded only in the Amarna period. Revived by Haremhab, they continued into Ramesside times in the residential town of Piramesse. The road to that town had been paved in the Eighteenth Dynasty, and it seems that Hatshepsut, for political reasons of her own, had a hand in it.

The discoveries at ᶜEzbet Helmy raise a host of questions, many of which remain unanswered. But they also provide evidence for the complete overturning of previous assumptions, and they shed a bright light on the surprisingly close relationship that existed in this period between Egypt and the Aegean world of the Minoans.

1. Bietak et al. 1994; Jánosi 1995; Bietak 1996; Jánosi 1996; Bietak 1997; Bietak, Dorner, and Jánosi 2001; Bietak and Forstner-Müller 2003.
2. Dorner and Jánosi 2001.
3. Bietak forthcoming.
4. Bietak and Marinatos 1995, p. 54.
5. Brysbaert 2002.
6. Jánosi 2002.
7. Davis 1986.
8. Bietak 1994; Bietak and Palyvou 2000.
9. B. Niemeier and W.-D. Niemeier 1998, 2000, and 2002.
10. W.-D. Niemeier 1991, pp. 199ff.; B. Niemeier and W.-D. Neimeier 1998, 2000, and 2002.
11. Bietak 2004b, p. 50, fig. 7.
12. Dorman 1991; Wachsmann 1987, pp. 31–32.
13. Vercoutter 1956; Wachsmann 1987, pp. 27–40; Matthäus 1995.
14. Norman de G. Davies 1930.
15. See Evans 1928, pp. 590–96, 604–6, figs. 368, 370–71, 377–79; and a useful summary in Press 1967.

16. Spiegelberg 1927.
17. Daressy 1928–29; Daressy 1929–31.
18. Habachi 2001, pp. 106–7.
19. Glanville 1931; Glanville 1932; Helck 1939, pp. 49–50; Badawī 1943, p. 43; Säve-Söderbergh 1946, p. 37; Badawī 1948, pp. 137–39; Helck 1971, pp. 446–73; Der Manuelian 1987, pp. 174–75; Bryan 1991, pp. 49–50.
20. Habachi 1972, p. 36; Bietak 1975, p. 192.
21. Bruyère 1930, p. 22; Bietak 1975, pp. 30, n. 37, 187, 205–6.
22. Stadelmann 1967, pp. 32–34.
23. Golénischeff 1913, verso, 15.
24. Glanville 1931, pp. 116 (recto, col. 18, 4), 121 (verso, col. 11, 5–6); Glanville 1932, pp. 22, no. 56, 30, no. 88.
25. Säve-Söderbergh 1946, p. 49.
26. Norman de G. Davies 1930, pl. XLVIII.
27. See H. Goedicke 2004, p. 128.
28. Bietak, Dorner, and Jánosi 2001, pp. 101–2.
29. Bietak 1985.
30. Bietak 1990.

37. Rhyton

Early 18th Dynasty, reign of Thutmose III
(r. 1479–1425 B.C.)
Faience
H. 17.5 cm (6⅞ in.), Diam. 7.5 cm (3 in.)
Museum of Fine Arts, Boston, Gift of the Egypt
Exploration Fund 00.702a–d

37

A rhyton is a slender, conical ceremonial vase with a handle, a type of vessel that originated in ancient Crete at the end of the Middle Minoan Period (ca. 1550 B.C.) and remained popular there and at Mycenae into the Late Minoan Period.[1] Made of pottery, stone, metal, or faience, ryhta were often decorated with elaborate patterns and figural elements. While imported rhyta are almost never found in Egypt,[2] the form was well known both there and in Nubia. In the procession of foreign tribute bearers depicted in the tomb of the vizier Rekhmire at Thebes (TT 100) during the reign of Thutmose III or Amenhotep II, two of the Keftiu (Cretans) carry slender rhyta covered in scalloped or scalelike patterns and with elaborate handles.[3] The rhyton form was adapted by local Egyptian faience artisans who produced broader, rather baggy, more simply decorated vessels with a plain loop handle at the rim.

This blue faience rhyton has the characteristic baggy shape. Its decoration combines a typical Egyptian motif often seen on pottery of the Eighteenth Dynasty—a band with pendant triangles in black paint—and a running spiral motif typical of Aegean decoration. Like the Minoan examples, the rhyton is pierced through the base so it can be used as a funnel. It was found at Abydos, in a disturbed tomb that also contained an imitation in alabaster of a Cypriot Base Ring I juglet (compare cat. no. 156) and a red polished figure vase in the form of a hedgehog decorated with Aegean-inspired molded floral elements (cat. no. 172).

Locally made faience rhyta have been found throughout Egypt, from Saqqara in the north to Nubia in the south. It has been suggested that the one rhyton found in Saqqara was made in Nubia, probably at Kerma, and brought into Egypt in the early Eighteenth Dynasty, probably during the reign of Amenhotep I. It was found in an intact grave along with an imported Cypriot Base Ring I juglet and two Kerma ware beakers (compare cat. no. 5).[4] An example from Tuna el-Gebel, near Amarna (British Museum, London, 22731), more closely copies the slender pointed form of the Cretan original but, like the present example, is decorated with typically

Egyptian motifs of pendant triangles.[5] At Kubban, in Nubia, a rhyton was found that has the Egyptian baggy shape but is decorated with three rows of running spirals and what appears to be a register with figural elements, motifs more like those on Aegean prototypes.[6] A faience fragment found in the ruins of the temple of Thutmose III at Deir el-Bahri and identified as part of a pot stand[7] may also be part of a rhyton. This fragment of a conical vessel in shades of blue and blue-green is covered with a pattern of overlapping scales like the rhyta depicted in the tomb of Rekhmire. The pattern is interrupted by a zone with upright lotus leaves and a rectangular plaque bearing the title *nṯr nfr* (Great God) and Hatshepsut's coronation name, Maatkare, in a cartouche. Larger than the rhyta found in private tombs, the vessel has a wavy rim.

Two pottery rhyta of Nile clay are known from Nubia. One, with a simple black band on the rim, was found in a grave at Fadrus,[8] and another example, more elaborately decorated in red and black with rows of dots and pendant triangles in the style of New Kingdom pottery, was found in a tomb at Arminna.[9]

The present rhyton exemplifies the way in

which Egyptian craftsmen adapted an imported form to the production of vessels in an Egyptian material, faience, and employed a mixed vocabulary of native and Aegean decorative elements to make the vessels both familiar and exotic.

SJA

1. Vermeule 1982.
2. A fragment of a Minoan pottery rhyton was found at Gurob (Petrie 1891, pl. XIX, 37).
3. Norman de G. Davies 1943, pls. XVIII, XIX.
4. Bourriau 1991, pp. 139–40, pl. 7, 1.
5. Emily Townsend Vermeule in *Egypt's Golden Age* 1982, p. 154, no. 160; Robert Steven Bianchi in F. D. Friedman 1998, pp. 135, 228, no. 124.
6. Firth 1927, p. 63, pl. 27c, 3.
7. Aksamit 1996, pp. 8–11, pl. VI.
8. Holthoer 1977, pl. 20 (upper left).
9. Simpson 1963, pp. 31–32, fig. 24, 14, pl. 15.

PROVENANCE: Abydos, Tomb D11; excavated by W. M. Flinders Petrie for the Egypt Exploration Fund, 1900

BIBLIOGRAPHY: Randall-MacIver and Mace 1902, p. 90, pl. 50; Nelson 1936; Emily Townsend Vermeule in *Egypt's Golden Age* 1982, p. 154, no. 161; Emily Townsend Vermeule in *Ägyptens Aufstieg*, p. 127, no. 32; Petschel and von Falck 2004, p. 229, no. 221

THE ROLE OF AMUN

James P. Allen

Inscriptions in Hatshepsut's mortuary temple at Deir el-Bahri describe her conception as resulting from the union of her mother, Queen Ahmose, with the god Amun-Re, "[in] the incarnation [of] her husband, the Dual King Aakheperkare (Thutmose I),"[1] and record the god's decree that Hatshepsut "will exercise the function of kingship in this entire land . . . rule the Two Lands (Egypt) and lead all the living."[2] Acknowledged here as the source of Hatshepsut's existence and her kingship, Amun-Re was the amalgamation of two gods, Amun and Re, in a single deity. In Hatshepsut's time, this fusion of the two divinities was the dominant theology of Egypt, with religious as well as political implications.

The god Re, whose name means "sun," was worshiped from the beginning of Egyptian civilization as the supreme force in the world. His chief center of worship was at Heliopolis (part of modern Cairo), just to the north of Memphis, the political capital for most of Egypt's history. Recognizing that the world's very existence depends on the sun, the Egyptians saw in Re not merely one phenomenon of nature but the governing force from which all natural phenomena derive. As such, Re was acknowledged as king of the world. In their role as rulers of the living—and thus, in Egyptian eyes, as the supreme human power—Egypt's kings saw both their own existence and their kingship as devolving directly from Re. This descent was reflected in the title Son of Re, which Egypt's kings had used since the Fourth Dynasty, more than a millennium before Hatshepsut's time. Hatshepsut adopted the title as well, though in her case it was occasionally changed to Daughter of Re, reflecting her gender.

In the theology of the New Kingdom, the role of the god Amun was that of the creator of the world. In that capacity, he was thought to have existed before all else, independent of his creation. As such, Amun was unlike Re and the other Egyptian gods, who represented the elements and forces of nature. The true extent of his being could not be discerned in these phenomena—a quality reflected in his name, which means "hidden." Nonetheless, the Egyptians felt Amun's presence in their daily lives. Since the world in its entirety had been created by him, its elements and forces could be seen not only as gods in their own right but also as

reflections of Amun himself. The god Amun-Re represented the primary expression of this theology: Amun's creative force manifest in the sun. Re's life-giving power and authority were honored in their own right, but Amun was recognized as their ultimate source. As such, Amun-Re was "King of the Gods" and "Lord of the Two Lands' Thrones."

Amun had first risen to prominence in the Eleventh Dynasty at Thebes, his primary center of worship from that time onward. His role in the Egyptian pantheon was closely linked to the patronage of Egypt's rulers of the Middle and New Kingdoms (Eleventh–Twelfth Dynasties and Seventeenth–Eighteenth Dynasties, respectively), both of which had originated at Thebes. These kings saw Amun not merely as the god of their hometown but as the source of their dynastic legitimacy. Even when they no longer resided at Thebes, they were either crowned there or, if the ceremony was held elsewhere, evidently felt the need to pay homage in Amun's Theban temple immediately after their coronation.[3]

The god's primary temple in Thebes was on the east bank of the Nile, at Karnak. Called "Of (all) places, the one that has been appointed," it was oriented perpendicularly to the Nile, with its sanctuary in the east. In Egyptian eyes, temples were homes of the gods. Karnak served as Amun's state temple: like the king's palace, it was his chief residence and site of contact with his subjects. The god also had a second Theban temple, at Luxor, two miles south of Karnak, built parallel to the Nile. This was known as Amun's Southern Residence and was viewed as the god's private enclave. On the west bank, the royal mortuary temples were also dedicated to Amun and belonged to Amun's Estate, which included all the Theban temples. The mortuary temple of Hatshepsut in the desert valley of Deir el-Bahri was built to face Karnak, and the valley itself was part of the region known as Facing Its Lord.

During annual festivals the god's image was taken in procession from Karnak to the other Theban temples: to Luxor on the Beautiful Festival of the Residence, and to the mortuary temples on the west bank during the Beautiful Festival of the Valley. During the early Eighteenth Dynasty, these two celebrations were

held in September and May, respectively. The Valley Festival was instituted in the Eleventh Dynasty by Mentuhotep II (r. 2051–2000 B.C.); its name refers to Deir el-Bahri, where his mortuary temple was situated (like that of Hatshepsut later on). The Festival of the Residence is first attested in the Eighteenth Dynasty and may have been initiated by Hatshepsut herself.

In Hatshepsut's time the temple at Luxor was little more than a chapel for the reception of Amun's image during the Festival of the Residence. Karnak was far grander. Begun in the Middle Kingdom, it was enlarged or enhanced by most of Egypt's kings thereafter. Hatshepsut's contributions included two obelisks, a new sanctuary, and a series of offering chapels in front of the Middle Kingdom sanctuary and a small shrine with two more obelisks, facing the rising sun, behind it. Scenes and inscriptions in her mortuary temple record the transport of two of these obelisks to Karnak as well as the expedition she sent to Punt to procure incense trees for her temple and that of the god. Hatshepsut also inaugurated a second, north-south, axis at Karnak, extending toward the temple of Luxor, by having a new pylon erected a hundred yards to the south of the entrance to Karnak. Moreover, she added to the temple of Amun's wife, Mut, which lay between Karnak and Luxor, and on the west bank she had a new temple to Amun constructed at Medinet Habu, where the god's body was believed to lie.

Although Hatshepsut had buildings for other gods erected or enhanced throughout Egypt, her Theban constructions are by far the grandest and most numerous of her reign. These gifts to Amun were seen not merely as a duty but as a privilege granted by the god himself. The dedicatory inscription on one of Hatshepsut's Karnak obelisks expresses this view eloquently:

I have made this with a loving heart for my father, Amun, having entered into his initiation of the First Occasion (i.e., having been given knowledge of Amun's role in the creation of the world) and having experienced his impressive efficacy. I have not been forgetful of any project he has decreed. For My Incarnation (i.e., Hatshepsut herself) knows he is divine, and I have done it by his command. He is the one who guides me. I could not have imagined the work without his acting: he is the one who gives the directions.

Nor have I slept because of his temple. I do not stray from what he has commanded. My heart is perceptive on behalf of my father and I have access to his mind's knowledge. I have not turned my back on the town of the Lord to the Limit (an epithet of Amun-Re as the sun), but paid attention to it. For I know that Karnak is heaven on earth, the sacred elevation of the First Occasion, the Eye of the Lord to the Limit—his favorite place, which bears his perfection and gathers his followers.[4]

The same sentiments undoubtedly governed all of Hatshepsut's construction projects for Amun, not only in Karnak but in the rest of Thebes as well.

Hatshepsut's reign also witnessed the beginning of an intellectual movement centered on the god Amun-Re. This is manifested primarily in nonroyal texts, particularly in hymns to the sun carved on stelae and in the tombs of Hatshepsut's officials. Such hymns were traditionally devoted to the sun as Re, Khepri (the sun at dawn), Atum (the sun at sunset), or Harakhti (the sun as ruler of the world). Under Hatshepsut, however, they began to be dedicated to Amun as well, as in this hymn inscribed on a statue of one of her contemporaries:

Scribe Amenhotep says:
Oh, my lord and the gods' lord,
Amun, Lord of the Two Lands' Thrones,
Re-Harakhti, eldest god, who made what has been made,
unique, without equal,
perfect in sunlight, glittering in kindness,
sunlike one, lord of appearance,
for you are air for noses
and one breathes only as you allow!
I have come unto you that I may worship your perfection
from the time when you appear in the east of the sky
until the sun sets in the western mountain.
May you let me be in the following of your life force,
my mouth full of the sustenance that comes from
your offering stand.

(Dedicated) by the scribe and steward of the high priest
(of Amun), Amenhotep.[5]

Such hymns represent not the incursion of Amun into the solar cult but an expanded view of the sun as a manifestation of Amun: as in this text, Amun and the sun god are addressed as a single being. The texts do not generally occur on the monuments of kings: their counterpart in the royal sphere is the solar chapels that Hatshepsut established both in Karnak and in her own mortuary temple at Deir el-Bahri.[6]

These texts introduced into worship of the sun as a natural phenomenon aspects derived from the more abstract theology of Amun: his status as the primordial creator, his accessibility as a personal god, and his role as arbiter of ethical values.[7] They also stressed the primacy of Amun over other gods, a concept that eventually led to what Jan Assmann has called the "crisis of polytheism": the view that all the gods could be understood not only as independent entities but also, and ultimately, as manifestations of a single god, Amun. This view did not reach its most profound expression until the Nineteenth Dynasty, during the reign of Ramesses II (r. 1279–1213 B.C.), but its beginnings can be traced to Hatshepsut's time.

Hundreds of years before Hatshepsut, a similar view of divinity had been expressed in the Middle Kingdom composition known as the Instruction for King Merikare:

People, the flock of the god, are provided for.
He has made the sky and the earth for their heart . . .
He has made the heart's air so that they may live
when they breathe.
They are his likenesses, who came from his body.
He rises in the sky for their hearts.
He has made for them the plants, flocks, and fish
that feed them . . .
He makes sunlight for their hearts and sails
(across the sky) to see them.
He has raised a shrine about them: when they weep
he is hearing . . .
The god knows every name.[8]

The deity in this text is anonymous—though clearly envisioned, at least in part, as the sun—and it is not known how widespread such sentiments were in the Middle Kingdom. By the time of Hatshepsut, however, this personal view of divinity had gained general currency and had become centered on the god Amun. From royal monuments to private statues, the different manifestations of Amun's cult in the early Eighteenth Dynasty can be traced to this sense of a single, approachable god behind all the phenomena of nature and human events.

1. *Urkunden* 4, p. 219, l. 11.
2. Ibid., p. 221, ll. 9 and 14–15.
3. This sentiment is expressed in a stela of Ahmose I (r. 1550–1525 B.C.), first king of the Eighteenth Dynasty, who was evidently crowned at a site north of Thebes. See Wiener and J. P. Allen 1998, pp. 7, 17.
4. *Urkunden* 4, p. 363, l. 2, p. 364, l. 6.
5. Vandier 1958, pl. CLIX.
6. Assmann 1995, p. 102.
7. Ibid., p. 10.
8. Helck 1988, p. 11, l. 10, p. 12, l. 8. Merikare was a king of the Ninth Dynasty, about two hundred years earlier than the Instruction. The text is placed in the mouth of Merikare's father, as advice to his son.

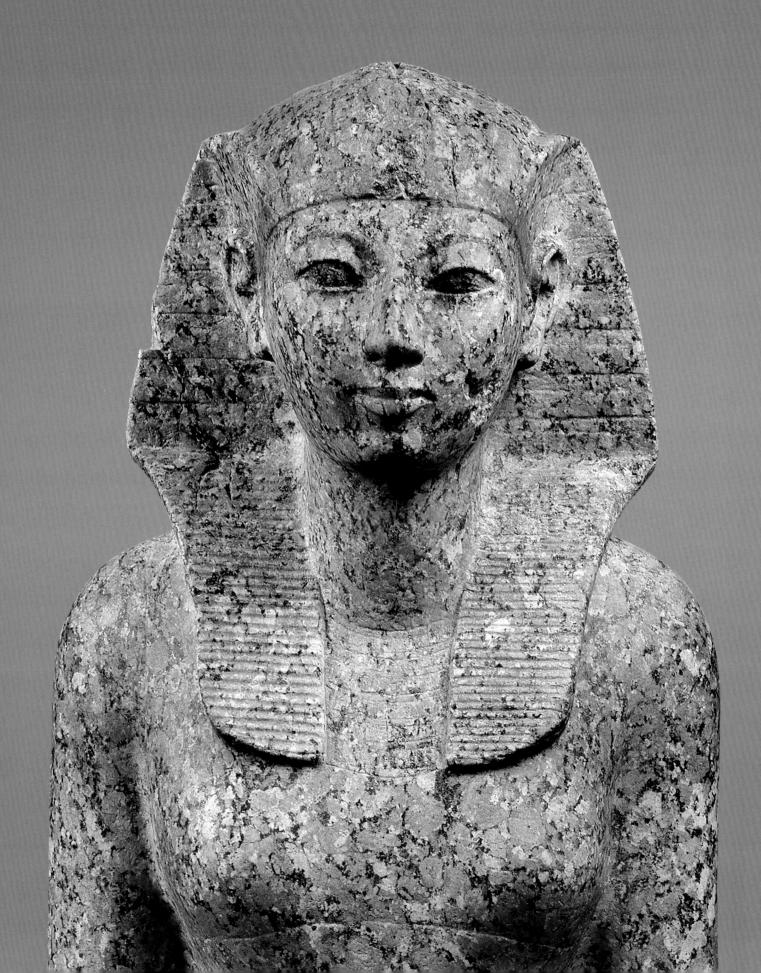

HATSHEPSUT
Princess to Queen to Co-Ruler

Peter F. Dorman

The only existing records of Hatshepsut's childhood and the years she spent as princess at the royal court are those that she herself had inscribed on the temples at Deir el-Bahri and Karnak during her later kingship. These accounts are couched in terms that patently emphasize her mythical descent from the Theban god Amun-Re and her oracular selection, while still a girl, as future monarch; their intention is retroactively to present the erstwhile princess as having been divinely sanctioned to become pharaoh from the time of her girlhood. One searches in vain for contemporary references to Princess Hatshepsut recorded during the reign of her father, Thutmose I. In fact, one would not expect her to be prominently featured, since at that time at least two of her brothers, Amenmose and Wadjmose, stood to inherit the throne before her, until their premature deaths—not to mention a third, also named Thutmose, who came to the throne when their father died.[1]

With the accession of Thutmose II, who was both her half brother and her husband, Hatshepsut acquired the normal queenly titles Great King's Wife and God's Wife of Amun, but the few monuments that can be dated to her tenure as chief queen do not suggest that she then held any unusual status or wielded extraordinary power.[2] A tomb, impressive enough for the time, was prepared for her in the isolated southern cliffs of the Theban mountain, but it does not seem to have been finished.[3] A rectangular quartzite sarcophagus inscribed with her queenly titles was discovered inside. Up to this point there were no intimations that Hatshepsut was destined to play a greater political role than that of queen. But Thutmose II seems to have died unexpectedly only a few years into his reign,[4] leaving on the throne a son perhaps just two or three years old—also named Thutmose—born to him not by Hatshepsut but by a minor queen named Isis.[5] The unusual nature of this royal succession was alluded to by the architect Ineni, who asserts in his tomb biography that after the death of Thutmose II,

Opposite: Fig. 36. Hatshepsut. Detail of a lifesize granite statue, early 18th Dynasty. The Metropolitan Museum of Art, New York, and Rijksmuseum van Oudheden, Leiden (see cat. no. 95)

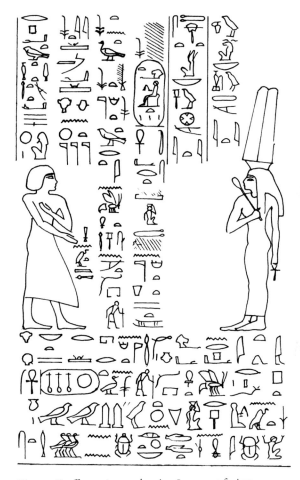

Fig. 37. Graffito at Aswan showing Senenmut facing Hatshepsut, who appears with the traditional regalia of a queen. Early 18th Dynasty

his son stood in his place as King of the Two Lands, having assumed the rulership upon the throne of the one who begat him, while his sister, the God's Wife, Hatshepsut, managed the affairs of the country, the Two Lands being in her care.[6]

Curiously, nowhere does Ineni state the name of the new pharaoh. Instead, he makes it perfectly clear that Hatshepsut—apparently by virtue of her roles as chief queen and God's Wife rather than as King's Mother—was the prime mover in governmental affairs.

Fig 38. Hatshepsut dressed as a woman and wearing a plumed crown with ram's horns. Block from the Chapelle Rouge, Karnak, Thebes, early 18th Dynasty. Quartzite

During the early years of her regency, Hatshepsut had herself portrayed in the traditional garb of a queen, often grasping the distinctive insignia of the God's Wife of Amun, as in the graffito engraved by Senenmut at Aswan, which commemorates the transport of two obelisks to Karnak at her behest (fig. 37).[7] At the temple of Semna in Nubia, Thutmose III, as reigning king, was depicted as the donor of the renewed temple offerings, but Hatshepsut was portrayed at one side, wearing her long gown and accompanied by her queenly titles.[8] In this period she also took pains to sanctify the memory of her recently deceased husband; a granite statue of Thutmose II, found at Elephantine and intended for the temple of Khnum there, shows him in a jubilee cloak and bears a dedicatory inscription from Hatshepsut "for her brother."[9]

But it seems clear that Hatshepsut's control over the mechanics of government, hers by default since the death of her husband, eventually required ideological expression as well, and relatively early on she devised a prenomen for herself, the equivalent of a coronation name: Maatkare. (It is a complete sentence, "Maat is the ka of Re," meaning "The proper manifestation of the sun's life force.") This prenomen, enclosed within a cartouche, was used on its first appearance in conjunction with the quintessential chief queen's title God's Wife, while Hatshepsut was represented in queenly regalia and female costume—an odd confluence of

consort and pharaoh.[10] Another offering depiction, from a limestone chapel at Karnak, presents a more explicit amalgam of female and kingly attributes, with Hatshepsut garbed in the usual tight-fitting robe but wearing a regal plumed crown with ram's horns, and her cartouches preceded by the titles King of Upper and Lower Egypt, and Mistress of Ritual (fig. 38).[11] It is at this point, when she acquires kingly titles and crowns (as at least one other Egyptian queen had done previously), that Hatshepsut's kingship may be said to begin. Yet the visual and textual incongruities of such an offering scene must have been striking to the literate observer. Indeed, there is evidence that in the later years of her co-regency, Hatshepsut had several such scenes recarved to eliminate the queenly features and replace her female image with the male one of her later persona.[12]

Another curious iconographic measure was attempted at the temple of Buhen in Nubia, which was decorated jointly by Hatshepsut and the young Thutmose III. On the walls of the sanctuary, Hatshepsut is shown still garbed in a long dress but adopting the wide striding stance of a male, as if the hem of her gown had become elastic (see fig. 2).[13] Since at Buhen the deceased Thutmose II was venerated together with the local god, Horus, Hatshepsut had not yet given up the active celebration of her husband's memory; but that was soon to change.

Probably by the seventh regnal year of Thutmose III,[14] representations of Hatshepsut had assumed the masculine form seen in so many of her royal monuments. In laying claim to the throne as a "male" pharaoh, however, she was forced to alter the basis of her legitimacy.[15] Ignoring the inconvenient facts of her marriage to Thutmose II and her former career as queen, she contrived instead an elaborate mythology of her predestination, supposedly signaled by an oracular event during her father's reign and by her miraculous birth through the Theban god Amun-Re.[16] Since her right to rule was now to be based on direct descent from her father, Thutmose I was glorified at her own temple in Deir el-Bahri, while Thutmose II, the father of her own co-regent, vanished from sight. From this point on, Hatshepsut was represented in male form and ruled as a pharaoh, a fully equal and even senior partner to the younger Thutmose III. But she never attempted to obscure her female essence; her inscriptions consistently employ the feminine gender, maintaining the tension between male and female elements evident in almost all her representations.

Thus Hatshepsut's metamorphosis into a "male" pharaoh took place gradually, over a period of years, and went through a series of exploratory phases. The extended transitional period itself belies the pretense that her kingship had been preordained. Hatshepsut's assertion of male kingship was not a usurpation of royal power, which in any case she had wielded from the death of Thutmose II. It should rather be viewed as the end result of an unprecedented experiment in which the possibility was explored that a female sovereign could ascend the Egyptian throne.[17]

1. For the genealogical interrelationships of the early Thutmoside family, see Wente 1980, pp. 129–31. Amenmose was named crown prince in year 4 of his father, and Wadjmose was accorded his own mortuary chapel in western Thebes, for which see Lecuyot and Loyrette 1995 and Lecuyot and Loyrette 1996. As deceased members of the royal family, both princes remained local cult figures.

2. For example, Hatshepsut is shown in a secondary place, behind Thutmose II and the queen "mother," Ahmose, on Berlin stela 15699; see Wildung 1974, pp. 255–57, pl. 34. The authenticity of the stela, however, has recently been questioned in C. Goedicke and Krauss 1998. The title God's Wife of Amun, connoting a female priestly office connected with the cult of Amun, was ordinarily given to major queens in the early Eighteenth Dynasty, a time when the title held considerable economic and political significance.

3. Carter 1917. An inaccessible location such as this was typical of interments prepared for queens of the early Eighteenth Dynasty, such as the tomb of three minor queens of Thutmose III, for which see Lilyquist 2003. See also Catharine H. Roehrig's "The Two Tombs of Hatshepsut" in chapter 3.

4. On the age of Thutmose II, see Gabolde 1987b; and von Beckerath 1990.

5. On the age of Thutmose III at this point, see Dorman 2005.

6. *Urkunden* 4, pp. 59–60; see also Dziobek 1992, pls. 34, 63.

7. Habachi 1957, pp. 92–96.

8. Caminos 1998, pl. 42; see also *Urkunden* 4, pp. 201–2. The depiction of Hatshepsut has been entirely erased and recarved, but it can be reconstructed on the basis of the extant traces.

9. Dreyer 1984.

10. For this depiction, see Gardiner, Peet, and Černý 1952–55, no. 177, pl. LVI; for a textual occurrence of titles and prenomen, see *Urkunden* 4, p. 34; see also Dorman 2005.

11. Chevrier 1934, p. 172, pl. IV.

12. Gabolde and Rondot 1996.

13. For example, see Caminos 1974, vol. 2, pls. 74, 82.

14. For the date, see Hayes 1957, pp. 78–80, 81, fig. 1.

15. An early sign of this shift may be seen in Senenmut's shrine at Gebel el-Silsila, where Hatshepsut calls herself the "King's First-Born Daughter"; see Caminos and James 1963, pl. 40.

16. These events are represented at the Chapelle Rouge at Karnak (Lacau and Chevrier 1977–79, pp. 97–153) and in the divine-birth reliefs at her Deir el-Bahri temple (Naville 1894–1908, pt. 2, pls. XLVII–LV), respectively.

17. On this subject, see also Ann Macy Roth's essay in chapter 1.

38. Relief Depicting Thutmose II

Early 18th Dynasty, reign of Thutmose II (r. 1492–1479 B.C.)
Limestone
H. 107 cm (42⅛ in.), W. 109 cm (42⅞ in.)
Karnak Open-Air Museum, Luxor

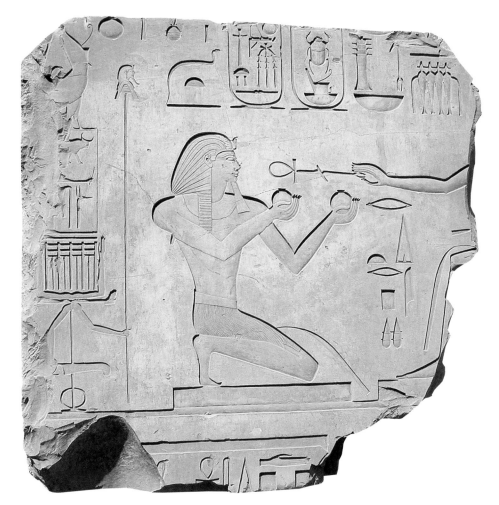

38

During the Eighteenth Dynasty, each successive ruler added a structure of some sort to the great temple of Amun at Karnak. Kings frequently chose to have a courtyard and a huge gateway, or pylon, built in front of the existing temple complex, thus creating a new principal entrance. Between 1957 and 1964, restoration work was done on what is now called the temple's Third Pylon.[1] This gateway was constructed by Amenhotep III (r. 1390–1352 B.C.), the great-grandson of Hatshesput's nephew and co-ruler, Thutmose III. For the foundation, Amenhotep's architects had used blocks from structures built by earlier kings. Among these were several limestone blocks from a festival court built about a century earlier in the same area by Hatshepsut's husband, Thutmose II.[2]

The block on which this relief is carved was removed from the foundation of the Third Pylon during the winter of 1957–58. It had originally been part of the southern face of the northern entrance into the festival court built by Thutmose II.[3] The king is shown kneeling, presenting *nw* jars (libation vessels) to Amun, who is seated at the right. With his extended right hand Amun holds out the ankh (life) and *was* (dominion) hieroglyphs to Thutmose. The king is identified as "Aakheperenre Thutmose-Protector-of-Re," which is written in the cartouches above him, and by his Horus name, "Forceful Bull of Powerful Strength," which appears in the rectangular device behind him.

This image of a kneeling king offering *nw* jars is repeated in the colossal statues of Hatshepsut (see cat. nos. 91, 92), but the weight of the stone dictated that in the statues the king's hands, held aloft in the relief, are shown resting on her knees.

The exquisite, crisp carving of this relief testifies to the technical skill of the sculptors. The perfectly preserved image of the king is an early example of the Thutmoside style, which became a hallmark of the joint reign of Hatshepsut and Thutmose III.

CHR

1. Muhammad 1966, pp. 143–45.
2. Gabolde 1993 and 2003.
3. Gabolde 1993, pl. xv.

PROVENANCE: From the foundation of the Third Pylon, Karnak temple; removed in 1957–58, during restoration work carried out for the Egyptian Antiquities Service by Mostafa Subhy, director of works of Karnak, Taha El-Sheltawy, director of the engineering section, and Dr. Abdul-Qader Muhammad, chief inspector of Upper Egypt

BIBLIOGRAPHY: Muhammad 1966, p. 150, pl. VIII, a; Myśliwiec 1976, pp. 42–43, pl. XIX, 39; Gabolde 1993, pl. xv; *KMT* 5, no. 1 (spring 1994), cover; Gabolde 2003, pl. x

39. Statuette of a King as Falcon

18th Dynasty, late reign of Thutmose III–early reign of Amenhotep II (1435–1420 B.C.)
Red jasper
H. 11 cm (4⅜ in.), D. 6.3 cm (2½ in.)
Musée du Louvre, Paris E 5351

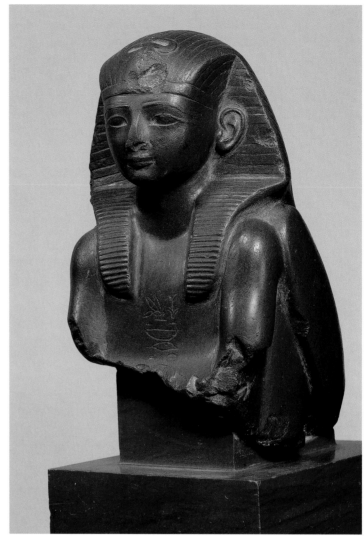

39

This statuette depicts the hybrid of a king and falcon god, the latter probably Horus, who embodied the powers of the monarch. The head, torso, and arms of the king are enveloped by the body, legs, and wings of the falcon. The arms, bent at the elbows, may have held an object of some type, or they may have been slightly raised, in an attitude of adoration.[1] Three-dimensional renderings of the king in close association with Horus are attested from the Old Kingdom; they include a well-known statue, now in Cairo, of the Fourth Dynasty ruler Khafre, with his head enclosed by the falcon's wings.[2] The melding of the bodies of the two divinities, however, appears to have been a Thutmoside-period invention.[3] Some scholars have reasoned that such an image, which so closely identified the king with the royal god Horus, would have been particularly appropriate for occasions on which the king initiated or reaffirmed his royalty, and they have therefore suggested that king-falcon figures were associated with the New Year, the coronation, or the Sed festival (the reenactment of the coronation).[4] Others have proposed that the image is an ingenious monogram that identifies the life force, or ka, of the king with a manifestation, or *ba*, of Amun.[5]

A head of a king, possibly Hatshepsut, as falcon (cat. no. 40) is probably derived from an enlarged version of this statuette. The statuette lacks the detailed plumage of catalogue no. 40: only an incised line separates the horizontal striations of the *nemes* headcloth from the undifferentiated avian body. The facial features, too, lack precision, making it difficult to associate the statuette with a specific king. Both Thutmose III[6] and Amenhotep II[7] have been advanced as the subject. A short line of formulaic text on the breast of the statue— "King of Upper and Lower Egypt, Lord of Ritual"—breaks off before the royal name would have occurred and may, moreover, be a later addition.[8]

CAK

1. Laboury 1998, p. 385, following Brunner 1962, pl. v.
2. In all earlier statue types in which king and falcon were associated, the two were physically separate, whether they were interacting (Egyptian Museum, Cairo, CG 14; Borchardt 1911–36, vol. 1 [1911], pp. 14–16, pl. 4; for bibliography up to about 1974, see Porter and Moss 1974, p. 22) or merely juxtaposed, without any interaction (as in the statuette of Pepi I in the Sed-festival cloak, Brooklyn Museum, 39.120; see, most recently, Romano 1998, pp. 240–42, no. 3, figs. 8–19).
3. Kriéger 1960, p. 58. A two-dimensional rendering of the king as falcon appears on one wall of the reconstructed peristyle court of Thutmose IV at Karnak; see Letellier 1991, p. 44, fig. 2.
4. Laboury 1998, p. 337, n. 901.
5. Ibid., p. 443, citing Martinez 1989, p. 116, and Goebs 1995, pp. 159–62.
6. Kriéger 1960, pp. 37–38.
7. Laboury 1998, p. 473.
8. Kriéger 1960, p. 44, n. 3, and Laboury 1998, p. 386.

PROVENANCE: Purchased in 1868 from the Rousset Bey collection

BIBLIOGRAPHY: Vandier 1958, p. 301; Kriéger 1960; Wildung 1977; Morenz 1984, p. 198, figs. 19, 20; Christophe Barbotin in *Ägyptens Aufstieg* 1987, p. 188, no. 104; Martinez 1989, p. 116; Gabriella Porta in *Arte nell'antico Egitto* 1990, p. 89, no. 37; De Putter and Karlshausen 1992, pp. 248–49, no. 87; Seipel 1992, pp. 248–49, no. 87; Kozloff and Bryan 1992, p. 197, n. 5; Goebs 1995, pp. 159–62, pls. III, IV; Berman and Letellier 1996, pp. 52–53, 95; Laboury 1998, pp. 385–87, 473; Ziegler and Rutschowscaya 2002, p. 51

40. Head of a King (Hatshepsut?) as Falcon

Early 18th Dynasty, joint reign of Hatshepsut and Thutmose III (1479–1458 B.C.)
Black granite
H. 26.9 cm (10⅝ in.), W. 21.3 cm (8⅜ in.),
D. 15.4 cm (6⅛ in.)
Brooklyn Museum, Charles Edwin Wilbour Fund 55.118

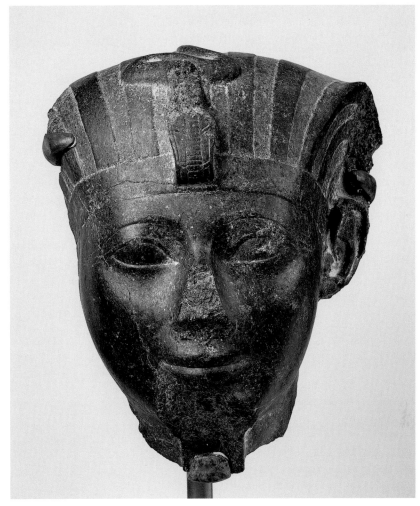

40

In frontal view this image of a king mirrors numerous depictions of the ruler wearing the *nemes* headcloth and the uraeus. On the proper left side of the *nemes*, however, are the remains of an incised feather pattern, which indicates that the representation is one of a king melded with a falcon divinity, probably Horus. In all likelihood, the statue to which this head belonged resembled the smaller but far more complete jasper statuette of the king as falcon (cat. no. 39).

In the absence of any inscription or a secure provenance, it is hard to establish which monarch is represented. Scholars have proposed both Hatshepsut and Thutmose III as the subject. The overall facial structure and such details as the elegant, slightly tilted eyes and the narrow chin are characteristic of the stylistic vocabulary of the sculptors employed by Hatshepsut toward the end of the co-regency period.

CAK

PROVENANCE: Unknown

BIBLIOGRAPHY: *Collecting Egyptian Art* 1956, pp. 5–6, no. 6, pls. 14, 15; Kriéger 1960, pp. 51–52, fig. 19; Brunner 1962; Wildung 1977; Fazzini et al. 1989, no. 36 (with bibliography); Laboury 1998, pp. 442–43, n. 1182 (with bibliography); Fazzini, Romano, and Cody 1999, p. 82, no. 37

THE TOMB OF RAMOSE AND HATNEFER

In January 1936, as Ambrose Lansing and William C. Hayes of The Metropolitan Museum of Art were carrying out a systematic clearance of the hillside below the Theban tomb chapel (TT 71) of Senenmut, a powerful courtier during the co-regency of Hatshepsut and Thutmose III, they uncovered a small sealed doorway beneath the artificial terrace that served as the forecourt of the tomb.[1] Behind the doorway, in a cramped chamber cut into the rock, lay four coffins surrounded by heaped boxes, baskets, and pottery—one of the few well-preserved private burials from the New Kingdom (fig. 39). Two painted anthropomorphic coffins bore the names of Ramose and Hatnefer, already known to scholars as the parents of Senenmut, and two rectangular coffins contained six additional mummies, all anonymous and almost certainly close family members.

While cataloguing the objects and mummies, Lansing and Hayes realized that the intended beneficiary of the burial must have been

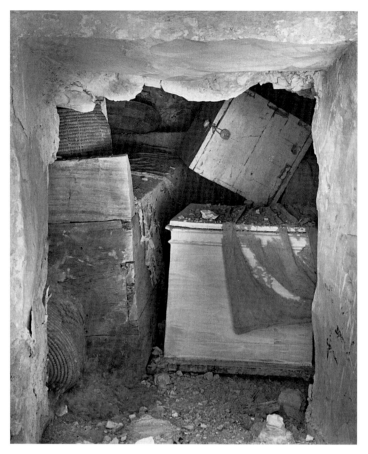

Fig. 39. The tomb of Ramose and Hatnefer as it appeared when it was opened by the archaeologists Ambrose Lansing and William C. Hayes

another, more modest cemetery, given fresh wrappings, and then laid to rest next to Hatnefer within the precincts of Senenmut's tomb. These other mummies were little more than skeletons, often bundled up with gravel and stones that must have come from their first grave. The mummy of Ramose was considerably younger than that of Hatnefer, suggesting that he had predeceased her by a number of years. The richness of her burial, and the relative poverty of her husband's, suggest that it was Senenmut's sudden rise to royal favor under Hatshepsut that had enabled her to enjoy a lavish funeral in later years.[2]

This crowded interment must have been made early in the carving out of Tomb 71, since the terrace fill consisted of loose chip that stonecutters would have dumped from above in great quantity. Several jar dockets and sealings from the tomb are dated to regnal year 7, indicating the approximate time the burial was sealed.[3] One amphora sealing bears a stamp referring to Hatshepsut as ruler (literally, "the Good Goddess") and is generally regarded as the earliest dated attestation of Hatshepsut as king.[4]

PFD

1. The discovery of the tomb is related in the preliminary report; see Lansing and Hayes 1937.
2. For a summary of other Eighteenth Dynasty private burials and the relative status and worth of the grave goods, see S. T. Smith 1992.
3. These conclusions were made at the time of the discovery; see Lansing and Hayes 1937, pp. 38–39.
4. Hayes 1957, pp. 78–80, 81, fig. 1.

Hatnefer, Senenmut's elderly mother. Her embalming had been carried out with the utmost attention, there was only a single set of canopic jars and other funerary equipment in the tomb, and many of the tomb goods were appropriate for a woman. Moreover, Hatnefer's was the only mummy equipped with a gilded funerary mask (fig. 40), a heavy serpentine heart scarab set in gold (cat. no. 41), scarab rings, and two funeral papyri. The boxes and baskets contained almost ninety sheets that were probably selected from her household linen, as well as two silver pitchers, a silver bowl, cosmetic implements, and an assortment of bread and fruit. A beautiful boxwood-and-ebony chair, found broken outside the tomb door, doubtless belonged to her as well (cat. no. 47). By contrast, the other mummies, including that of Ramose, had been summarily wrapped, and their burial goods were limited primarily to a few scarabs tied on to their fingers and, in one of the coffins, some dishware, apparently placed there as an afterthought (cat. nos. 42, 44, 45).

Because the door to the chamber had been sealed only once, the excavators believed that the anonymous relatives must have died during an epidemic at the time of Hatnefer's death, resulting in an unexpectedly crowded tomb. It is more likely, however, that when Hatnefer died, at an advanced age, several family members were deliberately exhumed from

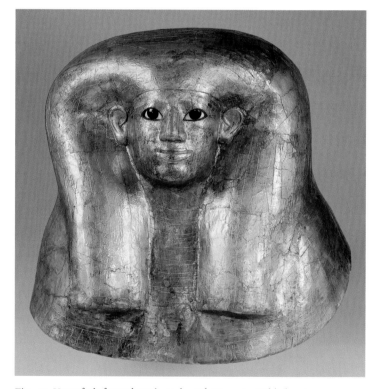

Fig. 40. Hatnefer's funeral mask, early 18th Dynasty. Gilded cartonnage. The Metropolitan Museum of Art, New York, Rogers Fund, 1936 (36.3.1)

41

PROVENANCE: Western Thebes, burial chamber of Ramose and Hatnefer, on the mummy of Hatnefer; Metropolitan Museum of Art excavations, 1935–36, acquired in the division of finds

BIBLIOGRAPHY: Lansing and Hayes 1937, pp. 20, 29, fig. 34; Hayes 1959, pp. 224–25, fig. 133; James P. Allen in N. Thomas 1995, pp. 178–79, no. 80; Roehrig 2002, pp. 35, 38, figs. 52a, 52b

41. Heart Scarab of Hatnefer

Early 18th Dynasty, joint reign of Hatshepsut and Thutmose III, period of Hatshepsut's regency (1479–1473 B.C.)
Serpentine, gold
L. 6.6 cm (2⅛ in.), W. 5.3 cm (2⅛ in.), H. 2.8 cm (1⅛ in.)
The Metropolitan Museum of Art, New York, Rogers Fund, 1936 36.3.2

Hatnefer's heart scarab is an exceptionally fine example of this type of funerary adornment and is comparable to those made for contemporary royalty.[1] Every feature of the beetle is exquisitely rendered, including the orblike eyes topped by slight ridges and the elytra (wing cases) outlined with incised lines. The legs are carved in high relief, and striations have been added to indicate the leg bristles. The base is set in a heavy hammered gold mount made of at least two pieces; a heavy gold ring is brazed to the head end. On the back of the scarab, a thin, T-shaped bandage cut from gold sheeting is held in place by an adhesive. The gold chain is made of strip-drawn gold wire, plaited in a quadruple-link pattern, and is threaded through the ring; it is 31⅛ inches (79 centimeters) long.

The base is engraved with a version of the Book of the Dead, chapter 30A, in which the deceased addresses her own heart, calling upon it to be the chief witness before the judges of the netherworld and to attest to her good deeds on earth. Hatnefer's name was inserted over an erased text, indicating that the scarab was not originally made for her. The inscription reads:

The mistress of the house, Hatnefer, says: /
"Heart of my mother, heart of my mother,
heart of my (actual) being, / do not rise up

41, base

against me as a witness; do not contend against me / in the court of judgment; do not make opposition against me in the / presence of the keeper of the balance. You are my bodily ka, a Khn- /um[2] who has invigorated my limbs. When you ascend to the perfection / from which we have come, do not cause our names to stink to / the entourage who create mankind in (their proper) sta- / tions, (but rather) may it go well with us and with the listener, so that the judge may rejoice. / Do not devise lies against me / in the presence of the god, for your reckoning / is (at hand)."

The scarab was found positioned on the breast of Hatnefer's mummy, in one of the outer layers of wrappings, tucked just under the edge of her gilded funerary mask (fig. 40) and adjacent to two rolls of papyrus and one roll of leather containing additional spells from the Book of the Dead. PFD

1. See, for example, the heart scarabs of the three minor wives of Thutmose III, in Lilyquist 2003, p. 129, figs. 103–7. See also catalogue no. 136.
2. The creator god Khnum fashioned children from clay and placed them in the womb.

42. Scarab Bezel of Queen Ahmose

Early 18th Dynasty, reign of Thutmose I (r. 1504–1492 B.C.)
Pale green–glazed steatite, gold
L. 1.6 cm (⅝ in.), W. 1.2 cm (½ in.), H. 0.6 cm (¼ in.)
The Metropolitan Museum of Art, New York, Rogers Fund, 1936 36.3.15

Though small, this scarab is carefully carved, with tiny eyes set at either side of an oval head and the major body elements demarcated by deeply incised lines. Details of the legs are partially obscured by the mount, which is made of gold sheet, somewhat cursorily hammered into place. At each end, small gold drums are soldered at the openings of a longitudinal hole piercing the scarab. The base is engraved "Great King's Wife, Ahmose." Queen Ahmose was the primary wife of Thutmose I and the mother of Hatshepsut.

The scarab was discovered among the finger bones of the mummy of a female adult, aged twenty-five to thirty-five, interred in one of the two uninscribed rectangular coffins found in the burial chamber of Ramose and Hatnefer.

PFD

PROVENANCE: Western Thebes, burial chamber of Ramose and Hatnefer, in coffin III; Metropolitan Museum of Art excavations, 1935–36, acquired in the division of finds

BIBLIOGRAPHY: Lansing and Hayes 1937, p. 31; Hayes 1959, p. 78

43. Ring with Lentoid Bezel

Early 18th Dynasty, reign of Thutmose II–early reign of Thutmose III (1492–1473 B.C.)
Blue-glazed steatite, gold
L. 2.9 cm (1⅛ in.), W. 1.4 cm (½ in.), Diam. 2.1 cm (⅞ in.)
The Metropolitan Museum of Art, New York, Rogers Fund, 1936 36.3.6

42, 43, 44

42, 43, 44, bases

This small plate is somewhat unevenly shaped and has a flat base. Both the rim and base are decorated with black pigment, and the interior is adorned with a vertical column of text, rather carelessly inscribed, consisting of the prenomen (coronation name) and epithets of Thutmose II: "The Good God, Aakheperenra, given life." The plate was discovered among the grave goods deposited in the foot end of one of two uninscribed rectangular coffins found in the burial chamber of Ramose and Hatnefer. PFD

PROVENANCE: Western Thebes, burial chamber of Ramose and Hatnefer, in coffin III; Metropolitan Museum of Art excavations, 1935–36, acquired in the division of finds

BIBLIOGRAPHY: Lansing and Hayes 1937, p. 30, fig. 42; Cox 1944, vol. 1, p. 277, fig. 453; Hayes 1959, p. 79; Porter and Moss 1964, p. 670 (incorrectly noted as MMA 38.3.9)

The scarab is finely detailed in every respect, with openwork spaces between the legs and with striations to indicate the leg bristles. The base has a rope border, and the device at the top of the design consists of the name of Hatshepsut and her chief queenly title, God's Wife of Amun. Below Hatshepsut's name a pair of kneeling figures flank a central vegetal motif that may represent the stalk and flower of a sedge plant. The image is perhaps a symbol of fecundity.

The body of the scarab is pierced by a longitudinal drill hole, through which a loop of two-ply linen cord was threaded. The scarab was tied on to the thumb of Hatnefer's left hand, in preparation for her burial. PFD

PROVENANCE: Western Thebes, burial chamber of Ramose and Hatnefer, on the mummy of Hatnefer; Metropolitan Museum of Art excavations, 1935–36, acquired in the division of finds

BIBLIOGRAPHY: Lansing and Hayes 1937, pp. 20, 22, 29, fig. 35; Meyer 1982, p. 5; Roehrig 2002, p. 38, fig. 51

44. Scarab Bezel of Queen Hatshepsut

Early 18th Dynasty, reign of Thutmose II–early reign of Thutmose III (1492–1473 B.C.)
Blue-glazed steatite, silver
L. 2 cm (¾ in.), W. 1.5 cm (⅝ in.), H. 0.75 cm (¼ in.)
The Metropolitan Museum of Art, New York, Rogers Fund, 1936 36.3.14

The detailing of this scarab is extremely fine, with the eyes, clypeus, and perimeters of the wing cases carefully outlined. As on the larger heart scarab (cat. no. 41), the legs on this example are carved in high relief. Some details of the legs are obscured by the mount, which is made of thin sheet silver, lightly hammered into place around the base. Small silver drums are attached at each end, at the openings of a longitudinal hole drilled through the scarab. The ring was found among the hand bones of a child of about five years of age, wrapped in linen and interred in one of the uninscribed rectangular coffins discovered in the burial chamber of Ramose and Hatnefer. Rotted remains of linen cord found in the mounting drums indicate that the bezel was originally threaded with string. The base is inscribed "The God's Wife (of Amun), Hatshepsut." PFD

PROVENANCE: Western Thebes, burial chamber of Ramose and Hatnefer, in coffin III; Metropolitan Museum of Art excavations, 1935–36, acquired in the division of finds

BIBLIOGRAPHY: Lansing and Hayes 1937, p. 31; Hayes 1959, p. 81

45. Plate

Early 18th Dynasty, reign of Thutmose II (r. 1492–1479 B.C.)
Greenish blue–glazed faience
H. 1.8 cm (¾ in.); rim: Diam. 8 cm (3⅛ in.)
The Metropolitan Museum of Art, New York, Rogers Fund, 1936 36.3.9

46. Razor

Early 18th Dynasty, joint reign of Hatshepsut and Thutmose III, period of Hatshepsut's regency (1479–1473 B.C.)
Bronze, wood
Handle: L. 11.5 cm (4½ in.); blade: L. 9.3 cm (3⅝ in.)
The Metropolitan Museum of Art, New York, Rogers Fund, 1936 36.3.69

This razor was found, carefully wrapped in strips of linen, in a basket in the tomb of Ramose and Hatnefer. The basket also contained two stone cosmetic jars, two small silver pitchers, and a silver, footed bowl. A necklace of faience lentoid beads (similar to cat. no. 109) had been placed in the bowl. Razors made entirely of metal were

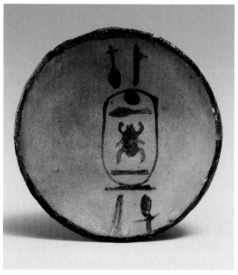

45

46

common in the Middle Kingdom and continued into the Eighteenth Dynasty (see cat. no. 145b). Razors like Hatnefer's, which combine a blade and a wood handle, appear for the first time in the Eighteenth Dynasty. CHR

PROVENANCE: Western Thebes, burial chamber of Ramose and Hatnefer; Metropolitan Museum of Art excavations, 1935–36, acquired in the division of finds

BIBLIOGRAPHY: Lansing and Hayes 1937, pp. 33, fig. 40, 35, fig. 45; Hayes 1959, p. 189; Roehrig 2002, p. 30, fig. 35

47. Hatnefer's Chair

Early 18th Dynasty, joint reign of Hatshepsut and Thutmose III (1479–1458 B.C.)
Boxwood, cypress, ebony, linen cord
H. 53 cm (20⅞ in.), W. 50 cm (19¼ in.), D. 54 cm (21¼ in.)
The Metropolitan Museum of Art, New York, Rogers Fund, 1936 36.3.152
New York only

This beautifully carved straight-backed chair of boxwood and ebony was found in front of the doorway to the tomb of Ramose and Hatnefer, dismantled and stuffed into a large rectangular tambourine of red-stained leather stretched over a wood frame. The tambourine, almost 30 inches (66 centimeters) in length, probably belonged to Hatnefer during her lifetime and may have been used in the funerary ritual performed at her burial.[1] The chair, which survived almost in its entirety, is now reassembled in its original shape. Its complete seat of string mesh, made of triple strands of linen cord interwoven in a herringbone pattern, miraculously withstood the chair's rough treatment when it was broken apart. This low, broad chair, with its

seat barely eight inches above the ground, is of a type usually favored by women, and it is assumed that it was owned by Hatnefer. The various elements were assembled with mortise-and-tenon joinery, and pegs reinforced by resinous glue held the tenons in place. The legs are carefully carved to represent those of a lion, and the frame of the paneled back is mounted on the seat with long right-angle braces held by pegs. An openwork design on the back includes a boxwood figure of the household god Bes flanked

on each side by alternating ebony *tyet* amulets (for protection) and boxwood *djed* amulets (for stability) to ensure Hatnefer's well-being. The craftsman who made the chair employed the light and dark woods to advantage in the decorative scheme, alternating them in the carved design on the back and in the border strips of the braces. Cypress wood, less polished than the rest of the chair, was used for the stretchers between the front and back legs. The entire chair was covered with a fine satin surface finish to add to its luster.

RD

1. Lansing and Hayes 1937, p. 13, figs. 23, 24. See also Roehrig 2002, p. 27, figs. 42, 43. It is not known why the red leather cover of the tambourine was slit and sections of the chair—the only piece of household furniture associated with Hatnefer's burial—were stuffed inside. For a description of the chair, see Baker 1966, p. 131, fig. 182.

PROVENANCE: Western Thebes, outside the burial chamber of Ramose and Hatnefer; Metropolitan Museum of Art excavations, 1935–36, acquired in the division of finds

BIBLIOGRAPHY: Lansing and Hayes 1937, p. 13, figs. 23, 24; Hayes 1959, p. 201, fig. 115; Baker 1966, p. 131, fig. 182; N. E. Scott 1973, fig. 18; Roehrig 2002, p. 27, figs. 42, 43

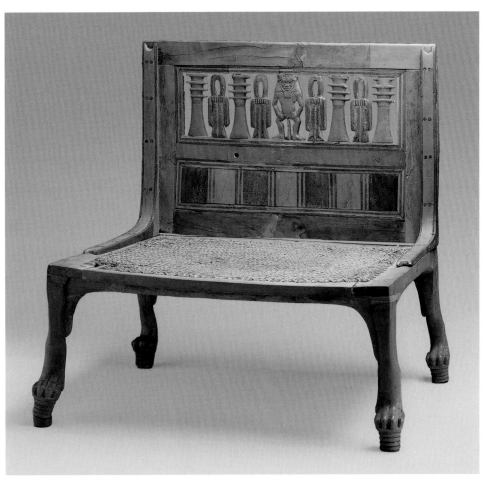

47

THE JOINT REIGN OF HATSHEPSUT AND THUTMOSE III

Cathleen A. Keller

Our information regarding the chronology and events of the regency period, before Hatshepsut completed her transformation into king of Egypt,[1] is limited to a few dated sources and a somewhat larger number of undated ones. The latter sources are assigned this time span by virtue of their choice of names for Hatshepsut (Hatshepsut rather than Maatkare) and titles (queenly rather than those used only to refer to reigning kings), and the manner of her depiction (in female rather than male dress). A scholarly consensus has developed that by regnal year 7,[2] when her first known datable use of royal titulary occurred, a critical stage in Hatshepsut's metamorphosis had been reached. Her adoption of male costume and attitudes appears to have taken place somewhat later.[3] It was, however, fully developed by the time she began the decoration of her temple at Deir el-Bahri, whose construction had started in regnal year 7,[4] and persisted until the last dated reference to her as king in regnal year 20.[5] There was no mention of Hatshepsut when Thutmose III embarked on his Megiddo campaign late in year 22, which thus marks the latest possible date for the end of the joint reign.[6]

The approximately fifteen-year period in which the two rulers effectively shared the throne of Egypt has yielded little evidence of rivalry between the two kings or their respective courts.

Indeed, on monuments of the time they frequently appear together as twin male rulers distinguished only by position (Hatshepsut usually takes precedence, as in fig. 41) or, occasionally, by regalia (see cat. no. 48).[7] They also shared a common system of dating (both using the regnal years of Thutmose III),[8] and a number of officials known to have served during the co-regency continued in power when Thutmose III reigned alone.[9] Historians who have envisaged a government divided into isolationist (Hatshepsut) and expansionist (Thutmose III) factions probably miss the mark.[10] Although the joint reign did not see the extensive military activity that characterized the sole reign of Thutmose III, there is evidence that Hatshepsut may have led a campaign into Nubia; moreover, her imperialist rhetoric is consistent with that of male rulers.[11] The single best-known foreign expedition of the joint reign was, however, not a military venture but the royally sponsored voyage to the exotic land of Punt, undertaken to obtain incense and other costly and precious materials for the cult of Amun-Re at Karnak.[12] The expedition was depicted in extenso on the southern portion of the middle portico of her Deir el-Bahri temple,[13] adjacent to the rebuilt chapel of Hathor, whose cult is associated with foreign lands. Its successful return is dated to year 9, early in the joint reign. Many historians have placed Hatshepsut's

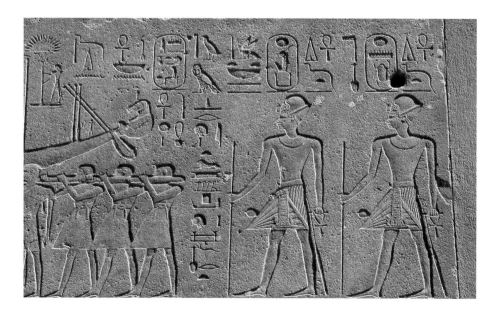

Fig. 41. Hatshepsut and Thutmose shown as identical kings. Detail of a block from the Chapelle Rouge, Karnak, Thebes, early 18th Dynasty. Quartzite

celebration of a Sed festival—a ritual renewing the king's royal powers—in regnal year 16; however, the evidence that this event actually took place is not conclusive.[14]

The accomplishments of the joint reign's building program were prodigious.[15] And although our knowledge of Thutmoside construction projects in the north of the country is meager, we have evidence that Hatshepsut's architects were active at numerous sites in the Nile valley proper (Elephantine, Kom Ombo, Hierakonpolis/El-Kab, Gebel el-Silsila, Meir [Cusae], Batn el-Baqqara and Speos Artemidos, Hermopolis, and Armant[16]), as well as in Nubia[17] and the Sinai.[18] However, it was in the Theban area that the core of her building program was centered, with projects undertaken on both the Nile's west bank (Medinet Habu, Deir el-Bahri, and the Valley of the Kings[19]) and its east bank (the temples of Karnak[20] and Luxor, along with their processional connection[21]). At Karnak, in particular, Hatshepsut continued the conversion of the temple, founded by Senwosret I (r. 1918–1875 B.C.) early in the Middle Kingdom and expanded by Amenhotep I and by her father, Thutmose I, turning the respectable but not spectacular complex into a true national shrine and in the process confirming the dynasty's, not to mention her own, association with the god Amun-Re.

Hatshepsut's constructions at Karnak reshaped the heart of the Middle Kingdom temple, which by the time of the joint reign was considered the southern counterpart of Heliopolis, the cult center of the sun god Re.[22] To the earlier part of the joint reign belong her erection of a pair of obelisks quarried by Thutmose II[23] and her fabrication of a small limestone shrine.[24] Among her later constructions were a monumental entrance to the southern (royal) axis of Karnak (the Eighth Pylon; see "The Temple of Hatshepsut at Deir el-Bahri" by Dieter Arnold in chapter 3), two pairs of obelisks, and the Palace of Maat,[25] a new complex giving entrance to the still extant portion of the Middle Kingdom sanctuary, which included a quartzite shrine, now known as the Chapelle Rouge (fig. 42), to house the portable barque of Amun.[26]

Although it is not possible to treat Hatshepsut's monuments in any detail here, some points of commonality in the corpus should be mentioned. First, there is the emphasis on the restoration of tradition, seen in the rebuilding of deteriorated structures, such as the temple of Hathor at Cusae and the "heart" of the temple of Amun-Re at Karnak.[27] It is evident also in the recalibration of the festival calendars and the reinstitution of cultic and festival celebrations, following a period of what Hatshepsut describes as ignorance of religious matters.[28] Second is the concentration on the site of Thebes, the dynastic and theological seat of the royal family. Here is concretized the theme of royal and divine reciprocity, wherein Amun rewards the king with legitimacy and prosperity in exchange for "the beautiful flourishing efficient monuments."[29] Finally, there is surely Hatshepsut's desire to accomplish things so truly unique[30] that they would amaze even generations yet to

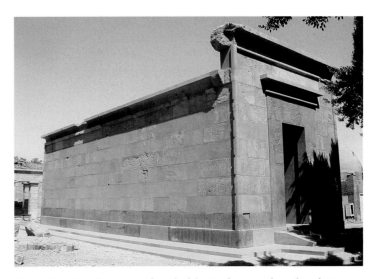

Fig. 42. The Chapelle Rouge, a shrine built by Hatshepsut in the early 18th Dynasty and now reconstructed in the Karnak Open-Air Museum, Luxor

come, so that "those who will hear these things will not say that what I have said (in my inscriptions) is exaggeration, but instead will say: 'How like her it is, to offer to her father (Amun)'!"[31]

In the end we remain unsure of the reason for Hatshepsut's adoption of kingly attributes. Its attribution by earlier scholars to naked (and unnatural) political ambition does not stand up to scrutiny.[32] That serious internal political developments made it necessary for her to continue as co-ruler until Thutmose could assume sole rule has been suggested more recently, but evidence supporting this thesis is scanty.[33] One aspect of this co-regency that sets it apart from other periods of joint rule in Egyptian history is its sheer length,[34] which the ancient Egyptians, being no more prescient than ourselves, could not have foretold. It may be that existing artistic conventions made it difficult to depict a female co-regent taking precedence over her male counterpart, eventually prompting Hatshepsut's adoption of kingly regalia even in the absence of any specific political or diplomatic concerns.[35] Equally obscure are the reasons for the *damnatio memoriae* inflicted upon her by her former co-regent some twenty years after the period of joint rule.[36] This was surely too long a time for Hatshepsut's youthful co-regent to have waited, if simmering resentment were his motivation, before embarking upon the task of defacing her monuments and destroying her images.

1. For the period of the regency, see "Hatshepsut: Princess to Queen to Co-Ruler" by Peter F. Dorman earlier in this chapter and Dorman 2005.

2. See conveniently Dorman 1988, pp. 18–45, and Dorman 2005.

3. Dorman 2005; note in particular Gabolde and Rondot 1996.

4. Winlock 1942, pp. 133–34; Hayes 1957, pp. 78–80.

5. Gardiner, Peet, and Černý 1952–55, pp. 152–53, no. 181, pl. LVII.

6. For a summary discussion of this argument, see Dorman 2005.

7. On stelae from Sinai (Gardiner, Peet, and Černý 1952–55, pp. 150–54, nos. 174a, 179, 181, 184, pls. LVII, LVIII) and on the exterior of the Chapelle Rouge at Karnak (Lacau and Chevrier 1977–79, pls. 7, 9).

8. For the most recent chronology of the joint reign, see Chappaz 1993a, pp. 93ff.

9. See Dziobek 1995, pp. 132–34, and "The Royal Court," below.

10. Wilson 1951, pp. 174ff., cited in Redford 1967, p. 63.

11. For the campaigns of Thutmose III, see most recently Redford 2003. For the Nubian campaign, see Habachi 1957, pp. 89, 99–104, and Redford 1967, pp. 57–59. For the possibility of Asian activity and additional campaigning in Nubia, see Redford 1967, pp. 60–63. Hatshepsut refers in her inscription at Speos Artemidos, to the refurbishing of troops, surely in preparation for military engagement (*Urkunden* 4, p. 386, ll. 1–2).

12. The precise location of the land of Punt has been the topic of much discussion; see generally Kitchen 1982.

13. For the Deir el-Bahri temple, see the essays by Dieter Arnold and Ann Macy Roth in chapter 3.

14. Even less likely to have occurred is a Sed festival jointly celebrated with Thutmose III (Uphill 1961).

 The argument for a year 16 jubilee is founded upon two separate inscriptions on the obelisk of Hatshepsut that still stands between the Fourth and Fifth Pylons at Karnak. On the north side of the base are inscribed the dates of the quarrying of the obelisk, from "regnal year 15 II *Peret* 1," down to "regnal year 16 IV *Shomu*, last day" (*Urkunden* 4, p. 367, ll. 3–4). The words "first occasion of the Sed festival" (*Urkunden* 4, p. 359) on the north side of the shaft occur, as noted by Eric Hornung and Elisabeth Staehelin (1974, pp. 56, 64–65), in a *Wünsch-Kontext*, among the wished-for results of dedicating the obelisks to Amun, rather than indicating a historical event.

15. For the purposes of this essay, monuments begun during the joint reign are considered to have been initiated chiefly by Hatshepsut. Our knowledge of building programs of this period is founded upon two types of primary sources: archaeological, including in situ remains of the constructions and portions reused in later projects; and textual, comprising royal and private inscriptions that mention the monuments. For a list of monuments and references known by the early 1970s, see Ratié 1979, pp. 175–96.

16. For a summary of the constructions of Hatshepsut at Elephantine, primarily the Satet and Khnum temples, see Kaiser 1993 (with bibliography); for more detailed discussion, see Kaiser 1975, pp. 50–51, Kaiser 1977, pp. 66–67, Kaiser 1980 (Satet temple), and von Pilgrim 2002 (temple of Khnum). For the statue of Thutmose II dedicated by Hatshepsut at Elephantine, see Dreyer 1984. For Kom Ombo, see *Urkunden* 4, p. 382. For Hierakonpolis/El-Kab, see Murnane 1977, p. 43, and Ratié 1979, p. 176. For Gebel el-Silsila, see Caminos and James 1963, pp. 7, 11, and Chappaz 1993a, pp. 98–99. For Meir (Cusae), see *Urkunden* 4, p. 386, ll. 4–13; Gardiner 1946, pp. 46–47. For Batn el-Baqqara, see Fakhry 1939. For Speos Artemidos, see *Urkunden* 4, pp. 383–91; Gardiner 1946; Fairman and Grdseloff 1947; Ratié 1979, pp. 178–82; Bickel and Chappaz 1988 and 1993. For Hermopolis, see *Urkunden* 4, p. 387, l. 10, p. 389, l. 17; Gardiner 1946, p. 47. For Armant, see Ratié 1979, p. 183 (with bibliography).

17. At the south temple at Buhen (Caminos 1974) and Semna (discussed by Dorman 2005) and Ibrim (Caminos 1968, pp. 50, 58, pls. 17–22).

18. Primarily at Serabit el-Khadim: Gardiner, Peet, and Černý 1952–55, pp. 37–38; Valbelle and Bonnet 1996, pp. 59, 71, 78–79, 100, 114, 181–83.

19. For Medinet Habu, see plans and reconstruction by Hölscher (1939, pp. 6–17, 45–48, pl. 4). The decoration of the Eighteenth Dynasty temple is currently being prepared for publication by the Epigraphic Survey of the University of Chicago. For Deir el-Bahri, see the essays by Dieter Arnold and Ann Macy Roth in chapter 3. For the Valley of the Kings, see Gabolde 1987b, pp. 76ff., and "The Two Tombs of Hatshepsut" by Catharine H. Roehrig in chapter 3.

20. For Hatshepsut's work in the heart of Karnak, the Palace of Maat, see below, n. 25. For the Mut complex, see the essay by Betsy Bryan in chapter 3. For the jointly produced Kamutef temple, see Ricke 1954. The so-called palace of Karnak, a royal mansion north of the Amun temple, is prominently referred to in inscriptions dating from Hatshepsut's reign (Gitton 1974). A list of monuments dedicated by Hatshepsut was inscribed on a wall of the Chapelle Rouge (Lacau and Chevrier 1977–79, pp. 73–84).

21. In the context of the festival of Opet as inscribed on the Chapelle Rouge, which shows six way stations marking the processional route between Karnak and Luxor: Nims 1955, p. 114, and Lacau and Chevrier 1977–79, pp. 154–69.

22. Gabolde 1998, pp. 143ff.; Grimal and Larché 2003, p. 16. The relationship is clearly stated in the Egyptian language: Heliopolis was *Iunu*, Thebes was *Iunu Shemaʿu*, "Upper Egyptian Heliopolis."

23. The obelisks were set up in Thutmose's Festival Court. (For the development of this area of Karnak, see Gabolde 1987a, 1993, and 2003.) These were probably the pair mentioned in the Senenmut graffito at Aswan (Habachi 1957, pp. 92ff.).

24. This shrine was later reused by Amenhotep III in his temple of Montu in North Karnak; Gabolde and Rondot 1996.

25. On the Eighth Pylon, see Martinez 1993. For the obelisks of Hatshepsut at Karnak, see Golvin 1993. The pair installed inside the *wadjit* (papyrus-columned hall) of Thutmose I were quarried in years 15–16 (Barguet 1962, pp. 96ff.; Gabolde 2003, p. 420) and a second, larger pair stood on axis east of the temple (Nims 1971, pp. 110–11; Gabolde 2003, p. 421). For the Palace of Maat, see Barguet 1962, pp. 141–53; Hegazy and Martinez 1993.

26. The Chapelle Rouge was called "The Place of the Heart of Amun" (Nims 1955, pp. 113–14); Lacau and Chevrier 1977–79; Graindorge 1993; Carlotti 1995; Larché 1999–2000. The shrine's decoration remained unfinished at the end of the joint reign. It was largely completed subsequently, but was soon dismantled by Thutmose III.

27. On the restoration of tradition, see Chappaz 1993a, p. 104. For the temple of Hathor, see *Urkunden* 4, p. 386, ll. 4–13; Chappaz 1993a. The restoration of the temple of Amun-Re used sandstone (Wallet-Lebrun 1994) to replace the deteriorated limestone structures of the Middle Kingdom (Gabolde 1998, pp. 137–40).

28. As stated in the Speos Artemidos inscription (*Urkunden* 4, p. 384, ll. 8–11, p. 386, ll. 8–9, p. 388, ll. 14–17) and exemplified in the form, orientation, and decoration of the Satet temple in Elephantine (Wells 1985 and 1991; see also the references in n. 16, above).

29. The phrase was used with some frequency; see, for instance, *Urkunden* 4, p. 200, l. 3; *Urkunden* 4, p. 298, ll. 1–6. Although many scholars have emphasized the stridency of Hatshepsut's efforts to assert royal legitimacy, citing the "divine birth" (*Urkunden* 4, pp. 215–34) and "jeunesse" (*Urkunden* 4, pp. 241–65) texts from Deir el-Bahri, which stress her association with her father, Thutmose I, and contrast with the lack of piety expressed toward her royal half brother and predecessor, Thutmose II (see, for example, Gabolde 1989, pp. 138–39), similar claims of divine ancestry were advanced by male rulers.

30. This desire may be why elements of earlier monuments, such as the temple of Mentuhotep II and the temple of Amun of Senwosret I, were adapted but never copied in the design of her Deir el-Bahri temple. The use of superimposed pillared facades there is a variant on the Mentuhotep II temple; the repetition of Osiride figures across the upper terrace facade that fronts a pillared court is surely derived from the Senwosret I Karnak temple (compare Gabolde 1998, pl. xxxviii). The identity of the creative genius at work at Deir el-Bahri may never be known; but that the monuments of the co-regency render an unusually sensitive homage to the works of earlier periods is undeniable and was surely approved by the king.

31. *Urkunden* 4, p. 384, ll. 12–13; *Urkunden* 4, p. 368, ll. 3–6.

32. There does not appear to have been any attempt to remove Thutmose III during his minority; nor was reference to him omitted from royal monuments of the period. Indeed, Hatshepsut used his regnal year calendar rather than instituting her own. See the remarks of Dorman 2005 and, for an earlier reevaluation of Hatshepsut, Teeter 1990.

33. Chappaz 1993a, pp. 109–10.

34. Murnane 1977, pp. 43–44.

35. On the problem of expressing female precedence within the male-oriented Egyptian artistic system, see Robins 1994b. On its effect on Hatshepsut's adoption of kingly regalia, see Dorman 2005, citing Gabolde and Rondot 1996, p. 215. One can only imagine how the western Asiatic states perceived the Egyptian female regent system; they may have viewed it as offering an opportunity to gain military advantage because the traditional male leader of the Egyptian army was absent.

36. Nims 1966; discussed in detail in Dorman 1988, pp. 46–65.

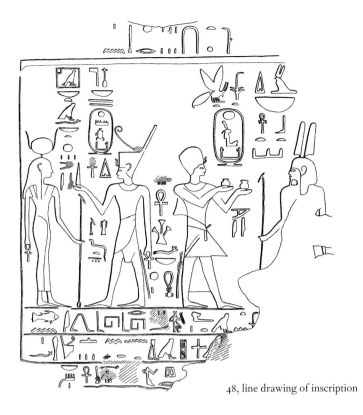

48, line drawing of inscription

48. Inscription of Hatshepsut and Thutmose III

Early 18th Dynasty, joint reign of Hatshepsut and Thutmose III, year 16 (1453 B.C.)
Sandstone
Inscribed area: H. ca. 87 cm (34¼ in.), W. 75 cm (29½ in.)
Egyptian Museum, Cairo JE 45493
Not in exhibition

This depiction of the joint rulers Hatshepsut and Thutmose III was inscribed near a turquoise mine in the Sinai by an official named Kheruef, who had been appointed "to explore the [mysterious] valleys" in search of this semiprecious stone so beloved of Egypt's elite. At the beginning of their joint reign the co-regents had launched mining expeditions in the Sinai. These expeditions follow a hiatus in such activity that had occurred during the Second Intermediate Period (1650–1550 B.C.) and marked an important resurgence of mining.[1] The fact that this graffito is the only Eighteenth Dynasty example from the site of Maghara, coupled with its close similarity to examples at the much-used mine site at Serabit el-Khadim, suggests that Kheruef may indeed have been carrying out some independent reconnoitering.[2]

The date, regnal year 16, appears floating above the sky sign[3] that forms the top border of a symmetrical offering scene, suggesting that it

applies to both rulers. At right, "the King of Upper and Lower Egypt Maatkare" offers two *nw* pots to the figure identified as "Sopdu, Lord of the East,"[4] while her co-regent "The Good God, Lord of the Two Lands, Menkheperkare" stands at left, proffering a long pointed loaf[5] to "Hathor, Mistress of Turquoise." Both kings are depicted as male rulers and wear broad collars but are distinguished from each other by their other dress and their regalia. Hatshepsut, wears the *khepresh* (or blue) crown and a short kilt with a projecting triangular apron over a loose robe that swings free at the back and hangs to just above her ankles. Thutmose III wears the red crown of Lower Egypt and a tight-fitting *shendyt* kilt.

CAK

1. Evidence for a New Kingdom presence in the Sinai prior to the joint reign of Hatshepsut and Thutmose III suggests only modest activity (Gardiner, Peet, and Černý 1952–55, pp. 149–50, nos. 171–74, pl. LVI). On New Kingdom expeditions in general, see Hikade 2001.
2. Of the Sinai turquoise sources, Maghara was the earliest to be mined extensively. Its supply dwindled, leading to the increased exploitation of Serabit el-Khadim during the Middle Kingdom (Gardiner, Peet, and Černý 1952–55, pp. 24, 36); for graffiti from the site, see nos. 175–77, 179–81, pls. LVI–LVIII.
3. The floating date has Middle Kingdom precedents; for examples, see Gardiner, Peet, and Černý 1952–55, nos. 57, 86, 90, 91–93, 100, 104–6, 115, 118, 120. It was used in other contexts to indicate the co-regencies in the Twelfth Dynasty; for Middle

Kingdom co-regencies in general, see Murnane 1977, pp. 1ff.
4. These pots almost certainly contained cool water (*kebehu*); see Gardiner, Peet, and Černý 1952–55, no. 181, pl. LVII, in which Thutmose III offers cool water and Hatshepsut offers white bread to the god Onuris-Shu.
5. The pointed loaf is probably white bread (*ta-hedj*), based on its resemblance to bread identified as such in numerous Middle Kingdom examples including those cited in n. 3, above.

PROVENANCE: Sinai, Maghara

BIBLIOGRAPHY: Gardiner, Peet, and Černý 1952–55, p. 74, no. 44, pl. XIV; Hikade 2001, pp. 11, 154–56, no. 6

49. A King and the Goddess Anukis

Early 18th Dynasty, 2nd half of joint reign of Hatshepsut and Thutmose III (1469–1458 B.C.)
Painted sandstone
H. 71 cm (28 in.), W. 99.5 cm (39⅛ in.)
Musée du Louvre, Paris B59 (formerly E 12921 bis)

In this relief the goddess Anukis, a divinity linked with southern Upper Egypt and with close ties to Nubian deities, proffers a *menit* necklace, associated with female divinities, toward the face of a king. The *menit* necklace was shaken rhythmically during temple and festival ceremonies; when proffered to an individual, it imparted life. The king, probably Hatshepsut, wears the composite *atef* crown and a false beard.[1] The identity of the goddess Anukis is made clear by her distinctive flaring headgear, probably of ostrich plumes. The features of both king and goddess are rendered in the style of the latter part of the co-regency.

This block was once part of a sandstone temple[2] built by Hatshepsut for the goddess Satis on the island of Elephantine, near Egypt's southern border, to replace an earlier limestone structure erected by Senwosret I, which may have fallen into decay.[3] The new temple was an elevated rectangular structure surrounded by thirty rectangular pillars and was oriented toward the midwinter sunrise.[4]

Anukis and Satis, together with the local creator god, Khnum, formed the Elephantine triad, with Khnum and Satis consorts and Anukis their offspring.[5] The three divinities were united more by topography than by any mythic ties. Khnum, as Lord of Elephantine (Abu) and Lord of the Cataracts, was associated with the annual inundation, which was thought to originate in

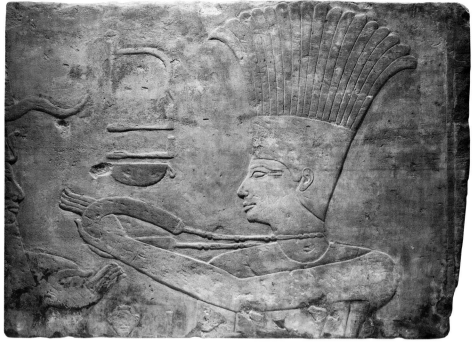

49

caverns at the First Cataract; Satis was linked with the star Sothis (Sirius), the island of Elephantine, and protection of the southern frontier, and was considered the astral herald of the inundation; and Anukis was associated with the island of Sehel and luxury goods imported into Egypt from the south.[6]

CAK

1. On Anukis, see Otto 1975a; Valbelle 1981, especially pp. 114–27. On the *menit* necklace, see Staehelin 1982. On the *atef* crown, see Goebs 2001, pp. 323–24.
2. Kaiser et al. 1972, p. 159, n. 7. Werner Kaiser's reconstruction (1980, pp. 254, 255, fig. 4, 257, no. 40), locates the block on the rear wall of chamber C, one of the rooms decorated by Hatshepsut.
3. On Satis, see Valbelle 1981, pp. 112–27, and Valbelle 1984. On Senwosret's temple, see Kaiser 1977, p. 66. Kaiser et al. (1972) compares these two Satis temples of the Twelfth Dynasty (pl. XLI, a) and Eighteenth Dynasty (pl. XLI, b). Hatshepsut's work on the Satis temple at Karnak appears to have been similarly prompted by the poor state of the Senwosret I structure (Gabolde 1998, pp. 137–40).
4. The Satis temple dates back to the Early Dynastic Period (Kaiser 1977, p. 65, fig. 1), and it appears to have served an astronomical as well as a cultic function. Hatshepsut's temple, the best preserved of the numerous rebuildings, has been the object of much study; see Wells 1985 and 1991.
5. On Khnum, usually depicted as a ram or ram-headed male, see Otto 1975b. The triad was first attested in the reign of Senwosret I (Valbelle 1984, col. 487).
6. These included ivory, ebony, and boxwood, exotic animals and animal skins, gold, and ostriches and ostrich eggs; see Valbelle 1981, pp. 96–97.

PROVENANCE: Elephantine, Temple of Satis; Clermont Ganneau excavations, 1907–10; acquired in 1908

BIBLIOGRAPHY: *La vie au bord du Nil* 1980, p. 77, no. 142; Valbelle 1981, pp. 14–15, no. 118, 115, fig. 5, 118B; Franco 2001, p. 286 (note)

50. Rings with Cartouches of Hatshepsut and Thutmose III

Early 18th Dynasty, 2nd half of joint reign of Hatshepsut and Thutmose III (1472–1458 B.C.)

a. Gold and green jasper
Diam. 2.3 cm (⅞ in.); plaque: L. 1.5 cm (⅝ in.)
The Metropolitan Museum of Art, New York, Gift of Mrs. Frederick F. Thompson, 1915 15.6.22

b. Gold and lapis lazuli
Diam. 2.5 cm (1 in.); scarab: L. 1.5 cm (⅝ in.)
The Metropolitan Museum of Art, New York, Purchase, Edward S. Harkness Gift, 1926 26.7.764

These two fine rings are made of costly materials and inscribed with the names of the joint rulers Hatshepsut and Thutmose III. Both of their bezels are mounted on swivels, which would have allowed them to be used to impress the fine mud sealings that protected documents, as well as the content of bags and chests, from tampering.

The lapis lazuli ring (b) is inscribed on the underside of the scarab "The Good God, Menkheperre, given life, (and) the Good Goddess, Maatkare, may she live!"[1] and has been identified as having belonged to a foreign wife of Thutmose III.[2] It was clearly something bestowed as a mark of royal favor rather than used as an official seal, because it is far too large to have been worn by a woman. In contrast, the square-cut jasper ring (a), which bears on its reverse the inscription "The First Prophet of Horus of Nekhen (Hierakonpolis) Tjeni," may actually have been used as a working seal.

CAK

1. The letter *t* follows the *netjer nefer* (Young God) above the cartouche of Hatshepsut but is not present above that of Thutmose III's, suggesting that the expression is to be read as feminine.
2. Lilyquist 2003, p. 182.

PROVENANCE: *50a*. Unknown; purchased from Mohammed Mohassib
50b. Probably western Thebes, Gabbanat el-Qurud, Wadi D, Tomb 1; purchased at Luxor by Howard Carter; formerly Carnarvon collection

BIBLIOGRAPHY: *50a*. Hayes 1959, p. 104
50b. Winlock 1948, p. 35, pl. XIX, d; Hayes 1959, p. 125, fig. 66 (bottom row, second from right); Lilyquist 2003, pp. 181, 182 (with bibliography), no. 140, figs. 179, 184 (top row, right)

50a, b

50a, b, bases

THE ROYAL COURT

The Egyptian royal court was located, according to official ideology, wherever the king and his following were present. In its most restricted sense this retinue comprised members of the royal family and their retainers, such as the stewards of the royal households (including those of Hatshepsut and her daughter Neferure), and the royal nurses and tutors.[1] But if the idea of the court is expanded to take in courtiers and officials responsible for governing the country's principal civil and religious institutions, the cast of characters grows dramatically.[2]

The early Thutmoside period saw a great increase in the complexity of the Egyptian bureaucracy. Particularly significant were the creation (for the first time) of a regular standing army, and the establishment of a network of officers to control the foreign possessions in Egypt's new "empire" in western Asia and to carry out the colonial administration of Nubia.[3] Although attempts have been made to devise an ancient Egyptian "flow chart" to track the reach of various individuals' authority within the royal, civil, religious, foreign, and military administrative divisions,[4] this has proved a difficult undertaking. Particularly powerful and influential officials, such as Senenmut, acquired large numbers of important positions in various divisions, seemingly in conflict with the simultaneous holding of the same titles and offices by contemporaries.[5] In fact, it appears that the king deliberately created overlapping functions, and therefore constituencies, effectively preventing any single official, no matter how much esteemed or favored, from amassing enough authority to rival the power of the crown.

The royal court comprised not only the group of individuals responsible for governing the country but also the setting within which their interactions, both private and official, took place. During the early Eighteenth Dynasty there were two major royal capitals (in Egyptian, *khenu*, literally "residence")—Memphis, in the north, and Thebes, in the south—and possibly several other less important ones.[6] Memphis was probably the true administrative capital of Egypt.[7] Thebes, which held Egypt's most important shrine, the Amun temple at Karnak in the northern part of the city, was more likely a site of occasional though probably fairly regular visitation by the king. There are several designations for the royal palace, but *pr-nswt* (literally, "King's House") most clearly indicates its function as both the residence of the Lord of the Two Lands and the seat of government.[8]

It was Hatshepsut's father, Thutmose I, who had founded the palace at Memphis, which continued to be used until late in the Eighteenth Dynasty.[9] The royal sons spent much of their time there,[10] possibly because Memphis was, for strategic reasons, the headquarters of the Egyptian military. Unfortunately the palace is known only from textual sources, and its actual location has not been discovered. Holders of the highest-level positions who had multiple jurisdictions, such as Senenmut, who was Royal Steward and Steward of Amun, were no doubt familiar faces in both Memphis and Thebes and probably shuttled back and forth between them. Among officials most closely associated with the governance of Egypt, the vizier (*ṯȝtj*) was second only to the king and headed the civil administration.[11] In year 5 in the reign of Thutmose III (thus during Hatshepsut's regency) a new vizier, Useramun (fig. 43), was appointed.[12] He followed the practice of many of the highest-ranking officials of the co-regency period who chose to be buried at Thebes, close to their sovereigns.[13] Others, however—including top military officers such as General Djehuti (cat. nos. 149a–c), who no doubt regularly appeared at the triumphal celebrations of Thutmose III—seem to have been buried in the Memphite necropolis.[14] And still others, particularly

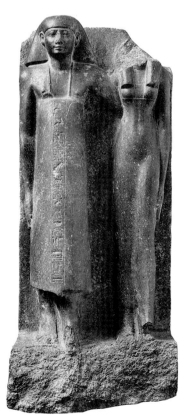

Fig. 43. Useramun and his wife, Tjuyu, early 18th Dynasty. Granite. Useramun was vizier to Thutmose III; he wears the long wrapped kilt with braces that is the distinctive uniform of his office. Egyptian Museum, Cairo (CG 42118)

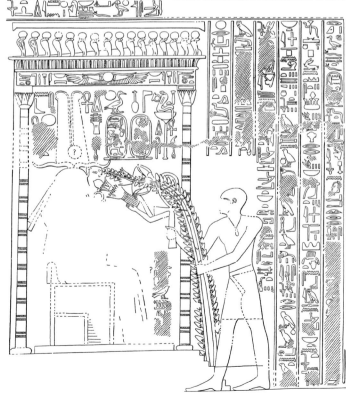

Fig. 44. The Royal Butler Djehuti presents a floral bouquet to King Hatshepsut. Wall relief from the Theban tomb of Djehuti (TT 110), early 18th Dynasty. The bouquet is one item in a long list of offerings presented at Karnak temple on Hatshepsut's behalf. Copy drawing

lower-ranking military like Maya (cat. no. 52), who had received provincial civil or religious appointments following their military service, preferred burial in their ancestral towns.

The palace of Karnak in Thebes was particularly associated with Hatshepsut and appears several times in her inscriptions;[15] probably located north of the Karnak temple, it was called "the royal palace (ʿḥ-nswt) I am not far from Him (Amun)."[16] When either or both co-regents were in residence—for instance, during the elaborate sacred rites and activities of the Opet festival, which celebrated the link between Amun and the pharaoh—illustrious members of the Theban court were in attendance. The First Prophet of Amun, Hapuseneb,[17] and the Second Prophet, Puyemre (see cat. no. 51), would have been among them, and not just because they led the hierarchy of the powerful Amun clergy. Both were also personally involved in Hatshepsut's building program,[18] and she is unlikely to have passed up the opportunity for a status report on (or personal tour of) the latest manifestations of her piety (fig. 44). Other eminent officials attached to the Amun temple, such as Sendjehuti, the Overseer of the Granary and Steward, would also have been in attendance.[19] Security for the palace would have been in the hands of attendants, among them Mentekhenu (cat. no. 54). And very likely individuals associated with such successful enterprises as the safe arrival of a pair of Hatshepsut's obelisks from Aswan—these included the mayor of Thinis, Satepihu (cat. no. 53)—received expressions of royal favor at the Theban palaces.

Much of what we know about ancient Egyptian court ceremony comes from later reigns, from which depictions of court life, such as that of King Ay's pavilion in the tomb of Neferhotep at Thebes,[20] survive. But clearly the complex ceremonies and protocols of the co-regency period included festival celebrations, receptions, and the investiture and rewarding of prominent officials, the most important of these taking place in the king's presence.[21] Another major occasion was the "sitting" (ḥms.t), when the king announced matters of royal policy in the presence of "the great ones of the entire land."[22] This public witnessing of royal proclamations and rewarding of officials was necessary as a visual legitimization and verification of the proceedings. All of these events unfolded within a formally structured palace complex[23] in which brightly painted royal reception areas[24] provided a regal setting for the splendidly arrayed king and her officials.

CAK

1. For the royal nurses and tutors, see "Senenmut, Royal Tutor to Princess Neferure" by Catharine H. Roehrig later in this chapter.

2. On the highest-level officials of both the co-regency period and the reign of Thutmose III, a convenient source is Dziobek 1998, pp. 132ff.

3. The difference between the types of administration applied to these two areas of Egyptian control is discussed in Kemp 1978a.

4. As in O'Connor 1983, p. 208, fig. 5.4; Van den Boorn 1988, pp. 323, fig. 11, 327, fig. 12.

5. Senenmut held so many offices that it is difficult to see how he was capable of carrying out even a fraction of the duties associated with them. On Senenmut, see Ratié 1979, pp. 243–64; Meyer 1982; Dorman 1988 and 1991; and several essays in this volume.

6. They would include the *harim* palace at Medinet al-Gurab, near the entrance to the Fayum, a residence for women that was probably founded sometime in the reign of Thutmose III (Kemp 1978b; Lacovara 1997a; Lacovara 1997b, pp. 36–38), and the military palace at Deir el-Ballas, which had been in use during the Seventeenth Dynasty and into the early Eighteenth Dynasty but was abandoned as a royal installation soon after that (Lacovara 1990; Lacovara 1997b, pp. 6–16).

7. See Van Dijk 1988.

8. See Van den Boorn 1988, pp. 74–75, 310–20.

9. Zivie-Coche 1982, col. 28. For the palace at Memphis founded by Thutmose I, see Badawī 1948, pp. 58ff.; Helck 1939, pp. 30–31; Helck 1958, pp. 96ff.; Helck 1961–69, p. 201; Lacovara 1997a.

10. Meyer 1986, col. 536.

11. For the office and functions of the vizier, see Van den Boorn 1988.

12. For the monuments and career of Useramun, see, most recently, Dziobek 1995 and 1998; Goyon and Cardin 2004 (pp. 24–36 for earlier references). The son of the (southern?) vizier Ahmose-ʿAmtju, Useramun was, it appears, so successful in holding on to the reins of power that he easily made the transition to the sole reign of Thutmose III and much later, in year 34, was directly succeeded by his nephew, Rekhmire.

13. Perhaps another motive was the benefit of proximity to their royal masters' funerary estates, since the memorial temple of the reigning king was probably the wealthiest such institution (as implied in Haring 1997, p. 394), and its lavish offerings were recycled to the tombs of officials.

14. Lilyquist 1988; Reeves 1993, p. 260.

15. Lacau and Chevrier 1977–79, p. 78, par. 126. There is also a second palace mentioned in the list on the wall of the Chapelle Rouge (ibid., par. 127), but it is a fragmentary reference, and whether it contains the name of Hatshepsut is uncertain.

16. For the location of the Theban Karnak palace, see Gitton 1974, pp. 71–72, and O'Connor 1995, pp. 271ff., 298, fig. 7.3, a. The only residential palace attested archaeologically at Thebes so far is that of Amenhotep III at Malqatta; see O'Connor 1995, pp. 279–80; Stadelmann 2001, p. 14.

17. Hapuseneb not only presided over the Amun priesthood but also was Governor of the South, "Mouth," and "Ear" of the king. For references, see Lefebvre 1929, pp. 76–81; Helck 1958, pp. 286–89; Ratié 1979, pp. 272–76.

18. Hapuseneb claimed responsibility for overseeing the construction of: Hatshepsut's tomb (*Urkunden* 4, p. 472, ll. 10-13 [KV 20]; see "The Two Tombs of Hatshepsut" by Catharine H. Roehrig in chapter 3), one of the river barques of the god Amun, a temple of Tura limestone, a pylon, and a wood naos, among other projects at Karnak (*Urkunden* 4, pp. 474, l. 5–476, l. 10). An ostracon is preserved carrying a mention of his wife's presenting offerings at the Deir el-Bahri temple (Hayes 1960, p. 37). For Puyemre, see the entry for catalogue no. 51.

19. Sendjehuti may not have served within the time of Hatshepsut, since he is first attested in year 43 of Thutmose III's reign (Dziobek 1998, p. 140).

20. Norman de G. Davies 1933, vol. 2, pl. 1.

21. O'Connor 1995, pp. 266ff., mentions some of the various types of palace activities.

22. On the ḥms.t, see Van den Boorn 1988, p. 17. A later but very striking example of the type of announcement made at a "sitting" is that of Amenhotep IV apparently presenting aspects of a new solar theology that would become "Atenism" (see Redford 1981).

23. Probably comparable in scale to the sprawling palace complex Amenhotep III built the following century at Malqatta in western Thebes (see Lacovara 1997b, pp. 25–28, 35–36 [with bibliography]); and in rigid organization to the ceremonial palace in Memphis of the Nineteenth Dynasty king Merneptah (see O'Connor 1991; O'Connor 1995, pp. 290–92).

24. For paintings at Malqatta, see Waseda University 1993, pls. 1–26, 28; Yoshimura 1995. For Minoan-type wall paintings at the early Eighteenth Dynasty palace at ʿEzbet Helmy in the Delta, see Bietak 1995, pls. 1–4; Bietak 1996, pls. III–VIII; and "Egypt and the Aegean" by Manfred Bietak in chapter 1.

51. Shawabti of Puyemre

Early 18th Dynasty, early reign of Thutmose III
(1479–1445 B.C.)
Limestone
H. 24.5 cm. (9⅛ in.), W. 9.5 cm (3¾ in.)
Museum of Fine Arts, Boston, Gift of Miss Mary S.
Ames 11.1495

This fine shawabti, now unfortunately incomplete, belonged to Puyemre, the Second Prophet of Amun. Puyemre is one of the best-documented officials of the joint reign,[1] and his career continued into the sole reign of Thutmose III. His numerous titles are preserved on a statue discovered in the Mut temple at Karnak and in his tomb in the Theban necropolis.[2] The inscriptions from his tomb, including those on his false-door stela, tell us that his parents were the Noble (*s3b*) Puya and the Royal Nurse Neferiah[3] and that his wives were Tanefret and Seniseneb. Puyemre's tomb

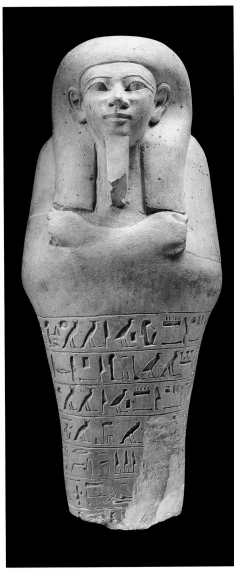

51

faced the causeway leading to Hatshepsut's Deir el-Bahri temple.[4] The architecture and decoration of Hatshepsut's temple are thought to have influenced those of Puyemre's tomb.[5]

Puyemre boasts in the tomb inscriptions of his accomplishments as Second Prophet, among them the supervising of the construction of "a *per-wer* of ebony, worked in fine gold"[6] and two doorways of fine limestone made for the Mut temple on behalf of Hatshepsut. The inscriptions also provide a list of the Theban temples whose deliveries of gold, costly stones, and incense he oversees as the supervisor of the Treasury of Amun.[7]

The decoration of Puyemre's chapel, like that in many other tombs of high officials of the period, was altered during the time of Hatshepsut's proscription: her image and titles were hacked out, and some royal standards of Thutmose III were inserted in front of Puyemre where he is shown receiving the proceeds of that king's campaigns on behalf of Karnak temple.[8] The tomb also suffered damage during the Amarna period, as well as post-pharaonic erasures,[9] but Puyemre's image and titles do not appear to have been the object of systematic attack. Indeed, he seems to have remained in favor, for his sons continued to serve in Theban priesthoods. His eldest son, Menkheper, served as a priest in the memorial temple of Thutmose III, and another son was a *w*ᶜ*b* priest of Amun;[10] however, their careers never approached the brilliance of Puyemre's.

CAK

1. Lefebvre 1929, pp. 24, 25, 80 (Pouyemrê); Kees 1953, pp. 12ff., 52, 317; Helck 1961–69, pp. 22–24, 28, 30, 34, 46, 58–59, 61–62, 64, 73, 76, 81, 83, 87–89, 92–95 (*jpw-m-rᶜ*).
2. For the statue (Egyptian Museum, Cairo, CG 910), see Benson and Gourlay 1899, pp. 315–17; Norman de G. Davies 1922–23, vol. 1, p. 21, vol. 2, pl. LXV, b; and Borchardt 1911–36, vol. 3 (1930), pp. 148–49, pl. CLVII. For the false-door stela from his tomb (Cairo, CG 34047 [JE 25792]), see Lacau 1909–57, pp. 80–82, pl. XXVIII; Lawrence Berman in Hornung and Bryan 2002, pp. 138–39, no. 55. Texts from these monuments are in *Urkunden* 4, pp. 520–22. For the tomb (TT 39), see Norman de G. Davies 1922–23 and Porter and Moss 1960, pp. 71–75.
3. Mond 1905, pp. 80–81: fragments of a costly, white anthropoid coffin with gold leaf bearing the name Puya (read by Mond as Puyim) were discovered early in the last century; see Roehrig 1990, p. 28, n. 76. Neferiah was probably the nurse of Thutmose II; see Roehrig 1990, pp. 28–31, 341, 345, 347.
4. Inscriptions in ink giving his name and main priestly titles appear on stones from the bottom of the walls in the western part of the Deir el-Bahri complex; see Carter and Carnarvon 1912, pp. 38–41, fig. 10.
5. W. S. Smith 1960, p. 115, and see the alternating false door, rounded tablets, and use of colonnades on his tomb facade (discussed in Norman de G. Davies 1922–23, vol. 2, pp. 55ff., app. B), which exhibit parallels with the alternating niches and Osiride figures on the west wall of the upper terrace at Deir el-Bahri.
6. A *per-wer* is a shrine in the form of the great shrine of Upper Egypt; see Dieter Arnold 1982.
7. A delivery of this kind of the treasury is the subject of a scene in Puyemre's tomb, as well as in the slightly earlier tomb of Ineni (TT 81). The significance of both scenes is discussed by Haring (1997, pp. 134ff.).
8. Norman de G. Davies 1922–23, vol. 1, pp. 24–25.
9. Ibid., pp. 22–23.
10. Kees 1953, p. 13, following Norman de G. Davies 1922–23, vol. 2, p. 16, pl. XXX, 1, and pp. 39–40, pl. XLIII.

PROVENANCE: Probably Thebes, TT 39

BIBLIOGRAPHY: Simpson 1977, p. 38, no. 31

52. Maya Seated

Early 18th Dynasty, reign of Thutmose III (r. 1479–1425 B.C.)
Limestone
H. 74 cm (29⅛ in.)
Ägyptisches Museum und Papyrussammlung,
Staatliche Museen zu Berlin 19286
Not in exhibition

Maya, a provincial official, sits, rather stiffly, on a simple block seat. (The flat planes of his face and squared chin accord with a date in Thutmose III's sole reign.) He wears a pleated *shendyt* kilt, a meticulously detailed wig, and the "gold of the king's gift" (*nbw n ḏd-nswt*), or "gold of honor" (*nbw n qn*), awarded him by Thutmose III, whose cartouches appear on his right breast and shoulder. Maya proudly displays the "king's gift," his reward for royal service, which takes the form of a double *shebiu* collar at his neck, two *aᶜa* armlets on each upper arm, and a pair of *mesektu* bracelets at each wrist.[1] Considering his provincial origins, he perhaps looks a little overdressed, but he could hardly appear prouder of his status. The inscriptions on the statue can be translated as follows:

> (front of seat): *Mayor and Overseer of Prophets Maya, justified.*[2]
> (right side of seat): *A royal offering of the gods and goddesses of Wadjyt (the tenth Upper Egyptian nome): May they give*

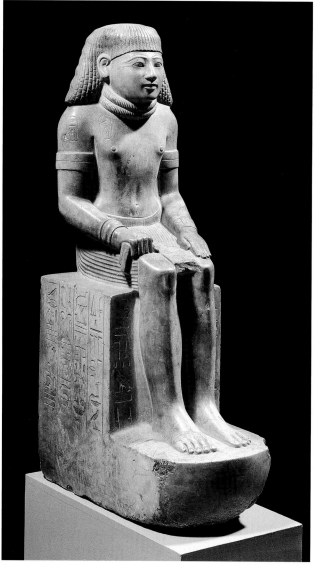

52

offerings. Maya's image was clearly meant to impress, suggesting that it was made for a more public setting, such as the local temple. The provenance of this well-preserved statue remains problematic.[3]

From the beginning of the New Kingdom, this "gold of honor" was associated with distinguished military service.[4] Scholars propose that civil and religious officials who received the award were retired military men.[5] The connection with military accomplishment appears to have still been in force in the Thutmoside period, since Maya names his bravery as the reason he was favored by the king. After the reign of Thutmose III, the gold of honor was no longer restricted to private individuals who served the crown; starting in the reign of his successor, Amenhotep II, the rulers themselves were depicted wearing the *nbw n qn*.[6] CAK

1. For examples of these ornaments in this exhibition, see a prototype of a *shebiu* collar (cat. no. 3), *aʿa* armlets (cat. nos. 110a, b), and a *mesektu* bracelet (cat no. 111).
2. The description "justified" (literally, "true of voice") indicates that the deceased has been judged favorably in the next world. See also the entry for catalogue no. 53.
3. Porter and Moss 1937, p. 14, provisionally accepts an Akhmim provenance; however, recent catalogue treatments of the statue by Karl-Heinz Priese (in *Ägyptens Aufstieg* 1987, p. 200, no. 120) and Klaus Finneiser (in Priese 1991, p. 88, no. 54) name Menshiya as the "probable" original location.
4. Feucht 1977. For another opinion, see Diana Craig Patch's discussion of jewelry in chapter 4.
5. See, for example, the tomb inscription of the Admiral Ahmose, son of Ibana: *Urkunden* 4, p. 3, l. 15, p. 5, ll. 2, 10, and p. 10, l. 3.
6. Feucht 1977, col. 732.

PROVENANCE: Uncertain, probably the ninth or tenth Upper Egyptian nome; acquired in 1909

BIBLIOGRAPHY: *Urkunden* 4, pp. 1370–71, l. 410 (trans. in Cumming 1984, pp. 88–89, l. 410); Roeder 1924, pp. 25–26; Karl-Heinz Priese in *Ägyptens Aufstieg* 1987, p. 200, no. 120; Klaus Finneiser in Priese 1991, p. 88, no. 54

invocation offerings of bread and beer, oxen, and fowl, and everything good and pure; the breathing of the sweet breath of the north wind and the drinking of water at the river eddy (rear of statue): for the ka of the Hereditary Noble and Count, whom the King of Upper Egypt magnified and the King of Lower Egypt enriched, whose place the Lord of the Two Lands advanced, one beneficial to the king, who was distinguished more than (other) men, and whom he elevated from among his attendants.
(left side): One who was rewarded with gold of the king's gift in the presence of the entire land. My lord favored me on account of my bravery, for he knew that I was useful to him.

Maya's studied opulence contrasts sharply with the simplicity with which Satepihu, another provincial official, is rendered in his block statue (cat. no. 53). Satepihu's image was found in the privacy of his tomb chapel, and, appropriately, he sits quietly, waiting to receive

53. Block Statue of Satepihu

Early 18th Dynasty, joint reign of Hatshepsut and Thutmose III (1479–1458 B.C.)
Painted sandstone
H. 82.5 cm (32½ in.), W. 43.5 cm (17⅛ in.), D. 58 cm (22⅞ in.)
The University of Pennsylvania Museum of Archaeology and Anthropology, Philadelphia, Gift of Egypt Exploration Fund E 9217

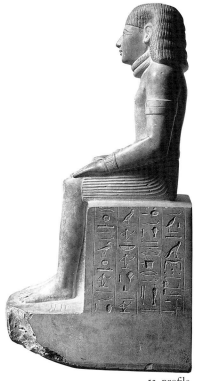

52, profile

Satepihu, a local headman and Overseer of Priests at Thinis, capital of Ta-Wer, the eighth Upper Egyptian nome, is portrayed in this large block statue. The sculpture and a limestone doorjamb bearing Satepihu's name and titles were discovered in his tomb at Abydos, the ancient cemetery of Thinis.[1] Although he was attached to the Thinite nome, Satepihu was also closely connected with the royal court: his mother, Tanetiunet, was a Royal Nurse, probably of Prince Ahmose, a son of Ahmose I.

The piece's large size, material, and good condition are unusual for a statue of its type and period. The appearance of Hatshepsut's Nebty name (*Wadjet-renput*, "green of years") on the doorjamb securely places Satepihu within the joint reign.[2] Additional evidence for this dating is Satepihu's inclusion in a relief at Hatshepsut's Deir el-Bahri temple in which he is shown as one of three jubilant officials at the prow of a barge transporting a pair of obelisks to Karnak.[3] The style of the statue, particularly the almost feminine facial features and the relative simplicity of its form, is consistent with this dating.

Block statues are more often found in temples than in tombs. It might appear, therefore, that Satepihu's image is exceptional because of its funerary use. This is, however, not the case, for Satepihu's tomb was located near the great processional way leading from the temple of Osiris to the Umm el-Qaab, burial place of the Early Dynastic kings of Egypt, which came to be identified with the tomb of the god. Because of its proximity to this holy place, which ensured that he would be able to participate in the great festivals of Osiris in perpetuity, Satepihu's tomb combined the functions of a real burial place and a votive chapel.[4]

The statue bears a long inscription that begins at the front at the upper right, proceeds in horizontal lines down to the feet, and then turns the corner to continue in vertical columns on the proper right side. The text begins with an invocation to Onuris,[5] propitiates the god with a series of laudatory epithets, such as "God of Gods, King of Heaven . . . the self-created Great God, primeval one who bore the primeval ones," and then lists some of the deceased's good qualities, characterizing him, for example, as "one gracious of heart who is served, the heir of one excellent of character . . . a god-given son." The inscription ends with an address to Satepihu, describing his rejuvenated state:

Your heart will guide you, and your limbs will obey you. You will prevail over the flood waters and the north wind that issues from the Marshlands. You will eat bread whenever you desire, as you did when you were alive. You will see Re every day, and your face will behold the disk (aten) when it rises. Offerings will be given to you in Heliopolis and gifts of Thinis in Ta-Wer. You will rest in the Hall of the Two Truths. The Netherworld will open its door to you so that you may adore the God (Osiris) upon his seat, without your being turned back at the doorposts. You will cross in a ferryboat as you desire and cultivate in the Field of Rushes. You will stride about freely with those who are in the retinue of the Followers of Horus. The Local Ruler and Overseer of Priests in Thinis Satepihu, justified.

CAK

1. For the tomb, see Randall-MacIver and Mace 1902, pp. 61, 64–65, 70–71, 84, 94–95, 97, pl. XXIII; for the doorjamb (The Metropolitan Museum of Art, New York, 00.4.60), see ibid., pp. 85, 95, pl. XXXIV; Hayes 1959, p. 113.

2. One of a king's formal names is the Nebty name, also called the Two Ladies name (it is shown with symbols of the goddesses Nekhbet and Wadjet).

3. *Urkunden* 4, p. 517, l. 6; Naville 1894–1908, pt. 6, pl. CLIV.

4. For an overview of Osiris and his cult, see Griffiths 1982 (with bibliography).

5. Onuris was the "royal huntsman" (Schenkel 1982b), whose cult had predated that of Osiris in the eighth (Thinite) nome. Although some scholars (Gary Scott in N. Thomas 1995, p. 180, no. 81, and Denise M. Doxey in Silverman 1997, pp. 132–33, no. 38) have maintained that Osiris is included in the invocations, his name appears only once, and as a designation of the deceased (*Urkunden* 4, p. 519, l. 12). It is possible, however, that the epithets on the front of the statue beginning with "God of Gods" obliquely refer to Osiris rather than to Onuris.

PROVENANCE: Abydos, Tomb D9; Egypt Exploration Fund Excavation, 1899–1900

BIBLIOGRAPHY: Randall-MacIver and Mace 1902, pp. 61, 71, 84, 94–95, pls. XXXII, XXXIII; Ranke 1950, p. 34, fig. 22; Horne 1985, p. 21, fig. 9; Gary Scott in N. Thomas 1995, p. 180, no. 81; Denise M. Doxey in Silverman 1997, pp. 132–33, no. 38

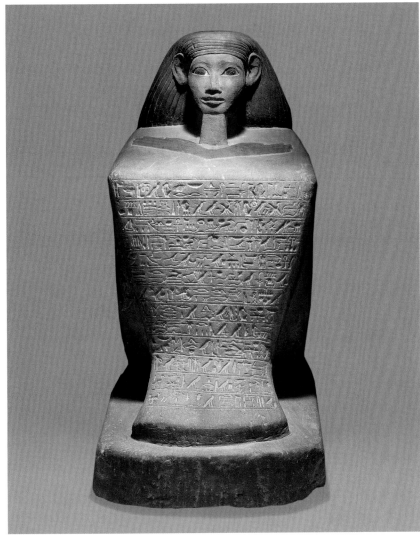

53

54. Mentekhenu, Seated

18th Dynasty, reign of Thutmose III–early reign of
Amenhotep II (1450–1420 B.C.)
Granodiorite
H. 83 cm (32⅝ in.)
Ägyptisches Museum und Papyrussammlung,
Staatliche Museen zu Berlin 19289

Like Maya (cat. no. 52), the Fanbearer on the
King's Right and Overseer of the Watch (at the
Palace) Mentekhenu wears the "gold of honor."
Maya's ensemble is more complete, however.
Mentekhenu has the double *shebiu* collar but no
mesektu bracelets, and only a single pair of *aʿa*
armlets is visible; if he has a second pair, it is hid-
den by the cloak that covers his proper left
shoulder. His cloak continues from his shoulder
down to his ankles, serving as a backdrop to a
single line of text that expresses his desire for
"everything that comes forth from upon the
altar of Amun in Ipet-Sut (Karnak) for the ka
of the Fanbearer Mentekhenu." Given this
inscription, we can probably assume that the
statue was intended for placement at Karnak, to
allow Mentekhenu to share in the bounty of the
offerings to the god. In his left hand Mentekhenu
holds an enlarged version of the flabellum hiero-
glyph used in the spelling of his title; it is his
emblem of office and he grasps it tightly.

The longer texts on either side of the seat are
inscribed with offering prayers: on the proper
left, one directed to Amun-Re; on the right, one
for Amun-Re's consort, Mut.

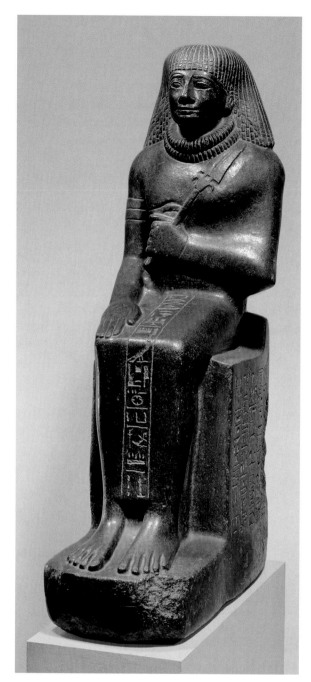

54

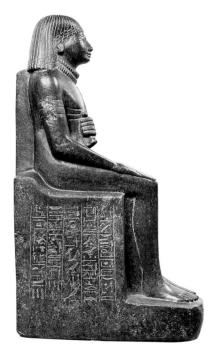

54, profile

We know nothing of Mentekhenu beyond
the information offered in the inscriptions on
this statue. His name, roughly translated, means
something like "enduring of obelisks."[1] Accord-
ing to the list of his titles, he was not only
Fanbearer and Overseer of the Watch but also a
Child of the Nursery (or page),[2] indicating that
he may have grown up close to a young king,
probably Amenhotep II. Although the gold of
honor and his role as a guardian of the palace
suggest that he, like Maya, may once have had a
military career, there is no specific reference to
such an occupation in the statue's texts.

A date late in the sole reign of Thutmose III
or early in the reign of Amenhotep II is sug-
gested by the squared-off chin, the heaviness of
the facial features, and the well-spaced eyes.

CAK

1. Perhaps a shortened form of a basilophoric name
(i.e., containing a king's name), such as "King
(Thutmose III) is enduring of obelisks." Porter and
Moss 1972, p. 281, gives the name as Menmenu
"Enduring of monuments."
2. Egyptian *ḫrd n k(ȝ)p*; see Schenkel 1977. Holders
of this title usually had achieved middle-rank
status at court.

PROVENANCE: Probably Thebes, Karnak temple;
acquired in 1909

BIBLIOGRAPHY: Roeder 1924, pp. 23–24; Karl-
Heinz Priese in *Ägyptens Aufstieg* 1987, pp. 246–47,
no. 177; Klaus Finneiser in Priese 1991, p. 89, no. 55;
Monika Dolińska in *Geheimnisvolle Königin
Hatschepsut* 1997, pp. 138–39, no. 45; Matthias Seidel
in Petschel and von Falck 2004, pp. 77–78, no. 66

THE ROYAL STEWARD, SENENMUT

THE CAREER OF SENENMUT

Peter F. Dorman

Senenmut may justifiably be described as one of the most eminent and influential personages of the Eighteenth Dynasty, yet nothing about his beginnings suggests future greatness. His parents were of relatively lowly origin, and neither seems to have risen to prominence or held any administrative or religious office. His father, Ramose, is known only by the honorific "worthy" and seems to have died rather young and without benefit of elaborate embalming. Senenmut's mother, Hatnefer, is referred to only as "Lady of the House," a title that connoted respectable married status. She lived long enough, however, to see her son acquire responsibility for the economic domains (agriculture, cattle breeding, wine making, and accounting) of the great temple of Amun at Karnak; consequently, she was buried in far more lavish style (see, above, "The Tomb of Ramose and Hatnefer" and cat. no. 41).[1] Senenmut was one of at least six siblings, but none of his brothers and sisters achieved the fame or influence that he did, and they are known chiefly from depictions and texts in Senenmut's tomb.[2] The family may have originated in the town of Armant, south of Thebes on the west bank of the Nile, for two resident goddesses of Armant, Renenutet and Iunyt, are well represented on Senenmut's statues, indicating a particular devotion to their local cults.[3]

The date at which Senenmut began to play an active part in public life is difficult to ascertain, since none of his monuments predates the accession of Thutmose III (r. 1479–1425 B.C.). It has been suggested that he spent some years as a soldier, but none of his numerous titles reflects any such involvement.[4] He may have begun service to the royal court as an Overseer of Seals or Overseer of the Audience Chamber, possibly as early as the reign of Thutmose I (r. 1504–1492 B.C.). His association with the royal women of the Eighteenth Dynasty seems to have been assured when he was appointed tutor to the princess Neferure and steward of her estate, very likely by her father, Thutmose II (r. 1492–1479 B.C.), and when he was later named Great Steward of the God's Wife, Queen Hatshepsut (Nefurure's mother). At the unexpected death of Thutmose II, when the necessity of ruling was suddenly thrust into Hatshepsut's hands (see, above, "Hatshepsut: Princess to Queen to Co-Ruler"), Senenmut was primarily in charge of administering the households of the widowed queen and her daughter and was otherwise only a midlevel administrator in the temple of Amun at Karnak.

The beginning of Hatshepsut's regency for Thutmose III allowed Senenmut expanded responsibilities, doubtless owing to her favor, including the extraction of two obelisks at Aswan (see fig. 37).[5] He dedicated three votive statues at Karnak, two of them depicting him as royal tutor with the princess Neferure (cat. nos. 60, 61), and had a sandstone shrine carved for himself at Gebel el-Silsila, south of Thebes, presumably in conjunction with his reopening the sandstone quarries there for new temple construction at Karnak.[6] When Hatshepsut declared herself pharaoh, probably by year 7, Senenmut acquired the primary office he would hold until his death—Great Steward of Amun—which gave him control over the burgeoning secular activities of the temple of Karnak. His administrative reach is attested by several objects owned by officials who worked as members of his staff (see cat. nos. 55, 56).

At the height of his official powers, Senenmut had a series of private monuments produced attesting to his achievements and status. He commissioned a vast funerary complex in western Thebes (numbered by modern scholars as two separate tombs; see, below, "The Tombs of Senenmut") that was the largest of its time, and no fewer than twenty-five of his statues are known, carved from a variety of materials.[7] This sculptural corpus is extraordinary not only for its sheer numbers but also for the many "firsts" found within it.[8] Senenmut can claim the earliest "tutor" statue, showing an individual with his royal ward (see cat. nos. 60, 61; figs. 48, 49);[9] the first sistrophorous statue, representing the owner kneeling to present a votive sistrum to a deity (see cat. nos. 66–69); the earliest naophorous sculpture, of a male subject holding a shrine;[10] the first statue depicting an individual with a field surveyor's coiled measuring rope (cat. no. 65); and the earliest sculpture showing an official presenting a votive emblem of the Maatkare (prenomen of Hatshepsut) cryptogram, a snake wearing a horned sun disk perched on a pair of raised arms (see cat. nos. 70–72). A good number of the statues were donated, according

Fig. 45. Senenmut in a devotional posture. Wall relief, early 18th Dynasty. This and similar images of Senenmut were carved behind door jambs in Hatshepsut's temple at Deir el-Bahri.

The latter part of Senenmut's career is obscure. It appears that he never married, as no wife is represented in the wall paintings in his tombs, nor are any children. In the tomb scenes, either Ramose or Hatnefer takes the position at the offering table normally occupied by the deceased's wife, and one of Senenmut's brothers is shown performing the daily ritual offering that would usually be undertaken by the oldest son.[15] Whether Senenmut outlived Hatshepsut, and exactly how and when he died, are questions that cannot yet be answered. He is shown with Princess Neferure on a stela of year 11, at Sinai (fig. 46), and the last dated document containing his name is an informal record of conscript labor, on an ostracon from year 16.[16] Curiously, there is no evidence that either component of his funerary monument was used for his burial: the decorated chamber in Tomb 353 was abandoned and sealed while still full of excavated chip and workmen's tools, and his quartzite sarcophagus was left unfinished in the corridors of Tomb 71.

Senenmut suffered a series of posthumous attacks on his memory. The inconsistent pattern of the erasures of his name on his statues and in his tomb, and of other damage, has led scholars to suggest a variety of agents and motives for this persecution. Some have posited Hatshepsut or Thutmose III as the instigator, either because Senenmut had inappropriately usurped royal prerogatives, or because he was supporting one of the co-regents

to their inscriptions, by Hatshepsut or Thutmose III and therefore reflect the finest output of the royal ateliers. More extraordinary marks of the royal favor lavished on Senenmut include a quartzite sarcophagus[11] and permission to carve his own devotional reliefs at Hatshepsut's funerary temple at Deir el-Bahri and in "all the temples of Upper and Lower Egypt" (fig. 45).[12]

As Great Steward of Amun, Senenmut oversaw construction at the temple of Mut in Karnak's southern precinct, at the main temple of Karnak, at the temple of Luxor, and at Hatshepsut's mortuary temple.[13] The common claim that Senenmut was the architect of Deir el-Bahri is based largely on his holding the rare title Overseer of Works of Amun in Djeser-djeseru (that is, the temple at Deir el-Bahri), but it is otherwise unsubstantiated.[14] Some of the smaller objects bearing his name are also inscribed with the cartouche of Hatshepsut and a dedication text referring to a deity and a specific temple (see cat. no. 59). Such objects may originally have been intended for a ceremonial deposit in a temple's foundation, with the name of Senenmut added secondarily. Other small objects displaying the names of both Hatshepsut and Senenmut (see cat. no. 58) seem to be devotional items designed from the start as tokens of royal favor.

Fig. 46. Year 11 stela. Senenmut is depicted behind Princess Neferure, who makes an offering to the goddess Hathor. Carved into the bedrock at Sinai, ca. 1468 B.C.

against the other.[17] Here again, there is no clear answer to be had. Senenmut's name—not his visage—was erased on many of his monuments, but not on all,[18] and a large number of his statues escaped this unwelcome attention. His persecution seems not to be connected with that of Hatshepsut, after her death,[19] nor is it a peripheral phenomenon linked with the Atenist attacks against the Amun cult, which took place in the reign of Akhenaten (r. 1349–1336 B.C.).[20] Like so much in the life of Senenmut, the reason for the attacks on inscriptions of his name remains for the moment a mystery.

1. For a comparison of Ramose's embalming and burial goods with those of Hatnefer, see Dorman 2003, pp. 32–33.

2. See Dorman 1991, pp. 137, 117, frontis., and pls. 82c, 83b; Dorman 1997. The six anonymous mummies placed in Ramose and Hatnefer's burial chamber may include some of these siblings. To judge from the amount of desert gravel and dirt mixed in with their bandages, the mummies may have been exhumed from a nearby family cemetery—indeed, Armant is not far away—and reburied in the precincts of Senenmut's grand mausoleum; see Dorman 1988, pp. 167–69; and Dorman 2003, pp. 33–34.

3. Inscriptions on three statues mention these goddesses: catalogue nos. 68, 70, and 71. Similarities in the composition and phraseology of the inscriptions suggest that the statues were made at the same time; see Dorman 1988, pp. 127–28. As intimated by Helck 1958, p. 222, Senenmut's title Overseer of Priests of Armant may indicate that he was in charge of construction projects in that town.

4. The primary evidence of a military connection is a badly damaged section of a wall painting in Senenmut's chapel (TT 71) depicting a running soldier holding an axe over his shoulder—perhaps a fragment of a battle scene—with booty mentioned in the accompanying text; see Helck 1958, p. 356, and Meyer 1982, pp. 9–10. However, none of the ninety-three titles known to have been held by Senenmut, or their variants (see Dorman 1988, pp. 203–11), has a military connotation.

5. Habachi 1957, pp. 92–96.

6. A third votive statue dedicated at this time is catalogue no. 64. For his Gebel el-Silsila shrine, see Caminos and James 1963, pp. 53–56, pls. 33, 34, 40–44.

7. The range of materials—diorite, quartzite, granite, sandstone, alabaster, graywacke, and porphyry—alone is astonishing, reflecting Senenmut's access to the production of a number of quarries scattered throughout Egypt and the deserts beyond.

8. On this phenomenon, see Meyer 1982, pp. 74–93. See also "The Statuary of Senenmut" later in this chapter.

9. No fewer than ten statues show Senenmut with Neferure. Two are illustrated in this publication (cat. nos. 60, 61); three are located above his tomb chapel (TT 71; fig. 47) and in the Sheikh Labib and Karakol magazines at Karnak;

and the others are in the Ägyptisches Museum und Papyrussammlung, Staatliche Museen zu Berlin (fig. 48), and the Egyptian Museum, Cairo (CG 42114, CG 42115, CG 42116, JE 47278).

10. Egyptian Museum, Cairo (CG 42117); see Meyer 1982, pp. 126–29, no. 3, for a description and Dorman 1988, p. 192, for later references.

11. Dorman 1991, pp. 70–76, pls. 30–34. Quartzite was typical of royal interments of the time. Moreover, as noted by Hayes (1950), in its unusual oval shape Senenmut's sarcophagus is strikingly similar to the cartouche-shaped sarcophagi carved for kings.

12. For the reliefs of Senenmut at Deir el-Bahri, placed behind a number of doors, and his express permission to place reliefs there, see Hayes 1957, pp. 80–84. His boast that he also had such images carved in other temples has been corroborated by the recent discovery of depictions of him in two doorways at the temple of Mut at Karnak, one of which is mentioned in Fazzini 2002, pp. 69–70; the second, discovered by Betsy M. Bryan in 2004, is unpublished.

13. Many of these activities are mentioned in the inscription on his statue discovered at the temple of Mut (cat. no. 66).

14. This title appears on a single statue (cat. no. 71) and in Senenmut's burial chamber (TT 353); its rarity suggests that Senenmut did not widely employ it. Other officials, such as Djehuti, owner of Theban Tomb 11, were more explicit about the role they claim to have played in the building of Hatshepsut's temple and in the training of the workmen; see *Urkunden* 4, pp. 419–30.

15. Such scenes appear on the interior lintel of the doorway of Tomb 71 and in the carved niche, and on both false-door stelae in Tombs 71 (cat. no. 73) and 353; see Dorman 1991, frontis. and pls. 9b, 10, 16a.

16. For the year 11 stela from Sinai, see Gardiner, Peet, and Černý 1952–55, no. 177, pl. LVI; for the year 16 ostracon, see Hayes 1960, pp. 39–41.

17. For a summary of the main scenarios suggested for Senenmut's persecution, see Dorman 1988, chap. 6.

18. In Senenmut's chapel (TT 71), which was never sealed, only inscriptions of his name exhibit damage. His intended burial chamber (TT 353) was sealed but breached, probably by potential tomb robbers, who scratched only some of the faces of the individuals portrayed in the tomb and never touched inscriptions of Senenmut's name; for these curious disparities, see Dorman 1991, p. 163. Oddly, during the systematic Ramesside restorations of inscriptions of the name of Amun, Senenmut's name on his false-door stela in Tomb 71 (cat. no. 73) was recarved. The stonecutters may have assumed that the hacking of his name was connected to the obliteration of Amun's, and took steps to repair it.

19. For example, on only three of his statues do inscriptions of both Hatshepsut's and Senenmut's names show evidence of attack; see Dorman 1988, pp. 158–59.

20. It is possible, as posited by Schulman 1969–70 and Jacquet-Gordon 1972, that inscriptions of Senenmut's name were targeted during the Amarna period because of the appearance of the vulture hieroglyph (equated with Amun's consort, Mut) in his name; for difficulties with this interpretation, see Dorman 1988, pp. 159–60.

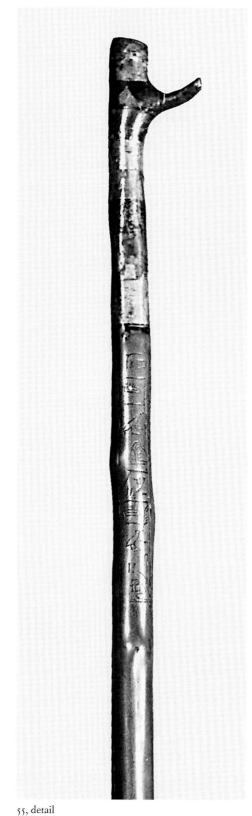

55. Staff of Tusi

Early 18th Dynasty, joint reign of Hatshepsut and
Thutmose III (1479–1458 B.C.)
Wood, birch bark, silver
L. 104 cm (41 in.)
Ägyptisches Museum und Papyrussammlung,
Staatliche Museen zu Berlin 14348

Staves were a sign of status in New Kingdom
Egypt. This staff is typical of the basic design: a
slender shaft of wood, slightly broadened at the
base, with a portion of twig protruding near the
upper end, presumably to serve as a handle over
which to hook the thumb. The butt end of this
example is sheathed in a ferrule made of ham-
mered silver, and the upper end is wrapped in
smooth strips of silver-birch bark to provide a
grip for the hand. The birch bark was in all like-
lihood a rare, luxurious addition. The birch is
not native to Egypt, and one of the few other
known uses of birch bark was to adorn royal
objects placed in the tomb of Tutankhamun.

An inscription on the shaft reads: "The
Overseer of Amun, Senenmut; the Overseer of
the Cultivators of Amun, Tusi." The juxtaposi-
tion of the two names is unusual. In view of
Senenmut's responsibility to oversee the agri-
cultural activities of the temple of Amun, the
staff was probably a prestigious gift from
Senenmut to one of his trusted administrators in
charge of supervising farm work. The staff is
somewhat short for practical use—another fea-
ture that may be indicative of its nature as pri-
marily a visible emblem of status. The staff was
intentionally broken, in antiquity, perhaps at the
time of burial, as an effort to render it harmless
to the owner in the afterlife. PFD

PROVENANCE: Unknown

BIBLIOGRAPHY: Spiegelberg 1897, p. 91; Helck
1939, p. 45 (zd); Helck 1958, p. 474 E; Porter and Moss
1964, p. 843; Hassan 1976, p. 139, pl. 8, 7; John K.
McDonald in *Egypt's Golden Age* 1982, pp. 178–79,
no. 204; Meyer 1982, pp. 261, 289, n. 4; Dorman 1988,
p. 139

56. Whip Handle of Nebiri

Early 18th Dynasty, joint reign of Hatshepsut and
Thutmose III (1479–1458 B.C.)
Wood, traces of pigment
L. 4.54 m (14 ft., 10¾ in.)
The Metropolitan Museum of Art, New York,
Rogers Fund, 1923 23.3.46

Carved in the shape of a long blunt club, this
heavy whip handle has a rectangular opening to
allow the attachment of two broad leather
thongs. Whips were not used only for chastise-
ment or punishment; tomb paintings occasion-
ally depict naval overseers wielding such whips,
urging their sailors on as they pull on the oars.
The inscription on the whip handle gives the
title and name of one such overseer: "The skip-
per of Senenmut, Nebiri."[1] Nebiri may have
received an appointment as captain on one of
the transport boats under Senenmut's charge.
The signs retain traces of the blue pigment with
which they were once colored. Both the shaft of
the handle and the opening for the leather lashes
are well worn, providing evidence of vigorous
and enthusiastic use. PFD

1. For the word *nfw*, "skipper," see Jones 1988, p. 77.
 The names of the boats skippered by these captains
 can appear as part of their title.

PROVENANCE: Western Thebes, Deir el-Bahri, from
the huts between the temple causeways of Mentuhotep
II and Hatshepsut; Metropolitan Museum of Art exca-
vations, 1922–23, acquired in the division of finds

BIBLIOGRAPHY: Winlock 1923, pp. 31–32, fig. 26;
Helck 1958, p. 475 L; Hayes 1959, p. 112, fig. 59; Porter
and Moss 1964, p. 626; Meyer 1982, p. 261; Dorman
1988, p. 139

55, detail

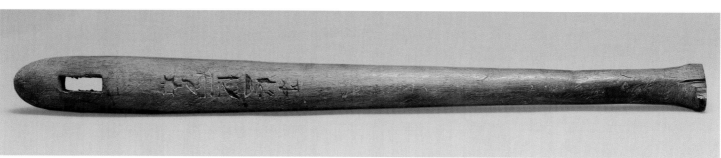

57 58 59

PROVENANCE: Unknown

BIBLIOGRAPHY: Bothmer 1969–70, p. 126, n. 5, figs. 9–11; James 1974, p. 78, no. 179, pl. XLVII; Del Nord in *Egypt's Golden Age* 1982, p. 251, no. 351; Richard A. Fazzini in *Ägyptens Aufstieg* 1987, pp. 337–38, no. 289; Dorman 1988

57. Cylinder Seal of Senenmut

Early 18th Dynasty, joint reign of Hatshepsut and
Thutmose III (1479–1458 B.C.)
Greenish blue–glazed steatite
H. 2.1 cm (⅞ in.), Diam. 1 cm (⅜ in.)
Museum of Fine Arts, Boston, Gift of Horace L.
Mayer, 1967 67.1137

This seal is one of the last manifestations in
pharaonic Egypt of a form of property valida-
tion that was adopted at the very dawn of
Egyptian history. Used to imprint moist clay
seals and tablets with the name and titles of the
owner of an object or the sender of a document,
cylinder seals were developed in Mesopotamia
and were apparently borrowed by the Egypt-
ians at the end of the fourth millennium B.C.
Ideal for writing systems that utilized clay as a
medium, such seals were of limited practical-
ity in Egypt; in the Nile valley the use of
cylinder seals was restricted to imprinting jar
stoppers and mud seals. Nonetheless, in the
Old Kingdom royal and private seals were
widely employed, some of them made of pre-
cious materials and given away as prestigious
royal gifts. By the Middle Kingdom, cylinder
seals were largely replaced by stamp seals and
scarabs for the purpose of sealing documents,
but the cylindrical form itself continued at least
into the early New Kingdom, though much
reduced in size and retained, perhaps, only for
archaized prestige reasons. Senenmut's seal is in-
scribed "Great Steward of (Amun), Senenmut;
Overseer of the Cattle of Amun, Senenmut" and
may have been worn as a form of jewelry.

<div style="text-align:right">PFD</div>

PROVENANCE: Unknown

BIBLIOGRAPHY: Edward Brovarski in *Egypt's
Golden Age* 1982, pp. 240, 308, no. 319; Edward
Brovarski in *Ägyptens Aufstieg* 1987, pp. 336–37,
no. 288; Dorman 1988, p. 110, n. 2

58. Hathor Amulet of Senenmut

Early 18th Dynasty, joint reign of Hatshepsut and
Thutmose III (1479–1458 B.C.)
Carnelian
H. 2.1 cm (⅞ in.), W. 1.7 cm (⅝ in.)
Brooklyn Museum, Gift of Mr. John Hewett, 1962
62.192

This polished red carnelian stone is carved in
the form of the goddess Hathor, shown in her
bovine aspect, as is evident from her cow's ears.
Heavy tresses of hair frame her face and fall
down either side of her neck, ending in heavy
rolls. The top and back of the amulet are
inscribed with a short text:

> *Maatkare (Hatshepsut),*
> *beloved of Iunyt;*
> *the hereditary prince and Great Steward*
> *of Amun,*
> *Senenmut*

The epithet "beloved of Iunyt" refers to the
resident goddess of Armant (Iunet), a town just
south of Thebes where Senenmut's family may
have originated.[1] Hathor is found in syncretic
associations with a number of goddesses, such
as Isis and Iunyt; indeed, Senenmut's statue in
Munich (cat. no. 68) depicts him presenting a
Hathor-headed sistrum, though the dedicatory
text refers to Iunyt of Armant. A number of
small objects are known that, like this amulet,
are inscribed with the names of both Hatshepsut
and Senenmut, one directly following the other.
The inscriptions suggest that the objects were
gifts of the monarch to her chief steward.[2]

<div style="text-align:right">PFD</div>

1. Meyer 1982, pp. 11–12; Dorman 1988, p. 166.
2. The most prominent example of the juxtaposed
names of Hatshepsut and Senenmut is the astronom-
ical decoration of the ceiling of Senenmut's intended
burial chamber (TT 353; see fig. 54). That tomb was
doubtless provided, at least in part, through royal
munificence.

59. Bead Inscribed for Hatshepsut and Senenmut

Early 18th Dynasty, joint reign of Hatshepsut and
Thutmose III (1479–1458 B.C.)
Glass
Diam. 2 cm (¾ in.)
The Metropolitan Museum of Art, New York,
Purchase, Edward S. Harkness Gift, 1926 26.7.746

This large glass ball bead has been pierced, pre-
sumably for stringing, and is among the smaller
decorative objects that attest to the construction
activities of Hatshepsut in the Theban area.
The incised inscription invokes Hatshepsut, by
her prenomen, and Hathor, in the form in which
she was worshiped at Hatshepsut's temple at
Deir el-Bahri, in her own shrine. It reads: "The
Good God(dess) Maatkare, beloved of Hathor,
who resides in Thebes, preeminent in Djeser-
djeseru; the hereditary count, the steward
Senenmut." Uncommonly, the feminine endings
of the royal epithets referring to Hatshepsut
have been dropped. The dedication to Hathor is
similar in form to the dedications inscribed on
objects (such as jars, tools, amulets, and scarabs)
found in foundation deposits, which were cere-
monially laid when construction began on a
temple. These inscriptions proclaimed the
monarch's filial piety toward the deity being
celebrated. The addition of the name and titles
of Senenmut in a separate line of text below the
dedication suggests that the bead was adapted
to a use other than its original one.[1]

<div style="text-align:right">PFD</div>

1. Senenmut seems to have confiscated several small
objects destined for foundation deposits for other
temples planned by Hatshepsut and to have placed
them in five deposits scattered around the entrance
of his own intended tomb (TT 353).

PROVENANCE: Purchased in Luxor; formerly
Amherst collection; formerly Carnarvon collection

BIBLIOGRAPHY: Sotheby's 1921, lot 654; Hayes
1959, p. 105; Dorman 1988, p. 200

SENENMUT, ROYAL TUTOR TO PRINCESS NEFERURE

In the early Eighteenth Dynasty, several titles that single out women and men entrusted with the upbringing of the royal children came into use.[1] Usually translated as Royal Nurse (*mnˁt nswt*) and Royal Tutor (*mnˁ nswt*), the titles appear only in the Eighteenth Dynasty. Both are derived from the word *mena*, which means "to suckle"; the feminine title can be interpreted literally, as "wet nurse."[2] A number of Royal Nurses lived into the reigns of their nurslings and gained a second title, One Who Nurtured the God (*šdt nṯr*).[3] Because of their close bond with the reigning king, these women are often prominently represented in the tombs of their husbands or sons, and at least two were given the signal honor of burial in the Valley of the Kings. One of these was Hatshepsut's nurse, Sitre, who was buried in a tomb only a short distance from that of her ruler (see fig. 75).

While the role of a Royal Nurse is relatively clear-cut, the office of Royal Tutor is somewhat more difficult to define. In one representation a tutor is seen teaching archery to a prince; however, most images simply depict the tutor with a young child, sometimes a boy and sometimes a girl. The men seem to have acted at first as guardians and later as overseers of the physical and/or intellectual training of the maturing child (or children) in their care.[4] In a few cases a tutor, like female counterparts, was eventually granted the title One Who Nurtured the God (*šdi nṯr*) after his charge became king.

The most famous Royal Tutor was Senenmut, who filled this function for Hatshepsut's daughter, Neferure, and was probably appointed during the reign of Thutmose II, Hatshepsut's husband and Neferure's father. Our first evidence of this relationship, however, comes in the form of a statue that dates from the years of Hatshepsut's regency for Thutmose III, her nephew and Neferure's half brother (cat. no. 60). This is the first work of Egyptian art showing the close association between a Royal Tutor or Royal Nurse and a young member of the royal family, and the statue itself, Senenmut seated and Neferure on his lap, is unique in pose.

Senenmut clearly valued his relationship with the princess to a very high degree, for he had not one but ten statues made of himself with her, including one that was carved out of the bedrock above his tomb chapel on Sheikh abd el-Qurna, in the vast necropolis of western Thebes (fig. 47).[5] It is in the form of a block statue, a type that dates from the Middle Kingdom, in which a man is shown seated on the ground with his knees pulled up in front of him and wrapped in a cloak. To this traditional form Senenmut added the small head of the princess, wearing a sidelock of hair and holding her finger to her mouth, two artistic conventions that identify a young child. The composition expresses Senenmut's guardianship of the princess, whose small form, with her head tucked under his chin, is completely surrounded and thus protected by his large enveloping one. This eloquent image became the one repeated later in the dynasty by tutors who wished to commemorate a relationship with a royal charge.[6] Senenmut himself commissioned six other block statues of this type, at least five of which were set up in the temple of Amun at Karnak, whose estates he oversaw. On the two best-preserved examples (see fig. 48), the title Royal Tutor does not appear in the inscriptions.[7] Presumably it was considered unnecessary, for the statue itself embodied the title.

Two other statues depict Senenmut with Neferure. One of these, now in the Egyptian Museum in Cairo (fig. 49), shows Senenmut seated on

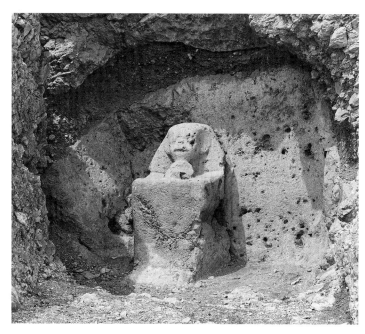

Fig. 47. Senenmut with Neferure. Block statue carved into the bedrock above Senenmut's Theban tomb chapel (TT 71), early 18th Dynasty

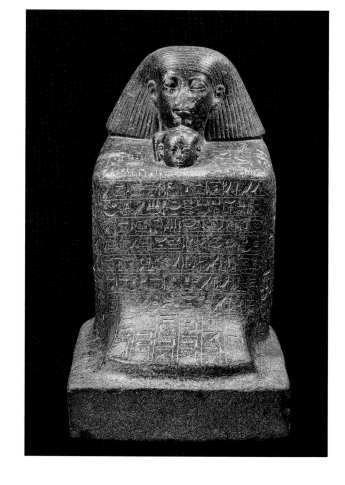

Fig. 48. Block statue of Senenmut with Neferure, early 18th Dynasty. Granite. Ägyptisches Museum und Papyrussammlung, Berlin (2296)

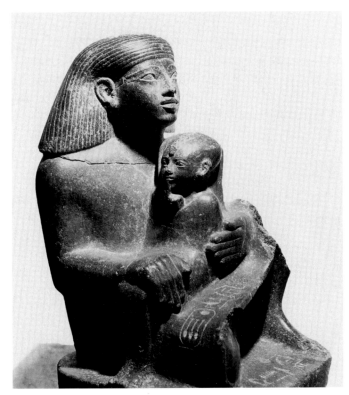

Fig. 49. Senenmut with Neferure, early 18th Dynasty. Granite. Egyptian Museum, Cairo (CG 42116)

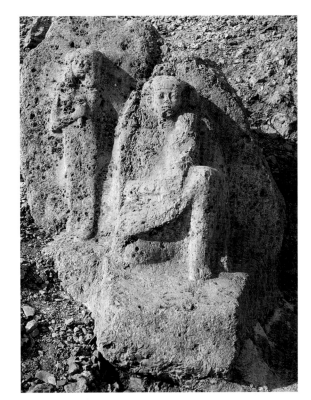

Fig. 50. Senimen holding Neferure and accompanied by his wife. Carved into a limestone boulder above Senimen's Theban tomb (TT 252), early 18th Dynasty

the ground with one leg raised. The small Neferure sits sideways on his lap, her back against his knee, while Senenmut's huge hands hold her snugly and protectively against his chest. This pose is based on traditional images of a mother and child that date back nearly a thousand years to the age of pyramids. Only on one other occasion was it used by a tutor, when Senimen, who was also briefly a guardian of Neferure, had a boulder above his tomb carved with the image (fig. 50).[8]

The final statue representing Senenmut with Neferure shows him striding forward, holding the princess before him (cat. no. 61). Like the earliest example (cat. no. 60), this is the only work of its kind.

Because of the variety and number of Senenmut's tutor statues and the fact that he is the first Royal Tutor or Royal Nurse to depict himself together with his royal charge, it seems natural to attribute the idea for the statues to Senenmut himself. This group is all the more impressive because the representation in sculpture of a royal and a nonroyal person together is unprecedented and abrogates a number of seemingly inviolate rules of Egyptian art. These include the general conventions that a royal person, even a child, is represented in a larger scale than nonroyalty; that a royal individual is never touched except by another royal person or a deity; and that a royal person never interacts in an obvious way with (let alone touches) a person of lower rank.

One other unique sculptural work may also owe its form to Senenmut. Many pieces of a statue were discovered by the Metropolitan Museum's Egyptian Expedition among the fragments of statuary in Hatshepsut's temple at Deir el-Bahri. The lifesize statue is of a woman sitting on a bench with a miniature king seated sideways on her lap. The inscription identifies the woman as the "Chief Nurse who nurtured the Mistress of the Two Lands, Sitre, also called Inet."[9] The miniature king is her former nursling, Hatshepsut. The same composition of a small king on the lap of an adult, used as a retrospective commemoration of a

nurse or tutor of the king, occurs in two later tomb paintings. They were undoubtedly inspired by the example of this statue, which once stood on the middle terrace in Hatshepsut's temple, probably near the reliefs depicting her divine birth.

Senenmut's role of guardian to Neferure, which he seems to have acquired early in his career, was probably a first step toward his later high position as one of Hatshepsut's principal officials. Beyond that, the great artistic creativity and capacity for innovation he demonstrated in his astonishing corpus of statuary indicate an innate talent that is likely to have been recognized and rewarded with further responsibilities and honors.[10] Although Senenmut has no titles that state a direct involvement in designing Hatshepsut's temple at Deir el-Bahri, the presence of his image in the temple (fig. 45) and the evidence of his statues suggest that it was he who provided the inspiration for this monument, in which structure, sculpture, and landscape combine to form one of the world's great architectural masterpieces.

CHR

1. The first evidence of the titles occurs in connection with Queen Ahmose-Nefertari, who had two nurses. For information on these titles and the individuals who held them, see Roehrig 1990.
2. On this title, see ibid., pp. 314–21.
3. A longer version of the title is One Who Nurtured the Body of the God (*šdt h3w ntr*). On this title, see ibid., pp. 327–29.
4. On the title Royal Tutor, see ibid., pp. 322–27.
5. For more on this tomb, see "The Tombs of Senenmut" by Peter F. Dorman, below.
6. For a list of these statues, see Roehrig 1990, pp. 282–86.
7. These statues are now in the Ägyptisches Museum und Papyrussammlung, Berlin (2296), and the Egyptian Museum, Cairo (CG 42114).
8. On Senimen, see Roehrig 1990, pp. 52–64, 280.
9. Winlock 1932a, pp. 5, 10.
10. See "The Statuary of Senenmut" by Cathleen A. Keller, below.

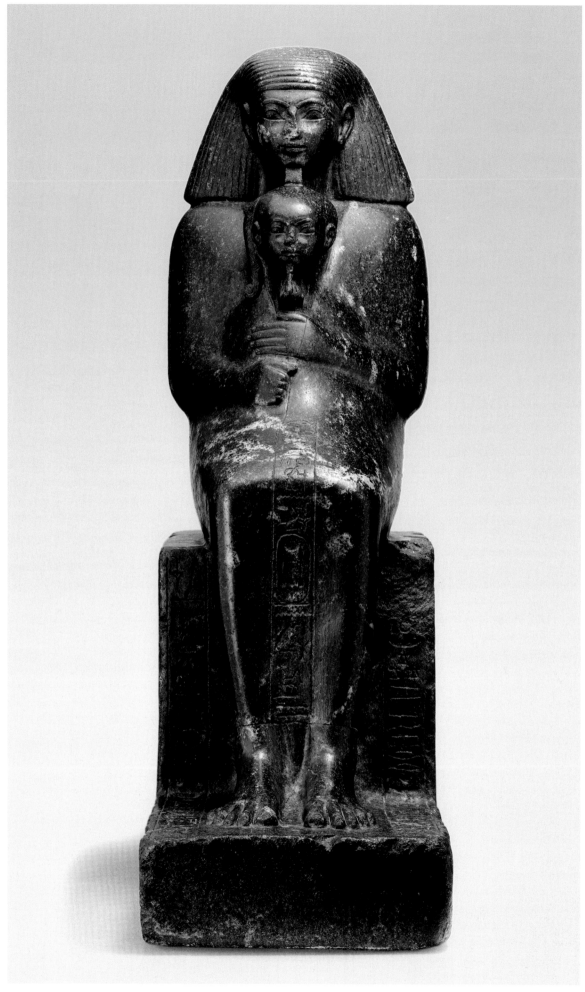

60

60. Senenmut Seated, with Neferure

Early 18th Dynasty, joint reign of Hatshepsut and
Thutmose III, period of Hatshepsut's regency
(1479–1473 B.C.)
Diorite
H. 72.5 cm (28½ in.), W. 23.5 cm (9¼ in.),
D. 48 cm (18⅞ in.)
The Trustees of the British Museum, London
EA 174

This statue depicts Senenmut in his position as
guardian of Hatshepsut's daughter, Neferure.
The princess sits on his lap, and he holds her
close to his chest, enveloping her protectively in
his cloak. Neferure wears her hair in a braided
sidelock and holds her finger to her lips, two
artistic conventions that identify a young child.
There is no royal cobra, or uraeus, at her brow,
as there is in all the other statues depicting her
with Senenmut. Both faces are very youthful
and relatively flat. The eyes are huge, with
almost no modeling around the upper lids, and
on both figures the mouth is in a slight smile.
Senenmut's title of Royal Guardian or Royal
Tutor does not appear in the inscriptions, since
the relationship is implicit in the statue itself.
One inscription that runs down the front of the
cloak identifies him as "Chief Steward of (in
cartouche) Princess Neferure, Senenmut."

An inscription on the proper right side of the
seat records that the statue was made "as a favor
of the Lady of the Two Lands, the God's Wife,
Hatshesput." Hatshepsut probably gave up the
title God's Wife when she became king, and the
statue can therefore be dated with relative cer-
tainty to the years when she served as regent for
Thutmose III.

The original placement of this statue is
unknown. The invocation offerings on the front
are given in the name of Amun, and seven
aspects of the god are listed in the inscription
on the proper left side of the seat. Therefore
the statue probably stood somewhere in the
precinct of Amun's temple, perhaps in the area
of North Karnak, as one author has convinc-
ingly argued.[1] In the inscriptions the names of
Senenmut, Hatshepsut, and Amun are all intact,
suggesting that the statue was buried out of
harm's way before the periods when these
names were attacked.

CHR

1. Eaton-Krauss 1998; Eaton-Krauss 1999, pp. 117–20.

PROVENANCE: Acquired in Luxor in 1906

BIBLIOGRAPHY: London, British Museum 1914,
pls. 30–32; Hall 1928, pp. 1–2, pl. II; Meyer 1982,
pp. 30 (bibliography), 120–25, no. 2, 304–5 (text);
Dorman 1988, pp. 118–19, 145, 188–89 (bibliogra-
phy); Roehrig 1990, pp. 71–72, 277–78; Fay 1995,
pp. 12–13; Marianne Eaton-Krauss in Russmann et al.
2001, pp. 120–21, no. 44

61. Senenmut with Neferure

Early 18th Dynasty, joint reign of Hatshepsut and
Thutmose III (1479–1458 B.C.)
Diorite
H. 53 cm (20⅞ in.), W. 14 cm (5½ in.), D. 26.5 cm
(10⅜ in.)
The Field Museum, Chicago, Gift of Stanley Field
and Ernest R. Graham 173800

This statue presents Senenmut carrying
Neferure, in a pose that is unique in the corpus
of Egyptian statuary. Also notable is the seem-
ingly affectionate gesture of the princess, whose
right arm encircles Senenmut's shoulder. The
gesture emphasizes the intimate relationship
between Neferure and her guardian, softening
the formal effect created by the otherwise stiff
poses of the figures and their rigid gazes
straight ahead.

The princess wears the sidelock of youth
and the royal uraeus. In her left hand she holds
a scepter that is sometimes connected with the
goddess Hathor[1] and may be associated with the
young Neferure's acquisition of the title God's
Wife, which she seems to have inherited from
her mother when Hatshepsut became king.
Except for hands, heads, and Senenmut's feet,
both figures are enveloped in a large cloak that
touches the ground on Senenmut's left and that
provides a wide, smooth surface for an inscrip-
tion. From this inscription Senenmut's name has

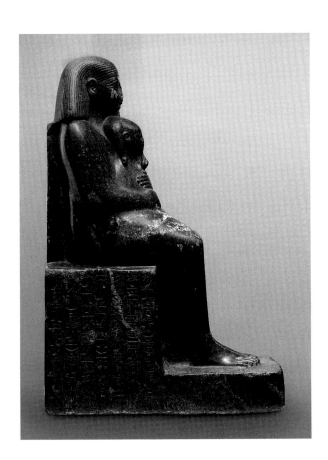

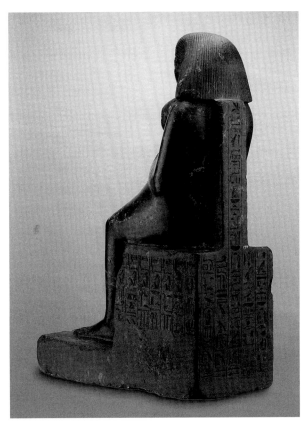

60, profile and back

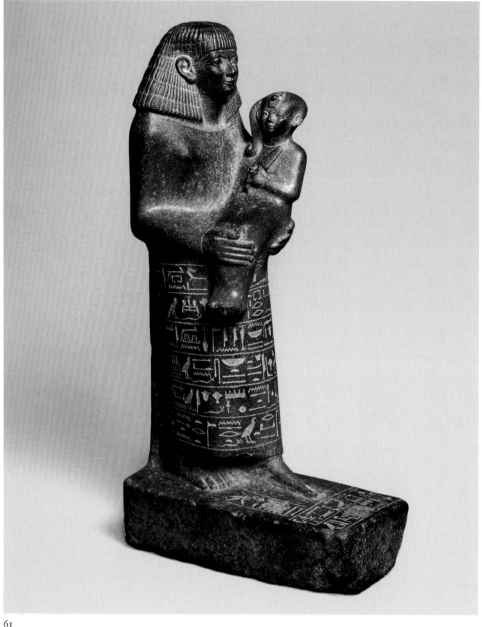

been erased; otherwise, the statue is in excellent condition. Even the name of the god Amun remains intact, suggesting that the statue was buried or otherwise hidden later in the Eighteenth Dynasty, before the reign of Akhenaten, who repudiated the worship of Amun.

The first part of the inscription is almost identical to that on a block statue depicting Senenmut with Neferure (fig. 48); both texts praise Senenmut and emphasize his privileged relationship with Hatshepsut, who, as in many inscriptions, is referred to in both genders. The second half of the inscription describes the relationship in which Senenmut "nurtured the eldest princess," having been "given to her as Goddess's Father." The complete inscription reads:

> *Given as a blessing of the king (to) the high official, the Steward of Amun, Senenmut. A royal offering of Amun, Lord of the Thrones of the Two Lands, giving all that appears upon his offering table in the course of every day to the ka of the high official pertaining to the white chapel of Geb, great confidant of the Lord of the Two Lands, who is blessed by the Good God, overseer of the double granaries of Amun, Senenmut.*

> *He says, "I am a dignitary, beloved of his lord, who has entrée to the wonderful character of the Mistress of the Two Lands (Hatshepsut). He (Hatshepsut) has ennobled me before the Two Lands and made me chief spokesman of his estate, and judge in the entire land, inasmuch as I was efficient in his opinion in that I nurtured the eldest princess (King's Daughter), the God's Wife, Neferure, alive. I was given to her as Goddess's Father (jt ntrt) because of my effectiveness on behalf of the king."*[2]

CHR

61

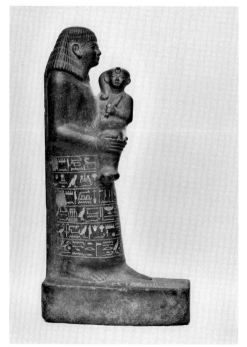
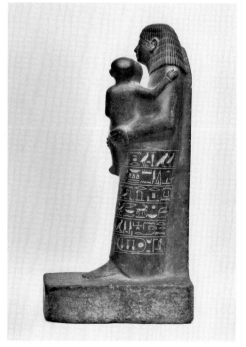

1. Troy 1986, pp. 83–84. In a relief scene from Hatshepsut's temple (see fig. 79), Neferure holds this scepter and a *menit* necklace; in another scene, Neferure's grandmother, Ahmose, is shown holding the same scepter (cat. no. 80).
2. Translation by James P. Allen.

PROVENANCE: Acquired in Luxor; donated early in 1925

BIBLIOGRAPHY: T. G. Allen 1927–28; Meyer 1982, pp. 39 (bibliography), 172–75, no. 11, 316 (text); Dorman 1988, pp. 123–24, 150, 193 (with bibliography); Roehrig 1990, pp. 73–74, 281–82; Anne K. Capel in Capel and Markoe 1996, pp. 109–11, no. 43; Dorren Martin-Ross in Ziegler 2002a, p. 454, no. 171

THE STATUARY OF SENENMUT

All ancient Egyptians were concerned with the continuation of their existence following the end of their earthly lives. For the richest and most powerful, many options were available to ensure their eternal existence and the survival of their memory: preparing a sumptuous tomb; dedicating small chapels, statuary, or other objects in temples; making donations to support temple priesthoods; even creating a cenotaph.

To gain permission to commission statues from royal workshops and to display those works in the principal temples, royal favor was essential.[1] One of Senenmut's repeated boasts was of his unimpeded access to the king,[2] and his implied expectation of royal largesse is evident in a striking request: "Grant that there be made for me many statues of every type of precious hard stone for the temple of Amun in Ipet-Sut, and for every place where the majesty of this god proceeds, like every favored ancestor. Then they will be in the following of your majesty in this temple."[3]

Lacking distinguished lineage, Senenmut could not, like some of his illustrious contemporaries, suggest his participation in a cycle of eternal renewal by depicting his extended family. Nor did he, apparently, have any children, so there would be no future generations to maintain his funerary cult; he stood alone. More than any other official of his time, he depended largely on temple statuary, rather than a tomb-based funerary cult, to create "a fair memory with people" (see cat. no. 66) and ensure his eternal fame. This significant monumental presence he established at Karnak temple in Thebes, the most important temple in Egypt.[4] Thus his eternal aspirations rested not upon an identification with the tomb-centered cycle of birth, death, and renewal that applies to humanity but rather on linking himself to temple-centered divine creation, with its variety and originality.

An aspect of Senenmut's originality was his invention of a number of composite devices, or cryptograms. Two of these appear on two block statues from Karnak that depict Senenmut and the King's Daughter, Neferure,[5] incised near the head of the princess (figs. 48, 51). The first cryptogram shows a flying vulture, with a protective *wedjat* eye superimposed on its body, grasping a set of ka arms in its talons. It faces a striding male figure with a composition *was* and ankh device instead of a head and holding a tall *was* scepter and an ankh sign in the usual manner of Egyptian divinities. (The *was* symbolized power, the ankh eternal life.) These cryptograms have been interpreted as standing for Hatshepsut's prenomen (Maatkare) and nomen (Khenemet Amun Hatshepsut), respectively,[6] and thus as constituting "new" ways of writing the king's cartouches on the statue. Senenmut stresses their originality in an additional text inscribed on both statues to the left of the princess's head: "Images which I have made from the devising of my own heart and from my own labor; they have not been found in the writing of the ancestors."

The most common device associated with Senenmut, however, is the uraeus cryptogram, which takes the form of a cobra crowned with bovine horns and a solar disk rearing up from a pair of ka arms (fig. 52).[7] This emblem was initially interpreted as a rebus rendering of the kingly Horus name of Hatshepsut, Wosretkaw,[8] and subsequently as a rebus of her prenomen: Maat (the cobra) + ka + Re (the sun disk) = Maatkare.[9] Alternatively, it has been understood[10] as referring to the harvest goddess Renenutet, Mistress of Food, who takes the form of the cobra, guardian of the granary from rodent predators (ka here meaning "provisions" or "food").[11] As recent scholars have noted, it quite likely referred to both the king and the goddess.[12]

Senenmut's statue program was unusually ambitious—in numbers far exceeding that of any other New Kingdom official (twenty-five so far attested)[13] and in scale, typological variation, variety of material, and quality of execution frequently approaching royal standards. Moreover, because he sought, as kings did, to emulate divine creation, Senenmut produced a sculptural corpus containing a notable number of creative "firsts." Some of these came to be so closely identified with Senenmut that they suffered (momentary) eclipse after the period of joint rule, but most became standards of the artistic repertoire.

During the early New Kingdom, the new era's artistic norms had not yet been codified, and there was considerable latitude in the means allowed for the expression of royal power (by kings) and the use of quasi-royal symbolism (by private officials).[14] And no king had greater reason to probe the boundaries of kingly symbolism more intently than Hatshepsut. Indeed, if Senenmut's goal was to obtain eternal remembrance by creating forms that had not existed "in the time of the ancestors," he lived in a propitious time, for that goal was shared by his king, who had need of new ways to express her divine lineage and kingly justification.

Egyptologists have tended to sort private statuary into two major groups, those intended to serve as the focus of a cult devoted to an individual (for example, in a tomb chapel) and those meant as a stand-in for the subject offering prayer in a temple context (the votive statue). While all Senenmut's statues appear to have functioned in a temple context,[15] they demonstrate great variety, not least in the number of formal categories, based on body position, represented in the corpus.

We know of eight block (or "cuboid")[16] statues commissioned by Senenmut: one of him alone (cat. no. 64) and seven with the King's Daughter, Neferure, whose tutor he was.[17] The block statue is a standard type generally depicting a man seated on the ground with knees drawn up to the chest, swathed in an enveloping cloak; often the body is reduced to a strict geometric form from which only the head and feet protrude. Senenmut's major innovation was to incorporate the young princess, whose head projects from the block so that the two seem like parts of a whole (fig. 48). The block statue type may have received an impetus from Senenmut's extensive use of it; it became extremely popular in the later Thutmoside period[18] and continued to thrive through the Ramesside, Third Intermediate, and Late periods.

Four statues of Senenmut seated are known. In two he sits upright, either alone on a bench[19] or, in a composition unique in the entire Egyptian

Fig. 51. Cryptograms carved on a black granite block statue of Senenmut and Neferure. Egyptian Museum, Cairo (CG 42114). Drawing by Ann Macy Roth

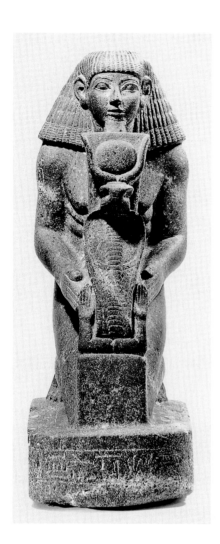

Fig. 52. Senenmut kneeling and holding a uraeus cryptogram, early 18th Dynasty. Granite. Brooklyn Museum, Charles Edwin Wilbour Fund (67.68; see cat. no. 70)

sistrophores are the earliest known examples of this statue type, which would become an extremely popular form for officials' expressions of devotion to a female divinity, particularly Hathor.

Three well-preserved statues of modest size show Senenmut kneeling to offer the uraeus cryptogram (see fig. 52; cat. nos. 70, 71).[25] Two were probably dedicated in the temple of Montu in Armant, where Senenmut had family ties, while the third was probably discovered at the temple at Karnak. The three are of different stones and differ stylistically; even similar images of Senenmut were never duplicates but rather variations on a theme. Like other innovative forms of Senenmut's, the cryptogram votives had artistic descendants (cat. no. 72). Although the ka arms of the device were occasionally attacked,[25] the fact that the uraeus cryptogram had earlier been associated with goddesses of sustenance and plenty ensured that it continued to be meaningful to donors.

Because so many of Senenmut's statues have survived—the size of his corpus is paralleled only by that of royalty—they present an excellent opportunity for investigating the stylistic oeuvre of a private individual. Attempts to produce a chronology of his statuary by applying a combination of inscriptional and stylistic criteria[26] have met with a certain limited success, but they are constrained by gaps in our knowledge. For instance, it is unclear whether the inscription on a statue named all of Senenmut's titles at the time of its making or, as seems more likely, presented selected titles according to the statue's function. Also open is the question of whether stylistic variations in the rendering of Senenmut's facial features or in the type of wig, for example, have chronological significance or reflect the activity of different temple workshops;[27] and there are a host of other issues as well. Senenmut's sculptural dossier has yet to receive the attention it deserves and still awaits a detailed, in-depth examination.

CAK

statuary corpus, on a square seat holding Neferure (cat. no. 60). Two others show him in an asymmetrical pose, seated on the floor, in one case holding the princess (fig. 49).[20] There is only one known depiction of Senenmut standing—another unique composition whose subject is the tutor together with his royal charge (cat. no. 61).

Depictions of Senenmut kneeling constitute a significant category that can be subdivided according to the nature of the votive element offered. The two simplest works, in which he is seen kneeling with arms raised in an attitude of adoration, are very fragmentary, and some additional element may originally have been included.[21] A (now headless) image of Senenmut offering a naos, or small shrine, decorated with an image of Amun and bearing dedication texts to Amun and Renenutet, found in the Karnak Cachette,[22] is an early New Kingdom example of the type. In another variant of the votive statue—one unattested before Senenmut—he is shown offering a field surveyor's cord (cat. no. 65). This form was taken up by later officials who, like Senenmut, oversaw the granary of Amun at Karnak temple.

Four of Senenmut's statues depict him kneeling and steadying between his hands a large sistrum[23] of the type that incorporates a naos. A sistrum is a sacred rattle that was held by ancient Egyptian priestesses and shaken to accompany the chanting in temple rituals, festive processions, and other religious ceremonies; a statue of this type is called a sistrophore.[24] Senenmut's sistrophores range from a large sandstone or quartzite statue from the Mut temple complex (cat. no. 66) to a tabletop-size version in diorite (cat. no. 67), with two other examples of granite or granodiorite (cat. nos. 68, 69), both of intermediate size. Senenmut's

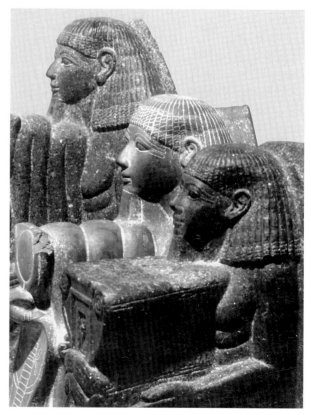

Fig. 53. Profile details of three statues of Senenmut that were originally from Armant (left to right, cat. nos. 70, 71, 68)

1. Inscriptions on several of Senenmut's statues (cat. nos. 66, 67) proclaim that they were "given as a favor of the King's gift."

2. For example, he is "confidant of the king" and "the chamberlain who speaks in privacy"; see catalogue no. 64.

3. Inscribed on a block statue of Senenmut (Egyptian Museum, Cairo, CG 42114): in Legrain 1906–25, p. 63. The request seems to have been fulfilled. A painting in Senenmut's tomb chapel (TT 71) shows a row of statues of various materials and forms, including one of him kneeling behind a serpent (cf. cat. nos. 70, 71), being towed to the temple (Dorman 1991, pls. 12a, 13a, b).

4. He also endowed temple cults; see Dorman 1988, p. 198. The three statues Senenmut dedicated at Armant (see cat. nos. 68, 70, 71) are significantly smaller than most of his Karnak statues.

5. Ägyptisches Museum, Berlin, 2296, and Cairo, CG 42114.

6. Drioton 1938, pp. 231–38.

7. Robins 1999, pp. 108–10 (with bibliography).

8. Sethe 1898, p. 49.

9. Marianne Eaton-Krauss in *Ägyptische Kunst* 1976, no. 34; Drioton 1938.

10. Graefe 1980.

11. On Renenutet, see Broekhuis 1971; Beinlich-Seeber 1984. On goddesses associated with nourishment in general, see Robins 1999, p. 110.

12. See Dorman 1988, p. 39, especially n. 108; Robins 1999, pp. 108–10.

13. For literature on all of the statue citations that follow, see app. A in Dorman 1988.

14. For instance, a niched tomb facade is topped by a pyramid in the private funerary architecture of Puyemre and Useramun (Dziobek 1995a, p. 131). Officials built their tomb chapels and burial apartments as separate units, following royal burial practice (for examples, see Dorman 1995b, pp. 144–45); Solar Litany and Amduat texts were incorporated in the burial chamber of Useramun (Dziobek 1995, pp. 139–40), and restricted liturgies as well as the widely used Book of the Dead texts in that of Senenmut (Dorman 1991, pp. 99ff.). These are all instances of nonroyal funerary complexes closely paralleling royal practice.

15. Some may have been housed in private chapels within the Karnak temple. James 1976; Eaton-Krauss 1998, pp. 208–9; Eaton-Krauss 1999, pp. 116ff.

16. This term is preferred by Schulz (1992).

17. Berlin, 2296; Cairo, CG 42114, 42115, and JE 47278; two statues now located in the "Sheikh Labib" and "Karakol" magazines at Karnak; and the rock-cut statue above tomb TT 71 (fig. 47).

18. Schulz 1992, p. 547.

19. The statue is in the shrine of his cenotaph at Gebel el-Silsila.

20. The other example is a statue base from Deir Rumi, on the west bank at Thebes. Senenmut may have been preceded in his use of this pose by Senimen; see figure 50. It is possible, however, that the rock-cut statue of Senimen was inspired by Senenmut, who was closely associated with him in some way (Roehrig 1990, pp. 55, 64, pl. 5).

21. The lower portion of a kneeling statue of Senenmut discovered at Deir el-Bahri by Édouard Naville (the "Naville" fragment), and a travertine statue base now in Geneva (23438).

22. Cairo, CG 42117.

23. See Ziegler 1984 for a summary of the symbolism, forms, and development of the sistrum. See also Reynders 1998, pp. 950ff., in which it is suggested that the *shm* scepter be interpreted as a divine incarnation of the goddess herself. With this interpretation the statue type is connected even more closely with those in which the donor presents an actual image of the divinity.

24. Meyer 1984.

25. On Senenmut's sistrophores: e.g., catalogue nos. 67, 69.

26. For example, it is generally agreed that the two British Museum statues (cat. nos. 60, 64) are the earliest statues of Senenmut, a conclusion based on both stylistic features and the titles of Senenmut and Hatshepsut inscribed on them, which signal a date before she became king.

27. See Meyer 1982, pp. 69–73; Eaton-Krauss 1998, p. 208, citing Fay 1995, p. 15. This research is still in its early stages but has shown some promising results.

62. Figured Ostracon with Ruled Sketch

Early 18th Dynasty, joint reign of Hatshepsut and
Thutmose III (1479–1458 B.C.)
Painted limestone
H. 22.5 cm (8⅞ in.), W. 18 cm (7⅛ in.), D. 3.5 cm
(1⅜ in.)
The Metropolitan Museum of Art, New York,
Rogers Fund, 1936 36.3.252

This gridded sketch of a man wearing a short wig probably portrays the steward Senenmut, whose services to Hatshepsut were rewarded with numerous favors. His appointment to many important positions, such as the stewardship of the temple of Amun at Karnak, enabled him to afford to have two tombs excavated for himself in the Theban necropolis.[1] Although the sketch is not labeled, its findspot (just down the hill from TT 71, Senenmut's tomb chapel[2]) and the care with which it was executed suggest that it was a preparatory drawing for one of the tomb's primary representations of a male figure. All these figures would have been patterned

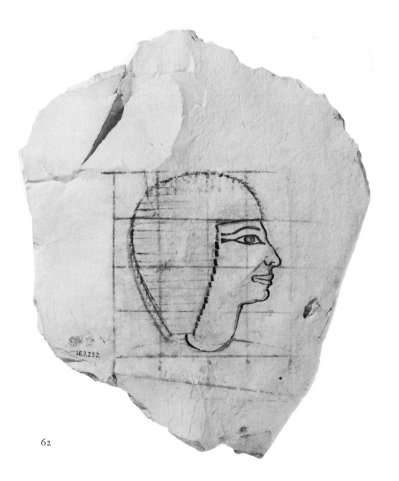

62

after an idealized depiction of the tomb owner.

As was common practice during the Eighteenth Dynasty, the artist responsible for the drawing, clearly an accomplished individual, would have made two separate versions of his sketch: the first, more summary and executed in diluted red paint over a freehand grid of the same color; and over it a second, more polished version using the red sketch as a sort of template and carried out in thick black lines.[3] The artist enlarged this gridded drawing to a size suitable for a tomb wall by transferring it to a portion of the wall on which a larger grid was painted. The result was an image virtually identical to the preparatory sketch except for its size. This process ensured that the decoration of the tomb would exhibit a degree of stylistic consistency, with respect to its main figures at least, that smoothed over the stylistic quirks and varying abilities of the individual artists who produced it.

<div align="right">CAK</div>

1. Dorman 1991; Dorman 1995b, pp. 144–45; see "The Tombs of Senenmut," below.
2. Hayes 1942, p. 4.
3. For this process, see, among others, Mackay 1917; Keller 1991, pp. 53–54; Robins 1994a, pp. 23–30. We know from a number of unfinished private and royal tombs that artists, whether relief sculptors or painters, followed the black versions of preparatory sketches to produce their wall decorations.

PROVENANCE: Western Thebes, Sheikh abd el-Qurna, below the tomb of Senenmut (TT 71); Metropolitan Museum of Art excavations, 1935–36, acquired in the division of finds

BIBLIOGRAPHY: Lansing and Hayes 1937, pp. 6, 8, fig. 7; Hayes 1942, pp. 4, 9, pl. I; Hayes 1959, p. 110; Peck 1978, no. 3, pl. IV

later king, Hatshepsut, and her daughter Neferure. This conclusion is based not only on the object's supposed findspot, in the vicinity of Senenmut's Deir el-Bahri tomb (TT 353), but also on the clear resemblance of the upper, more detailed drawing to a sketch in the tomb's first descending corridor, which an accompanying inscription identifies as of Senenmut (fig. 54).[1] All three portraits share a prominent, beaky nose, a furrow around the mouth, and a distinctly pouchy double chin. The two more finished versions add virtually identical wigs and emphasize the facial lines. These furrows imbue the depictions with a character that is lacking in the more formulaic sketch of Senenmut on an ostracon from his tomb chapel, TT 71 (cat. no. 62).

The prominent hooked nose, present on both the ostraca and wall sketch, also appears on some statues that portray Senenmut in which the face has survived intact (cat. nos. 68, 70).

Some scholars have proposed that these accurately represent Senenmut's nose.[2] A slightly more standardized version of a nose of this type is, however, seen on many images of Hatshepsut (for example, cat. nos. 88a, 91, 92, 96), which suggests that Senenmut may have

Fig. 54. Drawing of Senenmut on the wall of his tomb at Deir el-Bahri, western Thebes (TT 353), early 18th Dynasty

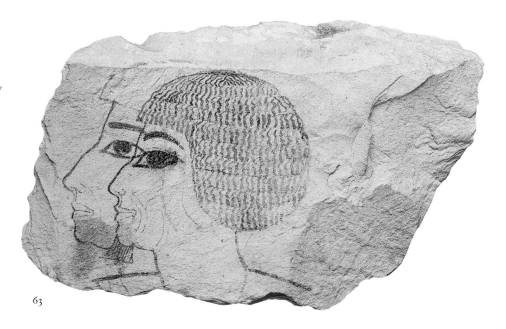

63

63. Double Portrait of Senenmut

Early 18th Dynasty, joint reign of Hatshepsut and Thutmose III (1479–1458 B.C.)
Painted limestone
H. 10 cm (4 in.), W. 17 cm (6¾ in.)
The Metropolitan Museum of Art, New York, Anonymous Gift, 1931 31.4.2

Despite the lack of an identifying text, it is certain that the double profile on this figured ostracon represents Senenmut, Steward of the queen,

63, back

chosen to have his nose depicted this way in his official portraits in order to enhance his identification with his sovereign.[3]

It has been observed that the facial lines we find so intriguing today may have had a satirical intent, since the drawing on the reverse side of the ostracon clearly did: it depicts "a lean, hairy rat with prodigiously long whiskers"[4] and perhaps was the artist's jibe at his all-important patron. CAK

1. Winlock 1942, pl. LXIII (top); Meyer 1982, p. 236; Dorman 1991, p. 147, pl. 57a.
2. Hayes 1959, p. 109, and Bothmer 1966–67 (2004 ed.), p. 170, among others.
3. This similarity is emphasized by Meyer 1982, pp. 72–73.
4. Hayes 1959, p. 110.

PROVENANCE: Thought to be from western Thebes, Deir el-Bahri, the area around the chapel of Senenmut (TT 353); purchased in Luxor; given to the Museum in 1931

BIBLIOGRAPHY: Hayes 1959, pp. 109, fig. 58, 110; Peck 1978, no. 4

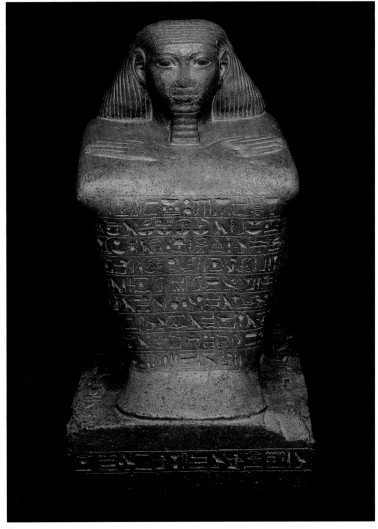

64

64. Block Statue of Senenmut

Early 18th Dynasty, joint reign of Hatshepsut and Thutmose III, period of Hatshepsut's regency (1479–1473 B.C.)
Reddish brown quartzite
H. 54 cm (21¼ in.), W. 30 cm (11¾ in.), D. 36 cm (14¼ in.)
The Trustees of the British Museum, London
EA 1513

On the basis of inscriptional as well as stylistic evidence, this statue has been identified as one of the earliest three-dimensional images of Senenmut.[1] The text that covers his cloaked form and continues on the base contains the traditional offering formula and a long compendium of titles and laudatory epithets. It is clear that an unusual amount of care went into the composition of the inscription, with its wide prosopographical repertoire, and into its arrangement on the statue surface.[2] The text on the body stresses Senenmut's relationship with Thutmose III, where the most significant passages describe him as one "who has followed the king in his journeys since his (the king's) youth," "one who has access to the marvelous character of the Lord of the Two Lands," and

"the Chamberlain who speaks in privacy, one vigilant concerning what is brought to his attention, one who finds a solution"—literally, "thing"—"every single day, Overseer of All Works of the King." Even in the lines that refer to his role as tutor of the Princess Neferure, she is identified as the daughter of Thutmose II, not of Hatshepsut. The inscriptions on the base, however, tell a different story. Here Hatshepsut dominates: Senenmut cites the favors accorded him by the God's Wife, Hatshepsut: "The king made me great; the king enhanced me, so that I was advanced before the (other) courtiers: and, having realized my excellence in her heart, she appointed me Chief Spokesman"—literally, "chief mouth"—"of her household." The God's Wife title was favored by Hatshepsut during the period immediately preceding the inception of the co-regency.[3] Its appearance here, therefore, indicates that this statue was set up before Hatshepsut assumed the kingship.[4]

Senenmut appears alone, in the squatting position indissolubly linked with what is known to Egyptologists as the "block" statue; it is the only block statue of Senenmut in which he is

not accompanied by the King's Daughter, Neferure, his royal charge. Here the body contours are slightly indicated, the elbows protrude from the matrix, and the forearms and hands are indicated in very low relief on the top of the cube. With these allusions to the body forms the statue perhaps more closely reflects a Middle Kingdom aesthetic than it does New Kingdom style, suggesting a placement of the work early in the New Kingdom corpus. However, not too much can be made of this, since there were, in fact, a good number of rather strictly geometrical images produced during the Middle Kingdom, and these too have counterparts in Senenmut's corpus (for example, fig. 48).[5]

Senenmut wears a shoulder-length wig with undulating striations. His short beard, of the kind typically worn by officials, is punctuated by a series of horizontal divisions. The forehead is quite low, and the high arched brows are close to the wig band. The eyes are well rounded and slightly bulging. The ears are quite large for an early Eighteenth Dynasty example, again reflecting Middle Kingdom influence.[6] Although the face is damaged, we can discern that the

nose was narrow but broad at the tip and the lips were straight and fairly thick. Both were shaved down after they were broken,[7] possibly in preparation for a restoration that was never realized.[8] In its current damaged state the face has a distinctly brutish aspect that is at variance with the fine quality of its material and execution.

Quartzite, the stone used here, is not the typical material of Senenmut's block statues.[9] The reddish brown hue of quartzite,[10] probably the hardest rock worked by the ancient Egyptians, was associated with the sun, and use of the stone was closely controlled by the king. That he should use a material so difficult to handle and with such exalted associations is surely an indication of Senenmut's great power, even at the beginning of the co-regency period, before he acquired the stewardship of the estate of Amun.

According to Sir Wallis Budge, this block statue was found in a brick-lined chamber within the Amun precinct at Karnak, along with a seated tutor statue in which Senenmut holds Neferure on his lap (cat. no. 60), a now-lost statue of Hatshepsut, and a number of private statues and stelae of various dates.[11] Because both Senenmut statues have suffered only minor damage to their faces and none at all to their texts, it is likely that they were originally placed near each other. Although it is possible that the chamber in which Budge saw the statues held a cache of much later Theban materials assembled by the dealer Mohammed Mohassib or by local entrepreneurs, a Karnak provenance for the present work seems secure.[12] CAK

1. Aldred 1961, no. 13; Meyer 1982, p. 69. The evidence considered was the form of the statue, its facial features, in addition to aspects of the inscription. See most recently Eaton-Krauss 1998, pp. 207–8.
2. As noted by Peter Dorman (1988, p. 116).
3. See "Hatshepsut: Princess to Queen to Co-Ruler" by Peter F. Dorman in this chapter.
4. Christine Meyer (1982, pp. 117–18) suggests that the statue might date from the reign of Thutmose II, but Dorman (1988, pp. 116–17) is not convinced that it is this early. The use of the term *pr-nswt* (King's House) to designate an entity under Senenmut's charge suggests that Hatshepsut was able to make him chief of the central administration, which she would have been unlikely to do while Thutmose II was still living. For *pr-nswt*, see Helck 1982 and Van den Boorn 1988, pp. 65, fig. 5, 310ff., 323, fig. 11, 327, fig. 12.
5. According to Schulz (1992, pp. 577–78), block statues with some indication of body contours and those with strong cubic tendencies were produced in similar ratios during the Middle Kingdom and Thutmoside periods.
6. This basic form of wig and rather large ears already appears on Middle Kingdom block statues:

National Museum of Beirut, B 1150; Egyptian Museum, Cairo, JE 46307; and British Museum, London, 569. See Schulz 1992, pl. 5, c, no. 012, pl. 76, no. 168, pl. 96, a, no. 215.
7. See the photograph of this detail in Bothmer 1969–70, p. 142, fig. 22. Although damage to the nose of a statue can be accidental, there is no doubt that breaking off the nose was believed to deprive the statue of life-giving breath.
8. Marianne Eaton-Krauss (1998, p. 208) aptly notes that the face of the statue of the aged Amenhotep, son of Hapu (Cairo, CG 42127; Russmann 1989, p. 107, no. 51), was similarly treated.
9. Three quartzite quarries are known to have been worked during the New Kingdom, at Gebel Ahmar, near Cairo, and at both Gebel Tingar and Gebel Gulab, near Aswan (Aston, Harrell, and Shaw 2000, pp. 53–54). Senenmut had ties with the Aswan area (Habachi 1957, pp. 92, 94, fig. 3, 95–96), and we have evidence of sustained activity there from the Old Kingdom on (Spencer 2004, p. 29), but any of these quarries could have been the source of the stone for this statue.
10. Aufrère 1991, pp. 698–700; Betsy M. Bryan in Kozloff and Bryan 1992, pp. 157–59, n. 13.
11. Eaton-Krauss (1998, p. 207) compares the block and seated statues in terms of style and shows that they differ in many respects. On Budge, see James 1976, pp. 8–10. James's account of the find is one of Egyptology's most fascinating detective stories.
12. Eaton-Krauss (1998, p. 209) evaluates the evidence for Budge's story and (1999, pp. 117–20) suggests a location in North Karnak for the provenance.

PROVENANCE: Thebes, probably Karnak; purchased from Mohammed Mohassib in 1911

BIBLIOGRAPHY: London, British Museum 1914, pl. 29; Hall 1928, p. 1, pl. 1; Porter and Moss 1972, p. 279; Vandier 1958, pp. 451–52, 505, 651; Ratié 1979, p. 247; Meyer 1982, p. 29 (bibliography), 112–20, no. 1, pl. 2; Dorman 1988, pp. 113, 116–22, 145–46, 147, 161, 171, 174, 189 (with bibliography), 220, no. A.3; Schulz 1992, pp. 385–86, no. 222 (with bibliography); Eaton-Krauss 1998, pp. 207–9, pl. XXII, 2; Eaton-Krauss 1999, pp. 117ff.

65. Senenmut Kneeling with Surveyor's Cord

Early 18th Dynasty, joint reign of Hatshepsut and Thutmose III (1479–1458 B.C.)
Red quartzite
H. 20.7 cm (8⅛ in.), W. 8.2 cm (3¼ in.), D. 11.5 cm (4½ in.)
Musée du Louvre, Paris E 11057

This votive statue depicts the Steward of Amun Senenmut kneeling and holding a ceremonial surveyor's cord (*nwḥ*) between his hands. Officials used surveyor's cords to measure the height

of the grain in the fields in order to estimate the size of the harvest and, by extension, the amount of rent to be collected from the cultivators working temple lands. Atop the thick roll of cord is a small, poorly carved human head surmounted by a small horned uraeus with the solar disk. The cord rests on a plinth bearing a larger horned and disk-crowned uraeus that is framed by a set of ka arms, and the whole rests on a rectangle inscribed with the hieroglyph for gold (*nbw*). The monogram on the plinth, which appears on other statues as well (cat. nos. 70, 71), has been interpreted as a reference to both Maatkare—the prenomen of Hatshepsut—and Renenutet, the harvest goddess.[1] This piece is one of a number of statues of Senenmut that are unusual types, and like many of them it is the earliest known example of its kind.[2] Two later parallels for the present statue are known: one from Abydos, which belonged to a local priest and agricultural official named Penanhur and dates from the reign of Amenhotep II (r. 1427–1400 B.C.); the second, from Thebes, depicts the Royal Scribe and Steward, Amenemhat-Surer, who served Amenhotep III (r. 1390–1352 B.C.)[3]

This statue is unusual in the corpus of Senenmut's sculpture for several reasons. First, it is the only one of his votive statues that depicts him with surveyor's cord. Second, it is his only known image that expresses his relationship to the sources of Egypt's agricultural wealth, both visually, by means of the cord, and textually, in the title Overseer of the Gardens of Amun inscribed on the base against his proper left leg. Third, if it indeed came from its purported findspot, El-Buha in the central Nile Delta,[4] it is Senenmut's only votive object from the north of Egypt. In an inscription from Deir el-Bahri, Senenmut claims that he had the right to have his name inscribed in the temples of both Upper and Lower Egypt.[5] Numerous inscriptions survive that attest to Senenmut's presence in religious centers of Thebes, Armant, Gebel el-Silsila, and Aswan,[6] but this statue is our only physical evidence that he recorded his name in temples in the north.

Senenmut apparently wished to employ a wide variety of materials for his sculptures. In particular he had a taste for materials with religious significance, as demonstrated in his choice of red quartzite for this statue and the brownish variety of the same stone for his block statue from Karnak (cat. no. 64), which both had solar associations.

Although the statue appears to be intact except for Senenmut's nose, which is merely chipped, some intriguing alterations have been

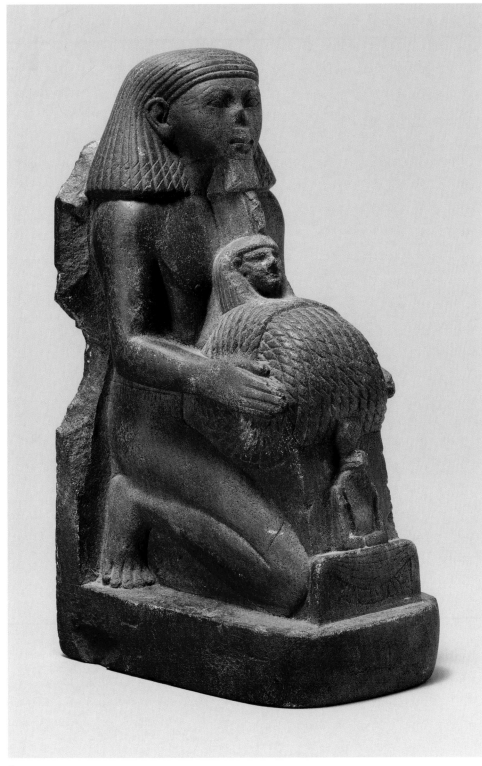

65

certed effort to conceal damage that could not be repaired simply by filling in discrete names or phrases but, rather, would have necessitated wholesale rephrasing. The damage exceeds that wrought by the usual Atenist activity[10] and suggests there may have been more than one attack, one on Senenmut, another on Amun,[11] followed by the preparation of the piece for restoration.[12] The block statue of Senenmut (cat. no. 64) was also damaged, whether accidentally or deliberately; however, it apparently was not available to the Atenist iconoclasts, as its inscriptions remained intact. That the restoration of the present statue was never completed was perhaps determined by contemporary priorities. Repair of damage inflicted on the symbol of Amun was deemed a necessity and was considered to improve, if not restore, the integrity of the votive object. But the restoration of the text was a more complex matter and thought to be less pressing, and so was left undone.[13] CAK

1. See "The Statuary of Senenmut," above.
2. For Senenmut's claims to originality in general, see "The Statuary of Senenmut," above. For Senenmut's innovations in regard to sistrophorous and cryptogram-bearing statues, see catalogue nos. 66, 70.
3. On the first, see Borchardt 1905; Borchardt 1911–36, vol. 3 (1930), pp. 49–50, pl. 131. On the second (Egyptian Museum, Cairo, CG 42128), see Legrain 1906–25, pp. 80–81, pl. LXXVII.
4. Porter and Moss 1934, p. 39.

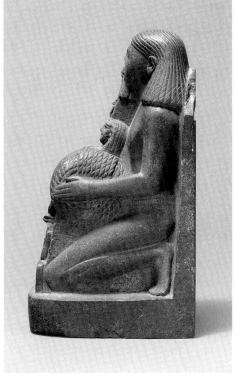

made. For one, the human head that surmounts the surveyor's cord was substituted for a ram's head adorned with a horned uraeus and sun disk, which was the usual embellishment for such objects. The ram was a potent symbol of Amun-Re, who would have appeared here in his role as Lord of Measurement.[7] That the ram was specifically targeted for removal suggests that it was destroyed during the reign of Akhenaten (r. 1349–1336 B.C.), when the names and images of the Theban triad (Amun-Re,

Mut, and Khonsu) were officially proscribed and removed from existing monuments. Its later replacement (albeit with a human head) indicates that there was a concerted attempt to restore the image, possibly during the Ramesside period, when a number of Senenmut's monuments were repaired.[8]

The statue's inscriptions have been obliterated and its surfaces smoothed down more or less uniformly.[9] The complete removal of inscriptions is unusual and here indicates a con-

5. Hayes 1957, pp. 82–84; Meyer 1982, p. 327, no. 16 (text); Dorman 1988, pp. 142–43.
6. See "The Statuary of Senenmut," above.
7. So Graefe 1973 and Schenkel 1982a; contra Barguet 1953a, p. 223, and Barguet 1953b.
8. Such as the much-discussed North Karnak stela, originally published in Christophe 1951. See Helck 1960; Murnane 1977, pp. 35–36; Meyer 1982, pp. 150ff.; Helck 1983, pp. 122–26 (improved text); Dorman 1988, pp. 29–31, 156 (with bibliography).
9. The removal of the owner's name deprived him of association with the image so that even when the image was left undamaged it could not be used for his benefit. So completely were the texts on the present statue ground down that it was not immediately recognized as belonging to Senenmut: Barguet 1953b, p. 23.
10. As Dorman has remarked (1988, p. 151).
11. At least one scholar has doubts there was an attack on Amun; see Dorman (ibid., p. 151), and also p. 149, where he expresses uncertainty about the same subject with regard to Cairo, JE 34582.
12. Whether the restoration was to be carried out on Senenmut's behalf or for use by another official is unknown.
13. Unless the statue was simply plastered and painted with new texts. However, no traces of this sort of activity have been detected on the present example.

PROVENANCE: Purportedly from El-Buha; purchased from Nahman, Cairo; Dosseur collection; acquired by purchase in 1905

BIBLIOGRAPHY: Barguet 1953a, p. 223; Barguet 1953b; Vandier 1958, pp. 476–77, 483, 493, 505–6, pl. CLXIV, 1; Schulman 1969–70, p. 38, no. 4; Meyer 1982, pp. 46 (bibliography), 209–11, no. 18, pl. 6; Ratié 1979, pp. 47, 209–11, and passim; Dorman 1988, pp. 112, 151, 163, 194 (with bibliography), 221, no. A.15

66. Senenmut Kneeling with Sistrum

Early 18th Dynasty, joint reign of Hatshepsut and Thutmose III (1479–1458 B.C.)
Reddish yellow siliceous sandstone or quartzite
H. 155 cm (61 in.)
Egyptian Museum, Cairo CG 579

This portrayal of Senenmut kneeling behind a large sistrum is the largest of his sistrophorous statues and was probably the most costly to produce. Moreover, its inscriptions contain more titles and laudatory epithets than any other monument of Senenmut, except perhaps his tomb in its original state, and it is the only one of his major statues for which there is a small model (cat. no. 67).

When viewed frontally the statue appears as a series of three superimposed volumes: the

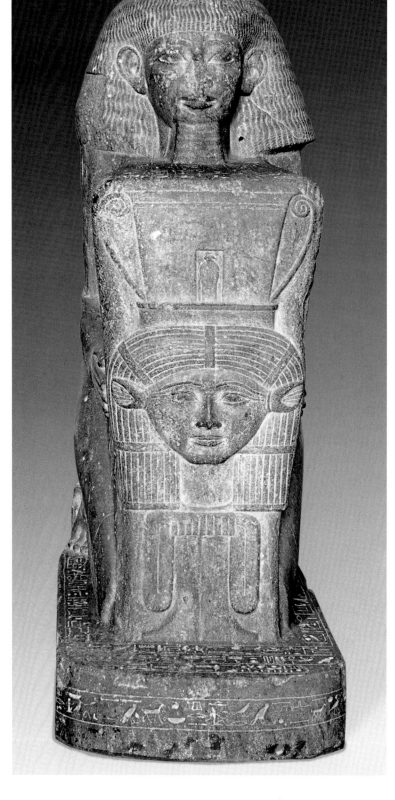

66

base, the sistrum, and the head of Senenmut. The sistrum is made up of several parts. The uppermost comprises the rattle and is in the form of a temple gateway (*bekhen*), with a small uraeus standing within its central opening.[1] The sistrum base bears a large *tayet* knot, associated with protection and particularly with the goddess Isis.[2] The upper loop of the knot has been replaced by a large female face with cow's ears and framed by a thick, banded wig.[3] Although sistra were associated with a variety of divinities, they are most closely identified with the cults of goddesses, in particular Hathor. The inscriptions on the statue give prominence to Mut, the consort of Amun of Karnak, but invoke Hathor once as well.

The head of Hathor and face of Senenmut are clearly the artistic and spiritual foci of the statue and are comparable in scale and detail. Senenmut's wig flares from the top of his head and ends with a crisp, angled cut just above the shoulders; the individual locks of hair are indicated by a series of carefully controlled wavy lines terminating in corkscrew curls. The short beard (typical of noblemen) was treated similarly but is now somewhat abraded. Framed by these detailed areas, the face is smooth and unlined, except where damaged, and appears youthful. It is proportionately shorter and broader across the cheekbones than some of the faces of his smaller statues (cat. nos. 68, 70).[4] The brows are plastically rendered and moderately arched; the eyes are almond shaped. The nose was broad at the tip, and the corners of the mouth extend just slightly beyond it. The upper and lower lips narrow noticeably at their corners. The neck is quite long but is masked by the beard, which effects a textured transition between the face and sistrum.

Only in side view is the rest of Senenmut's body visible. In pose and proportion, with its pendulous breasts, folds of fat, and lean limbs, it closely resembles the bodies in other, smaller pieces in the oeuvre devoted to him (cat. nos. 67, 68, 70, 71). As usual, his dress is minimal: only a short, wrapped kilt, with no jewelry or other ornamentation to compete with the large votive sistrum.

The front of the sistrum and Senenmut's face and figure alone remain uninscribed. Indeed, the sculptors of the statue appear to have been enjoined to cram as much hieroglyphic text onto the base, back pillar, and interstices of the piece as humanly possible. These inscriptions make important points about the statue: first, that it was a royal gift; second, that it was made specifically to be placed in the temple of the goddess Mut so that Senenmut could continue to share the bounty of her offerings. Also significant is Senenmut's appeal to the living members of the temple's priesthood to make an offering to the goddess so that she will continue to grant her gifts to him. Much of the text is devoted to enumerating the most important titles Senenmut held late in the joint reign of Hatshepsut and Thutmose III and to describing the important work he performed for his rulers, particularly Hatshepsut, and the gods, in statements such as "I am a true confidant of the king, one who does what his majesty praises daily, the Overseer of Cattle of Amun, Senenmut. I am one who makes correct decisions[5] and is impartial, one with whose

speech the Lord of the Two Lands is content." In this way Senenmut demonstrated how worthy he was of the attentions of his audience.

CAK

1. This is surely a subtle reference to the larger depictions of the prenomen of Hatshepsut (cat. nos. 68, 70, and 71) identified as cryptograms; see the entries for catalogue nos. 68, 71. The area in which the uraeus is located looks suspiciously flat, suggesting recarving, and would repay closer examination.
2. For the *tayet* knot, see Westendorf 1980.
3. The sistrum and bovine-eared female image were not combined until the Middle Kingdom; the earliest of the combined images were associated with the goddess Bat, rather than Hathor (Fischer 1962).
4. The faces of the larger statues of Hatshepsut (cat. nos. 88a, 91, 92, 94) are similarly broad in comparison with her lifesize images (cat. nos. 89, 95, 96).
5. *Jnk /wp?/ m ᵓᶜt*, literally, "I am one who cuts Maat (justice)."

PROVENANCE: Thebes, Karnak, temple of Mut; Benson and Gourlay excavations, 1895–96

BIBLIOGRAPHY: *Urkunden* 4, pp. 407–14; Benson and Gourlay 1899, pp. 399ff., pl. 12; Borchardt 1911–36, vol. 2 (1925), pp. 127–30, pl. 99; Vandier 1958, pp. 465, 483, 493, 505–6; Ratié 1979, pp. 65, 248, 255–58; Meyer 1982, pp. 44 (bibliography), 186–205, no. 16, 320–26 (text); Dorman 1988, pp. 1, 42, 121, 126–27, 139, 147, 161, 172–75, 190 (with bibliography), 220, no. A.5

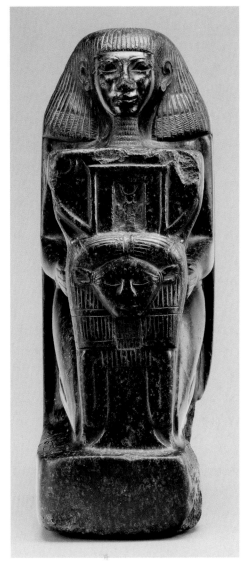

67

67. Senenmut Kneeling with Sistrum

Early 18th Dynasty, joint reign of Hatshepsut and Thutmose III (1479–1458 B.C.)
Black porphyritic diorite
H. 22.5 cm (8⅞ in.), W. 8.2 cm (3¼ in.), D. 12.3 cm (4⅞ in.)
The Metropolitan Museum of Art, New York, Bequest of George D. Pratt, 1935 48.149.7

A miniaturized version of the quartzite statue of Senenmut found at the Mut temple in Karnak and now in Cairo (cat. no. 66), this is the smallest of the Senenmut images in the exhibition. The materials are very different, but the pose, iconography, and text are the same in both statues. The present piece also shares pose and iconography with one of Senenmut's statues from Armant (cat. no. 68) and carries an inscription of the same type as those on the other sistrophores.[1] Because it was used as a grindstone at some time, its surface is abraded and has suffered loss of detail.

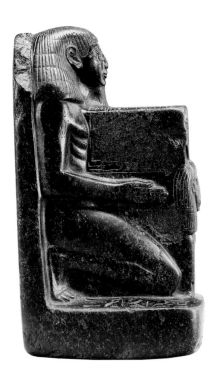

As in the other sistrophores, Senenmut kneels and supports a sistrum between his hands. However, the effect differs markedly from that of the larger statues. His face, for example, is much more angular here than elsewhere, almost forming an inverted triangle. Here, as in the large quartzite piece in Cairo, the brows describe a shallow arc, but the eyes are open wider and their inner canthi are emphasized. The nose is extremely abraded, but we can see that it was very narrow at the top and quite broad at the tip. And we can discern a slight smile. In general the sistrum resembles those of the Cairo and Munich (cat. no. 66, 68) statues. However, abrasion has robbed the goddess on the sistrum of most of her features, and the ka arms have been erased from the naos.

One wonders about the function of such a piece. Surely its small size and portability must provide a clue. Could it initially have been placed, as has been suggested,[2] in a family shrine in Senenmut's own house and perhaps transferred to his tomb or some other local chapel at a later date? Was it originally intended as a substitute for the Cairo statue at a presentation or dedication/installation ceremony?[3] Was it a model that could be circulated throughout the land to the various ateliers commissioned to produce temple statuary for Senenmut, the most favored of Hatshepsut's courtiers?

CAK

1. Most of the inscription is translated in Hayes 1959, p. 107.
2. Hayes 1957, p. 68; reference in Bothmer 1969–70 (2004 ed.), p. 234, n. 16.
3. The presentation ceremony would have been held when the king announced his intention to grant Senenmut the privilege of placing his image in temples. Seti I's temple model now in the Brooklyn Museum comes to mind as an example of this genre: Badawy and Riefstahl 1972; Brand 2000, pp. 143–45, fig. 26.

PROVENANCE: Unknown, probably Thebes; said to belong to Simon de Suzy (d. 1799); Pratt collection; acquired in 1948

BIBLIOGRAPHY: *Description de l'Égypte* 1821–30, vol. 5 (1823), pl. 69, figs. 12–14, vol. 10 (1826), p. 573 (for de Suzy); Hayes 1957, p. 86; Vandier 1958, pp. 465, 482, 493, 505–6, pl. CLV, 5; Hayes 1959, pp. 106–7, fig. 57; Bothmer 1969–70 (2004 ed.), p. 234, n. 16; Schulman 1969–70, p. 39; Ratié 1979, pp. 249, 258; Meyer 1982, pp. 45 (bibliography), 205–8, no. 17, pp. 328–29 (text); Dorman 1988, pp. 42, 126–27, 136, 139, 151, 159, 161, 172, 173–74, 194 (with bibliography), 221, no. A.16

68. Senenmut Kneeling with Sistrum

Early 18th Dynasty, joint reign of Hatshepsut and Thutmose III (1479–1458 B.C.)
Granite
H. 40.5 cm (16 in.), W. 12 cm (4¾ in.), D. 25 cm (9⅞ in.)
Staatliche Sammlung Ägyptischer Kunst, Munich
ÄS 6265
Not in exhibition

Like the large quartzite statue of Senenmut from Karnak (cat. no. 66), this much smaller work depicts Senenmut steadying a sistrum between his hands. As the text inscribed here on the right side of the sistrum states about Senenmut: "He supports the sistrum of Iunyt who resides in Armant, so that her place is elevated more than those of the (other) gods. He causes her to appear. He displays her beauty."[1] Armant (Iuny in Egyptian)[2] is one of several locations in the greater Theban area sacred to the Egyptian war god Montu.[3] At Armant, Iunyt was worshiped as consort to Montu and mother of their offspring Horus-Shu.[4]

Three statues of Senenmut are thought to have come from Armant; the other two are in Brooklyn (cat. no. 70) and Fort Worth (cat. no. 71). The Munich statue and the statue in Brooklyn are united by their use of the same material and their similar, although not identical, style. Of the two, the present statue's face is perhaps the more finely executed, and the details of its figure and the sistrum more carefully delineated. The wigs are identical, but the face of this Munich statue is proportionately shorter, the eyes smaller and more almond shaped, the ears much smaller, the nose straighter, and the smile more emphatic than corresponding elements of the Brooklyn image. Both statues bear undamaged cartouches containing the prenomen of Hatshepsut (Maatkare) on their proper right upper arms.

Senenmut's name has been removed everywhere it occurred on the statue, but Hatshepsut's name remains. References to Amun have disappeared only where they were inscribed close to Senenmut's name. These features indicate that Senenmut's name was singled out for effacement.[5] This pattern of destruction and preservation also characterizes the other two Armant statues, indicating that all three were set up together, suffered the same type of deliberate damage, and remained together until they were discovered in modern times.[6]

CAK

1. For a translation of the entire inscription, see Schulman 1987–88, pp. 67–68.
2. On Armant, see Eggebrecht 1975.
3. On Montu (Month), see Borghouts 1982.
4. Ibid., col. 202.
5. Bothmer 1969–70, p. 138, n. 20; Meyer 1982, p. 219, n. 2; Dorman 1988, p. 151.
6. The two Senenmut statues now in the British Museum (cat. nos. 60, 64) also exhibit a shared pattern of destruction and preservation. See Bothmer (1969–70 [2004 ed.], p. 221) on the discovery of the Armant material, including Senenmut's carnelian Hathor amulet (cat. no. 58).

PROVENANCE: Probably Armant, temple of Montu

BIBLIOGRAPHY: Bothmer 1969–70, pp. 125ff., 134ff., figs. 6–8, 25; Ratié 1979, p. 249; Wildung 1980, pp. 18–19; Meyer 1982, pp. 50 (bibliography), 219–22, no. 22, 332–33 (text); Schulman 1987–88, pp. 67ff., figs. 5, 6, 69 (provenance); Dorman 1988, pp. 121, 127–28, 145, 151, 158–61, 166, 172, 194–95 (with bibliography), 221, no. A.17, pl. 20 (text); Robins 1999, pp. 108–9

69. Senenmut Kneeling with Hathor Emblem

Early 18th Dynasty, joint reign of Hatshepsut and Thutmose III (1479–1458 B.C.)
Gray granite or granodiorite
H. 50 cm (19¾ in.)
Egyptian Department of Antiquities Magazine, Luxor
Not in exhibition

This superb but badly damaged statue of Senenmut was discovered in 1963 at Deir el-Bahri, in the ruins of the Djeser-Akhet temple. Both the upper part (the head, neck, and top of the back pillar) and the base are missing. The quality of the workmanship is, however, excellent, as is particularly evident from the front. The Hathor head and *tayet* knot are especially well executed, and the hieroglyphic text imparts a luxurious quality to the work, surrounding the statue as if it were wrapping Senenmut in an elaborately embroidered garment. That he is actually wearing a simple, unadorned kilt is revealed only in the side view, which also shows torso with folds of fat.

The inscriptions inform us that the statue was dedicated to both "Amun-Re and Hathor, preeminent of Thebes, who resides in Kha-Akhet on behalf of life, prosperity, health, and favor every day for the ka of the Steward Senenmut, like Re." The citation of Kha-Akhet, a shrine also attested in other inscriptions dating to the joint reign,[1] rather than of

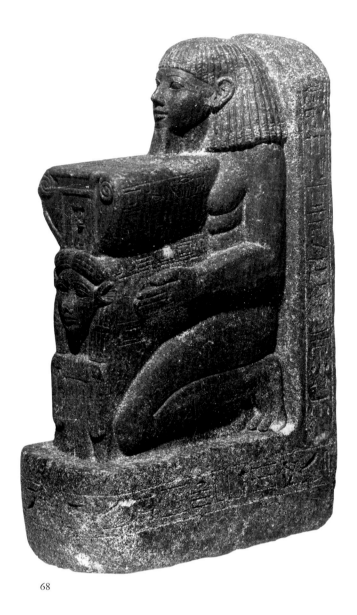

68

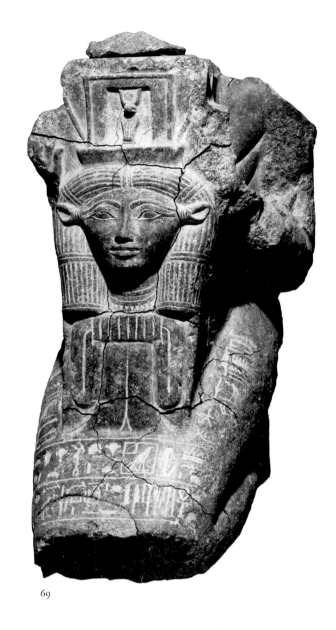

69

Djeser-Akhet, where the statue was found, is puzzling. Christine Meyer suggested that Kha-Akhet was the name of an earlier barque shrine built by Hatshepsut and later incorporated into the Djeser-Akhet temple, which Thutmose III began to build during the final decade of his reign.[2] A cartouche of Menkheperre (Thutmose III) appears on the upper right arm. This was perhaps inscribed when the piece was first completed or may have been added when the statue was placed in its new setting and rededicated.

The discovery of this statue provoked considerable discussion about the association of Senenmut and Thutmose III. It had long been believed that Thutmose III, who clearly was the force behind the *damnatio memoriae* inflicted upon Hatshepsut, had similarly punished her favorite Senenmut as well. However, the discovery of this statue of Senenmut with his name intact in a temple of Thutmose III led scholars

to speculate that the wily steward had survived his female Horus and, like many high officials of the period, successfully negotiated his transition into the sole reign of Thutmose III. This hypothesis might seem unlikely at first glance, given the relatively late date of Djeser-Akhet's construction (year 42 at the earliest)[3] and since we have no dated references to Senenmut after year 18–19.[4] Moreover, other officials who may have succeeded him are known from this time.[5] It may be that Senenmut did not, in fact, live on into the reign of Thutmose III and that his rehabilitation was posthumous.[6] In any event, that Senenmut's memory was not regarded as incompatible with the sole reign of Thutmose III is suggested not only by the present work but also by a second, even more fragmentary statue of Senenmut found at Deir el-Bahri.[7] Although only the lower portion of this kneeling figure, the so-called Naville fragment, remained at

the time of discovery, much of the text on the back pillar is intact and specifically mentions Djeser-Akhet.

The absence from the sistrum's Maatkare cryptogram of the ka arms, which were shaved off, constitutes the sole evidence of deliberate damage, and it was directed toward Hatshepsut's kingly prenomen rather than Senenmut. The shattering of the statue does not appear to have been the work of human hands but seems rather to be the result of the same late Ramesside-period earthquake and rockfall that first destroyed the temple of Djeser-Akhet and subsequently protected it until the twentieth century A.D.[8] CAK

1. References to the monument as "the Mansion of Maatkare Kha-Akhet Amun" are found in the tomb of Puyemre (Norman de G. Davies 1922–23, vol. 2, p. 78, pl. XL) and the Chapelle Rouge at

Karnak (Lacau and Chevrier 1977–79, pp. 74–75). See also Otto 1952, p. 61, and Haring 1997, p. 137.

2. Meyer 1982, pp. 60–65, 183; Dorman 1988, p. 135. A barque shrine held the sacred boat used to transport a deity.

3. The earliest ostraca from Deir el-Bahri that mention Djeser-Akhet's construction date from year 42: Hayes 1960, pp. 43–50; Dorman 1988, p. 178.

4. Dorman 1988, p. 136 and n. 114.

5. Ibid., n. 118. These officials, such as Djehutihotep and Ra-au, overlap with Senenmut and could have succeeded him.

6. For Peter Dorman (ibid., pp. 136–37), whether or not Senenmut lived on into the sole reign of Thutmose III is still questionable; Eberhard Dziobek (1995, p. 133, especially n. 29) believes that he did not.

7. This fragment (Hayes 1957, p. 89; Meyer 1982, pp. 183–85; Dorman 1988, p. 152) may postdate Hatshepsut (Dorman 1988, p. 137).

8. Schulman 1969–70, p. 41, and Lipińska 1977, pp. 10–11, 64. At the Ninth International Congress of Egyptologists (held in Grenoble in 2004), Andrzej Niwiński presented a paper in which he suggested that the rockfall may have resulted from an overzealous attempt to conceal an early Twenty-first Dynasty reuse of a tomb in the cliffs immediately above the Deir el-Bahri temples (Niwiński 2004). The abstract does not include this point, however.

PROVENANCE: Western Thebes, Deir el-Bahri, colonnaded hall of the Djeser-Akhet temple of Thutmose III; discovered by Polish Center for Mediterranean Archaeology expedition, winter 1963

BIBLIOGRAPHY: Marciniak 1965; Bothmer 1969–70 (2004 ed.), p. 228, fig. 14.23; Lipińska 1977, p. 71, ill. 5; Meyer 1982, pp. 42 (bibliography), 179–83, no. 14, 318 (text), pl. 1; Dorman 1988, pp. 14–15, 135–37, 143, 152–53, 161, 178, 196 (with bibliography), 222, no. A.21

70. Senenmut Kneeling with Uraeus Cryptogram

Early 18th Dynasty, joint reign of Hatshepsut and Thutmose III (1479–1458 B.C.)
Granite
H. 47.2 cm (18⅛ in.), 17.2 cm (6¾ in.), D. 29.3 cm (11½ in.)
Brooklyn Museum, New York, Charles Edwin Wilbour Fund 67.68
Not in exhibition

In this almost perfectly preserved statue, Senenmut, the Steward of Amun and Overseer of All Works of Amun and Mut, is shown kneeling. His arms are held out to steady a large version of the Maatkare cryptogram that appears in much reduced form in his sistrophorous statues (cat. nos. 66–68). Here the harvest goddess and Mistress of Food, Renenutet,[1] who takes the form of the cobra—guardian of the granary from rodent predators—shares equal billing with Hatshepsut. And it is to "Renenutet, August Lady of Armant" that the statue was dedicated in a long text that begins on the back pillar, continues around the statue's base, and terminates on its top.[2]

The careful carving of the monogram visible in the frontal view is consistent with the fine rendering of Senenmut's face and figure and the scrupulously detailed wig, which flares out gradually down to the shoulders, echoing the obelisk shape of the back pillar. When the statue is seen from the side, however, undulating volumes rather than incised detail claim our attention: the serpent's coils, the folds of fat on Senenmut's breast, and the smooth, unadorned forms of his limbs and torso. The facial expression and features, like those of so many other images of Senenmut, are youthful and appealing, with a wide, open gaze, full cheeks, and a small, slightly pursed mouth. This is the image of an official who has undergone eternal rejuvenation in recompense for his votive donation.

Like all other representations of Senenmut, this statue has sustained some damage. His name has been erased wherever it had been incised,[3] but the two cartouches of Hatshepsut have not been touched, and the names of the gods Amun and Mut appear to have been erased only where they are close to Senenmut's name.[4] Moreover, Senenmut's image here, as in the two other statues from Armant in this exhibition (cat. nos. 68, 71), is undamaged. All of this suggests that Senenmut's name was eradicated in a calm, methodical manner rather than in a vengeful attack. It may be that damage was limited to the removal of Senenmut's name because the Armant priesthood was unwilling to destroy completely objects consecrated to their goddess. It is also possible that these statues were deliberately left largely intact so that they could be reused. Yet another possibility is that the statues were originally deposited in a special chapel endowed by Senenmut and therefore received only the most basic attentions of his enemies. CAK

1. On the goddess Renenutet, see Broekhuis 1971 and Beinlich-Seeber 1984.

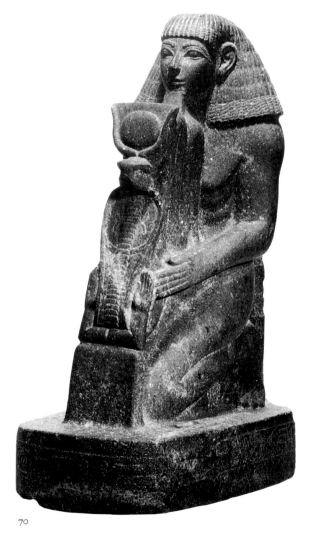

70

2. For a translation of the inscriptions, see Schulman 1987–88, pp. 63–65.

3. Dorman 1988, p. 145, n. 33.

4. So Dorman 1988, pp. 146–47, contra Schulman 1969–70, p. 42.

PROVENANCE: Probably Armant, temple of Montu

BIBLIOGRAPHY: Bothmer 1966–67 (2004 ed.), pp. 170–73, figs. 11.5–11.8; Bothmer 1969–70 (2004 ed.), pp. 217, fig. 14.1, 218, fig. 14.2, 221, 231–32, fig. 14.25; James 1974, pp. 75–76, no. 177, pl. XLVI; Ratié 1979, pp. 248, 255; Schulman 1987–88, pp. 63–65, 68ff. (provenance), 71–74; Meyer 1982, pp. 47 (bibliography), 83ff., no. 19, 330–331, no. 18 (text); Dorman 1988, pp. 121, 127–28, 146–47, 158–62, 166, 189–90 (with bibliography), 220, no. A.4; Richard A. Fazzini in Fazzini et al. 1989, no. 34 (with bibliography); Madeleine E. Cody in Fazzini, Romano, and Cody 1999, pp. 80–81, no. 36

71. Senenmut Kneeling with Uraeus Cryptogram

Early 18th Dynasty, joint reign of Hatshepsut and Thutmose III (1479–1458 B.C.)
Metagraywacke
H. 41.6 cm (16⅜ in.), W. 15.2 cm (6 in.), D. 30.4 cm (12 in.)
Kimbell Art Museum, Fort Worth AP 85.2

Like the two other surviving statues of Senenmut thought to have come from Armant, southwest of Thebes (cat. nos. 68, 70), this work is well preserved. Some incidental damage has been sustained by the back pillar, and Senenmut's name has been carefully erased from all the statue's inscriptions.[1] Again, as with the two other statues from Armant, we are confronted with an interesting dichotomy between the eradication of Senenmut's textual identification and the pristine, untouched condition of the image associated with it.

Senenmut's votive posture in conjunction with the composite emblem of the horned and disk-crowned uraeus and ka arms is also seen in one of the other Armant statues (cat. no. 70),[2] and all three Armant statues share a connection with Renenutet, the harvest goddess and eponymous Lady of Armant, as is confirmed by the texts inscribed upon them. However, the present statue stands somewhat apart in its material and style. The material—grayish green graywacke in contrast to the granite of the other examples—is especially interesting because it is firmly associated with the statuary of Thutmose III, rather than that of Hatshepsut.[3] Was its use here by Senenmut an intentional reference to the junior co-regent or was it chosen simply because it was available?

In terms of style, the torso is chunkier and the breast folds and arms markedly flatter here than in the other statues in question. The face has a distinctly squarish appearance in frontal view, primarily owing to the puffiness of the cheeks, which extend to the chin, producing a slightly jowly effect. The wig is more summarily

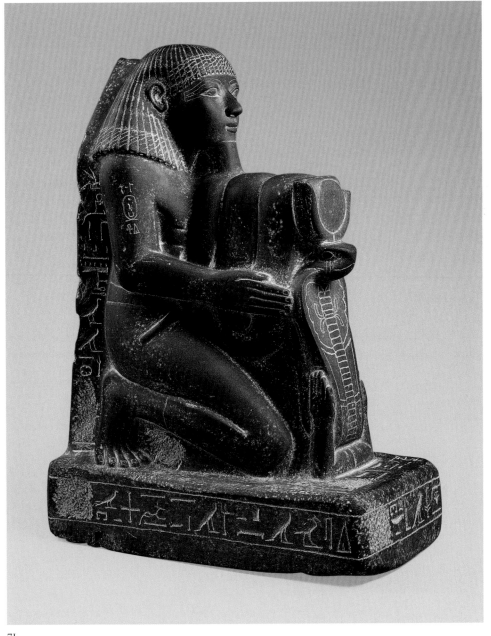

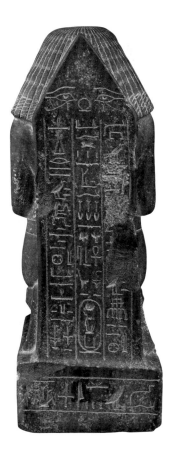

71

drawn and has a thicker fringe across the forehead. The eyebrows and cosmetic lines are incised rather than carved in relief, and the arcs of the eyebrows are so shallow that they come very close to the upper eyelids. The eyes bulge slightly. The curve of the nose is stronger here than in the Munich piece and less exaggerated than that of the Brooklyn statue's prominent beak. The mouth is small and the lips protrude slightly. The tip of the chin is obscured by the upper edge of the false beard, which rises slightly in front, accentuating the squareness of the face. A view of the three statues placed side by side (fig. 53) reveals that the facial features of the present piece are in general closest to those of the Brooklyn statue.

In all three examples Senenmut wears a simple wrapped kilt and no other adornment. Here the kilt has a double waistband and reaches to the figure's midcalf. The cryptogram rests directly upon the statue's base, so that it sits lower than in its two counterparts; as a result, Senenmut's arms lie over the serpent's folds instead of beneath them as in the other examples.

The top of the back pillar tapers to a point and thus forms an obelisk, a type of monument closely associated with Senenmut in other contexts.[4] The apex is decorated with a central *shen* sign (meaning "encirclement") flanked by protecting *wedjat* eyes, a combination often found on the tympani of Eighteenth Dynasty private stelae that signifies all-encompassing protection, in this instance protection that extends around the back of the statue.

CAK

1. For a translation of the inscriptions, see Schulman 1987–88, pp. 66–67.
2. Senenmut's statue from the temple at Luxor (Egyptian Museum, Cairo, JE 34582) is similar in type, but its cryptogram almost certainly refers only to Hatshepsut.
3. Fay 1995, p. 14.
4. Habachi 1957, pp. 92, 94, fig. 3, 95–96; Meyer 1982, pp. 94, 118, 267, 307 (text no. 4); Dorman 1988, pp. 115–16, 198–99 (with bibliography).

PROVENANCE: Probably Armant, temple of Montu

BIBLIOGRAPHY: Bothmer 1969–70 (2004 ed.), pp. 218–19 (on provenance), figs. 14.2–14.5; Meyer 1982, pp. 48 (bibliography), 214–17, no. 20; Schulman 1987–88, pp. 65–67, 68ff. (on provenance), 75–77, figs. 2–4; Dorman 1988, pp. 127–28, 150–51, 158–62, 166, 172, 193 (with bibliography) 221, no. A.14, pl. 21 (text); Robins 1999, pp. 108–9

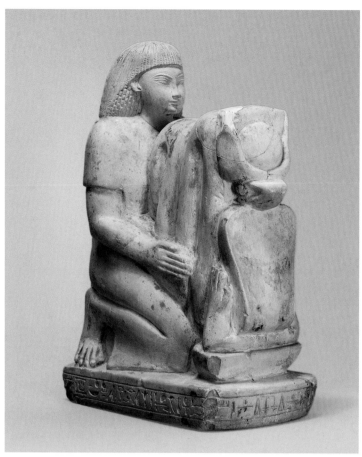

72

72. Setau Kneeling with Uraeus Cryptogram

Early 18th Dynasty, reign of Amenhotep II–early reign of Amenhotep III (1426–1380 B.C.)
Painted limestone
H. 26.5 cm (10⅜ in.), W. 10 cm (4 in.),
D. 17.5 cm (6⅞ in.)
Musée du Louvre, Paris N 4196

This statuette, which was probably found at the temple at Karnak, portrays the Overseer of the Workhouse of Amun in Ipet-Sut (the temple of Amun at Karnak),[1] Setau. Setau holds a monogram—a horned and disk-crowned uraeus with ka arms—that appears to be of the type seen in two statues of Senenmut catalogued above (cat. nos. 70, 71). Unlike Senenmut, who is always shown in his statuary in the simplest of garments, Setau is clad in the elaborate uniform of a mid-Eighteenth Dynasty official: a double-tiered wig and loose-fitting tunic over a flowing, ankle-length kilt. His facial features, notably his elongated, almond-shaped eyes and long nose turned up at the tip, also conform to the conventions of this period.

The motif inscribed on Setau's uraeus, which features a rearing cobra, is known as the Maatkare cryptogram (Maatkare being Hat-

shepsut's prenomen). It would be difficult to understand why Setau, whose fluorit dates to two generations after Hatshepsut's reign, would have chosen this motif for his votive if its meaning was connected only to Maatkare, a dishonored king.[2] In fact, the symbol's original and primary reference was to Renenutet and other sustaining goddesses; only on the monuments of Hatshepsut and her highest officials did it come to be identified with her. And attacks on Hatshepsut's kingly attributes ceased after the reign of Thutmose III, so that the revival of this cryptogram was not compromised by its relatively short-lived identification with his deceased co-regent.[3]

Setau's selection of a monogram centered on a rearing cobra is particularly appropriate, as he was the official in charge of food production at the Karnak temple and the snake was regarded as the rodent exterminator par excellence. Moreover, goddesses associated with food were commonly depicted in the form of snakes.[4]

Although the inscriptions on this statuette mention Amun-Re, for primary honors they single out Nekhbet, the tutelary goddess of Upper Egypt and a harvest divinity. Nekhbet was perhaps accorded prominence here because of the increasing syncretism of the female harvest divinities into a single deity.[5] It is also

possible that a member of Setau's family was somehow connected to Nekhbet's cult center at El-Kab.

<div align="right">CAK</div>

1. The workhouse, or *(pr)-šnꜥ*, often rendered as "ergastulum," or "storehouse," was a temple installation where low-ranking personnel attached to the temple produced such items as bread and beer for offerings, local consumption, or payment of staff. On this subject, see Gardiner 1947, vol. 2, pp. 209–10; Helck 1975a; Brovarski 1986, col. 392; and Martin-Pardey 1986, col. 404. The inscription is published by Pascal Vernus in *Naissance de l'écriture* 1982, p. 133.

2. This "revival" of the cryptogram was not unique to Setau; the cryptogram also appears on a sistrophore of the Steward of the God's Wife, Djehutinefer (Louvre E 5416). See Graefe 1981, pp. 236–37, no. P34.

3. See "Erasing a Reign" by Ann Macy Roth in this volume. Robins (1999, pp. 108–10) summarizes past discussions of the Maatkare cryptogram.

4. See the discussion of this cryptogram in "The Statuary of Senenmut," above.

5. Another work of similar date (Szépművészeti Múzeum, Budapest, stela 51.2148) depicts a certain Simut offering to a serpent goddess called "Nekhbet-Renenutet-Hathor"; references in Graefe 1980, p. 49, citing Broekhuis 1971, pp. 20–21, no. 22, fig. 5, and Robins 1999, p. 109

PROVENANCE: Probably Karnak, based on the inscription; acquired with the purchase of the Salt collection in 1826

BIBLIOGRAPHY: Drioton 1938, p. 231, pl. XXXII; Vandier 1958, pp. 466, 484, 497, 510, 514, pl. CLVI, 1; Ratié 1979, p. 255; Graefe 1980, p. 46; Meyer 1982, pl. 8; Pascal Vernus in *Naissance de l'écriture* 1982, pp. 133–34, no. 81; Seipel 1992, pp. 317–19, no. 123; Guillemette Andrieu in Andreu, Rutschowscaya, and Ziegler 1997, pp. 116–17, 252, no. 49; Robins 1999, p. 109, n. 42

THE TOMBS OF SENENMUT

It is an archaeological curiosity that Senenmut was the owner of two decorated tombs in the great necropolis of western Thebes: Theban tombs (TT) 71 and 353. Tomb 71 is located on the upper slopes of the rocky eminence known as Sheikh abd el-Qurna, overlooking the Nile valley, and has been recognized as Senenmut's tomb since the earliest recording expeditions to Thebes, in the 1830s. However, while excavating an ancient dump just outside the enclosure wall of Hatshepsut's temple at Deir el-Bahri for The Metropolitan Museum of Art in 1927, Herbert Winlock unearthed a second tomb (TT 353) inscribed with the name of the monarch's favorite steward, at the bottom of an ancient quarry in the Asasif valley (see the map of the Theban necropolis in the introduction).[1] Winlock believed that Senenmut had Tomb 353 built for himself late in his career, having abandoned the hillside location in favor of one closer to the memorial temple of Hatshepsut. The puzzle of the two tombs is solved by a close look at the architecture and decoration of these two monuments.[2]

Although Tomb 71 is badly damaged today, owing to the collapse of the friable rock in which it was carved, it is still evident that its size, proportions, and decorative features would have made it one of the jewels of the Theban necropolis. At the time of its creation, it was the largest rock-cut chapel in western Thebes, carved in the usual T shape, with a broad transverse hall supported by eight columns and—an unusual feature— lit by eight windows. The long axial corridor, with a ceiling more than four meters high, extended seventeen meters into the solid bedrock, ending in a false-door stela carved from a single block of quartzite (cat. no. 73) and, directly above it, a statue niche decorated with painted relief. Although only fragments of the wall paintings have survived, they reveal that much of the decoration of Senenmut's chapel was devoted to subjects commonly represented in contemporary tombs: the funeral procession of the deceased, with his possessions, to his tomb in the west; banqueting scenes showing the family and friends of the tomb's owner; the ritual funerary meal presented to the deceased; and the so-called pilgrimage to Abydos, that is, the tomb's owner on his way to visit the supposed tomb of the god Osiris at Abydos. The extant painted fragments, even in their damaged state, feature exquisite workmanship—even the wigs of the large-scale figures are worked in three-dimensional plaster relief—and this suggests that Tomb 71 was decorated by artists from the royal ateliers. One remarkable scene is preserved in the northwest corner of the transverse hall: the earliest known Egyptian representation of emissaries bearing offerings of typically Minoan manufacture (fig. 34), attesting to contacts between Egypt and the Aegean early in the co-regency of Hatshepsut and Thutmose III.[3]

In front of Tomb 71, a large artificial terrace was built over the steep slope, to provide an impressive forecourt for the chapel, and high above,

Fig. 55. Astronomical decoration on the ceiling of Senenmut's tomb at Deir el-Bahri (TT 353), early 18th Dynasty. Facsimile by Charles K. Wilkinson. The Metropolitan Museum of Art, New York, Rogers Fund, 1948 (48.105.52)

on the crest of the hill and directly over the axis of the tomb, an unfinished cube statue of Senenmut holding Princess Neferure was cut into the bedrock (fig. 47). During construction of the terrace, a modest burial chamber was hollowed out to receive the coffins of Senenmut's parents, Ramose and Hatnefer, as well as four coffins containing six anonymous mummies (see, above, "The Tomb of Ramose and Hatnefer"). On the open slope below the terrace, a number of simple coffin burials of the early Eighteenth Dynasty were deposited, presumably because the freshly quarried chip from Tomb 71 offered a convenient means to cover and conceal the interments of Thebans who could not afford a rock-cut chamber of their own.

Tomb 353 offers a stark contrast to the light-filled, spacious chapel on the hillside. A small, unadorned opening in the bottom of a shale quarry gives access to a long descending stairway cut into the floor of the Asasif valley. After almost a hundred meters, the stairs end in a small, low-slung chamber quarried into a layer of hard, fine limestone, its walls covered with columns of closely spaced hieroglyphs. The texts on the west side of the room are taken from several chapters of the Book of the Dead dealing with the topography of the underworld, and they are arranged around a false-door stela that serves as the centerpiece. The texts on the east side contain a series of funerary liturgies—words to be spoken and deeds to be enacted on behalf of the deceased—which are unique to the mortuary tradition of the New Kingdom. Though apparently available in temple archives of Senenmut's time, liturgies do not otherwise appear in a funerary context until the Ptolemaic period (332–30 B.C.). The flat painted ceiling of the chamber is equally noteworthy, for it is the earliest known astronomical ceiling in Egypt (fig. 55). The constellations of the northern sky are depicted; twelve circles represent the twelve recurrent months of the lunar year; and a chart lists the decan stars by which the Egyptians measured the passage of time during the night. Also represented are the constellation Orion, the star Sirius (Isis), and the five planets known to the ancients.

The two tombs are to be explained, not by Winlock's belief that one tomb was given up when the second was begun, but by their complementary roles: Tomb 71 served as Senenmut's public offering chapel, where his memory and that of his parents were to be commemorated, while Tomb 353 was the burial apartment, where his body was to have been interred. Such physical separation of the two most important components of a private Theban tomb of the early Eighteenth Dynasty is rare, but not unique, and it is the rule for kings of the New Kingdom, whose mortuary cult temples were located at the edge of the cropland at Thebes, far from their burials in the Valley of the Kings. Senenmut, therefore, possessed only one funerary monument, given two numbers by scholars. Curiously, the tomb seems never to have been used. Tomb 353 was in the process of being extended by the quarrying of additional descending ramps and two more chambers when the work was suddenly abandoned, and the tomb sealed at its entrance. There is no indication of an interment in either Tomb 71 or Tomb 353, although Senenmut's quartzite sarcophagus—also unused (and unfinished)—was found, in fragments, in his upper-tomb chapel. The real mystery is why Senenmut was never buried in the magnificent tomb prepared for him.

1. For the account of the discovery, see Winlock 1928a.
2. For final publication of Tombs 71 and 353, see Dorman 1991.
3. See also Manfred Bietak's essay "Egypt and the Aegean" in chapter 1.

73. False-Door Stela from the Funerary Chapel of Senenmut

Early 18th Dynasty, joint reign of Hatshepsut and Thutmose III (1479–1458 B.C.)
Quartzite
H. 152 cm (59⅞ in.), W. 108 cm (42½ in.)
Ägyptisches Museum und Papyrussammlung, Staatliche Museen zu Berlin 2066

This slab of reddish brown quartzite carved in the form of a false door, with a cavetto cornice, was the ritual focus of Senenmut's offering chapel in Thebes (TT 71). Located at the innermost point of the axial corridor of the rock-cut chapel, the stela served as the architectural and decorative culmination of the space and, conceptually, functioned as a means of access to the world of the living for the deceased.

The slim doorway is crowned by a pair of protective *wedjat* eyes and, above them, a miniature representation of Senenmut seated with his parents. The inscription is taken from the Book of the Dead, spell 148. The words are those of an officiant charged with maintaining the funeral offerings, who ensures the eternal provisioning of the deceased by invoking the bull and seven cows, depicted at the outer left of the door, who "provision the Westerners," or those who have passed on: "May you give bread and beer to the steward Senenmut, may you provision the steward of Amun Senenmut, may you give power to the steward Senenmut, may Senenmut follow you." The god Anubis and four mummiform figures representing the four "powers of heaven," or the cardinal points, are depicted at the outer right of the door. Anubis, too, is invoked in the inscription, as the "power of heaven who opens the sun's disk, goodly rudder of the eastern sky, circler who guides the two lands." The spell begins on the four frames on the left side (preference always being given to hieroglyphs facing toward the right), proceeding from the outermost to innermost frame in retrograde order; it continues on the central panel, below the *wedjat* eyes, and ends on the four frames to the right, again proceeding from the outermost to innermost and thus leading the eye in toward the central doorway and the access point for the soul.

A quartzite stela in a private chapel is quite unusual. Quartzite is not only extremely difficult to work; in the early Eighteenth Dynasty it was also preferred for royal monuments, presumably because of the solar symbolism of its reddish color.[1] Minor blemishes on this stela were filled in with red-colored plaster, and because of defects in the stone two blocks were patched into the upper left corner of the stela; these have since fallen away.[2] The inscription suffered damage at the hands of those who attacked Senenmut after his death by defacing monuments bearing his name, and again at the hands of the Atenists, who were intent on obliterating the name of Amun. These damaged areas were later repaired—presumably all at the same time—under the post-Amarna pharaohs, but not always correctly: in one place, for example, the name of Senenmut has been recut over the damaged word for "west." The hieroglyphs and vignettes, as well as the carved details of the

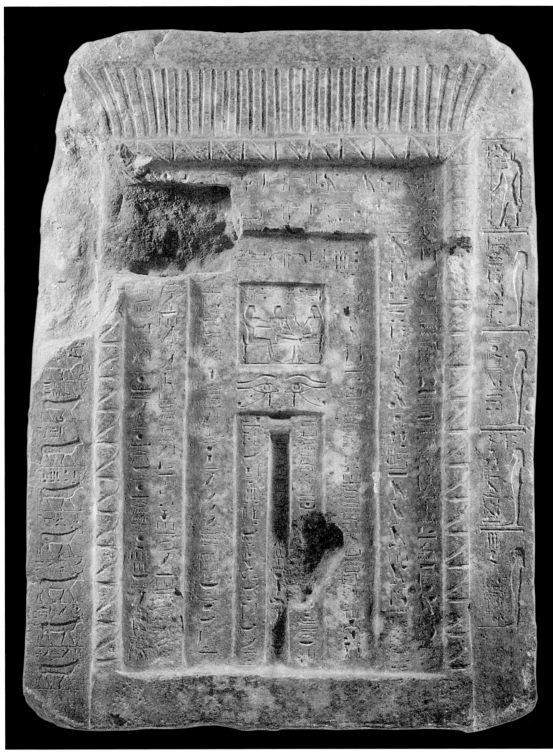

73

cornice and torus moldings, were filled in with blue pigment, of which only traces now remain.

PFD

1. The final rubric in the version of spell 148 found in the funerary papyrus of the Eighteenth Dynasty official Tjenna refers to the spell's being found on a block of quartzite, which lends significance to Senenmut's choice of stone.
2. Based on the very similar false-door stela present in the burial chamber of Senenmut (TT 353), the

now-missing portions would probably have been covered by another image of Anubis and a mummiform figure of the sun god.

PROVENANCE: Western Thebes, chapel of Senenmut (TT 71); Lepsius expedition, 1842–45

BIBLIOGRAPHY: Lepsius 1849–59, vol. 3, pl. 25 *bis*, a; Roeder 1924, pp. 92–96; Helck 1939, p. 45 R; Hermann 1940, p. 18, pl. 1, a; Helck 1958, p. 474 t; Porter and Moss 1960, p. 141; Lesko 1967, p. 114; Schulman 1969–70, pp. 43–44; Joanna Aksamit in *Geheimnisvolle Königin Hatschepsut* 1977, pp. 134–35, no. 42; Meyer 1982, pp. 230–32 and passim; Karl-Heinz Priese in *Ägyptens Aufstieg* 1987, p. 333, no. 287; Dorman 1988, pp. 1, n. 1, 15, 85, 89, 94, 95, n. 122, 100, n. 151, 146, 153–54, 222; Dorman 1991, pp. 54–55

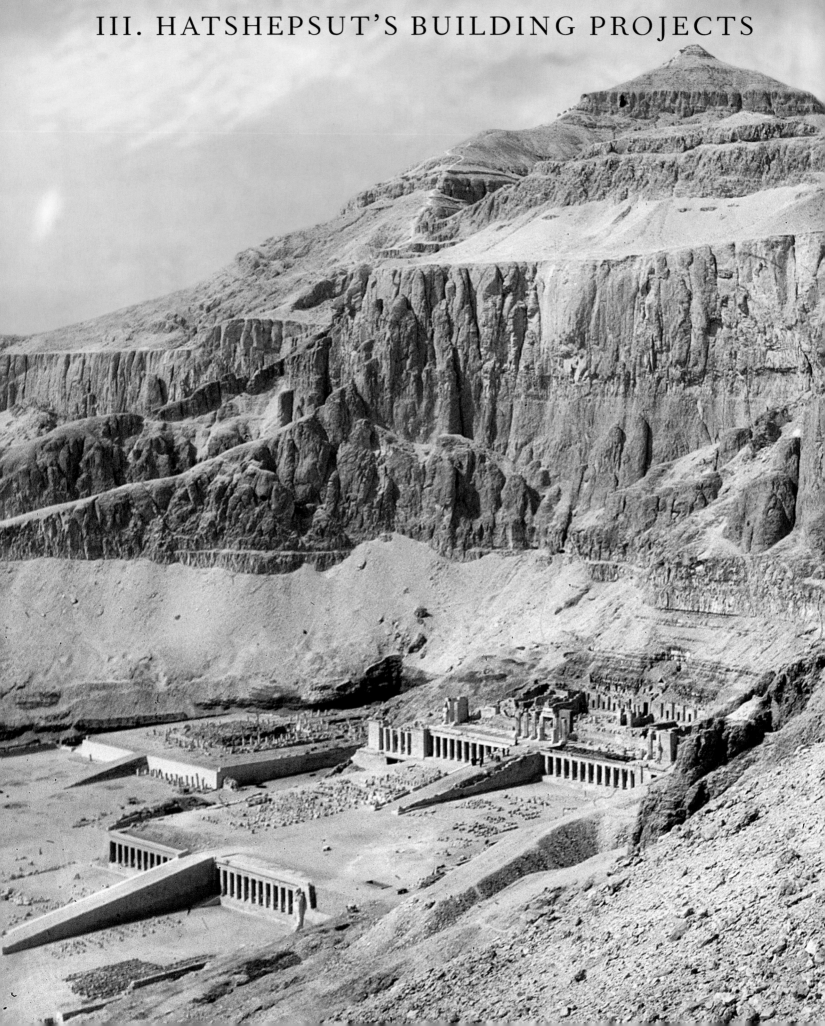

III. HATSHEPSUT'S BUILDING PROJECTS

DJESER-DJESERU

THE TEMPLE OF HATSHEPSUT AT DEIR EL-BAHRI

Dieter Arnold

Little architecture of note was produced during Egypt's Second Intermediate Period and early Eighteenth Dynasty—the centuries preceding Queen Hatshepsut's reign—but once she attained power she opened a new age of monumental temple building. Evidence of her construction activity is found from Buhen and Dakka in Nubia, in the south, to Beni Hasan (Speos Artemidos) in the north. Her main effort, however, was in Thebes, where she created a network of grand processional roads and structures for the ritual voyages made by the god Amun. Amun's image, placed in his divine barque, was carried from Karnak to the nearby temples at Luxor, Medinet Habu, and Deir el-Bahri. Hatshepsut had every reason to show gratitude to Amun, since—in addition to the invented story of her divine birth—what legitimized her claim to the throne was an oracle based on a miraculous act of the god's barque. She founded the Chapelle Rouge (fig. 42), the famous quartzite shrine that sheltered the barque of Amun in the heart of the temple of Karnak, on the east bank of the Nile, which was the starting point of the processions, and she erected her famous hundred-foot-high obelisks in front of the temple. She built a pylon (today known as the Eighth Pylon) at the main entrance to the temple from the south and adorned its front with colossal statues of herself. And to the Theban processional roads she added temples and colonnaded stations such as the temple of Mut, the predecessor of the present temple (see the essay by Betsy M. Bryan later in this chapter). The development of this enormous circulation path traversing the whole area of Thebes was an extraordinary accomplishment of pharaonic town planning. Centuries later, Homer would sing of "hundred-gated Thebes."[1]

The hierarchical climax in this profusion of processional roads and temples was Hatshepsut's memorial temple, Djeser-djeseru, or "holy of holies," which rose at a spot now called Deir el-Bahri ("northern monastery"). It is located at the base of the desert cliffs on the west bank of the Nile (figs. 56, 57), facing the Amun temple at Karnak more than three miles (5.3 kilometers) away and across the river.

A masterpiece of pharaonic temple architecture and indeed of architecture worldwide, the building was certainly designed by one of the greatest temple builders of ancient Egypt. We do not know his identity. Perhaps he was the Overseer of Works, Senenmut, or the High Priest, Hapuseneb; and Hatshepsut herself might have had definite ideas that molded the project. Whoever this master builder was, he broke with the tradition of copying recognized prototypes and designed an original and innovative building. One might at first speculate whether he was aware of contemporaneous Minoan architecture, with its characteristic open colonnades, monumental staircases, elevated platforms, and integration into the landscape. But all these features were known to Egyptian architects of the time. In fact, it seems possible that a kind of "international style" spread widely through the Mediterranean cultures about 1500 B.C., when a new tendency in palace architecture—away from fortresslike structures and toward light, open, indefensible buildings—made its appearance from Crete to the Levant to Egypt.

TERRACING

The formative elements of Hatshepsut's temple were two elevated platforms that enhanced the effect of the sacred buildings they supported and integrated the monument with the surrounding landscape. The placement of temples and palaces on high terraces has a long history in Egyptian architecture. As far back as the Fifth Dynasty, the sun temple of King Niuserre (r. 2420–2389 B.C.) rose on a steep platform above the Nile valley near Abu Sir. A front arranged in steps can be seen on many Middle Kingdom rock tombs in Middle and Upper Egypt, such as the ones at Qaw el-Kebir, and in the early Eighteenth Dynasty a royal palace was built on a high terrace overlooking the Nile valley at Deir el-Ballas, some 25 miles (40 kilometers) north of Thebes. But the most direct inspiration for Hatshepsut's complex came from the

Opposite: Fig. 56. The temples of Mentuhotep II and Hatshepsut at Deir el-Bahri in 1953, before restoration. The temple of Thutmose III lies between them, unexcavated.

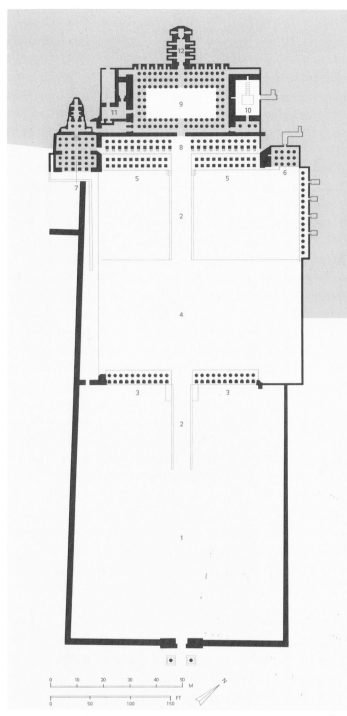

Fig. 57. Plan of Hatshepsut's temple at Deir el-Bahri: (1) lower court, (2) ramps, (3) lower colonnades, (4) lower terrace, (5) middle colonnades, (6) Anubis shrine, (7) Hathor shrine, (8) upper colonnade with royal-statue pillars, (9) upper court, (10) solar-cult court, (11) mortuary-cult complex, (12) barque shrine of Amun

temple of the Eleventh Dynasty king Mentuhotep II (r. 2051– 2000 B.C.), which was located just south of the spot where Hatshepsut built her temple (fig. 58). This time-honored shrine stood on a platform and was surrounded by open colonnades on two levels. Its exterior colonnades were undoubtedly derived from the pillared frontal porticoes of Upper Egyptian rock tombs, especially the so-called *saff* tombs of the Theban area. Mentuhotep's exterior colonnades pointed the way to the future of Egyptian temple building.

Similar colonnades lined the east fronts of the two platforms of Hatshepsut's temple. Each colonnade was divided into a northern and a southern section by a huge ramp in the center ascending to the top of the platform (fig. 59). While Mentuhotep's temple had one platform and Hatshepsut's two, an even more important difference between the temples was the overall spatial organization of their colonnades. In both structures, the lower colonnade formed the backdrop of a huge open court at ground level (fig. 57:1). The upper colonnade of Mentuhotep's temple wrapped around the forward section of the temple on three sides, making it look almost like a free-standing monument. The massive building at the core of this section was 36 feet (11 meters) high. The porticoes surrounded it, reducing the terrace to a narrow walkway.

In Hatshepsut's temple there were colonnades on three levels (figs. 57, 89). The first, at the base of the lower terrace, backed up the immense ground-level court (as in Mentuhotep's temple). The middle colonnades standing on that terrace, however, bordered another huge open space, enclosing this second court on the west side and partially on the north. Above was another terrace with a third colonnade made up of twenty-six pillars on which were royal statues. Thus the processional path led up two ramps and through a magnificent granite gate in the center of the third colonnade, into another, enclosed, court. This uppermost court was completely surrounded by fluted pillars, two rows deep along the north, east, and south sides and three rows deep on the west. The west colonnade sheltered ten wall niches that contained royal-statue pillars.

The lavish use of exterior colonnades on the temples of both Mentuhotep II and Hatshepsut is particularly remarkable because most Egyptian temples, from the Old Kingdom through the Roman Period, were screened off against the outside world by tall, faceless enclosure walls. The temples are like fortresses, and colonnades are found only along their interior courts. The two temples under discussion here belong more properly with a smaller group of temples of a different type: ambulatory temples that are surrounded on all four sides by open colonnades. These buildings, in which the idea of Mentuhotep's temple was further developed, came into use under Senwosret I (r. 1961–1917 B.C.). His famous white chapel at Karnak is the best-preserved example. Ambulatory temples, which became especially popular during the Eighteenth Dynasty, were the formal predecessors of the peripteral temples of ancient Greece. Most Egyptian buildings of this type were not meant to be the permanent residence of a cult image; they were, rather, temporary shelters employed during such ceremonies as the celebration of the birth of a divine child, or for the short-term deposition of the god's sacred barque during his visit to a neighboring temple. Since the basic purpose of these station temples was to offer a shady resting place, their roofs were supported not by solid walls but by columns or pillars. In order to

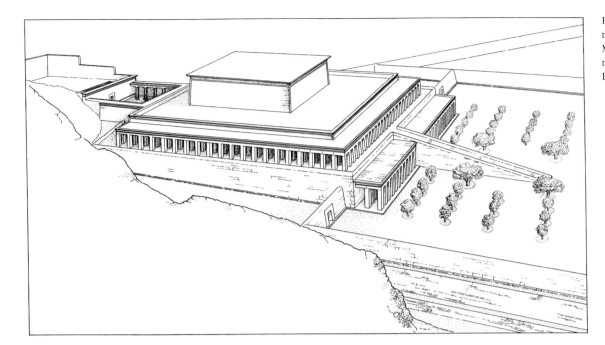

Fig. 58. Reconstruction of the 11th Dynasty temple of Mentuhotep II, viewed from the southeast. Drawing by Dieter Arnold

protect the sanctity of the cult image, some of these road stations were raised on a platform.

A BARQUE STATION OF AMUN

The resemblance Hatshepsut's temple bears to these buildings reveals the main purpose of Djeser-djeseru: it functioned as a huge barque station raised above the plain of the Asasif valley. This becomes even clearer when one examines the much larger overall complex that culminated at the temple. It included a colonnaded landing station (Valley Temple) two-thirds of a mile (1,000 meters) east of the temple, at the desert's edge, and a broad connecting causeway with a barque station located midway between the landing station and the main temple (see fig. 90). In order to highlight the importance of the temple, for the last third of a mile (500 meters) the processional approach was flanked by two rows of sandstone sphinxes, more than a hundred altogether. This was apparently the first avenue of sphinxes ever built in Egypt.

The barque sanctuary of Amun, the destination of the procession, was in the center behind the upper court (fig. 57:12). This magnificent chapel, a long, high space, had a transom window that allowed sunlight to illuminate the room. A door flanked by royal-statue pillars led into the holy of holies, and perhaps into another chamber that had a false door of granite.

We can be rather sure that the temples of Mentuhotep II and Hatshepsut were used only for special religious events because they both lacked subsidiary buildings for storing offerings, the accommodation of priests, temple administration, workshops, and other functions—structures that are prominent adjuncts to temples continuously in use. A few modest shelters were preserved on the slope north of Hatshepsut's temple, and other buildings may have been located around the landing station, but there was nothing comparable to the huge installations that surrounded later mortuary temples.

THE MORTUARY CULT

The characteristics of a monumental barque shrine of Amun are certainly predominant in the ground plan and appearance of Hatshepsut's temple. But the temple was not designed for a single purpose; it also sheltered five other, independent sanctuaries. Four were for the cults of Anubis, Hathor, a local Amun, and Re, the sun. The most important cult center was the installation for the funerary or memorial cult of Hatshepsut and of her father, Thutmose I (r. 1504–1492 B.C.; fig. 57:11). Here offerings would have been made to sustain the spirits of the deceased kings.

Huge, complex buildings to provide for the afterlife of the king were a substantial part of Egyptian culture and are best represented by the sumptuous pyramid complexes built during the Old Kingdom. The concept of a self-sufficient, monumental royal tomb slowly diminished, and during the reigns of Senwosret III (r. 1878–1840 B.C.) and Amenemhat III (r. 1859–1813 B.C.) in the Twelfth Dynasty, a different approach was developed by kings in their ongoing search for eternal life. The royal funerary cult was now attached to a sanctuary of the gods, an arrangement that promised to be more reliable and enduring than a separate pyramid cult. The roots of this new concept lie once again with Mentuhotep II, who had already sought a similar solution in his temple at Deir el-Bahri. The main front section of his temple was dedicated to the solar deity Montu-Re, and only the rear part was reserved for the royal mortuary cult; it included an open court, a hypostyle hall, and the royal crypt. But during the Second Intermediate Period

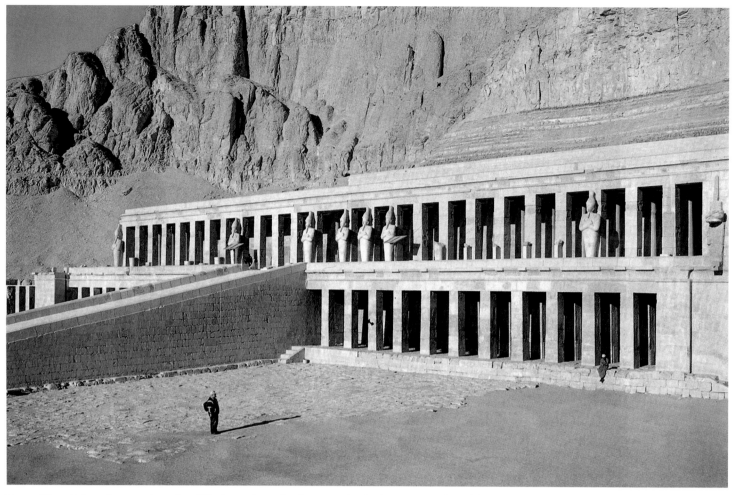

Fig. 59. The middle and upper colonnades of Hatshepsut's temple after restoration by the mission of the Polish Centre of Mediterranean Archaeology in Cairo, Warsaw University

(1650–1550 B.C.) and the early Eighteenth Dynasty, royal mortuary cults nearly vanished, and royal mortuary chapels rarely differed from those of private tombs. Although there was some indistinct movement in that direction under Ahmose I (r. 1550–1525 B.C.) and Amenhotep I (r. 1525–1504 B.C.), Hatshepsut was the first ruler to revitalize the royal mortuary complex as a monumental building and to refine the ideas of her early Middle Kingdom predecessor by attaching her own mortuary cult to a temple of the gods.

For reasons of cultic purity, however, the royal burial could not be in the temple. The royal tomb was now located in the mountain behind the temple and reached by way of the Valley of the Kings. Unlike Mentuhotep's, Hatshepsut's mortuary cult chapel did not occupy the central axis of the temple, a location that was reserved for the cult of Amun. Instead, her mortuary section was placed behind the south colonnade of the upper court (fig. 57:11). It contained an offering hall that was not based on the corresponding sanctuary of Mentuhotep's nearby temple but instead replicated offering halls in pyramid temples of the Old and Middle Kingdoms. With its striking dimensions—about 17 feet wide, 43 feet long, 21 feet high (5.25 x 13.25 x 6.35 meters)—and an enormous vaulted ceiling, the offering hall was in fact the most impressive interior room in the entire temple.

The uppermost terrace proclaimed the royal nature of the temple with an imposing row of twenty-six royal-statue pillars overlooking the temple terraces below (fig. 59). Because they resemble images of the mummified god Osiris they are termed "Osirides," but they more probably symbolized eternal, divine kingship. The use of royal-statue pillars was not new; there were colossal examples in the buildings of Senwosret I of the Twelfth Dynasty at Karnak and Lisht, of Amenhotep I at Deir el-Bahri (cat. no. 13; fig. 9), and of Hatshepsut's father, Thutmose I, at Karnak (cat. no. 14). The statues of Hatshepsut later fell victim to Thutmose III's anti-Hatshepsut campaign and were restored only recently by the Polish archaeological mission working at Deir el-Bahri.[2]

SANCTUARIES OF ANUBIS AND HATHOR

Two sanctuaries flanked the main temple of Hatshepsut on top of the first terrace but were not integrated into the system of the colonnades, instead being isolated by massive piers of masonry from the colonnaded central part of the temple. One, the shrine of Anubis, was located in the northwest corner of the middle terrace (fig. 57:6). Unpretentious from the exterior, the temple had a

harmonically proportioned pronaos of three rows of four fluted pillars. Behind that a sequence of cavelike interior chambers cut into the mountain carry depictions of the dwelling places of the jackal-shaped Anubis, the desert-based god of the netherworld.

Opposite, at the south end of the terrace, stood the more conspicuous shrine of the goddess Hathor (fig. 57:7). Its independence from the main structure is underlined by a separate ramp at a distance from the central ramp of the main temple. The facade projected considerably beyond the colonnade of the main temple. The front of the shrine was an open pronaos with four pillars *in antis* carrying Hathor capitals. The interior chambers here were also tunneled into the mountain and probably replaced an older cave shrine that was a local place of worship of Hathor in the shape of a cow.

The Hathor shrine might be clearly separated from the main temple, but a spiritual connection between the two temples was not completely absent. Since the Old Kingdom, cult installations for Hathor had been associated with kings' pyramid temples. Moreover, Hatshepsut seems to have sought a special relationship with the goddess, presenting herself as a reborn Hathor. Hatshepsut's offering hall is built directly above the Hathor temple, underlining this association. The Hathor shrine and other parts of Hatshepsut's temple as well show evidence of changes in plan, suggesting that the temple as it stood at the end of her reign was the outcome of a complex design and building process.

The other four sanctuaries of the Hatshepsut complex, for the gods mentioned above and for Hatshepsut and Thutmose I, were not visually emphasized by the colonnades of the upper court; they were, rather, disguised by them. This use of colonnades anticipates their function in the columned roads of Hellenistic cities, where long rows of columns screened off the buildings behind them so they could not be seen from the streets or squares.

THE SOLAR CULT

The temple of Mentuhotep was organized in two parts, with the back, westernmost section assigned to the mortuary cult of the king (see fig. 58). The eastern, colonnaded part of the temple was, according to the inscriptions on the dedication tablets, dedicated to the cult of Montu-Re—the Upper Egyptian counterpart of the god Re-Harakhti of Heliopolis, associated with the sun and a protector of the king. The main feature of this part of Mentuhotep's temple was a solid block of masonry towering high above the tops of the surrounding colonnades. But Hatshepsut's architect discarded this distinguishing, centralized element in favor of a solar-cult complex built on the upper terrace of her temple (fig. 57:10). For this purpose the architect designed a small open courtyard with a monumental altar. Since the ceremonies for the solar cult were conducted facing the rising sun, the altar had to be ascended

by a staircase from its western side. Movement in this direction ran counter to the processional path in the main temple, requiring a turn to be executed in the sun court. Four wall niches may have housed cult statues of Hatshepsut to ensure her participation in the life-restoring rites of the sun cult. The solar complex was therefore an important component of the program that had as its goal securing Hatshepsut's immortality.

SUCCESSORS

An architectural masterwork such as Hatshepsut's temple would be expected to become a model for future buildings. Remarkably, however, the principal follower of this prototype was Thutmose III, the very man who instigated the destruction of Hatshepsut's temple. Thutmose built two temples in which the main features of his hated relative's achievement are to some extent replicated: Mehenket-ankh, situated at the edge of the desert about a third of a mile (500 meters) south of the Valley Temple of Hatshepsut (see fig. 60, bottom, and map, p. 148); and Djeser-Akhet, wedged between Mentuhotep's and Hatshepsut's temples, directly south of the latter and high above it (see figs. 89, 104). Both temples were terraced and had ramps and open colonnades across the front. Because of the terrain, Djeser-Akhet rises by means of three

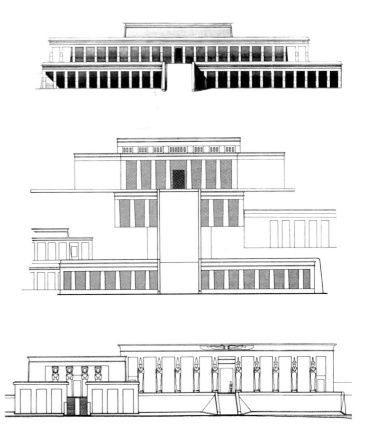

Fig. 60. Frontal elevations of reconstructed temples: top, temple of Mentuhotep II, 11th Dynasty; center, the Djeser-Akhet, and bottom, the Mehenket-ankh, both of Thutmose III, early 18th Dynasty

extremely high terraces (fig. 60, center). These two temples differed from Hatshepsut's mainly in the organization of the upper terrace. Where Hatshepsut had designed an open court with colonnades that disguised the entrances to the sanctuaries, Thutmose III's temples were traditional structures with the conventional sequence of forecourt, hypostyle hall, offering hall, barque room, and statue chambers—suggesting that these structures were considered not barque stations but fully equipped temples. The Mehenket-ankh temple, unlike Hatshepsut's, also has a huge pylon in front of the lower court.

Other structures that drew on the example of Hatshepsut's temple are found in Karnak, on the east bank of the Nile. One was built by Thutmose III's successor, Amenhotep II (r. 1427–1400 B.C.), south of Karnak temple and on its north-south axis. Raised on a high platform reached by a staircase in front, the building was a columned hall with twelve square pillars along the open front and probably was used for the celebration of a royal ritual. Thutmose IV (r. 1400–1390 B.C.) then built a pillared court in front of the Fourth Pylon at Karnak, borrowing the basic idea for it from the upper court of Hatshepsut's temple. Thutmose IV's court is now being partially reconstructed by French archaeologists[3] in the Karnak Open-Air Museum.

In the later New Kingdom, the traditional temple arrangement that Thutmose III had returned to became standard for royal mortuary temples. The best-preserved examples are the Ramesseum of Ramesses II (r. 1279–1213 B.C.) and the temple of Ramesses III (r. 1184–1153 B.C.) at Medinet Habu. The outer designs of these temples preserved no reflection of the architecture of Hatshepsut's temple, except for slight terracing and the use of royal-statue pillars. But within, Amun of Karnak still dominates the central axis, with the mortuary cult of the king consigned to the southern half of the building, the sun cult to the north. The selection of cults and the plan governing their locations inside the temple continued to follow the centuries-old example first set by Hatshepsut's architect.

1. Homer, *Iliad*, bk. 9, ll. 381–84.
2. The mission is led by Warsaw University's Polish Centre of Mediterranean Archaeology in Cairo, in cooperation with Egypt's Supreme Council of Antiquities.
3. Of the Centre Franco-Égyptien d'Étude des Temples de Karnak.

74. Head of Hatshepsut

Early 18th Dynasty, joint reign of Hatshepsut and Thutmose III (1479–1458 B.C.)
Painted limestone
H. 126 cm (49⅝ in.), W. 34 cm (13⅜ in.)
The Metropolitan Museum of Art, New York, Rogers Fund, 1931 31.3.164

This head was originally part of a statue depicting Hatshepsut as the god Osiris. A group of similar statues, each about eleven feet tall, were built into niches in the back wall of the upper terrace of her temple at Deir el-Bahri (see fig. 61). The statues on the southern half of the wall were depicted wearing the white crown of Upper Egypt; those on the northern half, like this one, wore the double crown, which combines the white crown of the south with the red crown of the north, symbolizing the union of Upper and Lower Egypt.

The fragments of this head were uncovered by the Egyptian Expedition of The Metropolitan Museum of Art between 1923 and 1928 in the excavation of two large depressions in front of the temple: the so-called Hatshepsut Hole and the Senenmut Quarry. Both had been used as convenient dumping sites after Thutmose III began the systematic destruction of his aunt's images some twenty years after her death.[1] CHR

74

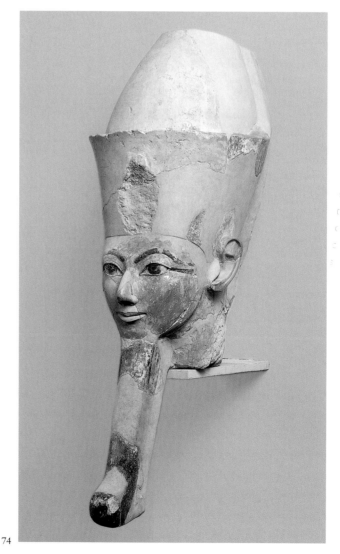

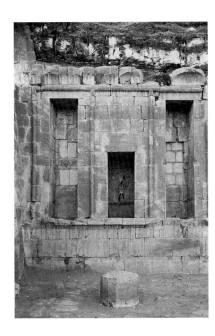

Fig. 61. Large niches in the back wall of the upper terrace of Hatshepsut's temple at Deir el-Bahri. The niches once held engaged Osiride statues of Hatshepsut, which were removed by Thutmose III.

1. For more information on the destruction of Hatshepsut's monuments, see the essays by Peter F. Dorman, Dorothea Arnold, and Ann Macy Roth in Chapter 5, below.

PROVENANCE: Western Thebes, Hatshepsut's temple at Deir el-Bahri; Metropolitan Museum of Art excavations, 1922–23, 1926–28, acquired in the division of finds in 1931

BIBLIOGRAPHY: Hayes 1959, p. 90, fig. 49; Ratié 1979, p. 126; Tefnin 1979, p. 41; Isabelle Franco in Ziegler 2002a, p. 390, no. 13

FOUNDATION DEPOSITS FOR THE TEMPLE OF HATSHEPSUT AT DEIR EL-BAHRI

As early as the Third Dynasty (2650–2575 B.C.), the ancient Egyptians began making foundation deposits at the start of a major building project.[1] Such deposits have been found in connection with temples, royal tombs, fortresses, and town walls.[2] They were usually created at the beginning of new construction, but deposits were also made by kings who added to structures that had been built by their predecessors. For a new project, the foundation deposits were laid out around the perimeter of the structure during a ceremony called the "stretching of the cord."[3]

Fourteen foundation deposits were discovered in the area of Hatshepsut's temple (fig. 62), and two others were found at the Valley Temple of this complex, which is in Lower Asasif, near the area of cultivation (see the map of western Thebes, page 5). One deposit was found in 1898 by Édouard Naville; several more were uncovered during the excavations of the Earl of Carnarvon and Howard Carter; but the majority were excavated in the 1920s by the Egyptian Expedition of The Metropolitan Museum of Art. The locations of these deposits suggest that the temple was originally laid out according to one plan and was later altered to its present design.[4]

The foundation deposits for Hatshepsut's temple contained pottery vessels, food offerings, tools and model tools (cat. no. 76a–g), and ritual and votive objects (cat. no. 76h–l).[5] In three of the deposits along the eastern end of the lower court (fig. 62: G, H, I), numerous scarabs and seal amulets were found (cat. no. 75). Some are inscribed with royal names and titles, including those of Hatshepsut, her co-ruler Thutmose III, and her daughter, Neferure. Others carry images or names of various gods, or geometric designs that are typical of the period. CHR

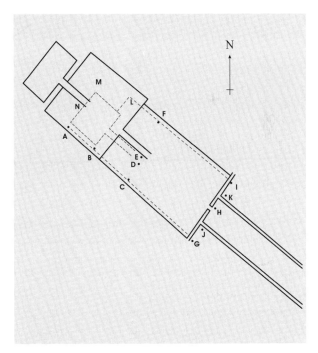

Fig. 62. Plan showing the positions of foundation deposits A–M at Hatshepsut's temple at Deir el-Bahri. Drawing by Julia Jarrett

1. The first foundation deposits that can be identified with certainty were found at the Step Pyramid complex of Djoser at Saqqara (Weinstein 1973, pp. 24–25).
2. Ibid., p. LXIX.
3. James Weinstein (ibid., chap. 1) discusses the foundation ceremony.

4. Winlock 1942, pp. 134–35. See also the discussion by Zygmunt Wysocki (1992), who suggests that the first stage of the temple was built by Thutmose II and the later building (essentially what can be seen today) was undertaken by Hatshepsut.
5. Bibliography for the foundation deposit objects catalogued below (cat. nos. 75, 76): Winlock 1942, pp. 132–34; Hayes 1959, pp. 84–88; Weinstein 1973, pp. 151–64.

75a–e (top), f–j (center), k–n

75. Scarabs and Seal Amulets

Early 18th Dynasty, joint reign of Hatshepsut and
Thutmose III, period of Hatshepsut's regency
(1479–1473 B.C.)
Glazed steatite; Egyptian blue (i)
The Metropolitan Museum of Art, New York,
Rogers Fund, 1927 27.3.164, .180, .198, .206, .232,
.251, .277, .285, .292, .320, .323, .326, .347, .394

a. Scarab

(27.3.198)
L. 1.8 cm (¾ in.), W. 1.3 cm (½ in.), H. 0.7 cm (¼ in.)

The base is inscribed "The King's Daughter,
Hatshepsut." The title King's Daughter is not
one that Hatshepsut would have retained after
she became king.

b. Cowroid Seal Amulet

(27.3.180)
L. 2.2 cm (⅞ in.), W. 1.3 cm (½ in.), H. 0.5 cm (¼ in.)

The design on the back shows a bolti fish eating
marsh plants. The base is inscribed "The God's
Wife, Hatshepsut." The title God's Wife is one
that Hatshepsut held when she was the principal
queen of Thutmose II. The title probably passed
to her daughter, Neferure, about the time
Hatshepsut adopted the titles of kingship.

c. Scarab

(27.3.206)
L. 2 cm (¾ in.), W. 1.5 cm (⅝ in.), H. 0.8 cm (⅜ in.)

The base is inscribed "Hatshepsut, united with
Amun."

d. Cowroid Seal Amulet

(27.3.164)
L. 2.2 cm (⅞ in.), W. 1.4 cm (⅝ in.), H. 0.7 cm (¼ in.)

An image of the falcon god Horus, with his
wings spread and wearing a feathered crown
similar to the king's *atef* crown, is carved onto

the back of this seal amulet. The name
Hatshepsut is inscribed on the base. Horus was
closely associated with the reigning king, who
was often described as the living Horus. (See
cat. no. 84, in which a small Horus falcon is
depicted at the back of the *atef* crown worn by
the king.)

e. Scarab

(27.3.277)
L. 1.6 cm (⅝ in.), W. 1.2 cm (½ in.), H. 0.8 cm (⅜ in.)

The base is inscribed "The God's Wife,
Maatkare, Lord of the Two Lands." This
inscription suggests that Hatshepsut adopted a
throne name (Maatkare) before she passed the
queenly title God's Wife to her daughter,
Neferure.

f. *Wedjat*-Eye Seal Amulet

(27.3.251)
L. 1.7 cm (¾ in.), W. 1.2 cm (½ in.), H. 0.8 cm (⅜ in.)

75a–e (top), f–j (center), k–n, bases

On the back is a *wedjat* eye, the eye of the god Horus, a symbol of healing that also seems to function as a general good luck charm. The base is inscribed "Maatkare, beloved of Amun."

g. Scarab

(27.3.232)
L. 1.7 cm (⅝ in.), W. 1.2 cm (½ in.), H. 0.7 cm (¼ in.)

On the base, a lion-headed goddess spreads her wings in a gesture of protection around a cartouche containing the name Maatkare, the throne name adopted by Hatshepsut when she became king.

h. Scarab

(27.3.285)
L. 1.7 cm (⅝ in.), W. 1.3 cm (½ in.), H. 0.8 cm (⅜ in.)

The base is inscribed "The female Horus, Wosretkau." This is Hatshepsut's Horus name, one of the five names that were part of a king's royal titulary.

i. Scarab

(27.3.292)
L. 1.5 cm (⅝ in.), W. 1.1 cm (½ in.), H. 0.7 cm (¼ in.)

The base is inscribed "Two Ladies, Wadjet-renput." This is Hatshepsut's Nebty (Two Ladies) name, which was part of a king's titulary.

j. Scarab

(27.3.320)
L. 1.9 cm (¾ in.), W. 1.3 cm (½ in.), H. 0.7 cm (¼ in.)

On the base are the names Menkheperre and Maatkare enclosed in cartouches and separated by a stylized plant. These are, respectively, the throne names of Thutmose III and Hatshepsut. In Egyptian iconography, the name at the right would be considered the dominant one. Thus the name of Hatshepsut, the senior co-ruler, is written at the right.

k. Scarab

(27.3.323)
L. 1.6 cm (⅝ in.), W. 1.3 cm (½ in.), H. 0.6 cm (¼ in.)

The base is inscribed "King's Daughter, Neferure." At this time, "king" could refer either to Neferure's father, Thutmose II, or to her mother, Hatshepsut.

l. Scarab

(27.3.326)
L. 1.5 cm (⅝ in.), W. 1.2 cm (½ in.), H. 0.6 cm (¼ in.)

The base is inscribed "God's Wife, Neferure." After her mother became king, Neferure assumed the title God's Wife, which was traditionally held by the principal queen.

m. Scarab

(27.3.347)
L. 1.8 cm (¾ in.), W. 1.3 cm (½ in.), H. 0.7 cm (¼ in.)

On the base of this scarab, the name of the god Amun-Re (far right) precedes the image of what appears to be a pregnant goddess pouring a libation. Behind the goddess is the hieroglyph ankh (life).

n. Scarab

(27.3.394)
L. 1.7 cm (¾ in.), W. 1 cm (⅜ in.), H. 0.7 cm (¼ in.)

A grazing male antelope with a plant motif above his back is incised on the base. CHR

PROVENANCE: Western Thebes, Hatshepsut's temple at Deir el-Bahri, from foundation deposits G (c, f, g, h, i, k, m, n), H (a, b), and I (d, e, j, l); Metropolitan Museum of Art excavations, 1927

76a–i. Tools and Two Jars

Early 18th Dynasty, joint reign of Hatshepsut and Thutmose III (1479–1458 B.C.)

a, b. Surveyor's Mallet and Stake

Wood
Mallet: L. 40.1 cm (15¾ in.); stake: L. 41.3 cm (16¼ in.)
The Metropolitan Museum of Art, New York, Rogers Fund and Edward S. Harkness Gift, 1922
22.3.245, .246

The term "stretching of the cord" refers to the ritual of dedicating a temple, but it also describes the action of laying out the temple's ground plan by driving stakes into the earth and stretching a piece of cord between them. The process still occurs on building sites in preparation for construction.

c, d. Model Saw and Axe

Wood and bronze
Saw: L. 38 cm (15 in.); axe handle: L. 55 cm (21⅛ in.)
The Metropolitan Museum of Art, New York, Rogers Fund, 1925 25.3.120, .129

e. Adze

Wood, bronze, and leather
Handle: L. 19.6 cm (7¾ in.)
The Metropolitan Museum of Art, New York, Gift of Egypt Exploration Fund, 1896 96.4.7

Unlike many foundation deposit tools, which are models, this full-size adze probably could have been functional. One side of the handle is

inscribed with the phrase "The Good God, Maatkare, beloved of Amun, foremost of Djeser-djeseru."

f, g. Two Chisels

Wood and copper
Tapered chisel: L. 33 cm (13 in.); wide chisel: L. 21.6 cm (8½ in.)
The Metropolitan Museum of Art, New York, Rogers Fund and Edward S. Harkness Gift, 1922 22.3.247, .248

The tapered chisel was probably used for mortising. Its handle is inscribed in ink, "The Good Goddess, Maatkare, beloved of Amun, foremost of Djeser-djeseru." CHR

PROVENANCE: Western Thebes, Hatshepsut's temple at Deir el-Bahri, from foundation deposits A (e), B (a, b, f, g), and C (c, d); Metropolitan Museum of Art excavations, 1922–25 (a–d, f, g), Egypt Exploration Fund, 1896 (e)

h, i. Two Flared Ointment Jars

Travertine
Left: H. 14.3 cm (5⅝ in.); right: H. 11.8 cm (4⅝ in.)
The Metropolitan Museum of Art, New York, Rogers Fund 1925 25.3.46a, b, .47a, b

Ointment jars made of travertine were included in foundation deposits beginning in the Twelfth Dynasty (1981–1802 B.C.), in the Middle Kingdom. Oil stains on many of the jars in Hatshepsut's foundation deposits suggest that

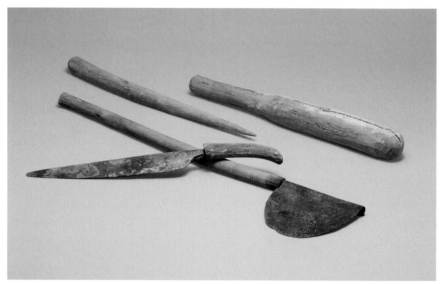

76a, b, c, d

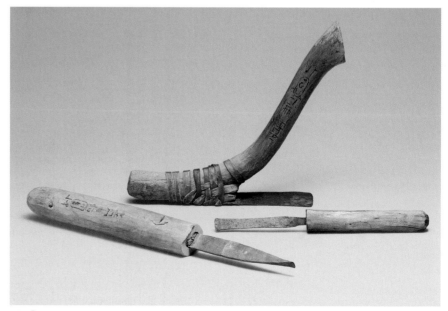

76e, f, g

they contained the ritual oils that would have been used to consecrate the temple and in daily temple rituals.

The smaller of these two vases is inscribed with Hatshepsut's prenomen, or throne name, Maatkare. The text on the jar reads: "The Good Goddess, Lady of the Two Lands, Maatkare, may she live! Beloved of Amun who is in Djeser-djeseru."

The taller jar is inscribed with her nomen, or personal name, Hatshesput. The text reads: "Daughter of Re, Hatshepsut, she has made it as an offering for her father Amun at the time of the stretching of the cord over Djeser-djeseru-Amun, that she may be made to live." The phrase Djeser-djeseru-Amun refers to Hatshepsut's temple at Deir el-Bahri.

CHR

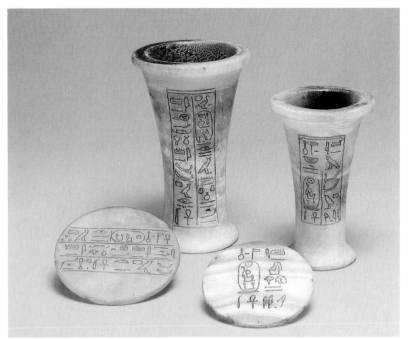

76h, i

PROVENANCE: Western Thebes, Hatshepsut's temple at Deir el-Bahri, from foundation deposit J; Metropolitan Museum of Art excavations, 1924–25

76j, k. Knot Amulet and *Meskhetyu* Instrument

Early 18th Dynasty, joint reign of Hatshepsut and Thutmose III
Knot amulet: cedar; *meskhetyu:* wood
Knot amulet: L. 15.2 cm (6 in.); *meskhetyu:* L. 27.1 cm (10⅝ in.)
The Metropolitan Museum of Art, New York, Rogers Fund, 1925 25.3.40
Rogers Fund, 1927 27.3.398

These two objects were included in their foundation deposits for ritual or protective purposes. The *meskhetyu* is a model of an instrument used in the Opening of the Mouth, a funerary ritual intended to allow the deceased to come to life. The ceremony would have been performed at the consecration of the temple to enable the sculptures and the images on the walls to function as their living counterparts. The ceremony is symbolized by the presence of the *meskhetyu* in the foundation deposit.

Inscribed on the knot amulet are Hatshepsut's throne name, Maatkare, and her expanded personal name, Hatshepsut, United with Amun.

CHR

PROVENANCE: Western Thebes, Hatshepsut's temple at Deir el-Bahri, from foundation deposits C and I; Metropolitan Museum of Art excavations, 1924–27

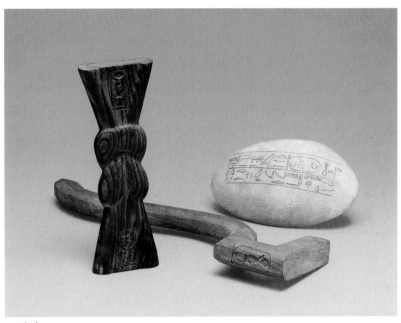

76j, k, l

76l. Ovoid Stone (Hammering Stone?)

Early 18th Dynasty, joint reign of Hatshepsut and Thutmose III
Travertine
H. 7.3 cm (2⅞ in.), W. 12.4 cm (4⅞ in.), D. 3.5 cm (1⅜ in.)
The Metropolitan Museum of Art, New York, Rogers Fund, 1927 27.3.400

This stone is inscribed "The Good Goddess, Maatkare, she made [it] as her monument for her father, Amun-Re, at the stretching of the cord over Djeser-djeseru-Amun, which she did while alive." Sometimes described as clamshells because of their shape, stones such as this one probably represent tools of some sort, such as hammering stones, that would have been used in the construction of a building.[1]

CHR

1. Weinstein 1973, p. 120 and n. 82.

PROVENANCE: Western Thebes, Hatshepsut's temple at Deir el-Bahri, from foundation deposit I; Metropolitan Museum of Art excavations, 1926–27

77. Inscribed Stone

Early 18th Dynasty, joint reign of Hatshepsut and
Thutmose III, year 7 (1473 B.C.)
Limestone
H. 22 cm (8⅝ in.), W. 14 cm (5½ in.), D. 7 cm (2¾ in.)
The Metropolitan Museum of Art, New York,
Rogers Fund, 1932 32.3.268

A large number of roughly shaped stones with
one smoothed surface were uncovered by sev-
eral archaeological expeditions working in Lower
Asasif, in what turned out to be the area of
Hatshepsut's valley temple.[1] The stones are
inscribed on the smooth side with one of
Hatshepsut's cartouches, and some include a line
of hieratic text in ink. The hieratic texts indicate
that the stones were sent by local Thebans to vari-
ous officials, including Senenmut, Hapuseneb,
Djehuti, and Puyemre,[2] all of whom were appar-
ently involved in the building of Hatshepsut's
temple.[3]

William C. Hayes has suggested that the
stones were placed in a retaining wall or the
foundations of the valley temple as votive
offerings. They may even represent contribu-
tions by individuals to the building of the
temple.

Many of the stones are quite crudely carved;
on this one, however, the cartouche is beauti-
fully incised and encloses Hatshepsut's throne
name, Maatkare. CHR

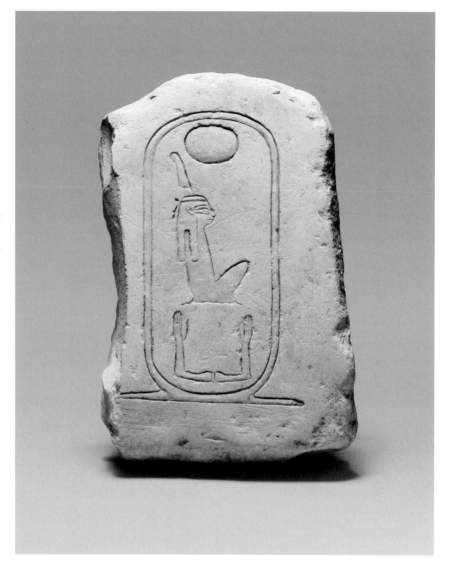

77

1. Stones were found by an expedition funded by the
 Marquis of Northampton in 1898–99 (see
 Northampton, Spiegelberg, and Newberry 1908,
 p. 37); more examples were discovered by Lord
 Carnarvon and Howard Carter in 1907–11 (see
 Carnarvon and Carter 1912, p. 40, pl. XXXII); and
 the Metropolitan Museum's Egyptian Expedition
 uncovered more in 1932 (see Hayes 1942, pp. 45–46).
2. For these men, see "The Royal Court" by Cathleen
 A. Keller in this volume.
3. Hayes 1942, p. 46.

PROVENANCE: Western Thebes, Lower Asasif, area
of Hatshepsut's Valley Temple; Metropolitan Museum
of Art excavations, 1931–32, acquired in the division
of finds

BIBLIOGRAPHY: Hayes 1942, pp. 45–46

HATSHEPSUT'S MORTUARY TEMPLE AT DEIR EL-BAHRI
Architecture as Political Statement

Ann Macy Roth

While Hatshepsut built and restored temples throughout Egypt in the course of her two-decade reign, her principal architectural achievement was her mortuary temple at Deir el-Bahri in western Thebes. This beautiful terraced temple erected at the base of sheer limestone cliffs was her own monument, built according to her own plans.[1] Called Djeser-djeseru, or "holy of holies," it was intended to serve as the site of the cult that would ensure her perpetual life after death. It is therefore not surprising that the temple contains carefully calculated expressions of Hatshepsut's political agenda. These address different constituencies within the Egyptian population and use historical and religious allusions to consolidate her power and that of her home city, Thebes.

Not only the temple's architecture and iconography but also the rituals and processions enacted in it would have communicated Hatshepsut's message to contemporary observers. At this time, four temples at Thebes were dedicated to Amun-Re, a deity who combined Re, the sun god and traditional ruler of the gods, with Amun, the main divinity of Thebes. These temples—this one at Deir el-Bahri, Karnak temple, the Opet temple at Luxor, and the small temple at Medinet Habu—served as the end points of three festival processions that inscribed a huge ceremonial rectangle upon the city of Thebes (fig. 63).[2] Hatshepsut either built or added to each of these temples.[3]

The temple at Deir el-Bahri played the principal role in the Beautiful Festival of the Valley, an older festival clearly enhanced by its construction. This annual procession included the king, the priests, and the populace of Thebes, who accompanied the divine barque of Amun-Re from its home at Karnak temple on the east bank of the Nile across the river to the cemeteries of the west bank, where they honored their ancestors. The temple's central shrine was assigned to Amun-Re rather than to Hatshepsut herself, probably in order to accommodate this festival. The procession from Karnak, by ritually associating the two temples, emphasized the bond between Hatshepsut and Amun-Re. The main axis of the

Deir el-Bahri temple is aligned with the front of Hatshepsut's Eighth Pylon at Karnak, which was probably the point of departure for the procession.[4]

Apart from the activities that took place in and around it, the most conspicuous aspects of the Deir el-Bahri temple were its location and its architectural form. Both of these suggested a connection between Hatshepsut and the Eleventh Dynasty king Mentuhotep II (r. 2051–2000 B.C.), who reunited Egypt at the end of the First Intermediate Period (2150–2030 B.C.).[5] Mentuhotep was probably already viewed as the founder of the second golden age of Egypt's history,[6] and by placing her temple next to his, Hatshepsut implied to viewers that she was the founder of another golden age. To emphasize this connection, the external appearance of her temple echoed that of her predecessor's, with colonnaded porticoes that flanked central ramps leading to terraces (figs. 56, 89). Mentuhotep had patterned his temple on the *saff* tomb, a local Theban form used by his ancestors and not known elsewhere in Egypt, and Hatshepsut was thus associating herself not only with Mentuhotep but also with Thebes and its local traditions.

Another visible, external feature of Hatshepsut's temple was its colossal statuary. The Osiride statues along the uppermost colonnade and the sphinxes lining its causeway show none of the gender ambiguities found in some of the smaller pieces. They represent a traditional, male king.[7]

Thus the most conspicuous features of Hatshepsut's temple—its festivals, location, and external appearance—were all designed to show Hatshepsut as a traditional, legitimate king, the proper successor to the great Mentuhotep, a ruler who had the support of Amun-Re and would revive Egyptian culture, bringing great honor to the god and to his city, Thebes. This message would clearly have appealed to the Theban populace.

Few ordinary Thebans, however, would ever have entered the temple to admire the relief decoration of the colonnades and the shrines of the upper terrace. Only the elite of Thebes joined members of the court and officials from the capital city of Memphis in

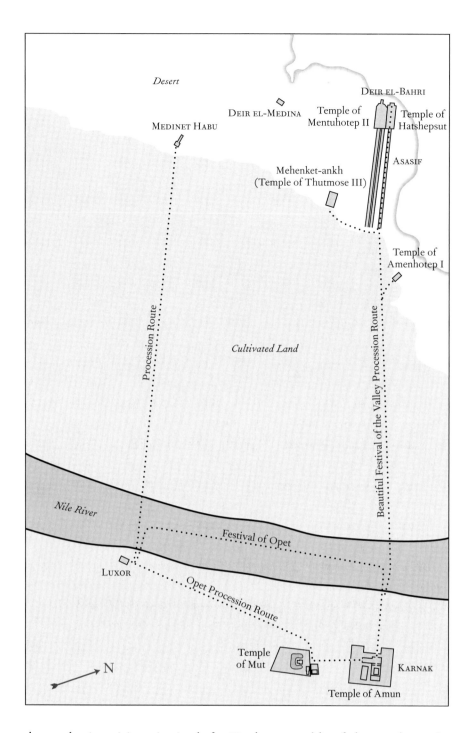

Fig. 63. Map of Thebes, showing the principal temples of the early 18th Dynasty and the routes of festival processions

the north to participate in rituals for Hatshepsut and her father and the annual Beautiful Festival of the Valley. For these viewers, a very different set of historical precedents was invoked, alluding to the glory of Egypt during the Old Kingdom, when powerful kings built impressive pyramids near Memphis. A particular focus was placed on the early years (2465–2389 B.C.) of the Fifth Dynasty, a period of strong kings who stressed their ties to the cult of Re at Heliopolis, north of Memphis.

An Egyptian temple was seen as a world in itself, whose center lay at its innermost shrine, and its decoration was arranged cosmographically.[8] Both replicating and rationalizing the geography of the larger world, the temple had its own cardinal points, which in general roughly correlated with its actual orientation. The principal axis was identified as the east-west path of the sun. The

decoration on its south side depicted the king wearing the white crown of Upper Egypt and smiting Nubians, while on the north he wore the red crown of Lower Egypt and defeated enemies from Asia or the Aegean. There was also a progression from the outside of a temple to its inside. Decoration on the exterior and near the entrance showed places that were farthest from the temple, including scenes of foreign wars or of hunting and fishing in the far deserts and Delta marshes. Such images represented the king's mastery over chaos. Inside the temple one encountered more ordered scenes of festivals and the king receiving gifts and prisoners, and finally, in the innermost rooms, intimate scenes of the king offering to the gods.

Hatshepsut's temple consisted of an entry-level courtyard and two higher platforms, each reached by a central ramp. Colonnades

flanked the ramps on each level, and a third pair of colonnades flanked the entrance to the highest platform. Behind these colonnades Hatshepsut placed the reliefs that most explicitly bolstered her right to the throne and the equation of Thebes with Heliopolis.[9]

The iconography of the lower colonnades (fig. 57:3) is geographically arranged. On the lowest level, reliefs on the end wall of the southern colonnade depict Dedwen, the Lord of Nubia, holding a rope attached to a list of southern towns, each represented as a crenellated oval with a Nubian head protruding from the top. The colonnade's back wall shows events that took place at the southern border of Egypt proper, the quarrying and loading onto boats of two monolithic obelisks for the temple of Karnak (see cat. no. 78). The boats proceed northward toward the ramp, where Hatshepsut is shown in Thebes, presenting the obelisks and the temple itself to Amun-Re. (Here, as throughout the temple, she is represented as a man.) Thus the colonnade encapsulates the geographic expanse from Nubia in the far south to the border town of Elephantine, where the granite was quarried, to Thebes itself, which appears next to the central ramp.

North of the ramp Hatshepsut is depicted as a sphinx, smiting and trampling on western Asians. In the central scenes of the northern colonnade she is shown fishing and fowling in the Delta marshes and offering statues and calves to the gods, perhaps in Memphis. The scenes of stereotyped violence on the lower, outermost level of the temple are ones that would normally appear on the entrance pylons of temples.

The more narrative scenes showing the transport of the obelisks and fishing and fowling in the marshes represent the king's ordering of the natural environment for the satisfaction of the gods. They also have antecedents in royal temples of the Old Kingdom. Fishing and fowling are first attested in a fragmentary scene from the Fifth Dynasty mortuary temple of Sahure (r. 2458–2446 B.C.) at Abu Sir. While the scene of transporting obelisks from Aswan has no exact parallel in the Old Kingdom, the causeway of Unis, last king of the Fifth Dynasty (r. 2353–2323 B.C.), has scenes depicting the transport of granite columns for his mortuary temple and may have been the inspiration for Hatshepsut's reliefs.[10]

The colonnades on the middle level again reflect geography (fig. 57:5). Depicted on the south side is the trading mission that Hatshepsut sent to Punt, a land far to the south of Egypt whose exact location is still unknown.[11] Previous voyages to Punt were undertaken at the height of the Old and Middle Kingdoms, to obtain exotic goods used in temple contexts, particularly incense. Hatshepsut's expedition would have recalled the glorious achievements of earlier times. On the southern end wall are images of Puntite villages and the exotic goods the Puntites offered the Egyptians; like the scenes in the lower terrace, these are set in a foreign land, but here a peaceful trading partner rather than a chaotic enemy. Echoing the scene of boats transporting the

obelisk on the colonnade below are boats bringing incense trees and the other treasures back to Thebes, again depicted nearest the temple's central ramp.

On the walls of the northern colonnade at this level are the most explicitly political scenes, presenting Hatshepsut's divine birth and election to the throne of Egypt, events that would have taken place in northern Egypt, in the palace at Memphis. In the center Hathsepsut's mother, Ahmose, is visited by Amun-Re in the guise of Thutmose I, and Hatshepsut is conceived during their meeting. By this historical myth, Hatshepsut identifies herself as the daughter of her royal father's body (and thus the legitimate heir to the throne) and simultaneously as the daughter of Amun-Re, important because Egypt's kings had been called Son of Re since the Fourth Dynasty. Directly above the scene of Hatshepsut's conception, Queen Ahmose is shown giving birth, and on either side are scenes in which Hatshepsut is presented to various gods and proclaimed king of Egypt.

The themes of this level's decoration, like those below, have Fifth Dynasty antecedents. Scenes of a king's expedition to Punt have recently been found at Sahure's temple at Abu Sir,[12] and a narrative of divine conception and birth survives in a literary text, papyrus Westcar, which recounts the divine births of the first three kings of the Fifth Dynasty.[13] Part of the story is lost, but it seems clear that its point was to glorify and legitimize these kings, who claim descent from Re. While the papyrus dates to the Seventeenth Dynasty (1635–1550 B.C.), it must transmit an older story, since its propagandistic motive only makes sense in the context of the Fifth Dynasty.

To the south of these colonnades was a chapel dedicated to Hathor (fig. 57:7), honored from the earliest period as the wife and mother of the divine kings. Hathor was also an important mortuary goddess in the Theban area, where she personified the western hills—the area of Deir el-Bahri. She is frequently identified as the Mistress of Punt, so her shrine's proximity to the Punt colonnade was appropriate.

To the north was a smaller shrine dedicated to Anubis (fig. 57:6), the jackal-headed god of mummification. Like Hathor, Anubis was a mortuary god. His occurrence here, however, is probably connected with the use of his name (Egyptian *jnpw*) to refer to the prince who was the designated heir to the throne, a role that Hatshepsut claims in the adjacent Birth colonnade.[14] Both Hathor and Anubis were particularly important in the period before the rise of Osiris in the late Fifth Dynasty.

Thus the middle terrace as a whole emphasizes divinity and the divinity of Hatshepsut's kingship. It expresses Hatshepsut's claim to combine within herself the roles of Hathor (who was both the daughter of Re and the queen of the kingly god Horus) and Anubis (the legitimate heir to the throne). The narrative cycles on the two colonnades are unified by the divine scent of incense

(*s-ntr*, which means "to make divine") that pervades both. Punt is "god's land," source of incense trees; and prior to Hatshepsut's conception Ahmose is awakened by the divine smell of Amun-Re in her husband's body, the same scent that, after he "does what he likes with her," fills her own body.[15]

The uppermost terrace of Hatshepsut's temple, which was accessible only to the highest-ranking members of the government and the priesthood, is not as well preserved as the lower areas. The northern colonnade carried a long inscription recounting Hatshepsut's coronation, while the southern colonnade contained offering scenes (now mostly obliterated by the inscriptions of later kings). In front of the colonnades' pillars are colossal mummiform statues of Hatshepsut in the guise of Osiris (fig. 59).

Three groups of shrines open off the central colonnaded court on the upper terrace. The court itself (fig. 57:9) is decorated with scenes of the Theban festivals, located geographically, with the Beautiful Festival of the Valley on the north wall and the festival of Opet on the east. Cut into the west wall of the courtyard were niches decorated with offering scenes, which were dedicated to members of Hatshepsut's family as well as to the queen herself (cat. no. 83; fig. 61).

The cult places surrounding the courtyard were also geographically arranged. The central shrine (fig. 57:12), to Amun, was aligned with Hatshepsut's Eighth Pylon, which in this period may have served as the principal entrance to Karnak temple. To the north (fig. 57:10), an open-air altar served the cult of the sun god Re, whose main cult place was in the city of Heliopolis in northern Egypt. To the south was the double chapel dedicated to Hatshepsut and her father (fig. 57:11), Thutmose I, corresponding to Tomb 20 in the Valley of the Kings, southwest of Deir el-Bahri, which Hatshepsut intended for herself and her father.

The double chapel of Hatshepsut and Thutmose I contained east-west offering chapels. Large false doors of red granite stood at their western ends (see cat. no. 87 for Thutmose I's), and on the eastern walls facing them, scenes of cattle being butchered were surmounted by scenes of piled offerings. The reliefs on the longer side walls present mirror images. To the west they depict the owner of the chapel, seated before a table of tall loaves of bread, an offering list, and priests performing the sequential actions of a mortuary ritual. Farther east are three registers of offering bringers and registers of piled offerings above. This arrangement of scenes is identical to the layout of east-west offering chapels in Sixth Dynasty nonroyal chapels, a layout that probably was borrowed from earlier prototypes.[16]

While the decoration of the northern court dedicated to the sun cult is mostly lost, depictions in its entrance vestibule include those of Thutmose II and Thutmose III. Smaller chapels around the open sun court also contained reliefs of members of Hatshepsut's family, including one chapel to the north where Thutmose I and his mother, Seniseneb, are shown offering to Anubis while Hatshepsut and her mother, Ahmose, offer to Amun-Re.[17]

On the upper terrace, the process of making Hatshepsut divine is complete. Hatshepsut, her father, and other members of her family are the recipients of offerings, as are the gods Amun-Re and Re. Thus the emphasis is on family ties not only between Hatshepsut's earthly relatives but between her family and the gods. The colossal Osiride statues along the colonnade identify Hatshepsut with the ancestral king Osiris, the dead god who is equated with all royal ancestors.

Throughout the temple, the elegant raised relief resembles reliefs of the Old Kingdom in proportions and style. The hieroglyphic writing includes many Old Kingdom spellings, often indicating a plural with the tripled determinative rather than the three strokes that later replaced such tripling. Some of the captions also have Old Kingdom antecedents.[18]

Its architecture and decorative programs locate Hatshepsut's temple cosmologically and geographically within the Egyptian universe. Allusions to the Eleventh Dynasty (outside the temple) and Fifth Dynasty (inside it) appealed, respectively, to the Theban populace and Memphite officials, by reflecting a past period of glory familiar to each. With its references to Thebes, where Hatshepsut's family originated, and also to Memphis, where she ruled, the temple ties two great periods of Egyptian history and the two most important cities of the Eighteenth Dynasty into a harmonious whole. This tying together reflected a very old theme indeed, the unification of Upper and Lower Egypt—a cyclical refoundation of the Egyptian state symbolically renewed by each new king.

The allusions to the early Fifth Dynasty in the decoration may have been meant to emphasize an earlier juxtaposition. It was during the Fifth Dynasty that the city of Heliopolis, with its cult of the sun god Re, became the religious center of the Egyptian state, forming a counterpart to the nearby administrative capital at Memphis. In Hatshepsut's reign, Thebes began to be called "Southern Heliopolis," marking it as the same kind of religious center.[19] Just as the early Fifth Dynasty kings had legitimized their rule by claiming divine birth and glorifying the city of their divine father, Re, Hatshepsut—by invoking their monuments—communicated to her court the parallel status that her construction projects and program of ritual processions conferred upon both herself and the city of her divine father, Amun-Re.

1. The fact that Hatshepsut's father, Thutmose I, is honored in the temple might suggest that building was begun by him, particularly to those who accept John Romer's arguments that Thutmose I began Tomb 20 in the Valley of the Kings (see Romer 1974 and "The Two Tombs of Hatshepsut" by Catharine H. Roehrig in this volume). However, the foundation deposits discovered in the middle colonnade bear Hatshepsut's name (Naville 1894–1908, pt. 6, p. 9, pl. CLXVIII), so previous work could only have been in the early stages. Zygmunt Wysocki (1992) suggests that changes in the upper terrace, where Thutmose III replaced Hatshepsut's name with that of Thutmose II, point to Thutmose II as the initial builder. Some wall decoration depicting Thutmose II in this area could have been inserted by Hatshepsut to honor his early work on the temple.

2. Barry Kemp (1989, pp. 201–5) discusses this ritual program but does not emphasize the connection of these four buildings and their attendant festivals to Hatshepsut. Rainer Stadelmann (1978) demonstrates similar orientations and connections, particularly in their names, for later Theban temples constructed by Seti I (1294–1279 B.C.) and Ramesses II (r. 1279–1213 B.C.).

3. While the oldest of these three festivals, the Beautiful Festival of the Valley, appears to go back to the Eleventh Dynasty (2124–1981 B.C.) (Graefe 1986, col. 187), the other two—the festival of Opet and the decade festival in which Amun of Opet visited Medinet Habu—were perhaps initiated by Hatshepsut. The Opet feast is first attested in representations on Hatshepsut's barque shrine and at Deir el-Bahri (Murnane 1982, col. 574), although Luxor temple, its end point, probably already existed in the Middle Kingdom (Borchardt 1896). Some kingly titles with feminine endings occur in hidden inscriptions on the barque shrine later incorporated into the colonnaded court of Ramesses II at Luxor temple, suggesting that Hatshepsut was the shrine's original builder (Habachi 1965). The procession of Amun of Opet to Medinet Habu every ten days is attested only in later periods, but the orientation of Hatshepsut's small Medinet Habu temple suggests that it may already have taken place in her reign (Stadelmann 1980, col. 1258). The plan of the temple itself, however, hints at a possible Eleventh Dynasty forebear (col. 1256).

These two newer festivals may themselves have revived older traditions, since the temples that served as their end points were already in place. These Theban festivals had perhaps fallen into abeyance or degenerated into small provincial affairs during the Twelfth Dynasty (1981–1802 B.C.). Hatshepsut emphasized them on her Theban monuments and seems to have built numerous way stations where the barques could rest on their processional journeys. Her construction of the Eighth Pylon, beginning the transverse axis of Karnak temple and extending it toward Luxor, was presumably connected to the Opet festival.

4. Although it is often said that the main axis of Hatshepsut's temple aligns with that of Karnak temple, surveys have shown that an extension of the Deir el-Bahri axis runs parallel to Karnak's axis at about 550 feet (170 meters) to the south (see the plan in Weeks 1978, pp. 34–35). The facade of her Eighth Pylon, the earliest of the monumental gateways built along the transverse axis of Karnak temple to emphasize the processional route to Luxor temple, is also about 550 feet south of Karnak's main axis and runs roughly parallel to it (see the plan in Golvin 1987, p. 202, pl. 1).

5. Hatshepsut claimed a similar feat by taking credit for her grandfather's expulsion of the Levantine Hyksos from the Egyptian Delta and, more plausibly, for the rebuilding of Egypt after the depredations of their rule. For a recent edition and translation of the inscription making this claim, see J. P. Allen 2002.

6. In the depiction of the festival of Min in the Nineteenth Dynasty Ramesseum, Ahmose I, Hatshepsut's grandfather and the first king of the New Kingdom's Eighteenth Dynasty, is shown as a statue together with Menes, the First Dynasty unifier of Egypt, and Mentuhotep, suggesting that all three were regarded as founders of golden ages. Wildung 1969, pp. 11–12.

7. The texts that labeled these colossal statues often contained feminine references, but these inscriptions would not have been visible to viewers outside the temple.

8. Although there are comparatively few Egyptian temples with well-preserved in situ decoration dating before the reign of Hatshepsut, extant fragments suggest that the patterns evident in later temples were already well established by the Eighteenth Dynasty.

9. The descriptions of scenes that follow draw on Naville 1894–1908.

10. Hatshepsut's scenes would thus have combined Unis's narrative of transporting materials from the borders of Egypt to its capital with the solar symbol of the obelisk—the *bnbn* stone so important in the earlier part of the Fifth Dynasty.

11. Punt clearly lay on the Red Sea, to judge from the species of fish depicted in these scenes. Both East Africa and the west coast of the Arabian Penninsula have been suggested as its location.

12. These scenes from Sahure's temple include myrrh trees in pots, Puntites, and boats bringing exotic animals back to Egypt. Information about them was presented by Tarek el-Awady at the Conference on Old Kingdom Art and Archaeology, Prague, May 31, 2004.

13. For a recent publication, see Blackman 1988.

14. What links the title to the name of the god is unknown. For a summary of recent discussions of the term and some interesting suggestions, see Feucht 1995, pp. 503–12.

15. The references to incense on both colonnades were pointed out in Harvey 2003.

16. For parallels, see, for example, the chapels of Mereruka and Kagemni in the Teti pyramid cemetery, cited in Porter and Moss 1978, pp. 522–37. This pattern of offering-chamber decoration is invariable in the early Sixth Dynasty. The A/B type offering list seems to have been used in the royal mortuary temples of the early Fifth Dynasty kings Sahure and Neferirkare (Altenmüller 1967, pp. 17–18), and other elements of the standard scenes probably occurred there as well.

17. There seems to be a correlation throughout Egyptian history between sun cults and an emphasis on family, as seen in the first depiction of a royal family in the small Third Dynasty shrine of Djoser in Heliopolis, in the Fourth and early Fifth Dynasties, when the cult of Re increased in importance (A. M. Roth 1993), and during the Amarna period in the later Eighteenth Dynasty, when the family of Akhenaten was given great prominence (Dorothea Arnold 1996).

18. For example, those quoting the shouts of the boatmen. There is a reference to a phyle organization in the palace in Naville 1894–1908, pt. 3, pls. LX, LXXIII, as discussed in A. M. Roth 1991, pp. 194–95. A reference to the Old Kingdom nautical term *t3-wr* is made in the same volume (pl. LXXIII). Old Kingdom parallels are given in A. M. Roth 1991, p. 27.

19. Stadelmann (1979, p. 321) has suggested the importance of Heliopolis as a prototype for the New Kingdom temples at Thebes. Kees (1949, p. 434) identifies an inscription of Hatshepsut at Deir el-Bahri as the first use of the term *jwnw šmʿw* (Upper Egyptian Heliopolis) to refer to the Theban area (*Urkunden* 4, p. 361). In addition to the historical allusions to the Fifth Dynasty and the rise of Heliopolis as the religious center of the Old Kingdom, Hatshepsut's reliefs also allude in their subject matter to the god Re and Heliopolitan themes: the divine birth of the children of Re; the collection of incense (important in all rituals, but particularly in solar religion, where the incense rises on an open altar to cense the god himself) from Punt in the east, land of the rising sun; and particularly the transportation of obelisks, symbols of the Heliopolitan cult.

This evocation of the Memphite gods in Thebes was later continued by Thutmose III in his complex of smaller temples around the temple of Amun-Re at Karnak. He built a temple to the north (significantly) of the principal temple dedicated to the Memphite god Ptah, and another, farther east, to the Heliopolitan form of Re. The high priests of both bore the same titles as their counterparts at the much larger temples in the north: *ḥrp ḥmwt* and *wr m33w*, respectively (Kees 1949, p. 430).

78. Fragment of an Obelisk

Early 18th Dynasty, joint reign of Hatshepsut and
Thutmose III, year 16 (1463 B.C.)
Granite
H. 106 cm (41¾ in.), W. 42 cm (16½ in.), D. 46 cm
(18⅛ in.)
Museum of Fine Arts, Boston, Gift of the Heirs of
Francis Cabot Lowell, 1975 75.12

To commemorate her jubilee, or Sed festival,
which she celebrated in year 16, Hatshepsut
ordered two obelisks from the granite quarries
at Aswan.[1] The two great monoliths, each
nearly 100 feet tall (29.5 m),[2] were carved with
scenes depicting Hatshepsut and her co-regent,
Thutmose III, appearing before or offering to
Amun-Re. They were set up in the temple of
Amun at Karnak, between what we now call the
Fourth and Fifth Pylons. The northern obelisk
of the pair still stands, but at some time the
upper part of the southern obelisk fell and
broke into many pieces.

On this fragment from the southern obelisk,
Hatshepsut is depicted wearing male attire, the
false beard of a king, and the double crown, a
symbol of the union of Upper and Lower
Egypt. The names and images of Hatshepsut
remain intact on both obelisks, as seen also on
the pyramidal top of the southern obelisk,
which now lies next to the sacred lake at
Karnak. Thutmose III encased the bases of
Hatshepsut's two obelisks in stone during his
renovation of the area, some time after her
death. Thus when he later began his systematic
attack on her monuments, her names and
images on these two obelisks were preserved.[3]

Relief decoration in the southern portico
of the lower terrace of Hatshepsut's temple at
Deir el-Bahri depicts the transport of two other
obelisks that were quarried earlier in Hatshepsut's
reign and were also set up at Karnak.

CHR

1. In setting up obelisks at Karnak, Hatshepsut was
 following a tradition begun by her father,
 Thutmose I. Before commissioning her own she
 seems to have erected a pair commissioned by her
 husband, Thutmose II (Gabolde 1987a; Gabolde
 2003, pp. 417–22, 430–35).
2. Habachi 1977, p. 60, where the weight of the north-
 ern obelisk is given as 323 tons.
3. Although the obelisks were visible from outside the
 temple, their inscriptions were probably not legible
 from a distance.

PROVENANCE: Thebes, Karnak temple; acquired in
1975

BIBLIOGRAPHY: W. S. Smith 1942; Habachi 1977;
Joyce L. Haynes in N. Thomas 1995, p. 175, no. 77

79. Ostracon with Drawing of the Queen of Punt

20th Dynasty, ca. 1150 B.C.
Limestone
H. 14 cm (5½ in.), W. 8 cm (3⅛ in.)
Ägyptisches Museum und Papyrussammlung,
Staatliche Museen zu Berlin 21442

In year 9 of her reign, Hatshepsut sent an expe-
dition to the land of Punt, the first such expedi-
tion recorded in the New Kingdom. Hatshepsut
commemorated the expedition in reliefs deco-
rating the southern portico of the middle terrace
of her temple at Deir el-Bahri (see Ann Macy

78

79

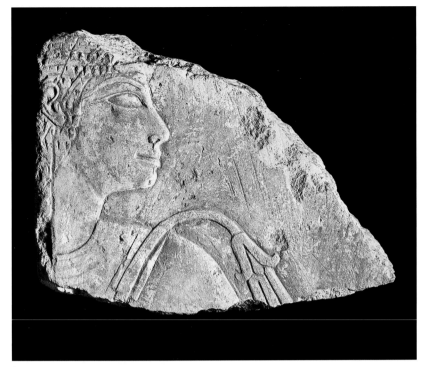

80

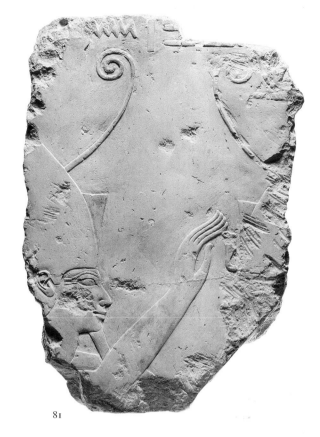

81

Roth's essay, above). Particular attention was taken to represent the local houses, unlike anything seen in Egypt, as well as animals, plants, and trade goods that would be transported back to Egypt. The Egyptians also carefully depicted the people of Punt, with their distinctive clothing, jewelry, facial features, hairstyles, and natural beards worn by the men. The most famous section of the Punt reliefs is a block showing the king, Parehu, and his wife, Ati. The artist was especially interested in the body of the queen, with her curved spine and heavy rolls of flesh. This may be an attempt to depict an extreme form of what is now termed steatopygia; or it may simply show that the queen was obese, a condition understood in some cultures as connoting prosperity.[1]

This limestone chip, or ostracon, was used as a sketch pad by an artist who was particularly taken with the distinctive image of Queen Ati. It was painted some three hundred years after the time of Hatshepsut and indicates that the reliefs showing the Punt expedition were still of interest to those who visited the temple many generations later. CHR

1. The queen's body may also have represented a combination of the two. For a discussion of these conditions and other possible artistic representations of them, see Ghalioungui 1949.

PROVENANCE: Western Thebes, Deir el-Medina; Deutsche Orient-Gesellschaft excavations, 1913

BIBLIOGRAPHY: Dietrich Wildung in Wildung 1997b, pp. 144–45, no. 145 (with bibliography)

80. Relief Fragment with Queen Ahmose

Early 18th Dynasty, joint reign of Hatshepsut and Thutmose III (1479–1458 B.C.)
Limestone
H. 10 cm (4 in.), W. 13.2 cm (5⅛ in.)
The Syndics of the Fitzwilliam Museum, Cambridge
E.G.A.3100.1943

The woman represented on this fragment is Ahmose, the principal queen of Thutmose I and mother of Hatshesput. Although the face is intact, some details were altered in ancient times, for unknown reasons. Ahmose's original wig of short, curled locks that covered her ears was changed to a lappet wig with a vulture headdress, and her baton, which would have been similar to the one held by her granddaughter Neferure in catalogue no. 61, was transformed into a lily scepter. CHR

PROVENANCE: Western Thebes, south wall of the upper court of Hatshepsut's temple at Deir el-Bahri; given by R. G. Gayer-Anderson in 1943

BIBLIOGRAPHY: Myśliwiec 1976, pp. 51, 54, pl. XXXVII, fig. 87; Vassilika 1995, pp. 46–47, no. 19

81. Relief Fragment Depicting Atum and Hatshepsut

Early 18th Dynasty, joint reign of Hatshepsut and Thutmose III (1479–1458 B.C.)
Painted limestone
H. 41 cm (16⅛ in.), W. 29 cm (11⅜ in.), D. 7.8 cm (3⅛ in.)
The Metropolitan Museum of Art, New York, Rogers Fund, 1936 36.3.271

This relief fragment was uncovered in Lower Asasif, in the area of Hatshepsut's Valley Temple. It depicts the god Atum, one of Egypt's creator gods, at the left, investing Hatshepsut with royal regalia. Both the god and Hatshepsut wear the double crown that symbolizes the union between Upper and Lower Egypt. Hatshepsut's crown also has a uraeus at the brow. Her face was probably hacked off during the later reign of her nephew Thutmose III.

CHR

PROVENANCE: Western Thebes, Lower Asasif, site of Hatshepsut's Valley Temple; Metropolitan Museum of Art excavations, 1935–36, acquired in the division of finds

BIBLIOGRAPHY: Lansing and Hayes 1937, p. 4, fig. 4; Hayes 1959, p. 89

82. Three Reliefs Depicting Running Soldiers

Early 18th Dynasty, joint reign of Hatshepsut and
Thutmose III (1479–1458 B.C.)
Painted limestone
a. H. 31 cm (12¼ in.), W. 41.5 cm (16⅜ in.)
b. H. 32.5 cm (12¾ in.), W. 39 cm (15⅜ in.)
c. H. 33.5 cm (13¼ in.), W. 59 cm (23¼ in.)
Ägyptisches Museum und Papyrussammlung,
Staatliche Museen zu Berlin (a) 18542, (b) 14141,
(c) 14507

82a

These reliefs come from the east wall of the
upper terrace of Hatshepsut's temple at Deir el-
Bahri, where they were part of a large scene of
the Opet festival,[1] in which the image of the god
Amun was transported from his temple at
Karnak to the temple of Luxor, a few miles to
the south. In this earliest representation of the
festival, groups of jubilant soldiers are depicted
running both north (left) and south (right) in
celebration.

Relief (a) shows Egyptian soldiers, painted
red, the conventional color for men in Egyptian
art, and carrying tree branches for the festival.
Two are armed with battle-axes and one with a
throw stick,[2] and a fourth carries a standard
depicting two horses. The Nubian soldiers rep-
resented on relief (b) are painted brown, their
facial features differ slightly from those of the
Egyptians, and each carries a bow and arrows as
well as a battle-axe. Relief (c), like (a), depicts
Egyptian soldiers armed with throw sticks and
axes. One at the front holds a fan. The rectan-
gular patches on the back of the soldiers' kilts
suggest that they wear a protective leather gar-
ment similar to two found in the Valley of the
Kings (see cat. no. 36; fig. 27). CHR

82b

1. Lipińska 1974, pp. 163–67.
2. These are often called boomerangs, but unlike true
 boomerangs, Egyptian throw sticks are not
 designed to return when they miss their mark.

PROVENANCE: Western Thebes, upper terrace of
Hatshepsut's temple at Deir el-Bahri; (a) acquired in
1907, (b) acquired in 1898, (c) acquired in 1900

BIBLIOGRAPHY: *82a, b*. Porter and Moss 1972,
pp. 375–76; Lipińska 1974, pp. 166–67 (with bibliog-
raphy); Karl-Heinz Priese in *Ägyptens Aufstieg* 1987,
pp. 116–17, nos. 16, 17; Laura Donatelli in *Arte
nell'antico Egitto* 1990, pp. 84–86, no. 3; Dietrich
Wildung in Wildung 1997b, pp. 146–47, nos. 146, 147;
Grimm and Schoske 1999a, p. 58, no. 14
82c. Porter and Moss 1972, p. 375; Lipińska 1974,
pp. 164–65 (with bibliography); Karl-Heinz Priese
in Priese 1991, pp. 76–77; Janusz Karkowski in
Geheimnisvolle Königin Hatschepsut 1997, p. 113,
no. 13; Grimm and Schoske 1999a, p. 58, no. 14

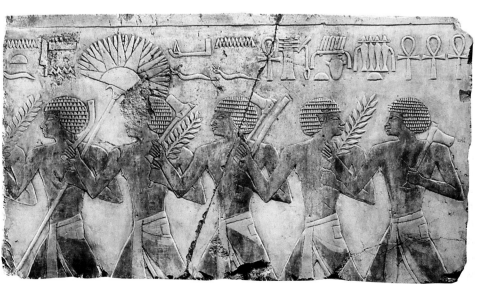

82c

83. Relief Fragment Depicting the Deified King Thutmose I

Early 18th Dynasty, joint reign of Hatshepsut and
Thutmose III (1479–1458 B.C.)
Painted limestone
H. 41 cm (16⅛ in.), W. 46 cm (18⅛ in.)
Roemer- und Pelizaeus-Museum, Hildesheim 4538

Thutmose I, Hatshepsut's father, is depicted
wearing an elaborate crown made up of two
feathers, ram's horns with a sun disk, and cobras.
The curved beard of a god at his chin indicates
that this is an image of the deified king. The
relief is from Hatshepsut's Deir el-Bahri temple,
probably from one of the small niches along the
west wall of the upper terrace (see fig. 61).[1]

<div align="right">CHR</div>

1. N. Strudwick 1985, p. 15, citing Wiebach 1981.

PROVENANCE: Western Thebes, Hatshepsut's
temple at Deir el-Bahri

BIBLIOGRAPHY: Steindorff 1900, fig. 17; Porter and
Moss 1972, p. 355, where the relief is thought to be
from the Anubis shrine in Hatshepsut's temple; Peck
1997, p. 55, and cover ill.; Schulz and Seidel 1998,
p. 185, no. 71

83

84. Relief Fragment Depicting Hatshepsut, Recarved as Thutmose II

Early 18th Dynasty, joint reign of Hatshepsut and
Thutmose III (1479–1458 B.C.), later reworked
Limestone
H. 44 cm (17⅜ in.), W. 33 cm (13 in.)
Musées Royaux d'Art et d'Histoire, Brussels E 3044

The king is shown wearing the squared-off false
beard of a living pharaoh and the *atef* crown—
the white crown of Upper Egypt flanked by two
ostrich feathers and combined with a pair of
ram's horns, a sun disk, and a uraeus at the
brow. At the back of the crown is a small repre-
sentation of the god Horus in falcon form.

Although the cartouche that is partially pre-
served in the upper right corner of this relief
was recarved in antiquity with the throne name
of Thutmose II, the hieroglyphs to the left of
the cartouche, an ankh followed by the feminine
ending *ti* (may she live), indicate that the king
depicted was originally Hatshepsut. The profile
of the face has also been altered. The recarving
was presumably done by order of Thutmose III
after Hatshepsut's death.

<div align="right">CHR</div>

84

85

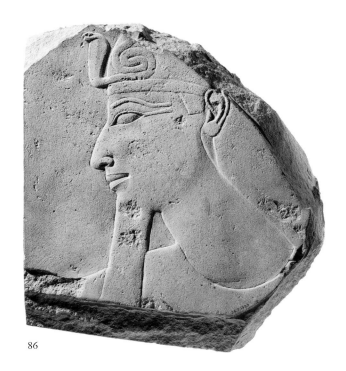

86

PROVENANCE: Perhaps western Thebes, Hatshepsut's temple at Deir el-Bahri; purchased in Egypt by Jean Capart for the Musées Royaux in February 1907, through the generosity of Baron Edouard Empain

BIBLIOGRAPHY: Capart 1911, pp. 9, no. 26, 22–24, fig. 6; Capart 1931, p. 57, pl. 60; Werbrouck 1949, p. 127, pl. XLVI; Porter and Moss 1972, p. 376 (with bibliography); Myśliwiec 1976, p. 44, pl. XX, fig. 41

85. Relief Fragment Depicting a Statue of Thutmose III

Early 18th Dynasty, joint reign of Hatshepsut and Thutmose III (1479–1458 B.C.)
Limestone
H. 38.6 cm (15¼ in.), W. 40.6 cm (16 in.), D. 6.7 cm (2⅝ in.)
Kestner-Museum, Hannover 1935.200.200

The figure in the center of this fragment is a statue of Thutmose III, identified by the cartouche containing his throne name, Menkheperre, and depicted wearing the *khepresh* crown, often called the blue crown. The block comes from a series of reliefs on the upper terrace of Hatshepsut's temple carved with scenes of the Opet festival, during which the image of Amun-Re was carried from Karnak temple to Luxor temple and back in a procession that also included royal statues like this one of Thutmose III. The inscription on this fragment mentions the statues. CHR

PROVENANCE: Western Thebes, upper terrace of Hatshepsut's temple at Deir el-Bahri; formerly Baron von Bissing collection; acquired for the museum in 1935

BIBLIOGRAPHY: Hans D. Schneider in *Ägyptens Aufstieg* 1987, p. 191, no. 107; Drenkhahn 1989, pp. 80–81, no. 24; Janusz Karkowski in *Geheimnisvolle Königin Hatschepsut* 1997, p. 111, no. 11; Rosemarie Drenkhahn in Busch 2002, pp. 158–59, no. 24

86. Relief Depicting Thutmose III(?)

Early 18th Dynasty, sole reign of Thutmose III (1458–1425 B.C.)
Painted limestone
H. 32 cm (12⅛ in.), W. 32 cm (12⅛ in.)
The Metropolitan Museum of Art, New York, Purchase, Edward S. Harkness Gift, 1926 26.7.1399

Carved in exquisite low relief, this portrayal of the king exhibits the slightly aquiline nose, almond-shaped eyes with curving brow, and wedge-shaped mouth that are seen in many reliefs of Hatshepsut and that continue to characterize royal portraits during the sole reign of Thutmose III, making it difficult to distinguish between the two rulers. This relief probably once decorated the Valley Temple built by Thutmose III at the east end of the causeway that leads to his temple at Deir el-Bahri.[1] It was discovered in the foundations of the unfinished

Ramesside temple later constructed in the same area. The king is shown leaning forward, probably in a kneeling position. He wears the beard of a living pharaoh and a *khat* headdress with a uraeus at his brow (see cat. no. 91).

CHR

1. See "The Temple of Thutmose III" by Jadwiga Lipińska in chapter 6.

PROVENANCE: Western Thebes, Birabi; excavated by Howard Carter and Lord Carnarvon, 1906, acquired by Carnarvon in the division of finds

BIBLIOGRAPHY: Hayes 1959, p. 118, fig. 60

87. False Door of Thutmose I

Early 18th Dynasty, joint reign of Hatshepsut and Thutmose III, period of Hatshepsut's regency (1479–1473 B.C.)
Red granite
H. 2.69 m (8 ft. 10 in.), W. 151 cm (59½ in.), D. 19.5 cm (7⅝ in.)
Musée du Louvre, Paris C48

The false door of Thutmose I, the focus of ritual for his funerary cult, was installed by his daughter Hatshepsut in his chapel on the southern side of the upper terrace of her temple at Deir el-Bahri. The form of the door, with a torus molding framing a door with six jambs

and topped by a cavetto cornice, first appeared in both royal and private contexts in the early and middle Fifth Dynasty.[1] However, several features of the door are later than the Old Kingdom period, notably the *wedjat* eyes on its lower lintel and the winged sun disk on its upper lintel. While the central tablet, showing Thutmose I wearing the white crown and seated before an offering table, follows the general pattern of Old Kingdom tablets, its erased figure of Hatshepsut, her hand extended above the offering table in the gesture associated with the ritual *ḥtp-dj-nswt* formula, is more typical of Eighteenth Dynasty stelae.

In addition to the erasure of the figure of Hatshepsut, the door shows several other alterations. The lower part of Hatshepsut's cartouche, on the outer left jamb, has been erased, though the Horus name above has been left intact. Her Horus name on the outer right jamb appears to have been changed to that of Thutmose I, most likely the correction of an error in the original carving, since the name of Thutmose I inscribed below appears to be original. Oddly, the names of the winged disk on both ends of the upper lintel, probably "The Behedite, the Great God," seem to have been erased during the Amarna period.

On the outer left jamb of the door, Hatshepsut's names are followed by the dedicatory inscription: "She made (it) as her monument for her father." (The feminine pronouns have been left intact.) The other names on the door all belong to Thutmose I. He is called Beloved of Osiris, the Great God (left center jamb), Beloved of the Souls of Pe (right center jamb), and Beloved of Anubis Who Is upon His Mountain (right outer jamb). The remaining titles and epithets are unremarkable.

AMR

1. N. Strudwick 1985, p. 15, citing Wiebach 1981.

PROVENANCE: Western Thebes, Hatshepsut's temple at Deir el-Bahri; formerly Salt collection; purchased in 1826

BIBLIOGRAPHY: Ratié 1979, pl. 4

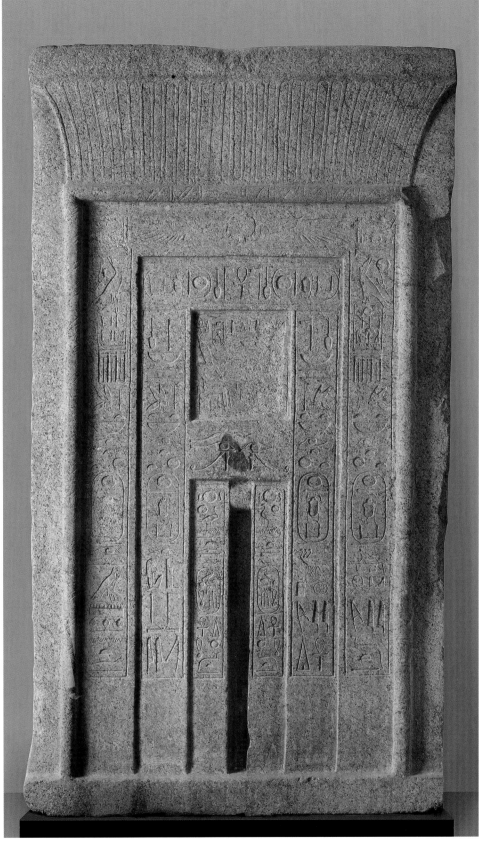

87

THE STATUARY OF HATSHEPSUT

Cathleen A. Keller

Any investigation of the statues of Hatshepsut must begin with the examples recovered from her temple at Deir el-Bahri, for, although in a ruined state, they constitute the largest corpus of surviving images known to date from her reign.[1] Moreover, since they derive from a common site, regional variation is not an issue.[2] Finally, the fact that a significant proportion of the Deir el-Bahri corpus is made up of architectural statuary allows us to use the temple's construction history to devise a stylistic framework for the freestanding statues. In 1979 Roland Tefnin published a chronology of the stylistic and iconographic development of Hatshepsut's statuary that rests upon the stylistic changes manifested by three series of engaged limestone statues at Deir el-Bahri.[3] These are all Osiride figures, that is, statues that associate the king with Osiris and thus present him as a deceased ruler. The development Tefnin posits began with four statues in the sanctuary and proceeded outward, first to the ten examples enclosed within niches in the rear (west) wall of the upper terrace (like cat. no. 74), and then to the twenty-six statues that fronted the upper terrace portico.[4] This sequence reflects Tefnin's hypothesis that the embellishment of the temple was initiated in the inner parts of the temple (on the west), which were most important in terms of ritual, and culminated, with some exceptions, at the outer (eastern) part of the temenos, or sacred enclosure.[5]

The sanctuary Osirides possess close stylistic affinities with sculptures of Thutmose II's reign:[6] a round face and straight nose whose vertical plays against the emphatic horizontals of the widely spaced eyes and broad mouth.[7] In both, the distinct smile (fig. 64) creates a relatively benign expression. Similar features appear, for example, in a relief on a limestone block from Karnak that shows Hatshepsut as chief queen of Thutmose II.[8] The sanctuary Osirides have skin that is yellow, the color traditionally used for representations of females. This color choice may reflect Hatshepsut's decision, for a brief time early in the co-regency period, to adopt kingly titles while retaining female aspects (fig. 38).[9] As we will show, these feminine forms would be replaced by increasingly masculinized representations, evident in both the Karnak and Gebel el-Silsila shrines as well as in

her temple at Deir el-Bahri, throughout the remainder of the joint reign.

The final transformation of Hatshepsut's figure from female to male and the adoption of full kingly iconography is epitomized in her seated statues from Deir el-Bahri (cat. nos. 95, 96) and in other, stylistically related works from the same temple.[10] The primary characteristics of this stylistic phase are the individuation of Hatshepsut's appearance (as distinct from earlier depictions of her in the generalized style of her immediate predecessors) and a unique combination of feminine traits with masculine symbols of royal power. The face lengthened and, at the beginning of this phase, sometimes took on a geometric appearance; later a broadening across the cheekbones, coupled with a narrow, sometimes pointed, chin, created a heart-shaped countenance. The brows in the works of this phase arch high above the slightly tilted almond-shaped eyes; the nose begins to assume a distinctly curved profile; the lips become thinner; and the expression tends to be more serious. These characteristics are shared by the Osiride figures from the west wall niches of the upper terrace (cat. no. 74) and the two limestone depictions of Hatshepsut as a maned sphinx (cat. no. 89).

The seated images of Hatshepsut are among the most interesting portrayals of her, for they exhibit the greatest individual variation. They do not constitute a series, but rather are a group of iconographically and stylistically unique images united solely by their seated pose. The other statues in question are true series, and their meaning and effect depend at least partly on this fact. Thus each series expresses a different concern: the devotional pair represent the permanence of adoration; the donor images stand for multiplication of the offering ritual; the sphinxes suggest the maintenance of the temple's protection; and the Osirides offer proof of the repetition of the jubilee.[11] The seated statues, however, depict the single recipient of a cult ritual, and with their nuanced variations, these images must represent the peak achievement of Hatshepsut's sculptors at the time they were made. Their stylistic, textual, and iconographic differences also account for the position of primary importance they occupy for historians and art

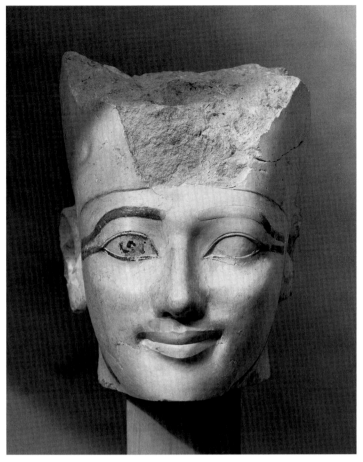

Fig. 64. Over-lifesize head of an Osiride statue of Hatshepsut from the sanctuary of her temple at Deir el-Bahri, early 18th Dynasty. Limestone. The Metropolitan Museum of Art, New York, Rogers Fund, 1931 (31.3.155)

historians alike, both as exemplars of the development of Hatshepsut's kingly iconography and as indicators of the evolution of style in the joint reign, during which Hatshepsut's image became increasingly masculine and was invested more and more with male kingship symbolism.[12] Recent studies of Hatshepsut's transition from chief queen of Thutmose II to regent and later co-regent of Thutmose III confirm the stylistic and iconographic evidence provided by the seated images: Hatshepsut assumed male guise only after she had already taken a full kingly titulary.[13]

Two seated images portray Hatshepsut in female dress. The earlier of the two is thought to be the badly damaged diorite statue that shows Hatshepsut in fully feminine guise, wearing a *khat* headcloth, sheath dress, amulet necklace, and other jewelry (fig. 65). It is inscribed with her complete royal titulary and uses feminine gender endings throughout. Hatshepsut's kingly status is, however, indicated more emphatically in the granite seated statue that shows her in female dress and jewelry but with the royal *nemes* headcloth (cat. no. 95). Although the texts inscribed on this work are poorly preserved, we can determine that her titulary also uses feminine epithets. In facial features this statue represents a departure from the received artistic style of her predecessors, but it does not exhibit the heart-shaped face, pointed chin, and aquiline

profile seen on most statuary from Deir el-Bahri; these appear to be associated with the male Hatshepsut.

The three remaining seated statues probably are the earliest surviving three-dimensional portrayals of Hatshepsut as a male ruler. The crystalline limestone statue shows her in full kingly, that is, male, regalia but with a torso that is extremely feminine (cat. no. 96). The face is distinctly heart shaped and displays the remnants of a very prominent nose. These features and the change in royal iconography suggest a date later than that of the granite statue. Again the texts retain referents that are chiefly feminine. The next example, an over-lifesize granite image, preserves a much enlarged, one might say flagrant, *nemes* headcloth and a defeminized torso (fig. 66). While some of the inscription's epithets exhibit feminine gender endings, the primary titles are rendered in their traditional masculine form. The headless torso and legs of a small black porphyritic diorite portrayal of a male king completes the corpus of seated images from Deir el-Bahri (fig. 67). Although the work lacks texts that identify it as a representation

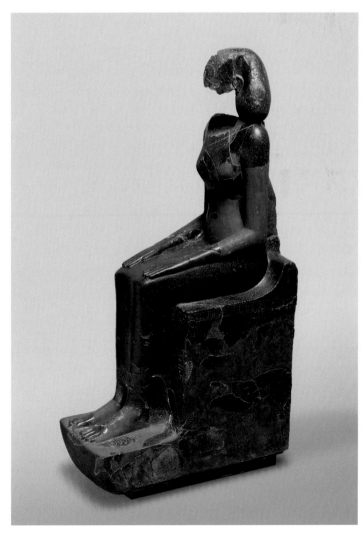

Fig. 65. Lifesize statue of Hatshepsut in female guise and wearing the *khat* headcloth, early 18th Dynasty. Diorite. The Metropolitan Museum of Art, New York, Rogers Fund, 1930 (30.3.3)

of Hatshepsut—its back and seat are uninscribed—the belt buckle was attacked, suggesting that it did indeed portray her. Fully masculine in form, it represents the completion of Hatshepsut's metamorphosis.

Hatshepsut's full transformation into a kingship icon is best embodied, however, in the colossal statuary from the temple at Deir el-Bahri, in which her male aspect is expressed on a monumental scale.[14] The best-preserved examples are the Osirides from the upper portico (figs. 59, 68) and the colossal figures of the king shown standing (cat. no. 94) and kneeling (cat. nos. 92, 93).[15] Although some of these are freestanding, all can be classified as architectural statuary, for they were intended to hold their own in the dramatic open courts of the temple and to impress viewers from a distance by means of their heroic proportions and exaggerated facial features. Among the most striking characteristics of the works in this group are the superhuman scale of the muscular development of the male torsos; the completely male kingly dress; and the enlarged and simplified facial features appropriate to the colossal scale of the figures.[16] In short, these are Hatshepsut supersized.

Although the fully masculine imagery exhibited by the portico Osirides and granite statuary has been interpreted as a relatively late development, it probably does not represent a separate artistic phase but rather embodies a specific application of the male kingship icon. Most of the statues in this category are either well over lifesize or extremely simplified small versions (cat. no. 91) of works that are over lifesize. While it is clear, from the small number and relatively early date of the depictions of Hatshepsut as female that this type of image was superseded by the male icon, the essential appearance of her distinctive physiognomy was retained and remains clearly recognizable. Thus, the face of the seated female figure in catalogue no. 96, for example, is without doubt that of the same person represented in the colossal statuary (cat. nos. 92–94) and the smaller red granite figures (cat. no. 91).

About year 42 of his reign, Thutmose III began a deliberate program of *damnatio memoriae* directed against his former coregent;[17] his central goal was the eradication of any trace of Hatshepsut's claims to kingly status. Her splendid mortuary temple at Deir el-Bahri was a primary target of this campaign.

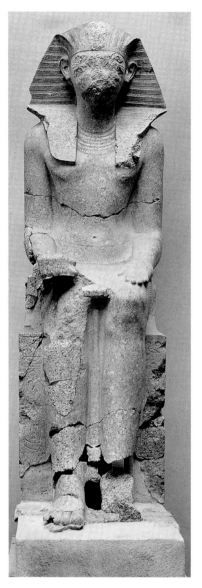

Fig. 66. Over-lifesize statue of Hatshepsut as king, early 18th Dynasty. Granite. The Metropolitan Museum of Art, New York, Rogers Fund, 1927 (27.3.163)

Perhaps his attacks on sculpture in the temple made a virtue out of necessity, since tearing it down would have been an enormous undertaking. Moreover, he may have been reluctant to destroy an entire temple dedicated to Amun. In any event, Thutmose III seems to have planned to convert Hatshepsut's temple, Djeser-djeseru, into a memorial temple for his immediate male predecessors, Thutmose I and II.[18] To this end, he removed Hatshepsut's name, titles, and occasionally her entire figure from the temple's relief decoration. Before destroying her three-dimensional images, he did away with her kingly status by striking off their uraei and erasing her cartouches from them. Once they were destroyed, he had the pieces removed from sacred ground and tossed into two open quarries located east of the temple precincts.[19] The fragments that were thrown into the hole south of Hatshepsut's causeway served as fill for the causeway leading to Thutmose III's own temple, Djeser-Akhet.[20]

Despite Thutmose III's campaign of destruction, both the number and the variety of the statues of Hatshepsut that survive are impressive. If the attitudes of these statues are traditional, their appearance is anything but predictable, for each combines a time-hallowed conventional posture with innovative elements that render it unique and uniquely expressive of Hatshepsut. Indeed, it was perhaps these very touches of originality that made Hatshepsut statuary unusable by Thutmose III when he sought to adapt Djeser-djeseru to his own ends. The time-honored method of usurping statues by simply altering the inscriptions on them was insufficient if they were to be rededicated to Thutmose I or II—the Deir el-Bahri statuary was simply too much Hatshepsut to represent anyone else, so it had to be destroyed.

Although some of the innovative features of Hatshepsut's Deir el-Bahri statuary have already been mentioned, certain more unusual attributes should be highlighted here. The five series of limestone Osiride statues from Hatshepsut's temple conform to a single, new type, in which the upper body is covered by a Sed-festival, or jubilee, cloak and the lower body and legs are mummiform.[21] Although they were broadly modeled on two prototypes at Deir el-Bahri—the freestanding, cloaked statues of Mentuhotep II and the engaged mummiform Osirides of Amenhotep I (see fig. 9)—Hatshepsut's Osirides grasp four implements, two in each fist: the ꜥnḫ and nḫꜣḫꜣ flail in the proper right and the ḥqꜣ crook and wꜣs scepter in the left (see fig. 68).[22] This combination of implements

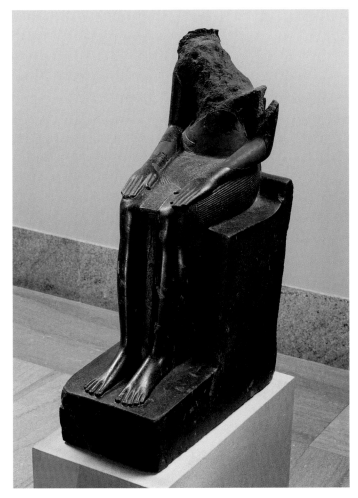

Fig. 67. Hatshepsut as king, early 18th Dynasty. Under lifesize, diorite. The Metropolitan Museum of Art, New York, Rogers Fund, 1931 (31.3.168)

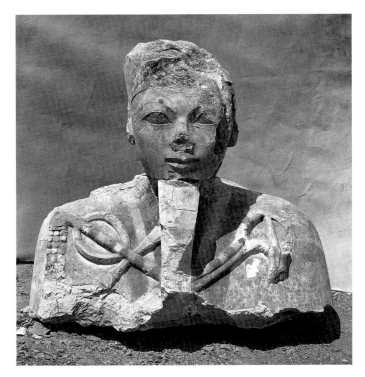

Fig. 68. Bust of an Osiride statue from the colonnade on the upper terrace of Hatshepsut's temple at Deir el-Bahri, early 18th Dynasty. Limestone. The head of one statue was placed on the upper body of another similar one for this excavation photograph.

is entirely unique to Hatshepsut's statuary. Not only her Osirides but also Hatshepsut's small kneeling figures from Deir el-Bahri present unusual elements, namely, the *nemset* vase, the *djed* pillar, and the prominent *khat* (see cat. no. 91).

A fragmentary sandstone nurse statue found at Deir el-Bahri is also unusual. Here, a miniaturized male Hatshepsut is shown on the lap of the Royal Nurse, Sitre, also known as Inet, their bodies arranged at right angles to each other.[23] Although statues featuring a large figure and a small one juxtaposed in this manner had been known since the Old Kingdom, they were usually reserved for depictions of the king on the lap of his mother or a goddess. The adaptation of the type here to depict the relationship between a royal nurse and her kingly charge, contemporary with the proliferation of imaginative tutor statues of Senenmut (cat. nos. 60, 61), constitutes another example of the artistic originality displayed by sculptors of Deir el-Bahri.[24]

HATSHEPSUT'S STATUARY PROGRAM THROUGHOUT EGYPT

The same destructive forces that were unleashed upon Hatshepsut's memorial temple statuary were responsible for the disappearance of her statuary from other sites. Hatshepsut is known to have undertaken building projects from the Sinai to Nubia. In most of her far-flung projects she would have installed images depicting herself as ruler of Egypt. However, the very fragmentary condition of this statuary and its original inscriptions make attribution uncertain.[25]

A case in point is statuary associated with one of Hatshepsut's grandest construction projects at Karnak: the Eighth Pylon (fig. 69). Larger than any pylon previously erected at Karnak, this monumental sandstone structure became the new entrance to the temple and accommodated the complex's twin processional axes, north-south and east-west.[26] The pylon was distinguished by two unusual features: it was entirely surrounded by a low wall of limestone, and an exceptionally large number of colossi stood in front of its south face. Ultimately there were six colossi, all made of limestone and quartzite, paralleling the combination of materials in the pylon itself. Three were placed before each wing of the pylon. The two easternmost were completely destroyed, and the remaining four have lost their faces. The two flanking the entrance gate were set up by Hatshepsut but bear the name of Thutmose II, having been rededicated by Thutmose III to his father, one in his year 22, the other in his year 42, as part of Thutmose's program of usurpation of the pylon itself. These years are significant: the first likely was the year of Thutmose III's accession to sole power, the second was when the official proscription of Hatshepsut's images began. As it was not uncommon for kings to usurp the statues of predecessors, Thutmose's rededication of the first of these two

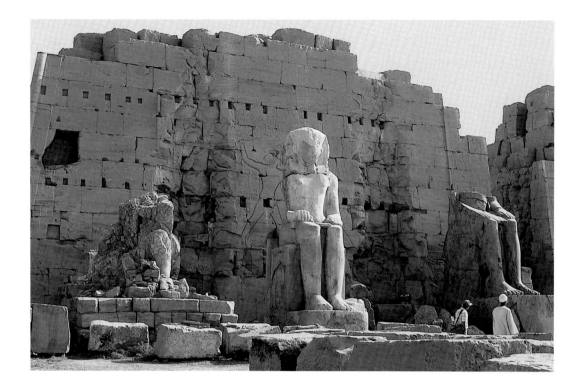

Fig. 69. The Eighth Pylon, built by Hatshepsut in the early 18th Dynasty at the temple of Amun at Karnak

colossi was not necessarily part of his systematic campaign to destroy her monuments that began two decades later. The other surviving colossi, those fronting the west wing of the pylon, were inscribed for Amenhotep II (the westernmost) and Amenhotep I. The latter, which is accompanied by a much smaller statue of Amenhotep I's mother, Ahmose-Nefertari, may, like the examples that now bear Thutmose II's name, have been part of Hatshepsut's original decorative program.[27]

Hatshepsut's construction within the temples of Amun and Mut at Karnak must have housed many images of her, both single figures and statues that were elements in statue groups. Only fragments of two such group portrayals have survived, both of which were associated with the bipartite Kamutef sanctuary at Karnak: one shows Hatshepsut with Amun-Re-Kamutef; the other portrays her with Thutmose III and the same divinity.[28]

It is likely that the devising of group statues was another of the innovative features of Hatshepsut's statuary production.[29] The statue from Deir el-Bahri of Hatshepsut with her nurse has been mentioned. Particularly interesting are the paintings in the tomb of one of her officials, Amenhotep, a royal steward and steward of Amun who followed Senenmut in this office. They contain depictions of no less than seven different group statues that portray Hatshepsut with a variety of divinities, including Amun, Atum, Weret-hekau, Thoth, Khnum, Satis, and Anukis.[30] In all of the paintings both Hatshepsut's figure and the accompanying texts have been erased. Text labels designating the statues' materials survive (*šs*, meaning "travertine"), and the stone can also be ascertained through color (red signifies red granite; yellow signifies travertine). One travertine triad represented Khnum and Anukis seated facing one another, with Hatshepsut sitting on the

lap of Anukis;[31] another triad of the same material depicted Hatshepsut kneeling between seated figures of Amun and Atum.[32] The most elaborate composition was a quadrad of Hatshepsut with three divinities. At the left, Thoth records Hatshepsut's regnal years on a palm rib; immediately to his right Weret-hekau stands before a throne dais, on which Amun sits. Hatshepsut was shown kneeling on the dais with her back toward Amun. Weret-hekau holds an ankh in her left hand and places her right palm on Hatshepsut's brow. Amun touches Hatshepsut's back and shoulders with both hands.[33] Some of the statues closely parallel contemporary royal relief decoration—in particular that in the Chapelle Rouge, the barque sanctuary that Hatshepsut built for Amun at Karnak.[34]

As these groups reveal, Hatshepsut's statuary program understandably featured images that visually as well as textually emphasize her close relationship to the gods and make explicit their acceptance of her kingship—a key example (cat. no. 40) shows her literally merged with the god Horus. Moreover, as four of the groups depicted in the tomb of Amenhotep indicate, she deliberately chose to be portrayed in the context of the elaborate coronation ritual in which the king is invested with insignia that symbolize his divine status.

Hatshepsut's female identity had been an appropriate aspect of her representation as the chief queen of Thutmose II and wife of Amun. However, it was not, ultimately, considered adequate if she was to appear as a king with the status equivalent to that of her male co-regent. In Egyptian art, facial features and bodies were translated into ideal forms, and it was according to a similar process of transformation that Hatshepsut's female nature was altered.[35] In ancient Egypt kingship had its own idealized graphic

and textual vocabulary, with an icon of kingship that was male. If Hatshepsut desired to achieve the status and power of an Egyptian king, it was necessary that she conform to that idealized icon. Her royal titulary remained clearly female, and there was never an attempt to pretend that as an individual she was anything other than female.[36] Yet in the imagery of the statues that presented her as king she of necessity portrayed herself as male: King Maatkare, the Son of Re, Hatshepsut, united with Amun, may (s)he live!

1. Tefnin 1979, pp. VIIff.

2. However, use of numerous fabrics and the individual styles of the sculptors have contributed to a certain degree of variation among them.

3. His conclusions are summarized in his chart in Tefnin 1979, p. 139. His chronology has been followed by numerous researchers, among them Pecoil (1993) and Laboury (1998, pp. 585ff.).

4. The four in the sanctuary constitute his series A; see Tefnin 1979, pp. 38–40. The ten are series B; see pp. 41–43. An example is catalogue no. 74. The last are his series C; see pp. 44–48. An example is fig. 68.

5. Arguments set forward by Tefnin and later by Christine Meyer positing the existence of a single stylistic trajectory for Deir el-Bahri statuary have been questioned (in the case of Tefnin 1979 by Bernadette Letellier [1981] and in that of Meyer 1982 by Peter Dorman [1985, cols. 299–300, and 1988, pp. 41, 212]). However, as Dimitri Laboury indicates (1998, pp. 591ff.), the general line of stylistic and iconographic development that Tefnin outlines has largely been verified by subsequent studies of the temple as well as by more recent studies of the early co-regency period.

 Here we should note that although Tefnin proposes three series, there are actually five. These are: the colossal Osiride figures on the north and south ends of the lower colonnade (fig. 110), which are more than 23 feet (7 meters) high and the much smaller Osirides carved on the north and south sides of the Hathor capitals in the goddess's shrine on the middle terrace, in addition to the three posited by Tefnin.

6. For the reign of Thutmose II, see generally Gabolde 1987b. For the development of relief sculpture and statuary of the regency and co-regency period, see Laboury (1998, pp. 585–621).

7. As noted by Tefnin (1979, pp. 38–40).

8. Chevrier 1955, p. 40, pl. XXII and Schott 1955, pl. 2; Myśliwiec 1976, p. 42, pl. XIX, fig. 39 (detail).

9. As on a limestone lintel from Karnak (Chevrier 1934, p. 152, pl. IV; Schott 1955, p. 216, pl. 3). The form originated in the limestone shrine but was reused in Amenhotep III's temple of Montu at North Karnak and in representations of Hatshepsut at Gebel el-Silsila (Gabolde and Rondot 1996, p. 214 and n. 89, with bibliography).

10. These works belong to Tefnin's Phase II and include, in addition to the seated statues, the Osirides from the west wall niches of the upper terrace, two limestone portrayals of Hatshepsut as a sphinx with a mane (cat. no. 89), and one of the smaller granite sphinxes (cat. no. 88b). For this subject and refinements of his classifications, see Tefnin 1979, pp. 135–39, 145–46.

11. The inscriptions on the portico Osirides make reference to the "first occasion of the Sed festival": Leblanc 1980, pp. 82, 86–87.

12. Tefnin 1979, pp. 1–36. The order in which the statues are discussed here follows Tefnin. It must be noted that the upper part of one is lost (Metropolitan Museum 31.3.168: Tefnin 1979, pp. 18–19, pl. VII, a), and the faces of two others are largely destroyed (Metropolitan Museum 30.3.3: Tefnin 1979, pp. 2–6, pl. I, 3, with face restored; and 27.3.163: Tefnin 1979, pp. 16–18, pl. VI, with face restored), limiting their usefulness for stylistic analysis.

13. These studies include Gabolde and Rondot 1966, p. 214; Chappaz 1993a and 1993b; Dorman 2005.

14. The Osirides that front the temple's upper terrace and works of similar style from Deir el-Bahri belong to Tefnin's Phase III. Tefnin (1979) characterizes this phase as a "return to tradition," in which kingship was once again represented according to long-standing male prototypes, although this development had already taken place during his Phase II.

15. The red granite, over-lifesize portrayals of the queen in the devotional pose (cat. no. 94) and its pendant in the Egyptian Museum, Cairo (JE 52458) are the only surviving standing statues of Hatshepsut from Deir el-Bahri. The attitude is clearly derived from late Middle Kingdom prototypes (see the entry for cat. no. 94), but the scale is larger than previously used and may represent an innovation on the part of Hatshepsut's sculptors. Thutmose III continued to employ this statue type. There surely were other standing images that have not survived. A pair of standing statues with contested attributions that may have belonged to Phase III are in Cairo (CG 594, JE 11249, SR 11619), and the Karnak Open-Air Museum, Luxor (MPA.T3. st.1). For both, see Laboury 1998, pp. 169–75, nos. C40, C41. Following Laboury, Rita Freed (in Hornung and Bryan 2002, pp. 82–84, no. 4) assigns them to Thutmose III. They are, however, also ascribed to Hatshepsut in Chappaz 1993b, p. 6, and cover ill.; Grimm and Schoske 1999a, p. 48, figs. 46, 47. Also included in Tefnin's Phase III are smaller kneeling figures of Hatshepsut (cat. no. 91), sandstone sphinxes wearing the *nemes*, and a granite sphinx in Cairo (JE 53114). In a transitional phase between Phases II and III he places a granite sphinx (Cairo, JE 55190) and two Osiride statues (Cairo, JE 56260) and Deir el-Bahri (C5) (Tefnin 1979, p. 139).

16. This is not to say that these images are identical; in fact, they reveal the variations one would expect to see in works produced by individual teams of sculptors.

17. See chapter 5 in this volume.

18. Dorman 1988, p. 65.

19. For a general discussion of the discovery and excavation of this material, see Winlock 1942. See also the essay by Dorothea Arnold in chapter 5.

20. Some fragments of Hatshepsut's broken statuary (cat. nos. 88b, 93, 95, 96) were acquired by European collectors in the nineteenth century. However, her Deir el-Bahri statuary did not reclaim its place in the corpus of New Kingdom art until Herbert E. Winlock excavated it for The Metropolitan Museum of Art. Beginning in the season of 1922, Winlock's excavations recovered thousands of fragments of Hatshepsut's statuary. We might say, therefore, that strange twists of fate made Thutmose III the preserver of the same images of Hatshepsut that he had ordered destroyed. It proved possible to reconstruct many impressive statues from these fragments, but others, particularly those made of sandstone and limestone, were lost to centuries of exposure to groundwater or burned in the lime kilns. Thus, our knowledge of the Deir el-Bahri repertoire remains incomplete.

21. Leblanc 1982, pp. 296–99, pl. XLIX.

22. Leblanc 1980, pp. 73, fig. 1 (A.7, A.10), 74. The identical combination of implements appears in reliefs on the Chapelle Rouge; see Leblanc 1982, pp. 300–305, pls. L, LI, LII, A, LIII.

23. For Sitre as the nurse of Hatshepsut, see Roehrig 1990, pp. 31–39.

24. It is likely that the sculpture programs of Hatshepsut and Senenmut inspired each other. See "Senenmut as Royal Tutor" and "The Statuary of Senenmut" in this volume.

25. Unfortunately, the only Karnak statue of Hatshepsut with a certain attribution known to have survived into modern times was allowed to disintegrate, according to the testimony of Sir Wallis Budge (James 1976; Eaton-Krauss 1999, pp. 117–20).

26. The north-south processional way linked the Karnak temple to the Luxor temple, the site of the Opet festival, which merged the divinity of Amun and the kingship of Hatshepsut. For more on the function of the Opet festival, see Bell 1985. The east-west way was the route of the Valley festival, during which Amun left Karnak to visit the Gods of the West. For this subject, see

"Hatshepsut's Mortuary Temple at Deir el-Bahri" by Ann Macy Roth in this volume.

27. Martinez (1993, p. 71) suggests that the six colossi constituted a "family gallery" of the Thutmosides, whose position, facing south toward Luxor temple (the shrine associated with the divine lineage of the king) emphasized the role of the Eighth Pylon as "a gate of initiation, through which royal power is affirmed."

28. Seidel 1996, pp. 135–37 (with bibliography). A third possible triad is slightly more questionable; Seidel 1996, pp. 138–39.

29. The images of her high official Senenmut shown with the princess Neferure (cat. nos. 60, 61) were equally innovative.

30. The tomb is TT 73 in western Thebes (see Habachi 1957, pp. 91–93, 95, and Säve-Söderbergh 1957, pp. 1–10); recently Laboury (2000, pp. 86–87) has analyzed three of the groups depicted in it.

31. Säve-Söderbergh 1957, pl. III; Seidel 1996, p. 129, fig. 38.

32. Säve-Söderbergh 1957, pl. IV; Seidel 1996, p. 130, fig. 40.

33. Säve-Söderbergh 1957, pl. III; Seidel 1996, p. 131, fig. 42.

34. See the discussion in Seidel 1996, pp. 132–34.

35. As Robins notes (1999, pp. 103, 110).

36. Inscriptions on statues from Deir el-Bahri include a mixture of male and female gender endings, but those on works from other sites, in particular Karnak, are chiefly male.

88. Two Colossal Sphinxes of Hatshepsut

Early 18th Dynasty, joint reign of Hatshepsut and Thutmose III (1479–1458 B.C.)

a. Granite
H. 164 cm (64⅝ in.), W. 90 cm (35⅜ in.), D. 343 cm (11 ft. 3 in.)
The Metropolitan Museum of Art, New York, Rogers Fund, 1931 31.3.166
Not in exhibition

b. Granite, paint
H. 131 cm (51⅝ in.), D. 287 cm (9 ft. 5 in.)
Ägyptisches Museum und Papyrussammlung, Staatliche Museen zu Berlin 2299

The depiction of the king as a sphinx, with a lion's body and a royal portrait head and frequently coiffed, as here, with *a nemes* headcloth, has a very long history in Egyptian art. The earliest sphinxes date to the Old Kingdom, shortly before the creation of the great sphinx at Giza—the most famous and largest example of the genre. The prominence of sphinxes in Old Kingdom pyramid complexes, both as freestanding statues and in relief depictions of the king trampling his enemies, suggests that they functioned as protectors of the royal mortuary complex.[1]

Six colossal granite sphinxes, some fragmentary, survive from Hatshepsut's temple at Deir el-Bahri.[2] Their original location was probably the lower terrace, where sphinxes appear to have been arranged, evenly spaced, in two east–west rows flanking the sacred route across the terrace to the ramp that ascended to the temple's middle level.[3] Therefore they were in a position to extend their guardianship over both the temple itself and the religious processions that passed along the route.

Although the sphinxes were symmetrically arranged along the temple's main axis in two facing rows, these two are not identical. The Berlin sphinx is smaller than its New York counterpart; its face is proportionally longer and narrower, with sharper facial planes, narrow, slanting eyes, and a small, terse mouth. The New York sphinx has a shorter, more heart-shaped face that is much broader across the cheekbones; its eyes are wide open and horizontally set.

On both sphinxes a battered column of text running down the breast is preserved and gives the prenomen of the king. The more intact text on the Berlin sphinx also contains the epithet of Amun "preeminent at Djeser-djeseru," the use of which would be consistent with the placement of the sphinxes outside the temple's upper terrace. CAK

1. Zivie-Coche 1984. On the protective qualities of the sphinx, see also Wit 1951.

2. In addition to the two granite sphinxes catalogued here, there are two fragmentary whole sphinxes in the Egyptian Museum, Cairo (JE 53114+55191, JE 56259) and the head from another (JE 55190) (see Winlock 1929a, p. 12, nn. 9, 10, p. 14, fig. 15; Winlock 1942, p. 172; and for descriptions and bibliography, see Tefnin 1979, pp. 107–12). The head and torso of a sixth are in The Metropolitan Museum of Art, New York (31.6.167); see Hayes 1959, pp. 93–94, and Tefnin 1979, pp. 114–15.

3. A primarily single placement of the granite sphinxes was suggested recently by Dorothea Arnold (see her essay in chapter 5). Previously, Winlock (1935a, pp. 159–60) hypothesized that they were on the middle terrace. The problem was reviewed by Tefnin (1979, pp. 102–3), who followed Winlock's siting of the granite sphinxes on the middle terrace and the colossal kneeling figures on the upper terrace.

PROVENANCE: *88a.* Western Thebes, Deir el-Bahri; Metropolitan Museum of Art excavations, 1928
88b. Western Thebes, Deir el-Bahri; head, transported to the Ägyptisches Museum, Berlin, by Karl Richard Lepsius in 1845; body, Metropolitan Museum of Art excavations, 1928, ceded to the Ägyptisches Museum, Berlin, as part of an exchange in 1929

BIBLIOGRAPHY: *88a.* Winlock 1935a; Winlock 1942, pp. 160, 189, pl. 50 (restored); Hayes 1959, pp. 92–93; Aldred 1961, pp. 48–49, no. 23; Tefnin 1979, pp. 102, 112–14 (bibliography, p. 113), 118, 120, 127, n. 1, 175–77, 187, pl. XXVII
88b. Winlock 1929a, pp. 3–9, figs. 7, 8 (body); Tefnin 1979, pp. 102, 103–7 (bibliography, pp. 103–4), 115–16, 120, n. 1, 122, n. 1, 127, n. 1, 139–41, 146, 174–76, figs. 6, 8, 9, pls. XXVIII, XXIX, a

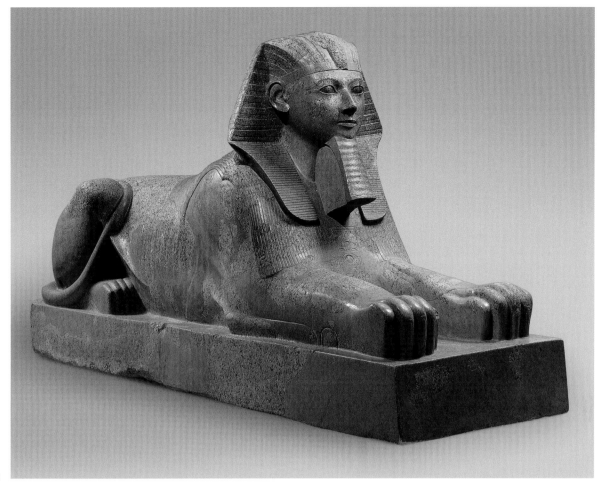

88a

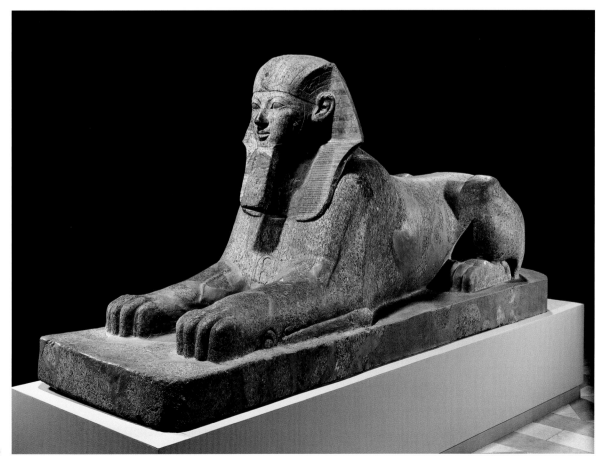

88b

89. Hatshepsut as a Maned Sphinx

Early 18th Dynasty, joint reign of Hatshepsut and Thutmose III (1479–1458 B.C.)
Painted limestone
H. 60 cm (23⅝ in.), W. 29 cm (11⅜ in.), L. 110 cm (43¼ in.)
The Metropolitan Museum of Art, New York, Rogers Fund, 1931 31.3.94

One of a pair, this maned sphinx of Hatshepsut juxtaposes the delicately feminine features of the king with the lean, taut body of a lion. This fragmentary example has been restored with casts of its mate in Cairo, which is almost complete and retains a considerable amount of the original pigment: blue on the mane and beard, a tawny yellow on the body, and traces of reddish brown on the proper left cheek.[1] The statues are inscribed with very similar texts, both reading "Maatkare, beloved of Amun, given life forever." The only difference is that on the Cairo sphinx masculine pronouns are used to refer to the king, and on the New York sphinx the forms are feminine.

While the impression given by the much larger granite sphinxes is of quiescent power, this statue and its mate communicate tranquil expectancy. If, as Herbert E. Winlock suggested,[2]

the sphinxes were placed atop the newel posts at the head of the ramp between the temple's lower and middle terraces, visitors would have encountered them just after passing through the imposing gauntlet of large granite sphinxes. Their role would seem to have been one of greeting, as opposed to the stern guardianship of the granite sphinxes, which were approached from the side, emphasizing the latent strength of the crouching lion.

Like much of the statuary from Hatshepsut's temple, the maned sphinxes were inspired by Middle Kingdom prototypes; however, they are more than simply scaled-down versions of the latter, whose tense and furrowed visages still present a truly forbidding aspect.[3] The Hatshepsut sphinxes have a lightness that results not only from the different scale and materials used by the Eighteenth Dynasty sculptors but also from the overtly youthful, feminine features of the king. This characteristic has caused some scholars to date the maned sphinxes to an earlier[4] and more artistically experimental[5] phase of the co-regency period.

CAK

1. Egyptian Museum, Cairo, JE 53113. For bibliography, see Tefnin 1979, p. 130.
2. Winlock 1942, pp. 172–73.
3. See, for example, the Amenemhat III sphinx from Tanis (Egyptian Museum, Cairo, 394). See also

Evers 1929, pls. 119, 121–23; Vandier 1958, pl. LXVIII, 3; Russmann 1989, p. 65, no. 89.
4. Tefnin 1979, p. 133.
5. For example, as noted in Russmann (1989, p. 65), the thick hair on the top of the head has been regularized and given a *nemes*-like appearance.

PROVENANCE: Western Thebes, Deir el-Bahri, Senenmut Quarry; Metropolitan Museum of Art excavations, 1927–29

BIBLIOGRAPHY: Winlock 1929a, p. 12; Winlock 1942, pp. 172–73, pl. 48 (bottom); Hayes 1959, pp. 91–92; Tefnin 1979, pp. 129–33 (bibliography, p. 130), 140, 143, 187

90. Relief with Hatshepsut as a Sphinx

Early 18th Dynasty, joint reign of Hatshepsut and Thutmose III (1479–1458 B.C.)
Painted limestone
H. 21.6 cm (8½ in.), W. 37.5 cm (14¾ in.), D. 7.5 cm (3 in.)
The Metropolitan Museum of Art, New York, Rogers Fund, 1923 23.3.172

This limestone fragment from the temple of Hatshepsut at Deir el-Bahri depicts a sphinx with the king's features protecting a cartouche containing her prenomen, Maatkare. The relief is noteworthy for the high quality of its execution. The facial features replicate in sunk relief ones seen on much of Hatshepsut's temple statuary, most notably the larger of the two granite sphinxes discussed above (cat. no. 88a).

The fragment was originally part of a square statue base approximately 26 inches (66 cm) on each side and 18 inches (46 cm) tall. No identifiable trace of the image that originally stood on the pedestal has been discovered, but the base's dimensions suggest that the statue showed the king in a standing pose. Assuming that the statue was also of limestone, it probably perished in the same near-total destruction visited on so much of the temple's limestone statuary. This pedestal fragment is a useful reminder that, although many of Hatshepsut's statues from Deir el-Bahri have been reconstructed,[1] the corpus remains incomplete.

CAK

1. Many more statues have been reconstructed from Hatshepsut's temple than from any other New Kingdom mortuary temple, except that of Amenhotep III; see Bryan 1992 and 1997.

PROVENANCE: Western Thebes, Deir el-Bahri, Hatshepsut Hole; Metropolitan Museum of Art excavations, 1922–23

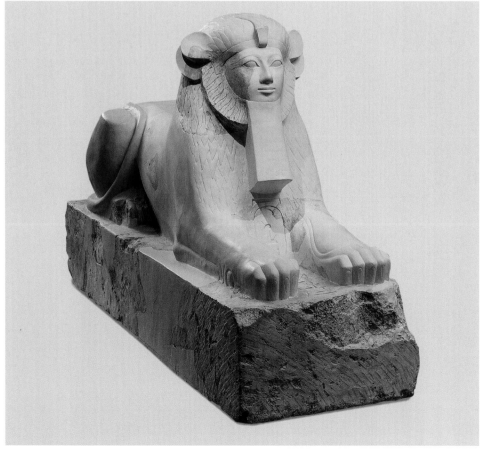

89

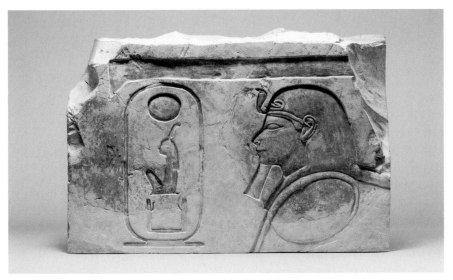

90

BIBLIOGRAPHY: Winlock 1942, pp. 79–80; Hayes 1959, pp. 100–101, 102, fig. 56; Tefnin 1979, p. 134

The fact that only the eyes and brows have been picked out in paint, combined with an absence of the final polish seen on the larger granite sculptures, has suggested to some scholars that this corpus was completed in haste, possibly for a purported Sed festival of the king in year 16.[7] CAK

1. Tefnin 1979, p. 88, following Hayes 1959, p. 97.
2. Roland Tefnin (1979, pp. 94–97) reviews the possibilities and concludes that the combined use of the *khat* headdress, the *nemset* vase, and the *djed* pillar is intended to evoke the erection of the *djed* pillar at the Sed festival.
3. Dietrich Wildung (1969, p. 135, n. 3), followed by Marianne Eaton-Krauss (1977), suggests, that the *khat*-wearing king in royal statue groups is actually the king's ka. The fact that in Hatshepsut's temple kings depicted wearing the *khat* are both making (Hatshepsut) and receiving (Thutmose I and II) offerings (Eaton-Krauss 1977, p. 28) might signify the dual role of ka as both the sustainer ("sustenance" offered by the king) and the sustained (the "life-force" that requires sustenance).
4. The inscription here faces right and reads: "Son of Re of (with feminine *t*) his body Khenem (no *t*) – Amun Hatshepsut."
5. Other members of the corpus include examples in the Ägyptisches Museum, Berlin (22883), the

91. Hatshepsut Kneeling

Early 18th Dynasty, joint reign of Hatshepsut and Thutmose III (1479–1458 B.C.)
Granite, paint
H. 87 cm (34¼ in.), W. 32.5 cm (12¾ in.), D. 51.5 cm (20¼ in.)
The Metropolitan Museum of Art, New York, Rogers Fund, 1923 23.3.1

Among the statues that originally embellished Djeser-djeseru was a series of perhaps a dozen[1] small kneeling depictions of Hatshepsut proffering a *nemset* vessel fronted by a *djed* pillar, a sacred object connected with Osiris, in high relief.[2] The king wears a short, closely fitting pleated kilt, with only the *khat* headdress and uraeus indicating her royal status.[3] The back pillars of all of the figures are inscribed with one of two types of text, featuring either the nomen or prenomen of Hatshepsut.[4]

Although the images closely resemble one another, demonstrating their derivation from a common model, their individual features are sufficiently distinctive to show that they were the work of different sculptors.[5] The facial and body forms are highly simplified, which is in keeping with their suggested placement in an architectural setting characterized by rhythmic repetition, such as a portico or peristyle court. If twelve is indeed the total number of these figures, they may be connected with the rituals of the twelve daily and nightly hours that feature in the decoration of the king's own cult chapel and the solar court, both located on the upper terrace of the temple.[6]

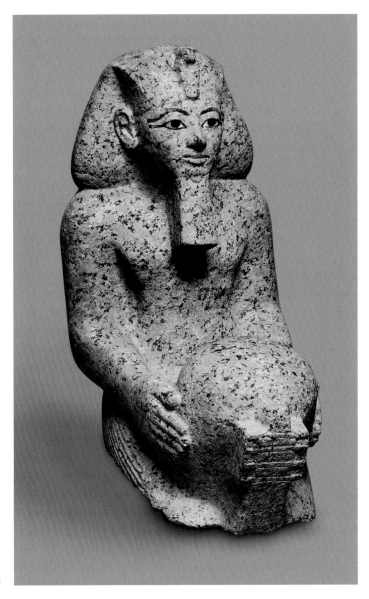

91

Egyptian Museum, Cairo (JE 47703–3), and the Metropolitan Museum (23.3.2, 31.3.160, .162).

6. The hours of the day and night are depicted on the ceiling of the cult chapel of Hatshepsut (Naville 1894–1908, pt. 4, pls. CXIV–CXVI) and in the solar court of Re-Horakhty (Karkowski 1976).

7. Tefnin 1979, p. 94, followed in Grimm and Schoske 1999a, p. 84.

PROVENANCE: Western Thebes, Deir el-Bahri, Hatshepsut Hole; Metropolitan Museum of Art excavations, 1922–23

BIBLIOGRAPHY: Winlock 1923, pp. 32–33, figs. 27, 28; Winlock 1942, p. 141, pl. 53; Hayes 1959, p. 97; Tefnin 1979, pp. 89–90, 93, n. 4, 186, fig. 4, pl. XXIII, a

92. Hatshepsut Offers *Maat* to Amun

Early 18th Dynasty, joint reign of Hatshepsut and Thutmose III (1479–1458 B.C.)
Granite
H. 261.5 cm (8 ft. 7 in.), W. 80 cm (31½ in.),
D. 137 cm (54 in.)
The Metropolitan Museum of Art, New York,
Rogers Fund, 1929 29.3.1
Not in exhibition

The central sanctuary located on the upper terrace of Hatshepsut's temple at Deir el-Bahri was dedicated to Amun-Re, whose barque traveled across the river from Karnak temple and then was carried until it came to rest in this shrine in the yearly Beautiful Festival of the Valley.[1] As the procession bearing the god's image crossed the middle terrace, it passed between a series of colossal granite images of Hatshepsut. These statues, one of which is included in the exhibition catalogue, depicted the king kneeling and offering spherical *nw* jars and are differentiated only by the head covering and text. On this statue the king wears the royal *nemes* headcloth, and the text on the base states that the king is offering *maat* to Amun.[2]

At first glance, the faces on these large statues appear to be the least individualized of those on statuary of Hatshepsut, an impression that has led scholars to date them at or near the end of the co-regency period.[3] However, they share many traits with faces on her smaller statues (see cat. no. 91), including highly arched brows, wide-open eyes, thin, aquiline nose, and small mouth, although these features are scaled up to accord with their colossal size. Clearly, this architectural statuary was intended to hold its own within a dramatic setting.

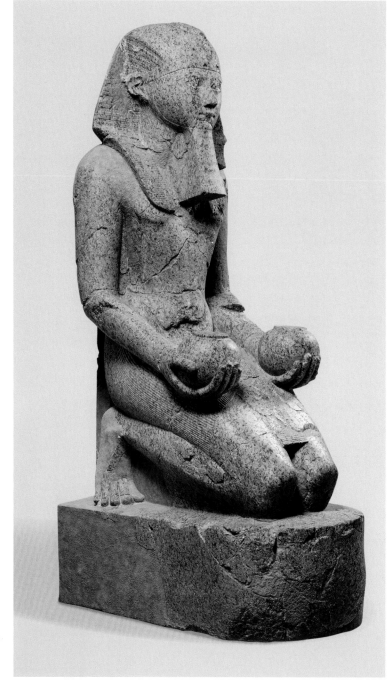

92

In contrast to her seated images, which are the passive recipients of funerary offerings, the over-lifesize donor statues are active participants in temple ritual. The kneeling pose is not one that can be held indefinitely, as the tensed calf muscle and splayed toes suggest, yet here it has been translated into permanence. In order to achieve an impression of eternal balance, the legs, feet, and toes have been elongated to a significant degree. Hatshepsut's thoroughly masculine guise is balanced by the use of feminine gender endings in the statue's inscriptions preserved on its back pillar and base. CAK

1. On the Valley festival, see Graefe 1986.
2. Offering *maat*, usually translated as "order,"

"truth," or "justice," was a prerogative of the king. It signified the sustaining of the gods (who were said to "live on *maat*") through this ultimate offering, and it reinforced the king's legitimacy as a maintainer of social and, therefore, cosmic order. On *maat*, see Assmann 1990. For the offering of *maat*, see Teeter 1997, especially pp. 81–83.
3. Tefnin 1979, p. 87.

PROVENANCE: Western Thebes, Deir el-Bahri, Senenmut Quarry; Metropolitan Museum of Art excavations, 1926–28

BIBLIOGRAPHY: Winlock 1928b, p. 10, figs. 9, 10; Winlock 1942, pl. 52 (left); Hayes 1959, pp. 95–97, fig. 53; Tefnin 1979, pp. 4, n. 8, 72 (with bibliography), 74–75, 78–81, 83, 85–86, 110–11, n. 4, 171–74,

177, 186, figs. 2a, 4, 7, 8, pls. XIX, b, XX; New York, Metropolitan Museum 1987, pp. 46–47, pl. 29; Grimm and Schoske 1999a, p. 35, fig. 30

93. Hatshepsut Wearing the White Crown

Early 18th Dynasty, joint reign of Hatshepsut and Thutmose III (1479–1458 B.C.)
Granite
H. 285 cm (9 ft 4 in.), W. 79 cm (31⅛ in.), D. 142 cm (55⅞ in.)
The Metropolitan Museum of Art, New York, Rogers Fund, 1930 30.3.1

The face on this statue is the best preserved of any of the faces of Hatshepsut's colossal kneeling figures from her temple at Deir el-Bahri. The image here is simplified and regularized to a degree not matched on the *nemes*-wearing colossi, and the high vertical crown does not frame the face as the *nemes* does; the overall effect is therefore naked and austere. The king's dress has been pared down to a minimum, a close-fitting kilt and belt.

A granite doorway set at the back of the upper terrace court marked the entrance to the barque sanctuary of Amun-Re. Its lintel was decorated in relief with a symmetrical composition of four images of Hatshepsut, set on bases, kneeling and offering *nw* jars.[1] The two figures on the viewer's right, to the north, wear the red crown, and the two on the left, to the south, the tall white crown. These depictions, together with more recent research on the placement of Hatshepsut's temple statuary, make it possible to situate this statue of the king in the southern row of statues flanking the processional way across the middle terrace (see below, pp. 270, 275, n. 9).

In order to ensure symmetry between the two rows of colossi, the base of this statue (and of the others with the tall white crown) is significantly lower than that on the statue of Hatshepsut wearing the *nemes* headcloth (cat. no. 92). It is inscribed " . . . Maatka[re] who offers fresh plants to Amun" and contains a feminine gender ending.[2] The height and slender proportions of the white crown also must have played a part in the placement of the text in a single column on the back pillar: "The Horus Powerful of K[as, King of Upper and Lower Egypt Maatkare, Son (or: Daughter?) of Re] Khenemet Amun Hatshepsut [beloved of A]mun who resides in Djeser-djeseru, given life."

CAK

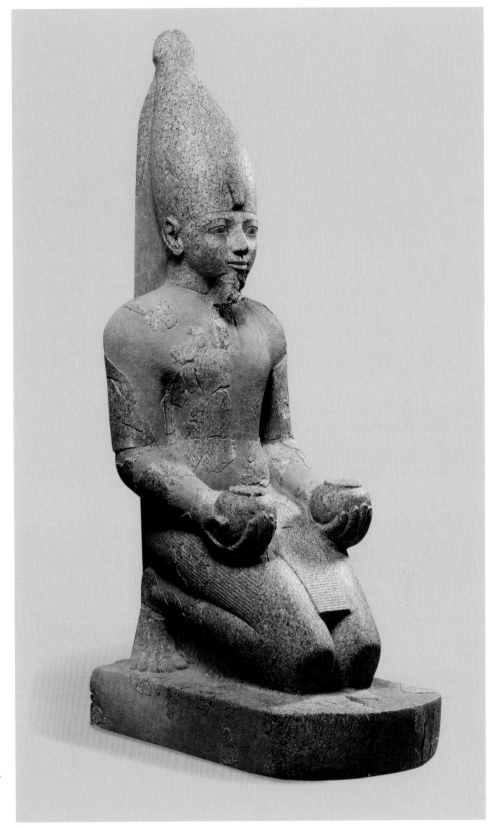

93

1. Naville 1894–1908, pt. 5, pl. CXXXVII.
2. Although *nw* jars generally held liquid offerings, for the sake of visual consistency they were used in images to imply other gifts, for example, green plants, as here, and *maat*, as on catalogue no. 91.

PROVENANCE: Western Thebes, Deir el-Bahri; head discovered by Karl Richard Lepsius, removed to Berlin in 1845, and subsequently given to the museum as part of an exchange in 1929; body discovered in the Senenmut Quarry in the Metropolitan Museum of Art excavations, 1926–27

BIBLIOGRAPHY: Winlock 1930, pp. 8–10, figs. 5, 6; Winlock 1942, pp. 170–71, pl. 52 (right); Vandier 1958, pl. XCIX, 6; Hayes 1959, pp. 5–7, fig. 53; Aldred 1961,

p. 48, no. 21; Tefnin 1979, pp. 26, 73 (with bibliography), 75, 77–79, 82–87, 118, 155, 159, 177, 186, figs. 2, 4, 8, pl. XXIIa

94. Hatshepsut in a Devotional Attitude

Early 18th Dynasty, joint reign of Hatshepsut and Thutmose III (1479–1458 B.C.)
Granite
H. (without base) 242 cm (8 ft. 2 in.), W. 74 cm (29⅛ in.), D. 111 cm (43¾ in.)
The Metropolitan Museum of Art, New York, Rogers Fund, 1928 28.3.18

This figure, and its pendant now in Cairo,[1] are the only statues of Hatshepsut striding that have survived from Deir el-Bahri. The statues were found together in a relatively undamaged state. The New York statue is lacking only the end of the nose; even the uraeus is almost intact. As with the large kneeling statues, the limbs are bulky and the volumes simplified. The face is broad across the brow, with a narrow chin. The features are, however, rather finely drawn for such a large-scale figure, and the mouth appears to be smiling slightly. It has been observed that overall the statue displays features characteristic of the fully developed "kingly" style of the later co-regency period.[2]

The statue originally bore three inscriptions, which are located on the back pillar, belt loop, and base. They contain references to Hatshepsut using both masculine and feminine forms and indicate that the statue stood in Djeser-djeseru, Hatshepsut's mortuary temple, where they surely flanked an important entrance.[3]

The king's arms are extended and the hands rest, palms down, on a projecting triangular apron—a pose that expresses reverence toward a deity.[4] This statue type had been used during the later Middle Kingdom, and in this instance the antecedents were right next door at the temple of Mentuhotep II, just south of Hatshepsut's temple. There Senwosret III had erected a series of statues of himself in the same pose, a gesture of respect toward the founder of the Middle Kingdom.[5] Hatshepsut's statue is built on more massive lines than its Middle Kingdom predecessors and demonstrates once again the reinterpretive abilities of the early Thutmoside artists, who sought to adapt forms already validated by tradition to benefit their royal patrons.

CAK

94

1. Egyptian Museum, Cairo, JE 52458: Tefnin 1979, pp. 26, 99–101, 111, n. 4, 159, 171, 173, 186, figs. 2a, 5.
2. Ibid., p. 101.
3. The main possibilities are before the granite gateway leading to the upper terrace (Hayes 1959, p. 94, following Winlock 1942, p. 160); or before the portal to the central sanctuary (Tefnin 1979, p. 98).
4. Edna R. Russmann in Russmann et al. 2001, pp. 100–104, nos. 28, 29.
5. Ibid. See also Naville 1907, pl. XIX, c–g; Naville 1910, pl. II; Naville and Hall 1913, pls. I, XXI; and Evers 1929, vol. 1, pls. 83–85, vol. 2, p. 40, no. 283.

PROVENANCE: Western Thebes, Deir el-Bahri, Senenmut Quarry; Metropolitan Museum of Art excavations, 1927–28

BIBLIOGRAPHY: Winlock 1928b, pp. 11, fig. 11, 13; Winlock 1942, pl. 51 (right); Hayes 1959, pp. 94–95, fig. 52; Ratié 1979, p. 125; Tefnin 1979, pp. 26, 99–101 (with bibliography), 111, n. 4, 159, 171–74, 177, 186, figs. 2a, 5, 7, pl. XXIV; Grimm and Schoske 1999a, p. 34, fig. 27

95. Hatshepsut as Female King

Early 18th Dynasty, joint reign of Hatshepsut and Thutmose III (1479–1458 B.C.)
Granite
H. 167 cm (65¾ in.)
(head and lower parts) The Metropolitan Museum of Art, New York, Rogers Fund, 1929 29.3.3
(torso) Rijksmuseum van Oudheden, Leiden F 1928/9.2

One of two statues from Deir el-Bahri that portray Hatshepsut in female dress, this is perhaps the most arresting of her portraits. Her dress and jewelry are understated: a sleeveless sheath, a broad collar, and striated bracelets and anklets, more or less standard in depictions of female royalty. But her headdress is the *nemes* headcloth and uraeus of a king.[1]

Those portions that remain of the inscriptions on the throne and back pillar seem to use feminine pronouns and gender endings in references to Hatshepsut. Also preserved on the back of the throne are two back-to-back standing images carved in sunk relief of the goddess Taweret, the only overtly divine representations on any of Hatshepsut's statuary (see detail). Since Taweret is associated with the protection of women in childbirth, this statue may have been intended for either the Hathor shrine or the Divine Birth colonnade, both located on the middle terrace of Hatshepsut's temple. Certainly the seated pose suggests that it was a focus of cult worship and the recipient of offerings.[2]

However, it is the statue's face, which has survived virtually intact, that commands attention. Indeed, the rest of the statue may have been deliberately generalized in order to function as a foil for the face. Large, compelling eyes, set below dramatically arched brows, fix the viewer with an unwavering gaze. The nose is rather short, thin at the top and broad at the tip, with a slight aquiline curve. The mouth appears a bit larger than those in other images of Hatshepsut, with a full lower lip. The chin is, as usual, narrow and slightly receding. In brief,

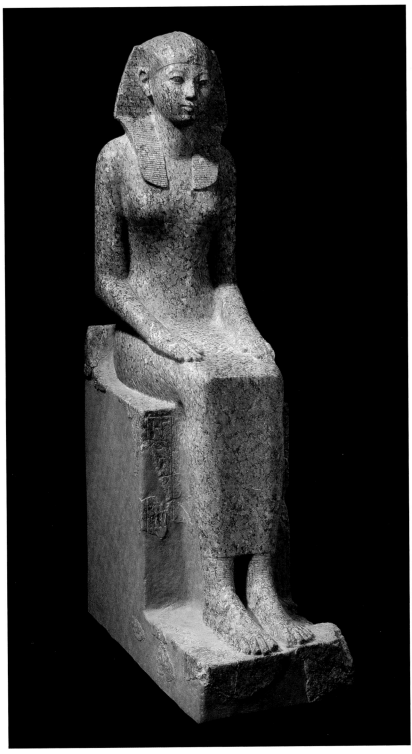

95

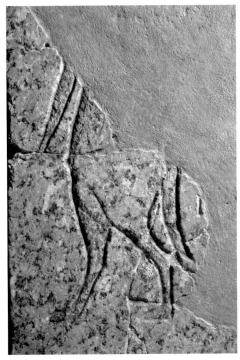

95, detail of back of throne with fragmentary image of Taweret

Metropolitan Museum of Art excavations, 1927–28; torso, removed to the Netherlands by Prince Henry, 1869, acquired by the Rijksmuseum van Oudheden, 1928; parts rejoined 1998

BIBLIOGRAPHY: Winlock 1928b, pp. 15–16, figs. 17, 18; Winlock 1942, pp. 168, 171–72, pl. 57 (right); Hayes 1959, pp. 100–101, fig. 55; Tefnin 1979, pp. 6–11 (bibliography, p. 6), 20–30, 140–41, 186, figs. 1, 3, 6, 8, pls. I, b, c, II, III, a; Grimm and Schoske 1999a, pp. 37, fig. 32, 40, fig. 36

96. Hatshepsut as King

Early 18th Dynasty, joint reign of Hatshepsut and Thutmose III (1479–1458 B.C.)
Crystalline (indurated) limestone, painted
H. 195 cm (76¾ in.), W. 49 cm (19¼ in.), D. 114 cm (44⅞ in.)
The Metropolitan Museum of Art, New York, Rogers Fund, 1929 29.3.2
New York only

In this statue representing the apotheosis of a female Egyptian king, the attitude, proportions, physical features, attributes, texts, and material combine to achieve a truly remarkable statement of royal divinity. The pose is virtually the same as in the granite seated statue of Hatshepsut in female dress (cat. no. 95), although here the

this portrayal of a female ruler is no bland, idealized presentation but an individualized image. One is tempted to infer that its subject was a resolute and self-controlled woman who exercised kingship with authority—a ruler accustomed to dealing with temporal matters while embodying the "efficient seed" of the god.[3]

CAK

1. We know only one precedent for the combination of female dress and *nemes* headcloth: the quartzite torso

of the Twelfth Dynasty female king Nefrusobek (Musée du Louvre, Paris, E27135); see Delange 1987, pp. 30–31; Grimm and Schoske 1999a, p. 38, fig. 33.
2. See "The Statuary of Hatshepsut," above.
3. "Pure egg and efficient seed" *Urkunden* 4, p. 361, l. 14); "efficient seed on earth" (*Urkunden* 4, p. 362, l. 4); "his living image" (*Urkunden* 4, p. 362, l. 6).

PROVENANCE: Western Thebes, Deir el-Bahri, Senenmut Quarry; head and lower part of statue,

96, detail of back of head

king's feet rest upon an incised depiction of the Nine Bows, the traditional enemies of Egypt, and the chin is slightly raised so that the eyes look beyond the viewer rather than directly ahead. Although the shoulders are noticeably broader than on the granite statue, the torso and limbs remain slender and elongated, and the small, softly rounded breasts subtly communicate the female gender of the king.[1] The face, heart-shaped and broad across the cheekbones, ends in a small, pointed chin. Almond-shaped eyes, very slightly angled, are set beneath arching brows. The mouth is small (particularly in profile) and set straight across, and the nose, to judge from what remains, was thin but prominent—the most individualized feature of this idealizing image.

Instead of the form-fitting sheath of the granite statue, the clothing here is the short pleated *shendyt* kilt, beaded belt, and pendant bull's tail worn by male royalty, and the parure is only a broad collar and a set of simple bracelets. The royal *nemes* encases the head so closely that it appears to be an emanation of the king's person, from which the protective uraeus, now destroyed, once reared.

The inscriptions that run down the front of the throne use exclusively feminine forms of the royal titles and epithets. Hatshepsut is described as "The Perfect Goddess, Lady of the Two Lands, Maatkare, beloved of Amun-Re, Lord of the Thrones of the Two Lands, may she live forever!" (along the proper left leg) and "The bodily daughter of Re, Khenemet-Amun-Hatshepsut, beloved of Amun-Re, King of the Gods, may she live forever!" (along the right).

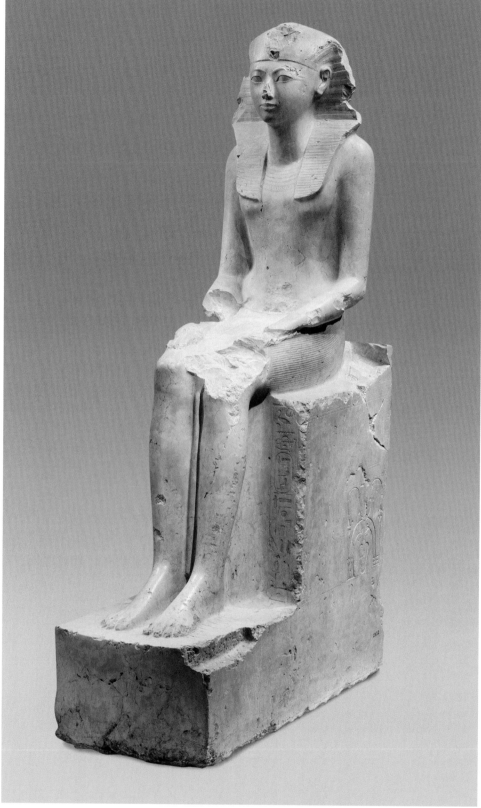

96

The hard crystalline limestone of which the image is made has an unusually high polish for this period and clearly was meant to be left largely unpainted.[2] When the doors of the shrine that housed this statue were opened at sunrise, "the bodily daughter of Re" was illumined by the rays of her progenitor and transfigured into a radiant being—an *akh*.[3] Until that moment, she waited, alert and prepared to rise, her gaze concentrated not on her priests but upon the domain of Amun-Re, Karnak, the "horizon."[4]

CAK

1. Roland Tefnin (1979, pp. 165–66) suggests that, by using "hybrid" forms, particularly at the beginning of the co-regency, Hatshepsut might have been seeking to express a new ideal that combined masculine and feminine aspects in order to appeal to women as well as men—though it is difficult to imagine how this could have aided her political ambitions.

2. Only the garments preserve traces of color: there is blue and yellow pigment on a fragment of the *nemes* on the back of the head (see detail), and some green pigment on the belt.

3. The original location of this statue has been a matter of some discussion. Herbert Winlock (1942, p. 187) thought it was placed in Hatshepsut's cult sanctuary in her temple at Deir el-Bahri. William Hayes (1959, p. 99), noting that the statue's texts do not mention Amun of Djeser-djeseru but instead Amun-Re as worshiped at Karnak temple, theorized

that the statue was originally made for use at Karnak and subsequently was transferred to Deir el-Bahri; in this he is followed by Tefnin (1979, p. 26). However, the central barque shrine at Deir el-Bahri was in fact dedicated to Amun-Re of Karnak, who is cited as "Lord of the Thrones of the Two Lands" and "King of the Gods" on the west wall of its chamber (reconstruction in Winlock 1942, p. 216). In this light, it is appropriate that a major cult statue of Hatshepsut in the temple of Deir el-Bahri should carry an inscription explicitly linking her with Amun of Karnak. There is therefore no reason to doubt that from its inception this statue was destined for Hatshepsut's temple at Deir el-Bahri.

4. The idea of Karnak as a "horizon" that both sees and is seen is expressed in Hatshepsut's own words (*Urkunden* 4, p. 364, ll. 1–4): "I know that Ipet-sut (Karnak) is the horizon on earth, the august hill of the First Occasion (the creation), the sound eye of the All-Lord (the Sun god)."

PROVENANCE: Western Thebes, Deir el-Bahri, Senenmut Quarry; head, left forearm, and parts of throne, Metropolitan Museum of Art excavations, 1926–28; lower parts of statue, transported to Berlin by Karl Richard Lepsius, 1845, acquired by the Metropolitan Museum in an exchange in 1929

BIBLIOGRAPHY: Winlock 1929a, pp. 4–12, figs. 4–6 (head); Winlock 1930, pp. 5–10, figs. 3, 4 (entire statue), 16–17, figs. 15a, b (restored head); Winlock 1942, p. 188, pl. 58; Vandier 1958, pl. XCVII, 6 (head restored); Hayes 1959, pp. 97–99; Aldred 1961, p. 48, no. 22; Tefnin 1979, pp. 11–16 (bibliography, p. 11), 20–30, 186, figs. 1, 2, 3, 6, 8, pls. III, b, c, IV, V; New York, Metropolitan Museum 1987, pp. 44–46, pl. 28

THE SHRINES TO HATHOR AT DEIR EL-BAHRI

Hathor, a daughter of the sun god Re, was a powerful member of the Egyptian pantheon.[1] Although her main temple was at Dendera, shrines in her honor were erected throughout Egypt, and from at least the First Intermediate Period (2150–2040 B.C.), Hathor was worshiped in the area of Deir el-Bahri.[2] Mentuhotep II (r. 2051–2000 B.C.) dedicated a portion of his mortuary temple in her honor, and Hatshepsut constructed a shrine to Hathor on the southern portion of the second terrace of her temple, Djeser-djeseru. Thutmose III continued the tradition by including a Hathor shrine in his temple, Djeseru-Akhet, located above and between the temples of Mentuhotep and Hatshepsut.

Little material has been recovered from inside the remains of the shrines, but numerous deposits of the votive offerings that once adorned them were discovered during various archaeological excavations in the area.[3] In the 1922–23 Metropolitan Museum of Art Egyptian Expedition season, Herbert Winlock uncovered what is now referred to as the "Hatshepsut Hole," an enormous ancient dump of building debris from the funerary temples of Hatshepsut and Thutmose III (see "The Destruction of the Statues of Hatshepsut from Deir el-Bahri" by Dorothea Arnold in this volume).[4] Ostraca, from the debris used as landfill to level the ground for Thutmose III's causeway, clearly date this material to the reign of Hatshepsut and Thutmose III.[5] Numerous small votive objects were concentrated in one area of the pit. Discards from the Hathor shrine of Djeser-djeseru, they were deposited there during Thutmose III's

building project. Other deposits of votive offerings found at Deir el-Bahri probably resulted from periodic cleaning of the various shrines during the New Kingdom.[6]

Unlike the large temples, which were largely inaccessible except to the king, Hathor shrines were places where anyone could make a dedication. The breadth of this cult's popularity is demonstrated by the sheer numbers of offerings that have survived, as well as by the variety of object types and the varying quality in their manufacture. Votive offerings to Hathor are easily recognized because they bear her name or titulary, cult images of her, or motifs that refer to her primary functions of fertility and rebirth (cat. nos. 97–99). They include stelae, textiles, models of Hathor masks, figures of cows and cats, fertility figurines and objects, vessels, amulets and jewelry, and models of ears and eyes so that the goddess would be able to see and hear her petitioners.[7] DCP

1. For a detailed discussion of Hathor's many roles in Egyptian religion and society, see Daumas 1977.
2. For an in-depth study of the Hathor shrines, see Pinch 1993.
3. In addition to Winlock's work (1923), see, for example, Naville 1907, p. 17.
4. Winlock 1923, pp. 26–39.
5. See Hayes 1959, pp. 29–30.
6. Pinch 1993, pp. 23–24.
7. Pinch 1993.

97

Ducks were popular pets in the New Kingdom, as is evident by their presence in family scenes on tomb walls. They are also common decorative motifs on boxes, spoons, and amulets.[1] Lise Manniche suggested that ducks had erotic connotations for the ancient Egyptians, which, if true, may explain their presence on cosmetic equipment and among votive offerings to Hathor.[2]

97. Votive Stela

Early 18th Dynasty, joint reign of Hatshepsut and Thutmose III (1479–1425 B.C.)
Limestone
H. 12 cm (4¾ in.), W. 17.5 cm (6⅞ in.), D. 0.3 cm (⅛ in.)
The Metropolitan Museum of Art, New York,
Rogers Fund, 1923 23.3.47

Hathor was often depicted in her bovine form. On this small votive stela,[1] most certainly made to honor the goddess, three cows, all with ankh symbols hanging from around their necks, are shown. The disks between their horns represent the sun disk and therefore the god Re, with whom Hathor was affiliated. Geraldine Pinch has interpreted these multiple cows as representing the herd associated with the Hathor cult.[2] The papyrus plant arching over the cows represents a marsh, a location sacred to Hathor. DCP

1. Pinch 1993, pp. 85, 101.
2. Ibid., p. 94.

PROVENANCE: Western Thebes, Deir el-Bahri, Hatshepsut Hole in the Mentuhotep causeway; Metropolitan Museum of Art excavations, 1922–23

BIBLIOGRAPHY: Winlock 1923, p. 38, fig. 33; Porter and Moss 1964, p. 626; Pinch 1993, pp. 85, 94

98. Scarabs and Seal Amulets, Probably from the Djeser-djeseru Hathor Shrine at Deir el–Bahri

Early 18th Dynasty, joint reign of Hatshepsut and Thutmose III (1479–1425 B.C.)
Glazed steatite, cord (a and e)
The Metropolitan Museum of Art, New York,
Rogers Fund, 1923 23.3.175, .189, .190, .225, .226

These scarabs and design amulets are all in excellent condition, without chips or other signs of wear, which strongly suggests that they were purchased specifically as gifts to Hathor. The fine preservation of the cords on the rings (a and e) also bears out this interpretation. The designs on the bases of these scarabs and design seals include royal names (b–d), phrases that honor a deity (d), and emblems or motifs of Hathor (a, c, e).

a. Ring with a Sleeping Duck

(23.3.226)
Amulet: L. 1.2 cm (½ in.), W. 0.9 cm (⅜ in.), H. 0.8 cm (⅜ in.); cord: ca. 6 cm (2⅜ in.)

b. Scarab with the Prenomen of Hatshepsut

(23.3.175)
L. 1.8 cm (¾ in.), W. 1.3 cm (½ in.), H. 0.9 cm (⅜ in.)

c. Rectangular Plaque

(23.3.189)
L. 1.5 cm (⅝ in.), W. 1 cm (⅜ in.), H. 0.65 cm (¼ in.)

One side of this plaque shows a Hathor capital, and the other side is inscribed with the name of Amenhotep I.[3]

d. Rectangular Plaque

(23.3.190)
L. 1.55 cm (⅝ in.), W. 1.1 cm (⅜ in.), H. 0.6 cm (¼ in.)

One side bears the name of Amenhotep I, and the other is inscribed "All praise Amun-Re."

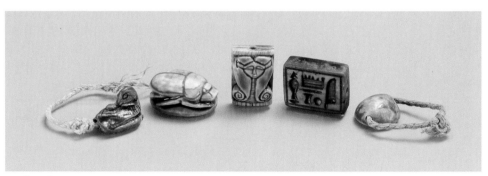

98a, b, c, d, e

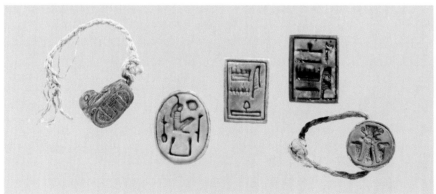

98a, b, c, d, e, bases

e. Ring with a Hemispherical Design Amulet

(23.3.225)
Amulet: L. 1.2 cm (½ in.), W. 1.15 cm (¾ in.),
H. 0.5 cm (³⁄₁₆ in.); cord: L. 2.5 cm (1 in.)

On the base, a sistrum (a rattle-like instrument used in cult ritual) that displays the visage of Hathor is shown flanked by two uraei. The rounded top is undecorated. DCP

1. Hermann 1932.
2. Manniche 1997, p. 40.
3. For a close parallel to this plaque, see Gretchen L. Spalinger in *Egypt's Golden Age* 1982, p. 253, no. 358.

PROVENANCE: Western Thebes, Deir el-Bahri, Hatshepsut Hole in the Mentuhotep causeway; Metropolitan Museum of Art excavations, 1922–23

99. Clapper

18th Dynasty (1550–1295 B.C.)
Ivory
L. 17.7 cm (7 in.)
Phoebe Apperson Hearst Museum of Anthropology, University of California, Berkeley 6-8436

At certain times during the year, a temple's deity was honored with a celebration, and music was integral to these events. Temple scenes show musicians playing stringed, wind, and brass instruments, accompanied by percussionists playing drums, sistra, or a pair of clappers.[1] Held one in each hand, clappers were struck together for an effect much like that of castanets, keeping the music's beat and emphasizing movement. This type of sound was believed to be magically beneficial.[2]

Since Hathor, the goddess of joy, love, and fertility, was also the patron of music and dance, decorating a clapper with her features was entirely appropriate. On this example, the Hathor capital imitates a bracelet. The clappers most likely belonged to a pair employed during Hathor's festivals.

Clappers were most often used at temples, but many come from private burials and some are inscribed with an individual's name and title. Their owners probably spent part of each year in service to their local temple, where they used the clappers. DCP

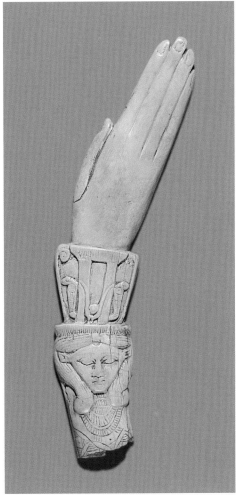

99

1. For other clappers with similar motifs, see Christiane Ziegler in *Egypt's Golden Age* 1982, p. 262, no. 369; Hans D. Schneider in *Ägyptens Aufstieg* 1987, p. 179, no. 97.
2. Hans D. Schneider in *Ägyptens Aufstieg* 1987, p. 179, no. 97; Anne K. Capel in Capel and Markoe 1996, pp. 101–2, no. 36.

PROVENANCE: Deir el-Ballas; Reisner excavations

BIBLIOGRAPHY: Elsasser and Fredrickson 1966, p. 68; Anne K. Capel in Capel and Markoe 1996, pp. 101–2, no. 36b

100. Bowl with Floral Scene

Early 18th Dynasty, reign of Thutmose III (r. 1479–1425 B.C.)
Egyptian faience
H. 9.5 cm (3¾ in.), Diam. 32 cm (12½ in.)
The Metropolitan Museum of Art, New York, Rogers Fund and Edward S. Harkness Gift, 1922
22.3.73

This fragment of a broad shallow bowl is made of turquoise faience and decorated in black with motifs based on the blue lotus flower. On the exterior the open petals and sepals of a lotus spread from the small ring base all the way to the rim. Inside the bottom of the bowl a central square, a pool, is framed by a band of zigzag lines that represent water. A single rosette, a design also based on the lotus, is centered in the

100, base

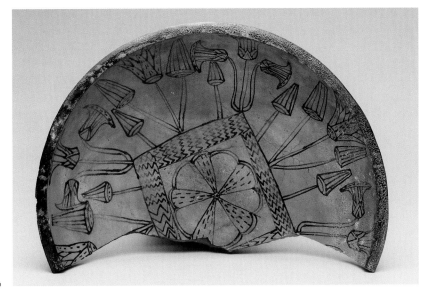

100

pool, and around the pool are arranged groups of lotus flowers and buds and papyrus umbels, which reach up to the lip of the vessel. Both the rim and the base are painted black. The very formal design, which radiates from the center on both the interior and exterior surfaces, is rigidly symmetrical.

This bowl was found in the debris below the Hathor shrine of the temple of Thutmose III at Deir el-Bahri, and it was probably dedicated to Hathor as a votive gift.[1] Many fragments of similar bowls were found in the debris over the adjacent mortuary temple of Mentuhotep II; they probably also came from this shrine.[2] Large numbers of fragments of shallow decorated faience bowls have been found associated with shrines to Hathor at Faras in Nubia[3] and Serabit el-Khadim in the Sinai.[4] SJA

1. Pinch 1993, pp. 308–15.
2. Naville and Hall 1913, pp. 17–18, 26, pls. XXVI, XXVII.
3. Griffith 1921, pp. 85–86, pl. 20.
4. Petrie 1906, pp. 140–41, figs. 147, 155, 156.

PROVENANCE: Western Thebes, Deir el-Bahri, rubbish heaps of the Hathor shrine of the temple of Thutmose III, near Pit 219; Metropolitan Museum of Art excavations, 1920–22

BIBLIOGRAPHY: Winlock 1922, pp. 32, 35, fig. 25; Krönig 1934, p. 155, pl. XXVI, c; Strauss 1974, p. 16, fig. 7; Barbara A. Porter 1986, pp. 96–99, no. 15, fig. 13, pl. 29

FAIENCE BOWLS

Egyptian faience, a nonclay ceramic material made from quartz, soda, and lime, was used to make amulets, scarabs, beads, rings, figurines, and vessels. The ancient Egyptian word for faience, *tjehnet*, means "dazzling"; because of the reflective properties of its glazed surface, faience was equated with light and therefore, magically, with life. Objects of faience had already appeared in the Predynastic Period (ca. 3400 B.C.), along with others of glazed steatite, a related technique.[1]

A versatile medium, faience can be molded, modeled, carved, or inlaid before it is fired. The bowls discussed below may have been made by forming over a core, then cutting and trimming the base and rim before the faience paste had completely hardened. The surface was often painted with designs in a blackish color using a manganese-based paint. The characteristic blue and green colors of the glaze derive from copper compounds and develop during the firing process.[2] Its blue-green color led faience to be associated with the goddess Hathor, the Lady of Turquoise, and to be used for making votive objects dedicated in her shrines, including a bowl discussed above (cat. no. 100). Similar bowls in this exhibition were placed in burials, where they symbolized rebirth.

Thus the faience bowls catalogued here, low, open vessels decorated with motifs of aquatic vegetation and animals, come from both tombs and temples. While the most complete bowls have usually been found in tombs (cat. nos. 101–105), most of the bowl fragments found in excavations come from temples and shrines associated with Hathor, where they were given to the goddess as votive offerings from the living. Bowls from both sources are similar in shape, decoration, and the symbolism of the motifs employed—lotus, tilapia fish, papyrus, water—which was probably equally effective in both temple and funerary settings for evoking fertility, rebirth, and regeneration.

The fragmentary bowls found in great quantities in excavations of Hathor shrines and temples at Deir el-Bahri,[3] Serabit el-Khadim,[4] and Faras[5] have received little attention until recently.[6] More work has been done on the bowls from funerary contexts,[7] which, because of their better state of preservation, have frequently been displayed in museum collections and special exhibitions.[8] The first general study on them was published in 1934 by Wolfgang Krönig, who examined the bowls in the collection of the Ägyptisches Museum in Berlin, comparing them to other examples known at the time, and looked at the origin of some of their motifs, especially the tilapia.[9] In 1974 Elisabeth Strauss, who studied the bowls in the Egyptian collection in Munich, called the bowls "Nunschale," that is, Nun bowls, because she believed that their decorative scheme, usually with a central pool and aquatic plants and fish, represented the birth of the sun god Re from the primeval lotus and Nun, the ancient Egyptian waters of creation.[10] A 1986 study by Barbara Porter examined excavated bowls in the collection of The Metropolitan Museum of Art in New York.[11] Geraldine Pinch, in her 1993 study of votive offerings to Hathor, offered the neutral term "marsh bowls," arguing that the symbolic meaning of all the motifs used is more closely associated with Hathor than with Nun and has several layers of meaning in both temple and funerary contexts.[12] To date, no comprehensive study of these faience bowls has been made.

By the early Eighteenth Dynasty, the production of high-quality faience objects and vessels already had a long history. Faience cups and bowls decorated with aquatic vegetation and fish from the later years of the Middle Kingdom (which ended about 1650 B.C.) have been found both at Thebes[13] and in provincial tombs.[14] Small dishes and closed vessels, such as bottles and jars, adorned with an open lotus with radiating petals and sepals have also been uncovered.[15] The faience industry continued in Egypt through the Second Intermediate Period (1650–1550 B.C.), but the best evidence for an unbroken tradition of faience bowls decorated with aquatic plants and animals may come from Kerma in Nubia. George Reisner found large quantities of fragments of elaborately decorated faience bowls, cups, and jars in the ruins of the temples and tumuli there dating to the Classic Kerma Period (1750–1550 B.C.).[16] Peter Lacovara has suggested that these may be broken vessels imported to Kerma from Egypt and reused there to make new vessels or inlaid architectural decoration.[17] Like the Middle Kingdom statuary that was taken to Kerma, they may represent spoils removed from Middle Kingdom cult places. The shapes of the faience vessels found at Kerma are similar to those of

Middle Kingdom pottery—deep bowls and cups with carinated profiles and drop-shaped jars with short everted rims. They are decorated in the center of the interior and often on the base of the exterior with an open lotus or rosette and on the upper body with a band of fish, birds, animals, and lotus flowers. This decoration is set off from the rim by single or multiple bands of geometric motifs, including running spirals, hatched triangles, and zigzag and maze patterns.[18] The elements of their decoration, diverse representational motifs, and use of patterned bands, particularly the running spiral, closely ally the Kerma bowls and cups with the fragments of bowls found in the early Eighteenth Dynasty Hathor shrines. It is interesting to note, however, that no well-dated faience vessels of the Middle Kingdom or Second Intermediate Period have been found in the Hathor shrines in Egypt, Nubia, and Sinai.

The imagery of fish and aquatic plants on the interior of vessels was not limited to faience vessels. Krönig suggested that the designs on the early New Kingdom faience bowls might be related to those on light-colored marl clay pottery "fish plates" of the Middle Kingdom.[19] These large oval handmade dishes are decorated on the interior with deeply incised designs of fish, lotus blossoms with spotted sepals, and pondweed. On some dishes the fish itself is the principal element, filling the bottom of the dish; in others there is a central rectangle analogous to the central pond of the faience dishes, with lotus flowers, hatched triangles, and pondweed radiating out from it. Some examples have a raised platform in the center of the dish decorated with incised cross-hatching or fish, which makes it clear that these trays were not meant for everyday domestic use.[20] These marl clay plates seem to exist as a unique, highly decorated class of forms separate from the normal corpus of domestic and funerary pottery in the late Middle Kingdom; they have no precursors or successors but must have had quite specific uses. They are found in settlement contexts of the late Middle Kingdom at Kahun[21] and Tell el-Daba.[22]

In the early Eighteenth Dynasty, especially during the reigns of Hatshepsut and Thutmose III, shallow open bowls of blue and blue-green faience decorated with marsh, aquatic, or Hathoric motifs became popular. The sides of these bowls flare out from a small disk or ring base and turn upward near the rim, which is finished with a flat edge. They range from 4 to 16 inches (10 to 40 centimeters) in diameter. The bowls are decorated with linear designs drawn in a black pigment, probably manganese. The exterior is almost always decorated with the radiating petals and sepals of the Egyptian blue lotus (*Nymphaea caerulea* Savigny). The sepals of this flower have purple dots on the exterior, which the artists indicated by dashes or stippling. The base of the bowl forms the center of the flower, and the tips of the petals reach up to touch the rim. The decoration inside these bowls is also usually a radial arrangement of motifs, most often based on a central square or rectangle that may represent a pond of water, or less frequently, a rosette from which the lotus flowers and buds, the papyrus umbels, and the pondweed (*Potamogeton lucens* Linnaeus)[23] reach up to the rim. Animals associated with aquatic and marsh environments, such as fish and birds, are incorporated into the designs as well. Less frequently a single Nile tilapia fish (*Tilapia nilotica*) or lotus blossom in the form of a rosette fills the interior of a bowl. Other elements such as Hathor heads, Hathor cows, gazelles, and inscriptions were also used. The artists endeavored to fill the interiors of these bowls completely with an often dense design that has a highly symmetrical, radial organization. This format differs markedly from that of the later New Kingdom faience bowls, which show a single narrative composition such as a woman playing a lute or a fishing scene.[24]

All of the motifs on these marsh bowls are symbols of regeneration and rebirth. The blue lotus, which opens in the morning and closes at night, is associated with the rebirth of the sun god each morning. The tilapia incubates its fertilized eggs in its mouth and shelters its hatchlings there, and so the emergence of the newborn fish from the mother's mouth was a potent symbol of regeneration to the ancient Egyptians. The blue color of the bowls, which ties them to Hathor, the Lady of Turquoise, and their association with this deity, the Goddess of the West, from whence the dead are reborn, provided additional layers of meaning. And marsh scenes themselves are symbolic of fertility. Thus the symbolic meaning of the bowls may have made them suitable both as offerings by the living to Hathor and as potent funerary gifts to the dead to assist their rebirth in the next world. SJA

1. Glazed steatite was often used for scarabs and other sealing devices, as well as cosmetic vessels and shawabtis (see cat. nos. 16, 141, 194).
2. In the later New Kingdom, the production of faience was closely related to glassmaking and probably was also associated with other refractory industries, such as smelting. See Nicholson 2000, pp. 183–84.
3. Naville and Hall 1913, pp. 17–18, pls. XXVI, XXVII; Griffith 1921, pp. 85–86, pl. 20; Winlock 1922, pp. 31–32; Winlock 1923, p. 38.
4. Petrie 1906, pp. 140–41, figs. 147, 155, 156.
5. Griffith 1921, pp. 85–86, pl. 20; Karkowski 1981, p. 109, pl. XI.
6. Pinch 1993, pp. 308–15, fig. 1, pls. 3, 7, 32, 39, 63.
7. Strauss 1974; Barbara A. Porter 1986.
8. Milward 1982; Angela J. Milward in *Egypt's Golden Age* 1982, pp. 142–45, nos. 138–44; Barbara A. Porter in *Mummies and Magic* 1988, pp. 138–39, no. 76; F. D. Friedman 1998, pp. 112–13, 211–12, nos. 76–79; Spurr, Reeves, and Quirke 1999, pp. 28–29, nos. 26–31.
9. Krönig 1934.
10. Strauss 1974, pp. 70–71. The collection is in the Staatliche Sammlung Ägyptischer Kunst, Munich.
11. Barbara A. Porter 1986.
12. Pinch 1993, pp. 308–15.
13. A faience dish with a wavy rim and lotus blossoms on the inside and a small carinated cup decorated with lotuses and an inscription invoking the goddess Hathor on behalf of the owner, the lady Ibiau, were found by Lord Carnarvon and Howard Carter in Tomb 24 at Thebes (Carnarvon and Carter 1912, p. 52, pl. XLIV, 4, 5).
14. A small carinated cup now in the Petrie Museum, London (UC18758), was found in a tomb at Hu. It is decorated on the inside with tilapia and on the outside with birds, lotus buds, and other pondweeds (Bourriau 1988, pp. 131–32, no. 126, ill. p. 128).
15. Bourriau 1988, pp. 128–29, nos. 122a, b, pp. 130–31, no. 125.
16. Reisner 1923, pp. 134–75, figs. 172–88, pls. 45–47.
17. Lacovara 1998.
18. See Reisner 1923, pl. 46.
19. Krönig 1934, pp. 146–47, pl. XXIV, a, b.
20. Bader 2001, pp. 79–99, pls. I, II.
21. Petrie 1891, pl. V.
22. See Bader 2001, pp. 79–99, pls. I, II.
23. Keimer 1929.
24. For examples of this type of bowl, see Angela J. Milward in *Egypt's Golden Age* 1982, pp. 144–45, nos. 143, 144; Spurr, Reeves, and Quirke 1999, pp. 28–29, no. 31.

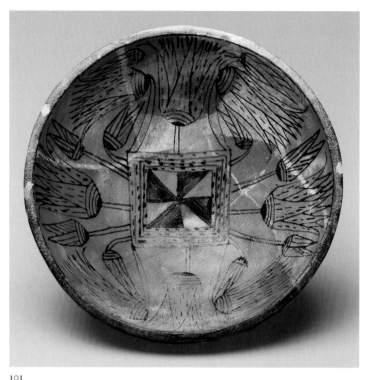

101

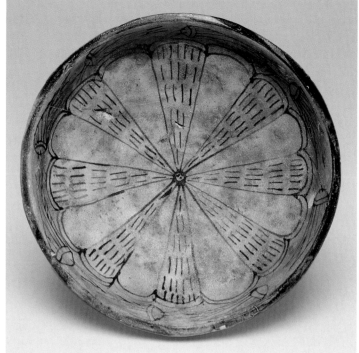

102

101. Bowl with Lotuses

Early 18th Dynasty, joint reign of Hatshepsut and
Thutmose III (1479–1458 B.C.)
Egyptian faience
H. 6 cm (2⅜ in.), Diam. 17.3 cm (6¾ in.)
Museum of Fine Arts, Boston, Gift of the Egypt
Exploration Fund 09.377

Found in a private tomb at Abydos, this faience
bowl is approximately half the size of the one
found in the debris from the Hathor shrine of
Thutmose III at Deir el-Bahri (cat. no. 100). It
has a flat disk base and a flat rim, both painted
black. On the exterior, petals and sepals of a
blue lotus radiate from the base. On the inte-
rior, a central pool consisting of four nested
squares marked with dashes and enclosing a
pinwheel is surrounded by lotus flowers and
buds with both straight and drooping stems that
skillfully fill the interior of the bowl.

In addition to their use as votive offerings to
Hathor at her shrines, low open faience bowls
decorated with lotuses, papyrus, fish, and birds
were deposited in private tombs and seem to be
associated with female burials.[1] One of the
largest groups of such bowls was found in the
family tomb of Neferkhawat, a midlevel offi-
cial in the court of Hatshepsut (cat. no. 105). His
tomb in Lower Asasif, MMA Tomb 729, con-
tained seven intact bowls buried with his wife,
Renennefer, and daughter, Ruyu.[2] Three more
were found in the tomb of Ramose and Hatnefer,
parents of Senenmut, the steward of Hatshepsut's
daughter, Neferure (see cat. no. 45).[3] Among all

101, base

these examples, the closest parallel to this bowl
from Abydos is one found next to the head of
Renennefer: it is the same size and is decorated
with a central pinwheel within nested squares
from which lotus blossoms and papyrus umbels
sprout.[4] SJA

1. This also appears to have been true in the Middle
 Kingdom, as in burial of the Lady Ibiau; Carnarvon
 and Carter 1912, pp. 51–52, pl. XLIV, 4, 5.
2. Hayes 1935b, pp. 30–32, fig. 14.
3. Lansing and Hayes 1937, pp. 30, 34, fig. 42.
4. Egyptian Museum, Cairo, 65366; Barbara A. Porter
 1986, pp. 55–58, no. 2, fig. 2, pls. 6, 7, 9.

PROVENANCE: Abydos, Tomb F15; excavated by
W. M. Flinders Petrie for the Egypt Exploration
Fund, 1909

BIBLIOGRAPHY: Ayrton and Loat 1908–9; Barbara
A. Porter in *Mummies and Magic* 1988, pp. 138–39,
no. 76

102. Small Bowl with Stylized Lotus

Early 18th Dynasty, joint reign of Hatshepsut and
Thutmose III (1479–1458 B.C.)
Egyptian faience
H. 4.6 cm (1¾ in.), Diam. 13.2 cm (5¼ in.)
The Syndics of the Fitzwilliam Museum, Cambridge
E.35.1921

The sharply carinated profile of this small bowl
affects the layout of the usual lotiform decora-
tion: on the exterior, the petals and sepals of the
lotus radiate out from the black-painted ring
base but stop where the body of the bowl turns
upward, a juncture marked by a black horizon-
tal line. The upper body on the exterior is deco-
rated simply with widely spaced groups of three
vertical lines, and the rim is painted black. On
the interior, the bottom of the bowl is filled by a
single flattened-out, stylized blue lotus flower, a
motif sometimes found as the central element of
the square pool (see cat. no. 100). The upright

102, base

103

104

103, base

wall of the bowl interior is filled with a running design of eight elongated, partially open lotus buds. Simpler bowls decorated with only a single rosette were found in private tombs at Saqqara[1] and Aniba,[2] and a small saucer with a central rosette comes from the tomb of Ramose and Hatnefer at Deir el-Bahri (see cat. no. 45).[3]

SJA

1. Jéquier 1933, p. 45, pl. X, 20.
2. Steindorff 1935–37, vol. 2, p. 142, pl. XCI, 1.
3. Metropolitan Museum of Art, New York, 36.3.10; Lansing and Hayes 1937, p. 30, fig. 42 (lower right); Barbara A. Porter 1986, pp. 91–92, no. 13, fig. 11, pl. 27.

PROVENANCE: Sedment, Tomb 1723; excavations of W. M. Flinders Petrie for the British School of Archaeology, 1920–21

BIBLIOGRAPHY: Petrie and Brunton 1924, vol. 2, p. 26, pl. LXIII (lower right, "J"); Krönig 1934, p. 157, fig. 19; Barbara A. Porter 1986, fig. 49

103. Small Bowl with Lotuses and Fish

Early 18th Dynasty, joint reign of Hatshepsut and Thutmose III (1479–1458 B.C.)
Egyptian faience
H. 4 cm (1½ in.), Diam. 13 cm (5⅛ in.)
Ägyptisches Museum der Universität Leipzig 6057

The simple, rather open design inside this bowl centers around a pool of nested rectangles filled with a checkerboard motif. From the sides of the pool, four large blue lotus blossoms on straight stems extend to the rim. Between the lotus blossoms are four tilapia, their mouths pointing downward toward the corners of the pool and their tails upward to the rim, which is painted the customary black. The exterior of the bowl is covered with alternating lotus petals and sepals radiating from the black-painted disk base.

For the ancient Egyptians the tilapia, which incubates its eggs in its mouth, and the lotus, which opened each day at dawn, were symbols of regeneration and rebirth. This made bowls decorated with such motifs suitable as offerings in tombs.

SJA

PROVENANCE: Aniba, Tomb Sx; excavations of the Mission Archéologique de Nubie, 1929–34

BIBLIOGRAPHY: Steindorff 1935–37, vol. 2, pp. 141–42, pl. 90, 1; Frank Steinmann in Krauspe 1997a, p. 86, no. 70

104. Bowl with Pond and Lotuses

Early 18th Dynasty, joint reign of Hatshepsut and Thutmose III (1479–1458 B.C.)
Egyptian faience
H. 11 cm (4⅟₁₆ in.), Diam. 28 cm (11 in.)
The Metropolitan Museum of Art, New York, Purchase, Edward S. Harkness Gift, 1926 26.7.905

This blue faience bowl is one of the larger examples of the type (see cat. no. 100). It has a thick, flat disk base, painted black, from which the petals of an open lotus blossom radiate up to the rim. As with other examples of early Eighteenth Dynasty bowls, the rim is flat. The center of the interior is decorated with an elaborate square filled with alternating checked, solid, and reserved bands surrounded by a plaited pattern, which represents a pond. All around the pond and extending up to the rim of

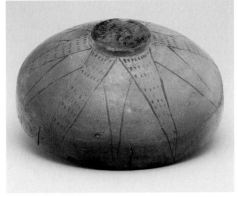

104, base

the bowl is a continuous design of lotus blossoms, some fully opened with erect stems and some partially opened buds with drooping heads. Lotus buds also fill the empty spaces around the stems.

This beautifully preserved bowl came from one of the tombs in Birabi at Thebes, the area where Hatshepsut later constructed her Valley Temple. These tombs, originally cut in the Middle Kingdom, were reused in the early part of the Eighteenth Dynasty.[1] The bowl was found in the coffin of the Mistress of the House Teti,[2] which contained the bodies of two adults and a girl. SJA

1. Carnarvon and Carter 1912, pp. 51–88.
2. The Metropolitan Museum of Art, New York, 12.181.302; unpublished.

PROVENANCE: Western Thebes, Birabi, Tomb 47, burial 12; excavations of Lord Carnarvon and Howard Carter, 1912

BIBLIOGRAPHY: *Ancient Egyptian Art* 1922, p. 58, no. 10, pl. 38 (top); Krönig 1934, pp. 149–50, fig. 6; N. E. Scott 1947, fig. 16; N. E. Scott 1973, fig. 24; Barbara A. Porter 1986, pp. 80–83, no. 9, fig. 9, pls. 22, 23; N. Strudwick 2001, p. 27, no. 10

105. Bowl with Pond, Lotuses, Birds, and Fish

Early 18th Dynasty, joint reign of Hatshepsut and Thutmose III (1479–1458 B.C.)
Egyptian faience
H. 5.5 cm (2⅛ in.), Diam. 21 cm (8¼ in.)
The Metropolitan Museum of Art, New York, Rogers Fund 1935 35.3.78

This low, wide bowl is decorated on the exterior with a standard open lotus blossom. The more complex interior, however, centers around a pond represented by a simple rectangle filled with wavy lines signifying water. From each side of the pond a large lotus flower in full bloom extends upward to the rim, and at each corner is a closed bud on a straight stem. The intermediate spaces close to the pond are filled with smaller inverted lotus buds on drooping stems that emerge from the larger flowers and

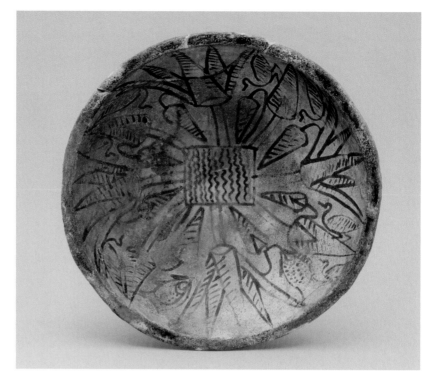

105

buds. Just below the rim, between the flowers and buds, are six waterfowl that stand on the lotuses with their heads pointing downward toward the pond. A seventh bird was begun but apparently not finished, and instead of a bird, one of the flowers has two fish, one on either side. The blue-glazed surface of the bowl is now discolored to brown, but the lightness of the very loosely drawn flowers and animals remains clear, and the drawing has not lost its vitality.

The bowl is one of three found in the coffin of the lady Renennefer, wife of Neferkhawat, a royal scribe at the court of Hatshepsut, from their family tomb in Lower Asasif.[1] The bowls were placed near her head and were probably originally contained in a basket. Four other blue faience bowls covered with fish and lotus motifs were associated with Ruyu, daughter of Neferkhawat and Renennefer, who was buried in another chamber of the tomb.[2]

SJA

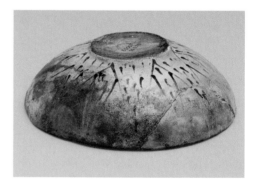

1. The second bowl (The Metropolitan Museum of Art, New York, 35.3.77) is rather similar to catalogue no. 103 from Aniba, which also has a central rectangular pond filled with a checkerboard pattern. The third bowl, now in the Egyptian Museum, Cairo (65366), has a pinwheel design within nested squares, similar to the bowl from Abydos (cat. no. 101); Barbara A. Porter 1986, pp. 55–62, nos. 2, 3, figs. 2, 3, pls. 6–11.
2. Hayes 1935b, pp. 30–32, fig. 14; Barbara A. Porter 1986, pp. 63–76, nos. 4–7, figs. 4–7, pls. 12–21.

PROVENANCE: Thebes, area of the Ramesside temple, Tomb 729 (West A), burial II (Renennefer); Metropolitan Museum of Art excavations, 1934–35

BIBLIOGRAPHY: Hayes 1935b, pp. 30–32; Barbara A. Porter 1986, pp. 52–54, no. 1, fig. 1, pls. 5–8

THE TEMPLE OF MUT
New Evidence on Hatshepsut's Building Activity

Betsy M. Bryan

The goddess Mut, Mistress of Isheru, whom the Egyptians depicted as either a woman or a lion-headed woman, was the wife of the national god, Amun-Re, whose Theban temple, Karnak, stood on the east bank of the Nile. Mut was also identified with lion deities, whose temperaments—benevolent or hostile—were thought to determine the fate of mankind. A great religious enclosure in southern Karnak housed sanctuaries and the central temple of Mut. The site, called Isheru, was named for the sacred lake that wrapped around the rear of the main temple. Now in a ruinous state, the Mut temple consists of a Thutmoside platform atop which are walls built in the late Eighteenth Dynasty, about 1375 B.C.; the front of the temple was transformed in the Twenty-fifth Dynasty, about 700 B.C.

The earliest cult place for Mut may have been constructed in the Middle Kingdom or the Second Intermediate Period, but remains of the original structure have yet to be identified. While the oldest known written reference to the temple dates from the Seventeenth Dynasty,[1] it may be that a structure was erected in stone only in the Eighteenth Dynasty—perhaps during Hatshepsut's rule. It is no secret that during the co-regency Hatshepsut chose to carry out construction at the temple of Mut. Our information about this comes from a variety of sources. Several of Hatshepsut's best-known courtiers—in particular the high priest of Amun, Hapuseneb, the steward Senenmut, and the Second Priest of Amun, Puyemre—installed statues in that temple with inscriptions that mention their own supervision of the building of monuments for the goddess. During Hatshepsut's co-regency, Mut's role as the divine consort of Amun-Re was emphasized in rituals for the god in Thebes. At that time the processional path between Amun-Re's sanctuary and the Luxor temple was enhanced by the building of the Eighth Pylon, a monumental doorway facing south toward the Mut temple, and by the creation of a group of shrines, or way stations, where the god's movement could be halted temporarily to encourage public involvement in the festival. A double shrine was erected on this processional route near the north entrance to the Mut temple enclosure.[2] The way stations are named and depicted in reliefs on Hatshepsut's quartzite shrine at Karnak (the Chapelle Rouge), while the Opet festival celebrated at the Luxor temple was commemorated both on that small building and in the ruler's temple at Deir el-Bahri. It should be stressed, however, that in the context of Amun-Re's cult, Mut was worshiped as wife and mother. Until recently it had been assumed that these were also Mut's primary roles within her own precinct during the Eighteenth Dynasty.[3]

The view that the goddess was mainly venerated as the queen of the gods and mother of Amun's offspring Khonsu (or, in the Opet festival, of the king himself) may have been influenced in part by the poor state of preservation of several temples and chapels within the precinct of Mut. The best-preserved wall decoration from the precinct is in the so-called temple of Khonsu-pa-kherod (Khonsu the child). Located in the northeast corner of the enclosure, this temple was identified by the excavator Richard Fazzini as a *mammisi*—the place in which Mut was thought to have given birth to Khonsu—and dated by him to the Twenty-fifth Dynasty,[4] some seven hundred years after Hatshepsut. The relief shows a striding Amun-Re as a central actor in the birth scenes, while Mut, not surprisingly, appears most often in a seated posture—on a bed, or in the sanctuary on a throne. Fragmentary column drums of the same period, now placed in front of the west

Fig. 70. View looking north from the back of the temple of Mut, Luxor, showing remains of limestone walls from the early to mid-18th Dynasty building

wing of the main Mut temple's first pylon, also feature Amun-Re prominently.[5] Moreover, fragmentary wall scenes (of probable Twenty-fifth Dynasty date) uncovered in 2004 treat similar themes: these decorations, originally located on the temple platform and reused in a Ptolemaic doorway foundation, show Amun-Re receiving offerings, with Mut in a protective stance behind him.[6]

The few remains of reliefs from the Eighteenth Dynasty temple walls, however, reveal a different emphasis. The upper portions of the walls are missing along the east side of the temple platform, but the legs of figures in an offering scene are preserved. There Mut is the center of the cult ritual. Two texts from doorways east and west of the central barque shrine are also preserved. Both are dedicated to Mut alone and, like the offering scene, indicate that in the Eighteenth Dynasty she was the focus of the decoration in the central Mut temple.

This year new information emerged concerning an aspect of Mut's divinity that was worshiped in Hatshepsut's new temple. The material came to light in the course of study of the temple's platform foundation; its original early or mid-Eighteenth Dynasty structure had been enlarged with stone rubble and sandstone blocks from the Thutmoside building. These blocks, parts of square piers approximately one meter to a side, were cut vertically and used in the perimeter of the expanded platform. Reliefs on these piers represent rulers, including Thutmose III (identified by name in an inscription) and Hatshepsut (identifiable by the presence of a feminized grammatical form in the accompanying inscription). These sandstone blocks, lying directly on earth, were penetrated by groundwater and are in an extremely deteriorated state. For this reason, archaeologists have begun to dismantle a portion of the platform and treat and preserve the blocks in concert with their study of the New Kingdom remains. Approximately seven feet behind the front of the platform, at the northwest-west corner of the temple, the rubble of stone used behind the large pillar blocks ends and a solidly built foundation, mortared into place,[7] stands. This well-constructed foundation, whose breadth west to east is as yet undetermined (approximately 130 square feet are now exposed), contains large blocks of limestone as well as sandstone column drums of various lengths.

When the limestone blocks were removed, they were discovered to be parts of a doorway; reliefs on them show the ruler before the goddess Mut, who is depicted as a woman wearing the vulture headdress (see fig. 71). On the other visible Thutmoside blocks in the precinct, the name and image of the goddess Mut were mutilated as a result of King Akhenaten's proscription of her, Amun-Re, and other deities (later the scenes were restored). The limestone blocks, however, show the goddess's name and figure untouched. This definitively demonstrates that the solid foundations were built before the reign of Akhenaten (r. 1349–1336 B.C.). On

the doorway's upper right jamb was found the name Thutmose III and a reference to the goddess as Mut, Mistress of Isheru-Bastet. The left jamb shows the king before Mut, who is called Mistress of the Per-wer, probably here meaning the shrine to which this gate gave access.[8] The upper portion of this mirror-image jamb, which also would have named the ruler, was not uncovered; however, the sandstone column drums reused together with the blocks were inscribed for both Hatshepsut (Maatkare) and Thutmose III (Menkheperre). It may be that this shrine is the one referred to on a statue dedicated by Puyemre, second priest of Amun, in the Mut temple. In the inscription on that image, the priest states "I oversaw the erection of a *per-wer* shrine in ebony, worked with electrum, on behalf of the King of Upper and Lower Egypt, Maatkare, for her mother Mut, Mistress of Isheru. I oversaw the erection of the doors out of good limestone of Tura on behalf of the King of Upper and Lower Egypt Maatkare, Mistress of Isheru."[9] The only limestone works still extant in the temple are the badly deteriorated east and west walls of a shrine a few meters behind the findspot of the blocks.

The surprising new evidence that sheds light on the temple's function and the role of Mut in Hatshepsut's reign is a text preserved on the sandstone column drums that reads: "[She made it as a monument for her mother Mut] Mistress of Isheru, making for her a columned porch of drunkenness anew, so that she might do [as] one who is given life [forever]."[10] The reference is to the location of the Festival of Drunkenness, a ritual known to have existed in the Middle Kingdom but not identified in temple architecture until the Ptolemaic and Roman periods.[11] However, ritual activities associated with drunkenness carried out in the reign of Hatshepsut are known from texts from Deir el-Bahri[12] and were also part of the ritual of the Beautiful Festival of the Valley (when statues of the king and gods from Karnak were brought across the Nile to visit the temples of deceased rulers); in both cases they were specifically associated with funerary rites. The Festival of Drunkenness, intimately connected with Hathor and the appeasement of lion deities such as Sekhmet, Ai, Nehemetawai, and Rattawi,[13] was celebrated principally during the first month of the year.[14] At Dendera the goddess was propitiated with beer and enthroned in the temple during the feast that took place. She then traveled through the temple's hypostyle hall to arrive in the front court of the precinct, where a kiosk was erected.[15] The celebrants at the festival there and at Medamud as well as at the Mut temple became so inebriated that they fell asleep in the temple forecourt, only to be awakened in the wee hours by the sounds of singing and dancing, apparently accompanied by sexual activity. Then they awaited the appearance of the goddess.

At the Mut temple in the time of the co-regency of Hatshepsut and Thutmose III, a court, similar to the present second court, fronted the temple, and a porch of fluted columns and square piers

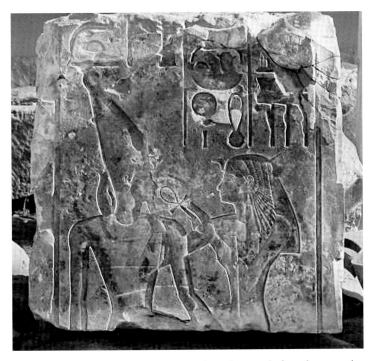

Fig. 71. Left jamb block of a limestone gate from the period of Hatshepsut and Thutmose III, temple of Mut, Luxor. Discovered in the temple foundations in 2004

of Hatshepsut, late in the sole reign of Thutmose III. The name of the female ruler was not destroyed on the gateway, and an image of Senenmut, carved in sunk relief in the doorway's left reveal, also remained intact. The reason Thutmose III altered Hatshepsut's temple remains uncertain, but the archaeological evidence makes it clear that in the mid-Eighteenth Dynasty the goddess Mut was not merely worshiped as the queen of heaven or mother of Khonsu but played other roles as well.

stood before a limestone gate, or, more probably, more than one gate, that led to Mut's shrine. In that court the Festival of Drunkenness was celebrated to welcome back the goddess in her lion form of Sekhmet and to offer her beer to ensure that she returned. As described on the Ptolemaic gate to the Mut temple, the beer was red, constituting an allusion to the red brew offered to the goddess Sekhmet in the myth of the Destruction of Mankind, where it is used to make her drunk and stop her slaughter of humans.[16] This festival at the Mut temple may have been established to associate it with other Theban feasts, including the Beautiful Festival of the Valley. In any event, it seems likely that the porch for inebriation was dismantled before the proscription

1. Fazzini and Peck 1982 and 1983; Fazzini 1984–85 and 2001.
2. Cabrol 1995.
3. Velde 1982; Troy 1997.
4. Fazzini and Peck 1981.
5. Ibid.; Fazzini and Peck 1982; Goyon 1983.
6. To be published by Richard Fazzini.
7. The method of construction used for this foundation closely parallels that employed at the temple of Hatshepsut and Thutmose III at Buhen in Nubia. For this, see Emery, H. S. Smith, and Millard 1979; H. S. Smith 1976 details the dismantling of the temple and its removal to Khartoum.
8. *Per-wer* (Great House) is the name of the Upper Egyptian national shrine in El-Kab, which was dedicated to the goddess Nekhbet, but it was also used to refer to sanctuaries in various other temples. Spencer 1984, pp. 111, 112.
9. *Urkunden* 4, p. 521.
10. The last words, "given life," refer to Hatshepsut, as is shown by the paired inscriptions at Deir el-Bahri where the jubilee wish naming Maatkare ends with "may she do very many" and that for Menkheperre ends with "may he do very many." *Urkunden* 4, p. 355, ll. 10–15. Compare also *Urkunden* 4, p. 359, a text on the obelisk of Hatshepsut that ends: "first occasion of the jubilee, may she do given life forever."
11. Gutbub 1961; A. Spalinger 1993a.
12. Drioton 1927, pp. 12–15, referring to a festival mentioned in Papyrus Boulaq 18, probably a portion of the Festival of Drunkenness. See also A. Spalinger 1993b, pp. 166–67, and Darnell 1995, p. 47.
13. Darnell 1995; M. Smith 2004.
14. For a discussion of the dates and the routes of the festival at Dendera, see Cauville 2002, pp. 50–59. The late calendar identifies the twentieth day of Thoth as the day of the festival, although several days before were associated with it.
15. Ibid., pp. 58–59; Darnell 1995, pp. 59–63; M. Smith 2004.
16. A. Spalinger 1993b; for the myth, see the translation in Lichtheim 1976, pp. 197–99.

THE TWO TOMBS OF HATSHEPSUT

Catharine H. Roehrig

Hatshepsut began her ascent to power as the principal queen of her half brother, Thutmose II. When Thutmose became king, less than sixty years into the Eighteenth Dynasty, no clear-cut traditions governing the burial of New Kingdom queens had yet been established. During the immediately preceding Second Intermediate Period, at least some Seventeenth Dynasty rulers provided space in their tombs at Thebes for their wives, but other royal women were buried in their own graves.[1] Several of Hatshepsut's predecessors in the Eighteenth Dynasty were buried in their own multichambered shaft tombs in the vicinity of Deir el-Bahri or on the ridge above Dra Abu el-Naga (see the map of western Thebes, page 5).[2] Although we cannot identify with certainty the tombs of many of Queen Hatshepsut's immediate predecessors, we know that the most important of them were buried with a wealth of jewelry, in immense, beautifully crafted anthropoid coffins made of wood (fig. 72).[3]

In preparation for her own burial as queen, Hatshepsut demonstrated her talent for innovation by creating a new type of tomb in a previously unused section of the Theban necropolis.

HATSHEPSUT'S QUEEN'S TOMB

Sometime between her husband's accession to the throne (ca. 1492 B.C.) and her own adoption of kingly titles (ca. 1473 B.C.), a cliff tomb was prepared for Hatshepsut in the Wadi Gabbanat el-Qurud, a huge drainage system of wadis, or dry riverbeds,

Fig. 72. Coffin of Queen Ahmose-Meryetamun, the wife of Amenhotep I, early 18th Dynasty. Wood. Egyptian Museum, Cairo (JE 53140). The tomb of this queen, near Hatshepsut's temple at Deir el-Bahri, was discovered by The Metropolitan Museum of Art Egyptian Expedition.

that cut into the cliffs of the high desert in the southwest section of the Theban necropolis (see Hatshepsut's Queen's Tomb in the map on page 5).[4]

In choosing the southwest wadis as the location of her queen's tomb, Hatshepsut may have been attempting to introduce a new tradition for queens' burials.[5] In doing so she would have been imitating her father, Thutmose I, who had recently established a new cemetery—the Valley of the Kings. Whatever her intention, only four cliff tombs—identified as Wadis A1, A2, C1, and D1—were prepared in the Wadi Qurud, of which Hatshepsut's, Wadi A1, is the most elaborate.[6]

Hatshepsut's tomb (fig. 73) was originally entered by a staircase (1) cut into the bottom of a cleft in the cliff face. A long corridor (2) ends in a room (3) that has a second corridor (4) leading off to the right. This goes to a larger room (5) that contained a yellow quartzite sarcophagus inscribed with Hatshepsut's name and titles as queen (fig. 74). The first stone sarcophagus made for a royal family member, it foreshadows the long series of quartzite sarcophagi that would become traditional for Eighteenth Dynasty kings.[7]

The plan of the tomb is similar in some respects to those of the shaft tombs that probably belonged to Hatshepsut's predecessors Ahmose-Nefertari and Ahmose-Meryetamun.[8] However, Hatshepsut's cliff tomb includes a ramp that descends to a room on a lower level (fig. 73:6, 7), elements not present in the earlier examples, and its general configuration has some features in common with the tombs of kings in the

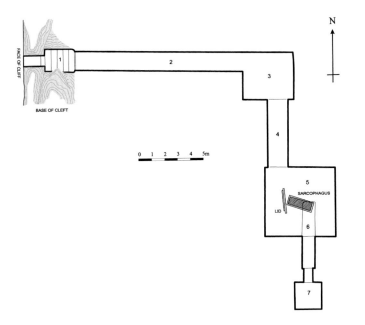

Fig. 73. Plan of Hatshepsut's cliff tomb in Gabbanat el-Qurud, Wadi A1, western Thebes. Drawing by Julia Jarrett

Fig. 74. Sarcophagus found in Hatshepsut's queen's tomb (Wadi A1), early 18th Dynasty. Quartzite. Egyptian Museum, Cairo (JE 47032)

Valley of the Kings.[9] Although her sarcophagus was found in room 5, the largest element of the complex, it was positioned at the edge of the ramp, which suggests that it was being moved to room 7 when the tomb was abandoned, probably at the time Hatshepsut became king.

HATSHEPSUT'S KING'S TOMB

When Hatshepsut officially assumed the role of king, with all the accompanying political and religious implications, it was no longer appropriate for her to be buried in a cliff tomb in the Wadi Gabbanat el-Qurud. Therefore, she moved her burial preparations to the new royal cemetery, the Valley of the Kings.[10] This

cemetery is located in a desert wadi west of Deir el-Bahri, where the mortuary temples of the Eleventh Dynasty king Mentuhotep II and Hatshepsut stand (see map, page 5).

The tomb associated with Hatshepsut, KV 20, was cut into the base of the cliffs on the east side of the Valley of the Kings, almost directly behind the Deir el-Bahri temples (see fig. 75). The entrance was visible in 1799, when Napoleon's expedition of scientists and scholars entered the Valley. However, the accessible portion of the tomb was undecorated, and its owner remained unknown until 1903, when Howard Carter excavated the tomb (see fig. 76).[11] At the entrance (A) he uncovered pieces of a foundation deposit inscribed with Hatshepsut's throne name, Maatkare. In the burial chamber (J2) he found two quartzite sarcophagi. One was inscribed for Hatshepsut as king; the second was also inscribed for Hatshepsut but had later been adapted and reinscribed for her father, Thutmose I (cat. no. 108). From this evidence, Carter quite logically concluded that Hatshepsut had commissioned the tomb for her joint burial with her father, whose body she removed from his original tomb, probably KV 38, at the south end of the Valley, and reinterred in her own tomb.[12] The reburial of Thutmose I in Hatshepsut's tomb has generally been interpreted as one of the steps she took to legitimize her position as king.[13]

In 1974, after carefully studying the architecture of KV 20 (fig. 76), British Egyptologist John Romer presented a different and intriguing theory about the tomb's history. In his view, KV 20 had been constructed by Thutmose I and later altered by Hatshepsut, who added a second burial chamber (J2) to accommodate both her father and herself.[14] Romer's theory has been accepted by some scholars, but others still believe Thutmose I built and was originally buried in KV 38.[15]

For reasons elaborated elsewhere, I am among those who believe that KV 38 is the tomb of Thutmose I.[16] However, I agree with part of Romer's hypothesis, namely, that KV 20 was originally made for one of Hatshepsut's predecessors and then adapted by her. When Hatshepsut became king, there were only two royal tombs in the Valley: that of her father, Thutmose I (KV 38, in my opinion), and that of her husband and half brother, Thutmose II. The tomb of this king has never been identified with certainty because no tomb in the Valley of the Kings is inscribed for him and no tomb has yielded even fragmentary burial equipment belonging to him. However, on the basis of its plan and its location, I suggest that KV 20 was the tomb originally made for Thutmose II. Although KV 20 is the longest tomb in the Valley of the Kings, its plan is relatively simple. If it is compared with the earliest datable kings' tombs in the Valley, KV 20 can be chronologically placed between KV 38 (Thutmose I) and KV 34 (Thutmose III).[17]

It has long been assumed that the location of KV 20 was chosen because of its proximity to Deir el-Bahri, and that the tomb and the temple were intended as part of the same funerary complex.[18]

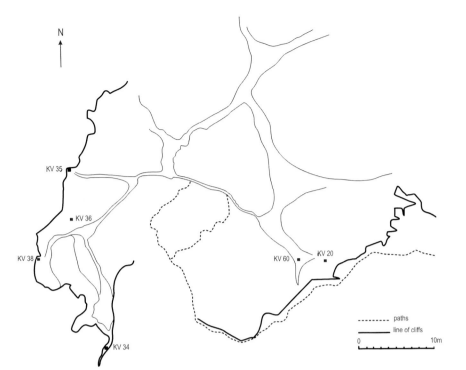

N

KV 35

KV 36

KV 38

KV 60 KV 20

KV 34

- - - - paths
———— line of cliffs

0 10m

Fig. 75. Map of the Valley of the Kings showing the tombs of Thutmose I (KV 38), Thutmose II and Hatshepsut (KV 20), Hatshepsut's wet nurse, Sitre (KV 60), Maiherperi (KV 36), and Thutmose III (KV 34). Drawing by Julia Jarrett

However, there is some question as to which king was responsible for the first building phase of Hatshepsut's mortuary temple. Was it Hatshepsut, or was it her husband, Thutmose II, as has been suggested by Zygmunt Wysocki? If one accepts the theory that Thutmose II initiated the first building phase of the temple, it is logical to assume that he also initiated work on KV 20.[19]

After her husband's death, Hatshepsut seems to have taken over some of the building projects begun during his reign. At Karnak, for example, she raised two obelisks in his honor, and at Deir el-Bahri she and her architects may have redesigned and completed construction of the temple.[20] Having risen to power in an unorthodox though not unprecedented manner, Hatshepsut may have found it more expedient to appropriate her husband's funerary monuments and adapt them than to build her own. To KV 20 she added a second burial chamber (J2).[21] The two quartzite sarcophagi discovered in this room indicate that Hatshepsut envisioned a double burial in the tomb: her own and her father's. Each sarcophagus can be associated with one of the small side chambers (J2, a1 and J2, a2) according to its position.[22] The presence of a third side chamber (J2, a3) suggests to me that there was a third burial in the tomb. The most likely candidate for this third burial is Thutmose II, the original owner of the tomb.[23]

1. Both papyrus Abbott B and the Amherst Papyrus record that Queen Nubkhas was buried in the tomb of her husband, King Sebekemsaf, and describe how both burials were later violated; see Winlock 1924, pp. 237–39. The wife of Intef VI, Queen Sebekemsaf, was buried in her own family cemetery at Edfu (Winlock 1924, p. 233). The Seventeenth Dynasty queen whose burial is now in Edinburgh (see above, pp. 15–16 and cat. nos. 2–6) is an example of a royal woman with her own tomb.

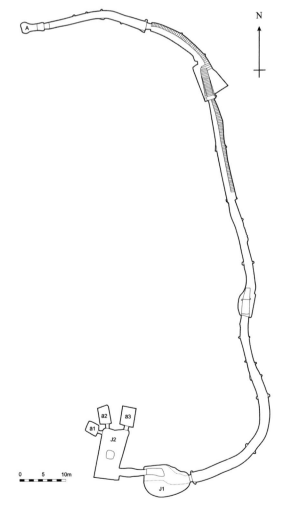

N

A

a2 a3
a1
J2

J1

0 5 10m

Fig. 76. Plan of Hatshepsut's tomb in the Valley of the Kings (KV 20). Drawing by Julia Jarrett

2. The tomb of Ahmose-Meryetamun, wife of Amenhotep I, was discovered near Hatshepsut's temple at Deir el-Bahri by The Metropolitan Museum of Art. The site had probably been chosen for the tomb because the area had long been sacred to Hathor, a goddess closely associated with queens. Not far away, Amenhotep I had built a mud-brick barque shrine for the yearly Beautiful Festival of the Valley procession. The name of Ahmose-Nefertari, the mother of Amenhotep I, was found in a shaft tomb above Dra Abu el-Naga. The burial of Queen Ahhotep I, which seems to have included gold jewelry and other accoutrements, was found on the slopes of Dra Abu el-Naga; the contents are now in the Egyptian Museum, Cairo. For images of some of the jewelry, see Saleh and Sourouzian 1987, nos. 120–26.

3. The huge coffins of Ahmose-Nefertari and Queen Ahhotep II were discovered in the Deir el-Bahri cache of royal mummies (Daressy 1909, CG 61003, 61006).

4. The tomb was discovered by local residents in 1916. Its location was reported to Howard Carter, who first commented on the tomb in Carter 1916b, giving a lively account of chasing off a group of would-be tomb robbers. He discussed the tomb further in Carter 1917, pp. 114–18.

5. Carter suggested that the Wadi Gabbanat el-Qurud was a lost cemetery for queens that dates from before the better-known Valley of the Queens; see Carter 1916b, p. 179.

6. Wadi A2 has a stairway leading to a room with a small side chamber; its owner is not known. Wadi C1, made up of a cruder version of elements 2–4 (see fig. 73) of Hatshepsut's tomb, may have belonged to her daughter, Neferure. Wadi D1 has a stairway leading to a corridor that ends with a chamber; it was used for the burial of the three foreign wives of Hatshepsut's nephew, Thutmose III (see Lilyquist 2003, p. 79, fig. 29, for a plan of this tomb).

7. See catalogue no. 108. Until this time, royal sarcophagi were made of wood.

8. For a discussion of these tombs, see E. Thomas 1966; Romer 1976, where the author identifies them as kings' tombs; and Reeves 2003.

9. Room 3 in Wadi A1 is similar to chamber E in the royal tombs in the Valley of the Kings; room 5 can be compared to chamber F, usually a pillared hall; room 7 is probably comparable to chamber J, the burial chamber of a king's tomb. For more on this subject, see Roehrig forthcoming.

10. For the interpretation of the early history of the Valley of the Kings on which this essay is based, see Roehrig 2005. For other theories, see E. Thomas 1966; Romer 1974 and 1976; Reeves 1990b; Reeves and R. H. Wilkinson 1996. The Valley of the Kings was the principal cemetery of New Kingdom rulers for about four centuries, from its founding in approximately 1504 to about 1070 B.C.

11. At the time, Carter was Chief Inspector of Antiquities for Upper Egypt. He had been excavating in the Valley with the financial support of Theodore M. Davis, an American from Newport, Rhode Island. For a report on the excavation of the tomb, see Naville and Carter 1906.

12. Ibid., pp. xiv–xv.

13. Winlock 1929b, p. 64.

14. Romer 1974.

15. Reeves 1990b, pp. 13–18; Reeves and R. H. Wilkinson 1996, pp. 91–92; N. Strudwick and H. Strudwick 1999, pp. 97–98, accept Romer; those who dispute him include Altenmüller 1983a, pp. 25–38; Hornung 1990, passim.

16. Roehrig 2005.

17. On this subject, see ibid.

18. William C. Hayes even suggested that KV 20, which is close to 650 feet (200 meters) in length, was originally intended to extend farther through the cliff, allowing the burial chamber to be located beneath the temple at Deir el-Bahri, some 820 feet from the entrance (Hayes 1935a, pp. 17, 146–47; Hayes 1959, p. 103). However, since the tomb curves markedly to the right almost immediately after the entrance, it is unlikely that the builders ever intended it to tunnel straight to Deir el-Bahri (see Roehrig forthcoming).

19. Herbert Winlock first suggested, because of the position of the foundation deposits, that the original plan of Hatshepsut's temple was subsequently altered (Winlock 1942, pp. 134–35; see also cat. nos. 75, 76 in the present volume). More recently, Zygmunt Wysocki argued that the first phase of the temple's construction was begun during the reign of Thutmose II (Wysocki 1986, pp. 225–28; Wysocki 1992, pp. 233–44).

20. On the obelisks, see Gabolde 1987b; Gabolde 2003. It seems likely that the same architects and officials (among them Senenmut) were involved in the projects of both Thutmose II and Hatshepsut.

21. As suggested in Romer 1974.

22. For the significance of these side chambers in the royal tombs, see Roehrig forthcoming.

23. Like his predecessors, Thutmose II probably had burial equipment constructed of wood rather than stone. This might account for the lack of evidence for his burial in KV 20, which has been subject to periodic flooding that would have contributed to the destruction of highly perishable wood artifacts.

106. Two Jars

Early 18th Dynasty, reign of Thutmose II–joint reign of Hatshepsut and Thutmose III, year 7 (1492–1473 B.C.)
Travertine
a: H. 23 cm (9 in.), Diam. 15.3 cm (6 in.)
b: H. 12.3 cm (4⅞ in.), Diam. 13 cm (5⅛ in.)
The Metropolitan Museum of Art, New York,
(a) Fletcher Fund, 1926; Rogers Fund, 1926 26.8.8
(b) Rogers Fund, 1918 18.8.15

These two vessels, which would have been used to store unguents or oils, are inscribed with Hatshepsut's personal name and her titles as queen. The spherical jar bears the inscription:

King's Daughter, King's Sister, God's Wife, King's Great Wife (principal queen), Hatshepsut, may she live and endure like Re forever.

106a, b

The text on the pyriform, or pear-shaped, jar reads:

God's Wife, King's Great Wife whom he loves, Mistress of the Two Lands, Hatshepsut, may she live.

The jars were purchased by the Metropolitan Museum with groups of stone vessels and other objects that are associated with the tomb of the three foreign wives of Thutmose III, which is located at the end of Wadi D in the Wadi Gabbanat el-Qurud. The designation "King's Great Wife whom he loves" suggests that at least the pyriform jar was made before the death of Hatshepsut's husband, Thutmose II.

The jars may originally have been intended to furnish Hatshepsut's queen's tomb in Wadi A. However, after she became king, Hatshepsut seems to have distributed materials inscribed with her queen's titles, such as linen, pottery, and stone storage jars, to be placed in the burials of individuals she deemed important (see "The Tomb of Ramose and Hatnefer" in chapter 2). Thus, it is quite possible that she contributed the vessels seen here to the burial equipment of her nephew's foreign wives.

CHR

PROVENANCE: Purchased in Luxor, 1917 (a) and 1920 (b), with other stone vessels presumed to be from western Thebes, Gabbanat el-Qurud, Wadi D, Tomb 1

BIBLIOGRAPHY: Winlock 1948, pp. 11, 53–57, pl. XXXII; Hayes 1959, p. 80, fig. 43; Lilyquist 1995, pp. 34–35, nos. 58, 60, figs. 67, 68; Lilyquist 2003, pp. 141, no. 54, 142, no. 57, figs. 21 (top), 126 (second from left), 127a, 128a

107

name, Maatkare, is visible on the top of its head, and "Hatshepsut, linked with Amun" is inscribed on the back of the neck. CHR

1. Wiese 2001, p. 91, no. 53.
2. Cairo Temporary Register 26.7.14.52; this information was provided by Christine Lilyquist.
3. See catalogue no. 128 for a gaming box with a board for *senet* on one side, a board for twenty squares on the other, and a drawer for the gaming pieces.

PROVENANCE: Unknown; Hilton Price collection, sold at Sotheby's, London, July 12–21, 1911; Carnarvon collection; purchased for the Metropolitan Museum in 1926

BIBLIOGRAPHY: Towry-Whyte 1902, pl. I, 10

107. Gaming Piece(?)

Early 18th Dynasty, joint reign of Hatshepsut and Thutmose III (1479–1456 B.C.)
Jasper
H. 3.2 cm (1¼ in.), W. 3 cm (1⅛ in.), D. 3 cm (1⅛ in.)
The Metropolitan Museum of Art, New York, Purchase, Edward S. Harkness Gift, 1926 26.7.1452

Two jasper gaming pieces almost identical to this one are known. One is on loan to the Antikenmuseum Basel,[1] the other is in the Egyptian Museum, Cairo.[2] Presumably all three were part of a set used for playing *senet* and twenty squares, two board games popular in the New Kingdom.[3]

The leopard head has been carved with great detail. A cartouche with Hatshepsut's throne

108. Sarcophagus of Hatshepsut, Recarved for Thutmose I

Early 18th Dynasty, joint reign of Hatshepsut and Thutmose III (1479–1458 B.C.)
Yellow quartzite, painted
H. 82 cm (32⅜ in.), D. 87 cm (34¼ in.), L. 2.25 m (7 ft. 5 in.)
Museum of Fine Arts, Boston, Gift of Theodore M. Davis 04.278

Hatshepsut was the first ruler of the New Kingdom who had a sarcophagus made of stone. This is one of three quartzite sarcophagi that changes in her status led her to commission during her lifetime. The earliest, made before she became king, was found in her cliff tomb in Wadi A (see fig. 74). Its decoration is quite simple, consisting of a band of inscription around

the top of the box, twelve columns around the sides, and the eyes of Horus on the left side near the head end. The distribution of the text follows the pattern of inscriptions on wood coffins dating from the Middle Kingdom.[1] The top of the lid, however, carries a huge incised cartouche, a royal device not previously used on this part of a sarcophagus.

Hatshepsut's two other sarcophagi were discovered in her tomb in the Valley of the Kings (KV 20) in 1904. Though made of yellow quartzite, both were painted red. The larger of them (Egyptian Museum, Cairo, JE 37678/52459), rounded at the head and thus a cartouche-shaped box, is inscribed with her titles as king. The smaller sarcophagus, shown here, is rectangular and was recarved with the names and titles of Hatshepsut's father, Thutmose I. The recarving is most visible along the lip of the box, where Hatshepsut's throne name and personal name (enclosed in cartouches) were filled in with a colored paste into which the names of her father were incised (see detail). The original inscription on the outside of the sarcophagus was removed by cutting away the stone to a depth of more than half an inch. The new surface was then carved with new texts. The inside of the sarcophagus has also been carved away at the head and foot, presumably because the coffin of Thutmose I was too long to fit.[2]

The dedication begins with Hatshepsut's full titulary and reads:

May the Horus Wosret-Kau (Powerful of Kas), Two Ladies Wadjet-renput (Green of Years), Golden Horus Netjeret-khau (Divine of Appearances) live. The King of Upper and Lower Egypt, Maatkare, Son of Re, Hatshepsut-united-with-Amun, may she live forever. She made it as a monument for her beloved father, the Good God, Lord of the Two Lands, King of Upper and Lower Egypt, Aakheperkare, Son of Re, Thutmose, justified.

The decoration of the sarcophagus exterior includes images of the funerary goddesses Isis, at the foot, and Nephthys, at the head. (These two goddesses are also painted in corresponding positions on the inside surface of the sarcophagus.) The four sons of Horus, gods who protect the four organs removed during mummification, stand near the corners (see detail), and an image of Anubis, god of mummification, stands near the center on each side of the box. The top of the lid is inscribed with a cartouche, and the small figure of Nut, goddess of the sky, kneels at the head end. Two figures of Nut the length of the sarcophagus also appear, one on the inside of the lid and the other on the bottom

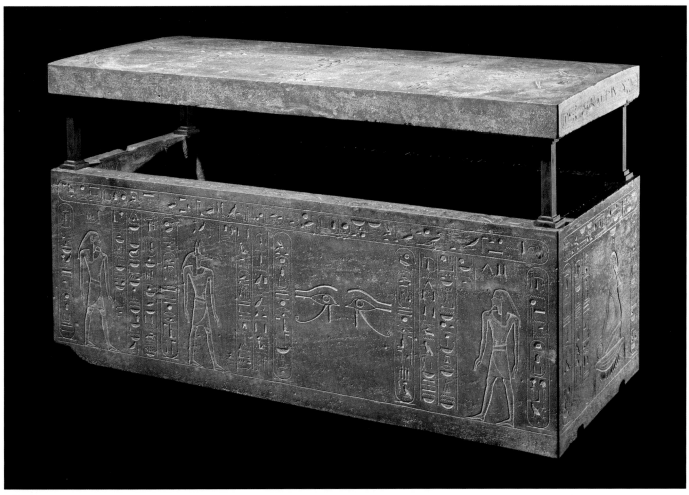

108

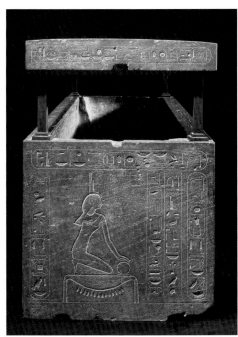

108, foot, with Isis

108, details: son of Horus

recarved names

inside the box, where her raised arms, carved along the sides, wait to embrace and protect the body of the king. CHR

1. See Grajetzki 2005 for a comparison of the texts on Hatshepsut's sarcophagus with those on the

sarcophagus of Princess Neferuptah of the Twelfth Dynasty.
2. Thutmose I had been buried in another tomb, KV 38, from which he was transferred by Hatshepsut.

PROVENANCE: Western Thebes, Valley of the Kings, Tomb KV 20; discovered by Howard Carter during

excavations of Theodore M. Davis, 1904; acquired by Davis in the division of finds and given to the Museum of Fine Arts in 1904

BIBLIOGRAPHY: Hayes 1935a; Der Manuelian and Loeben 1993

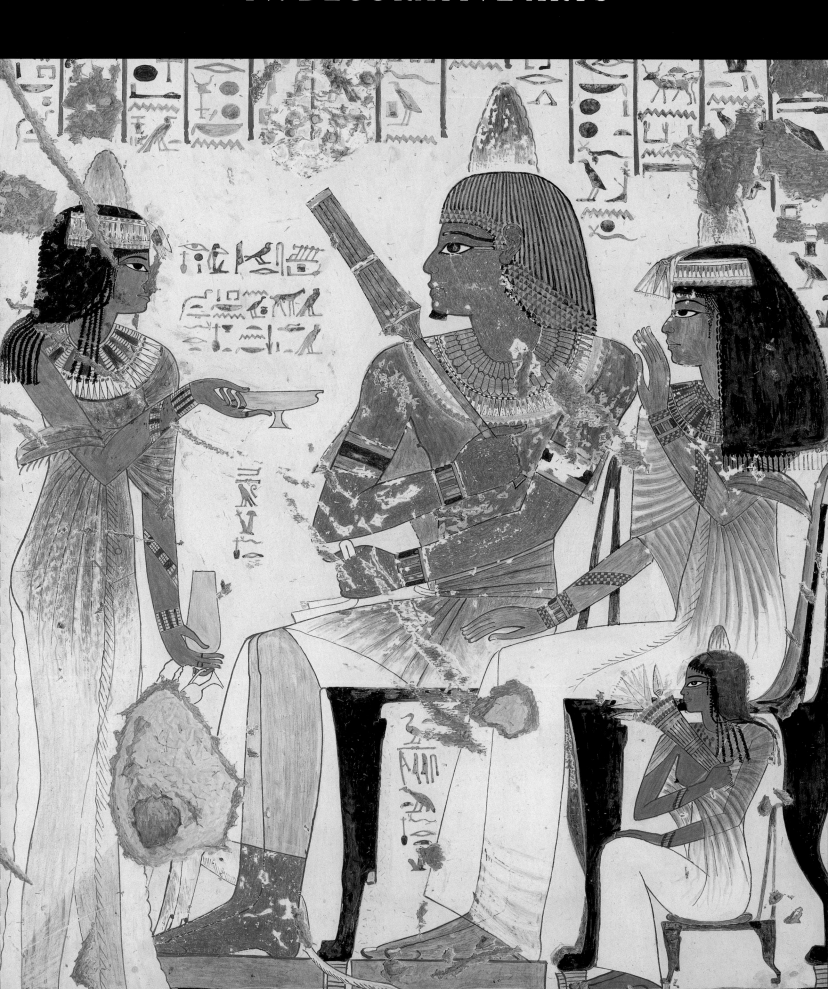

IV. DECORATIVE ARTS

JEWELRY IN THE EARLY EIGHTEENTH DYNASTY

Diana Craig Patch

Jewelry from any period of Egyptian history commands attention. Using colorful materials, technological skill, and rich iconography, ancient jewelers fabricated many impressive pieces. As is the case today, jewelry was principally worn as personal adornment. Ornaments were also used to honor a temple's cult statue,[1] protect a mummy, and confer the king's esteem on members of his court. Identifying a piece of jewelry's function—personal, funerary, or ritual—is not always straightforward, and factors such as material, manner of stringing, securing mechanism, and imagery must be considered in making a determination.

Archaeological finds indicate that a variety of jewelry forms were in use during the first half of the Eighteenth Dynasty. The context in which they were found, supplemented by a study of tomb scenes and other representational art, from about 1560 B.C., in the Seventeenth Dynasty, into the reign of Amenhotep III (r. 1390–1352 B.C.), allows an understanding of the function of jewelry in ancient Egyptian society. In order to define what was considered proper jewelry for formal occasions in ancient Egypt—a funeral, for example, or presenting an offering in a temple, or a royal audience—it is most effective to study the people who composed the upper class in ancient Egyptian society. These individuals possessed the means and the influence to acquire what was considered the most appropriate adornment. By contrast, graves belonging to lesser officials, soldiers, and workers offer an excellent opportunity to study the types of jewelry the majority of ancient Egyptians wore and to identify which materials were accessible to the general population.

REPRESENTATIONS OF EARLY EIGHTEENTH DYNASTY JEWELRY

Information about where and when certain jewelry forms were worn in the first half of the Eighteenth Dynasty comes from two sources.[2] Archaeological finds show us what jewelry the ancient

Egyptians owned and wanted with them in the afterlife. Depictions of people in wall paintings from private tombs,[3] relief scenes at Deir el-Bahri, as well as statues and stelae, reveal not only the choices available to ancient Egyptians of the time but also which jewelry they believed to be appropriate in rituals. By the end of the reign of Thutmose III (r. 1479–1425 B.C.), the jewelry forms depicted in sculpture, relief, and painting appear consistent. Tomb paintings and statues indicate that by the middle of the Eighteenth Dynasty, people wore greater quantities of jewelry and more types and variations than they had at the dynasty's beginning.

In tomb wall paintings, people who are represented participating in the funeral activities of the tomb's owner, toiling in the various temple workshops, or laboring in fields are rarely shown wearing jewelry. Although it is impractical to wear most types of jewelry when actively engaged in labor, the lack of personal ornamentation in such tomb scenes may have been influenced more by the religious nature of these scenes than by any practical consideration. Banquet scenes and scenes in which female servants bring offerings to the tomb's owner are the exceptions. The attendees in banquet scenes wear a variety of jewelry types, including broad collars and bracelets, and sometimes earrings, and the female and male servants are often adorned as well (see fig. 78). The male servants seem to have only collars, if they have any jewelry. Women dressing and serving female guests wear broad collars and some combination of earrings, bracelets and armlets, and girdles (see fig. 78). Although known from archaeological contexts, girdles (see cat. nos. 119, 120) are rarely depicted on anyone except female servants and musicians (for an unusual example of girdles worn in a ritual context, see fig. 79).[4]

In general, the figures represented in Egyptian statues display little jewelry. Statues of women are more likely to display jewelry than statues of men, and in pair statues the woman is more likely to wear jewelry than the man.[5] The difficulty of carving stone, especially hard stone such as granite, probably limited the amount of added detail, such as jewelry, to only the most essential. Furthermore, many elements were added to early

Opposite: Fig. 77. Nebamun and his family adorned in ritual and fancy-dress jewelry. From the Theban tomb of Nebamun and Ipuky (TT 181), late 18th Dynasty. Facsimile painting by Nina de Garis Davies. The Metropolitan Museum of Art, New York, Rogers Fund, 1930 (30.4.106)

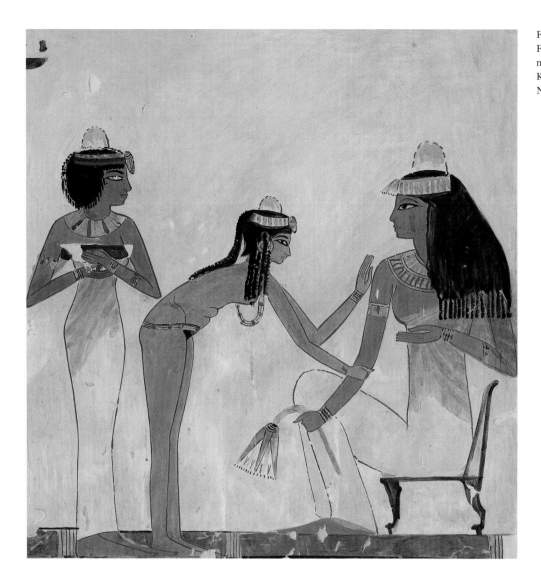

Fig. 78. Servants attend a woman at a banquet. From the Theban tomb of Tjener (TT101), mid-18th Dynasty. Facsimile painting by Charles K. Wilkinson. The Metropolitan Museum of Art, New York, Rogers Fund, 1930 (30.4.8)

Eighteenth Dynasty statues and stelae with paint.[6] Since paint often does not survive, it is not surprising that statues as we see them today do not consistently depict elements of jewelry. When the subject of the statue is positioned in the traditional seated pose of one ready to receive offerings, however, the figure frequently does wear the divine set of jewelry, discussed below (see cat. nos. 7, 8, 10, 96).[7] On statues whose subjects are participating in pious activity, such as presenting a stela or offering containers, jewelry seems to be absent even when paint remains intact (see cat. nos. 91, 93).[8] Even the ubiquitous broad collar is rarely represented.

Divine and Award Jewelry

The surviving reliefs at Deir el-Bahri provide the best illustrations of the ritual jewelry the gods and the king wore in the early Eighteenth Dynasty. The gods display a broad collar, with rows in alternating colors, and one or two pairs of rigid cuff bracelets and armlets on each limb, both with vertical bands of alternating colors (see fig. 1).[9] The consistency with which the gods wear this combination and style of jewelry indicates that this set must be considered "divine jewelry," the most formal ensemble (see cat.

nos. 95, 96, 114, 116a, 116b).[10] In places where color decoration has been preserved, the beads on the broad collar are alternating rows of gold and green, as is the predominant pattern on the cuff bracelets, although occasionally a red band is added.[11] Except for some scenes where deities and queens have beaded anklets,[12] jewelry in ritual scenes at Deir el-Bahri is remarkably consistent.

The subject of the scenes in tombs of high officials is generally the tomb's owner, often accompanied by his wife. When either the official or the couple are shown receiving offerings, both consistently wear broad collars, often with matching rigid cuff bracelets, paralleling the ensemble of deities and royalty.[13] There is another combination of jewelry forms exclusive to high officials. Given by the pharaoh, these pieces are generally referred to as gold of honor, gold of valor, or award jewelry.[14] In private-tomb scenes, a fully outfitted official will wear two choker-style necklaces of thick gold beads, or *shebiu* collars (cat. nos. 52, 54); a set of two narrow gold bands, called *aʿa* armlets, on each upper arm (cat. nos. 52, 54, 110b); and the thick curved gold cuff bracelet called a *mesektu* bracelet (cat. nos. 52, 111) on one wrist.[15] The other wrist is either bare or adorned with the divine gold-and-bead cuff bracelet, or with a second type of *mesektu* bracelet, green bordered with

bands of gold.[16] The combination of *shebiu* collars, *aᶜa* armlets, and at least one *mesektu* bracelet must be considered a second complete set of formal jewelry.

Personal Jewelry

The most common type of jewelry in early Eighteenth Dynasty tomb paintings and sculpture is the broad collar; if a person is depicted wearing only one piece of jewelry, it will be the broad collar (cat. nos. 10, 15, 25, 38). Most broad collars illustrated on tomb and temple walls and on statues are simply rendered, semi-circular rows of cylinder beads in alternating colors, usually blue, green, and gold. Broad collars made from plain cylinder beads continue to appear in ritual contexts, and judging by the representational evidence, these broad collars seem to have been a significant component of the parure of any upper-class Egyptian intent on following custom, although few examples exist (cat. no. 114).[17]

Broad collars on women often displayed new patterns and forms (see figs. 77, 78). Designs such as zigzags, triangles, and vertical banding were produced through the creative use of different-colored beads in both cylinder and ball shapes. However, many patterns that appear new, because they were not part of the Middle Kingdom repertoire, are in fact well-known late Old Kingdom compositions.[18] Collars with beads in the forms of amulets and flowers were new designs (see cat. no. 115). Pectorals—large decorative elements hung from a string of beads to rest on the chest—are only occasionally illustrated or recovered from burials (for a possible pectoral, see cat. no. 112).

In representations, bracelets and armlets are the most common jewelry form after broad collars, although neither is common archaeologically. In the first half of the Eighteenth Dynasty, bracelets and armlets are generally worn in unmatched pairs, and all kinds of bracelets are worn in quantity. Women wear bracelets and armlets more frequently than men, and they wear many more types, including bangles, often made from wood or ivory, and single and multiple strings of beads, meant to hang loosely on the arm. The bracelets display a wide variety of patterns created through the use of beads of diverse geometric shapes and materials of different colors. Women also put on several varieties of cuff bracelets, both rigid and flexible (cat. nos. 116a, 116b, 117; figs. 77, 78). Displaying a variety of bracelets at one time or wearing only one are new traditions.

Personal jewelry in the early Eighteenth Dynasty also included earrings, rings, fillets, and diadems. Men, women, and sometimes children are shown wearing penannular hoop earrings in both smooth and ribbed styles (cat. nos. 118a–e; fig. 78).[19] These shapes, as well as leech and spiral forms, are also found in many burials. Gender and status do not affect who wears earrings, as officials, members of their family, and their female servants—and even

royalty, on rare occasions—all wear them in tomb paintings.[20] Although few earrings are illustrated before the middle of the Eighteenth Dynasty, finds from tombs of lesser officials, soldiers, and workers indicate that earrings were popular during the reigns of Hatshepsut and Thutmose III.[21] Rings, while common in burials, are unusual in tomb paintings. The hands of a young woman offering wine are rich in blue rings, with more than one on some fingers (see fig. 77).

In tomb paintings, women attending banquets or accepting offerings wear fillets with an open lotus or lotus bud positioned just above the forehead (figs. 77, 78). The most remarkable fillet, however is the one that was buried with the early Eighteenth Dynasty queen Meryetamun.[22] She wore a floral fillet made from gold wire and beads. Other illustrated fillets display patterns, such as rosettes or rectangles, which suggest that they were made from metal and inlaid with stone.[23] Only three examples of actual diadems survive: two belonging to royal women (see cat. no. 113) and one for a king.[24]

ARCHAEOLOGICAL FINDS OF EARLY EIGHTEENTH DYNASTY JEWELRY

Archaeological information on jewelry comes from two sources: finds from high-ranking tombs[25] and from cemeteries with numerous burials of nonelite people. In general, the burials of the high-ranking individuals whose tomb paintings have supplied important depictions of people wearing jewelry (see above) have not survived. The undisturbed tomb at Deir el-Medina of the architect Kha and his wife, Meryet,[26] provides a rare opportunity to study which jewelry an official believed important or desirable for an interment. Kha served three kings in the middle of the Eighteenth Dynasty (1427–1352 B.C.) and must be counted at least among the ranks of middle-class officials. The burials of Kha and his wife contained royal gifts, which adorned the mummies: a single strand of *shebiu* beads was around the neck of Kha's mummy, and an elaborate broad collar of amuletic beads lay on the body of his wife.[27] The other pieces indicate that their mummies wore a mix of personal and funerary jewelry and that these two categories were not mutually exclusive.

Archaeological excavations at five sites—Abydos, Buhen, Aniba, Fadrus (Qadrus), and Birabi[28]—uncovered cemeteries of the New Kingdom, and many of the graves can be dated to the early Eighteenth Dynasty on the basis of scarabs, pottery, and stone vessels associated with the burials. The finds from the tombs must be considered carefully, since for a variety of reasons few of the tombs survived intact, so that for most of the sites only general conclusions can be reached. The occupants of these tombs must largely have been middle-ranking and lesser officials, soldiers, local entrepreneurs, and, possibly, successful farmers who lived in

the immediate vicinity of the sites. Overall, inscribed material—such as statues, stelae, or papyri—indicative of Egyptian society's educated class is absent. That does not mean that these people were poor, however, as the burials can have precious materials.

Much of the jewelry in these burials is made from sturdy materials such as stone, ivory, and metal, designed to last although not necessarily for everyday wear. Faience is common, but many beads are made from more durable materials such as turquoise, carnelian, lapis lazuli, and gold. Strings of beads, scarabs and design seals, bracelets, earrings, and rings occur regularly, and some in numbers. Broad collars are not found. Given that the collars were a jewelry form of long standing and were still widely used to decorate statues and coffins, their absence is interesting. It seems reasonable to suggest that the owners of these graves, who were not members of the elite, did not wear broad collars. These individuals probably had few opportunities to attend affairs requiring such fancy dress. Instead, one or two strings of beads were the fashion among these people.

At Fadrus, Lana Troy's analysis indicates that about fifty percent of the burials at the largest cemetery, Site 185, had design seals, generally scarabs, and some type of bead necklace (see cat. nos. 121–126).[29] Figurative pendants were part of the string of beads in twenty percent of the cases. Necklaces could be composed of one kind of bead, but mixed strands were also common (fig. 79). Small pendants in the shape of cornflowers, poppy buds, and amuletic signs match those from the fancier broad collars. Other forms, such as the Bes-image and Taweret, *wedjat* eyes, flies, and fish, occur regularly but generally in small numbers and are unknown in representations (cat. nos. 123, 124a, b). The most popular amuletic bead takes the form of a poppy bud or cornflower (they are difficult to differentiate; cat. nos. 125a, b).[30]

Some design seals were mounted in a bezel to make a ring (cat. nos. 42, 44, 128f, 129a, 131b). In addition to these, many scarabs and design seals were found on or near the hands of mummies; they had probably been tied to a finger with string (cat. nos. 98a, e; for scarabs and seals, see cat. nos. 128a–e, 129b, 130b, 131c).[31] About twenty percent of the burials at Fadrus had earrings (see cat. nos. 118a–e). In striking contrast to the representations in tomb paintings, bracelets were rare (cat. nos. 116a, 116b, 117). Less than one percent of the mummies had one. There is little sign of

formal jewelry, whether divine or honor. Burials at Buhen and Fadrus produced a total of three *mesektu* bracelets, made of ivory. Since they are not made of gold, it is difficult to be sure they are honor jewelry. They may be local survivals of the gold bracelet's precursor or royal gifts of local manufacture for lesser officials.

CONCLUSION

Personal adornment was just one of many aspects of ancient Egyptian life that underwent change at the beginning of the Eighteenth Dynasty. Although some jewelry forms and designs are tied to the Middle Kingdom tradition, a number of others, including the divine and honor sets of jewelry, amuletic broad collars, and a variety of earring styles, originated no earlier than the Second Intermediate Period. The highest stratum of Egyptian society wore the divine and honor jewelry, as they conveyed the king's highest regard. Broad collars, an integral part of the divine set and an important royal gift, also seem to have been reserved for the upper class, as they are not found in the burials of lower-ranking members of Egyptian society.

Many pieces of jewelry, such as the divine set, had no gender or age limitations. To judge by tomb paintings, women had more selection in what they put on. This point is supported by the varied broad-collar designs and the variety in the bracelets they wore, although the forms are consistent. Certain pieces, such as girdles, that were deemed inappropriate for most adult women when they were depicted participating in a ritual nonetheless could be worn on the mummy.

Although much of the jewelry depicted in tomb paintings has not been found in excavations, the paintings in all likelihood accurately record how the jewelry was used by the class of society that owned the tombs. Surviving fragments from royal parure support this assertion. Most Egyptians, regardless of class, were buried in the jewelry they regularly wore during their lifetimes. When an individual was prepared for his or her afterlife, some or possibly all of the jewelry worn in life was placed on the body. A few additional pieces, generally funerary amulets and a heart scarab, completed the mummy's adornment for eternity.[32]

I thank Claudia Farias for help in locating and checking information and Catharine H. Roehrig for support of this research.

1. Carol Andrews (1990, fig. 169) published a miniature gold collar that she suggested once adorned a cult statue. See also the entry for cat. no. 112.

2. The data in this essay is based on research that the author is preparing for publication.

3. The concentration of evidence cited comes from tombs that date prior to the reign of Amenhotep III.

4. See Norman de G. Davies 1923, pls. IV, V (TT 75, Amenhotepsise), XXIII (TT 90, Nebamun); Norman de G. Davies 1943, pl. LXIV (TT 100, Rekhmire); Nina de G. Davies 1963, pl. 6 (TT 38, Djeserkare-seneb). Both Meryetamun (Winlock 1932b, p. 15, pl. 17) and Meryet (Curto and Mancini 1968, p. 79, pls. I–III) were buried wearing girdles, and three have been reconstructed from finds in the tomb of the three foreign wives of Thutmose III (Lilyquist 2003, pp. 174–75, fig. 234).

5. See Thutmose IV and his mother (Egyptian Museum, Cairo, CG 42080) in Vandersleyen 1975, fig. 184.

6. Much of Nebamun and Nebet-ta's jewelry exists only as paint on the statue (Fazzini, Romano, and Cody 1999, p. 89, no. 44). See also the group statue (Rijksmuseum van Oudheden, Leiden, AST 69) in H. D. Schneider 1997, p. 61, no. 78.

7. See Hatshepsut (Metropolitan Museum of Art, New York, 27.3.163); Isis (Egyptian Museum, Cairo, CG 42072) in Saleh and Sourouzian 1987, no. 137.

8. See also the statue of Thutmose III (Egyptian Museum, Cairo, JE 43507A) in Russmann 1989, pp. 89–90, no. 39.

9. I have decided to use the word "cuff" for large bracelets that fit tightly at the wrist. In the Eighteenth Dynasty, there are two different styles: those that are rigid, made from formed pieces of gold with hinges into which beads have been inlaid (see cat. nos. 116a, b), and those that are strung on wire (see cat. no. 117); in both, a row of colored beads alternates with a stripe of gold. In the divine jewelry, the rigid form seems to be used exclusively. Upper-class women wear both forms (see figs. 77, 78).

10. See, for example, Naville 1894–1908, pt. 2, pls. XL, XLIII, and a statuette of a goddess dating from later in the Eighteenth Dynasty (Ägyptisches Museum und Papyrussammlung, Staatliche Museen zu Berlin, 23725) in Kaiser 1967, pp. 52–53, no. 552.

11. Naville 1894–1908, pt. 1, pl. XIV.

12. Ibid., pls. III, XIII, pt. 2, pl. XXXIII, pt. 3, pl. XVI, pt. 5, pp. 101–2.

13. See Norman de G. Davies 1917, pl. XII (TT 52, Nakht); Norman de G. Davies 1948, pl. II (TT 45, Djehuti); Säve-Söderbergh 1957, pl. XXII (TT 17, Nebamun); Nina de G. Davies 1963, pl. I (TT 38, Djeserkare-seneb). Deities depicted in private tombs wear the same set of jewelry as those at Deir el-Bahri. See, for example, a depiction of Hathor in Nina de G. Davies 1963, pl. 17 (TT 162, Kenamun).

14. See Aldred 1971, pp. 18–19, 228–29, figs. 117–120; A. Wilkinson 1971, pp. 101, 108; Eaton-Krauss 1982; Andrews 1990, pp. 181–84.

15. For a summary of the types of award jewelry, see Feucht 1977. For examples of the styles of each type, see Norman de G. Davies 1923, pl. XX (TT 90, Nebamun); Desroches-Noblecourt et al. 1986, pp. 26, 47 (TT 96, Sennefer). For statues of figures wearing the basic gold of honor, see cat. nos. 52 and 54, as well as Luxor J1 in Romano 1979, pp. 64–65, no. 82.

16. At Deir el-Bahri, Thutmose I has such a bracelet on his right hand when he is depicted making an offering (Naville 1894–1908, pt. 1, pl. XIV). Nebamun (TT 181) is shown reviewing a set of formal jewelry that includes the two types of bracelets (Metropolitan Museum of Art, New York, 30.4.103; C. K. Wilkinson and Hill 1983, p. 36).

17. An example in the Brooklyn Museum (40.522) has been dated to the Eighteenth Dynasty (James F. Romano in *Ägyptens Aufstieg* 1987, p. 234, no. 166). It is evident from its semicircular shape that this broad collar was not worn and was intended only for funerary use.

18. The vertically divided necklaces are based on the patterns found in *shenu* collars, whereas the zigzag and triangular motifs are derived from other varieties of collars (Brovarski 1997, figs. 5, 7, pl. 1).

19. Lilyquist 2003, pp. 162–63, figs. 152–54. See also Desroches-Noblecourt et al. 1986, pp. 58, 73 (TT 96, Sennefer). The wives of Amenhotepsise and Nebamun wear ribbed penannular hoops (Norman de G. Davies 1923, pls. XIV [TT 75, Amenhotepsise], XXIII [TT 90, Nebamun]).

20. For a good discussion, see A. Wilkinson 1971, pp. 121–28.

21. See, for example, finds from Abydos, Tombs D102 and D116 (Randall-MacIver and Mace 1902, pl. LIII); Aniba, Cemetery S (Steindorff 1935–37, vol. 2, pl. 58); Fadrus, Cemetery 185 (Säve-Söderbergh and Troy 1991, p. 29); Buhen, Cemeteries H and J (Randall-MacIver and Woolley 1911, pl. LX).

22. For Meryetamun, see Winlock 1932b.

23. Säve-Söderbergh 1957, pl. XXI (TT 17, Nebamun).

24. Metropolitan Museum of Art, New York, 68.136.1; Aldred 1971, pls. 82, 83.

25. Nubkheperre Inyotef, a Seventeenth Dynasty king; a woman who may be a Seventeenth Dynasty queen, from Dra Abu el-Naga; Ahhotep, the wife of Tao I; the early Eighteenth Dynasty queen Meryetamun. Alix Wilkinson (1971, pp. 93–96) provides a good summary of these finds, although her date for Meryetamun is too late. For a thorough discussion of the finds from the tomb of the foreign wives, see Lilyquist 2003. For a recent discussion of the Seventeenth Dynasty queen, see Eremin et al. 2000.

26. Schiaparelli 1927; Curto and Mancini 1968.

27. Her necklace is quite impressive, with seven rows of beads that include several types of hieroglyphic signs, a leafy plant, lilies, and palmettes (Rosati 1988, fig. 321).

28. For Abydos, see Arthur Cruttenden Mace in Randall-MacIver and Mace 1902; for Buhen, see Randall-MacIver and Woolley 1911; for Aniba, see Steindorff 1935–37, vol. 2; for Fadrus, see Säve-Söderbergh and Troy 1991; for Birabi, see Carnarvon and Carter 1912. Christine Lilyquist is now studying this material in more depth, for a future publication.

29. Lana Troy in Säve-Söderbergh and Troy 1991, pp. 78–79. Finds from the Eighteenth Dynasty tombs at Aniba appear to be fewer, but necklaces and design seals are still the most common jewelry. Rings, earrings, and a few bracelets were also recorded at Cemetery S at Aniba (Steindorff 1935–37, vol. 2).

30. Troy (in Säve-Söderbergh and Troy 1991, pp. 129–30) discusses how to identify each flower by the decoration on the bud. A wonderful necklace in alternating red- and blue-faience flowers—poppy and cornflower, respectively—indicates that the Egyptians clearly intended to depict both kinds of flowers (Kunsthistoriches Museum, Vienna, 8167; Seipel 2001, pp. 84–85, no. 85).

31. Troy in Säve-Söderbergh and Troy 1991, pp. 139–41.

32. In the case of the three foreign wives of Thutmose III, their royal status provided for more elaborate funerary items in sheet gold (see cat. nos. 132a, 132b, 134, 135a, 135b).

109. Strand of Lentoid Beads

Early 18th Dynasty, reign of Thutmose III (r. 1479–
1425 B.C.)
Egyptian blue
L. 41 cm (16⅛ in.); bead: Diam. 1.2–1.8 cm
(½–¾ in.), Th. 0.1 cm (1/16 in.)
The Metropolitan Museum of Art, New York,
Fletcher Fund, 1926 26.8.69a

The components of a set of award jewelry—
shebiu collars, *aʿa* armlets (cat. nos. 110a, 110b),
and at least one *mesektu* bracelet (cat. no. 111)—
were made in royal workshops and then delivered
to the pharaoh. Because these objects were made
for him, they often bear his name.[1] The pharaoh
wore these items, donated them to temples, or
bestowed them on the favorites in his court. The
high-ranking officials who received these special
pieces stood out as honored individuals. These
officials included pieces of award jewelry in their
burials, and in the paintings from their tombs
they are depicted wearing them.

Shebiu collars were traditionally made of
lentoid beads of gold[2] strung together and tied
around the owner's neck, often in sets of two
(see cat. nos. 52, 54; fig. 77).[3] This string of
beads, however, is made from Egyptian blue.[4]
Such faience or Egyptian-blue versions of the
shebiu have been interpreted as imitations of the
gold examples.[5] One wonders, however, why a
royal award would be imitated in faience.
Perhaps, in the same way that a faience or
Egyptian-blue *aʿa* armlet could be paired with a
gold one, collars of faience or Egyptian-blue
lentoid beads were made to complement a gold
collar. Although no known artistic representa-
tion can be cited to support this interpretation,
the burial of Tutankhamun (r. 1336–1327 B.C.),
for example, did include *shebiu* necklaces that
have faience beads mixed among the gold ones.

DCP

1. Amenhotep III displays a *mesektu* bracelet with his
 cartouche in an audience scene (Metropolitan
 Museum of Art, New York, 33.8.8; C. W. Wilkinson
 and Hill 1983, p. 125 [TT 120, Anen]). An excellent
 example belonging to Thutmose III is in the
 Rijksmuseum van Oudheden, Leiden (AO 2a;
 Raven 1995, fig. 193). An *aʿa* bracelet bears the
 name of Amenhotep III. Not all pieces of royal jew-
 elry bear inscriptions, however; those that did must
 have been especially desirable.
2. See Curto and Mancini 1968, pl. XII; Andrews 1990,
 p. 183, fig. 169.
3. That these necklaces seem to have been tied on
 probably explains why no clasp is visible on the
 one worn by the mummy of the mid-Eighteenth
 Dynasty official Kha (Curto and Mancini 1968, p. 78).
4. These beads are often found in faience, another

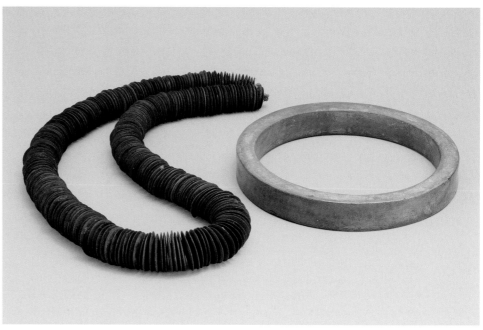

109, 110a

man-made material that is generally blue in color.
See the discussion of faience bowls in chapter 3.
5. Eaton-Krauss 1982; Andrews 1990, p. 183.

PROVENANCE: Western Thebes, Gabbanat el-
Qurud, Wadi D, Tomb 1

BIBLIOGRAPHY: Lilyquist 2003, pp. 136–37, fig. 120
(top)

110. *Aʿa* Armlets

a. Early 18th Dynasty, reign of Thutmose III (r. 1479–
1425 B.C.)
Egyptian blue
Diam. 10 cm (4 in.), Th. 1.4 cm (⅝ in.)
The Metropolitan Museum of Art, New York,
Fletcher Fund, 1926 26.8.140

b. Early 18th Dynasty (1550–1425 B.C.)
Gold
Diam. 10.5 cm (4⅛ in.), W. 1.9 cm (¾ in.), Th. 0.4 cm
(⅛ in.)
Rijksmuseum van Oudheden, Leiden AO 2c

Aʿa armlets appear to be the most commonly
owned piece from the set of gold award jewelry
(see cat. no. 109). One, two (cat. no. 52), or
three (fig. 77) were worn on each upper arm.
When the armlets were tripled, the upper and
lower ones were gold and the middle one was
blue. Thus the faience and Egyptian-blue
examples (cat. no. 110a) that have often been
called imitations of *aʿa* armlets or "poor man's
armlets"[1] were in fact part of a triple set. It

seems likely that those found with other jewelry
in the tomb of the three foreign wives of
Thutmose III were worn with gold armlets that
are no longer extant.

The few examples that have survived indi-
cate that the armlet was manufactured by beat-
ing a sheet of gold over a wood form to make a
three-sided shape. The final side was soldered
onto the internal face, creating the armlet's dis-
tinctive rectangular outline.[2] The king and
high-ranking officials wore this type, but lower-
ranking officials may have been given a simpler
version; the mummy of the architect Kha,
for example, has only a strip of gold wrapped
around the upper arms.[3]

DCP

1. Andrews 1990, p. 183.
2. Edward Brovarski in *Egypt's Golden Age* 1982, p. 243,
 no. 326; Andrews 1990, pp. 183–84, fig. 169.
3. Curto and Mancini 1968, p. 79, pl. XII.

PROVENANCE: *110a*. Western Thebes, Gabbanat
el-Qurud, Wadi D, Tomb 1
110b. Unknown

BIBLIOGRAPHY: *110a*. Winlock 1948, pl. XV, b
(lower left); Lilyquist 2003, p. 138, fig. 121
110b. H. D. Schneider 1997, p. 100, no. 153b

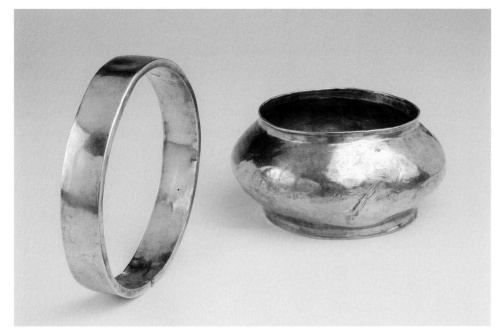

110b, 111

111. *Mesektu* Bracelet

Early 18th Dynasty (1550–1425 B.C.)
Gold
Diam. 10.5 cm (4⅛ in.), W. 5.4 cm (2⅛ in.)
Rijksmuseum van Oudheden, Leiden AO 2a

The *mesektu* bracelet is the rarest[1] of the three pieces of jewelry that compose the so-called gold-of-honor set, or award jewelry that the kings gave to high-ranking officials (see cat. no. 109).[2] If an official owned a *mesektu* bracelet, he also had *shebiu* collars and *aᶜa* armlets.

DCP

1. Only four examples survive in collections (Andrews 1990, p. 184).
2. Hans D. Schneider (in *Ägyptens Aufstieg* 1987, p. 233, no. 165) suggested that catalogue no. 111 belonged to Djehuti, one of the generals of Thutmose III, but his ownership is not documented (see Lilyquist 1988, p. 40).

PROVENANCE: From Thebes

BIBLIOGRAPHY: Hans D. Schneider in *Ägyptens Aufstieg* 1987, p. 233, no. 165; Raven 1995, p. 115; H. D. Schneider 1997, p. 100, no. 153a

112. Lotus Clasp

Early 18th Dynasty, reign of Thutmose III (r. 1479–1425 B.C.)
Gold, stone, glass
H. 8.7 cm (3⅜ in.)
Rijksmuseum van Oudheden, Leiden AO 1b

The size and quality of this spectacular clasp, as well as the cartouche of Thutmose III on the underside, indicate that it was made in a royal workshop. Remains of the ring attachments for joining strings of beads to the clasp are visible on the two removable sidepieces.[1] This large clasp was possibly part of a very large collar meant to adorn a cult statue in a temple, or an element of a pectoral, in which case the flower would have been the central element in the jewelry.

DCP

1. See, for example, the tombs of Thenuna (TT 76) in Säve-Söderbergh 1957, pl. LXXII; Kenamun (TT 93) in Norman de G. Davies 1930, pl. XV; Nebamun (TT 181) in Norman de G. Davies 1925, pl. XXXVII; Amenhotepsise (TT 75) in Norman de G. Davies 1923, pl. X; Nakht (TT 52) in Norman de G. Davies 1917, pl. XXIV; and C. K. Wilkinson and Hill 1983, fig. 63.

PROVENANCE: Perhaps from Saqqara

BIBLIOGRAPHY: Leemans 1846, p. 25, pl. 42, no. 362; H. D. Schneider and Raven 1981, no. 70; H. D. Schneider 1987, no. 83; Lilyquist 1988, pp. 40, 60; Raven 1995, p. 122; H. D. Schneider 1995, pp. 44–46, no. 15

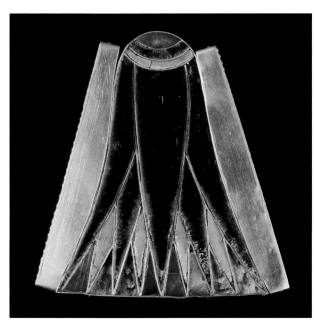

112

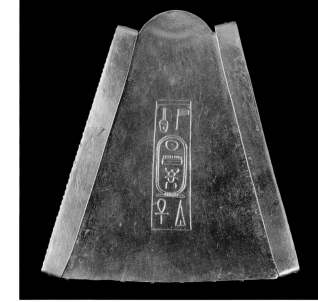

112, back

113. Diadem with Two Gazelles' Heads and Rosette Inlays

Early 18th Dynasty, reign of Thutmose III (r. 1479–1425 B.C.)
Gold, carnelian, opaque turquoise glass, crizzled glass
L. (of forehead band) 48 cm (18⅞ in.), W. (at bottom of vertical strip) 3 cm (1⅛ in.)
The Metropolitan Museum of Art, New York, Purchase, George F. Baker and Mr. and Mrs. V. Everit Macy Gifts, 1926 26.8.99

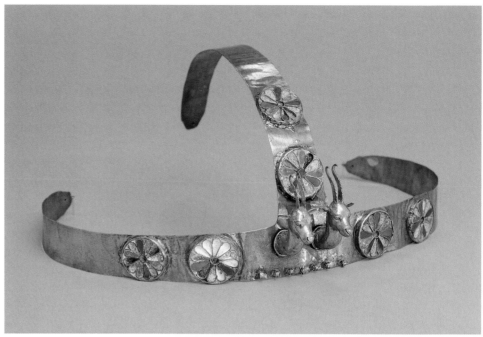

113

Head ornaments have a long tradition in ancient Egypt, with at least three different types known from Predynastic burials dating from about 3650–3100 B.C. During the Old Kingdom, pictures in tomb chapels and details on statues show, there were a variety of types, including fillets with the inlaid rosette pattern seen here, a thousand years later. In New Kingdom banquet scenes, many women wear fillets with a lotus above the brow. A few illustrations clearly indicate that circlets were made in metal. Once an emblem of royalty, such as the uraeus, is added to the fillet, the piece becomes a diadem, like those of the princesses Neferure and Nefrubiti (fig. 79). Surviving examples are rare. However, the T shape seen here—the form created when the three strips are pulled together with a tie—has parallels among Tutankhamun's parure, later in the Eighteenth Dynasty.

Christine Lilyquist has discussed in detail the possible meanings of the use of rosettes, leopards' heads (located at the end of each strip), and gazelles' heads on this piece.[1] Most important, she concluded that women from the royal harem probably wore diadems with gazelle's-head protomes when taking part in rituals honoring the goddess Hathor.

DCP

1. Lilyquist 2003, pp. 159–61.

PROVENANCE: Western Thebes, Gabbanat el-Qurud, Wadi D, Tomb 1

BIBLIOGRAPHY: Winlock 1933, pp. 156–60, fig. 3; Winlock 1935b, fig. 8; Winlock 1948, p. 16, pls. III, IV, VII, VIII, b, XLI, a, b; Hayes 1959, p. 133, fig. 70; N. E. Scott 1964, pp. 231–34, figs. 26, 27; Aldred 1971, pp. 205–6; A. Wilkinson 1971, pp. 115–16, 219, n. 15, pl. LXI, colorpl. IV; Elfriede Haslauer in Seipel 2001, pp. 74–75, no. 74; Christine Lilyquist in Ziegler 2002a, p. 460, no. 186; Ziegler 2002b, p. 263, fig. 31; Lilyquist 2003, pp. 154–62, 347–48, no. 108, figs. 91g, 92a–d, 155

BROAD COLLARS

As early as the beginning of the Fourth Dynasty (2575 B.C.), broad collars, a type of necklace made from multiple strands of beads gathered in endpieces, or terminals, were worn whenever a deity, king, or high-ranking official took part in a formal event at a temple, palace, or tomb. In the early Eighteenth Dynasty, the formal dress jewelry of the gods consisted of a broad collar and rigid cuff bracelets and armlets, and for the rest of ancient Egyptian history this set remained the most traditional Egyptian jewelry. The conventional broad collar consisted of cylindrical beads in green, blue, and red, strung vertically in rows of solid colors. Sometimes a row of gold-foil beads was included, or as in an example here (cat. no. 115), a thin row of much smaller beads separated each colored row. By the reigns of Hatshepsut and Thutmose III, women wore broad collars in a variety of beaded patterns (fig. 78). Tear-shaped drop pendants often hung from the bottom row, and although terminals could be simple semicircles, in the Middle Kingdom and later, falcon-head terminals are well known. A reconstructed collar with such terminals (cat.

no. 114)[1] belonged to one of the foreign wives of Thutmose III and may have been his gift to her, as such collars are well documented among the products of the king's workshops.

As early as the Seventeenth Dynasty (1640–1550 B.C.) some collars were made of decorative beads.[2] A reconstructed collar that belonged to a royal woman from Thutmose III's *harim* is made from gold and blue *nefer* signs[3] and palmettes, a floral-bead type (cat. no. 115). Like the broad collar with falcon-head terminals, such decorative collars are found among royal gifts.

DCP

1. For a complete discussion of the source of the beads in catalogue no. 114, see Lilyquist 2003, pp. 169–72.
2. Queen Ahhotep had beads that must have come from this type of collar (Aldred 1971, fig. 55).
3. W. Raymond Johnson (1999) has stated that the amulets read as *nefer* signs should be identified as *ḥrw* signs, but further study of this interesting suggestion seems necessary.

114. Broad Collar with Falcon-Head Terminals

Early 18th Dynasty, reign of Thutmose III (r. 1479–
1425 B.C.)
Gold, obsidian or black stone, jasper, carnelian,
turquoise glass, transparent crizzled glass
Collar: W. 36.5 cm (14⅜ in.); cylinder beads:
H. 0.5–0.95 cm (¼–⅜ in.); drop-shape beads:
H. 2.6 cm (1 in.)
The Metropolitan Museum of Art, New York,
Fletcher Fund, 1926 26.8.59a

PROVENANCE: Western Thebes, Gabbanat
el-Qurud, Wadi D, Tomb 1

BIBLIOGRAPHY: Winlock 1935b, fig. 13; Aldred 1971,
p. 208, fig. 65; Andrews 1990, pp. 120–21, fig. 103;
H. W. Müller and Thiem 1999, pp. 162, 163, fig. 347;
Lilyquist 2003, pp. 169–73, no. 129, figs. 91a, 163

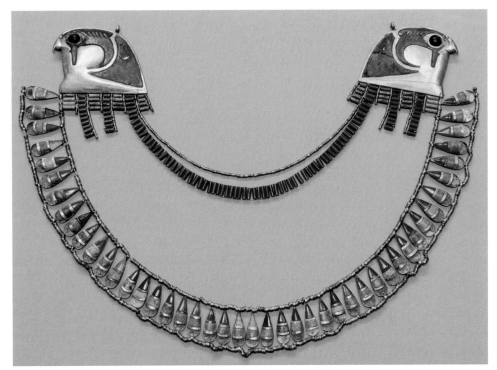

114

115. Broad Collar of *Nefer* Amulets

Early 18th Dynasty, reign of Thutmose III (r. 1479–
1425 B.C.)
Gold, crizzled glass, Egyptian blue
Collar: W. 31 cm (12¼ in.); *nefer* amulets: H. 1.4–
1.7 cm (⅝–¾ in.); palmette beads: H. 1.25 cm (½ in.)
The Metropolitan Museum of Art, New York,
Fletcher Fund, 1926 26.8.135a
Purchase, Frederick P. Huntley Bequest, 1958
58.153.9, 58.153.10
Purchase, Lila Acheson Wallace Gift, 1982
1982.137.3
Purchase, Lila Acheson Wallace Gift, 1988 1988.17
(selective)
Purchase, Lila Acheson Wallace Gift, 1988 1988.25.1
(selective)

PROVENANCE: Western Thebes, Gabbanat
el-Qurud, Wadi D, Tomb 1

BIBLIOGRAPHY: Aldred 1971, pp. 208–9, fig. 66;
Andrews 1990, p. 120, fig. 102; H. W. Müller and
Thiem 1999, p. 163, fig. 348; Lilyquist 2003, pp. 169–
73, no. 132, figs. 91d, 164

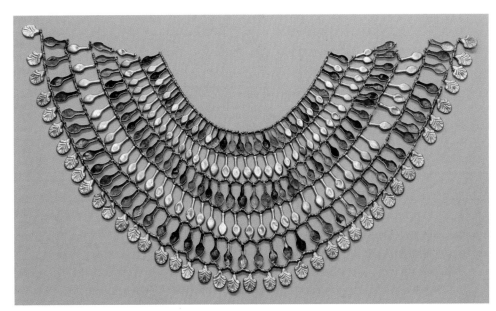

115

In the first half of the Eighteenth Dynasty, the types of jewelry people wore at formal events, such as a banquet, were consistent and the styles limited, except in the case of bracelets. Although men, when they wore bracelets, typically wore the solid inlaid cuff from the divine set (cat. nos. 116a, b), women expressed their personal taste by varying the number and styles of the bracelets they wore. Representations from tomb paintings depict four forms in addition to the solid cuff: the flexible beaded cuff (cat. no. 117), the non-fitted bracelet of multiple beaded strings (figs. 77, 78), the single string of beads, and the bangle (cat. nos. 166, 167). The use of beads of different sizes and colors, and variations in the manner in which they were strung, allowed craftsmen to produce a wide variety of designs. Most women attending banquets or partaking in offerings wore more than one bracelet and often an armlet as well. Apparently, it was unnecessary to wear matching bracelets, although some women did, especially the solid cuff type.

DCP

116. Pair of Solid Cuff Bracelets from the Divine Set

Early 18th Dynasty, reign of Thutmose III (r. 1479–1425 B.C.)

a. Gold, carnelian, turquoise glass
H. 7 cm (2¾ in.), Diam. 4.8 x 6 cm (1⅞ x 2⅜ in.; top), 5.1 x 6.3 cm (2 x 2½ in.; bottom)
The Metropolitan Museum of Art, New York, Fletcher Fund, 1926 26.8.129

b. Gold, carnelian, turquoise glass, crizzled glass
H. 7.2 cm (2⅞ in.), Diam. 4.8 x 6 cm (1⅞ x 2⅜ in.; top), 5.1 x 6.3 cm (2 x 2½ in.; bottom)
The Metropolitan Museum of Art, New York, Fletcher Fund, 1926 26.8.130

Made from fused sheets of gold with beads cemented into place, these large solid bracelets had hinges so that they could be clasped around the wrists. A pin was slipped through interlocking openings opposite the hinge to keep the bracelet in place. The bracelets were gifts to one of his wives from Thutmose III, whose name appears on the inside of each cuff. DCP

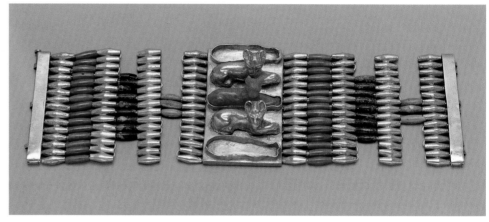

117

PROVENANCE: Western Thebes, Gabbanat el-Qurud, Wadi D, Tomb 1

BIBLIOGRAPHY: Winlock 1948, pl. XVII (bottom); Aldred 1971, p. 208, pl. 64 (bottom); Lilyquist 1988, figs. 61, 62; Andrews 1990, p. 154, fig. 125; H. W. Müller and Thiem 1999, p. 164, fig. 350; Elfriede Haslauer in Seipel 2001, p. 76, no. 76; Donadoni Roveri 2002, p. 335, figs. 10, 11; Christine Lilyquist in Ziegler 2002a, p. 461, no. 188; Lilyquist 2003, pp. 178–80, no. 141, figs. 89e, 91i, 172, 176, 225 (left)

117. Flexible Cuff Bracelet with a Spacer Depicting Cats

Early 18th Dynasty, reign of Thutmose III (r. 1479–1425 B.C.)
Gold, carnelian, lapis lazuli, turquoise glass
L. 16.8 cm (6⅝ in.); cat spacer: L. 6.2 cm (2½ in.), W. 2.9 cm (1⅛ in.); amulets: H. 2 cm (¾ in.); barrel bead: L. 0.6–0.9 cm (¼–⅜ in.)
The Metropolitan Museum of Art, New York, Fletcher Fund, 1919, 1920 26.8.121a

PROVENANCE: Western Thebes, Gabbanat el-Qurud, Wadi D, Tomb 1

BIBLIOGRAPHY: Lansing 1940, fig. 9; Winlock 1948, pp. 29–31, pls. XVI, b, c, XLII, d; Hayes 1959, pp. 134–35, fig. 72; Aldred 1971, pp. 214–15, fig. 84; A. Wilkinson 1971, pp. 103–4, pl. XXVII, a; Feucht 1975, pp. 390–91, no. 396a; Casson 1981, pp. 56–57; Andrews 1990, fig. 134; H. W. Müller and Thiem 1999, p. 160, fig. 342; Reeves 2000, p. 151; Christine Lilyquist in Ziegler 2002a, p. 461, no. 187; Lilyquist 2003, pp. 176–78, no. 137, figs. 91m (below), 170

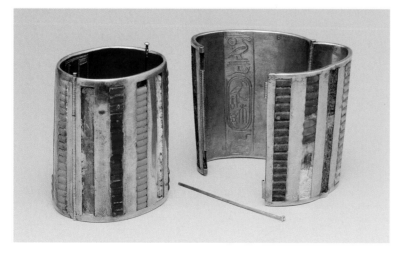

116a, b

EARRINGS

Earrings were popular jewelry in both the Near East and Nubia before their appearance in Egypt, and in time Egyptians borrowed styles from both these cultural areas.[1] The first evidence of Egyptian earring use is found on statues of servants made about 1850–1640 B.C., during the late Middle Kingdom. These statuettes, found in tombs, have thin spiral-shaped pieces of wire slipped through a hole in the earlobe.[2] By the early Eighteenth Dynasty, earrings are regularly part of funerary equipment. At this time, the most common form is penannular, in plain as well as ribbed versions. The thin spiral earrings of the Middle Kingdom as well as the leech type based on forms known throughout the Mediterranean appear, too. Men wore earrings, although with the exception of the highest-ranking officials they are rarely portrayed adorned thus.[3]　DCP

1. Andrews 1990, p. 111.
2. Eaton-Krauss 1982; Bourriau 1988, p. 124.
3. A. Wilkinson 1971, pp. 121–23; Eaton-Krauss 1982.

118.

a. Pair of Penannular Earrings

Early 18th Dynasty (1550–1425 B.C.)
Gold
Diam. 2.8 cm (1⅛ in.), Th. 1 cm (⅜ in.)
The Metropolitan Museum of Art, New York,
Rogers Fund, 1916 16.10.473, 16.10.474

b. Pair of Wire Earrings

Early 18th Dynasty (1550–1425 B.C.)
Electrum
Diam. 2.2 cm (⅞ in.), Th. 1.2–1.3 cm (½ in.)
The Metropolitan Museum of Art, New York,
Rogers Fund, 1916 16.10.469, 16.10.470

c. Pair of Beaded Penannular Earrings

Early 18th Dynasty (1550–1425 B.C.)
Gold, lapis lazuli
Diam. 1.9–2 cm (¾–⅞ in.), Th. 0.7 cm (¼ in.)
The Metropolitan Museum of Art, New York,
Purchase, Edward S. Harkness Gift, 1926 26.7.1355, 26.7.1357

118a, b

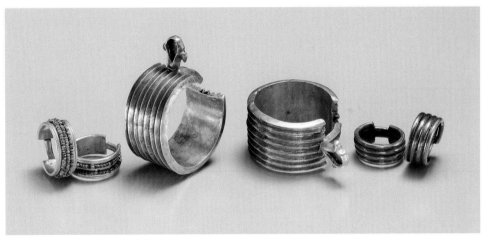

118c, d, e

d. Pair of Earrings for a Queen

Early 18th Dynasty, reign of Thutmose III
(r. 1479–1425 B.C.)
Gold
Diam. 3.5 cm (1⅜ in.), Th. 1.9–2 cm (¾–⅞ in.)
The Metropolitan Museum of Art, New York,
Fletcher Fund, 1926 26.8.92a, b

This pair belonged to one of the foreign wives of Thutmose III. Predictably, wealthy members of Egyptian society wore larger earrings than did others, and the representations seen in upper-class tombs are corroborated by rare archaeological finds like this pair. The earrings in catalogue number 118e, which are similar in style but come from a less elaborate burial, are much smaller although well made.　DCP

e. Pair of Ribbed Penannular Earrings

Early 18th Dynasty (1550–1425 B.C.)
Gold
Diam. 1.8 cm (¾ in.), Th. 0.8 cm (⅜ in.)
The Metropolitan Museum of Art, New York,
Purchase, Edward S. Harkness Gift, 1926 26.7.1335, 26.7.1336

PROVENANCE: *118a.* Western Thebes, Lower Asasif, CC41, Pit 3, burial B1; Metropolitan Museum of Art excavations, 1915–16
118b. Western Thebes, Lower Asasif, CC41, Pit 3, burial E4; Metropolitan Museum of Art excavations, 1915–16
118c. Western Thebes, Mandara; Carnarvon excavations, 1914
118d. Western Thebes, Gabbanat el-Qurud, Wadi D, Tomb 1
118e. Western Thebes, Birabi; Carnarvon excavations, 1911

BIBLIOGRAPHY: *118c. Ancient Egyptian Art* 1922, p. 19, no. 6
118d. Winlock 1935b, fig. 13; Winlock 1948, p. 18, pls. VIII, a, IX, XIV; Hayes 1959, p. 70; A. Wilkinson 1971, pp. 122, 220, n. 15, pl. XLV, a; Lilyquist 2003, p. 163, no. 113, fig. 154

GIRDLES

Girdles are one of the few jewelry forms worn exclusively by women, although apparently not in public at a formal event, to judge by the evidence of tomb scenes and statues. Servants, especially young ones, sometimes do wear girdles when they are depicted working at banquets or when they are included in the decoration on a cosmetic item (see cat. no. 167; fig. 78). Female musicians seem to be another group that wears girdles in public, but again only when they are at work, playing their instruments, or dancing.[1] All New Kingdom women apparently wore girdles, as we have examples from at least four strata of society: royal women, wives of middle-ranking nobles, wives of nonliterate men, and servants.[2] Girdles illustrated in tomb scenes have one or two thin strands of small beads, often with a large decorative bead inserted at consistent intervals among the beads (cat. nos. 119, 120, 167).

The two examples here represent girdles owned by women from different economic and social groups. The first belonged to one of the foreign wives of Thutmose III and, as a result, is made from a precious metal (cat. no. 119). It may even have been a formal gift from the king, as products of royal workshops include girdles resembling this one.[3] The second (cat. no. 120), a string of red and white beads, is tentatively identified as a girdle because it matches others found in burials still in position around the hips of nonroyal women.[4] DCP

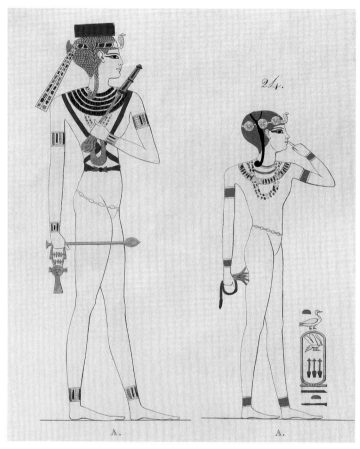

Fig. 79. Two young princesses, Neferure and Nefrubiti, wearing elaborate sets of jewelry, including diadems and girdles. Painted reliefs from Hatshepsut's temple at Deir el-Bahri, early 18th Dynasty. Nineteenth-century copies

1. See the tomb of Djeserkare-seneb (TT 38) in Nina de G. Davies 1963, pl. 6. In the Middle Kingdom, many girdles were constructed so that when the wearer moved they made a light jingle, making girdles fitting for musicians. This tradition must have continued into the New Kingdom, although the girdles do not seem to be designed to make sounds. Servants may have worn them for the same reason, although in their case youth appears to have been a factor as well.
2. Queens: Seventeenth Dynasty royal woman (Petrie 1909, p. 9, pl. XXIX); foreign wives of Thutmose III (Lilyquist 2003, pp. 174–75, nos. 135, 136, figs. 167, 168); Meryetamun (Winlock 1932b, p. 15, fig. 1, pl. XVII, a); middle-ranking women: Meryet (Curto and Mancini 1968, p. 79); women of the working class: western Thebes, Birabi, Tombs 37 (Burial 75), Lower Asasif, CC41, R2, Burial F5 (Metropolitan Museum of Art, New York, 16.10.275); servants: numerous tomb scenes, for example, Rekhmire (TT 100) in Norman de G. Davies 1943, pl. LXIV, or Djeserkare-seneb (TT 38) in Nina de G. Davies 1963, pl. 6.
3. Rekhmire (TT 100) in Norman de G. Davies 1943, pl. XXXVII.
4. This color combination is a popular one, at least in Thebes. See, for example, Carnarvon and Carter 1912, pl. LXXIII; Western Thebes, Lower Asasif, CC41, P2, Burial C1 (Metropolitan Museum of Art, New York, 16.10.394).

119. Girdle with Wallet Beads

Early 18th Dynasty, reign of Thutmose III (r. 1479–1425 B.C.)
Gold, lapis lazuli
Girdle: L. (as strung) 81.3 cm (32 in.), lapis lazuli bead: L. 1.2–1.5 cm (½–⅝ in.), W. 0.8–1.2 cm (⅜–½ in.), Th. 0.25 cm (⅛ in.)
The Metropolitan Museum of Art, New York, Fletcher Fund, 1926 26.8.60
Frederick P. Huntley Bequest, 1958 58.113.8 (selective)
Purchase, Lila Acheson Wallace Gift, 1982 1982.137.5 (selective)

It is generally accepted that the larger so-called wallet beads represent stylized cowrie shells.[1] Beads shaped like cowries were very popular in Middle Kingdom girdles. DCP

1. Andrews 1994, p. 42.

PROVENANCE: Western Thebes, Gabbanat el-Qurud, Wadi D, Tomb 1

BIBLIOGRAPHY: H. W. Müller and Thiem 1999, p. 165, figs. 355, 356; Lilyquist 2003, pp. 174–75, no. 135, fig. 167

120. Girdle (?)

Early 18th Dynasty (1550–1425 B.C.)
Calcite, carnelian
L. 98 cm (38⅝ in.); bead: Diam. 0.3 cm (⅛ in.)
The Metropolitan Museum of Art, New York, Purchase, Edward S. Harkness Gift, 1926 26.7.1389

PROVENANCE: Western Thebes, Birabi, Tomb 37, burial 78; Carnarvon excavations

BIBLIOGRAPHY: Carnarvon and Carter 1912, p. 85, pl. LXXIII, 78

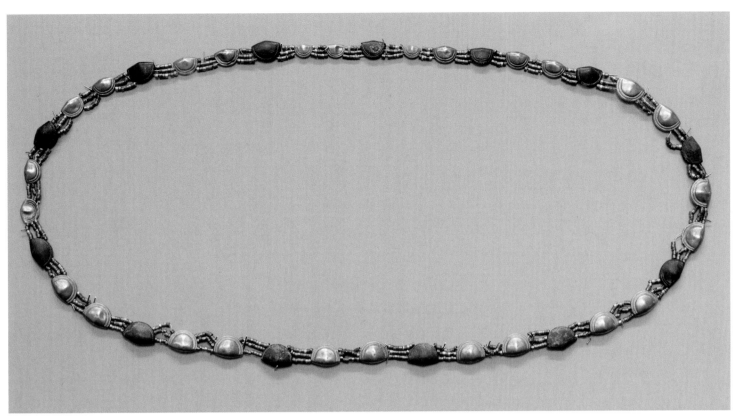

119

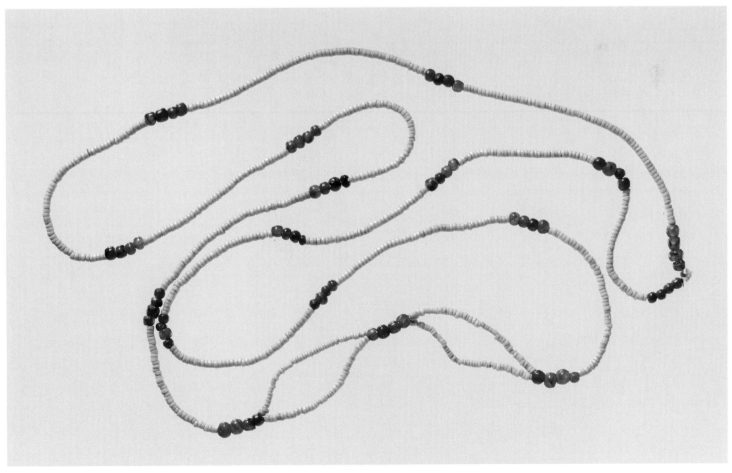

120

Single strands of beads, sometimes accompanied by amulets, were almost certainly the most common type of jewelry in any period of ancient Egyptian history.[1] In New Kingdom burials, necklaces have been found on mummies and in small boxes or baskets nearby.[2] Both men and women probably wore necklaces, but judging by details on statues, necklaces were clearly more popular with women. Representations of women occasionally show strands of beads around the neck, sometimes hanging between the breasts (see cat. no. 167; fig. 78). More than one necklace could be worn at a time, and given the length of some strings, they may have been looped over the head to look like several strands. Most strands of beads seem to have been designed, however, to rest on the upper

chest, just below the neck, where they would be less likely to get caught and break. Popular colors are turquoise, dark blue, red, white, and black—colors that were common for beads as early as Predynastic Egypt.[3]

DCP

1. Lana Troy (in Säve-Söderbergh and Troy 1991, p. 77) states that beads are the most common finds in New Kingdom sites and are mostly neck ornamentation.
2. Carnarvon and Carter 1912, p. 80, tomb 53.
3. In the Eighteenth Dynasty, beads no longer seem to be made from amethyst, the purple stone common earlier, in the Middle Kingdom. Whether this is due to a change in color preference or to a lack of access to the stone is unclear.

121. Choker of Gold Rings

Early 18th Dynasty (1550–1425 B.C.)
Gold
L. 33.5 cm (13¼ in.), Diam. 0.6 cm (¼ in.)
The Metropolitan Museum of Art, New York, Rogers Fund, 1916 16.10.314

Thin chokers made from tiny ring beads strung over a pad of fiber are rare and seem to be a style largely found in the Theban area, with the earliest identified example dating from the Eleventh Dynasty (2040 B.C.).[1] Burials from some five hundred years later, at Birabi, yielded a number of similar necklaces, including this one, of early Eighteenth Dynasty date.[2] It

seems that a few, perhaps wealthier, individuals had increasing numbers of strands of gold rings: a two-stranded example comes from Birabi,[3] and a rich burial of a woman at Qurna produced a necklace with four strings that come together in a clasp (cat. no. 3).[4] This design seems to be the foundation for a number of necklaces known from later periods, such as two collars of the Twenty-first Dynasty king Psusennes I (r. 1040–992 B.C.).[5]

Neither the thin rings nor the necklace's style matches that of collars specifically identified as *shebiu*, although these chokers have often been referred to as such. Several of these examples come from women's tombs, and there is no evidence from the early Eighteenth Dynasty that women were awarded honor collars.

DCP

1. Metropolitan Museum of Art, New York, 22.3.322, from Deir el-Bahri, temple of Mentuhotep II, tomb of Mayet; Andrews 1990, p. 117.
2. See the entry for catalogue no. 3 for a list.
3. Egyptian Museum, Cairo, JE 45661: Tomb 37, burial P1A1 (photograph 5A 105 in the archives of the Department of Egyptian Art, Metropolitan Museum).
4. Petrie 1909, pp. 6–11, pl. XXIX.
5. Cairo, JE 85751 and 85752; see Andrews 1990, p. 10, fig. 5; H. W. Müller and Thiem 1999, p. 209, figs. 433, 434.

PROVENANCE: Western Thebes, Asasif, CC41, R4, C1; Metropolitan Museum of Art excavations, 1915–16

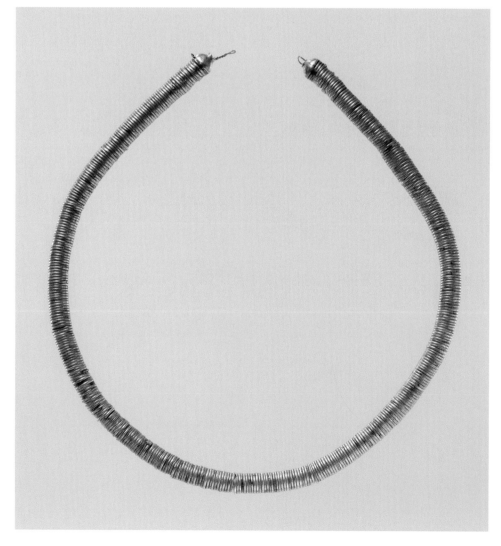

121

122. String of Beads with Feline's-Head Amulets

Early 18th Dynasty (1550–1425 B.C.)
Gold, Egyptian blue
L. 67 cm (26⅜ in.); bead: Diam. 0.7 cm (¼ in.)
The Metropolitan Museum of Art, New York,
Purchase, Edward S. Harkness Gift, 1926 26.7.1364

The use of feline's-head ornaments in jewelry
is well known from the Twelfth Dynasty (1981–
1802 B.C.) and continues in the early Eighteenth
Dynasty (see cat. no. 117).[1] It is difficult to iden-
tify the type of cat that the Egyptians had in
mind, although most seem to be leopards, an
animal that in the Middle Kingdom has apo-
tropaic properties.[2] On several necklaces with
matching beads found in early Eighteenth
Dynasty tombs, a feline's-head bead was used
as a centerpiece, so that the result looked like a
string tie.[3] DCP

1. Regine Schulz in *Ägyptens Aufstieg* 1987, p. 228,
 no. 157.
2. Andrews 1994, pp. 64–66; Lilyquist 2003, p. 159.
3. Randall-MacIver and Mace 1902, pp. 88–89,
 pl. XLVI; Marianne Eaton-Krauss in *Egypt's Golden
 Age* 1982, pp. 240–41, no. 320; Patch 1990, pp. 50–
 51, no. 35.

PROVENANCE: Western Thebes, Mandara;
Carnarvon excavations, 1914

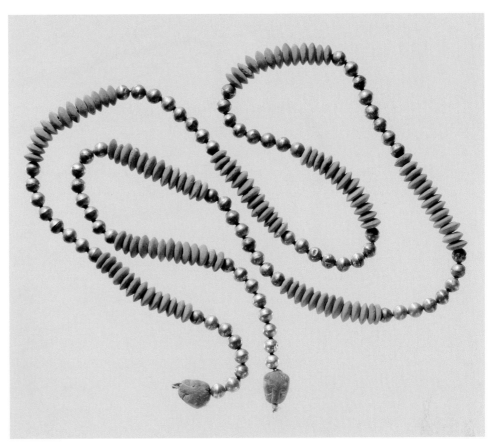

122

123. Necklace with *Nefer* Amulets

Early 18th Dynasty, reign of Thutmose III (r. 1479–
1425 B.C.)
Gold
L. 18.5 cm (7¼ in.); amulet: average H. 0.9 cm (⅜ in.)
The University of Pennsylvania Museum of
Archaeology and Anthropology, Philadelphia,
Gift of British School of Archaeology E 15789

The *nefer* sign was a hieroglyphic symbol that
stood for "good," "happy," or "beautiful." It
was a popular amulet in New Kingdom neck-
laces, both in simple forms, like the one here,
and as a component in broad collars (see cat.
no. 115). DCP

PROVENANCE: Sedment, probably Tomb 254;
W. M. Flinders Petrie excavations, 1921

BIBLIOGRAPHY: Marianne Eaton-Krauss in *Egypt's
Golden Age* 1982, p. 237, no. 310; Denise M. Doxey in
Silverman 1997, pp. 190–91, no. 54

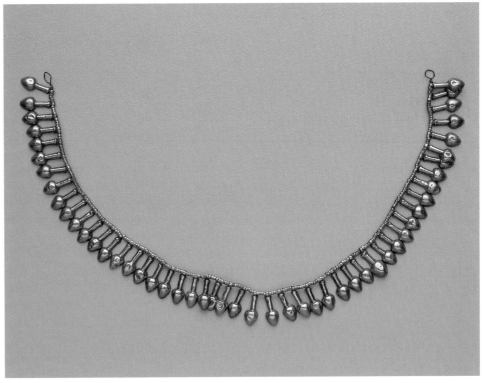

123

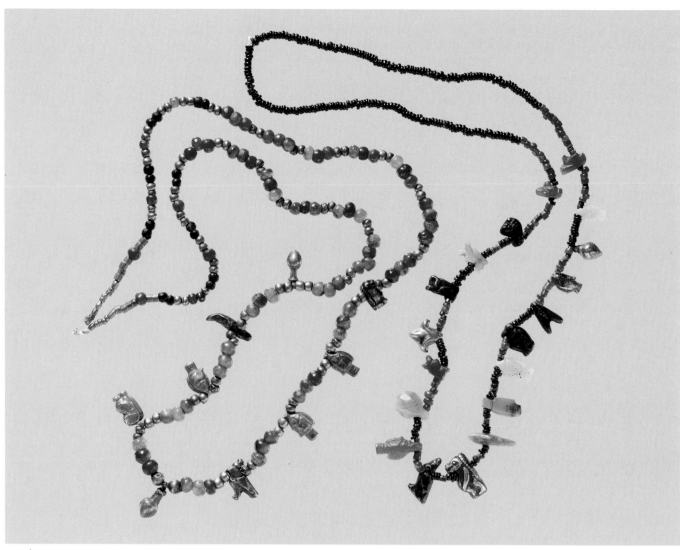

124a, b

124a. Necklace with Amulets

Early 18th Dynasty (1550–1425 B.C.)
Gold over pitch, carnelian, lapis lazuli
L. 42 cm (16½ in.); amulets: H. 0.9–1.1 cm (⅜ in.),
W. 0.3–0.5 cm (⅛–¼ in.)
The Metropolitan Museum of Art, New York,
Purchase, Edward S. Harkness Gift, 1926 26.7.1384

124b. Necklace of Beads and Amulets

Early 18th Dynasty (1550–1425 B.C.)
Carnelian, gold, silver, faience, glass, yellow stone,
tin
L. 34 cm (13⅜ in.); amulets: H. 0.5–1.1 cm (¼–⅜ in.)
The Metropolitan Museum of Art, New York,
Purchase, Edward S. Harkness Gift, 1926 26.7.1375

Catalogue number 124b is composed of tiny disk beads interspersed with a variety of amulets, including falcons, a frog, Tawerets, a lotus, bolti fish, a shell or bullae, a hand, and a *nefer* sign. Falcon amulets are a survival from the Middle Kingdom, when they were quite popular; they become rare in the New Kingdom. Some images, such as the lotus, frog, and fish, symbolize fertility, while Taweret and the falcon offer protection. The *nefer* sign conveys a good wish. This necklace was one of three stored in a small jewelry box in a man's burial.[1] DCP

1. Carnarvon and Carter 1912, p. 80.

PROVENANCE: *124a.* Western Thebes, Birabi, Tomb 37, burial 78; Carnarvon excavations, 1911
124b. Western Thebes, Birabi, Tomb 37, burial 53; Carnarvon excavations, 1911

BIBLIOGRAPHY: *124a.* Carnarvon and Carter 1912, p. 85, pl. LXXIII, 78
124b. Carnarvon and Carter 1912, p. 85, pl. LXXIII, 53

125a. Poppy-Bead Necklace

18th Dynasty (1550–1070 B.C.)
Faience
L. 35 cm (13¾ in.); amulet: H. 1.5 cm (⅝ in.),
W. 0.6 cm (¼ in.)
The Metropolitan Museum of Art, New York, Gift of Mrs. Edward S. Harkness, 1940 40.9.26

125b. Cornflower-Bead Necklace

18th Dynasty (1550–1070 B.C.)
Faience, glass
L. 37 cm (14⅝ in.); amulet: H. 1.2–1.5 cm
(½–⅝ in.), W. 0.6 cm (¼ in.)
The Metropolitan Museum of Art, New York,
Bequest of Mary Anna Palmer Draper, 1914 15.43.82

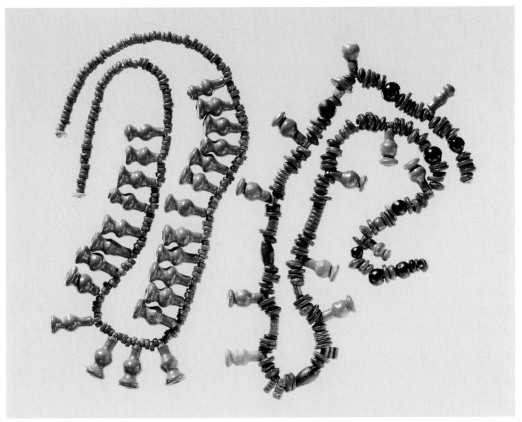

125a, b

A large group of New Kingdom bead types are based on flowers or their buds. Like the *nefer* signs, these elements are found in single strands of beads as well as broad collars, although flowers as components of broad collars seem to be most common after Hatshepsut's time. Two of the most popular floral beads depict the buds of poppies and of cornflowers. Both were staples of the Egyptian garden and were used to fashion fresh bouquets for shrines and floral broad collars.[1] Because the buds of these flowers have a similar shape, it is sometimes difficult to be sure which one is represented.[2] DCP

1. Germer 1985, pp. 44–45, 173; Manniche 1989, pp. 13, 24, 27–32, 85, 130–31.
2. Lana Troy (in Säve-Söderbergh and Troy 1991, p. 130) observed that cornflower-bud beads could have striations around the edge, imitating the laciness of the flower. However, a necklace from Amarna (Elfriede Haslauer in Seipel 2001, pp. 84, 85, no. 85) with a mixture of red and blue bud beads, suggesting poppies and cornflowers, shows the marks on beads of both colors.

The finest example of a necklace of cornflower or poppy buds (Metropolitan Museum of Art, New York, 26.7.1346, 26.7.1348, 30.8.66) was made from tiny gold rings soldered together to form the flowers. It was found in a royal tomb from the late New Kingdom, dating about 1070 B.C.

PROVENANCE: *125a, b.* Unknown

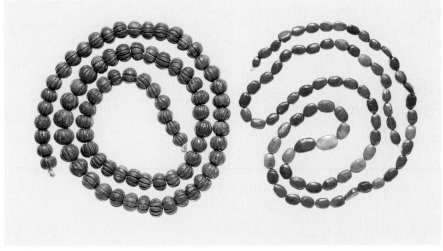

126a, b

126a. Melon-Bead Necklace

Early 18th Dynasty (1550–1425 B.C.)
Faience
L. 75.5 cm (29¾ in.); bead: Diam 1–1.3 cm (⅜–½ in.)
The Metropolitan Museum of Art, New York, Purchase, Edward S. Harkness Gift, 1926 26.7.1365

126b. String of Scaraboids

Early 18th Dynasty, reign of Thutmose I–reign of Thutmose III (1504–1425 B.C.)
Faience
L. 80 cm (31½ in.); scaraboid: L. 0.7–1.5 cm (¼–⅝ in.), W. 0.5–0.9 cm (¼–⅜ in.)

The Metropolitan Museum of Art, New York, Purchase, Edward S. Harkness Gift, 1926 26.7.1369

These scaraboids were among a large number spilled from a basket that had been placed in a child's coffin. DCP

PROVENANCE: *126a.* Western Thebes, Birabi, Tomb 37, burial 13; Carnarvon excavations, 1911
126b. Western Thebes, Birabi, Tomb 37, burial 31; Carnarvon excavations, 1911

BIBLIOGRAPHY: *126a.* Carnarvon and Carter 1912, p. 71, pl. LXXIII, 13
126b. Carnarvon and Carter 1912, pp. 69, 78, pl. LXXIII, 31

From the earliest times, the ancient Egyptians carried charms, many carved in the shapes of animals, and by the Middle Kingdom (2040–1650 B.C.), the scarab beetle was the most common amulet type. The Egyptians chose this insect to represent Khepri, the god of the morning sun, because of specific behaviors in the beetle's life cycle that were reminiscent of the sun's form and movement across the sky.[1] Because of its association with the sun, the scarab became a potent symbol of rebirth and an immensely popular amulet.

Scarab amulets are easily identifiable, as the beetle's head, body, and wing cases were delineated on the amulet's back. Its legs were often outlined along the sides. When the scarab was made from steatite, an easily carved stone, the base was inscribed either with a name and title or with a design. After carving, the finished object was generally dipped into a glaze and baked. The result was a sturdy blue or green amulet. In the New Kingdom, faience, a ceramic material that could also be glazed, and glass were likewise used to produce scarabs and the related design or seal amulets.

In the Old Kingdom (2649–2150 B.C.), before the appearance of scarabs, small stamp seals whose backs could be a human, animal, or geometric shape were used to impress damp clay sealing containers or other goods. Over time, the amuletic aspect of seals became pronounced, so

that these new design seals or amulets, as they are now known, appear to have been used as good-luck charms, sources of protection, or a means to communicate a wish to a deity. In the Middle Kingdom, scarabs supplanted stamp seals and design amulets in popularity, but in the New Kingdom design amulets again became common, although scarabs never went out of use.

When a scarab's owner wanted to protect himself from the many negative forces around him, such as disease, injury, infertility, or hunger, he would wear an amulet that bore a powerful name, such as that of a god or king, or depicted a protective or sympathetic sign, such as a *wedjat* eye (cat. no. 75f).[2] The scarab beetle itself most certainly was a good-luck charm, as were the depictions of bolti fish or ankh signs. The Egyptians wore scarab and design amulets in rings, strung them in jewelry, kept them in a basket or wooden box at home, and may have carried them in a small pouch when it was not practical to wear jewelry. DCP

1. For discussion of the scarab beetle's life cycle, see Ben-Tor 1989 and Andrews 1994, pp. 50–51.
2. To see a complete range of designs on scarabs from the reign of Thutmose III, see Jaeger 1982.

127. Cowroid Beads Mounted for Rings

Early 18th Dynasty (1550–1425 B.C.)

a. Silver, calcite
L. 1.7 cm (⅝ in.), W. 1.1 cm (⅜ in.), Th. 0.3 cm (⅛ in.)
The Metropolitan Museum of Art, New York,
Purchase, Edward S. Harkness Gift, 1926 26.7.1125

b. Gold, glass
L. 1.8 cm (¾ in.), W. 1.6 cm (⅝ in.), Th. 0.4 cm (¼ in.)
The Metropolitan Museum of Art, New York,
Purchase, Edward S. Harkness Gift, 1926 26.7.1126

c. Gold, lapis lazuli
L. 1.7 cm (⅝ in.), W. 1.4 cm (½ in.), Th. 0.4 cm (¼ in.)
The Metropolitan Museum of Art, New York,
Purchase, Edward S. Harkness Gift, 1926 26.7.1127

These rings are three of at least five discovered in a woman's grave. Two were found together on her finger. DCP

PROVENANCE: Western Thebes, Birabi, Tomb 37, burial 78; Carnarvon excavations, 1911

BIBLIOGRAPHY: Carnarvon and Carter 1912, p. 85, pl. LXXII, 78

128.
a. Plaque Inscribed for King Ahmose I

Early 18th Dynasty (1550–1425 B.C.)
Glazed steatite
H. 1.4 cm (½ in.), W. 1.2 cm (½ in.), Th. 0.5 cm (¼ in.)
The Metropolitan Museum of Art, New York,
Purchase, Edward S. Harkness Gift, 1926 26.7.121

The base of the design amulet is inscribed with Ahmose I's prenomen, Nebpehtyre. The winged sphinx on the back is a protective device symbolizing the king's power. The wings appended to the lion may relate to the original identity of the sphinx, which was that of Horus of the Horizon, a falcon-headed god merged with the sun.

b. Scarab of Ahhotep

17th Dynasty, reign of Tao I (r. 1560 B.C.)
Glassy faience
L. 2.1 cm (¾ in.), W. 1.5 cm (⅝ in.), Th. 1 cm (⅜ in.)
The Metropolitan Museum of Art, New York,
Purchase, Edward S. Harkness Gift, 1926 26.7.120

127a, b, c

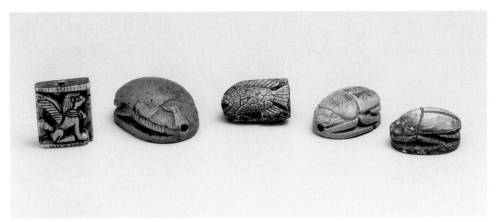

128a, b, c, d, e

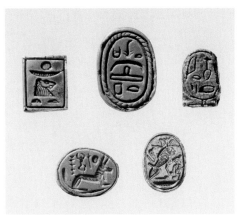

128, bases: a, b, c (top), d, e

The scarab was made to honor the wife of Tao I, a Seventeenth Dynasty king, and the elements on its back and base are typical for that period. The inscription on the base reads "King's Wife, Ahhotep."

c. Design Amulet of a Bolti Fish

Early 18th Dynasty, reign of Thutmose II (r. 1492–1479 B.C.)
Glazed steatite
L. 1.5 cm (⅝ in.), W. 1 cm (⅜ in.), Th. 0.6 cm (¼ in.)
The Metropolitan Museum of Art, New York,
Purchase, Edward S. Harkness Gift, 1926 26.7.125

The inscription on the base of the amulet reads "Nefertari" and may refer to Ahmose-Nefertari, the wife of King Ahmose I and the mother of Amenhotep I. She was held in high regard throughout the New Kingdom.

d. Scarab of Thutmose II

Early 18th Dynasty, reign of Thutmose II (r. 1492–1479 B.C.)
Glazed steatite
L. 1.6 cm (⅝ in.), W. 1.2 cm (½ in.), Th. 0.8 cm (⅜ in.)
The Metropolitan Museum of Art, New York,
Purchase, Edward S. Harkness Gift, 1926 26.7.145

This scarab shows a reclining jackal, probably representing Anubis, with the prenomen of Thutmose II, Aakheperenre, above its back.

e. Scarab with a Protective Motif

Early 18th Dynasty (1550–1425 B.C.)
Glazed steatite
L. 1.5 cm (⅝ in.), W. 1.2 cm (½ in.), Th. 0.8 cm (⅜ in.)
The Metropolitan Museum of Art, New York,
Purchase, Edward S. Harkness Gift, 1926 26.7.484

The scarab's base depicts a falcon-headed sphinx wearing the *atef* crown as it subdues an enemy of Egypt. The falcon represents Re-Herakhti, or the god Horus when he is merged with the sun, while the sphinx represents another aspect of Horus as well as the might of the pharaoh. The *atef* crown is most closely associated with Osiris, the ruler of the underworld. Such iconography would make this scarab an excellent amulet, as the image connects the two realms that protect Egypt: that of the king and that of the gods. The uraeus seen in the background also was a powerful symbol of protection.

f. Ring with a Scarab Bezel

Early 18th Dynasty, joint reign of Hatshepsut and Thutmose III (1479–1458 B.C.)
Glazed steatite, silver
Ring: Diam. 2.4 cm (1 in.), diam. with bezel 2.7 cm (1⅛ in.); scarab: L. 1.4 cm (½ in.), W. 1.2 cm (½ in.), Th. 0.7 cm (¼ in.)
The Metropolitan Museum of Art, New York,
Purchase, Edward S. Harkness Gift, 1926 26.7.770

This ring is typical in shape for New Kingdom rings having a mounted scarab. It was discovered on the third finger of a man's left hand.

DCP

PROVENANCE: *128a*. Western Thebes, Lower Asasif, Tomb 47, burial 13; Carnarvon excavations, 1912
128b. Western Thebes, Lower Asasif, Tomb 44, burial 4; Carnarvon excavations, 1912
128c. Western Thebes, Birabi, Tomb 37, burial 59d; Carnarvon excavations, 1911
128d. Western Thebes, Birabi, Tomb 37, burial 59d; Carnarvon excavations, 1911
128e. Western Thebes, Lower Asasif; Carnarvon excavations, 1907–11
128f. Western Thebes, Birabi, Tomb 37, burial 21; Carnarvon excavations, 1911

BIBLIOGRAPHY: *128a*. Hayes 1959, p. 44
128b. Hayes 1959, pp. 5, fig. 1, 10
128c. Carnarvon and Carter 1912, pl. LXXII, 59d; Hayes 1959, p. 46
128d. Carnarvon and Carter 1912, pl. LXXII, 59d; Hayes 1959, p. 79
128f. Carnarvon and Carter 1912, p. 73, pl. LXXII, 21

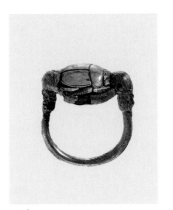

128f

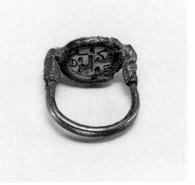

128f, base

129a. Ring with a Feline's Head

Early 18th Dynasty (1550–1425 B.C.)
Glazed steatite, bronze
Ring: Diam. 2.1 cm (¾ in.) x 2.2 cm (⅞ in.); amulet:
L. 1.1 cm (⅜ in.), W. 0.9 cm (⅜ in.), Th. 0.7 cm (¼ in.)
The Metropolitan Museum of Art, New York,
Purchase, Edward S. Harkness Gift, 1926 26.7.773

The animal depicted on the back of this design amulet is most likely a cat, although we cannot be certain that is the animal the craftsman intended to represent. Nor can the amulet be precisely identified with any one goddess, as there were a number of deities associated with felines. It is possible that the ring's owner wished for fertility, which the ancient Egyptians associated with cats. The inscription is of no help, as the signs do not convey a particular message, although the ankh reads "life" and the lotus is a rebirth symbol. The excellent condition and the subject matter of the ring suggest that it was a votive offering to a shrine of Hathor at Deir el-Bahri.

129b. Design Amulet Depicting a Fly

Early 18th Dynasty (1550–1425 B.C.)
Glazed steatite
L. 1.4 cm (½ in.), W. 1 cm (⅜ in.), Th. 0.7 cm (¼ in.)
The Metropolitan Museum of Art, New York,
Purchase, Edward S. Harkness Gift, 1926 26.7.644

Examples of amulets shaped like a fly are known from Predynastic graves (3600 B.C.). It remains unclear why the fly possessed an amuletic purpose; possible explanations for its depiction include both its fecundity and the need to rid oneself of this common pest.[1] During the Second Intermediate Period and the early New Kingdom, the king bestowed large gold fly amulets on men who had fought with valor alongside him. The best known are the

three from the burial of Queen Ahhotep, the wife of Seqenenre and mother of Ahmose I—two kings who fought the Hyksos rulers. It seems unlikely, though, that the piece here is related to the large award examples, especially given the long history of fly amulets in ancient Egypt.

The underside is inscribed with a group of hieroglyphs inside a cartouche, which would imply a royal name, although whose is unknown. DCP

1. Andrews 1994, pp. 62–63.

PROVENANCE: *129a.* Western Thebes, Lower Asasif; Carnarvon excavations, 1907–11
129b. Western Thebes, Lower Asasif; Carnarvon excavations, 1907–11

BIBLIOGRAPHY: *129a.* Andrews 1994, pp. 32–33

130a. Scarab with a Fish Holding the Bud of a Lotus

Early 18th Dynasty, probably 2nd half of joint reign of Hatshepsut and Thutmose III (1473–1458 B.C.)
Jasper
L. 1.4 cm (½ in.), W. 1.2 cm (½ in.), Th. 0.7 cm (¼ in.)
The Metropolitan Museum of Art, New York,
Purchase, Edward S. Harkness Gift, 1926 26.7.525

Both the bolti fish and the lotus inscribed on the base were symbols of rebirth, suggesting that this scarab was specifically made to assist the deceased with a successful transition into the afterlife.

130b. Scarab of Amenhotep I

Early 18th Dynasty, reign of Amenhotep I (r. 1525–1504 B.C.)
Jasper

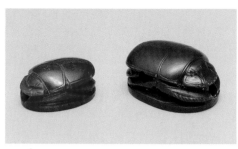

130a, b

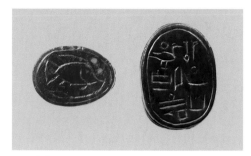

130a, b, bases

L. 1.8 cm (¾ in.), W. 1.3 cm (½ in.), Th. 0.9 cm (⅜ in.)
The Metropolitan Museum of Art, New York,
Purchase, Edward S. Harkness Gift, 1926 26.7.133

Scarabs made from hard stone, which is difficult to carve, are not common in the New Kingdom. This one bears the prenomen and nomen of the king. DCP

PROVENANCE: *130a.* Western Thebes, Birabi, Tomb 37; Carnarvon excavations, 1911
130b. Western Thebes, Lower Asasif, CC 37, burial 16, basket; Carnarvon excavations, 1910–1911

BIBLIOGRAPHY: *130a.* Carnarvon and Carter 1912, p. 80, pl. LXXII, 52
130b. Carnarvon and Carter 1912, p. 72, pls. LXV, LXXII, 16; Hayes 1959, p. 51

131.
a. Scarab with a Rearing Ibex

Early 18th Dynasty, reign of Thutmose I–reign of Thutmose III (1504–1425 B.C.)
Glazed steatite
L. 1.4 cm (½ in.), W. 1.2 cm (½ in.), Th. 0.7 cm (¼ in.)
The Metropolitan Museum of Art, New York,
Purchase, Edward S. Harkness Gift, 1926 26.7.539

The ibex was often employed as a symbol for renewal.[1]

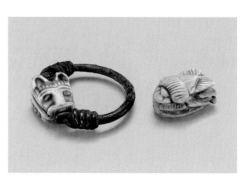

129a, b

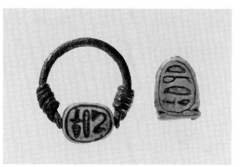

129a, b, bases

b. Scarab in a Ring Bezel

Early 18th Dynasty, reign of Thutmose I–reign of
Thutmose III (1504–1425 B.C.)
Glazed steatite, electrum
Ring bezel: L. 1.6 cm (⅝ in.), W. 1.2 cm (½ in.),
Th. 0.7 cm (¼ in.); scarab: L. 1.2 cm (½ in.), W. 0.9 cm
(⅜ in.), Th. 0.7 cm (¼ in.)
The Metropolitan Museum of Art, New York,
Purchase, Edward S. Harkness Gift, 1926 26.7.560

A giraffe is the central image on the base of this
scarab, which was once part of a ring. This ani-
mal was associated with prophecy,² so that it, in
combination with the hieroglyphs, predicted for
its owner a "life of all good things."

c. Scarab with a Seated Man

Early 18th Dynasty, reign of Thutmose II (r. 1492–
1479 B.C.)
Glazed steatite
L. 1.4 cm (½ in.), W. 1.1 cm (⅜ in.), Th. 0.7 cm (¼ in.)
The Metropolitan Museum of Art, New York,
Purchase, Edward S. Harkness Gift, 1926 26.7.506

The motif of a seated man smelling a lotus was
a common one for the base of scarabs. DCP

1. Dorothea Arnold 1995, p. 13.
2. Brunner-Traut 1977.

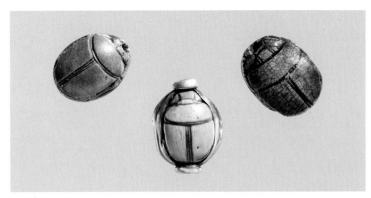

131a, b, c

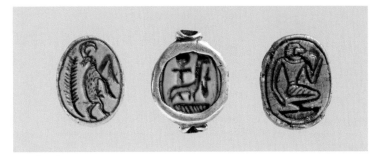

131a, b, c, bases

PROVENANCE: *131a.* Western Thebes, Birabi, Tomb
37, pit D, burial 59; Carnarvon excavations, 1911
131b. Western Thebes, Birabi, Tomb 37, burial 59a;
Carnarvon excavations, 1911
131c. Western Thebes, Birabi, Tomb 37, burial 59d;
Carnarvon excavations, 1911

BIBLIOGRAPHY: *131a.* Carnarvon and Carter 1912,
p. 81, pl. LXXII, 59
131b. Carnarvon and Carter 1912, p. 81, pl. LXXII, 59a
131c. Carnarvon and Carter 1912, p. 81, pl. LXXII, 59d;
Hayes 1959, p. 36, fig. 17

FUNERARY JEWELRY

The burial, in western Thebes, of the three foreign wives of Thutmose
III (r. 1479–1425 B.C.) is in some ways typical of most ancient Egyptian
burials of the New Kingdom. It contained objects used during the
women's lives as well as objects manufactured solely for use in the tomb.
A sizable quantity of the ornaments recovered from the tomb were
made exclusively to adorn the mummies. The funerary jewelry can be
distinguished from pieces worn during the women's lifetime either
because it is fragile, as it did not need to withstand the rigors of frequent
use, or because the pieces depict religious iconography associated with
the afterlife.

Since the period of transition from this world to the next was a dan-
gerous one, mummies were given amuletic pieces to protect them. The
heart scarabs, gold collars and breastplates, and certain beads found in
the burial of Thutmose III's foreign wives were meant to protect the
women between death and rebirth. The falcon collar (cat. no. 132a) and

the vulture breastplate (cat. no. 132b) display iconography that had long
been part of funerary ritual: such objects are among those depicted on
Middle Kingdom coffins. Similar pieces found with Tutankhamun's
mummy indicate that they were to be placed on the mummy's chest.¹

In order to embellish their mummy for the afterlife, the wealthy could
also afford gold sandals (cat. no. 134) and stalls for the fingers and toes
(cat. nos. 135a, b). During the mummification process the nails of the
fingers and toes became fragile, and stalls kept them in place. In life, only
the highest-ranking individuals in ancient Egyptian society wore sandals
as an article of dress.² The use of sheet gold for the sandals in the exhibi-
tion makes them clearly funerary jewelry. DCP

1. Reeves 1990a, pp. 112–13.
2. Sandals were also among the objects depicted on the *frise d'objets* on Middle
 Kingdom coffins.

132a. Collar with Falcon-Head Terminals

Early 18th Dynasty, reign of Thutmose III (r. 1479–1425 B.C.)
Gold sheet
Max. W. 32 cm (12⅛ in.), Th. 0.12–0.14 mm (1/200 in.)
The Metropolitan Museum of Art, New York, Fletcher Fund, 1926 26.8.102

132b. Vulture Breastplate

Early 18th Dynasty, reign of Thutmose III (r. 1479–1425 B.C.)
Gold sheet
Max. W. 37.3 cm (14¾ in.), Th. 0.1–0.13 mm (1/250–1/200 in.)
The Metropolitan Museum of Art, New York, Fletcher Fund, 1926 26.8.105

PROVENANCE: Western Thebes, Gabbanat el-Qurud, Wadi D, Tomb 1

BIBLIOGRAPHY: *132a.* Winlock 1948, pl. XXIV (center); Lilyquist 2003, pp. 130–32, no. 27, fig. 111 *132b.* Winlock 1948, pl. XXV (top); Lilyquist 2003, pp. 130–32, no. 28, fig. 109

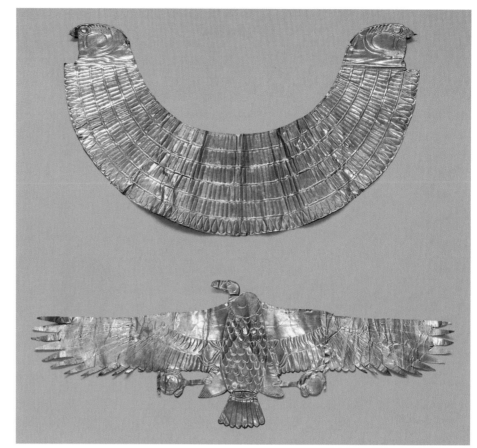

132a, b

133. *Sweret* Bead on a Wire

Early 18th Dynasty, reign of Thutmose III (r. 1479–1425 B.C.)
Gold wire, carnelian
Bead: L. 1.9 cm (¾ in.), Diam. 1 cm (⅜ in.); wire: Diam. 10 cm (4 in.)
The Metropolitan Museum of Art, New York, Fletcher Fund, 1926 26.8.113

The *sweret* bead was a popular amulet from about 1981 B.C. to about 1650 B.C., during the Middle Kingdom. Worn at the throat, a carnelian bead was often inscribed with the deceased's name, to insure its preservation.[1] The three foreign wives of Thutmose III may have included *sweret* beads in their burials out of a desire to continue this old practice, although the beads may have a new meaning too. By the early New Kingdom, it was no longer necessary to place the *sweret* bead at the throat. Instead, the beads were strung on a strand of wire, its ends twisted so that the amulet could be slipped onto the arm during mummification. Tutankhamun's mummy illustrates this practice, for he has a number of amulets, including *sweret* beads, attached in the same manner.[2]

DCP

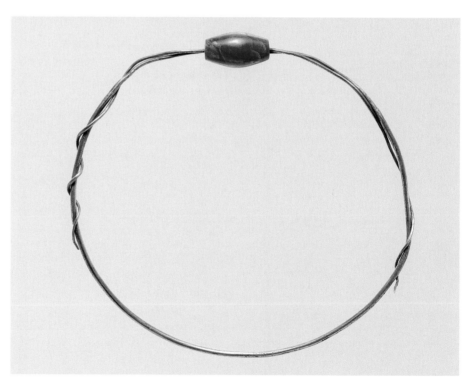

133

1. Andrews 1994, p. 99.
2. Photographs TAA 1015, 1232, and 1250 in the archives of the Department of Egyptian Art, Metropolitan Museum.

PROVENANCE: Western Thebes, Gabbanat el-Qurud, Wadi D, Tomb 1

BIBLIOGRAPHY: Winlock 1948, pl. XXXIII, a; Lilyquist 2003, p. 130, no. 20, fig. 104 (top center)

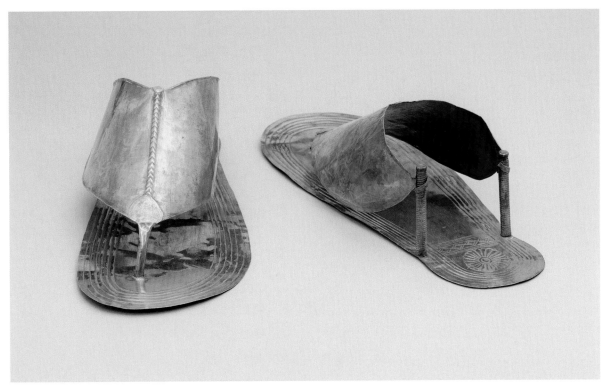

134

134. Sandals

Early 18th Dynasty, reign of Thutmose III (r. 1479–
1425 B.C.)
Gold
L. 25.8 cm (10⅛ in.), W. 9.6 cm (3¾ in.)
The Metropolitan Museum of Art, New York,
Fletcher Fund, 1926 26.8.148a, b

PROVENANCE: Western Thebes, Gabbanat
el-Qurud, Wadi D, Tomb 1

BIBLIOGRAPHY: Winlock 1948, pl. XXVI (bottom);
H. W. Müller and Thiem 1999, p. 164, fig. 351;
Lilyquist 2003, pp. 133–35, no. 33, fig. 118

135a. Finger Stalls

Early 18th Dynasty, reign of Thutmose III (r. 1479–
1425 B.C.)
Gold sheet
L. 4.5–5.4 cm (1¾–2⅛ in.)
The Metropolitan Museum of Art, New York,
Fletcher Fund, 1926 26.8.149, .154–.155, .157–.161,
.163, .166

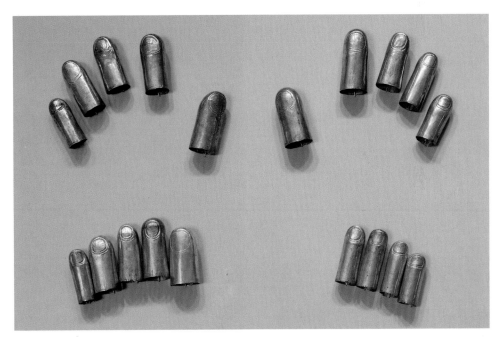

135a (top), 135b

135b. Toe Stalls

Early 18th Dynasty, reign of Thutmose III (r. 1479–
1425 B.C.)
Gold sheet
L. 4.5–5.4 cm (1¾–2⅛ in.)
The Metropolitan Museum of Art, New York,
Fletcher Fund, 1926 26.8.190–.192, .195–.197,
.200–.202

This nearly complete set is among the earliest
known examples of such coverings, which
appear to be the prerogative of royalty.[1]

DCP

1. Lilyquist 2003, p. 135.

PROVENANCE: Western Thebes, Gabbanat
el-Qurud, Wadi D, Tomb 1

BIBLIOGRAPHY: Lilyquist 2003, p. 136, no. 35, fig. 114

HEART SCARABS AND AMULETS

In the New Kingdom, spells protecting the deceased during his travel to the underworld and his judgment before Osiris were formalized in a collection that the Egyptians referred to as the Book of Coming Forth by Day, now more popularly known as the Book of the Dead. Among these spells, one (chapter 30B) calls upon the deceased's heart to be silent when he stands before Osiris, while the god decides whether he is worthy of an afterlife. If an individual's heart was silent at this crucial point in the journey to the afterlife, no error in judgment that the heart's owner had made during his lifetime would catch Osiris's attention. To ensure that the deceased would be without difficulties, the Egyptians began to manufacture large scarabs, now known as heart scarabs (cat. nos. 41, 136), upon which they frequently inscribed this vital spell.[1] The earliest example inscribed with the spell dates from the reign of the Thirteenth Dynasty king Sebekhotep IV (r. 1731–1719 B.C.).[2]

Ownership of either a heart scarab or a heart amulet (see below), especially when inscribed, seems to have been the prerogative of the upper class. The scarabs' significance is reinforced by the way they were worn: generally mounted in a gold bezel and often hung from a long, thick gold chain.[3] Wall paintings from the tombs of Sennefer and Rekhmire depict large scarab pectorals—presumably heart scarabs, as they are on long necklaces—among their funerary equipment.[4] Some heart scarabs may have been royal gifts, as a scarab pectoral is illustrated among the products of a king's workshop.[5]

Heart amulets had a different function, as they were designed to replace the heart if it was somehow lost or damaged—the Egyptians considered the heart to be the center of a person's intellect. It seems that the functions of the heart amulet and heart scarab occasionally merged, resulting in a heart amulet inscribed with chapter 30B from the Book of the Dead (cat. no. 137).

DCP

1. Andrews 1994, pp. 56–59, 72–73.
2. Ibid., p. 56.
3. Curto and Mancini 1968, p. 78, pl. XII.
4. Sennefer (TT 96) in Desroches-Noblecourt et al. 1986, p. 66.
5. Puimre (TT 39) in Norman de G. Davies 1922–23, vol. 1, pl. XXIII.

136. Heart Scarab of General Djehuti

Early 18th Dynasty, reign of Thutmose III (r. 1479–1425 B.C.)
Gold, green stone
Scarab: L. 8.3 cm (3¼ in.), W. 5.3 cm (2⅛ in.),
Th. 2.7 cm (1⅛ in.); chain: L. 133 cm (52⅜ in.)
Rijksmuseum van Oudheden, Leiden AO 1a

This heart scarab is large and heavy, with an extremely long gold chain. Djehuti's name and one of his titles, Overseer of Northern Foreign Lands, are inscribed on the back, and the spell from chapter 30B of the Book of the Dead is inscribed on the base.

DCP

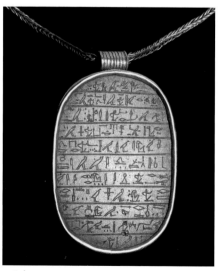

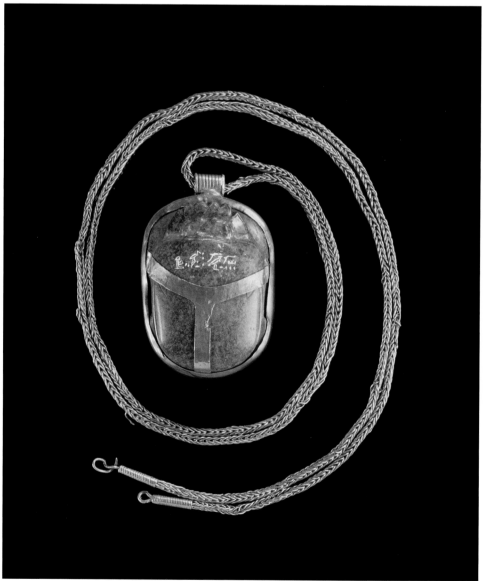

136, base
136

PROVENANCE: Perhaps from Saqqara, tomb of General Djehuti

BIBLIOGRAPHY: *Urkunden* 4, p. 1001, ll. 4–6; Leemans 1846, p. 20, pl. 35, no. 94; Maspero 1886, p. 69; Devéria 1896, p. 36; Leiden, Rijksmuseum van Oudheden 1981, no. 15; H. D. Schneider and Raven 1981, no. 67; Hans D. Schneider in *Ägyptens Aufstieg* 1987, pp. 344–45, no. 296; Lilyquist 1988, pp. 13–15, 59; Raven 1995, p. 115; H. W. Müller and Thiem 1999, p. 148, figs. 295, 296

137. Heart Amulet of the Royal Wife, Manhata

Early 18th Dynasty, reign of Thutmose III (r. 1479–1425 B.C.)
Gold, green schist
Wire: L. 20.4 cm (8 in.), Th. 0.2 cm (1/16 in.); bezel: H. 5.5 cm (2⅛ in.)
The Metropolitan Museum of Art, New York, Fletcher Fund, 1926 26.8.144

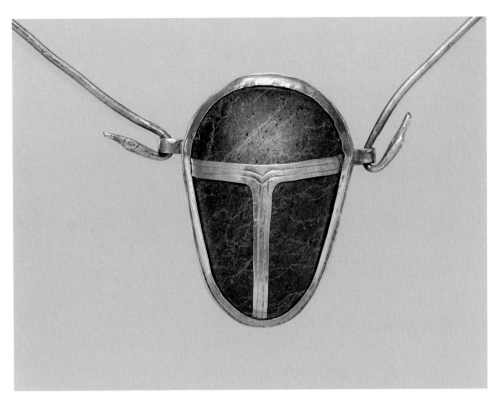

137

PROVENANCE: Western Thebes, Gabbanat el-Qurud, Wadi D, Tomb 1

BIBLIOGRAPHY: Winlock 1948, pl. XXII (right); Lilyquist 2003, p. 129, no. 17, figs. 103 (right), 106, 264c

COSMETIC EQUIPMENT

To the ancient Egyptians, it was essential to stay clean, smell sweet, and protect hair and skin, despite a dry climate and a blazing sun. Passages in love poetry of the New Kingdom help us understand how important these goals were. In one stanza a woman says that she is so lovesick she cannot even undertake the basics of getting dressed, painting her eyes, or anointing her body.[1] Other poems speak of anointing the hair and perfuming and oiling the skin.[2]

Ancient Egyptians, both women and men, used cosmetics to enhance their appearance.[3] They outlined their eyes with kohl,[4] the most common cosmetic, to enhance their beauty. But kohl also served as potent medicine for the Nile valley's numerous eye diseases.[5] The importance of eye paint as a medicine was reinforced by the decorative motifs on the jars in which it was stored. These small containers, often with a place for an applicator (cat. nos. 140, 141, 142a, 142b, 145a),[6] frequently depict the Bes image, Taweret, or Ipi, all powerful protectors of the home's most vulnerable occupants. Some motifs on cosmetic equipment, rather than having a protective function, are straightforward fertility symbols (cat. nos. 146, 147, 194). Others do not appear to have a particular meaning but instead feature things familiar to people's lives, such as a dog or a mouse (cat. nos. 138, 139). When Egyptians employed cosmetics—not only kohl but also rouge, which was applied to the cheeks and lips—and when they arranged their hair (cat. no. 148), they used mirrors (cat. nos. 145e, 146, 147).

The ancient Egyptians rubbed oils and salves into their skin to keep it soft and supple, while perfumed oils helped them smell sweet during the hottest summer days. To reduce evaporation, these scented substances were stored in capped stone jars—most commonly made of Egyptian alabaster (travertine). A number of recipes for the manufacture of scents have survived.[7] These tell us that perfumes were made from materials as varied as gum resins, for example myrrh; flowers, such as lilies and irises; and herbs and spices, including marjoram and cinnamon.

Keeping hair short was a way to combat the heat and stay clean. A knife, a razor, and tweezers (cat. nos. 46, 145b, 145c) are often found together as a cosmetic kit, along with a mirror, and are standard components of burial equipment in New Kingdom tombs.[8] DCP

1. Lichtheim 1976, p. 183.
2. Simpson 1973, pp. 301–2, 307, 311.
3. Manniche 1999, pp. 127–42.
4. Kohl (the word is from the Arabic) is a mixture of galena, oxide of manganese, brown ocher, and sometimes other materials with animal fat, vegetable oil, and beeswax (Lucas and Harris 1989, pp. 80–84; Schoske 1990, pp. 53–55).
5. Lucas and Harris 1989, p. 80; Schoske 1990, p. 25.
6. For more examples, see Brovarski 1982.
7. For a fine discussion of perfumes, salves, and unguents and their manufacture, which includes recipes, see Manniche 1999.
8. W. V. Davies 1982; Freed 1982.

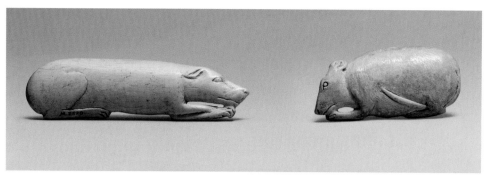

138, 139, undersides

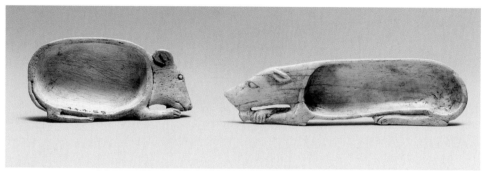

139, 138, spoon sides

PROVENANCE: *138.* Formerly Rev. C. Murch collection

139. Formerly J. Pierpont Morgan collection

BIBLIOGRAPHY: Hayes 1959, pp. 190, 191, fig. 106; Dorothea Arnold 1995, pp. 57, 58

140. Kohl Jar Inscribed for Hatshepsut as God's Wife

Early 18th Dynasty, reign of Thutmose II or first two regnal years of Thutmose III (1492–1477 B.C.)
Egyptian alabaster
H. 6.3 cm (2½ in.), Diam. 4.5 cm (1¾ in.)
The Metropolitan Museum of Art, New York,
Purchase, Edward S. Harkness Gift, 1926 26.7.1437

Egyptians used bundles of several pieces of reed joined together with leather strips to make one compact kit[1] in which they could have at hand a variety of different eye paints.[2] This kohl jar inscribed with the name of Queen Hatshepsut is an imitation in stone of such a reed bundle. Six tubes surround a seventh central tube, all carved out of a single piece of alabaster. A flat lid, now missing, swiveled around a metal pin, a piece of which remains in the vertical hole that was drilled for it into the top of the outer wall of the back tube. A horizontal hole just below the top of the inscribed tube at the front of the jar accommodated the peg of a knob that corresponded to a similar knob on the lid. The lid could be securely fastened to the vessel by tying a string around the two knobs. Two small holes in the proper right side of the back tube correspond to two additional holes in the left side of the tube next to it. Metal strips threaded across between the corresponding sets of holes must have served to hold an applicator.

Inscribed with the queen's birth name, Khenemet Amun Hatshepsut, and the title God's Wife, which she acquired in her early years, this elegant vessel can hardly have been part of Hathsepsut's final burial equipment. It must have been made during the time of the queen's marriage to Thutmose II or the years of her regency for Thutmose III. She may have given it to a valued courtier or family member during that same time. It might subsequently have found its way into the burial of that courtier or family member.[3] We have no means of ascertaining whether she used the little vase herself before she passed it on as a queenly gift. There are remains of various cosmetics inside the tubes. DoA

138. Cosmetic Spoon in the Shape of a Resting Dog

18th Dynasty (1550–1295 B.C.)
Bone
L. 9.7 cm (3⅞ in.), W. 2.7 cm (1⅛ in.),
D. 0.8 cm (⅜ in.)
The Metropolitan Museum of Art, New York, Gift of Helen Miller Gould, 1910 10.130.2520

139. Cosmetic Spoon in the Shape of a Crouching Mouse

18th Dynasty (1550–1295 B.C.)
Bone
L. 6.5 cm (2½ in.), W. 3.2 cm (1¼ in.),
D. 0.9 cm (⅜ in.)
The Metropolitan Museum of Art, New York,
Rogers Fund, 1944 44.4.55

Even in prehistoric times Egyptians deposited elegant spoons of bone or ivory in graves, close to the bodies of the deceased. During the entire pharaonic period, implements of this type must have been used in daily life to bring small amounts of cosmetic substances close to the face and body, thus facilitating application. The most elaborately carved spoons—some of them made of stone or fine wood—probably served in rituals, when precious ointments were offered or actually applied to the images of deities. Once the rituals were completed, the pious could express their veneration by dedicating such spoons in sanctuaries, or they could perpetuate the rituals in the afterlife by placing these objects in tombs.[1]

These two bone cosmetic spoons belong to a variant of the type that has no handle but is differentiated from a cosmetic box (cat. no. 144) by the lack of both a lid and a flat base or foot. People must have held minicontainers of this kind in the palms of their hands, and, indeed, the smooth animal bodies carved on the undersides of the present examples fit snugly into a cupped palm. The delicately carved images that decorate these two spoons are taken from the intimate environment of a private household. The rendering expresses some of the mischievous humor in which Egyptian artists indulged when they were not concerned with the loftiest and most serious subjects. The dog lies with its belly on the ground, its head resting on crossed front paws in an expectant posture familiar to all dog lovers. Are the crossed paws a satirical reference to the well-known pose of some dignified Eighteenth Dynasty royal lion statues?[2] The mouse with its thin little tail wrapped around its body displays the typical demure expression that has endeared these rodents to children and adults through the ages. DoA

1. On the problems of determining the function (or functions?) of cosmetic spoons, see Wallert 1967, pp. 49–52, 69–70; Delange 1993, pp. 5–14 (with bibliography).
2. Hourig Sourouzian in Russmann et al. 2001, pp. 130–31, no. 51.

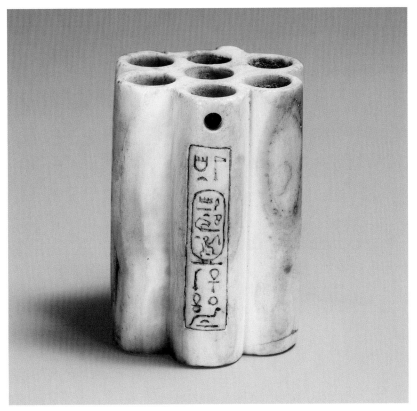

140

1. Schoske 1990, p. 158.
2. EA 5337: Glanville 1928, p. 297, pl. xxx; Schoske 1990, p. 26.
3. There were vessels inscribed for Hatshepsut as royal wife in a number of burials, for instance, those of Senenmut's parents, the three foreign wives of Thutmose III, and the royal tomb KV 20: Lilyquist 1995, pp. 34–35, nos. 57–61. For gifts of royal objects to courtiers, see also the discussion of jewelry in chapter 4.

PROVENANCE: Formerly Carnarvon collection (no. 1205)

BIBLIOGRAPHY: Hayes 1959, pp. 80–81, fig. 43; Reeves and Taylor 1992, p. 118; Lilyquist 1995, p. 50, no. K

141. Kohl Jar

Early 18th Dynasty, reign of Thutmose III
(r. 1479–1425 B.C.)
Glazed steatite
H. 3.8 cm (1½ in.), Diam. 3.8 cm (1½ in.)
Museum of Fine Arts, Boston, Gift of the Egypt Exploration Fund, 1900 00.701a, b

The shape of this vessel is typical for New Kingdom containers of black eye paint, or kohl. The container is decorated with incised plant motifs on the lid and shoulder, and divine emblems and animal figures are carved around the body. The emblems flank a head symbol of the goddess Hathor. On one side are two *was* (dominion) scepters with a small ankh (life) sign between them, and on the other side is a feline climbing a ropelike standard—an ancient symbol for the goddess Mafdet, who embodied the triumph over evil. The other animals are familiar from age-old Egyptian representational themes symbolizing rejuvenation: the outdoor life of herds, here symbolized by two goats flanking a tree,[1] and the hunt in the desert, here evoked by two hares in full flight and a hunting dog.[2] We should, however, notice that the tree is not the usual acacia or sycamore but a less naturalistic palm.[3] The whole ensemble is not without echoes of ancient Near Eastern images,[4] which underlines the fact that Egyptians were open to the art of neighboring countries when this jar was made.

DoA

1. For Old and Middle Kingdom examples: Vandier 1969, pp. 86–92, 233–34; for one of the less common examples of the New Kingdom: Norman de G. Davies 1927, pl. xxxiv.
2. Vandier 1964, pp. 787–825.
3. For Egyptian associations of the palm tree with Hathor, see Wallert 1962, pp. 105–6; for Near Eastern parallels, see W. S. Smith 1965b, p. 29, figs. 40, 48.
4. W. S. Smith 1965b, p. 105; Harper 1995, p. 44, no. 44. I thank Joan Aruz, Daphna Ben-Tor, and Irit Ziffer for discussing and providing references on this piece.

PROVENANCE: Abydos, Tomb D 10; excavations of the Egypt Exploration Fund, 1900

BIBLIOGRAPHY: Randall-MacIver and Mace 1902, p. 86, pl. xxxviii; Janine Bourriau in *Egypt's Golden Age* 1982, p. 219, no. 266

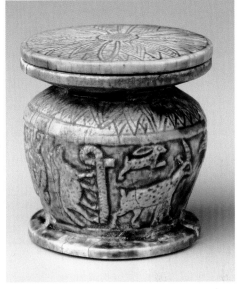

141

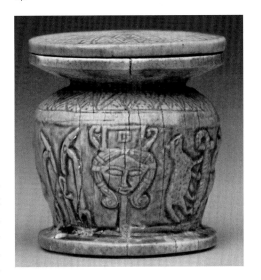

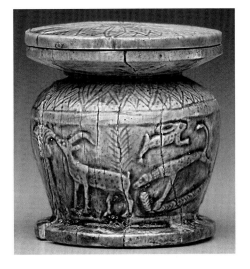

142. Kohl Jar and Applicator belonging to Senenmut's Mother, Hatnefer

Early 18th Dynasty, joint reign of Hatshepsut and Thutmose III, year 7 or earlier (1479–1472 B.C.)

a. Jar

Serpentine
H. 5.6 cm (2¼ in.); rim: Diam. 5 cm (2 in.)

b. Applicator

Ebony
H. 9.5 cm (3¾ in.), Diam. 1.2 cm (½ in.)

The Metropolitan Museum of Art, New York, Rogers Fund, 1936 36.3.62, 36.3.63

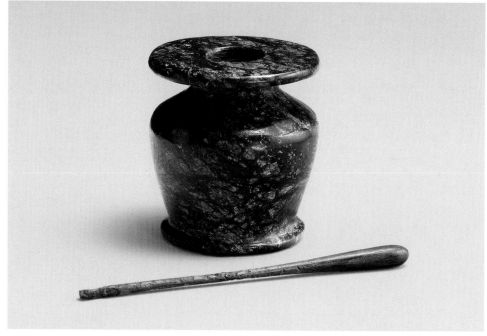

142

Hatshepsut's great courtier and official Senenmut buried his parents directly below his own tomb on the hillside of what is today called Sheikh abd el-Qurna, northwest of the later mortuary temple of Ramesses II in western Thebes. The parents' rock-cut tomb chamber was primarily made for Hatnefer, Senenmut's mother, who outlived her husband to witness the early days of her son's lofty career. Senenmut's father, Ramose, was reburied beside Hatnefer, and six other people—probably family members—were entombed, in two coffins, in the same crypt. The four coffins left little room for Hatnefer's grave goods, which were tightly packed around the four coffins. Among the many containers thus stowed was a beautifully decorated basket. Inside it were a smaller basket, an alabaster vessel, and this graceful kohl jar accompanied by its applicator. Lady Hatnefer may well have used the little eye-paint container and its kohl applicator during her lifetime. DoA

PROVENANCE: Western Thebes, Sheikh abd el-Qurna; Metropolitan Museum of Art excavations, 1935–36

BIBLIOGRAPHY: Lansing and Hayes 1937, p. 28; Dorman 2005

143.
a. Gold-Rimmed Ointment Jar with Lid

Early 18th Dynasty, reign of Thutmose III (r. 1479–1425 B.C.)
Serpentinite, gold
H. (without lid) 10.7 cm (4¼ in.); lid: Diam. 8.7 cm (3⅜ in.), Th. 0.4 cm (⅛ in.)
The Metropolitan Museum of Art, New York, Fletcher Fund, 1926 26.8.36a, b

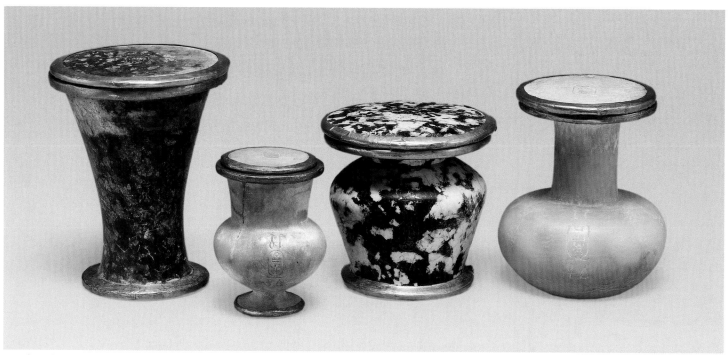

143a, b, c, d

b. Gold-Rimmed Wide-Necked Jar with Lid

Early 18th Dynasty, reign of Thutmose III
(r. 1479–1425 B.C.)
Anhydrite, reddish gold
H. (without lid) 7 cm (2¾ in.); lid: Diam. 4.5 cm
(1¾ in.), Th. 0.35 cm (⅛ in.)
The Metropolitan Museum of Art, New York,
Fletcher Fund, 1926 26.8.35a, b

c. Gold-Rimmed Kohl Jar with Lid

Early 18th Dynasty, reign of Thutmose III
(r. 1479–1425 B.C.)
Porphyritic diorite (?), gold
H. (without lid) 7.8 cm (3⅛ in.); lid: Diam. 3.4 cm
(1⅜ in.); Th. 0.7 cm (¼ in.)
The Metropolitan Museum of Art, New York,
Fletcher Fund, 1926 26.8.38a, b

d. Gold-Rimmed Toilet Flask with Lid

Early 18th Dynasty, reign of Thutmose III
(r. 1479–1425 B.C.)
Homogeneous travertine, gold
H. (without lid) 9.4 cm (3¾ in.); Diam. 8 cm (3⅛ in.);
lid: Diam. 6.5 cm (2½ in.), Th. 0.4 cm (⅛ in.)
The Metropolitan Museum of Art, New York,
Fletcher Fund, 1926 26.8.31a, b

On a wall in the tomb of Rekhmire, vizier of King Thutmose III, a group of guests are depicted at a festive event.[1] While a lute player and two harpists make music, servants adorn the guests with floral collars and anoint their arms, chests, and necks with perfumed oils and ointments. These unguents are stored in vessels painted with patterns that show they were made of precious stone. In their materials as well as in some of their shapes they closely resemble the present four vases, which were part of the funeral outfit of Manuwai, Manhata, and Maruta, the three foreign wives of King Thutmose III. All but the wide-necked jar (cat. no. 143b) retain some residue of the oily substances that once filled them.[2] The shapes of two (cat. nos. 143a, c) follow the dictates of age-old Egyptian traditions, while a third (cat. no. 143d) is a new type. Another (cat. no. 143b) reflects influences from the Levant, demonstrating the tendency of Eighteenth Dynasty artisans to incorporate new forms into the Egyptian vessel repertoire.[3] Sheet gold trimmings on rims and bases enhance the luxurious appearance of these masterpieces from the royal workshops of Thutmose III.

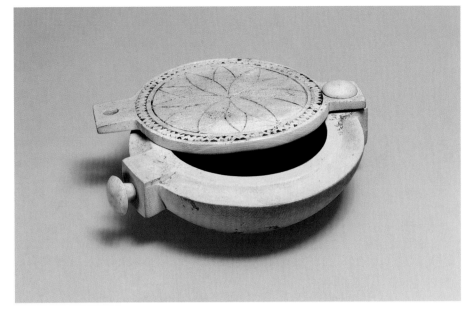

144

Three of the four carry the incised inscription "the Good God, Menkheperre (Thutmose III), given life." The bulbous body of the fourth, the wide-necked jar (cat. no. 143b), provided room only for the phrase: "the Good God, Menkheperre." The inscriptions mark the vessels as gifts from the pharaoh to the women with whom they were buried.

DCP

1. Norman de G. Davies 1943, pls. LXIV, LXVI.
2. According to Christine Lilyquist (2003, p. 147, no. 89), catalogue no. 143c was filled "within 1.0 [cm] of top with hard gray substance, no doubt hardened kohl," and catalogue no. 143d contained an oily residue and considerable incrustation inside the vase and on the bottom of the lid. Catalogue no. 143a had a clean but stained and weathered interior, the contents having left a white ring.
3. Lilyquist 1995, pp. 9–10.

PROVENANCE: Western Thebes, Gabbanat el-Qurud, Wadi D, Tomb 1

BIBLIOGRAPHY: *143a*. Winlock 1948, p. 52, no. I, pl. XXX, 5; Lilyquist 1995, p. 51, no. P
143b. Winlock 1948, p. 51, no. D, pl. XXX, 1; Lilyquist 1995, p. 51, no. Q; Lilyquist 2003, p. 148, no. 94, figs. 140, 141 (upper right)
143c. Winlock 1948, p. 51, no. A, pl. XXX, 4; Lilyquist 1995, p. 52, no. X; Lilyquist 2003, p. 147, no. 89, figs. 137a, 137e (left)
143d. Winlock 1948, p. 52, no. G, pl. XXX, 7; Lilyquist 1995, p. 52, no. V; Christine Lilyquist in Ziegler 2002a, p. 462, no. 191; Lilyquist 2003, p. 148, no. 95, figs. 142b, 142c (right)

144. Toilet Box

Early 18th Dynasty (1550–1450 B.C.)
Elephant ivory, Egyptian blue
H. 2.6 cm (1 in.), W. (with peg) 9.2 cm (3⅝ in.); lid:
Th. 0.4 cm (⅛ in.)
The Metropolitan Museum of Art, New York,
Rogers Fund, 1916 16.10.425
New York only

Cosmetic containers made of wood, bone, or ivory must have been used for storing fairly dry substances such as powder or rouge. This little box consists of a hollowed round lower part with two squared protrusions, one at the back and one at the front. The shape of the flat lid follows that of the box, but its circular central part is smaller than the lid and covers only the container's cavity. A peg inserted through the rear protrusions of the lid and box serves as a swivel pin for the lid, while a knob on the protrusion at the front of the box once corresponded to a now-missing knob on the front part of the lid. As usual for such containers, a string wound around the two knobs fastened the two pieces together. On the upper surface of the lid a flower petal design surrounded by a zigzag circle is incised. The incised lines of the floral motif must have been made with the help of a compass. They are filled with Egyptian blue. DoA

PROVENANCE: Western Thebes, Lower Asasif, CC 41, Pit 3, chamber B; Metropolitan Museum of Art excavations, 1915–16

BIBLIOGRAPHY: Lansing 1917, p. 17, figs. 19, 20, and p. 21; Hayes 1959, p. 65

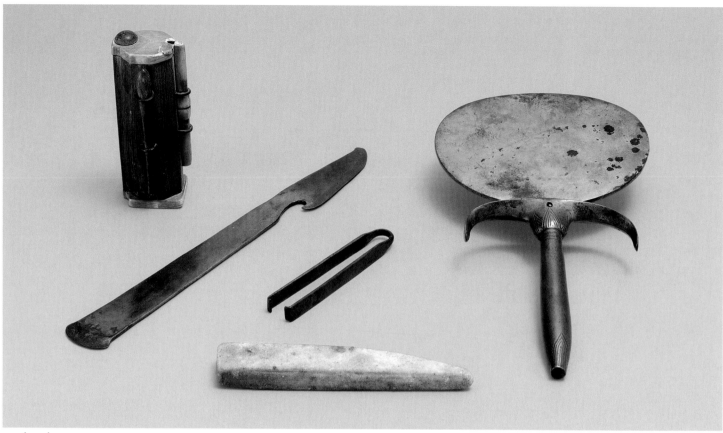

145a, b, c, d, e

145a. Kohl Tube and Applicator

Early 18th Dynasty (1550–1450 B.C.)
Wood, ivory
Tube: H. 7.9 cm (3⅛ in.), Diam. 2.6 cm (1 in.);
applicator: L. 6.5 cm (2½ in.), Diam. 1.1 cm (½ in.)
The Metropolitan Museum of Art, New York,
Purchase, Edward S. Harkness Gift, 1926 26.7.1447

This container of black eye paint, or kohl (see
"Cosmetic Equipment," above) is a neat little
portable object. It consists of an octagonal
wooden box with an ivory base and lid. The lid
swivels around a wooden peg with a studded
head. A copper-wire loop has been fixed to the
front of the lid, and two pairs of such loops are
attached to the main body of the container. The
two pairs on the front of the body hold a small,
accurately shaped replica of a kind of bolt used
in ancient Egypt to close doors of houses and
shrines. When pushed upward this bolt fits into
the wire loop on the lid and thus closes the box.
The two other wire loops hold the implement
with which the owner applied the kohl.

<div align="right">DOA</div>

PROVENANCE: Western Thebes, Lower Asasif,
Tomb 37, hall C, central passage, no. 16; Carnavon
excavations, 1911

BIBLIOGRAPHY: Carnarvon and Carter 1912, p. 72,
pl. LXV, 1; Hayes 1959, p. 64, fig. 33

145b–e. Toilet Set

Early 18th Dynasty (1550–1450 B.C.)

b. Razor

Bronze
L. 8.4 cm (3¼ in.), W. 2.4 cm (1 in.),
Th. 0.1 cm (¹⁄₁₆ in.)

c. Tweezers

Bronze
L. 7.2 cm (2⅞ in.), W. 1.2 cm (½ in.)

d. Whetstone

Granular stone
L. 9.9 cm (3⅞ in.)

e. Mirror

Bronze
L. 9.1 cm (3⅝ in.), W. 6.8 cm (2⅝ in.)

The Metropolitan Museum of Art, New York,
Purchase, Edward S. Harkness Gift, 1926
26.7.837a–d

In ancient Egypt, as today, care of the body
demanded not only a supply of ointments and
oils but also certain implements made from
metal and other hard materials. This set
includes a bronze mirror, the handle and disk
of which are cast separately, a bronze razor,
bronze tweezers, and a whetstone. The objects
were discovered together with a kohl container
(cat. no. 145a) in a rush basket that had been
deposited in a tomb. Curator William C. Hayes
appropriately called the whole group "dressing-
table accessories," while the excavator Howard
Carter wrote, "The preservation [of the razor]
is so good that the knife edges are still keen, and
the prints of the ancient finger-marks are still
visible upon its polished surfaces."[1] In ancient
Egypt both men and women used razors, which
were also often used to shave the heads of chil-
dren, leaving only tufts of hair or a braid on one
side of the head.[2]

Egyptian hand mirrors are known from at
least the time of the Old Kingdom.[3] They con-
sist of a polished metal disk with a tang at its
lower end and a handle of metal, wood, ivory,
or faience. The tang is fitted into a hole at the
top of the handle. Mirror disks usually are not
completely circular but instead noticeably
flattened at the top; the lower part is sometimes
slightly pointed, as in this example.[4] Again as in

this piece, many mirror handles take the shape of a stylized papyrus plant or a variation of that motif. From early on, papyrus plants were associated with important female deities such as Hathor, Bastet, Neith, and Isis, and the papyrus swamp was a mythical place of regeneration.

DoA

1. Hayes 1959, p. 64; Carnarvon and Carter 1912, p. 72.
2. Feucht 1995, pp. 497–98, and see Princess Neferure (cat. nos. 60, 61).
3. Lilyquist 1979, pp. 4–14; Schoske 1990, pp. 27–28, 120.
4. Hayes (1959, p. 63) likens mirror disks of this shape to palm-leaf fans, but the mirror case in the shape of an ankh (life) hieroglyph from the tomb of Tutankhamun suggests an association with the uppermost part of an ankh sign (see Reeves 1990a, p. 159).

PROVENANCE: Western Thebes, Lower Asasif, Tomb 37, hall C, central passage, no. 16; Carnarvon excavations, 1911

BIBLIOGRAPHY: Carnarvon and Carter 1912, p. 72, pl. LXV, 1; *Ancient Egyptian Art* 1922, p. 115, no. 16; Hayes 1959, pp. 21, 64, fig. 33; Reeves and Taylor 1992, p. 102

146. Mirror with Two Falcons

Early 18th Dynasty (1550–1425 B.C.)
Bronze
L. 21.9 cm (8⅝ in.); disk: W. 12 cm (4¾ in.); handle: Th. 1.4 cm (⅝ in.)
Museum of Fine Arts, Boston, Harvard University–Museum of Fine Arts Expedition, 1927 27.872

This mirror is of a type more commonly dated to the Middle Kingdom and the Second Intermediate Period (1981–1550 B.C.) than to the early Eighteenth Dynasty. However, it was found in association with objects in a burial near the fort at Semna, in Nubia, that show characteristics of early Eighteenth Dynasty style and

is dated accordingly.[1] This mirror demonstrates that the personal arts of the early Eighteenth Dynasty frequently embody the styles of earlier Egyptian tradition, although elements of the handle's decoration are characteristic of the Kerma culture.[2] The two falcons on the handle are solar symbols[3] and their shape and position on this piece mimic the horizon symbol consisting of two mountains with a valley between them. This point is reinforced by the mirror's shape, which imitates the solar disk as it rises between the mountains that lie to the east of the Nile River.

DCP

1. The Metropolitan Museum has a mirror that is a close parallel (30.8.112), but it does not have a context.
2. Christine Lilyquist in *Egypt's Golden Age* 1982, p. 186, under no. 214.
3. Christine Lilyquist in *Ägyptens Aufstieg* 1987, p. 213, no. 137.

PROVENANCE: Semna, Tomb S552; Harvard University–Museum of Fine Arts Expedition, 1927

BIBLIOGRAPHY: Dunham and J.M.A. Janssen 1960, p. 93, pl. 129; Christine Lilyquist in *Egypt's Golden Age* 1982, pp. 185–86, no. 214; Christine Lilyquist in *Ägyptens Aufstieg* 1987, p. 213, no. 137; Jean Leclant in Wildung 1997b, p. 83, no. 89

147. Mirror with Hathor-Face Handle

Early 18th Dynasty, reign of Thutmose III (r. 1479–1425 B.C.)
Silver (disk), gold foil over modern wood (handle)
L. 30 cm (11⅞ in.); disk: W. 14.5 cm (5¾ in.)
The Metropolitan Museum of Art, New York, Fletcher Fund, 1926 26.8.97

Although occasionally found in men's graves,[1] Egyptian mirrors are usually decorated with feminine motifs.[2] The simple stylized papyrus plant was an old symbol of creative female powers (see cat. no. 145e). In the present example, the face of the goddess Hathor is inserted between the stem and umbel of the papyrus to embellish the plant design. Hathor was not only the Aphrodite of ancient Egypt, in charge of love and beauty, but also—as daughter of the sun god Re—a sky goddess who commanded both the creative and destructive forces of nature. Egyptians believed that at set intervals the goddess withdrew to faraway countries beyond the reach of humans and reappeared in

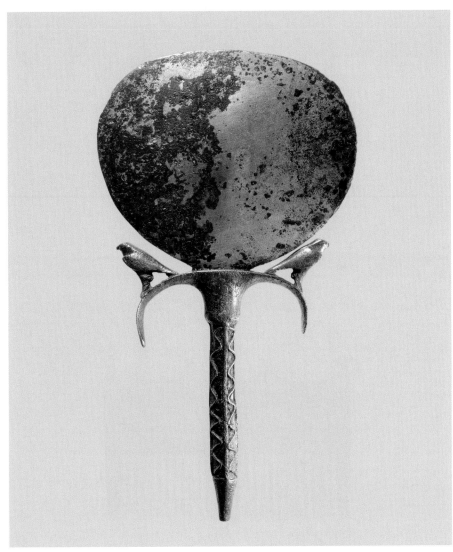

146

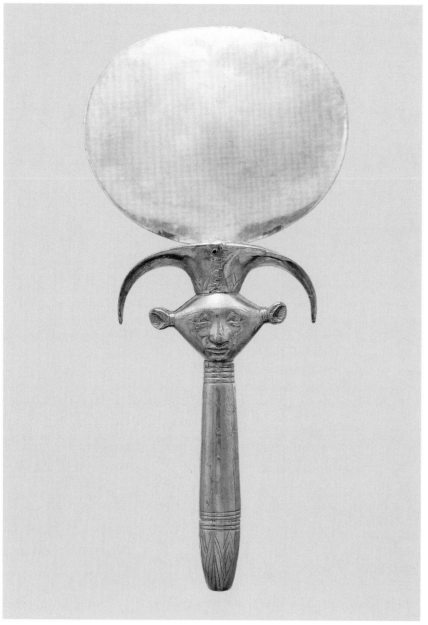

147

The front surface of the disk was polished in the Museum. DCP

1. See, for instance, the mirror from the burial of Wah in the Metropolitan Museum (Winlock 1942, p. 30).
2. Lilyquist 1979, p. 97; Schoske 1990, pp. 27–28, 120–21.
3. Desroches-Noblecourt 1995.

PROVENANCE: Western Thebes, Gabbanat el-Qurud, Wadi D, Tomb 1

BIBLIOGRAPHY: Winlock 1948, pl. XXIX (left); Elfriede Haslauer in Seipel 2001, pp. 77, no. 78, 79; Christine Lilyquist in Ziegler 2002a, p. 462, no. 189; Ziegler 2002b, p. 263, fig. 32; Lilyquist 2003, p. 152, no. 106, figs. 149, 151

148. Comb

Early 18th Dynasty (1550–1450 B.C.)
Wood
L. 7.1 cm (2¾ in.), W. 5 cm (2 in.), Th. 1.1 cm (½ in.)
The Metropolitan Museum of Art, New York, Purchase, Edward S. Harkness Gift, 1926 26.7.1448

This beautifully preserved comb has three neatly carved shallow indentations at the top to allow the fingers a secure grip. The flat area between the undulated top and the comb's teeth is embellished with groups of perfectly straight, incised, parallel lines. The comb does not show wear and thus cannot have been used for long, if at all, before it was deposited in a burial for use in the next world. DOA

PROVENANCE: Western Thebes, Lower Asasif, Tomb 37, chamber A, no. 73; Carnarvon excavations, 1912

BIBLIOGRAPHY: Carnarvon and Carter 1912, pl. LXX, 2; Winlock 1935b, fig. 7; Hayes 1959, p. 63, fig. 32

a glorious epiphany in a new season.[3] The well-known image of the Hathor cow emerging from a papyrus thicket evokes that reappearance. In the symbolic world of this mirror, Hathor's face appears united with the papyrus plant to bear what might be interpreted as a sun or moon disk. For the owner of the mirror, this reminder of heavenly beauty must have signified both a compliment and a wish.

The name of Thutmose III is inscribed on the umbel and suggests that the mirror was a gift of the pharaoh to one of the three foreign wives from whose tomb it probably came. Another mirror in the Metropolitan Museum (26.8.98) was also found in this tomb, indicating that each of the three ladies buried there probably owned her own mirror.

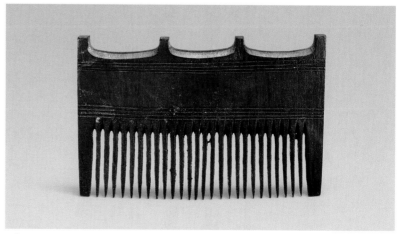

148

POTTERY AND STONE VESSELS IN THE REIGN OF HATSHEPSUT AND THUTMOSE III

Many new vessel forms were introduced with the beginning of the New Kingdom and the establishment of the Theban Eighteenth Dynasty's rule over the whole of Egypt. The pottery tradition of the Memphis-Fayum region had been dominant during the Middle Kingdom; now, however, an Upper Egyptian ceramic tradition, which had existed independently since the Thirteenth Dynasty,[1] spread throughout Egypt. By the joint reign of Hatshepsut and Thutmose III the pottery style of the New Kingdom was fully developed, and traces of the earlier Middle Kingdom and Second Intermediate styles of both Upper and Lower Egypt were rare. To the new Egyptian style were added vessel forms imported from the Aegean, Cyprus, the Levant, and Nubia.

Egyptian craftsmen produced copies of the imported originals and adaptations of them in which elements of the foreign prototypes were combined with native forms. Types with handles, such as jugs and flasks, became more popular, perhaps as a result of the influence of Levantine Late Bronze Age styles. Two-handled Canaanite trade amphorae, which had been imported into Egypt as containers for wine and oil since the Early Dynastic period, were often depicted in the tomb paintings of the early Eighteenth Dynasty but were soon replaced by a similar Egyptian-made form. Decorated pottery became more common, initially employing linear black-and-red designs but later featuring more formal compositions with plant and animal elements, which again reflect foreign influences, here of Levantine Bichrome ware[2] and Cypriot White Slip and White Pendant Line styles (cat. nos. 160a, b).[3] Traditional Egyptian forms like the flaring beaker (cat. nos. 76h, 76i, 151b) continued to be used. New forms were introduced, such as the pyriform, or pear-shaped, jar (cat. nos. 106b, 149a, 149b, 151a, 151d). Types based on a combination of imported and local ceramic prototypes are the Canaanite jar (cat. no. 153), the bilbil (cat. no. 156), and the basket-handled jar (cat. nos. 149c, 154).

Stone is more suitable than clay for the preservation of precious oils, ointments, and medicines. Stone vessels for such substances were manufactured and deposited in tombs in increasing numbers in the New Kingdom.[4] That they were included in so many burials during this period indicates not only that more and more individuals could afford them but also that their precious contents were becoming more widely available. Travertine and serpentine, which could be secured from quarries in the Eastern Desert,[5] were the preferred stones for many cosmetic jars. Light-colored marl clay fabrics and polished white coatings were in favor for pottery ointment vessels, perhaps because they resembled the travertine vessels. The containers for precious oils and medicines found in burials, which outnumber those for foodstuffs, include both imported examples (cat. no. 156) and locally made products (cat. nos. 157, 158, 160a, 160b).

Forms developed from indigenous prototypes continued to appear side by side with those adopted from foreign sources throughout the New Kingdom not only in pottery and stone but also in other materials, such as glass and faience.

SJA

1. Bourriau 1997, p. 168.
2. Bourriau 1981b, pp. 133–35, nos. 261–64.
3. Ibid., p. 127, no. 251.
4. Bourriau 1984, col. 365.
5. Aston, Harrell, and Shaw 2000, pp. 59–60 (travertine), 56–57 (serpentine).

149.
a. Pyriform Ointment Jar with Lid

Early 18th Dynasty, reign of Thutmose III (r. 1479–1425 B.C.)
Travertine
H. 26.6 cm (10½ in.), Diam. 18.6 cm (7⅜ in.)
Rijksmuseum van Oudheden, Leiden, Barthow/de Lescluze Collection L.VIII.20

b. Pyriform Ointment Jar with Lid

Early 18th Dynasty, reign of Thutmose III (r. 1479–1425 B.C.)
Travertine
H. 26.6 cm (10½ in.), Diam. 20.4 cm (8 in.)
Museo Egizio, Turin, Drovetti Collection 3226

c. Basket-Handled Ointment Jar with Lid

Early 18th Dynasty, reign of Thutmose III (r. 1479–1425 B.C.)
Travertine
H. 26.4 cm (10⅜ in.), Diam. 21.2 cm (8⅜ in.)
Museo Egizio, Turin, Drovetti Collection 3227

These three stone ointment jars come from the unidentified tomb of Djehuti, who bore the titles of general, scribe, and Overseer of Northern Foreign Lands. Pyriform jar shapes were introduced in Egypt at the beginning of the Eighteenth Dynasty,[1] and the basket-handled jar with tall cylindrical neck first appeared there during the joint reign of Hatshepsut and Thutmose III.[2] The two forms are among the commonest used for ointment vessels in the New Kingdom (see also cat. nos. 151a, 155). A total of seven ointment jars including the present three, now divided among collections in Turin, Leiden, and Paris (Musée du Louvre), are thought to have come from Djehuti's tomb.[3] All entered these museums between 1824 and 1826 and were originally collected by Bernardino Drovetti (Turin), Giovanni Anastasi (Paris, Leiden), and Jean-Baptiste de Lescluze (Leiden). It is probable that the vessels were discovered in Saqqara by Giuseppe Nizzoli between 1820 and 1822.[4] The present three jars are made of polished crystalline travertine, are approximately the same height, and are similarly inscribed with two columns of incised hieroglyphs filled with blue paste. The inscriptions all follow the same format, beginning with a wish for a desired offering and ending with a title or epithet and the name Djehuti. They do not mention ointment or oils, but all three jars contained residues of ointment or resin. The inscriptions can be translated as follows:

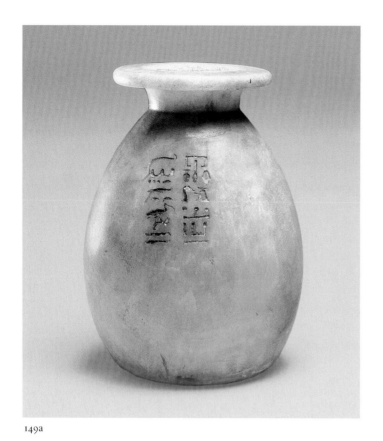

149a

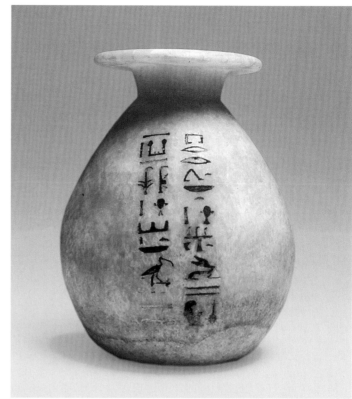

149b

149a: An invocation-offering of bread and beer, meat and poultry for the ka of / the Overseer of Northern Foreign Lands, Djehuti, justified.

149b: May whatever comes from off Onnophris's offering table / be for the ka of the king's follower in every foreign land, Djehuti.

149c: May whatever comes from off the offering table of Osiris / be for the ka of the trusted one of the king in the God's-land, Djehuti.[5]

The jar from Leiden (cat. no. 149a) was made after Djehuti's death and bears his most important and interesting title: Overseer of Northern Foreign Lands. This title has led some scholars to connect this Djehuti to the Djehuti in a story in the Nineteenth Dynasty Papyrus Harris 500.[6] According to this text, Djehuti captured the Canaanite coastal city of Joppa (modern-day Jaffa) for King Menkheperre (the prenomen of Thutmose III) by sending Egyptian troops hidden in baskets into the city. It is likely that the conquest of Joppa took place in the second half of the reign of Thutmose III as detailed in the Annals of Thutmose III in Karnak.[7] If the Djehuti who owned these ointment jars is the hero of Joppa, his title of Overseer of Northern Foreign Lands would be appropriate. SJA

1. Aston 1994, p. 154 (Type 185).
2. Janine Bourriau in *Egypt's Golden Age* 1982, p. 127, no. 114; Aston 1994, p. 152 (Type 175).
3. Lilyquist 1988, pp. 10–13, pp. 57–58, nos. 5–11.
4. Ibid., p. 37.
5. Translations by James P. Allen.
6. J. P. Allen 2001. See also Lilyquist 1988, pp. 6–7, for a detailed discussion of the evidence for this identification.
7. Weinstein 2001.

PROVENANCE: Unknown, possibly from Saqqara
149a. Formerly Barthow/de Lescluze collection
149b, c. Formerly Drovetti collection

BIBLIOGRAPHY: *149a.* Hans D. Schneider in *Ägyptens Aufsteig* 1987, p. 341, no. 294; Lilyquist 1988, pp. 10–13, fig. 13 (left), 58, no. 11; Lilyquist 1995, p. 62, fig. 155 (left)
149b. Elvira D'Amicone in *Ägyptens Aufsteig* 1987, p. 341, no. 293; Lilyquist 1988, pp. 10–13, fig. 13

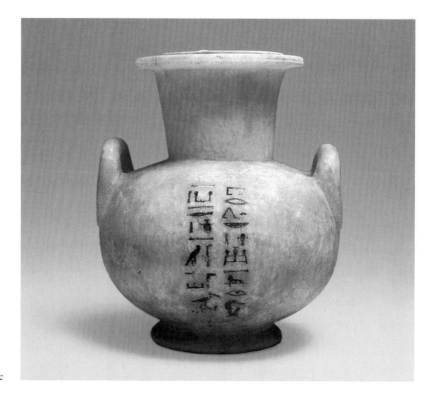

149c

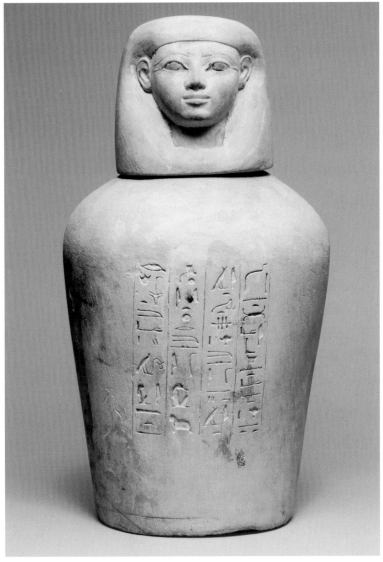

150

BIBLIOGRAPHY: Winlock 1948, pp. 46–48; Lilyquist 2003, pp. 126–27, no. 4, figs. 95c (left), 263a (right), 267 (center)

151.
a. Pyriform Ointment Jar

Early 18th Dynasty, reign of Thutmose III (r. 1479–1425 B.C.)
Serpentine
H. 20 cm (7⅞ in.), Diam. 15.2 cm (6 in.)
The Metropolitan Museum of Art, New York, Rogers Fund, 1918 18.8.17a

b. Flared Ointment Jar

Early 18th Dynasty, reign of Thutmose III (r. 1479–1425 B.C.)
Travertine
H. 17.4 cm (6⅞ in.); Diam. 14.4 cm (5⅝ in.)
The Metropolitan Museum of Art, New York, Rogers Fund, 1926 26.8.1a, b

c. Shouldered Ointment Jar

Early 18th Dynasty, reign of Thutmose III (r. 1479–1425 B.C.)
Crystalline travertine with limestone lid
H. 23.5 cm (9¼ in.), Diam. 17.5 cm (6⅞ in.)
The Metropolitan Museum of Art, New York, Fletcher Fund, 1926 26.8.15a

d. Pyriform Ointment Jar with Handle

Early 18th Dynasty, reign of Thutmose III (r. 1479–1425 B.C.)
Serpentine
H. 22.5 cm (8⅞ in.), Diam. 15.2 cm (6 in.)
The Metropolitan Museum of Art, New York, Fletcher Fund, 1926 26.8.16a, b

(second from left), 58, no. 6; Lilyquist 1995, p. 62, fig. 155 (second from left)
149c. Elvira D'Amicone in *Ägyptens Aufsteig* 1987, p. 340, no. 292; Lilyquist 1988, pp. 10–13, fig. 13 (second from right), 58, no. 7; Lilyquist 1995, p. 62, fig. 155 (second from right)

150. Canopic Jar of Manuwai

Early 18th Dynasty, reign of Thutmose III (r. 1479–1425 B.C.)
Limestone
H. 36.2 cm (14¼ in.)
The Metropolitan Museum of Art, New York, Rogers Fund, 1918 18.8.12a, b

At some time during his reign, Thutmose III acquired three wives from the area of modern Syria, probably for political reasons. These women were sent to Egypt and were absorbed into the royal court. They seem to have died at about the same time, and all three were buried in the same cliff tomb deep in the southwest wadis of the Theban necropolis. With a few exceptions—notably, a glass vessel that one of the women may have brought as part of her dowry (cat. no. 32)—the objects associated with their burials are typically Egyptian. Only the women's names, which were transliterated phonetically into the Egyptian language, identify their non-Egyptian origins.

Each of the wives had for her burial a complete set of four canopic jars, which were used to store the four internal organs removed during mummification. This jar is inscribed for Manuwai. The lid, in the shape of a human head, is beautifully carved. The eyes were highlighted with black paint, of which only traces remain; the inscription, which invokes the goddess Neith and the minor god Imsety, retains traces of blue paint. CHR

PROVENANCE: Western Thebes, Gabbanat el-Qurud, Wadi D, Tomb 1; acquired in 1918

These stone vessels are part of a set of thirty-nine jars from the burial of the three foreign wives of Thutmose III. They were intended for the storage of valuable ointments, a necessary component of New Kingdom burials.

Two of the jars (cat. nos. 151a, d) are pyriform, or pear shaped, a type that was especially popular for ointment jars (see cat. nos. 106b, 149a, 149b). Both are made of light brown serpentine that probably came from the Red Sea hills and wadis northeast of Thebes, between modern-day Qena and Quseir.[1] Pyriform jars in travertine are known from the reign of Amenhotep I onward.[2] They also occur in pottery[3] and as so-called dummy vases, jars made of wood, gesso, and paint that imitate hard stone.[4]

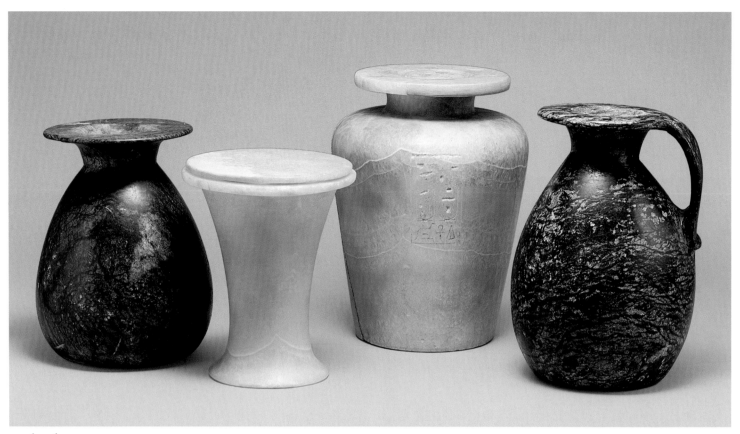

151a, b, c, d

The pyriform jug with a handle (cat. no. 151d) has an inscription that has been determined to be modern on the basis of paleography and the fact that it is placed next to rather than opposite the handle.[5]

A third vessel (cat. no. 151b) is a deep, flaring beaker with a flat ledge rim, splayed foot, and flat disk lid, a type used for ointments from the time of the earliest dynasties; it appears in the decoration and offering lists of Old Kingdom tombs dated as early as the Third Dynasty[6] and in the *frise d'objets* on wooden coffins of the Middle Kingdom.[7] This is one of the vessel shapes associated with the seven sacred oils and is used in specially made boxed sets of eight jars, such as those found in the tombs of Queen Hetepheres, of the Fourth Dynasty,[8] and Princess Sithathoryunet, of the Twelfth Dynasty.[9] As a hieroglyph it is used to write the word "oil" (*mrḥt*).[10] Large jars such as the present example and those depicted in the tomb paintings would have been used for the storage of ointment. Smaller jars were receptacles for cosmetics and were also included in foundation deposits. Two such jars in travertine with inscriptions of Hatshepsut dedicating them to Amun (cat. nos. 76h, i) were found in foundation deposits in the forecourt of her mortuary temple at Deir el-Bahri.[11]

The broad-shouldered container (cat. no. 151c)

displays the flat base, short cylindrical neck, and very broad, flat ledge rim characteristic of the *nmst* jar, which is associated with the purification ritual and funerary rites.[12] This example is still full of hardened ointment. On its barrel-shaped body an inscription of Thutmose III is enclosed in a frame: "The Young God, Menkheperre, Son of Re, Thutmose Perfect of Being, given life forever."

Each of these jars is closed with a flat stone lid, the underside of which is shaped to fit the vessel's narrow mouth. These lids were probably held in place by linen covers that were tied over them. SJA

1. Aston 1994, pp. 56–59; Aston, Harrell, and Shaw 2000, pp. 56–57.
2. Carter 1916a, pl. XXII, 1–4.
3. Brunton 1930, p. 13, pl. XXVIII, 136; Randall-MacIver and Mace 1902, p. 101 (tomb D102), pl. LV, 61; Janine Bourriau in *Egypt's Golden Age* 1982, p. 81, no. 58.
4. Quibell 1908, pp. 42–45, pl. XX; Peter Lacovara in *Mummies and Magic* 1988, pp. 139–40, no. 79a.
5. Lilyquist 2003, pp. 282–83.
6. Quibell 1913, pl. XXI.
7. Jéquier 1921, pp. 141–42.
8. An eighth jar is added to make two equal rows in the wood box. Reisner and W. S. Smith 1955, p. 42, fig. 41, pl. 34a.
9. Winlock 1934, pp. 68–69, pl. XVI, b; Hayes 1953, pp. 243–44.
10. J. P. Allen 2000, p. 445, W1.

11. Hayes 1959, pp. 84–85, figs. 46, 47.
12. Jéquier 1921, pp. 309–11; Dorothea Arnold 1984, cols. 214–16.

PROVENANCE: Western Thebes, Gabbanat el-Qurud, Wadi D, Tomb 1

BIBLIOGRAPHY: *151a*. Winlock 1948, pp. 53–57; Lilyquist 2003, p. 144, no. 74, figs. 133 (left), 134a
151b. Winlock 1948, p. 56, pl. XXXIV (right); Lilyquist 2003, pp. 140–41, no. 48, fig. 122
151c. Winlock 1948, p. 54, pl. XXXII, c; Lilyquist 1995, p. 38, no. 74, fig. 83; Lilyquist 2003, p. 141, no. 49, fig. 123
151d. Winlock 1948, pp. 53–57, pl. XXX, d; Hayes 1959, p. 140, fig. 76; Lilyquist 2003, p. 144, no. 77, figs. 133, 134d

152. Ointment Jar in the Form of a Pitcher

Early 18th Dynasty, reign of Thutmose III (r. 1479–1425 B.C.)
Crystalline travertine
H. 20.7 cm (8⅛ in.), Diam. 15 cm (5⅞ in.)
The Metropolitan Museum of Art, New York, Fletcher Fund, 1926 26.8.18

This handled pitcher is an ointment jar. It has a globular body, a tall, straight cylindrical

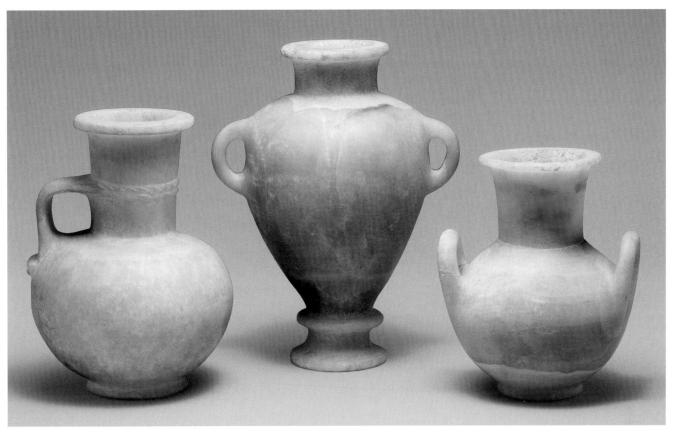

152, 153, 154

neck with a flat ledge rim, and a ring base. The flat strap handle extends from the neck to the shoulder. Surrounding the neck where it joins the handle is a double-ribbed raised band with diagonal notches imitating a twisted cord. The same raised-relief decoration is carved at the base of the handle where it meets the shoulder. The surface of the handle has three deep grooves.

Handled jugs were included in sets of jars for the seven sacred oils as early as the Fourth Dynasty.[1] However, specific features of this jar are derived from the so-called bilbils, or juglets, of Cypriot Base Ring I ware (see cat. no. 156), which were imported into Egypt from the beginning of the Eighteenth Dynasty. In particular, the double raised band around the neck and the spherical shape of the body are attributes copied from Base Ring juglets. A stone ointment flask from the tomb of Yuya and Tjuya even more closely copies the Base Ring type but adds papyrus umbels in raised relief to the base of the handle.[2]

A similar jug also found in the tomb of the three foreign wives of Thutmose III, though taller and with a more ovoid body, has the same broad grooved handle and raised-relief decoration imitating twisted cord. It is now in a private collection in Switzerland.[3]

SJA

1. Reisner and W. S. Smith 1955, p. 42, fig. 41, pl. 34a.
2. Egyptian Museum, Cairo, 51106; Quibell 1908, p. 48, pl. XXVI.
3. Lilyquist 2003, p. 145, no. 84, fig. 135f.

PROVENANCE: Western Thebes, Gabbanat el-Qurud, Wadi D, Tomb 1

BIBLIOGRAPHY: Winlock 1948, p. 63, pl. XXXVII (lower right); Lilyquist 2003, p. 145, no. 83, figs. 135b, g

153. Amphora-Shaped Jar on Stand

Early 18th Dynasty, reign of Thutmose III (r. 1479–1425 B.C.)
Travertine
H. 24.5 cm (9⅝ in.), Diam. 14.2 cm (5⅝ in.)
The Metropolitan Museum of Art, New York, Rogers Fund, 1918 18.8.19

This travertine amphora with an attached stand is modeled after a vessel type called a Canaanite jar.[1] Commodities such as wine and oil were traded throughout the Eastern Mediterranean and imported into Egypt from the Levant in Canaanite jars from the time of the Middle Kingdom.[2] The tomb of Rekhmire, which dates to the reign of Thutmose III, is decorated with scenes showing the princes of Retenu[3] bringing as tribute amphorae of this kind, labeled as containing incense.[4] And indeed, analyses of residues found in New Kingdom amphorae from Amarna have shown that they contained pistacia resin, a substance from the Levant used as incense.[5]

Later in the New Kingdom, this vessel shape was incorporated into the Egyptian pottery corpus and produced locally.[6] The Egyptian-made pottery jars were produced in marl clays and covered with light-colored polished slips that resemble the polished stone used here.[7] Large numbers of such jars have been recovered from the palaces of Amenhotep III at Malqata, where, according to hieratic dockets inscribed on them,[8] they contained wines from all over Egypt that were used in the Sed festivals of the king. Similar vessels resting on stands are frequently depicted in vineyard and estate scenes in other New Kingdom tombs.[9]

The present jar was found in the tomb of the three foreign wives of Thutmose III. It is still full of hardened ointment. The jar may originally have been closed with a small disk of alabaster to protect its valuable contents, although no lid survives.

An identical jar, now in Cairo, was found by the Egyptian Expedition of The Metropolitan

Museum of Art in a burial of the early Eighteenth Dynasty in Deir el-Bahri.[10] Another example, this one inscribed for Thutmose III, was found in a tomb on Crete,[11] and a third was discovered reused in the burial of Psusennes I (r. 1040–992 B.C.), of the Twenty-first Dynasty, at Tanis.[12] A jar and stand of the same type inscribed for Amenhotep II, formerly in the Gallatin Collection and now in the Metropolitan Museum, is thought to have come from this king's tomb.[13] Jars of similar shape with attached or accompanying stands have also been found in the tombs of Maiherperi, a courtier of Hatshepsut and Thutmose III,[14] and Yuya, the father-in-law of Amenhotep III, in the Valley of the Kings.[15] SJA

1. Grace 1956, pp. 80–81; Amiran 1970, pl. 43; Bourriau 1990, p. 18.
2. Dorothea Arnold, F. Arnold, and S. J. Allen 1995, pp. 27–29, fig. 6.
3. Norman de G. Davies 1935, pl. x; Norman de G. Davies 1943, pls. XXII, XXIII (top registers).
4. Virey 1889, pp. 37–38; Norman de G. Davies 1943, p. 28, pls. II, XXI.
5. Serpico and White 1998, p. 1038; Serpico and White 2000, pp. 434–36.
6. Peet and Woolley 1923, pl. LII (Type XLIII/67, XLIII/120), pl. LIII (Type LXX/130); Frankfort and Pendlebury 1933, pp. 112–13 (Types XVI, "Wine jars," XVII, "Two-handled bottles," XIX, "Two-handled jars"); Rose 1984, p. 135, fig. 10.1 (Types 20, 21), 137.
7. Nicholson and Rose 1985, p. 136; Bourriau and Nicholson 1992, p. 56.
8. Hayes 1951; Hayes 1959, p. 248, fig. 151.
9. Norman de G. Davies 1923, pl. XXX (Nebamun, Theban tomb 90).
10. Egyptian Museum, Cairo, 45638. Deir el-Bahri, CC41, Pit 3, chamber B, burial 4; Lansing 1917, pp. 17, fig. 18 (second from left), 21.
11. Karetsou and Andreadaki-Blasaki 2000, pp. 220–21; Lilyquist 1995, p. 41, no. 95, figs. 90, 91.
12. Montet 1951, pp. 93–94, no. 331, pl. LXII.
13. Metropolitan Museum of Art, New York, 66.99.23. Cooney 1953, p. 7, no. 21, pl. XVIII; Lilyquist 1995, p. 53, no. BB, fig. 146.
14. Daressy 1902, pp. 12–13, pl. IV, 24007.
15. Quibell 1908, p. 48, pl. XXIV.

PROVENANCE: Western Thebes, Gabbanat el-Qurud, Wadi D, Tomb 1

BIBLIOGRAPHY: Winlock 1948, p. 63, pl. XXXVII (lower left); Karetsou and Andreadaki-Blasaki 2000, p. 224; Lilyquist 2003, p. 145, no. 79, figs. 135a, g

154. Two-Handled Ointment Jar

Early 18th Dynasty, reign of Thutmose III (r. 1479–1425 B.C.)
Crystalline and banded travertine
H. 22.8 cm (9 in.), Diam. 17 cm (6¾ in.)
The Metropolitan Museum of Art, New York, Rogers Fund, 1918 18.8.18

The shape of this vessel, with its round body, ring base, and tall cylindrical neck, was first introduced in the Eighteenth Dynasty and was used until the Twentieth Dynasty. The horizontal, or basket, handles seen here appeared on pottery jars in the reign of Hatshepsut[1] and on stone containers in the reign of Thutmose III. The thickness of the wall of this example varies considerably; it is quite thin in the neck and shoulder. A hole has developed in one of the thinnest areas, near the juncture of one of the handles and the body of the vessel. There are traces of ointment on the interior and exterior. No lid has survived.

SJA

1. Daressy 1902, pp. 17–18, pl. v, 24021, 24023 (Maiherperi); Brunton and Engelbach 1927, pl. XXXVIII (Type 51).

PROVENANCE: Western Thebes, Gabbanat el-Qurud, Wadi D, Tomb 1

BIBLIOGRAPHY: Winlock 1948, pp. 63, 67, pl. XXXVII (upper right); Lilyquist 2003, p. 145, no. 81, figs. 22 (top), 135d, g

155. Carinated Jar

Early 18th Dynasty, early joint reign of Hatshepsut and Thutmose III (1479–1458 B.C.)
Limestone
H. 16.7 cm (6⅝ in.), Diam. 19 cm (7½ in.)
The Metropolitan Museum of Art, New York, Rogers Fund, 1916 16.10.451a, b

The baggy shape and sharp carination of the lower body of this limestone vessel copies a traditional Egyptian form called the *dšrt* jar.[1] The form is common in pottery from the Old Kingdom onward in burials and in the funerary ritual.[2] It is related to similar pottery forms that appeared in Upper Egypt as early as the Second Intermediate Period.[3] A raised band with carved diagonal lines imitating a twisted cord decorates the base of the neck, and it is possible that the limestone used here is meant to mimic pottery, specifically the light-colored marl clay employed for jars of this type. Stone jars with flat lids, however, were made to contain ointment.

This vessel was deposited in the lowest chamber of a pit tomb cut into the forecourt of a reused Middle Kingdom tomb.[4] The tomb was covered over during the construction of the causeway of Hatshepsut's mortuary temple sometime after year 7 of her reign.[5] The burial, excavated by The Metropolitan Museum of Art in 1916, belonged to a man named Nakht.[6] In addition to this stone vase, the tomb yielded two coffins (one a finely decorated and gilded anthropoid inner coffin), four bronze vessels, a bronze mirror, a bronze sword and other tools and weapons, a porphyry stone jar (possibly an

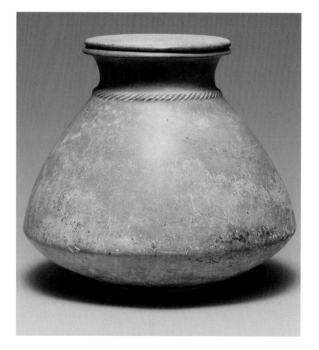

155

antique), two hard stone cosmetic or ointment vessels, bronze toilet equipment, and a large heart scarab set in gold.[7] SJA

1. Dorothea Arnold 1984, cols. 214–16.
2. Reisner and W. S. Smith 1955, p. 64, figs. 59, 60.
3. Brunton 1930, pl. XVI (Type 55 with round base).
4. Lansing 1917, p. 16, fig. 15 (showing jar in situ).
5. Dieter Arnold 1975, col. 1017.
6. Lansing 1917, pp. 22–24.
7. Ibid., figs. 8, 21, 23–25.

PROVENANCE: Western Thebes, Lower Asasif, courtyard of Tomb CC41, pit 3, chamber D; Metropolitan Museum of Art excavations, 1916

BIBLIOGRAPHY: Lansing 1917, pp. 16, fig. 15, 22–24; Hayes 1959, pp. 66–67, fig. 35; Lilyquist 1995, p. 62, fig. 159 (right)

156. Cypriot Base Ring I Juglet

Early 18th Dynasty, reign of Thutmose III (r. 1479–1425 B.C.)
Pottery, linen stopper
H. 14.3 cm (5⅝ in.), Diam. 7 cm (2¾ in.)
The University of Pennsylvania Museum of Archaeology and Anthropology, Philadelphia, Gift of Egypt Exploration Fund E15425

Cypriot Base Ring I juglets, or bilbils, were first imported into Egypt in the early Eighteenth Dynasty and reached their greatest popularity in the reign of Thutmose III.[1] The juglets are very common throughout the eastern Mediterranean world, and it is likely that they came into Egypt via Ras Shamra, in Syria.[2] The type is characterized by a spherical or pyriform body on a small trumpet-shaped or low ring base, a tall, narrow neck tapering to a funnel-shaped rim, and a single loop handle extending from below the rim to the shoulder. Applied bands of clay around the neck at its juncture with the handle, as seen here, are also common.[3] The juglets are finely made and have a highly polished surface, which ranges in color from red to brown to black. The body of the vessel is sometimes also decorated with raised clay bands.

It has been suggested that the form of the vessel was modeled after an inverted poppy pod and was intended as a deliberate reference to its contents, namely opium.[4] The spherical or slightly pyriform body does indeed resemble the seed capsule of the opium poppy (*Papaver somniferum*), and the small low ring or high flaring trumpet base on which it is set seems to be modeled after the stigma of the poppy. The long, thin cylindrical neck of the juglet may represent the stem. The mouth and neck of the vessel are very small and narrow, probably to protect the contents, which, if opium, must have been in liquid form and dispensed in small amounts. The sudden appearance of Base Ring I juglets in Late Cypriot I (1600–1450 B.C.)[5] may indicate that they were specially produced to contain and export opium. If this were so, the shape of the vessel served as an advertisement for its contents.

Though many of these juglets have been tested for opium,[6] only one example, which lacks an excavated provenance, has been shown to have contained the drug.[7] All the others contained oils or fatty substances. Most of the juglets have been found in tombs and, like this example, had been stoppered or sealed with Egyptian linen. It is probable that the juglets entered Egypt containing opium, which was used up by the living, and were refilled with oils or ointments, resealed, and placed in tombs. Certainly the association of the vessel shape with opium and its beneficial medicinal properties[8] was a factor that encouraged their reuse and inclusion in tombs.

Soon after these juglets were first imported, Egyptian craftsmen began to imitate them locally or produce new vessel types derived from them, in the same way they had adapted many other foreign vessel forms in local Nile clay.[9] They also adapted these forms for ointment vessels in other materials, such as stone (see cat. no. 152).

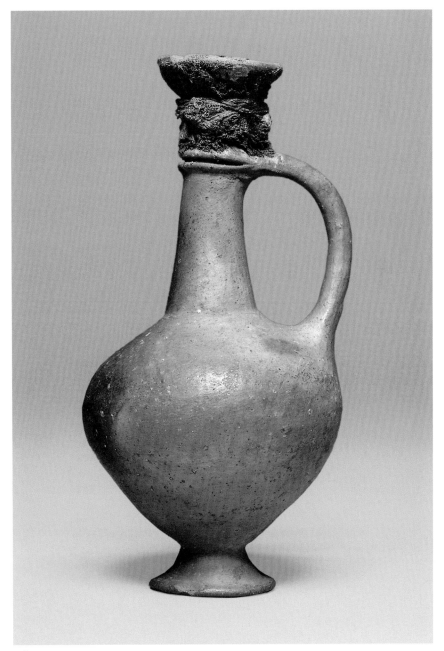

156

This juglet is one of five similar imported Cypriot vessels found in an intact burial at Sedment, which was dated by its excavators to the reign of Thutmose III.[10] A single coffin contained the remains of two women, a man, and a child. They had been furnished with five beautifully preserved baskets containing alabaster ointment jars, wood and alabaster kohl tubes, two small painted and inlaid boxes, a wood comb, a scarab, and a few beads. Four of the five juglets were found in the baskets and one was wedged into the corner of the coffin. All had been filled with some sort of resinous material and had been sealed with linen tied over their mouths. Two other vessels, both Egyptian made, of unusual shape, and red polished (see cat. nos. 157, 158), were also found in one of the baskets. SJA

1. Robert Merrillees (1968, p. 191), in his study of Cypriot pottery in Egypt, maintained that Base Ring I vessels were first imported into Egypt in the Second Intermediate Period. Recently this has been questioned by Kathryn Eriksson (2001), who argues that there are no firmly dated examples from the Second Intermediate Period.
2. Merrillees 1968, pp. 187–91.
3. Ibid., p. 203. This form corresponds to Type IBa(II) in his typology, which he states is the most commonly found form in Egypt (p. 151).
4. Merrillees 1962, p. 289, pl. XLII; Merrillees 1968, pp. 154–55.
5. The Cypriot chronology used here is based on that published in Karageorghis 2000, p. XII.
6. Bisset et al. 1996.
7. Bisset, Bruhn, and Zenk 1996.
8. Merrillees 1962, p. 292; Merrillees 1974, p. 36.
9. Merrillees 1968, pp. 149–54; Bourriau 1981b, pp. 135–36, no. 266.
10. Petrie and Brunton 1924, p. 26.

PROVENANCE: Sedment, Cemetery A, Tomb 254; W. M. Flinders Petrie excavations for the British School of Archaeology in Egypt, 1920–21

BIBLIOGRAPHY: Petrie and Brunton 1924, pp. 24, 26, pls. LV (upper left), LVII, 32; Merrillees 1968, pp. 62–64, pl. X; Merrillees 1974, pp. 30–35, fig. 22

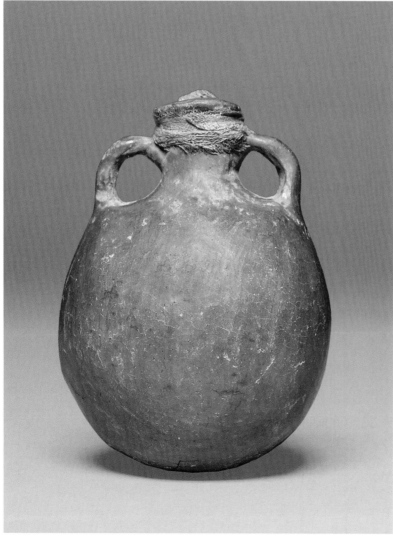

157

157. Pilgrim Flask

Early 18th Dynasty, reign of Thutmose III (r. 1479–1425 B.C.)
Pottery, linen stopper
H. 10 cm (4 in.), Diam. 7.3 cm (2⅞ in.)
The University of Pennsylvania Museum of Archaeology and Anthropology, Philadelphia, Gift of Egypt Exploration Fund E 14337

Pilgrim flasks became popular throughout the Aegean and Levant during the Late Bronze Age, and their canteen-shaped form was adopted by Egyptian potters in the New Kingdom.[1] (Only much later, after they were manufactured as souvenirs for Christian pilgrims visiting holy sites, did they become known as pilgrim flasks.)[2] This flask of red-polished pottery has a lentoid body made in two halves. After the halves were joined, the neck and rim were added and the two loop handles were applied. The vessel is stoppered and sealed with linen placed over the mouth and tied around it.

This flask was found in a basket that accompanied a multiple burial in a single coffin at Sedment. In the same basket were found a red-polished flask imitating a leather original (cat. no. 158) and a Base Ring I juglet (cat. no. 156). Although canteens are today associated with water or other liquid to be drunk, this vessel probably contained some sort of oil or ointment. SJA

1. Amiran 1970, pp. 166–67, pl. 51.
2. Bourriau 1981b, pp. 75–76, no. 143.

PROVENANCE: Sedment, Cemetery A, Tomb 254; W. M. Flinders Petrie excavations for the British School of Archaeology in Egypt, 1920–21

BIBLIOGRAPHY: Petrie and Brunton 1924, pp. 24, 26, pls. LV (upper left), LVII, 36; Merrillees 1968, p. 63; Merrillees 1974, pp. 38–39, fig. 26

158. Flask

Early 18th Dynasty, late reign of Thutmose III (r. 1479–1425 B.C.)
Pottery with remains of linen and string
H. 12 cm (4¾ in.), W. 9.9 (3⅞ in.), D. 6.3 cm (2½ in.)
The University of Pennsylvania Museum of Archaeology and Anthropology, Philadelphia, Gift of Egypt Exploration Fund E 15426

This pottery vessel imitates a leather flask or canteen. The body is covered in a thick red burnished slip, and bands of clay in raised relief along the vertical side seams with both incised and painted black lines indicate the welts and stitches that would have held the separate pieces of the leather body together. A tall, thin neck rises from the body of the flask, and a stopper made of string and linen is still in place. Traces of linen that held the stopper in place appear around the mouth. There are two small loops for carrying or suspending the flask at the corners. The strap handle and the two raised ribs of clay seen on the vessel's neck below the rim are adapted from the ones on Cypriot Base Ring I juglets, examples of which were found in the same tomb as this flask (see cat. no. 156).[1]

The flask was discovered inside one of five baskets placed in a coffin containing the undisturbed bodies of three adults and a child. As the basket held other toilet articles, it is possible that this vessel contained some valuable cosmetic or medicinal compound.[2] The flask is dated to late in the reign of Thutmose III based on the style of other objects found in this burial.[3]

Vessels of this type are rare, and most examples are more simply made than the present piece. Two are known from another tomb at Sedment,[4] one from Abydos, now in the Ashmolean Museum, Oxford,[5] and one, probably from Thebes, now in The Metropolitan Museum of Art in New York.[6] Two copies in alabaster are also known.[7] SJA

1. Merrillees 1974, p. 38.
2. Petrie and Brunton 1924, p. 26; Merrillees 1968, pp. 62–64.
3. Janine Bourriau in *Egypt's Golden Age* 1982, p. 103, no. 85.
4. Petrie and Brunton 1924, p. 24 (Tomb 53).
5. Ashmolean Museum, Oxford, E2405, tomb E178; Garstang 1901, p. 14, pl. XIX; Bourriau 1981b, pp. 76–77, no. 144.
6. Metropolitan Museum of Art, New York, 25.7.26; Hayes 1959, p. 209, fig. 123.
7. From tomb S66 at Aniba (Steindorff 1935–37, vol. 2, p. 146, pl. 95, 1) and in the collection of the Musée Georges Labit, Toulouse (Guillevic and Ramond 1971, pp. 14–15).

PROVENANCE: Sedment, Tomb 254; W. M. Flinders Petrie excavations for the British School of Archaeology in Egypt, 1920–21

BIBLIOGRAPHY: Petrie and Brunton 1924, pp. 24, 26, pls. LV (upper left), 12, LVII, 33; Merrillees 1968, p. 63; Merrillees 1974, pp. 37–38, fig. 25; Janine Bourriau in *Egypt's Golden Age* 1982, p. 103, no. 85

159. Vessel in the Shape of a Basket

18th Dynasty (1550–1295 B.C.)
Pottery
H. 14.3 cm (5⅝ in.), Diam. 7 cm (2¾ in.)
The Metropolitan Museum of Art, New York, Theodore M. Davis Collection, Bequest of Theodore M. Davis, 1915 30.8.209

Ancient Egyptian potters often copied the form of a container normally made in a material other than clay. This practice is demonstrated by the present vessel in the shape of a round basket gathered shut by its two handles. Large, round two-handled baskets of this kind were common in ancient Egypt[1] and are still in use today. Workers employed similar baskets, for example, to carry away dirt and debris from the temples of Deir el-Bahri during The

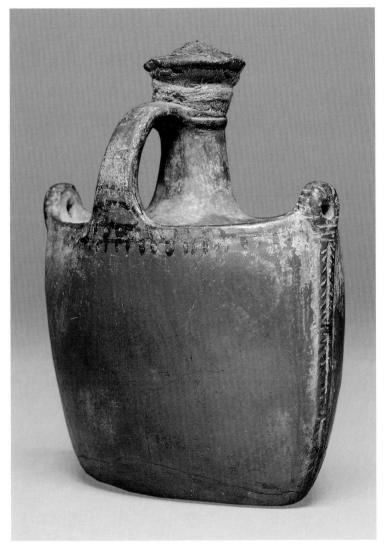

158

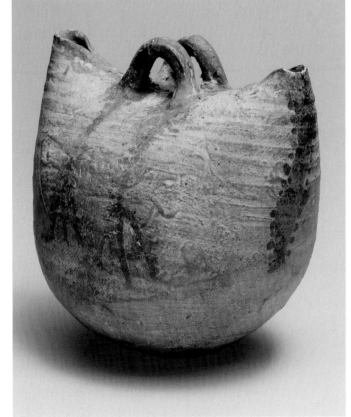

159

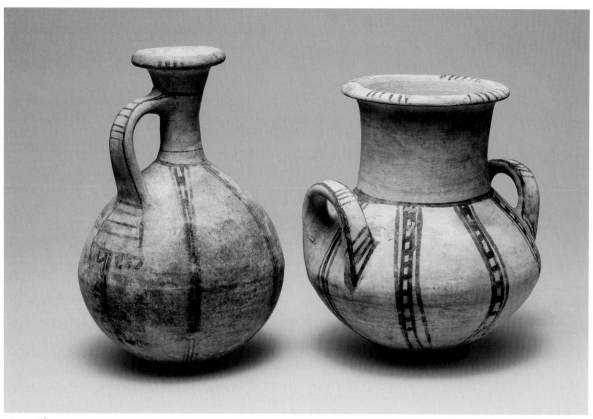

160a, 160b

Metropolitan Museum of Art's excavations between 1911 and 1931.[2]

This vessel was formed by pinching the rim of a small, deep round-bottomed cup closed and applying two small loop handles at its top. The surface of the pot is coated with a pale cream color and lightly ribbed to imitate the individual strips of a woven basket. The handles and rim are painted red, and two pairs of forked red lines bordered by black dots extend down from the handles. These lines are meant to show that the handles are from separate cords that are woven into the basket to reinforce their attachment.[3] The black band outlined in red dots at each end of the vessel may be purely decorative or perhaps imitates some functional element of the original basket, such as a leather reinforcement. The pot's small size and the fact that it is almost completely closed may indicate that it was meant to contain a precious substance that could be poured from one of the two small openings at the rim.

Round or oval baskets, especially those with lids, were commonly placed in New Kingdom burials as containers for personal items such as cosmetic jars, jewelry, toilet implements, clothing, and wigs. Eight large lidded baskets that may have stored clothes or linen and two smaller baskets for toilet articles and false braids were found in the tomb of Queen Meryetamun, wife of Amenhotep I.[4] SJA

1. Gourlay 1981, vol. 2, pl. XXI, b.
2. Winlock 1942, pl. 1.
3. Gourlay 1981, vol. 1, pp. 83–84, fig. 145.
4. Winlock 1932b, pp. 34–36, 75–78, pls. XXXII, XXXIV–XXXVI, XXXIX, a.

PROVENANCE: Formerly Theodore M. Davis collection

160a. Jug with Handle

Early 18th Dynasty, early joint reign of Hatshepsut and Thutmose III, after year 7 (1479–1458 B.C.)
Pottery jug
H. 20.3 cm (8 in.), Diam. 13.3 cm (5¼ in.)
The Metropolitan Museum of Art, New York, Rogers Fund, 1916 16.10.426

160b. Jar with Basket Handles

Early 18th Dynasty, early joint reign of Hatshepsut and Thutmose III, after year 7 (1473–1458 B.C.)
Pottery jar
H. 20.3 cm (8 in.), Diam. 13.3 cm (5¼ in.)
The Metropolitan Museum of Art, New York, Rogers Fund, 1916 16.10.427

Both the jug and the biconical jar are wheel-made of marl clay and are probably of Upper Egyptian origin. They are covered with a coating that ranges from pale yellow to pale brown and are burnished. The burnishing strokes are still visible, especially on the necks of the vessels. Their painted decoration is applied with a brush or reed.

The jug (cat. no. 160a) has a pyriform body and a flat base. The tall, slender neck flares out at the top and has a flattened ledge rim. A single strap handle runs from the neck below the rim to the shoulder. The decoration on the body is made up of alternating patterns, a black line bordered by two red lines and a black ladderlike band bordered by two red lines, which descend from the base of the neck and divide the body into zones. Four groups of four tick marks each are arranged around the top of the rim. The black outline of the handle continues around the neck of the vessel; at the base of the handle the lines are extended downward and diverge to form a trapezoid filled with alternating horizontal red and black lines and with four small half circles along its lower edge. This design is perhaps meant to represent a floral element, as a similarly decorated jug found at Badari has three clearly leaflike elements at the base of its handle.[1]

In both its shape and decoration this Egyptian-made jug is similar to Cypriot White Pendant Line juglets that were imported into Egypt from the end of the Second Intermediate Period into the early years of the Eighteenth Dynasty.[2] The division of the vessel body into zones by bands, the use of groups of tick marks

on the rim and bands on the handle, and the contrast between the light-colored background and the dark red and black paint of the linear designs are all characteristics of this Cypriot style. The decoration is freely applied rather than rigidly symmetrical. The artist must have been familiar with the decorative style to have applied it so skillfully.

This style of red and black decoration painted on a light surface was adopted into the pottery repertoire of the New Kingdom and applied to purely Egyptian forms such as the biconical, or carinated, jar (see cat. no. 155). Such squat carinated jars with outturned rims were common in the Second Intermediate Period.[3] In the early New Kingdom the form evolved so that the bodies became less sharply carinated, a long cylindrical neck with a ledge rim and flat or ring base developed, and a clear distinction between the body, neck, and rim was made. The shape

was used during the New Kingdom for plain jars without handles, for jars with two horizontally applied basket handles, and for jugs or pitchers with a single handle. The red and black ladderlike decoration is applied to the bodies, rims, and handles of these vessels. They are usually finely made of marl clay but occasionally were produced in Nile clay fabrics.

These two pottery vessels were deposited with one of four burials in a five-chambered pit tomb cut into the forecourt of a reused Middle Kingdom tomb[4] that was covered over during the construction of the causeway of Hatshepsut's mortuary temple sometime after year 7 of her reign.[5] The burial included an anthropoid coffin and a cartonnage mummy mask, a large bronze mirror, a set of ointment jars in alabaster and serpentine, a glass hairpin, three combs including one of ivory, and a circular toilet box with a swiveling lid and incised designs filled in with

Egyptian blue (see cat. no. 144). Neither jar shows any traces of its original contents or of sealing or closing, but their fine quality suggests that they were meant for the use of the deceased, either for storing cosmetics or as tableware.[6] SJA

1. Brunton 1930, p. 14, pl. XXIX, 200. The vessel from grave 5297, which the excavator dated to the New Kingdom, contained plaits of human hair.
2. Merrillees 1968, pp. 145–47, pl. I, 2–4, pl. II, 1, 2.
3. Bourriau 1997, fig. 6.18.
4. Lansing 1917, p. 21.
5. Dieter Arnold 1975, col. 1017.
6. Bourriau 1981b, pp. 78–79, no. 150.

PROVENANCE: Western Thebes, Lower Asasif, courtyard of Tomb CC41, pit 3, chamber B; Metropolitan Museum of Art excavations, 1915–16

BIBLIOGRAPHY: Lansing 1917, p. 21; Hayes 1959, p. 66

FIGURE VASES

Elegant, finely crafted pottery vessels shaped like animals and humans are among the art forms that thrived during the mid-Eighteenth Dynasty, beginning in the reign of Thutmose III. Scholars making the earliest studies of these vases thought they were of foreign manufacture or at least heavily influenced by cultures outside Egypt.[1] More recent studies argue that they were made in Egypt by Egyptian potters.[2] Figure vases appeared at a time of great creativity and experimentation in all of the arts in Egypt. During this period, Egyptian potters both copied and adapted the forms of vessels imported from abroad.[3] However, although some details of the vases reflect foreign influence, when compared with contemporary Egyptian painting the figures appear recognizably Egyptian both in style and in subject.[4]

Some of the human-shaped figure vases are unique, such as those representing a lute player, a serving girl, and a scribe, catalogued here (cat. nos. 166–168). However, similar figures can be found among the secondary characters (entertainers, servants, and workers) depicted in wall paintings in contemporary tombs. These vessels may have served as both containers in this life and servants in the afterlife,[5] although it is also possible that the more unusual vases were valued principally for their inherent beauty and charm, as suggested by Geneviève Pierrat.[6]

By far the most common type of human-shaped figure vase is the kneeling mother and child (cat. nos. 161–164). These figures depict a more private and domestic milieu than is usual in Egyptian art. The women are clothed in simple garments, including shawls, and wear their hair down, not in the elaborate styles seen in banquet scenes in contemporary tomb paintings.[7] The woman is usually shown holding the child on her lap, sometimes suckling it (cat. no. 161), sometimes merely cuddling it (cat. nos. 162, 163); in a few cases, the child is in a sling on the mother's back (cat. no. 164). Although a number of the figures are alike in pose, no two are ever exactly the same, either in size or in style (see

fig. 80). Because of the similarity of their material and manufacture, Janine Bourriau has suggested that the kneeling women were probably all made in a single workshop over a period of a generation or two.[8] Unfortunately, only a few of these vases are from excavated contexts, and these range from Sedment in the north to Abydos in the south (see cat. no. 164); thus nothing indicates the location of such a workshop.

The question of how figure vases depicting a mother and child were used has been discussed extensively by a number of scholars, and a variety of interpretations have been put forward.[9] The current consensus is that these vessels had some connection with medicine and/or midwifery.

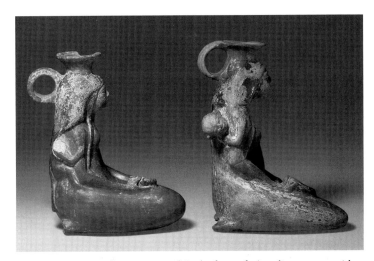

Fig. 80. Two pottery figure vases, each in the form of a kneeling woman with a child suspended on her back in a sling. Early 18th Dynasty. On the vase at the left, the head of the child is missing. The Trustees of the British Museum, London (EA 54694, EA 24652; see cat. no. 164)

Mother's milk, especially that of a woman who had borne a male child, was considered a potent ingredient for the treatment of certain maladies,[10] and it has been suggested that the vases were containers for breast milk.

The image of a mother and child, and, more specifically, of a mother suckling her infant (cat. no. 161), has a long history in Egyptian art.[11] Such images are symbolically tied to the Egyptian concept of rebirth in the next world and to rejuvenation and healing during life. What better container could there be for medicine than one depicting a mother and her child? And considering the Egyptians' belief in magic, it is also possible that any type of milk, or any liquid decanted into a bottle shaped like a woman suckling or holding a child, took on the healing properties of real mother's milk. The infants represented on figure vases are generally of unspecified sex, but one of the vessels in this catalogue depicts a woman holding what is obviously a baby boy (cat. no. 163), perhaps imparting to the container a potency greater than the others'.

The idea that vases depicting kneeling women are associated with midwifery is supported by the simple horn container that several of the figures hold on their laps (cat. no. 164; see also cat. no. 2), and the pot that one figure has slung over her shoulder where one would expect to find a child (cat. no. 165). These accoutrements suggest that the women represented are themselves practitioners of medicine. Another category of figure vase is made up of stone vessels depicting naked women who are clearly pregnant (cats. nos. 169, 170). It has been suggested that these jars held a substance used to ensure the health of the unborn child or to ease the discomfort of pregnancy and childbirth for the expectant mother.

It is noteworthy that of the few figure vases found in closed archaeological contexts, two—a pottery vase (cat. no. 164) and a stone vase (cat. no. 170)—were in the same tomb. The burial also included a large number of small containers of pottery and stone, a faience bowl (for similar bowls, see cat. nos. 100–105), and a scribe's palette. In the same group was a unique vase that has been described as resembling *dom*-palm fruit hanging from the tree,[12] although the pendant fruit is also strongly suggestive of a human breast. This fantastic jar seems impractical for ordinary use; however, as a magical container intended to give potency to the liquid inside, it would complement the figure vases. The scribal palette, magical vases, and array of small jars suggest that one of the tomb's owners was a doctor, midwife, or other medical practitioner.[13]

It has been proposed that the kneeling women represent wet nurses,[14] but there is nothing about the vases that would identify them as such. Nor is there any magical quality associated with wet nurses or their milk. Assuming that the vases contained mother's milk for use as medicine, it is likely that they depict a mother and her child rather than a wet nurse with her nursling, and that the infant is to be understood as a boy.

CHR

1. See Murray 1911.
2. For an in-depth study, see Bourriau 1987; for shorter discussions, see Bourriau 1981b and 1982. For a differing view, see "Egypt and the Near East" by Christine Lilyquist in this volume.
3. See "Pottery and Stone Vessels," above.
4. As pointed out by Janine Bourriau (1987, p. 83), who describes the figure vases as "alien" to the pottery traditions of western Asia and the Aegean.
5. Other "servant" figure vases are discussed in Bourriau 1987, pp. 90–93.
6. Pierrat 2005, p. 41.
7. For another interpretation, see Lilyquist, "Egypt and the Near East" (n. 2, above).
8. Bourriau 1987, p. 94.
9. Desroches-Noblecourt 1952; Brunner-Traut 1970b; Rand 1970; Bourriau 1987, pp. 93–95.
10. For examples, see Doll 1982, p. 291.
11. For an Old Kingdom example—a statuette of a woman suckling her children—see *Age of the Pyramids* 1999, p. 393, no. 17. For a Middle Kingdom statuette of a mother suckling her infant, see Hayes 1953, p. 222, fig. 138. From both periods there are also many examples of cosmetic vessels that depict a mother monkey and her infant.
12. Bourriau 1987, p. 93, pl. xxx.
13. The tomb has a number of chambers and contained eight burials. According to Snape (1986, pp. 360–61), there were two undisturbed burials in room 949, which contained the objects described here. For a photograph of the objects, see Garstang 1909, pl. xvi.
14. Emma Brunner-Traut (1970b) suggested that the vases represent wet nurses.

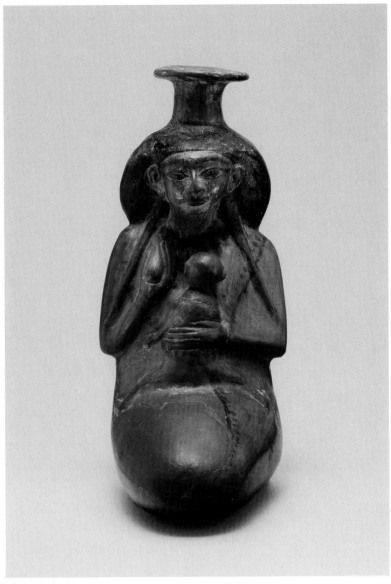

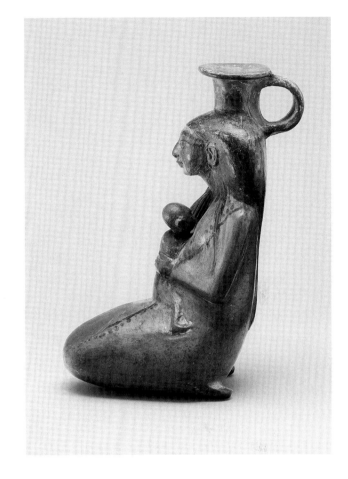

161

161. Vase in the Form of a Kneeling Woman Suckling a Child

18th Dynasty, reign of Thutmose III–reign of
Amenhotep III (1479–1352 B.C.)
Pottery, painted
H. 17 cm (6¾ in.), W. 7.5 cm (3 in.), D. 9.5 cm (3¾ in.)
Musée du Louvre, Paris N 969 (formerly AF 6643)

The figure is a woman with her right breast
bared, preparing to suckle her child. She wears
a shawl that obscures her arms in the back and
crosses over her body in the front. The painted
fringed edge of the shawl appears to be
wrapped around the child's back, covering the
lower part of his body (although his legs are
sharply modeled) and leaving his left arm free.
The woman's well-defined hands protrude
from the edges of the shawl. She wears three

bangles on her right wrist and a necklace of
amulets or large ball beads. A line painted
around her neck may represent a tie necklace
(see cat. no. 122), or it might indicate that she
wears a garment similar to that of the lute
player discussed below (cat. no. 166).[1] A third
possibility is that the decoration represents a
necklace of disks and crescents, as described by
Christine Lilyquist.[2]

The smiling woman has a wide face with
broad cheeks, huge almond-shaped eyes, and
pointed nose with flaring nostrils. She wears her
hair down, with two long locks pulled forward
over her shoulders and the rest drawn back
behind her ears in a thick ponytail that reaches
below her waist. In its kneeling position, this
figure is well balanced, with back straight and
head jutting slightly forward. A tall spout with
a small handle attached is set far back on the
head. CHR

1. Because the woman's right breast is bared, this last
explanation might seem unlikely; nevertheless, the
left breast is completely covered, presumably by a
garment worn beneath the shawl. One of the kneel-
ing women below (cat. no. 164) has a similar tie at
her throat, which appears to be part of a garment.

2. See "Egypt and the Near East" by Christine
Lilyquist in this volume. The neck area of this
figure is best seen in Robins 1993, p. 81, fig. 27,
which shows the vase before the baby's head was
restored. The original head was probably turned to
the child's left, as in catalogue no. 162.

PROVENANCE: Unknown; formerly Drovetti collec-
tion (no. 192); purchased in 1827

BIBLIOGRAPHY: Brunner-Traut 1970b, p. 149, no. 6,
figs. 9, 10; Robins 1993, p. 81, fig. 27; Quaegebeur
1999, p. 34, fig. 31

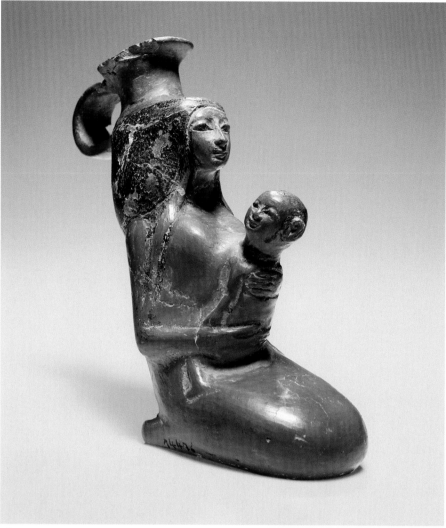

162

the figure leans distinctly backward, as though weighted by the spout and handle on its head.

CHR

1. A similar vase, with mother and child in the same pose but with the mother's back straighter, is in the Museum of Fine Arts, Boston (1985.336); see James F. Romano in Capel and Markoe 1996, pp. 61–62, no. 10b. The similarity of the infants' poses suggests that the child in catalogue no. 161 should have been restored to show its head turned to the left, toward the offered breast, rather than facing forward, toward the mother's chest.

PROVENANCE: Unknown; Deibel Legacy

BIBLIOGRAPHY: Desroches-Noblecourt 1952, fig. 3; Brunner-Traut 1970b, p. 147, no. 1, fig. 1; Susan K. Doll in *Egypt's Golden Age* 1982, pp. 293–94, no. 405

162. Vase in the Form of a Kneeling Woman Holding a Child

18th Dynasty, reign of Thutmose III–reign of Amenhotep III (1479–1352 B.C.)
Pottery, painted
H. 14 cm (5½ in.)
Ägyptisches Museum und Papyrussammlung, Staatliche Museen zu Berlin 14476
Not in exhibition

Like the infant on the previous vase (cat. no. 161), this child has his legs on either side of his mother's lap, and his left arm is visible. The head, with large ears, is turned to the left.[1] On this figure the paint that would indicate the woman's garments or jewelry is not preserved, but an amulet worn around the child's neck remains. The woman's hairstyle is similar to that in the previous example, except that her ears are covered.

In profile, the pose appears badly balanced;

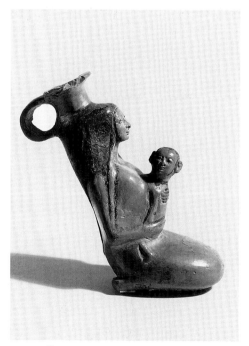

162, profile

163. Vase in the Form of a Kneeling Woman Holding a Child

18th Dynasty, reign of Thutmose III–reign of Amenhotep III (1479–1352 B.C.)
Pottery, painted
H. 11 cm (4⅜ in.), W. 6 cm (2⅜ in.), D. 9 cm (3½ in.)
Musée du Louvre, Paris AF 1660

On this vase the woman holds her child facing forward on her lap. Although most of the painted detail that would show clothing is gone, the lack of definition of the mother's upper arms suggests that she wears a shawl. The baby boy sits on top of this garment; his arms and legs are distinctly modeled and his sex clearly indicated. His left hand rests rather limply on his mother's arm, but with his right hand he clutches her right wrist, suggesting an interaction lacking in two comparable examples (cat. nos. 161, 162).

The woman sits in a well-balanced pose, back straight and chin slightly lifted. Her hairstyle is similar to those seen in the previous two examples, with two locks drawn forward and a long ponytail in back. While the woman's feet can be seen on the other figure vases in this catalogue, here they are not indicated. The now-missing handle was attached in two places to the back of the woman's head, not to the spout.

CHR

PROVENANCE: Unknown

BIBLIOGRAPHY: Desroches-Noblecourt 1952, p. 51, figs. 4–7, pl. 3; Brunner-Traut 1970b, p. 148, no. 3, fig. 4

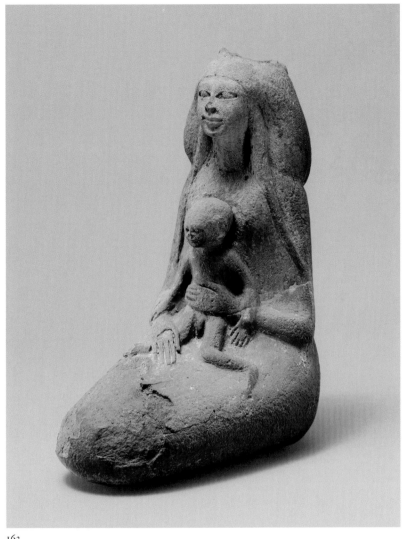

163

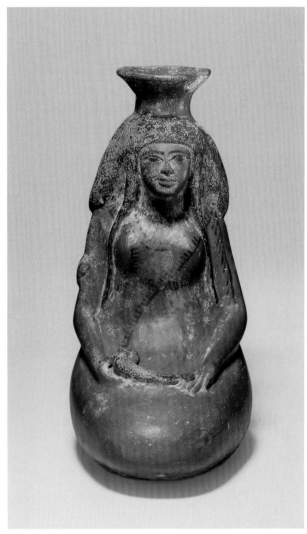

164

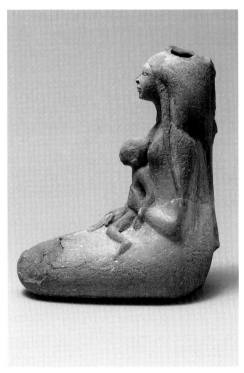

163, profile

164. Vase in the Form of a Kneeling Woman with a Baby and an Oil Horn

18th Dynasty, reign of Thutmose III–reign of
Amenhotep III (1479–1352 B.C.)
Pottery, painted
H. 12.2 cm (4¾ in.), W. 6 cm (2⅜ in.), D. 10 cm (4 in.)
The Trustees of the British Museum, London
EA 54694

This vase is shaped like a woman carrying a
small child on her back. On her lap she holds a
simple horn container, with the spoon resting
on her open left palm.[1] The child is wrapped in
his mother's shawl, the fringed edge of which is
visible along his back. His legs can be seen
beneath the shawl; with his free right arm, he
clutches his mother's upper arm. Although the
baby's head is missing, a similar figure vase in
the British Museum suggests that he was origi-
nally depicted looking over his mother's shoul-
der (see fig. 80, above). Egyptian women are

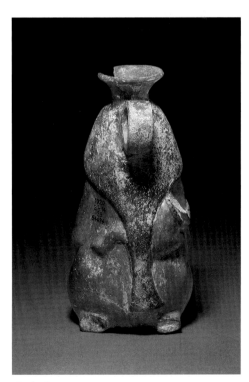

164, back

seldom represented carrying their children, but in at least one other instance a woman carries an infant in a sling that is probably fashioned out a shawl.[2]

The crossing edges of the mother's garments are difficult to interpret, but beneath the shawl there is at least one garment, tied at the neck. Although Egyptians are usually shown wearing a minimum of clothing, they must have worn shawls in cold weather. There are statues of men wearing enveloping cloaks (cat. no. 60), and similar garments were undoubtedly worn by women.[3]

The woman's hairstyle is similar to that seen in the previous examples, and here the long ponytail partially covers the child's body. In shape and features the face resembles catalogue no. 163, but the eyes here are larger and the neck somewhat shorter. The woman wears two strands of beads around her neck; the child seems to wear a single bracelet. The figure's pose is well balanced and relaxed. The spout is completely separate from the handle, which is a ring attached to the back of the head. CHR

1. For an example of a more elaborate horn container, see catalogue no. 2.
2. This scene is in the tomb of Menna at Thebes (TT 69). For an illustration, see Capel and Markoe 1996, p. 16, fig. 7.
3. In Egyptian tomb paintings people are not shown wearing cold-weather garments, because one purpose of the paintings was to perpetuate circumstances that were ideal in life.

PROVENANCE: Abydos, Tomb 949; excavated by John Garstang, 1909; given by Mrs. Russell Rea in 1920

BIBLIOGRAPHY: Garstang 1909, p. 129, pl. XVI; Brunner-Traut 1970b, pp. 149–50, no. 8, fig. 12; Bourriau 1987, pp. 93–94, pl. XXXI; Robins 1995, p. 76, no. 40

165. Vase in the Form of a Kneeling Woman with a Pot and an Oil Horn

18th Dynasty, reign of Thutmose III–reign of Amenhotep III (1479–1352 B.C.)
Pottery, painted
H. 12 cm (4¾ in.), W. 7 cm (2¾ in.), D. 9 cm (3½ in.)
Musée du Louvre, Paris E 11276

Like the figure in the previous entry, this woman holds an oil horn on her lap, with the large end grasped in her right hand and the

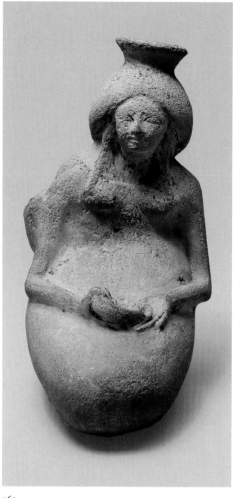

165

spoon lying in her open left palm. At first glance she also seems to carry a baby on her back, but closer inspection reveals that the object is a pot. Although the surface of the vase is quite degraded, remaining traces of paint indicate that the woman originally wore a shawl, the

edges of which can be seen on her back, over her shoulders, and crossing her chest. An undergarment is tied at the neck.

The figure's spindly arms are well defined even above the elbow both front and back, and seem not to be covered by the shawl. The hair is shorter than that in the previous examples, with the front locks ending at the woman's breasts and the ponytail in back reaching only to the waist. The pose is relaxed in profile, but the woman lists decidedly to her left. The wide spout is set at the center of the head and the round handle attached to the back of the head.

CHR

PROVENANCE: Unknown; formerly Nahmen collection; acquired in 1912

BIBLIOGRAPHY: Desroches-Noblecourt 1952, p. 63, figs. 8–11; Brunner-Traut 1970b, p. 150, no. 10, fig. 3

166. Vase in the Form of a Female Lute Player

18th Dynasty, reign of Thutmose III–reign of Amenhotep III (1479–1352 B.C.)
Pottery, painted
H. 21.5 cm (8½ in.), W. 8 cm (3⅛ in.), D. 5.7 cm (2¼ in.)
The Trustees of the British Museum, London EA 5114

The lute player depicted here twists her body slightly to the left, holding her left arm back so that she can more easily play her instrument. To

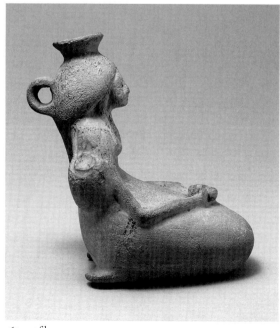

165, profile

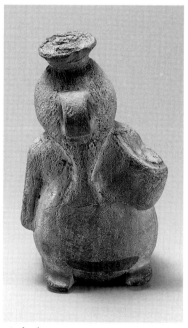

165, back

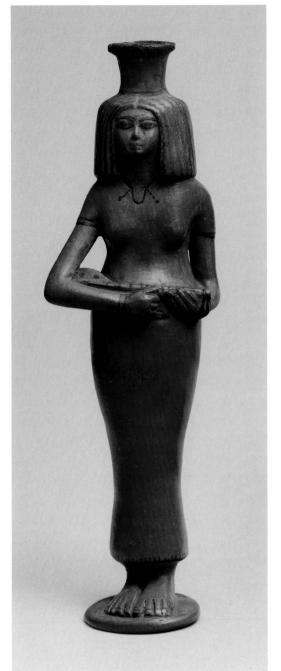

166

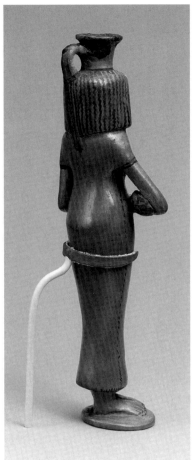

166, back

167. Vase in the Form of a Serving Girl

18th Dynasty, reign of Thutmose III–reign of
Amenhotep III (1479–1352 B.C.)
Pottery, painted
H. 18.5 cm (7¼ in.), W. 15.1 cm (6 in.)
Musée du Louvre, Paris AF 6335

In certain respects, this figure of a nude serving
girl is quite similar to the lute player (cat. no. 166).
In both, the body is short-waisted with wide
hips, and the arms are partially separated from
the body. Both also have shoulder-length hair
(although here the neck is longer). Like the lute
player's, the girl's feet are side by side and the
toenails are highlighted with black paint; the
nude girl's left foot is slightly advanced. While

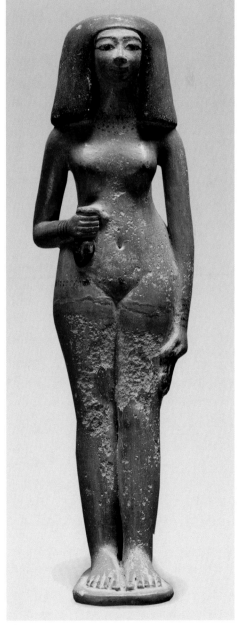

167

steady her right hand she places her little finger
on her belly. She wears a long dress with a
fringe at the hem; the ties at the neck, the hem
around the sleeves, and the stitching up the
sides are indicated in paint.[1] On her right wrist
is a single bangle. At the back of her head, two
braids hang down slightly below her shoulder-
length hair.

The lute has been carefully painted, with
frets on the neck and tassels at the end. The
openings on the front of the sound box are indi-
cated, and the back is painted as though it were
made of a large tortoiseshell.

This object would have been impractical for
use as a vessel. Because the base is small and the

figure leans back, it is impossible for the vase to
stand on its own. CHR

1. A similar garment is worn by a female musician in a
 wall painting in the tomb of Djeserkare-seneb at
 Thebes (Tomb 38). For a photograph, see Capel
 and Markoe 1996, p. 15, fig. 5.

PROVENANCE: Thebes; given by James Burton in
1836

BIBLIOGRAPHY: Bourriau 1981b, pp. 35–36, no. 49;
Bourriau 1987, p. 92, pl. XXX; Edna R. Russmann in
Russmann et al. 2001, p. 170, no. 80

the surface of the vase has suffered damage, most of the painted detail is visible, presenting an array of jewelry that includes one or more beaded necklaces, bangles at both wrists, and a girdle around the hips (similar to cat. no. 119). The girl holds a flask in her right hand and a small double pot similar to a cruet in her left.

The spout on the head that is typical of figure vases is lacking here. Instead, a tube extends along the figure's back from her heels to her buttocks. There are two large holes in the back—at the top of the tube and another at the neck—one of which may have been the opening for a spout. Some elements of the vase are missing, making it difficult to understand how it functioned as a vessel.

Both this figure and the lute player bring to mind the servants and entertainers pictured in the banquet scenes in Theban tombs, where girls wearing only jewelry pour perfume and wine from small flasks, and musicians play for assembled guests. Perhaps figure vases like these were used on such festive occasions, serving either as decoration or as containers for wine or perfume. CHR

PROVENANCE: Unknown

168. Vase in the Form of a Scribe

18th Dynasty, reign of Thutmose III–reign of
Amenhotep III (1479–1352 B.C.)
Pottery, painted
H. 15.3 cm (6 in.), W. 8.6 cm (3⅜ in.), D. 9.5 cm
(3¾ in.)
The Trustees of the British Museum, London
EA 24653

This figure vase is one of the few that represents a man. He is shown seated in the position of a scribe, with the right leg raised. The left foot hooks around the right ankle. Although his back is straight and his head lifted as though he awaits dictation, the scribe appears relaxed, leaning slightly to the left as one might expect with the legs in this position. He wears a kilt, on the surface of which he has unrolled a papyrus.[1]

With his spindly arms and listing pose, this figure brings to mind the kneeling woman of catalogue no. 165. On both these vessels the spout is an organic part of the head, while on most figure vases it seems like an afterthought. This scribe vase is also unusual in having no handle. CHR

1. The left hand and part of the left arm have been restored.

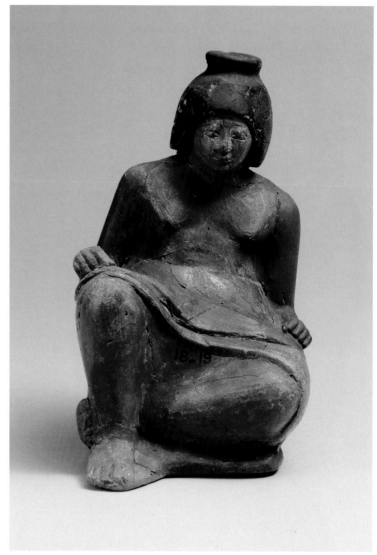

168

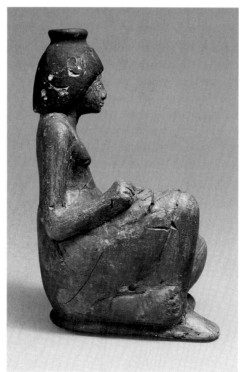
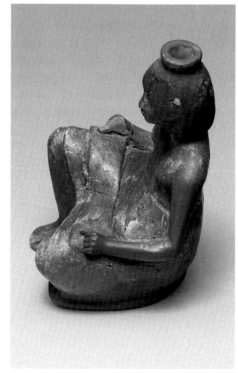

PROVENANCE: Unknown; purchased in 1893

BIBLIOGRAPHY: Parkinson 1999, p. 130, no. 45; Edna R. Russmann in Russmann et al. 2001, pp. 152–53, no. 64

169. Vase in the Form of a Pregnant Woman Playing a Lute

18th Dynasty, reign of Thutmose III–reign of Amenhotep III (1479–1352 B.C.)
Egyptian alabaster
H. 20.3 cm (8 in.)
The Trustees of the British Museum, London
EA 30459

Figure vases of stone are less common than those made of pottery. The stone versions generally represent nude pregnant women either standing or kneeling, and as a group they are much less detailed than their pottery counterparts. This woman, shown standing with her knees slightly bent, holds a lute similar to the one depicted in catalogue no. 166. Her hair is pulled back and falls just below her shoulders. At the back of the vase, the prominent handle loops from the base of the spout on the woman's head to her back at the level of her shoulder blades, just below the ends of her hair. CHR

PROVENANCE: Unknown; purchased through Rev. Chauncey Murch in 1899

BIBLIOGRAPHY: Brunner-Traut 1970a, p. 38, pl. 6; Robins 1993, p. 66, fig. 20; *Art and Afterlife in Ancient Egypt* 1999, no. 134

170. Vase in the Form of a Pregnant Woman with a Child on Her Back

18th Dynasty, reign of Thutmose III–reign of Amenhotep III (1479–1352 B.C.)
Egyptian alabaster
H. 19 cm (7½ in.), W. 7.5 cm (3 in.), D. 7 cm (2¾ in.)
The Trustees of the British Museum, London
EA 65275

From the front, this vase representing a pregnant woman appears unremarkable. She stands with her bowed legs slightly bent at the knees and her hands brought together above her swollen belly. Her hair, parted in the middle, is drawn back from her face, and her features have been rendered in a rudimentary fashion. The figure becomes more interesting when viewed from the side, as one discovers that the handle of the vase is carved in the form of a naked child

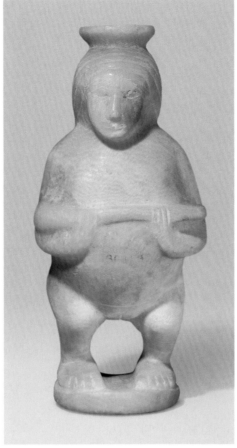

169

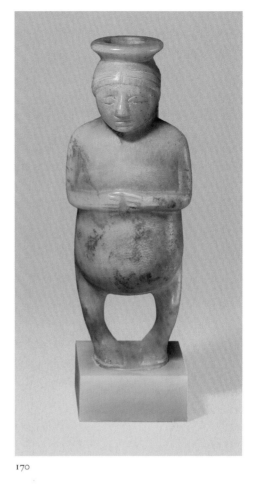

170

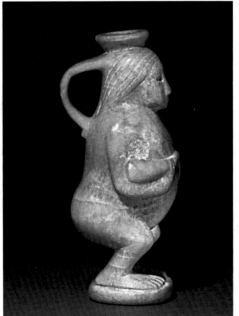

169, profile

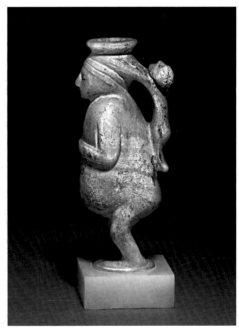

170, profile

clutching either side of its mother's head. The child's features are rather crudely indicated, but the hair is rendered with more detail.

This vase was discovered in the same intact burial as one of the pottery figure vases above (cat. no. 164). CHR

PROVENANCE: Abydos, Tomb 949; excavated by John Garstang in 1909, acquired as a bequest of Sir Robert Ludwig Mond in 1939

BIBLIOGRAPHY: Garstang 1909, pp. 128–29, pl. XVI; *Ancient Egyptian Art* 1922, pl. XXXVI; Brunner-Traut 1970a, p. 37, no. 3, pl. 5; Robins 1995, p. 73, no. 38

ANIMAL VASES

Animal-shaped vessels have a long tradition in Egyptian art dating back to prehistoric times; they display the great skill and sensitivity toward motifs drawn from nature that the Egyptians developed over the centuries. The earliest examples in pottery, which include vessels shaped like birds, fish, hedgehogs, and perhaps even monkeys, date to the later Naqada II period (4000–3000 B.C.).[1] Stone vases of female monkeys and their young are found in the Old Kingdom,[2] and stone cosmetic vessels shaped like monkeys and fish were popular in the Middle Kingdom and continued into the New Kingdom, when a wide variety of animal figure vases of clay were produced (cat. nos. 171–174).[3] The animals represented on the vases catalogued below include a bolti fish, a hedgehog, and two ibexes, subjects that are common in Egyptian art and often depicted in tomb scenes of hunting in the desert or in the Nile marshes.

The contents of these small containers were almost certainly cosmetics, perfumed oils, or unguents. The vases seem to have been used to store these expensive commodities despite the danger of spillage as a result of the placement of the spouts (see cat. no. 171), although some of these vessels appear to have been kept suspended. The animals represented had particular meaning to the Egyptians, because of their association with a specific god, with fertility, or with rebirth in the next life, and a vessel in one of these animal forms may have imbued its contents with magical qualities of strength or healing. Many are also beautifully crafted, exhibiting the practical skill, artistic sensibility, and humor of the artists who made them. Indeed, it seems quite likely that these vases were valued as much for their visual appeal as for their usefulness.

RD

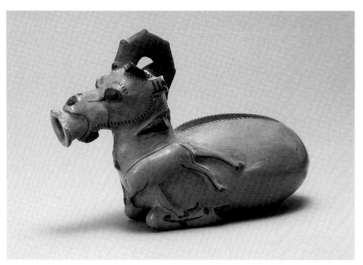

Fig. 81. Animal vase in the form of an ibex with two fawns, early 18th Dynasty. Painted clay. Musée du Louvre, Paris (E 12659; see cat. no. 174)

1. Bourriau 1981b, pp. 30–32.
2. *Age of the Pyramids* 1999, pp. 446–47, no. 178a–c.
3. Bourriau 1981b, p. 30.

171. Fish Vase

Early 18th Dynasty, reign of Thutmose III (r. 1479–1425 B.C.)
Clay with burnished red slip
H. 8.8 cm (3½ in.), L. 16.8 cm (6⅝ in.)
Museum of Fine Arts, Boston, Harvard University–Museum of Fine Arts Expedition 24.1785

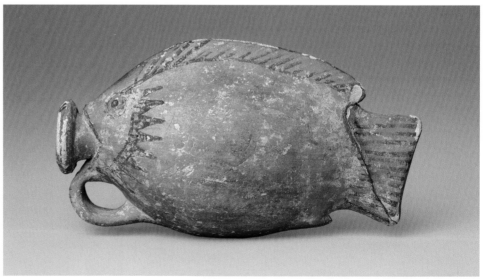

171

The fish depicted in this figure vase is a bolti (*Tilapia nilotica*), a type abundant in antiquity in the shallow parts of the Nile where water vegetation was plentiful, and then as now an important source of food.[1] As early as the Predynastic Period, slate palettes were carved in the form of bolti and many other objects were also made in this distinctive shape. Bolti were revered as symbolic of fertility, rebirth, and the renewal of life, a significance that may have derived from the species' resilience and high rate of fertility and from the unusual fact that the female incubates her newly laid eggs and young larvae in her mouth until they are hatched and expelled as young fish.

In many representations the bolti is shown sucking on a lotus blossom,[2] and here it holds the spout of the vessel in its mouth in much the same way. The body of the molded vase was in two parts, which were joined lengthwise; the neck and handle were applied separately. The surface was covered in red slip and burnished after firing, and the spines of the dorsal fin, gills, and rounded tail were painted in black.[3] The vase was found in a rock-cut tomb in Semna, with objects datable to the reign of Thutmose III.[4]

RD

1. Wallert 1970, pp. 24–27, 109–13; Brewer and R. F. Friedman 1989, pp. 76–79.
2. For example, see Angela J. Milward in *Ägyptens Aufstieg* 1987, p. 167, no. 82, and André Wiese in Wiese and Brodbeck 2004, pp. 170–71, no. 21.

3. See Janine Bourriau in *Egypt's Golden Age* 1982, pp. 103–4, no. 86, and Bourriau 1987, pp. 85, n. 2, 89.
4. Dunham and J.M.A. Janssen 1960, p. 76, fig. 33; Bourriau 1987, p. 89.

PROVENANCE: Semna, Tomb S 502; Harvard University–Museum of Fine Arts Expedition excavations; acquired from Sudan in the division of finds in 1924

BIBLIOGRAPHY: Dunham and J.M.A. Janssen 1960, p. 76, fig. 33; Janine Bourriau in *Egypt's Golden Age* 1982, pp. 103–4, no. 86; Janine Bourriau in *Ägyptens Aufstieg* 1987, p. 219, no. 148; Bourriau 1987, pp. 85, 89, pl. XXIV, 2

172. Hedgehog Vase

Early 18th Dynasty, reign of Thutmose III (r. 1479–1425 B.C.)
Clay with burnished red slip
H. 7.4 cm (2⅞ in.), Diam. 22.5 cm (8⅞ in.)
The Visitors of the Ashmolean Museum, Oxford, Gift of Egypt Exploration Fund E. 2775

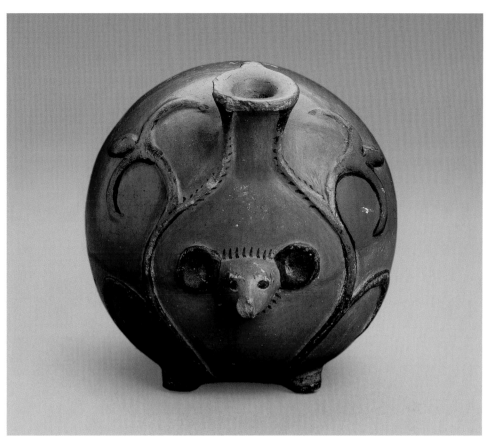

172

The artist who created this delightful hedgehog-shaped vase observed that normally neither the legs nor the tail of a hedgehog are clearly visible. When threatened, a hedgehog rolls itself into a ball of interlocking spines, rendering it almost invulnerable to any natural predator. This vessel takes the form of a spherical body and projecting head, to which have been added stumpy feet, an applied top spout, a small handle for suspension, large, erect ears, and a protruding snout. The body is embellished with stylized tendrils of lotus-flower scrolls that frame the tiny appealing face and cover the hindquarters, forming a heart-shaped flourish. This foliage decoration recalls the similarly treated faience hippopotami of the Middle Kingdom, which are covered with depictions of lotus flowers and pondweed.[1] Here the flowers and stems are executed in raised relief, and the hairs on the tendrils, ears, eyes, brows, and fur of the hedgehog are painted in black. The wheel-made vessel[2] was covered with red slip and carefully burnished, creating a light reddish brown surface; the unslipped, burnished surface on the stomach is a yellowish red.

Apparently not a sacred animal but one with magical properties,[3] the hedgehog is frequently represented throughout Egypt's long history. Its importance has been variously explained. As a hibernating animal, it may have been associated with self-renewal and resurrection. It could have had apotropaic significance because of its

defensive strategy of curling itself into a ball with projecting spines; or, with its natural resistance to poison, it may have provided protection against snake bites, as described in Egyptian folklore. Hedgehog vases were popular, especially during the New Kingdom, although examples are known from Predynastic times to the Twenty-sixth Dynasty. RD

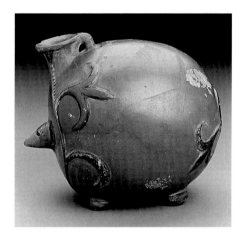

1. See Janine Bourriau (1981b, pp. 36–37, no. 51, and in *Egypt's Golden Age* 1982, p. 104, no. 87). See also Hayes 1953, p. 227, fig. 142, for a faience hippopotamus from the Twelfth Dynasty.
2. Bourriau 1987, p. 87.
3. Muscarella 1974, no. 230 *bis*. See also Berman 1999, p. 296, fig. 227.
4. Murray 1911, p. 40, no. 68, pl. XXV; with a description of the type of hedgehog common in Egypt.

PROVENANCE: Abydos, Tomb D11; excavations of the Egypt Exploration Fund, 1899–1901

BIBLIOGRAPHY: J. L. Myres in Randall-MacIver and Mace 1902, pp. 73–75; Murray 1911, pp. 40, 45–46, no. 68, pl. XXV; von Droste zu Hülshoff 1980, p. 121, no. 77, pl. VII, 77; Bourriau 1981b, pp. 36–37, no. 51; Janine Bourriau in *Egypt's Golden Age* 1982, p. 104, no. 87; Moorey 1983, p. 57, fig. 24; Bourriau 1987, p. 87, pl. XXV, 1; Houlihan 1996, pp. 66–67, fig. 49, 69–70

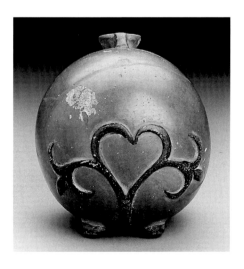

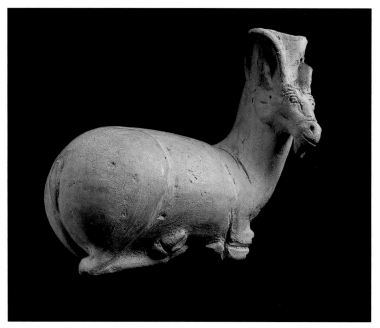

173

BIBLIOGRAPHY: Brussels, Musées Royaux d'Art et d'Histoire 1934, pl. 81; Capart 1947, p. 38, no. 740, pl. 740; *Un siècle de fouilles françaises en Égypte* 1981, p. 227; Elisabeth Maraite in *Ägyptens Aufstieg* 1987, p. 205, no. 128; Quaegebeur 1999, p. 71, n. 64

173. Ibex Vase

18th Dynasty, reign of Thutmose III–reign of Amenhotep III (1479–1352 B.C.)
Clay with light brown slip
H. 10.9 cm (4¼ in.), L. 12.3 cm (4⅞ in.)
Musées Royaux d'Art et d'Histoire, Brussels
E. 6729

This vase in the form of an ibex is made of fine clay and was modeled by hand, with great care given to the delineation of contour and details. The legs are drawn up in a resting pose, while the head is turned to the right as if the animal were twisting to sense potential danger. The combination of relaxation and movement lends to the figure a presence that is at once alert and contained. The spout of the vessel sits atop the animal's head between the paired ears and horns (one of which is broken). The long, curved horns and goatee identify the figure as a male Nubian ibex (*Capra ibex nubiana*), a wild goat native to Egypt, as distinguished from the *Capra aegagrus*, which has horns curved only at the ends and which originated in Asia, perhaps Syria.[1]

The ibex, a desert animal valued for its meat, was a frequent subject in Egyptian art even in the Predynastic era, when it was depicted on vases of the Naqadean and Gerzean periods.[2] It became especially popular during the New Kingdom, when it began to appear on such objects as unguent jars, cosmetic dishes and spoons, combs, amulets, and pottery jars.[3] Images of ibexes continued to be made in the Late Period (743–332 B.C.) and figure in scenes of hunting and processions of livestock being led away as offerings on the walls of tombs and funerary temples. RD

1. For discussions of the distinction between these two species of ibex, see *Un siècle de fouilles françaises en Égypte* 1981, p. 227, and Quaegebeur 1999, p. 115, in which also p. 32, fig. 28, for another reclining but more simplified ibex figure vase, also with the spout on the head (Staatliche Sammlung Ägyptischer Kunst, Munich, ÄS 2729), on which the innovative artist curved the horns of the young ibex backward onto its body to form a handle.
2. Quaegebeur 1999, p. 116.
3. Dorman 1980, pp. 11–12.

PROVENANCE: Unknown

174. Ibex Vase with Two Fawns

18th Dynasty, reign of Thutmose III–reign of Amenhotep III (1479–1352 B.C.)
Terracotta, painted
H. 10 cm (4 in.), L. 15.5 cm (6⅛ in.)
Musée du Louvre, Paris E 12659

The ibex was thought by the ancient Egyptians to bring good luck. It was also a symbol of renewal[1]—perhaps because of its ability to survive in the desert, its inhospitable natural habitat, where its split hooves enable it to navigate the rocky high reaches. Or perhaps the connection with regeneration stems from the animal's ridged horn, which in appearance somewhat resembles the hieroglyphic sign for "year" that began as an image of a curved, leafless palm branch.[2]

This elaborate vase takes the form of a

174, underside

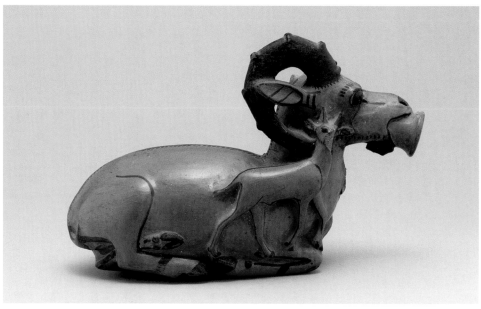

174

reclining female ibex flanked by her two young fawns, each pressing against her body in a completely natural manner. The animal's mouth is open to receive the spout of the vase, and a projecting spur, from the jaw to the chest, once formed a loop that may have been used for a suspension cord (observable in the 1908 image).[3] The ibex is shown in a characteristic pose resting on its left haunch, with its forelegs folded beneath it and its left rear hoof peeking out from under the right side of its body. The hooves, the sharply curved and ridged horn, and the large ear (one hoof, one horn, and one ear are missing) are depicted with great care.[4] The head of the fawn on the left rear is broken

at the base of the neck (see fig. 81), while the fawn on the right has lost most of its face. The loss makes it possible to see that the fawns were modeled separately and applied to the body of the vase. The surface was covered in a thick red slip and burnished, and black lines were added to accentuate outlines and details.　　RD

1. Dorothea Arnold 1995, p. 13. See also Quaegebeur 1999, p. 122.
2. See Quaegebeur 1999, p. 120, on the use of the word for "horn of an ibex" as a term meaning "year." The sharp ridges on the horn may have been associated with the annual rings indicating the age of the animal, a correlation perhaps supporting the idea of regeneration and rebirth. For this

reason images of the ibex were appropriate for New Year's gifts and the rites performed at New Year's festivities (Dorothea Arnold 1995, p. 13).
3. Gauthier 1908, pl. III.
4. See Janine Bourriau in *Egypt's Golden Age* 1982, p. 105, no. 89.

PROVENANCE: Dra Abu el-Naga, 1906

BIBLIOGRAPHY: Chassinat 1905–6, p. 84; Bénédite 1908; Gauthier 1908, pp. 144–45, pl. III; Capart 1947, p. 38, no. 740, pl. 740; *Un siècle de fouilles françaises en Égypte* 1981, pp. 226–27, no. 255; Janine Bourriau in *Egypt's Golden Age* 1982, p. 105, no. 89; Quaegebeur 1999, p. 32, fig. 29

METALWORK

Copper was found in abundance in the Eastern Desert, and during the Eighteenth Dynasty, additional amounts were imported from Syria and western Asia. When copper is alloyed with a small portion of tin, the resulting metal is harder than pure copper, its melting point is lower, and it is more easily cast.[1] Bronze, the alloy formed by this combination, is used to make tools and domestic utensils as well as many more-elaborate objects.

The decoration of metal objects became increasingly intricate in the New Kingdom, and even the most commonplace objects were ornamented. By this time the Egyptians had become accomplished metalsmiths, refining designs and improving upon already-established techniques. Examples are the elaborate bronze axe blades with openwork designs that date back to the beginning of the Middle Kingdom (cat. nos. 180–184). These weapons were more often ceremonial than functional, since the perforated blade was unstable. They were given as gifts for valiant military service; those with protective signs appear to have served amuletic and apotropaic functions.[2] Scenes of animals and sometimes men hunting and fighting are common. One blade (cat. no. 183) is a rare example showing an animal triumphant over a man, and another (cat. no. 180) is extraordinary for its depiction of a horse and rider, perhaps the earliest such representation from Egypt.[3] The same use of intricate openwork patterns is also found on bronze vessel stands of this period. One such stand (cat. no. 179) contains images of birds in papyrus thickets, a well-known subject in tomb reliefs. Another (cat. no. 178) depicts a palmette flanked by two goats, a formal and symmetrical composition that originated in the Near East.

The techniques of solid and lost-wax casting were perfected during the New Kingdom. The simplest method of casting is to pour the molten metal into open molds of stone, pottery, or even sand. Most molds known from this period, however, may have been used to make the wax models used in the lost-wax casting process, rather than to cast the bronze directly. In this process (already used in the Old Kingdom for casting copper), the model is molded of wax or some other material that is easy to form and has a low melting point. This model is then coated

with clay or a clay mixture and pierced with a hole. When the clay is fired, the wax burns away or flows out through the hole. Then molten metal can be poured into the hardened mold. Once the metal has cooled and solidified, the mold is broken, and the casting is ready for the finishing touches.[4]

Another metalworking method perfected at this time was cold hammering. It was used to make the body of a vessel, often from a single sheet of metal, by working it over a form, which was removed once the vessel had taken shape (cat. no. 177).[5] The repertoire of innovative metalworking techniques also included soldering, burnishing, engraving, chasing, and repoussé,[6] by means of which the Egyptian craftsmen of the New Kingdom created a wide variety of effects. Repoussé work is hammered from the back to form a raised relief on the front. Chasing, used to produce sharp outlines and details, is carried out on the face of the piece with a thin, sharp tool. Often both of these processes were used on the same object, as is the case with the sumptuous gold patera seen below (cat. no. 176).

Gold, both mined and alluvial, was plentiful in the Eastern Desert,[7] and during the Middle Kingdom, Egypt began extracting gold in its Nubian territories as well. From the earliest times Egyptian goldsmiths displayed a high degree of skill, producing luxury items that were shaped by hammering and casting and then elaborately decorated. The objects made by Egyptian metalworkers, whether practical, decorative, or ceremonial, combine sophisticated design with superb craftsmanship.

　　RD

1. Lucas and J. R. Harris 1989, p. 217; Ogden 2000, p. 153.
2. Kühnert-Eggebrecht 1975a; W. V. Davies 1987, p. 53; Christian Schulz in Petschel and von Falck 2004, p. 125.
3. W. V. Davies 1987, p. 53; Hall 1931.
4. Ogden 2000, p. 157.
5. Ibid., p. 158.
6. See G. L. Spalinger 1982, p. 116.
7. Lucas and J. R. Harris 1989, pp. 224–35.

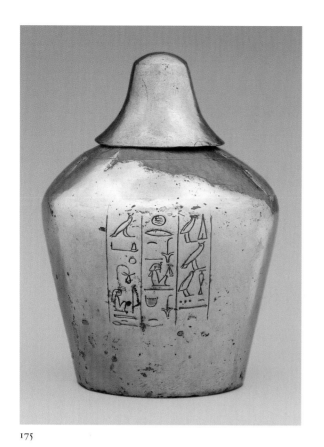

175

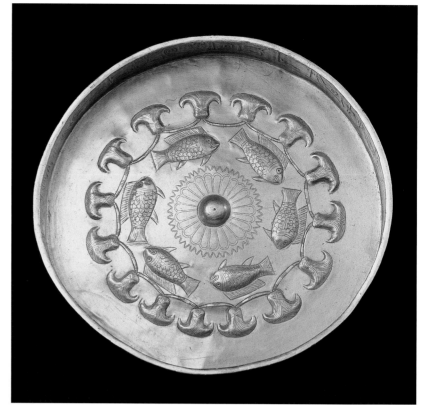

176, interior

175. Libation Vessel of Manuwai

Early 18th Dynasty, reign of Thutmose III (r. 1479–1425 B.C.)
Silver
H. 19.5 cm (7⅝ in.)
The Metropolitan Museum of Art, New York, Rogers Fund, 1918 18.8.21a, b

Manuwai was one of three minor wives of Thutmose III who came from western Asia. When these women died, they were mummified and buried with the same equipment one would expect to find in an Egyptian royal tomb. Among other things, each was provided with a silver canister like this one, which is similar in shape to a type of libation vessel but has no spout. Similar spoutless vessels were found in the tombs of Amenhotep II and Thutmose IV in the Valley of the Kings.

The inscription reads "Given as a blessing of the King to the King's Wife, Manuwai, justified." Manuwai could be the Amorite name Manawa, which may derive from the verb "to love."[1] The name can be seen, written in hieroglyphs, in the column of text on the left.

CHR

1. For a discussion of the names of the three women, see Lilyquist 2003, pp. 329–32.

PROVENANCE: Western Thebes, Gabbanat el-Qurud, Wadi D, Tomb 1; acquired in 1918

BIBLIOGRAPHY: Winlock 1948, pp. 60–61, pl. XXXVI; Lilyquist 2003, pp. 128, no. 13, 195, figs. 99 (top), 100 (left), 101 (left)

176. Patera belonging to General Djehuti

Early 18th Dynasty, reign of Thutmose III (r. 1479–1425 B.C.)
Gold
H. 2.2 cm (⅞ in.), Diam. 17.9 cm (7 in.), weight 371.5 g (13.1 oz.)
Musée du Louvre, Paris N 713

According to the dedication along the outside rim, this gold dish was presented by Thutmose III to a general named Djehuti as a royal gift, in recognition of services rendered in foreign countries and among the Mediterranean islands. The inscription also specifies that the general had filled the royal treasury with lapis lazuli, silver, and gold.[1] It was customary for the king to honor his most dedicated servants with gifts, which might include the highly prized "gold of valor" necklace, a tomb and funerary furnishings, or luxury objects, of which this shallow dish, or patera, is an excellent example. Djehuti must have been an outstanding general much valued by his sovereign, who bestowed upon him numerous gifts of exceptional quality.[2]

This vessel is a version in gold of a type of bowl popular in the New Kingdom that was commonly made of blue faience and often decorated with plants and aquatic animals. Its delightful interior design centers on a rosette and shows, as if seen in a pond from above, six bolti fish (*Tilapia nilotica*) swimming in a circle, surrounded by papyrus umbels. Water, an important symbol for the ancient Egyptians as a source of life, is suggested by the zigzag line surrounding the central flower. The bolti (see cat. nos. 171, 194) and the papyrus-reed thicket (associated with the goddess Hathor) are also symbolic of regeneration and renewed life. The patera is made of hammered gold. The figures were embossed from underneath in repoussé to form a raised relief; then details were created by outlining and chasing with an incising tool. A vessel of such high-quality workmanship must have been produced by craftsmen employed by the royal family.[3]

RD

1. "Given as a sign of the King's favor, by the King of Upper and Lower Egypt, Menkheperre, to the prince and earl, father of the god, beloved of the god, companion of the king in all foreign lands and on the islands in the middle of the sea, who fills

the storerooms with lapis lazuli, silver and gold, governor of the foreign lands, commander of the army, praised by the perfect god, whose rank is granted by the Lord of the Two Lands, the king's scribe, Djehuti the justified one" (H. W. Müller and Thiem 1999, p. 144). See also *Urkunden* 4, p. 999; Gretchen L. Spalinger in *Egypt's Golden Age* 1982, p. 119–21, no. 107; Christiane Ziegler in Andreu, Rutschowscaya, and Ziegler 1997, pp. 110–12, no. 46.

2. In addition to alabaster vases (cat nos. 149a-c), a gold bracelet, and a heart scarab (cat no. 136), there is a second cup with his name, this one of silver, also in the Louvre collection (Ziegler in Andreu, Rutschowscaya, and Ziegler 1997, p. 112).

3. Isabelle Franco in Ziegler 2002a, p. 429, no. 105; Ziegler in Andreu, Rutschowscaya, and Ziegler 1997, pp. 110–12, no. 46.

PROVENANCE: Unknown; formerly Drovetti collection

BIBLIOGRAPHY: Capart 1947, p. 24, no. 669, pl. 669; Kayser 1969, pp. 184, fig. 159, 187; Aldred et al. 1979, pp. 230, 280, fig. 304; Gretchen L. Spalinger in *Egypt's*

Golden Age 1982, pp. 119–21, no. 107; Janine Bourriau in *Ägyptens Aufstieg* 1987, pp. 338–39, no. 290; Clayton 1994, ill. p. 110; Christiane Ziegler in Andreu, Rutschowscaya, and Ziegler 1997, pp. 110–12, no. 46; H. W. Müller and Thiem 1999, pp. 142–45, figs. 290, 291; Ziegler 2002a, p. 59, fig. 7; Isabelle Franco in Ziegler 2002a, p. 429, no. 105

177. Flask and Stand

18th Dynasty (1550–1295 B.C.)
Bronze
Flask: H. 21 cm (8¼ in.), Diam. of rim 7.7 cm (3 in.);
stand: H. 9 cm (3½ in.), Diam. 13.4 cm (5¼ in.)
Museum of Fine Arts, Boston, Harvard University–
Museum of Fine Arts Expedition, 1929 29.1204, 29.1201

This graceful pyriform flask, hammered from a single sheet of bronze, is of a type that began to appear toward the end of the Middle Kingdom

and was common during the New Kingdom, being made in many different materials including pottery, stone, and glass.[1] The flaring, everted rim of the vessel is set on a long, elegant, slightly concave neck emerging from a bulbous body. The ring stand was found with the flask and probably was used with it.[2] It too was hammered from a single sheet of metal, which was formed into a hollow ring in the shape of a spool with flaring rims, echoing the curves of the flask. Both stand and flask were subsequently scraped smooth to erase any trace of hammer marks. Since vessels with a rounded or tapering bottom cannot stand unsupported, stands or some other means of holding them upright were a necessity for such objects. Stands were made in the same materials as their matching flasks, and containers sitting on ring stands were so widespread that they themselves became a popular motif. A vessel made in the shape of a vase on a ring stand was a common type in the New Kingdom.[3]

This flask and stand were found in the fort at Semna, under the mud brick temple of the Twenty-fifth Dynasty king Taharqa. RD

1. For a description, see Gretchen L. Spalinger in *Egypt's Golden Age* 1982, pp. 118–19, nos. 104, 105.
2. Jean Leclant (in Wildung 1997b, p. 132, no. 134), however, points out that this stand might have been fashioned for a larger vessel.

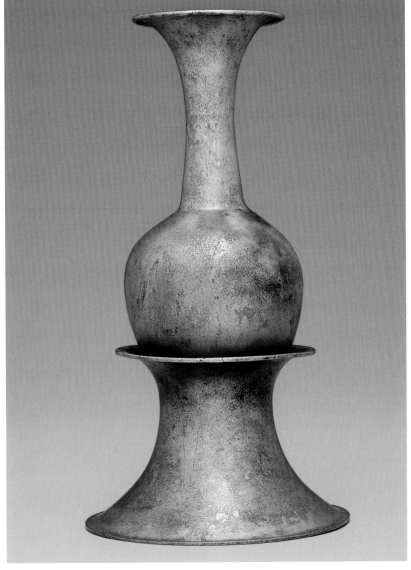

177

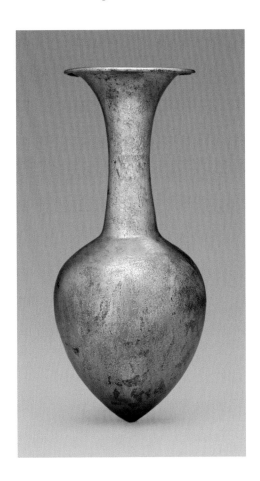

3. An early example, from the Early Dynastic Period, is mentioned by Spalinger in *Egypt's Golden Age* 1982, p. 119, no. 105; see no. 153 in the present catalogue for a combined amphora and ring stand made of a single piece of stone, another popular type in the New Kingdom.

PROVENANCE: Semna, beneath the Taharqa temple, room BN; Harvard University–Museum of Fine Arts Expedition, 1929

BIBLIOGRAPHY: Capart 1947, p. 30, no. 698, pl. 698; W. S. Smith 1952, pp. 112, fig. 69, 113; Dunham and J.M.A. Janssen 1960, p. 54, pl. 130D; Gretchen L. Spalinger in *Egypt's Golden Age* 1982, pp. 118–19, nos. 104, 105; Radwan 1983, p. 140, no. 397, pl. 70; Gretchen L. Spalinger in *Ägyptens Aufstieg* 1987, pp. 220–21, no. 151; Jean Leclant in Wildung 1997b, pp. 131, 132, nos. 133, 134

178. Flask and Openwork Stand

18th Dynasty (1550–1295 B.C.)
Bronze
Flask: H. 16 cm (6¼ in.), Diam. 8.5 cm (3⅜ in.);
stand: H. 9.5 cm (3¾ in.), Diam. 7.5 cm (3 in.)
The Field Museum, Chicago 30177a, b

On each side of this openwork ring stand, two confronting goats rear up on their hind legs to nibble at the top blossoms of a palmette that is the central feature. Small upside-down versions of the palmette fill the space between the goats' backs, separating the two scenes. While the palmette motif is a stylized design meant to be understood as a flowering tree, the animals flanking the palmettes are realistically rendered and naturally posed, and the openwork conveys the sense of real animals in a decorative or even symbolic space. The representation of a goat and a tree is one of the most engaging and popular images in the ancient Near East and also expresses on a symbolic level essential concerns about plant fecundity and animal fertility.[1] Objects in Egyptian art depicting goats on either side of a floral composition appear to have been inspired by Near Eastern examples.[2]

The flaring bottom rim of the stand carries a short inscription: "What the helmsman of His Majesty, Pa-aam, made." On the body of the tall flask is an identical inscription placed between two horizontal lines, and just above it are partially erased remains of another, perhaps earlier, dedication.[3] The openwork stand was cast by the lost-wax method and then chased to bring out the texture on the palmette and the animals' horns. The flask, which is similar to the previous one (cat. no. 177), was cold hammered from a sheet of bronze. RD

1. See Donald P. Hansen in Aruz 2003, pp. 121–22, no. 71, for a third-millennium B.C. example from Ur, in southern Mesopotamia.
2. See Petrie 1894, p. 29, pl. XVI, 181, which shows this theme in a mold for a cylinder seal made, according to Petrie, at Tell el-Amarna. See also catalogue no. 25, a painted box the ends of which carry a similar image. For an example of a palmette that closely resembles this one, see Tiradritti 1999, p. 264, the vase with a handle in the form of a rampant goat.
3. Steindorff 1937, pp. 122–23, pl. XXI, and Gretchen L. Spalinger in *Egypt's Golden Age* 1982, pp. 119, 120, no. 106.

PROVENANCE: Unknown

BIBLIOGRAPHY: Steindorff 1937, pp. 122–23, pl. XXI; Capart 1947, p. 30, no. 698, pl. 698; Gretchen L. Spalinger in *Egypt's Golden Age* 1982, pp. 119, 120, no. 106; W. S. Smith and Simpson 1998, p. 137, fig. 238

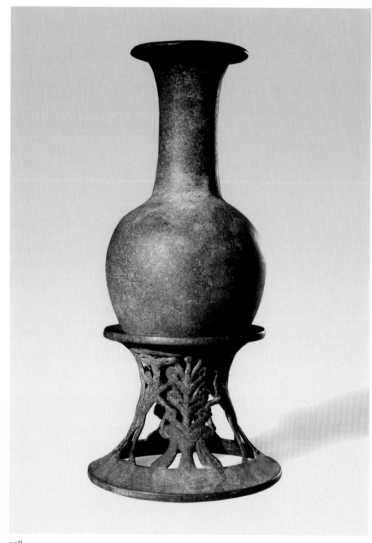

178

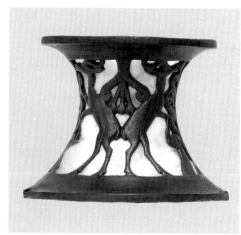

178, stand

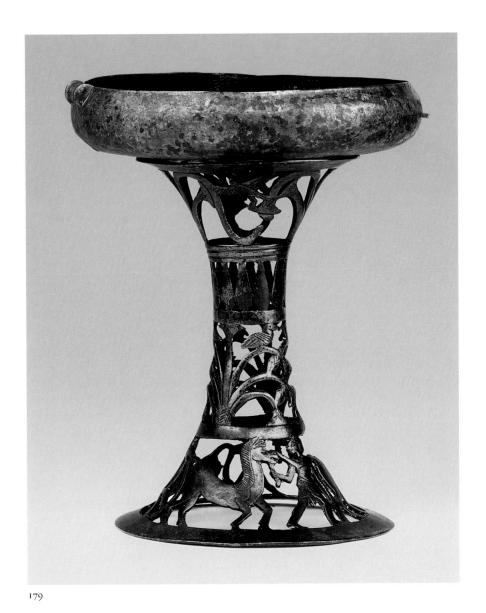

179

them extensively. In the New Kingdom horses became more common, but ownership was confined primarily to the military elite and wealthy individuals. In general, Egyptians did not ride horses but used them in pairs to draw chariots.[4] RD

1. Renate Krauspe in *Ägyptens Aufstieg* 1987, p. 222, no. 152.
2. See Kelley 1976, vol. 1, pl. 11.1, nos. 36, 37, and *Meisterwerke altägyptischer Keramik* 1978, pp. 123–34, no. 147, for example; also Jean Leclant in Wildung 1997b, pp. 130–31, nos. 130, 131.
3. Krauspe in *Ägyptens Aufstieg* 1987, p. 222, no. 152.
4. But see catalogue no. 180 for a rider mounted on a horse.

PROVENANCE: Aniba, Tomb S 91; Ernst von Sieglin expedition, 1912

BIBLIOGRAPHY: Steindorff 1935–37, vol. 2, pp. 148, 199, pl. 98, 2 and 4; Capart 1947, p. 30, no. 697, pl. 697; Kayser 1969, pp. 191, 192, fig. 168; Renate Krauspe in *Ägyptens Aufstieg* 1987, pp. 222–23, no. 152; Jean Leclant in Wildung 1997b, pp. 130–31, nos. 130–31.

179. Bowl with Openwork Stand

18th Dynasty (1550–1295 B.C.)
Bronze
Bowl: H. 3.5 cm (1⅜ in.), Diam. 16 cm (6¼ in.); stand: H. 16.5 cm (6½ in.)
Ägyptisches Museum der Universität Leipzig 4804, 4807

This shallow bronze bowl and its cast bronze openwork stand are from the tomb of a scribe named User, in Aniba,[1] which is situated in Lower Nubia between the First and Second Cataracts. The stand, with its double funnel shape, is of a form found in pottery as early as the Old Kingdom.[2] Here the stand has been transformed by a delightful, decorative openwork design that is divided horizontally into four registers. In the top band is a lively depiction

of papyrus plants blowing in the wind with flying ducks between them. The wings of the birds have been chased to delineate feathers. In the next register, at the narrowest part of the stand, is a row of droplike petals that form a wreath or garland. Two large papyrus plants with ducks perched on the overlapping branches embellish the next band and echo the top motif. The register at the foot of the stand shows two men holding horses by their bridles, while between them a spirited third horse, whose reins are hanging loose, runs wild. Beneath the horse is a bent papyrus stalk, suggesting a natural setting. These representations of papyrus thickets and the waterfowl on the upper registers might indicate that in this scene the horses are being brought to a spot for watering.[3]

Horses were introduced into Egypt during the Second Intermediate Period (1650–1550 B.C.) by the Hyksos from western Asia, who used

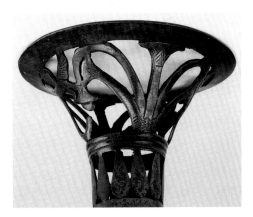

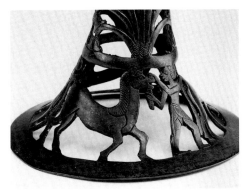

179, top and foot of stand

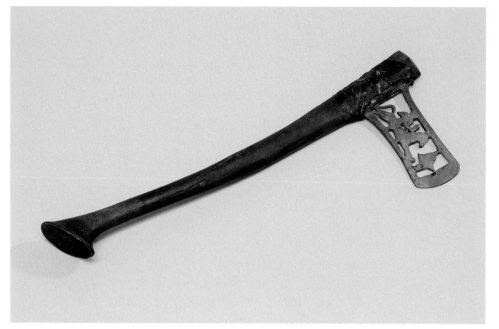

180

180. Axe with an Equestrian Figure on the Blade

18th Dynasty (1550–1295 B.C.)
Bronze, painted wood, leather
Blade: L. 11.4 cm (4½ in.), H. (at cutting edge)
5.3 cm (2⅛ in.); haft: L. 43.5 cm (17⅛ in.)
The Trustees of the British Museum, London
EA 36766

The blade of this axe contains openwork decoration representing a figure, perhaps a deity, on the back of a galloping horse.[1] Although the design—an early example of horse and rider in Egyptian art—appears crude and perhaps unfinished, it is nonetheless a lively portrayal. In front of the horse there is a floral motif consisting of two papyrus umbels, one upside down and on top of the other. The upper umbel is incised with striations and the lower one is similarly striated on one side. The rider, who perhaps represents the Syrian war goddess Astarte,[2] appears to be riding sidesaddle. The forward hand grasps the looped end of a rein, and the other rein is held in the rider's right hand.[3] On one face of the blade, the figure is shown wearing a long wig and a necklace or collar; the eye is indicated, but not the nose or mouth. On the other side the head is unmarked. Although few details describe the rider, the horse, with an incised mane, is well defined on both sides of the blade.

The haft consists of a curved piece of wood painted reddish brown and decorated with black stripes arranged in a crisscross pattern. The butt end is painted black. The blade was bound to the haft with a leather thong, much of which is still intact. RD

1. For a complete description, see W. V. Davies 1987, p. 52, no. 163.
2. See Leclant 1960, pp. 35–37. See also Kühnert-Eggebrecht 1969, p. 83. In art of the New Kingdom, Astarte is often depicted on horseback, with warlike attributes, and sometimes accompanied by a floral element.
3. According to Schulman 1957, p. 266, rather than reins the rider holds an object, possibly a mace or a battle-axe.

PROVENANCE: Uncertain, said to have been found at Thebes; formerly Athanasi collection, 1845

BIBLIOGRAPHY: J. G. Wilkinson 1878, vol. 1, p. 278, no. 92, figs. 1a, 2 (detail); Erman 1894, pp. 492–93, ill.; Hall 1931, pp. 3–5, pl. 1; Schulman 1957, pp. 265ff., pl. XXXIX, 4; Leclant 1960, pp. 35–37, no. 6a, figs. 12–14; Yadin 1963, p. 218; Kühnert-Eggebrecht 1969,
pp. 83, 135, no. P 51, pls. XXV, 1, XXVIII, 3; el-Sadeek and Murphy 1983, p. 174 and n. 73; W. V. Davies 1987, p. 52, no. 163, pl. 28, fig. 163, and pp. 87, 93, 109, 116, 128

181. Axe Blade with a Hunter

18th Dynasty (1550–1295 B.C.)
Bronze
H. 8 cm (3⅛ in.), W. 10.4 cm (4⅛ in.)
Museo Egizio, Turin 6307

In this unusual openwork composition, a hunter taking aim with his bow and arrow stalks an unsuspecting lion.[1] The hunter wears a short wig and a kilt and carries a quiver on his back. He kneels behind a bush where he is out of sight of the lion, which seems unaware of the danger at hand. The animal walks at an easy pace, its four legs anchored to the curved bottom of the frame, its nose meeting the edge of the blade; its tail can be seen on both faces of the blade in front of the plant, which occupies the center of the scene. Both the hunter and his bow extend from the top to the bottom of the frame, and the quiver connects to the rear of the blade. The details are finely depicted, and the textures of the wig, the foliage, and the animal's muscular body and mane have been modeled with care.

What makes this hunting scene exceptional is the fact that it is an ordinary man who is pursuing the lion and not, as was commonly the case, the king, whose exclusive prerogative this was during the New Kingdom.[2] Moreover, while the king is always portrayed as a worthy opponent of the powerful lion and therefore is shown confronting him head-on, here the hunter sneaks up from behind. This is not the standard lion hunt scene common throughout the ancient Near East—which belongs to royal iconography expressing the king's overwhelming

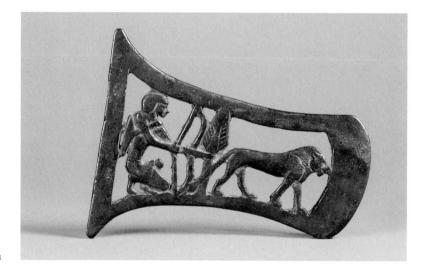

181

power—but is instead a depiction with a certain realism. RD

1. For a full description, see Kühnert-Eggebrecht 1969, pp. 79–80, and Elvira D'Amicone in *Ägyptens Aufstieg* 1987, pp. 118–19, no. 19.
2. D'Amicone in *Ägyptens Aufstieg* 1987, p. 118.

PROVENANCE: Unknown; formerly Drovetti collection

BIBLIOGRAPHY: Kühnert-Eggebrecht 1969, pp. 79–80, 135, no. P 44, pl. XXVII, 1; Elvira D'Amicone in *Ägyptens Aufstieg* 1987, pp. 118–19, no. 19; W. V. Davies 1987, pp. 88, 95; Donadoni Roveri 1990, p. 47

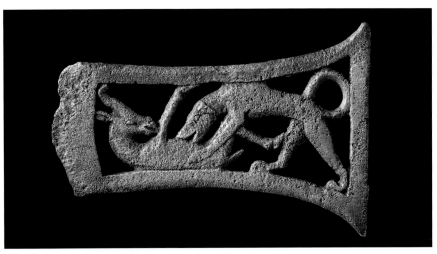

182

182. Axe Blade with a Dog Attacking an Antelope

18th Dynasty (1550–1295 B.C.)
Bronze
H. 7.3 cm (2⅞ in.), W. 10.9 cm (4¼ in.)
The Visitors of the Ashmolean Museum, Oxford
1927.1389

The openwork decoration of this axe blade captures the violence of a hunting dog fiercely attacking an antelope. The antelope has fallen onto its back and is struggling to fight off its predator, looking up and with its hind leg vainly attempting to push the hound away. But the ferocious lop-eared hunting dog, slim and muscular, is already sinking its teeth into the antelope's abdomen, and the fallen animal is no match for its attacker's powerful jaws. The dramatic scene fits harmoniously into the open space within the blade, and the animals' bodies form interlocking half circles in a balanced composition.

Models for the hunting scenes on axe blades can be found in Old Kingdom wall reliefs.[1] In these depictions, trained dogs accompany the huntsman, who often carries a bow and arrow and a lasso.[2] Egyptians enjoyed the hunt, and those of greater means are shown in the reliefs with attendants, who carried their weapons and provisions. The representations on axe blades are far more savage, however, since they focus on the moment when the final blow is delivered. RD

1. Kühnert-Eggebrecht 1969, p. 79.
2. For examples, see *Age of the Pyramids* 1999, pp. 334–36, no. 112, 400–401, no. 147.

PROVENANCE: Unknown; formerly John Evans collection

BIBLIOGRAPHY: Capart 1947, p. 39, no. 745, pl. 745; Kühnert-Eggebrecht 1969, pp. 79, 135, no. P 41, pl. XXVI, 2; W. V. Davies 1987, pp. 88, 110, 115

183. Axe Blade with a Bull Throwing a Man

18th Dynasty (1550–1295 B.C.)
Bronze
H. 7.3 cm (2⅞ in.), W. 11.4 cm (4½ in.)
Ägyptologisches Institut der Universität Tübingen 1736

The energetic scene on this axe blade captures a bull in the act of goring a man, who has been thrown into the air by the force of the animal's blow and is now falling to the ground. The shapes of the bronze figures beautifully counterbalance the empty spaces in this openwork design.[1] The bull's powerful body conveys the sense of forward motion as his right foreleg

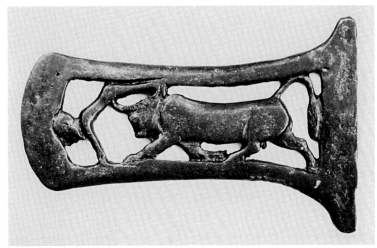

183, showing bearded man

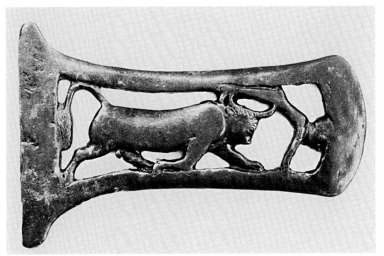

183, reverse, showing clean-shaven man

bends beneath him on the ground, his right rear leg propels him, and his left legs advance toward his victim. The man's hands are just landing on the ground, while the rest of his body is still held aloft by the animal's horns. His head touches, and appears to push out, the enframing edge of the axe blade, while on the opposite side the bull's bushy tail and right rear leg are anchored to the frame. Chasing emphasizes the realistic details. One face of the blade seems to show a bearded Asiatic, while on the other, which has been restored, the man appears clean-shaven. It is possible that the figure is meant to represent an Asiatic on one side and an African on the other, thus presenting the two traditional enemies of Egypt being subdued by the victorious king, symbolically depicted as a bull.[2]

It has been suggested that the axe blade might have been given to a favorite soldier by his king in return for valor in battle, and that this valued possession was later buried with him.[3]

RD

1. For a description, see Brunner-Traut and Brunner 1981, p. 203, no. 1736, pl. 1736, and Brunner-Traut, Brunner, and Zick-Nissen 1984, pp. 114, 115, no. 92.
2. This was suggested by Professor Karola Zibelius-Chen of the University of Tübingen in personal correspondence.
3. Brunner-Traut, Brunner, and Zick-Nissen 1984, p. 114.

PROVENANCE: Unknown

BIBLIOGRAPHY: Brunner-Traut and Brunner 1981, p. 203, no. 1736, pl. 1736; Brunner-Traut, Brunner, and Zick-Nissen 1984, pp. 114, 115, no. 92; W. V. Davies 1987, pp. 88, 95

184. Axe Blade with a Child

18th Dynasty (1550–1295 B.C.)
Bronze
H. 5.8 cm (2¼ in.), W. 9.3 cm (3⅝ in.)
Kestner-Museum, Hanover 1935.200.323

In this extraordinary design, the openwork of the axe blade contains a representation of a nude boy with his index finger to his lips. The figure stands frontally aligned with the long axis of the blade, perpendicular to the now-lost handle. It is cast almost in the round. The child's head touches one end, and his feet, placed side by side, rest on the other. His straight left arm hangs at his side; the clenched fist connects with the edge. The right arm had been broken at the elbow and is now reattached.

The subject of a boy with his finger to his mouth can be identified as a depiction of the god Horus, son of Osiris and Isis, as a child.[1] After the murder of Osiris by his brother Seth, Isis gave birth to a son, Horus, who after many ordeals triumphed over the wicked Seth. In Greek literature Horus was called Harpokrates. In Egyptian mythology, the battle for supremacy the untried Horus had to undergo as a youth is dealt with at length. Among representations of the child Horus, this one is unusual for its simplicity and lack of embellishment.

RD

1. Eva Kühnert-Eggebrecht (1969, pp. 84–85) refers to the Pyramid Text describing Horus as a little child, his finger in his mouth (Utterance 378), and notes that Horus as a child possessed apotropaic power and that the symbol is found on amulets as well as ornamental axe blades (p. 76).

PROVENANCE: Unknown

BIBLIOGRAPHY: Kayser 1969, p. 251, fig. 228; Kühnert-Eggebrecht 1969, pp. 55, 61, 64, n. 23, 84, 135, no. P 52, pl. XXIX, 2; W. V. Davies 1987, pp. 87, 92

185. Dagger

Early 18th Dynasty (1550–1525 B.C.)
Bronze, ivory
L. 23.5 cm (9¼ in.)
Phoebe Apperson Hearst Museum of Anthropology, University of California, Berkeley 6-17311

The form of this elegant bronze dagger, with its smoothly finished circular pommel of ivory, evolved from Middle Kingdom weapons and was first seen in daggers with lunate handles of the Twelfth Dynasty.[1] The slender proportions, narrow grip—scarcely long enough for the forefinger and thumb—and long, tapering ribbed blade of this dagger, however, reveal its New Kingdom origin. Moreover, its similarity to a ceremonial dagger buried with Kamose (r. 1552–1550 B.C.) at Dra Abu el-Naga[2] indicates an early Eighteenth Dynasty date for this type of weapon. The evolution of this form based on an earlier model demonstrates the pride of the New Kingdom Thebans, who, after ousting the Hyksos from their land, looked to their past glories for artistic inspiration.[3]

The dagger was discovered at Deir el-Ballas, a site on the edge of the Western Desert some thirty miles north of Thebes and the location of a small royal city of the late Second

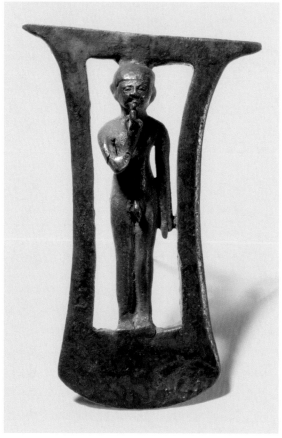

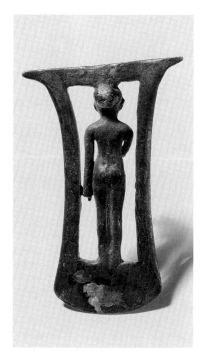

184

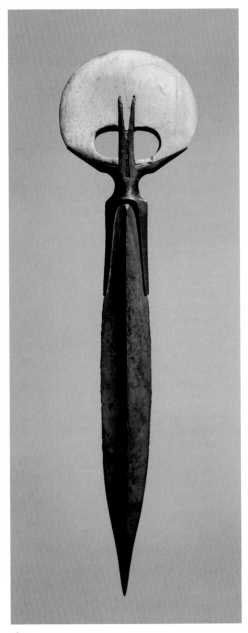

185

Intermediate Period that was abandoned in the early Eighteenth Dynasty.[4] It was found with a number of other weapons, as well as models of weapons in painted clay used as votive offerings, in and around the royal residence known as the North Palace. The dagger is in remarkably good condition, suggesting that the leather sheath with an openwork floral design[5] that was found nearby may have protected it.[6] RD

1. Fazzini 1975, pp. 59, 70, no. 47; Kühnert-Eggebrecht 1975b. See also Hayes 1959, p. 43, W. S. Smith and Simpson 1998, p. 126, and, especially, Aldred 1978.
2. Isabelle Franco in Ziegler 2002a, p. 428, no. 103. In addition there is a similarly shaped dagger, a gift from Ahmose I to his mother, Ahhotep II, that was found in her tomb, also at Dra Abu el-Naga. See Petrie 1917, p. 29, for a discussion of the two daggers from her tomb; see also Fazzini 1975, p. 70, and Peter Lacovara in N. Thomas 1995, p. 168, no. 72a, b.

3. The resemblance reflects a trend in which New Kingdom craftsmen deliberately imitated the art of the late Eleventh and early Twelfth Dynasties.
4. See W. S. Smith 1965a, pp. 156–59, and Lacovara 1981.
5. Now in the Museum of Fine Arts, Boston (47.1682).
6. Lacovara in N. Thomas 1995, p. 168, no. 72a, b.

PROVENANCE: Deir el-Ballas, North Palace; Phoebe A. Hearst Expedition of the University of California, discovered by George A. Reisner, 1900

BIBLIOGRAPHY: Reisner 1923, p. 188; Elsasser and Fredrickson 1966, p. 67; Fazzini 1975, pp. 59, 70, no. 47

186. Dagger

Second Intermediate Period (1650–1550 B.C.)
Bronze, horn, ivory, gold
L. 40.5 cm (16 in.)
Ägyptisches Museum und Papyrussammlung,
Staatliche Museen zu Berlin 2053

This elegant dagger, with its long blade, trapezoidal ivory handle, and slender horn grip decorated with gold studs, exemplifies an important stage in the evolution of the dagger into a short sword. It is longer than a standard dagger, and its blade tapers almost imperceptibly up to the end, where it forms a sharp point. Both daggers and swords were used by the Egyptians for close combat; the sword, which came into use in the New Kingdom, is by far the more effective weapon.

Axes and clubs were the infantry's primary weapons for close combat; spears were used for intermediate distances; and for long-distance battle the principal items in the Egyptian arsenal were bows and arrows. Weapons used in battle were simple and unadorned.

The decorative elements on this dagger mark it as an ornamental or ceremonial object much like the narrow-bladed dagger from Buhen, in Nubia.[1] A similar weapon, which has been referred to as a Classic Kerma sword, appears to be based on an Egyptian prototype but probably was made in Nubia.[2] Daggers of this type and also the one from Deir el-Ballas in this catalogue (cat. no. 185) contain two small holes between the pommel and the hilt. Too narrow to allow a finger to be inserted in them, they make it possible for the fingertips to grasp the dagger and remove it from its sheath.[3] In fact, this dagger was found in a close-fitting leather sheath.[4]

RD

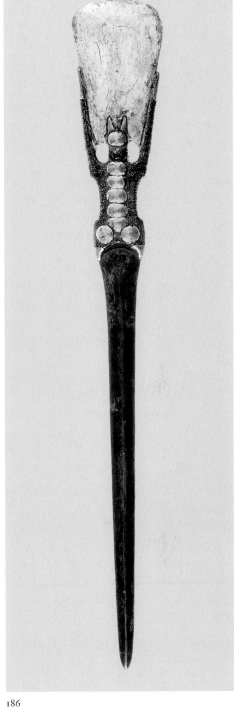

186

1. See Petrie 1917, p. 29, pl. XXXIII, 14, where the dagger is described as a Nubian form of the Twelfth Dynasty. See also the section on daggers in Reisner 1923, pp. 187–94, and Kühnert-Eggebrecht 1975b.
2. O'Connor 1993, p. 137, no. 51, pl. 8.
3. Reisner 1923, p. 188.
4. See J. G. Wilkinson 1878, p. 212, and Erman 1894, p. 460, for the dagger with its sheath.

PROVENANCE: Said to be from a burial in western Thebes; purchased from Giuseppe Passalacqua

BIBLIOGRAPHY: J. G. Wilkinson 1878, p. 212; Erman 1894, p. 460; Petrie 1917, p. 29; Reisner 1923, p. 187; Schulz and Seidel 1998, p. 367

FURNITURE AND CARPENTRY

The dry climate of Egypt has preserved numerous examples of wood furniture of the New Kingdom, and much of it has survived in remarkably good condition. These pieces, together with the detailed representations of furniture found in painting, relief, and sculpture, constitute a body of information that is invaluable for the understanding of daily life in ancient Egypt. Shortly after the beginning of the Eighteenth Dynasty, new trends in furniture design appeared. Stools, chairs, beds, and tables embody a refined and elegant style that reflects the cosmopolitan tastes of the time and frequently display superb craftsmanship as well.

Egypt produced little wood, and most indigenous timber was either too small or of too poor quality to be used in furniture production. Therefore wood had to be imported, principally from those areas neighboring the eastern Mediterranean—especially Syria and Lebanon—that had a wide variety of good-quality wood.[1] Carpenters and cabinetmakers were numerous, and their occupations are one of the most important themes in the paintings that represent Egyptian trades.

All the hand techniques used today were already employed by ancient Egyptian carpenters, who achieved a high level of competence. Their main tools were the mallet, the axe, the adze, the saw, chisels of various kinds, and the bow drill. First the wood was reduced to a proper size by sawing. Sawing wood was difficult because Egyptian carpenters used a pull saw with teeth pointed toward the handle.[2] Then the adze—the chief woodworking tool of ancient Egypt—was used as both a carving knife and a plane, for trimming, shaping, and finishing. Finally, a fine finish was achieved with an abrasive stone or scraper. These techniques of basic joinery have continued with little change to the present day.

RD

1. For useful descriptions of Egyptian furniture and the wood and tools used, see Killen 1980 and Baker 1966, pp. 17–160.
2. J. G. Wilkinson 1878, vol. 2, pp. 196–98. The importance given to the pull saw is illustrated by a model in the Eleventh Dynasty tomb of Meketre. In the model carpenters can be seen sawing, trimming wood with adzes, cutting mortises, finishing surfaces, and sharpening tools. One carpenter grasps a saw handle with both hands and pulls it toward himself. See Killen 1980, pp. 12, 20, no. 24.

187. Box with Two Sliding Lids

18th Dynasty, joint reign of Hatshepsut and
Thutmose III (1479–1458 B.C.)
Cypress, boxwood
H. 6.7 cm (2⅝ in.), W. 13.8 cm (5⅜ in.),
D. 13 cm (5⅛ in.)
The Metropolitan Museum of Art, New York,
Rogers Fund, 1936 36.3.199

This compartmented box of cypress and boxwood was found inside a rush basket in an anonymous burial in a small chamber only large enough for the coffin, a few pieces of pottery, and the basket.[1] The burial and the box have been associated with a sister of Senenmut's, although because of the lack of inscribed evidence one should be cautious about this identification.[2] Small boxes like this one have yielded, in addition to jewelry and cosmetics, a wide array of odds and ends, such as lichen, leaves, nuts, flint flakes, acacia thorns, scarabs, amulets, clay sealings, beads, shells, and bits of resin, wax, pitch, and aromatic wood.[3] This box contained a drop-shaped ornament of faience, a small lump of bright blue pigment, a chunk of rock salt, and five purple berries, presumably precious belongings collected by the owner in the course of her lifetime.

The box is fitted with four boxwood legs and two small sliding lids. The lids were held closed by means of cord wrapped around the two knobs on the lids and around the two similar

187

knobs on one side of the box. When pushed open, the lids slide beneath the crosspiece at the back.

RD

1. Hayes 1959, p. 196, fig. 111. For the original report, see Lansing and Hayes 1937, p. 8, fig. 12.
2. Dorman 1988, pp. 165–69; "The Career of Senenmut," in this catalogue, n. 2. Senenmut appears to have had at least three brothers and two sisters, who are named in Tombs 71 and 353. Six mummies that were interred in two whitewashed

coffins discovered inside Hatnefer's burial chamber may be members of Senenmut's family; see Lansing and Hayes 1937, pp. 31–32.
3. Baker 1966, p. 147.

PROVENANCE: Western Thebes, Sheikh abd el-Qurna, anonymous burial no. II; Metropolitan Museum of Art excavations, 1935–36

BIBLIOGRAPHY: Lansing and Hayes 1937, p. 8, fig. 12; Hayes 1959, p. 196, fig. 111

188

188. Multicompartmented Box

18th Dynasty, sole reign of Thutmose III (1458–1425 B.C.)
Wood
H. 5.8 cm (2¼ in.), L. 9.4 cm (3¾ in.)
The University of Pennsylvania Museum of Archaeology and Anthropology, Philadelphia, Gift of British School of Archaeology E 14198

This unique four-legged rectangular box has three lidded compartments. All are secured by cords sealed at the knot where they are wound around the projecting mushroom-shaped wood knobs. The elements are assembled with butt joints; strips of a darker wood serve as trim and are held in place by tiny dowels. The box's unusual design combines two flat sliding lids—the most popular type of lid for small caskets in ancient Egypt—and a gabled compartment at the rear that opens by swinging back its two-hinged lid.[1] Most small boxes had just one type of lid, and such containers, in both styles, were found in the tombs in Sedment.[2] Small boxes were used to hold jewelry, cosmetics, and other keepsakes. This casket, however, was found empty, perhaps indicating that it had been made to form part of the deceased's funerary equipment.[3]

The box was discovered in an unusual burial within a rectangular wood coffin with a gabled lid and projecting rectangular end boards, which held a set of perfectly preserved baskets. This box and a second casket, of the inlaid, gable-lid form, were found in one of these baskets. A variety of pottery and stone vessels uncovered in the tomb can be dated to the end of the reign of Thutmose III. RD

1. See, in this catalogue, the box with two sliding lids (cat. no. 187) and the painted chest of Perpauti, which has a double gabled lid (cat. no. 25).
2. Petrie and Brunton 1924, vol. 2, pp. 24, 26, pls. LVII, LXIII, 254, LV, LXXXII. For a description of the box, see Rita E. Freed in *Egypt's Golden Age* 1982, p. 202, no. 235.
3. Merrillees 1968, pp. 62–63, and Merrillees 1974, p. 24; on Tomb 254, see also the section "Ancient Egypt's Silent Majority: Sidmant Tomb 254" in Merrillees 1974.

PROVENANCE: Sedment, Tomb 254; excavated by W. M. Flinders Petrie and Guy Brunton for the British School of Archaeology in Egypt, 1924

BIBLIOGRAPHY: Petrie and Brunton 1924, vol. 2, p. 24, pl. LVII, 31; Ranke 1950, p. 79, fig. 48; Merrillees 1968, p. 63; Merrillees 1974, pp. 23, fig. 10, 24; Rita E. Freed in *Egypt's Golden Age* 1982, p. 202, no. 235

189. Game Box with Lions, Gazelles, and a Hound

Late 17th or early 18th Dynasty
Wood, ivory, bronze
H. 5 cm (2 in.), W. 25 cm (9⅞ in.), D. 6.7 cm (2⅝ in.)
The Metropolitan Museum of Art, New York, Rogers Fund, 1916 16.10.475

Board games existed in ancient Egypt from Predynastic times to the late Roman Period.[1] They were buried with the dead beginning in the earliest dynasties and have been found in the graves of commoners, nobles, and kings alike. The presence in a Seventeenth or early Eighteenth Dynasty Theban burial of this small, reversible game box overlaid with ivory testifies to the popularity of these amusements among the Egyptians of late Hyksos and early New Kingdom times.[2] Dampness and termites in the tomb severely damaged the wood of the box, and it has been restored.

On one side of the box (not shown here), squares and strips of ivory are arranged to form a board with three rows of ten squares each. The Egyptians called the game played on this board *senet*, which modern writers sometimes refer to as "the game of thirty squares." The other, better-preserved side of the box carries the board for a companion game, newly introduced from the

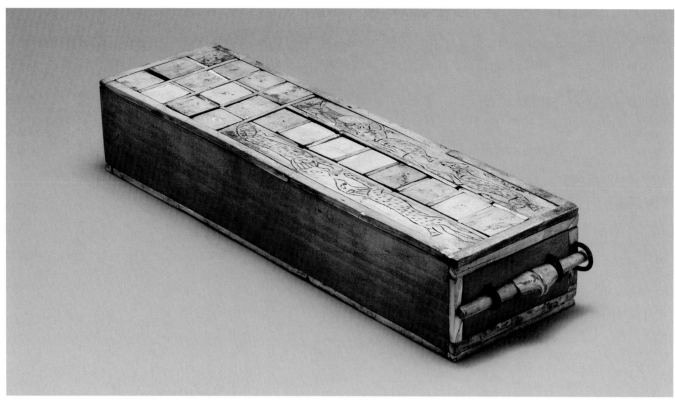

189

Fig. 82. A lion facing two gazelles (above) and a lion facing a hound (below), decoration incised in the ivory panels of the game box (cat. no. 189). Drawing by Julia Jarrett

Near East and in antiquity called "20" or "twenty squares." Both *senet* and "twenty squares" seem to have been games of position in which opponents race each other, like our Parcheesi or backgammon. Each was played with two sets of five or more pieces, whose moves were determined by throwing knucklebones or sets of flattened marked sticks, the equivalent of dice.

An unusual feature of this board is the incised decoration on the long panels flanking the central grid (see fig. 82). A crouching lion and two gazelles appear on one panel, and on the other a lion is confronted by a lop-eared hound. These stippled animals in lengthened postures are characteristic of the style developed during the Hyksos era. The game box has a small drawer locked with an ivory bolt, which slides into three bronze staples. Inside were found twelve ivory playing pieces for the games, six conical and six

spool shaped, as well as six ivory casting sticks pointed at both ends and a pair of knucklebones.[3]

RD

1. Kendall 1978, pp. 7–43; Pusch 1979. On the board games, see Kendall 1982; Timothy Kendall in *Egypt's Golden Age* 1982, pp. 266–72, nos. 370–76.
2. Pusch 1979, pp. 199–201; Needler 1983, p. 116. About thirty examples of this boxlike type are known, suggesting that this was by far the most common form of *senet* board deposited in tombs during the Eighteenth and Nineteenth dynasties.
3. Hayes 1959, pp. 25–26, fig. 10

PROVENANCE: Western Thebes, Lower Asasif; Metropolitan Museum of Art and Carnarvon excavations, 1915–16

BIBLIOGRAPHY: Pusch 1979, pp. 199–201, no. 22; Needler 1983, p. 116; Hayes 1959, p. 25, fig. 10

190. Headrest

18th Dynasty, joint reign of Hatshepsut and Thutmose III–reign of Amenhotep II (1479–1400 B.C.)
Wood
H. 18 cm (7⅛ in.)
Brooklyn Museum, New-York Historical Society, Charles Edwin Wilbour Fund 37.440E

Headrests are known from Old Kingdom tombs, where they supported or were placed next to the head of the mummy. From the First Dynasty on, they were also an essential element of daily life. Often wrapped with strips of cloth to soften the hard surface, headrests were used as we use pillows. They were usually made of wood or sometimes stone, although one well-known wood example from the Fourth Dynasty is embellished with precious materials—ivory, faience, glass, and overlays of gold and silver sheet.[1]

During the New Kingdom, elaborately ornamented headrests were created. Decorative imagery was thought to possess a magical and amuletic significance, giving it protective powers. The ancient Egyptians saw the hours of darkness as the time when they were most defenseless against malevolent forces, and the head, the most vulnerable part of the body, was

190

Fig. 83. Decorations incised on the headrest (cat. no. 190). Top: the goddess Taweret; bottom: the god Bes; right: an inscription identifying the owner, Yuyu. Drawing by Julia Jarrett

particularly threatened by evil gods, spirits, and demons as well as dangerous snakes and scorpions. Therefore they protected themselves with representations on their headrests of the god Bes and a hippopotamus deity with lion's claws and a crocodile tail running down its back.[2] By the Eighteenth Dynasty, these potent guardian deities had become standard images on headrests and other bedroom articles, such as footboards and the legs of beds.

This wood headrest has a flat oblong base, a neckpiece curved to accommodate the head, and a faceted vertical support inscribed on one side "Doorkeeper and Child of the Nursery, Yuyu, repeating life" (see fig. 83).[3] On the other side of the support is a frontal image of Bes. Bes appears in profile on one end of the base, and what may be the hippopotamus goddess Taweret on the other end. These two figures each hold a *sa* sign, the hieroglyph for "protection," and carry a long, pointed knife. They both also have long undulating serpents protruding from their mouths, perhaps to signal the fate of any dangerous animal encroaching on the sleeper.

RD

1. On Egyptian headrests, see Reisner 1923, pp. 229–41, and Fischer 1980. On the wood headrest of Queen Hetepheres, which was covered with precious metal, see Reisner and W. S. Smith 1955, pp. 23–40, and Baker 1966, pp. 45–46, fig. 36.

2. Quirke 1992, p. 108.
3. See New-York Historical Society 1915, p. 31, no. 486; James 1974, p. 90, no. 207; Fischer 1980; and a description of the headrest by James F. Romano can be found in *Egypt's Golden Age* 1982, pp. 74–75, no. 46.

PROVENANCE: Said to be from Saqqara

BIBLIOGRAPHY: New-York Historical Society 1915, p. 31, no. 486; James 1974, p. 90, no. 207, pls. IX, LII; James F. Romano in *Egypt's Golden Age* 1982, pp. 74–75, no. 46

191. Fittings from a Bed

Early 18th Dynasty (1550–1425 B.C.)
Hardwood, overlaid with gold and silver; modern wood footboard
H. 73.8 cm (29 in.), W. 81.3 cm (32 in.),
D. 38.2 cm (15 in.)
The Trustees of the British Museum, London
EA 21574, EA 21613 (silver overlay)

These fragments were reputed to be remains of the royal throne of Hatshepsut when they were presented to the British Museum in 1887. They have now been correctly reassembled as a couch or bed; the footboard between the uprights is a

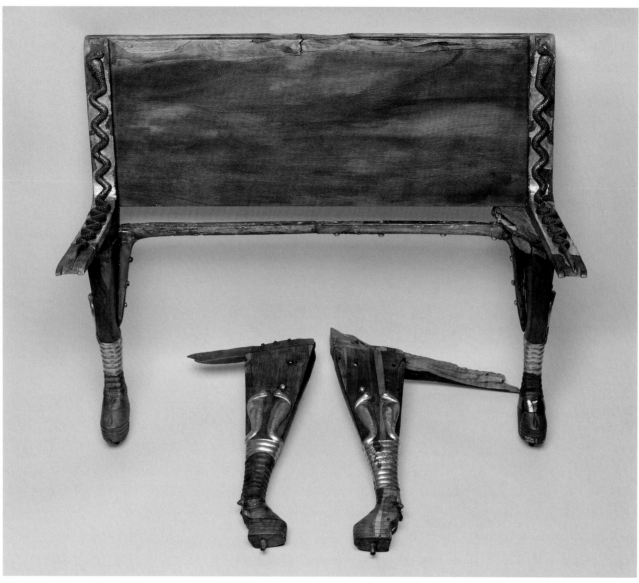

191

modern restoration. The original association of this piece with Hatshepsut's burial has also been reevaluated, since the connection was based on a fragmentary cartouche-shaped lid of wood purportedly found with it. Neither the identification of these objects with Hatshepsut nor their significance as royal objects is certain, and both must therefore remain in question.[1] The legs of the bed are made from a fine, dark hardwood and are beautifully carved into a bovine form, and the hooves, like the crossrail, are embellished with silver. The legs are overlaid with coiled cobras of heavy gold sheet metal that follows the contours of the intricate design carved into the hardwood and is attached by gold and silver nails. Ebony cobras that snake along the uprights of the footboard are inlaid with tiny silver rings punched into the wood.[2]

One of the New Kingdom refinements in furniture design was an almost universal change in the type of animal-shaped legs, with the more elaborate feline legs replacing bulls' legs.

Thus it is noteworthy that this bed retains the bovine form that was used as a furniture support from Egypt's earliest period.[3] It is possible that this bed is an import or copy of the type of beds (or biers) found in Nubia in the great Kerma tumuli of the Second Intermediate Period (1650–1550 B.C.); the shapes of the beds in those finds and the technique of their construction show many similarities with this example.[4] Regardless of where this bed was constructed, it demonstrates the appreciation of good craftsmanship and elegant decoration that was widespread in the early Eighteenth Dynasty.

RD

1. The legs and footboard uprights of this bed were presented to the British Museum together with a gaming board and associated pieces; in Pusch 1979, no. 38, the gaming board is said, based on an early account, to have been "purchased at Thebes." According to C. N. Reeves's summary (1990b, p. 17), there are several possible findspots for the bed: the one usually named is a cache in Deir el-Bahri;

Greville Chester was informed by local Egyptians that the group of finds was uncovered in a side chamber of the tomb of Ramesses IX; W. M. Flinders Petrie had suggested that the objects were removed from Hatshepsut's tomb in antiquity and hidden. The lack of evidence, Reeves concludes, leaves the significance of the bed and the group it is said to have been found with open to debate. See also Tyldesley 1996, p. 213, and Bickerstaffe 2002a.

2. Killen 1980, p. 10, pl. 1.

3. There are other rare examples of the bovine form on beds and chairs during this period. In Baker 1966, p. 41, this substitution of animal legs is described as occurring sporadically as early as the Fourth Dynasty. See also Fischer 1996, p. 146, and Bickerstaffe 2002b.

4. Lacovara 2002; Reisner 1923, pp. 208ff., figs. 191, 207–8, 212, pl. 51.

PROVENANCE: Uncertain; fittings given by Jesse Haworth and silver overlay given by G. Armitage in 1887

BIBLIOGRAPHY: A. B. Edwards 1891, pp. 125–26; London, British Museum 1930; Porter and Moss 1964,

p. 586; Baker 1966, p. 61, pls. 64, 65; Killen 1980, p. 10, pl. 1; Reeves 1990b, p. 17; Quirke 1992, p. 118, pl. 70; Fischer 1996, pp. 146–47; Tyldesley 1996, p. 213; Bickerstaffe 2002a; Bickerstaffe 2002b; Lacovara 2002

192. Chair of the Scribe Reniseneb

18th Dynasty (1550–1295 B.C.)
Wood, ivory, linen
H. 86.2 cm (34 in.), W. 49.5 cm (19½ in.), D. 59.5 cm (23⅜ in.)
The Metropolitan Museum of Art, New York, Purchase, Patricia R. Lassalle Gift, 1968 68.58

The chairs and stools used in everyday Egypt were ordinarily plain and undecorated. In contrast, seating furniture used for official purposes was often lavishly decorated, testifying to the high standard of Egyptian cabinetmaking, particularly during the Eighteenth Dynasty; this chair of the scribe Reniseneb suggests the quality and elegance of these extraordinary pieces

of furniture. Both in form and in construction, this wood chair is typical of the period. The curved backrest slants backward and is supported in back by two vertical stiles and a center brace, which, like the backrest itself, are mortised into the rails of the seat frame below and the headrail above.[1] Since there are no stretchers to hold the legs apart, they are braced by the structure of the side rails, while the front and back reinforcement is supplied by a pair of knee braces that overlap at the center. These are attached to the legs by mortise and tenon and are secured by animal glue and pegged to the underside of the crossrails.[2] The shorter crossrails are mortised into the longer side ones. The seat thus framed was filled with a webbing of linen cord drawn through sixty-eight holes, sixteen on each side and one in each corner. Enough of the webbing remained to restore it to its original appearance.

Even in the First Dynasty the Egyptians had mastered the technique of applying a veneer of fine wood to an inner layer of wood of inferior

quality. Here, East African blackwood was used to cover the front upper surfaces, legs, and sides of the chair. The lion's legs set on tall drums are each made of a single piece of a species of salt cedar (tamarisk), a small native tree, whose wood is also used throughout the basic framework of the chair.

Ivory veneer is applied to the high backrest, where it alternates with blackwood on four of the seven splats and the horizontal elements to which the splats are attached, producing a beautiful contrast of light and dark. Ivory decoration is also inlaid in the claws of the lion's feet and elsewhere. Incised into the central splat of the backrest, beneath an inscription, is a charming profile of Reniseneb before a *k3* emblem, holding a lotus and seated on a chair that is identical to this one.[3]　　　　　　　　RD

1. For a general discussion of Egyptian furniture, see Fischer 1986, pp. 169–202; for Reniseneb's chair, see also pls. 86–88, and Fischer 1996, pp. 141–76.

2. On the use of glue in this chair, see Fischer 1996, p. 144 and n. 6, which includes a description of the interesting addition of blackening to the animal glue to match the color of the veneer, and the use of an amber-colored animal glue to hold the ivory elements. On Egyptian furniture in general, see also Killen 1980, and, especially for glue, pp. 9, 13, fig. 2.

3. According to Fischer (1996, p. 151), this is the only representation of a nonroyal owner with an inscription appearing on a functional chair (one not designed as a piece of insubstantial tomb equipment). The inscription reads: "(1) A gift which the king gives, and Amun, Lord of Karnak, (2) that offerings go forth (including) bread, beer, oxen and fowl, alabaster (jars of ointment), clothing, incense and oil, offerings (3) of food and everything (4) goodly and pure that comes forth in the presence of (5) the Lord of the Gods (*scil.* Amun) in the course of every day (6) to the Loving Son of the Lord of the Two Lands, the Scribe *Rn(.i)-snb*, justified" (Fischer 1996, p. 157).

PROVENANCE: Unknown

BIBLIOGRAPHY: Fischer 1968; N. E. Scott 1973, fig. 15; Lilyquist 1975, p. 76; Fischer 1986, pp. 190–92, pls. 86–88; Fischer 1996, pp. 141–76

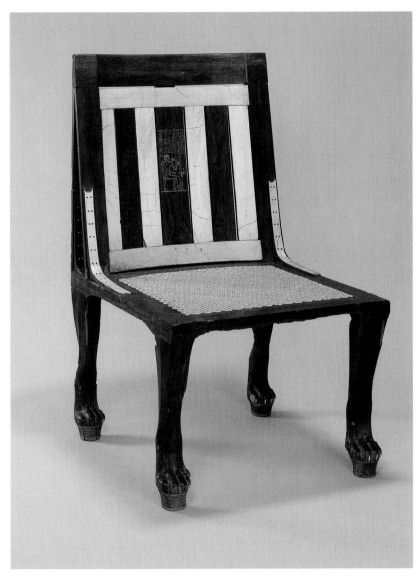

192

V. THE PROSCRIPTION

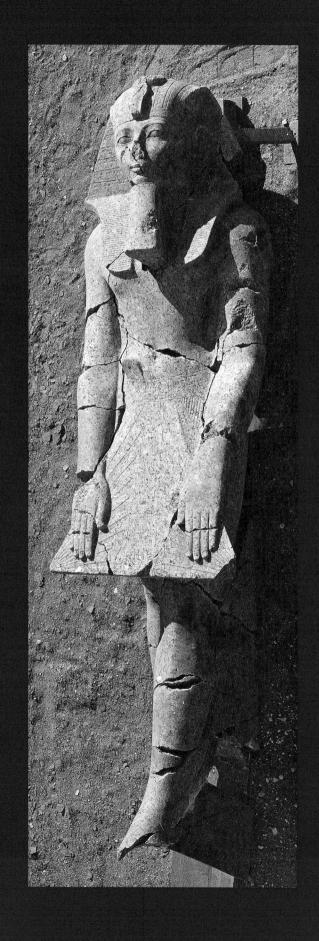

AFTER HATSHEPSUT
The Military Campaigns of Thutmose III

James P. Allen

After sharing the throne with Hatshepsut for a decade and a half, Thutmose III became sole ruler of Egypt at her death, a little less than three months shy of the twenty-third anniversary of his own accession. A stela he had erected in the temple of Montu at Armant, dated by year, month, and day—regnal year 22, 2 Growing 10 (January 16, 1458 B.C.)—is generally believed to mark the occasion.[1]

In the inscriptions on the stela the king is twice called "Thutmose, Ruler of Maat" ($ḥq3\ m3^ct$). This epithet, used here for perhaps the first time in Thutmose's reign, undoubtedly reflects the traditional role of the pharaoh as champion and enforcer of *maat*, the principle of order, justice, truth, and propriety. It also asserts Thutmose's own claim to the administration of *maat*, subsequent to that of Hatshepsut, who had taken as her throne name the epithet Maatkare, or "Proper Manifestation ($m3^ct$) of the Sun's Life Force." Establishing this right was probably the primary motive behind the new epithet. Since the erasure of Hatshepsut's name and images did not occur until some two decades after the stela's date, Thutmose's adoption of the epithet may not have implied any deprecation of the legitimacy of her rule.

The first years of a new pharaoh's reign were often devoted to military expeditions against the countries and nomadic peoples on Egypt's borders. These served to demonstrate to the gods, to the Egyptians, and to potential enemies the king's commitment to safeguard Egypt. The perceived need for such campaigns was especially critical in the early Eighteenth Dynasty, when the memory of the Hyksos domination of Lower Egypt a century earlier was still acute: a text from the final years of Hatshepsut's reign describes the period of their hegemony as "the time when Asiatics were in the midst of the Delta, (in) Avaris, with vagrants in their midst toppling what had been made."[2] Hatshepsut had sent at least one military expedition to Syria-Palestine, and Thutmose III's Armant stela records two campaigns he led to Mesopotamia and Palestine during the co-regency.

Two and a half months after assuming sole rule, Thutmose embarked on the first of what were to be seventeen military expeditions to Asia Minor undertaken during the next two decades of his reign. These are documented primarily in the text known as the Annals of Thutmose III, which was adapted from the king's campaign journals and inscribed on the walls of the temple of Amun at Karnak. The description of the first campaign begins:

Regnal year 22, 4 Growing 25. Passing of His Incarnation by the fortress of Sile on the first campaign of force, [in order to drive off] in bravery, [in force, in strength, and in righteousness, those who were violating] Egypt's borders. For though it had been [many] years [since the Hyksos were] pillaging, every man [working] at their direction [in the towns of the Delta], yet in the time of others there had come to be troops who were there in the town of Sharuhen, and from Yaradja to the ends of the earth had started to defy His Incarnation.[3]

The Armant stela also describes the beginning of this campaign, with the king's "emergence from Memphis to kill the highlands of wretched Retenu on the first occasion of force."[4]

Although the Annals mention the Asiatic military presence in Sharuhen as the *causa belli*, it was in fact merely indicative of a far larger threat and the true opponent of this first campaign: a coalition of several Asiatic countries led by the king of Qadesh, a Syrian city north of modern Damascus, and centered in the Palestinian stronghold of Megiddo (see map, p. 60). Situated in the western end of the Jezreel Valley, Megiddo lay at the eastern foot of the Carmel mountains. Less than a month after setting out from Egypt, on 1 Harvest 16 (April 22), Thutmose and his army had reached the western slope of the mountains, eighteen miles from Megiddo. At this point the Annals record one of the more memorable events of the king's reign.

Three routes led eastward through the mountains. Two of these, relatively broad passes, emerged north and south of Megiddo. The third led directly to the city itself but was narrow enough to require an army to proceed at times in single file, leaving it vulnerable to ambush. The king's generals argued for the northern or

Opposite: Fig. 84. An over-lifesize statue of Hatshepsut as reassembled from fragments, discovered in western Thebes, 1928. Granite. Now restored (see cat. no. 94)

southern route, but Thutmose, seeking a tactical advantage, decided to use all three passes. The strategy succeeded, leaving the coalition in Megiddo bracketed by the Egyptians with no possible direction of escape. After a brief skirmish on the twenty-first (April 27), the Asiatic army retreated to the city, which Thutmose then besieged, encircling it with a ditch and a wall of wood seven feet high and three feet thick. When Megiddo eventually capitulated, the coalition collapsed and Thutmose returned to Egypt with some three thousand captives and tribute for the temple of Amun at Karnak, including 194 pounds of gold and silver and 526,000 bushels of wheat.

Thutmose III campaigned in Asia sixteen more times between regnal years 24 and 42 (1456–1438 B.C.). The conquest of Megiddo had removed the most serious threat to Egypt's domination of western Asia, but pockets of resistance remained throughout the region, with potential rivals to Egyptian control in Syria and Mesopotamia. Expeditions between regnal years 24 and 29 were largely tours of inspection to confirm the victory of the first campaign and to receive tribute. The fifth, sixth, and seventh campaigns, in regnal years 29–31 (1451–1449 B.C.), succeeded in quelling the Syrian threat, with the conquest of Tunip, Qadesh, and Ullaza.

In regnal year 33, Thutmose III returned once more to Mesopotamia, where he conquered a number of cities, crossed the Euphrates, and set up two boundary stelae on its east bank. The proceeds from this expedition included tribute from Babylon and the Hittites. Another campaign was needed two years later to quash a revolt in Mesopotamia, and several more expeditions took the king to coastal Lebanon and Syria between regnal years 36 and 38

(1444–1442 B.C.). The following year saw the king's fourteenth campaign, with battles against the nomadic Shasu on Egypt's northeastern border and a further tour of western Asia. Thutmose's final campaign, in regnal year 42 (1438 B.C.), took him once more to Syria, where he reconquered Tunip and several cities in the region of Qadesh.

Although Thutmose III devoted most of his attention to Asia during the first two decades of his sole rule, he did not neglect Egypt's other foreign interests. The Annals mention two expeditions sent to Punt, in regnal years 33 and 38, and the receipt of regular tribute from the kingdoms of Wawat and Kush, in Nubia, from regnal year 31 onward.

Thutmose's intensive military efforts, culminating in his final Asiatic campaign, apparently produced a period of relative stability. For this reason, or perhaps merely because of old age, he devoted the remainder of his reign to peaceful pursuits within Egypt. Nevertheless, despite his extensive construction projects in Karnak and throughout Egypt, Thutmose III was remembered primarily as a great military leader. This reputation has survived to our own time, which has labeled him "the Napoleon of ancient Egypt."

1. Mond and Myers 1940, pl. 103.
2. J. P. Allen 2002, p. 5.
3. *Urkunden* 4, pp. 647, l. 12–648, l. 8. The date is April 1, 1458 B.C. The fortress of Sile lay on the eastern edge of the Delta. "The time of others" refers to the reigns of Thutmose III's predecessors. Sharuhen, mentioned in the Bible (Josh. 19:6), is the modern Tell el-Sheria, thirty miles northwest of Beersheva and thirty-five miles southeast of Gaza. Yaradja is modern Yerza, in the Gaza plain.
4. *Urkunden* 4, p. 1246, ll. 13–15. Retenu was a generic term for the coastal mountain ranges of Palestine, Lebanon, and Syria.

193. Thutmose III Seated

Early 18th Dynasty, reign of Thutmose III
(r. 1478–1425 B.C.)
Granite
H. 107 cm (42⅛ in.), W. 33 cm (13 in.), D. 56 cm
(22 in.)
Egyptian Museum, Cairo JE 39260

In this magnificent statue, Thutmose III is por-
trayed as a powerful ruler at the height of his
youthful vigor. The well-balanced features and
the expression, with a slightly smiling mouth,
epitomize the Thutmose style discussed early in
this volume (see "Art in Transition" by Edna R.
Russmann in chapter 1).

Inscribed on the side panels of the king's
throne is a device symbolizing the union of the
two lands of Upper and Lower Egypt: a lily and
a papyrus plant tied around the *sema* hiero-
glyph, which means "to unite" or "to join."
Nine bows are incised beneath Thutmose's feet
to symbolize his subjugation of the enemies of
Egypt. He wears a *nemes* headcloth and the
royal *shendyt* kilt, the belt of which is inscribed
with his throne name, Menkheperre.

There is some confusion about where the
statue was discovered, but it seems most likely
that it was found in a sanctuary built just east
of Karnak temple by Thutmose III.[1] Dimitri
Laboury, who recently published a study of the
statuary of Thutmose III, has suggested a date
in the middle of the king's reign for the statue.[2]
This would place it after the death of
Hatshepsut, in the first half of Thutmose's
reign as sole king. CHR

1. For a discussion of the possible findspots, see
 Laboury 1998, pp. 241–46.
2. Ibid., p. 241.

PROVENANCE: Thebes, Karnak, east temple of
Thutmose III, room 1; discovered by Georges
Legrain, January 1907

BIBLIOGRAPHY: Georges Legrain in Griffith
1906–7, p. 21; Matthias Seidel in H. W. Müller and
Settgast 1976, no. 1; Mohamed Saleh in Freed,
Markowitz, and D'Auria 1999, p. 200, no. 1

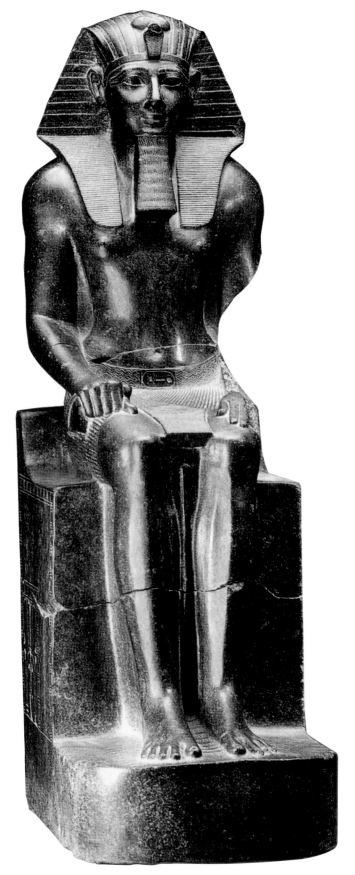

193

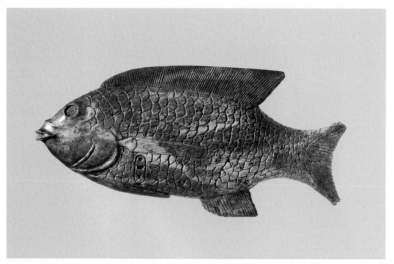

194

194. Cosmetic Dish in the Shape of a Fish

Early 18th Dynasty, reign of Thutmose III
(r. 1479–1425 B.C.)
Glazed steatite
H. 8.5 cm (3⅜ in.), W. 2 cm (¾ in.), L. 18.1 cm
(7⅛ in.), D. 2 cm (¾ in.)
The Metropolitan Museum of Art, New York, Gift
of James Douglas, 1890 90.6.24

The bolti fish, or tilapia, common in the Nile
valley since ancient times, is easily recognized
by its long dorsal fin. The fish, which hatches its
eggs in its mouth, was a symbol of regeneration
and was also associated with the sun god, Re.
While carved in the round, this object is actu-
ally a fish-shaped dish, with a depression in one
side that would have been used for the prepara-
tion of cosmetics. The cartouche just behind the
gill contains the throne name of Thutmose III,
Menkheperre. The dish may have been given by
the king to a temple. [1] CHR

1. See Dorothea Arnold 1995, p. 37.

PROVENANCE: Unknown; acquired as a gift in 1890

BIBLIOGRAPHY: Hayes 1959, p. 123, fig. 65;
Dorothea Arnold 1995, p. 37; Lilyquist 1995, cover
(left foreground) and p. 50, no. M, fig. 137

195. Four Seal Amulets, One in a Ring

Early 18th Dynasty, reign of Thutmose III
(r. 1479–1425 B.C.)
Glazed steatite, gold
a. Ring: Diam. 2.6 cm (1 in.); amulet: L. 1.5 cm (⅝ in.),
W. 0.75 cm (5/16 in.), H. 0.6 cm (¼ in.)
b. H. 1.75 cm (¾ in.), W. 1.28 cm (½ in.)
c. L. 1.3 cm (½ in.), W. 0.8 cm (5/16 in.),
H. 0.6 cm (¼ in.)
d. H. 2.75 cm (1⅛ in.), Diam. 1 cm (⅜ in.)
The Metropolitan Museum of Art, New York
(a, b, d) Theodore M. Davis Collection, Bequest of
Theodore M. Davis, 1915 30.8.564, .418, .433
(c) Gift of J. Pierpont Morgan, 1917 17.190.2011

These seal amulets are all inscribed with
Thutmose III's throne name, Menkheperre, and
were probably all made during his reign. Two
are decorated on the back with a mouse (a) and
a duck (c) rather than the more usual scarab
beetle. Both of these have the king's throne
name on the base. The mouse, which is still set
into a gold ring, is also inscribed on its back
with the words "Menkheperre, living forever."

On one side of the oval plaque (b), Thutmose
is depicted seated, holding the crook and flail
and wearing the blue crown, a headdress usu-
ally associated with the king as warrior. On the
other side, he is shown as a sphinx wearing the
atef crown and trampling a captive. The bead
(c) has two vignettes. One shows Thutmose as
king, wearing the blue crown and kneeling
before the god Amun, who reaches out with
one hand to touch the king's crown and extends
the ankh hieroglyph, a symbol of life. Above
Thutmose's head, not in a cartouche, are the
words "Menkheperre, beloved of Amun," and in
front of his face is written "The Good God, Lord
of the Two Lands forever." This column of
hieroglyphs separates the image from the second
vignette, which depicts the king kneeling and
offering *nw* jars, presumably to Amun. In front of
his head are the words "Beloved of Amun."

CHR

PROVENANCE: *195a, b, d.* Unknown; formerly
Theodore M. Davis collection; bequeathed to the
Museum in 1915
195c. Unknown; acquired in 1917

BIBLIOGRAPHY: *195a.* Hayes 1959, p. 105
195b, d. Hayes 1959, p. 125, fig. 66

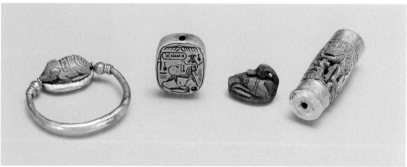

195a, b, c, d

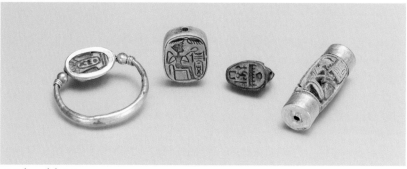

195a, b, c, d, bases

196. Leaf from the Hearst Medical Papyrus

Early 18th Dynasty, joint reign of Hatshepsut and
Thutmose III (1473–1458 B.C.)
Ink on papyrus
H. 17.3 cm (6⅞ in.)
Bancroft Library, University of California, Berkeley

The Hearst Medical Papyrus was found by a
local resident at Deir el-Ballas, the site of an
Eighteenth Dynasty town, which is about
twenty miles north of ancient Thebes.[1] In 1901
the still-rolled papyrus was offered to George
A. Reisner, who was then conducting excava-
tions for the University of California, Berkeley.[2]
When unrolled, the papyrus was identified as a
compendium of prescriptions and incantations
that had probably been compiled from a variety
of sources for the use of a local physician.[3]

This section of the papyrus deals specifically
with ailments of the body's vessels. The titles,
among them "a prescription for healing ves-
sels," "to remove the swelling of a vessel," and
"to quiet twinges in a vessel,"[4] are written in red,
and the ingredients to be used are listed in black.

CHR

1. The papyrus is named for Mrs. Phoebe Apperson
 Hearst, who sponsored excavations conducted by
 the University of California, Berkeley, 1899–1904.
2. Reisner 1905, p. 1.
3. Ibid., p. 4.
4. Ibid., p. 10.

PROVENANCE: Deir el-Ballas; acquired by George A.
Reisner from a local resident in 1901

BIBLIOGRAPHY: Reisner 1905; Elsasser and
Fredrickson 1966, p. 66; Susan K. Doll in *Egypt's
Golden Age* 1982, p. 295, no. 406 (with bibliography)

196

197. Magical Jar

Second Intermediate Period–early 18th Dynasty
(1650–1492 B.C.)
Glazed steatite
H. 6 cm (2⅜ in.), W. 3.2 cm (1¼ in.), D. 4 cm
(1⅝ in.), Diam. (of opening) 1.9 cm (¾ in.)
The Metropolitan Museum of Art, New York, Gift
of G. Macculloch Miller, 1943 43.8a, b

This jar takes the form of a monstrous female
deity whose body was that of a pregnant hip-
popotamus with a crocodile's tail, a lion's mane,
and a woman's breasts. Known as either Ipi or
Taweret, she protected pregnant and nursing
women and young children, all people in vul-
nerable stages of life.

The goddess is represented here in a blocky
style and has a sharply contoured muzzle and a
tail that begins at her head. These features are
comparable to those of two-dimensional images
of the deity that frequently appear on late
Middle Kingdom knives. However, it is rare for
vessels of Middle Kingdom date to depict
deities or animals, while such shapes are not
uncommon in jars dating to the Second
Intermediate Period and the New Kingdom.
These circumstances, together with the jar's
deep green color, suggest a post–Middle
Kingdom date.

The jar has a cylindrical cavity that is cov-
ered by a slightly rounded lid. A hole visible in
the center of the goddess's teeth is the begin-
ning of a tubelike opening that extends into her
head; another opening passes through the bot-
tom of the lid, and a third through the back of
her head, where it exits at the top of the tail.
When the lid is positioned so that its holes line
up with those in the front and back of the head,
they form a single continuous conduit. Since in
representations of Ipi/Taweret on magical knives
the goddess is consistently depicted either with
a protruding tongue or clenching an aroused
cobra in her teeth (see fig. 85),[1] it seems likely
that this unusual jar originally had a piece of
wire shaped at one end to imitate a tongue or
cobra emerging from Ipi/Taweret's mouth.
The wire would have been inserted through the
goddess's teeth, snaked through the head and
lid, and, where it exited at the back of her head,
probably bent to keep the lid in place. The addi-
tion of the cobra would have enhanced the pro-
tective power of the deity, reflected already in
her commanding form.[2]

Another unusual feature of this jar is the
design carved into the underside of the base, a
well-known motif referred to as convoluted
coils[3]—in this case with ties that bind the coils.
The carving would produce a delicate impres-
sion if the vessel's base was used as a seal.

To explain the function of this remarkable
object, we must account for the jar's unusual
elements—the small cavity, the way the lid is
secured, the presence of the added tongue or

cobra, and the seal—combined with the form of Ipi/Taweret. The method by which the lid is attached is unknown in cosmetic vessels, and there is no obvious discoloration in the cavity from either eye paint or an oily substance. This would suggest that the jar was not used to store a cosmetic substance. Nevertheless, whatever it held was surely prized. Ipi/Taweret would have effectively guarded the contents and protected the individual who used the vessel.[4] The motif of linked coils on the base brings to mind the magic associated with knots and binding,[5] and the design's position beneath the deity's feet probably contributed to its effectiveness as well.[6]

Perhaps instead of a substance, the vessel held a papyrus inscribed with a spell for a pregnant or nursing woman.[7] The magician would recite the spell and perhaps then magically bind it to the ailing person, using the seal[8] (when pressed to the skin, the seal leaves a brief impression). This possibility is reinforced by a spell in the Leiden magical papyrus that indicates that pictures or designs were inked onto the skin before a spell was said.[9] It seems likely that this jar was an important component of a magician's kit.

<div align="right">DCP</div>

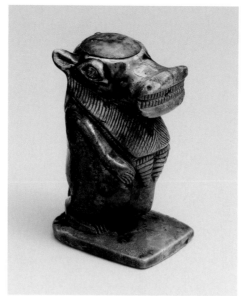

197

197, back

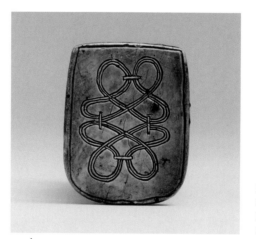

197, base

Fig. 85. The goddess Ipi/Taweret biting a cobra. Incised on a magical knife, 12th Dynasty, in The Metropolitan Museum of Art, New York, Rogers Fund, 1908 (08.200.19). Drawing by Julia Jarrett

1. See, for example, The Metropolitan Museum of Art, New York, 08.200.19, 22.1.153 (Hayes 1959, p. 249) and the Walters Art Gallery, Baltimore, 71.510 (Anne K. Capel in Capel and Markoe 1996, p. 64, no. 12). An Ipi/Taweret biting a cobra is also depicted in relief on a steatite kohl jar clearly of early Eighteenth Dynasty date (Ägyptisches Museum, Berlin, 16138; Schoske 1990, p. 165).
2. Bourriau 1988, p. 113.
3. The design is well known from objects of the Twelfth through the Seventeenth Dynasty (1981–1550 B.C.) (Tufnell 1984, pp. 125–60). Recent work by Daphna Ben-Tor of the Israel Museum, Jerusalem, demonstrates that it is found on Eighteenth Dynasty scarabs as well (personal communication, 2005).
4. A statue of a boy carrying a calf was among a group of items of magical equipment excavated at the Ramesseum in 1896; Ritner (1993, pp. 225–27) suggested that the piece was physically held during a

spell's recitation. Bourriau (1988, p. 110) also calls it a magical piece.
5. Tying, binding, and sealing were all ways of containing negative forces; see Pinch 1994, pp. 83–84.
6. Ibid., p. 85.
7. Inserting an inscribed papyrus inside a statue or amulet was a tradition in ancient Egypt, although most examples date later than the New Kingdom. For a discussion of papyri inside amulets, see J. J. Janssen and R. M. Janssen 1992, pp. 161–62.
8. Pinch 1994, p. 84.

9. The papyrus is in the Rijksmuseum van Oudheden, Leiden. For spell 26, see Borghouts 1978, p. 22. The seal on the present jar, however, shows no signs of staining.

PROVENANCE: Theodore M. Davis collection

BIBLIOGRAPHY: J. P. Allen 2005

THE PROSCRIPTION OF HATSHEPSUT

Peter F. Dorman

The systematic erasure of Hatshepsut's name and figure from her kingly monuments some years after her death has, inevitably, become a lens through which historians have viewed the events of her life and reign. On some monuments, her cartouche was shaved down and recut in the name of another Thutmoside king; on others, her entire figure and accompanying inscription were effaced and replaced with the image of an innocuous ritual object such as an offering table. At her mortuary temple at Deir el-Bahri, all the statues of Hatshepsut were dragged out and dumped into the bottom of a quarry near the temple causeway. Since this widespread damage was undertaken by Thutmose III, her nephew and erstwhile co-regent, scholars of the mid-twentieth century for the most part assumed that the motive was retribution, undertaken because Hatshepsut had forcibly usurped the throne from Thutmose when he was far too young to protest and had relegated him to relative obscurity during his childhood and adolescence. Thus her death offered him the chance to erase her hated memory from the public record and vengefully reclaim his rightful place on the throne. While this scenario sounded convincing, it was called into question in 1966 by Charles Nims, who pointed to evidence indicating that the attack on Hatshepsut's monuments could not have predated Thutmose III's regnal year 42 (see below). That was at least twenty years after her death, far too late a date to lend support to the theory of a motive based on personal revenge.[1] This later date for Hatshepsut's official "disgrace" is now widely accepted, and as a result the primary question surrounding the proscription has been significantly recast. It is now: Why did Thutmose III initiate a program of erasures so long after his stepmother and co-regent died, and so late in his own reign?

The answer can be approached, in part, through a careful observation of the extent and nature of the alterations to Hatshepsut's name and figure. These vary from place to place. Her proscription cannot be characterized as a straightforward *damnatio memoriae*—that is, an attempt to erase all traces of a person's existence—because Hatshepsut's representations as queen were never touched; the attacks were directed solely at her kingly representations.[2] The distinctive rebus frieze representing her throne name, Maatkare, and consisting of a serpent adorned with a horned sun disk perched on a pair of ka arms, was altered by chiseling away the arms, rendering the title unreadable but leaving the divine symbols intact (fig. 101). Nor is there any evidence that her burial in the Valley of the Kings was desecrated for the purpose of dishonoring her; there are many other possible reasons. Noteworthy also is that although Thutmose III was responsible for this far-reaching program of alteration, it is only rarely that his own name is carved over Hatshepsut's. Rather, in nearly every instance, he inserted the name of his father, Thutmose II, or that of his grandfather, Thutmose I, into Hatshepsut's royal titulary, thereby appropriating her royal monuments not for himself but for his immediate male ancestors (fig. 86).[3] This activity reflects a plan to rewrite the recent history of the dynasty through the effacement of Hatshepsut's kingship while deliberately eschewing any appearance of usurpation on the part of the reigning king. Whatever his motive, Thutmose III never intended to claim the creation of Hatshepsut's monuments as his own accomplishment.

Thutmose III's overall intentions are also reflected in the way the scenes and inscriptions were altered in stages, apparently by direction to the stonecutters. Raised relief was first cut back with wide-bladed chisels, which removed the stone efficiently, and usually smaller chisels were then employed to take off as much as possible of the original carving. Next the background surface was smoothed, and finally the draft of a revised scene or text was laid

Fig. 86. Inscription with cartouches in which the names of Thutmose II were carved over those of Hatshepsut. In Hatshepsut's temple at Medinet Habu, western Thebes. Drawing by Christina Di Cerbo and Margaret De Jong

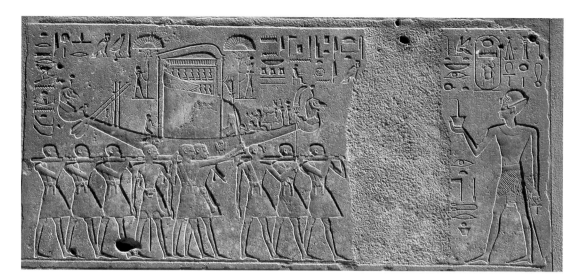

Fig. 87. Thutmose III appears at the far right; Hatshepsut once stood in front of him, facing the barque of Amun, but her names and image have been completely erased. Block from the Chapelle Rouge, Karnak, Thebes, early 18th Dynasty. Quartzite

down, recut, and repainted. These revisions were made with care and deliberation, thus minimizing extensive damage and facilitating the process of redecoration. To be sure, there are exceptions to this systematized historical revisionism. For example, the figures and cartouches of Hatshepsut on blocks from the quartzite Chapelle Rouge are ruthlessly hacked out, with no attempt made to preserve the surrounding surface (fig. 87). However, at the time of the proscription the Chapelle had been dismantled. Its blocks were evidently lying in a great heap, since only certain depictions of Hatshepsut, which must have been the ones visible, were attacked; many others, presumably protected by overlapping stones, were preserved (see figs. 3, 41).[4] Because the Chapelle was not in a state to be rededicated as a religious structure, the careful alterations made to other temples were in this case unnecessary.

The treatment accorded Hatshepsut's magnificent temple statuary at Deir el-Bahri offers still another perspective. Rather than being reinscribed for Thutmose I, her father, or Thutmose II, her husband, the sculptures were cast out, many of them deliberately broken, and thrown into the quarry as debris. Even the Osiride pillars that fronted the uppermost portico were painstakingly cut away from their square piers and discarded. Perhaps the statues made for her funerary monument had such immediate personal associations with Hatshepsut or were so closely tied to the ritual ceremonies of her mortuary cult that they could not be attributed to other rulers. Whatever the reason, their desecration and destruction present a distinct contrast to the careful reuse of her wall reliefs elsewhere. (On Hatshepsut's statues, see the essay following, by Dorothea Arnold.)

The clue to the timing of the proscription can be found at the very center of the temple at Karnak. After erecting a new red granite barque shrine in the temple, Thutmose III clad the sanctuary wall north of it with fresh limestone blocks and there recorded in relief a continuous account of his military campaigns from regnal year 22 (1458 B.C.) through year 42 (1438 B.C.), known to scholars as the Annals of Thutmose III. The wall had originally been decorated by Hatshepsut, and at the moment it was covered over, the initial and secondary phases of chiseling on both her figure and certain surrounding texts were under way, but not yet completed (fig. 88). At that time, then, the proscription must have been recently enacted; and since Thutmose III's campaign annals could not have been inscribed before year 42, that is the earliest possible date for the proscription. The barque shrine itself bears a date of regnal year 45, which may more accurately indicate the time of the alterations undertaken at the heart of Karnak. This very late date is also reflected in the decoration of the Eighth Pylon on the south side of Karnak temple, which was originally adorned with colossal reliefs of Hatshepsut. These scenes were

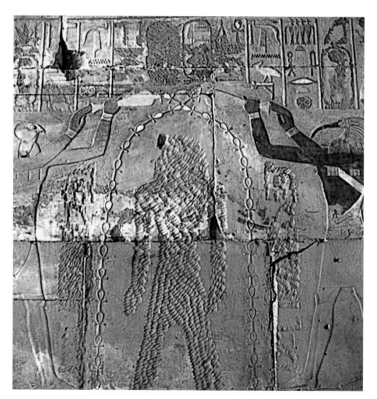

Fig. 88. Various stages of hacking of Hatshepsut's image and names on a section of wall behind the new wall built by Thutmose III and carved with his Annals, Karnak temple, Thebes

carefully erased, but apparently Thutmose III had no time to have the front of the pylon recarved before his death; the final scenes were added by his son and successor, Amenhotep II (r. 1427–1400 B.C.).

Although the proscription of Hatshepsut seems both irrevocable and ruthless in its obliteration of her kingly presence, the campaign was also short-lived and incomplete. In her temple at Deir el-Bahri, the innermost sanctuaries were altered according to the usual program, but the reliefs of the outer terrace porticoes, which commemorate her mythical divine birth, the expedition to Punt, and the transportation of her great obelisks to Karnak, were shaved down in only a preliminary fashion. The original representations and text, though damaged, are quite legible today. Indeed, even after the defacement, Hatshepsut's kingly achievements and her claims to a legendary childhood could have been read by any literate person of ancient times, as they can be by modern scholars.[5] The suspension of this work of revision before it was fully carried out can only indicate that at some point the urgent motivation for the attacks vanished. This abandonment of the proscription of Hatshepsut seems to have occurred during the reign of Amenhotep II, who completed the redecoration of the Eighth Pylon in his own name but evidently felt little necessity to renew or revise the partly erased scenes at Deir el-Bahri.

The reason for Hatshepsut's proscription remains elusive. If it was not a matter of personal vengeance on the part of Thutmose III, other possible explanations seem equally unconvincing. After fifty years on the throne, during which he had secured a long-lasting sphere of Egyptian political hegemony in the Levant as well as in Nubia, Thutmose can have had little to fear by way of challenges to his own legitimacy or comparison with his former co-regent. Indeed, posterity would justly remember him as one of the greatest kings of Egypt. The need for the proscription seems to have arisen toward the end of his reign and to have vanished shortly after Amenhotep II became co-ruler, two years before Thutmose III's death. The timing and short duration of the attack on Hatshepsut's image and name suggest that it was driven by concerns related to the royal succession and ceased once Amenhotep was securely enthroned.[6] The heir apparent, like his father at his own succession, may have been quite young. It has been suggested that toward the end of Thutmose III's life there were two contenders for the throne, one the scion of the Thutmoside dynastic line of the king himself and another representing the "Ahmoside" bloodline,

to which Hatshepsut directly belonged through her mother, Queen Ahmose. The proscription of Hatshepsut would then have been initiated in order to discredit the legitimacy of the rival Ahmosides and to secure the throne for Amenhotep II. Such an interpretation is weakened, however, by the fact that there seems to be no known candidate, about the time of Thutmose III's fiftieth year, who can be identified as an Ahmoside contender. Nor do we even know with any certainty that such relatively fine distinctions of descent were matters of contention.

The more likely explanation may simply be this: the recently invented phenomenon of a female king had created such conceptual and practical complications that the evidence of it was best erased. It is interesting to note that the principal title Hatshepsut employed during her regency was God's Wife of Amun, a powerful economic and political office that may initially have given her special leverage to act in the name of Thutmose III during the years of his minority. Years later, shortly after his reign ended, the title fell into disuse—perhaps an intentional downgrading—and the great queens of the late Eighteenth Dynasty, such as Tiye and Nefertiti, never adopted it. The obliteration of Hatshepsut's kingship may thus be linked with a determination to eradicate the possibility of another powerful female's ever inserting herself, as the personification of Horus on earth, into the long line of Egyptian male kings.[7]

1. Nims 1966; further clarified in Dorman 1988, pp. 46–65, and Van Siclen 1989.
2. Certain of Hatshepsut's shrines were apparently dismantled prior to the onset of her dishonoring, but this act does not in itself imply persecution. Older, obsolete structures were occasionally removed to make way for new construction projects, especially at the center of Karnak temple, which witnessed extensive rebuilding.
3. A particularly clear example of this commemoration of Thutmose III's ancestors may be found on the upper terrace of Hatshepsut's temple at Deir el-Bahri, where a long text describing her coronation was replaced by an equally elaborate text purporting to celebrate the coronation of Thutmose I. For the text, see Porter and Moss 1972, p. 96 (the chronology of the two texts in question is incorrectly noted), and Lacau and Chevrier 1977–79, pp. 93–94.
4. Dorman 1988, pp. 52–55.
5. These reliefs bear "restoration" inscriptions of Ramesses II (r. 1279–1213 B.C.), who can be credited with very little actual repair of the sadly vandalized walls but who chose nevertheless to leave his name on them.
6. For the duration of the proscription, see Dorman 1988, pp. 64–66; for an overview of possible motives, see Meyer 1989 and Bryan 1996, p. 34.
7. Suggested by Robins 1993, p. 152.

THE DESTRUCTION OF THE STATUES OF HATSHEPSUT FROM DEIR EL-BAHRI

Dorothea Arnold

The attacks on Hatshepsut's Deir el-Bahri statuary differ in many respects from those directed at her names and representations in reliefs. For instance, none of Hatshepsut's statues were altered to represent another person and almost all of her names in inscriptions on the statues were left intact, while such alterations and erasures were common on the reliefs. These differences alone demonstrate the complexity of historical developments behind the acts of violence perpetrated against Hatshepsut's memory.

The smashed statuary from Hatshepsut's monuments was retrieved primarily through excavations that The Metropolitan Museum of Art undertook under the direction of Herbert E. Winlock. During the 1922–23, 1926–27, and 1927–28 seasons, Winlock uncovered literally thousands of discarded fragments of Hatshepsut's statues at various locations around her temple. He and his coworkers subsequently assembled these broken parts into more than thirty-five masterpieces of sculpture that now grace the Egyptian Museum in Cairo[1] and the Metropolitan Museum in New York (cat. nos. 88a, 89–95).[2] As the reconstruction proceeded, it became clear that a number of fragments of some of the statues being worked on were in collections in Berlin (Ägyptisches Museum) and Leiden (Rijksmuseum van Oudheden), having found their way there in the course of the nineteenth century. Collegial exchanges between the museums followed, and as a result it was possible to reassemble four major works (cat. nos. 88b, 93, 95, 96).[3]

In addition to writing a series of reports in Metropolitan Museum bulletins, Winlock left three substantial notebooks and hundreds of photographs documenting the circumstances surrounding his finds.[4] These records allow us to reconstruct the progress of the statues' destruction and by inference also to identify some of their original locations in the temple.

The story starts with an image of dazzling beauty.[5] During the annual journey of the god Amun's image from his temple at Karnak to Deir el-Bahri, the accompanying priests and dignitaries approached Hathsepsut's temple on a causeway that was closed off from public view by high walls (fig. 89). Inside these walls the upper section of the processional path was flanked by more than a hundred brightly painted sandstone sphinxes representing Hatshepsut wearing the royal *nemes* headcloth (as in cat. nos. 88a, b).[6] More sandstone sphinxes were placed along the central axis of the first court. These wore ceremonial *khat* headdresses (as in cat. no. 91) and tripartite wigs (as in cat. no. 9).[7] Having passed two pools afloat with vegetation, the procession ascended the first ramp to reach the second court. Glancing to right and left, the priests could glimpse two giant limestone statues of Hatshepsut, one standing against the north end of the lower colonnade (fig. 110), the other at the south end.[8] On the level of the second court, the procession continued between rows of over-lifesize images portraying Hatshepsut kneeling and offering various gifts in globular vessels, or *nw* jars (cat. nos. 92, 93).[9] Six of these imposing statues were of granite, two of granodiorite.[10] The sandstone and limestone images were completely covered with paint, but the granite and granodiorite statues were painted only on the faces and headdresses, leaving visible the reddish brown granite and almost black granodiorite, which stood out in striking contrast against the beige color of the temple itself.[11] After ascending the second ramp to the uppermost colonnade and passing its frontal pillars with their twenty-six Osiride limestone statues, the cortege arrived at a granite doorway, the entry to the most sacred part of the temple. This entry was flanked by two standing statues of Hatshepsut,[12] whose devotional attitude (cat. no. 94) emphasized her role as prime mediator between the people of Egypt and their gods. The grayish color of these granite statues set them off against the red granite doorway.[13] Once inside the uppermost courtyard, the processional path continued between lines of small kneeling images of Hatshepsut (cat. no. 91). In their pose they recalled the large kneeling statues in the second court, but here the objects in Hatshepsut's hands, jars and *djed* (stability) pillars,[14] were more complex than the accessories of the figures on the lower level: it was as if a chant to the god was intensifying at this point close to the end of the procession.[15] Passing more Osirides in niches at the rear of the court (cat. 74; fig. 61), the cortege finally reached the sanctuary, where four figures of Hatshepsut, again in the form of Osiris, stood ready to guard the god's image throughout the night it

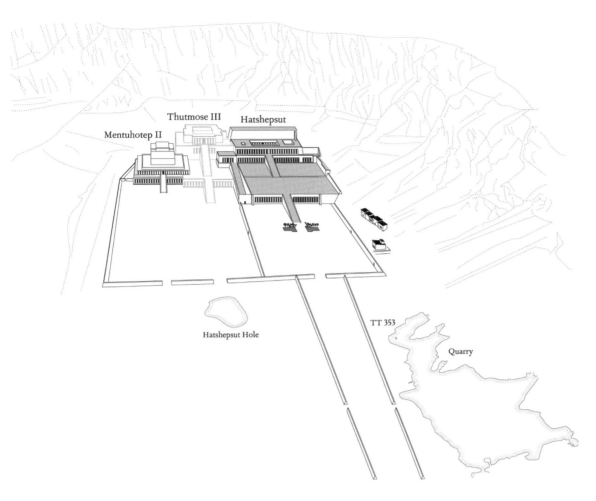

Fig. 89. The three royal temples at Deir el-Bahri, seen from the east, as they might have appeared about 1425 B.C. Some 2,300 years later, Hatshepsut's broken statues were discovered in the Hatshepsut Hole and the "quarry." TT 353 is the lower tomb of Senenmut. Drawing by Pamlyn Smith

Fig. 90. View of Deir el-Bahri and the Asasif valley from the cliffs above, 1922–23, showing: (1) temple of Hatshepsut (Djeser-djeseru); (2) temple of Thutmose III before excavation (Djeser-Akhet); (3) temple of Mentuhotep II; (4) "quarry" before excavation; (5) Hatshepsut Hole; (6) barque shrine; (7) Hatshepsut's Valley Temple

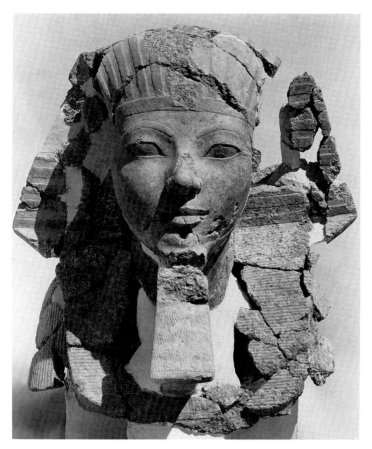

Fig. 91. Head of a sphinx of Hatshepsut, early 18th Dynasty, during restoration. Granite. Egyptian Museum, Cairo (JE 55190)

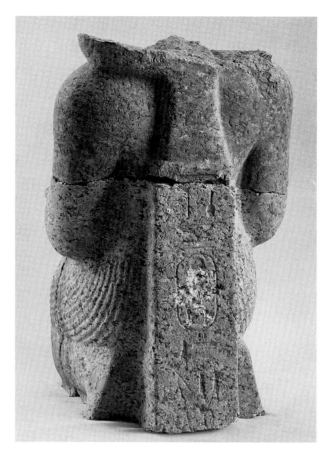

Fig. 92. Erasure in an inscription on the back of a small statue of Hatshepsut kneeling, early 18th Dynasty. Granite. The Metropolitan Museum of Art, New York, Rogers Fund, 1931 (31.3.160)

would spend in the temple.[16] Beyond the processional path, the temple itself was adorned with at least six large granite sphinxes (cat. nos. 88a, b), only two of which were displayed as a pair,[17] and eight statues of the seated Hatshepsut made, variously, of indurated limestone (cat. no. 96), granite (cat. no. 95), diorite (figs. 65, 67), and alabaster.[18] Most of the seated images were themselves probably recipients of cult rituals in the temple's chapels and secondary sanctuaries.

The first intimation of the violence that would be unleashed against this magnificent display of statuary came—some time after Hatshepsut's demise—in the form of a careful removal of the uraeus cobras from all the granite sphinxes (cat. nos. 88a, b) and seated statues (cat. nos. 95, 96).[19] Even today, the battered surfaces left from this chiseling display a gray patina that differentiates them from the areas of much fresher, later damage. Thus, we can clearly see that the head of a sphinx in Cairo (fig. 91) was broken sometime after the careful removal of the uraeus.[20] It is difficult to say what exactly was achieved by this initial obliteration of a piece of regalia that was standard for queens and princesses as well as pharaohs and that therefore could not be denied the daughter of Thutmose I.[21] Or was Hatshepsut's successor, Thutmose III, at this point attempting to deny even that she was of royal descent?[22]

Either in connection with this damage of the uraei or at the beginning of the major attacks, two minor erasures were made in inscriptions on statues:[23] on the back pillar of a small kneeling figure (fig. 92) and on the seated diorite statue of Hatshepsut in female form (fig. 65), the hieroglyph *maat* in her throne name, Maatkare, was chiseled out.[24] Again, it seems likely that by this defacement the legitimacy of Hatshepsut's royal status was being called into question, since a pharaoh's ability to rule depended on a close relationship to Maat, goddess of "justice and right order."[25] There is only one case of a whole cartouche with Hatshepsut's name being erased. This occurred on the back of the sandstone statue of Hatshepsut's nurse Sitre in Cairo; but another cartouche with the same name, located on the front of the statue, was left intact. The only reasonable explanation for this strange pattern of erasure is that the statue was partially buried in debris, with its front beneath the surface but its back still exposed, at the time late in his reign when Thutmose III ordered all names of Hatshepsut removed or altered.[26]

The fact that almost all Hatshepsut's names on her statuary remained undamaged during the campaign of statue destruction at Deir el-Bahri provides an important clue about the date of the event. It must have been prior to year 42 of the reign of Thutmose III, when the total elimination of Hatshepsut's names and figures is

known to have begun.[27] A reasonable suggestion would be that the destruction of the statuary at Deir el-Bahri took place between year 30 (1466 B.C.) and 42 (1438 B.C.), about the time when the red quartzite sanctuary at Karnak was dismantled, also without damage to its inscriptions.[28]

The photographs taken during Winlock's excavations show with disturbing clarity how the demolition must have been carried out. The architectural Osirides, of course, had to be broken into pieces on the spot in order to remove them from the pillars and walls of which they were an integrated part, but most of the unattached sculptures were dragged out of the temple more or less complete. Only the uraeus cobras that had not yet been removed were hacked off on-site,[29] probably because the crews feared magical retribution from these potent symbols of might. Similar apprehensions must have inspired some workmen to damage the eyes or even whole faces of statues.[30] Curiously, some heads and faces were left intact (cat. nos. 91, 93, 95), and some cobras suffered damage only to their heads (cat. no. 93). Once the workmen had uprooted the statues from their bases, they pulled the heavy pieces over the platforms and ramps of the temple in a remarkably orderly fashion, starting with the sculptures on the uppermost level and then proceeding downward from level to level. For each group of statues the most convenient exit out of the first court was chosen.

There were two final destinations for the statues. The most important was a deep depression just northeast of the first court (fig. 93; see also figs. 89, 90:4).[31] It is usually called a "quarry," although it was in reality a burrow pit that had been dug into the local marl (tafl) sediment to obtain fill material for landscaping around Hatshepsut's temple.[32] The workmen had also tried—unsuccessfully—to reach groundwater for plots of vegetation that were planted in the temple area by digging a well more than fifty feet deep in the center of the pit. And also during Hatshepsut's reign, her major official, Senenmut, had ordered the entrance to his tomb to be cut into the western face of the so-called quarry (fig. 89: TT 353).[33]

Having dragged the statues to the edge of the burrow pit, the workmen proceeded to smash them to pieces with sledgehammers and large blocks of stone. The photographs show that many pieces were lying on their sides during these attacks, and as a result they are more heavily damaged on one side than on the other (fig. 94). The broken fragments were then dumped into the pit over its perpendicular south face. Some groups of fragments came to rest on a ledge along this face of the pit (fig. 93),[34] others accumulated on the uneven quarry floor. In the center of the pit, where the well had been dug, the fragments rolled even farther down, toward the corner of a square depression that surrounded the well.[35] A few reached the well itself and tumbled into it. The edge of the pit, just beside the causeway to the temple, was not cleaned up thoroughly, and some groups of fragments remained lying where they had been smashed, ultimately to spread out across layers of wind-blown sand that reached a depth of thirteen feet in the course of the centuries that followed the reign of Thutmose III.[36]

In addition to the quarry, the so-called Hatshepsut Hole served as a repository for her broken statuary. This hole—or, more accurately, depression—was situated east of the vast forecourt serving both the temple of King Mentuhotep II and the temple of Thutmose III (see figs. 89, 90:5), and the causeway to the temple of Thutmose III was actually constructed over it. Most of the small kneeling statues of Hatshepsut (cat. no. 91) were found in

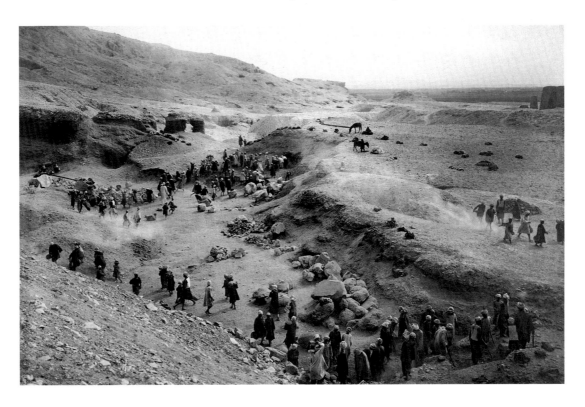

Fig. 93. The "quarry" in front of Deir el-Bahri during excavation by The Metropolitan Museum of Art, 1926–27 season. The underside of the base of the Museum's sphinx of Hatshepsut (cat. no. 88a) is visible in the foreground.

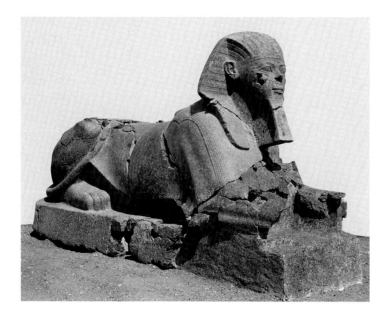

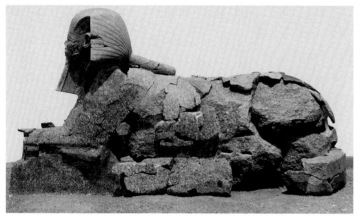

Fig. 94. A large sphinx of Hatshepsut, reassembled, showing light damage on the proper right side (top image) and heavy damage on the left. Granite. Egyptian Museum, Cairo (JE 53114/55191)

the fill material that was used to level the ground where the causeway crossed the Hatshepsut Hole. Building debris and cast-out votives from the Hathor shrine (see cat. nos. 97–100) were also dumped here.[37]

How are we to understand the violent destruction of sculptures that contemporary Egyptians must have known to be primary achievements of their art?[38] A clue may unfold from the recognition that Hatshepsut's name and image were removed from her various monuments not in a single act but in a process undertaken step by step.[39] Thutmose III is sometimes popularly called "the Napoleon of ancient Egypt." Inadequate as it may be to equate two figures from widely differing historical eras, in this case the comparison can nevertheless help us understand the basic nature of the various attacks Thutmose instigated against the images of his predecessor. Just as Bonaparte gradually transformed himself from a successful general into consul, then consul for life, and finally emperor of France, Thutmose III evidently had to undergo a protracted evolution before he could fully supersede his eminent

predecessor. Military feats and political maneuvering certainly played a major role in this process, but so did the manifestation of the new king's achievements in the form of his increasingly visible presence at the country's sacred monuments. "Le temple lieu de conflit," the title of a recent conference, succinctly expresses the fundamental role of Egyptian (and ancient Near Eastern) temples as places in which society played out its conflicts.[40] Indeed, one might be tempted to call ancient monuments the media of their time[41]—keeping in mind, however, that in ancient Egypt, politics and religion were two sides of the same coin. The gradual elimination of Hatshepsut's images from the monuments was therefore not merely a reflection of political events but a royal power struggle enacted on the country's principal public stage: the temple.

Seen in this context, the violent smashing of Hatshepsut's statues and other images does not particularly seem the manifestation of a personal hatred felt by Thutmose III for his predecessor. Rather it speaks of the brutal force of the political antagonisms very much alive inside Egypt barely one hundred years after the Thebans had fought for supremacy, if not survival, against the Hyksos in the northeast and the Nubians in the south of their land.[42] Ultimately, the acts of destruction meted out to her images testify to Hatshepsut's importance in the history of her country.

1. In Cairo: **a large granite sphinx, JE 53114** with fragment, **JE 55191** (Winlock 1928a, p. 51, fig. 51 [top]; Winlock 1928b, p. 13, figs. 14, 15; Winlock 1929a, cover and p. 14, fig. 15; Winlock 1930, p. 11, fig. 10; Tefnin 1979, pp. 107–10, pl. xxv); **head and shoulders of a large granite sphinx, JE 55190** (Winlock 1930, p. 10, figs. 8, 9); **largest granite sphinx, JE 56259** (Tefnin 1979, p. 112); **head of a sandstone sphinx with *khat* headdress, JE 56263** (Winlock 1932a, p. 9, fig. 5 [bottom]; Tefnin 1979, p. 122, pl. xxx, a); **small limestone sphinx, JE 53113** (Winlock 1929a, pp. 12–13, figs. 13, 14; Tefnin 1979, pp. 129–30, pls. xxxi, b, xxxii). **Standing figure, JE 52458** (Winlock 1928b, p. 11, fig. 12 [right]; Tefnin 1979, p. 98). **Large kneeling figure, JE 53115** (Winlock 1928b, p. 18, figs. 21, 22; Tefnin 1979, pp. 71–72, 74, pl. xix, a); **small kneeling figure, JE 47702** (Winlock 1923, pp. 33–34, figs. 27, 28 [second from left]; Tefnin 1979, pp. 89–90); **small kneeling figure, JE 47703** (Winlock 1923, p. 34, fig. 28 [right]; Tefnin 1979, pp. 89–90, pl. xxxiii, b). **Nurse with the infant Hatshepsut, JE 56264** (Winlock 1932a, pp. 5, 10, fig. 6; Tefnin 1979, p. 134. **Three heads of Osiride statues, JE 56259** (Winlock 1928a, pp. 44, 47, fig. 47; Saleh and Sourouzian 1987, no. 129, and cover), **JE 56260** (Winlock 1928b, p. 9, fig. 8, 20; Tefnin 1979, pp. 45–48), **JE 56261** (Winlock 1932a, p. 16, fig. 16; Tefnin 1979, pp. 41–43).

2. In New York: **a head and shoulders of a large granite sphinx, MMA 31.3.167** (Winlock 1935a; Tefnin 1979, pp. 114–15); **large granite sphinx, MMA 31.3.166** (Winlock 1935a; Tefnin 1979, pp. 112–14, pl. xxvii). **Standing figure, MMA 28.3.18** (Winlock 1928b, p. 11, fig. 11; Tefnin 1979, pp. 99–101. **Large kneeling figure, MMA 29.3.1** (Winlock 1928b, p. 10, figs. 9, 10; Winlock 1932a, pp. 6, 8, figs. 2, 4; Tefnin 1979, pp. 72, 74–75, pls. xix, b, xx); **large kneeling figure, MMA 30.3.2** (Tefnin 1979, pp. 72–73, 75, pl. xxi); **small kneeling figure, MMA 23.3.1** (Tefnin 1979, pp. 89–90); **small kneeling figure, MMA 23.3.2** (Winlock 1923, p. 34, fig. 28 [left]; Tefnin 1979, pp. 89–90); **parts of small kneeling figures: MMA 31.3.160** (body); **MMA 31.3.161** (lower part, in museum 1931, is now joined with head J) (Tefnin 1979, p. 90); **MMA 30.3.162** (figure missing face and left shoulder; Winlock's H) (Tefnin 1979, p. 90, wrongly calling 30.3.161 a headless statue). **Seated figure, MMA 27.3.163** (Winlock 1928a, pp. 53, 55, figs. 52, 53; Tefnin

1979, pp. 16–18, pl. VI, with restored face; **seated figure in female form with _khat_ headdress, MMA 30.3.3** (Winlock 1930, p. 9, fig. 7, without head fragment; Tefnin 1979, pp. 2–6, pl. I, a, with restored face); **seated figure, male, MMA 31.3.168** (Winlock 1928b, p. 14, fig. 16; Tefnin 1979, pp. 18–19, pl. VII, a). **Heads of Osiride statues** (for all, Tefnin 1979, pp. 38–48), **MMA 31.3.153, .154, .155** (Winlock 1932a, p. 14, fig. 11), **31.3.156** (with shoulders belonging to another statue: Hayes 1959, p. 90, fig. 49), **31.3.157** (Winlock 1932a, pp. 12, fig. 8, 16), **31.3.158, .159, .163** (Hayes 1959, p. 92, fig. 50 [left]), **31.3.164.**

3. **Large kneeling figure with white crown, MMA 30.3.1** (Winlock 1929a, pp. 8–9, figs. 9, 10), was completed by combining the body in the MMA with a head from **Berlin 2279** (Tefnin 1979, pp. 73, 75, pl. XXII, a). In exchange Berlin received a body excavated by the MMA which joined with the sphinx head it had received from Karl Richard Lepsius to create the **large granite sphinx, Berlin 2299** (Winlock 1928a, pp. 48, 51, figs. 48, 51 [bottom]; Winlock 1929a, p. 7, figs. 7, 8; Tefnin 1979, pp. 103–7, pls. XXVIII, XXIX, a). **Seated figure of indurated limestone, MMA 29.3.2** (Winlock 1929a, p. 6, figs. 4–6 [head]; Winlock 1930, pp. 5–10, figs. 3, 4; Tefnin 1979, pp. 11–16, pls. III, b, c, IV, v), the head and fragments found by Winlock joined with the body, **Berlin 2306.** In exchange for both **2299** and **2306,** the Berlin museum received the **small kneeling figure, now Berlin 22883** (Winlock 1923, p. 34, fig. 28 [second from right]; Tefnin 1979, pp. 88–90, pl. XXII, b; Grimm and Schoske 1999a, p. 54, no. 8, and back cover). The **head of a sandstone sphinx, Berlin 2301,** was already in Berlin through Lepsius (Lepsius 1849–59, vol. 3, pl. 25, c). In 1998 the MMA and the Rijksmuseum van Oudheden, Leiden, cooperated, allowing the **seated granite female figure, MMA 29.3.3,** to be completed by joining with it the torso **Rijksmuseum F 1928/9.2** (Winlock 1928b, p. 15, figs. 17, 18; Tefnin 1979, pp. 6–11, 20–30, 140–41).

4. Winlock's notebooks and photographs are all in the archives of the Department of Egyptian Art, Metropolitan Museum. See Winlock, Notebooks VII, VIII, and IX; and the articles published by Winlock in the _Bulletin of The Metropolitan Museum of Art_ (cited under Winlock in the bibliography of this volume).

5. The following description of the placement of statuary in Hatshepsut's temple at Deir el-Bahri differs in a number of points from Winlock's reconstruction (Winlock 1928b, pp. 17–20), which has been widely accepted since he formulated it (Porter and Moss 1972, pp. 369–74). The individual points of evidence that led this author to alternative conclusions will be discussed fully in Dorothea Arnold forthcoming.

6. For the sandstone sphinxes: Winlock 1928b, pp. 17–18; Winlock 1932a, pp. 10–12, 14; Winlock, Notebook VIII, pp. 101–42. The station halfway between the river and the temple is documented in Winlock, Notebook IX, and by drawings AM 4375, 4376, 4382 and photographs M14C 8–17, 50–55 (architectural remains), 19–35 (relief fragments), 36–49, 56, 57 (finds). The bases of the sphinxes that lined the causeway are documented on the Wilkinson and Lepsius maps and were clearly visible in the nineteenth century (J. G. Wilkinson 1830; Lepsius 1849–59, vol. 1, pl. 87). Winlock (Notebook VIII, pp. 137–39) notes that the bases were made of two courses: the upper one, about 8 inches (20 cm) high, part of the sculpture, was decorated with inscriptions and figures of prisoners (see photographs M12C 229–31); the lower one, about 25–30 inches (65–80 cm) high, was a separate element. See also photographs M14C 4–7 and reconstruction drawings AM 1524–29. The sandstone sphinxes were inscribed with texts that varied according to the side of the processional path on which they stood (Winlock, Notebook VIII, pp. 135–36).

7. According to Winlock's Notebook VIII, pp. 121–26, no recognizable fragment of a sandstone sphinx wearing a _nemes_ was found in the first temple court, but several pieces of sphinxes with _khat_ headdresses and wigs were discovered there (Winlock 1928b, pp. 17–18; Winlock 1932a, p. 14, fig. 5; Winlock, Notebook VIII, pp. 103–20; photographs M12C 223, 224, 227, 228).

8. Winlock 1928b, pp. 21–23, fig. 25; Winlock 1929a, pp. 13, 15, fig. 16; Winlock, Notebook VII, pp. 59–64.

9. Winlock 1928b, pp. 18–19; Winlock, Notebook VIII, p. 16. Winlock based his theory about the location of the large kneeling statues on the fact that there were images of the king offering _nw_ jars on the walls of the sanctuary

and on the presence of traces of lime plaster extending up to a height of 7 centimeters on "a fragment of the base probably of [statue] G." "This tends to show," he writes, "that the statue stood in a paved court, which the peristyle of the Temple was. The lower courts were unpaved." The evidence provided by the plaster, however, is not as strong as it sounds. Kneeling statue G was preserved only in small fragments and from the waist down. In fact, Winlock writes in Notebook VIII, p. 198: "Lower part of statue broken in small pieces and fragments only found." Whether he is correct in connecting the fragment with plaster to this statue cannot be determined. The pieces are kept in a storeroom somewhere in Luxor or on the west bank, and among the available photographs, M8C 303 shows only the upper part of the statue to the extent that it could be reassembled; on M8C 135, 136, no base fragment is visible. Moreover, there are no base fragments noted in the listing of findspots for kneeling statue G (Winlock, Notebook VIII, p. 202). Winlock's placement of the large statues in the confined upper court would have created a claustrophobic effect, making his conclusions suspect (pointed out by Catharine H. Roehrig in conversation). Moreover, the findspots of the statue fragments indicate that they were located elsewhere. According to Winlock's descriptions in his Notebook VIII, pp. 160–204, the overwhelming number of fragments of large kneeling figures were discovered in the central and eastern parts of the quarry, together with fragments of granite sphinxes, a headless male granodiorite statue (seated statue F, MMA 31.3.168), and the sandstone statue of Hatshepsut's nurse (JE 56264). The original placement of this last statue was surely in either the Hathor shrine or the northern middle colonnade with the relief recounting the queen's divine birth, both on the level of the second court. Therefore it is most likely that the large statues of kneeling figures were in the second court.

10. The large kneeling figures on one side of the processional way were differentiated from those on the opposite side by the types of crowns they wore, the shapes of their back pillars, and the direction, length, and arrangements of their inscriptions. MMA 30.3.1 and a fragmented unpublished piece identified as "Kneeling statue H" by Winlock both had an obelisk-shaped back pillar; the hieroglyphs on the MMA piece face left but on H face right; MMA 30.3.1 wears the white crown; H the double crown. It is possible, therefore, that MMA 30.3.1 and H formed a pair that faced each other across the processional path. Large kneeling statues JE 53115 and unpublished G both have a double column of inscriptions on their back pillars, and the hieroglyphs in the two columns face each other; on JE 53115 the royal names are on the left (Winlock 1928b, p. 18, fig. 22) and on G they are on the right. Both statues wear the _nemes_. These are, therefore, also from opposite rows. Large kneeling statues MMA 29.3.1 and 30.3.2 both wear the _nemes_ and have a single column of right-facing hieroglyphs on the back pillar. These two must, therefore, have stood in the same line (Winlock, Notebook VIII, pp. 168, 177, 183–84, 196, 200, 201, 204).

11. Winlock 1928b, pp. 15–16; Winlock, Notebook VIII, pp. 165, 174, 181 (remains of paint mainly around eyes).

12. Winlock 1928b, pp. 18, 19; Winlock wrote in his Notebook VIII, p. 149, that the two standing statues "could have stood in the vestibule in front of the first granite door or they could have stood on either side of the sanctuary door." The find of remains of two similar statues at the sides of the granite doorway in the Deir el-Bahri temple of Thutmose III reinforces a placement at the granite door here: Lipińska 1984, p. 14, nos. 2, 3, figs. 18–23. Since these statues flanked a doorway, their inscriptions face in opposite directions. Similarly, on the back pillar of Cairo JE 52458 the hieroglyphs face left, on MMA 28.3.18 they face right. On the belt of the Cairo example the hieroglyphs face right, on the MMA statue they face left. On the Cairo piece JE 52458, the two columns in front of the right foot face each other.

13. Winlock, Notebook VIII, pp. 151, 155.

14. Tefnin 1979, pp. 94–97, has pointed out the _djed_ pillar's role in the Sed festival. The oblique position of the pillars in the small kneeling statues may be a reference to the ritual of raising the _djed_ pillar.

15. Winlock, having filled the uppermost court with the large kneeling statues, was somewhat vague about the placement of the small ones. In Notebook VIII, p. 205, he considers the Hathor or Anubis shrines as possible locations. The findspots of the statues unequivocally indicate, however, that originally they

were close to the sanctuary: the overwhelming majority of fragments of small kneeling statues were found close to fragments of Osirides originally located in the main sanctuary room and in the niches of the uppermost court (Dorothea Arnold, forthcoming).

There are interesting variations in the use of names and directions of hieroglyphs on the back pillars of the small kneeling statues (Winlock, Notebook VIII, pp. 205–18): the hieroglyphs on Cairo JE 47702 and JE 47703 and on MMA 31.3.160 face left, and the nomen of the queen is used. The hieroglyphs on Berlin 22883 and MMA 31.3.162 face right, and the nomen also appears. MMA 31.3.161, 23.3.1, and 23.3.2 have the prenomen: the hieroglyphs on 31.3.161 face left and the ones on 23.3.1 and .2 face right. This means that the nomen and prenomen inscriptions alternated on the statues in each of the two facing rows. In addition, there was variation in Hatshepsut's *epitheta*. On JE 47702 and 47703 and MMA 31.3.162 she is called *nb jrt ḫt* (Lord [*sic*] of Ritual), but MMA 31.3.160 has *nb-t3wj* (Lord [*sic*] of the Two Lands), and MMA 31.3.161, 23.3.1, and 32.3.2 have *ʒ3(t)-rꜥ nt ḫt.f* (Re's Bodily Daughter). This suggests the following pairings and sequences: JE 47702 opposite MMA 31.3.162 (prenomen, *nb jrt ḫt*); MMA 31.3.161 opposite MMA 23.3.2 (nomen, *ʒ3(t)-rꜥ nt ḫt.f*); MMA 31.3.160 opposite missing (prenomen, *nb t3wj*); MMA 23.3.1 opposite missing (nomen, *ʒ3(t)-rꜥ nt ḫt.f*); and JE 47703 opposite Berlin 22883 (prenomen, *nb jrt ḫt*). I thank James P. Allen for looking at these inscriptions with me. There would have been at least ten and, as Winlock assumed, probably twelve small kneeling statues, with one whole nomen pair missing (Winlock, Notebook VIII, p. 205).

16. Winlock 1932a, pp. 13, fig. 10, 16–20.

17. That most of the granite sphinxes were installed as single pieces, rather than as elements in flanking rows, is strongly suggested by their considerably different sizes. The lengths of the granite sphinxes are as follows: Cairo JE 53114 with fragment 55191, calculated total length 3.45 m; Berlin 2299, total length about 2.9 m; MMA 31.3.167, according to Winlock's calculation of a length about midway between the two preceding; Cairo JE 55190, calculated as almost exactly the same as MMA 31.3.166, whose restored length is 3.43 m; Cairo JE 56259, original length 4.35 m (Winlock, Notebook VIII, pp. 70, 77, 85, 88, 92, 97). The incoherent character of the granite sphinxes, noted by Tefnin 1979, pp. 115–20, also supports the notion that they were set up as single works. It should also be noted in this context that unlike the inscriptions on all images that face each other across the processional path (such as the sandstone sphinxes, the large and small kneeling figures, and the two standing statues), the texts on all the granite sphinxes except MMA 31.3.166 face in one direction, to the right, which is normal in Egyptian writing. And, as noted, the MMA sphinx is the same length as Cairo JE 55190. It is possible, therefore, that these two beasts formed a pair facing a doorway. Since the others did not correspond in terms of either size or inscription, they must have been installed in single positions. That all Hyksos inscriptions on Amenemhat III's sphinxes with manes are on the same right shoulder and that one dyad arranged side by side certainly existed (Habachi 1978, pp. 79–92, pls. 23–26) provide evidence that some sphinxes stood side by side and facing in the same direction in single rows. On single sphinxes versus sphinx pairs and avenues in an early text, see Schweitzer 1948, pp. 60–61.

18. The alabaster fragments, a piece of the wrist with bracelet and a piece of a finger resting on the knee, are unpublished, and no photograph exists. They are described in Winlock, Notebook VIII, p. 265, as from a statue roughly the size of the indurated limestone statue (cat. no. 96). One of them was found by the MMA on the middle terrace in 1931 and the other by Édouard Naville, probably also on the middle terrace.

19. Observed by Winlock, Notebook VIII, p. 39.

20. Winlock 1930, p. 11, figs. 8, 9; Tefnin 1979, pp. 110–12; Winlock, Notebook VIII, pp. 88–90.

21. S. Roth 2002, pp. 21, 22 (with bibliography).

22. See Roehrig 1990, p. 337, and Peter F. Dorman, "The Proscription of Hatshepsut," above, who suggest that some of the hostility toward Hatshepsut was inspired by the threat she posed to the succession of Thutmose III's sons.

23. Not mentioned here are the erasures of the name of Amun carried out in iconoclastic attacks during the Amarna period, a century later. The most conspicuous of those is on the front of the large MMA sphinx 31.3.166 (cat. no. 88a). A series of photographs shows that fragments of this sphinx, M8C 118, 126, 129, were still exposed when Winlock started his excavation. They may well also have been exposed during the Amarna period.

24. Small kneeling figure, MMA 31.3.160: Winlock 1923, pp. 32–33, inscription: Winlock, Notebook VIII, pp. 210, 218. Seated figure, MMA 30.3.3: Winlock 1930, p. 9, fig. 7, inscription: Winlock, Notebook VIII, p. 255.

25. See Teeter 1997. On the ritual associated with kingship under Thutmose III, see Teeter 1997, p. 7.

26. Nurse: Winlock 1932a, pp. 5, 6, 10, fig. 6. The damage to the cartouche in the inscription on the back of the seat is recorded in Winlock, Notebook VIII, p. 268. Unfortunately, Winlock does not document exactly where the fragment from the back of the nurse's seat was found. In Notebook VIII, p. 267, he states under "Finding Place" for the nurse statue: "In the pile of fragments on the east side of the hole in the quarry floor. Small fragments above to the east." We can only assume that the fragment containing the damaged cartouche was among the "small fragments" found "above," that is, closer to the surface.

27. Dorman 1988, pp. 46–65, and in his essay in this chapter (see n. 22, above).

28. Dorman 1988, pp. 52–55, has shown convincingly that the few erasures on blocks from the quartzite shrine were carried out after the building was dismantled. Van Siclen 1989 has advanced further evidence of this fact.

29. Winlock 1928b, p. 17.

30. Ibid., p. 15.

31. The path from the temple to this depression can be reconstructed in part by tracing fragments that were found along the route in the first court of the temple. These were deposited near some brick priests' houses north of the first court, in an area designated by the archaeologists as "Wilkinson's much pottery" because the spot at the northeast corner of the first court on the Wilkinson map is thus marked (Dieter Arnold and Winlock 1979, pl. 42) and around the western edge of the quarry.

32. Winlock 1928b, p. 3.

33. Dorman 1991, pp. 85–86, pls. 40, 50, 51.

34. The most important Winlock photographs showing the position of fragments are the following: M8C 20, 21, 73, 107 (also Winlock 1928a, p. 45, fig. 45), 108, 118, 124–27 (Winlock 1928a, p. 49, figs. 49, 50), 129, 131 (Winlock 1928a, p. 48, fig. 48), M9C 47, 125 (Winlock 1928b, p. 8, fig. 7), 126, 174, 175 (Winlock 1928b, p. 7, fig. 5) 185 (Winlock 1928b, p. 7, fig. 6), 289 (Winlock 1928b, p. 12, fig. 13), 290, 291, 316.

35. This place was nicknamed "The Cascade" by the excavators: Winlock 1928b, pp. 13–14; Winlock, Notebook VIII, p. 34. Photographs M9C 289–92, 296.

36. Post-Thutmoside destruction and scattering of statue fragments are described by Winlock 1928b, p. 15, and Winlock, Notebook VIII, p. 49. Photograph M9C 179 shows fragments scattered over thick layers of drift sand that covered the quarry well. The find of a Third Intermediate Period coffin in the drift sand dates the scattering of fragments above it to the Late Period or after. The rectangular slots cut into the sphinx (fig. 94, bottom) just above the base date no earlier than the Ptolemaic Period.

37. In Dorothea Arnold forthcoming, it will be shown that the deposition of the broken Hatshepsut statues in the Hatshepsut Hole was secondary and it will be suggested that the smashed small kneeling statues were first thrown from the roof of the Hathor shrine onto the area in which Thutmose III later had his temple built.

38. The vast literature on iconoclasm includes the following useful recent studies: Dupeux, Jezler, and Wirth 2000 and Varner 2004, with many further references.

39. This was also discussed by Dorman (1988, pp. 46–65).

40. Borgeaud et al. 1994.

41. For recent studies on the active role of images in the formulation of a society's concepts and ideas, see Naumann and Pankow 2004.

42. The inscriptions at Speos Artemidos clearly show how vivid these struggles still were in the time of Hatshepsut and Thutmose III: J. P. Allen 2002.

ERASING A REIGN

Ann Macy Roth

In less than a quarter century of rule, Maatkare Hatshepsut erected monuments astonishing in both quantity and beauty. Unfortunately, several violent attacks and their aftermath have left posterity only recarved remnants of their original relief decoration.[1] Those attacks carried out during the monotheistic Amarna revolution in the late Eighteenth Dynasty destroyed most depictions of the gods, but the earliest attack was aimed at Hatshepsut herself. The erasure of Hatshepsut's name and image from her temple walls through these attacks raises interesting historical and religious questions.

TARGETS FOR ERASURE

Figures of Hatshepsut represented as a conventional male king were routinely erased. Depictions of her that show subtle feminine characteristics and the rare representations that are entirely female were no more likely to be attacked than the male images.

Hatshepsut's cartouches were consistently erased, although the divine names ☉ Re and ⌷ Amun within them were often left intact. Oddly, her nomen ⬭ (Hatshepsut, Beloved of Amun) was usually attacked more violently than her prenomen ⬭ (Maatkare). This greater damage to the nomen may result from Amarna-period attacks on the name Amun within it, although damage is sometimes seen on walls that were inaccessible to the iconoclasts.[2] Perhaps the 𓀻 šps hieroglyph in the nomen, an image of a seated woman, was offensive. In contrast, Hatshepsut's Horus name and her two minor names were often left intact.

Feminine markers referring to Hatshepsut were also often attacked: these include the final feminine *t* of titles and epithets, the second person pronoun *ṯ*, the third person pronoun *s*, and the feminine stative ending *tj*.

TECHNIQUES OF ERASURE

Eight techniques of erasure can be distinguished in the areas of damage to Hatshepsut's name and figure. Often several of them were used on the same wall.

Scratching. Most often used on feminine pronouns and endings, thin scratches with a pointed tool were sometimes applied to figures as well. Some examples show only a few cuts, while on others the scratches are more numerous. Regardless of the density of the scratches, this technique is clearly perfunctory and leaves the decoration completely legible. Erasures of this kind are quite common in the Hathor chapel and on much of the upper terrace at Deir el-Bahri.

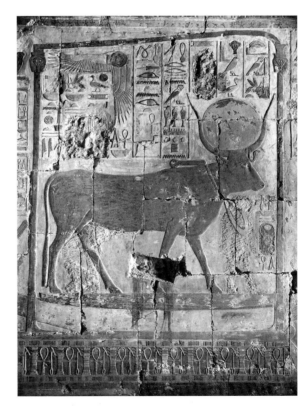

Fig. 95. Hatshepsut originally appeared twice in this scene depicting the goddess Hathor as a cow. Silhouettes of the two figures, which were removed by chipping, are still visible: one stands under the cow's chin, the other kneels between its hind legs (compare fig. 102). The cartouche at the lower right is only slightly chipped, and the Re hieroglyph is intact. Cartouches in the inscriptions above Hathor were more ferociously attacked. North wall of the outer sanctuary, Hathor chapel, Hatshepsut's temple at Deir el-Bahri

Chipped silhouette. On the walls surrounding the barque shrine at Karnak (fig. 88) and scattered throughout the Deir el-Bahri temple (see fig. 95), the raised areas of Hatshepsut's images and the hieroglyphs identifying her have been removed with short strokes made by a narrow, flat chisel. The painted background was untouched, allowing the decoration to be read in silhouette. Less frequently, the chips are shallow and sparse, leaving some surface details intact.

Fig. 97. Here, scratching was used to erase the figure of Hatshepsut, which was replaced by a table of offerings and two jar stands. At the right, Hatshepsut's royal ka, which originally was seen walking behind her, has been left intact. However, the name resting on the head of the ka was changed to that of Thutmose II. Most of the feminine endings and pronouns were erased. West wall of the south chamber, upper terrace, Hatshepsut's temple at Deir el-Bahri

Fig. 96. This scene originally depicted Hatshepsut as a male king wearing a triangular kilt and probably the *atef* crown. Her figure and the descriptive text in front of it have been completely erased in a roughened rectangle. In the blackened area above the scene, the title King of Upper and Lower Egypt and the prenomen that follows were erased with deep chipped lines. However, the title Son of Re (a duck with a circle above its back) and the name of the god Amun seem to have been recarved during the post-Amarna restorations. West wall of the northeast niche, entrance hall, Hathor chapel, Hatshepsut's temple at Deir el-Bahri

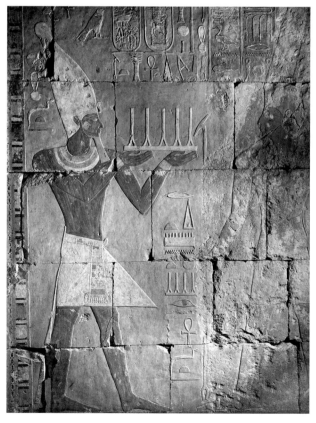

Fig. 98. Here the figure of Hatshepsut was left intact; that of Amun, at right, was recarved during the post-Amarna restorations. Hatshepsut's cartouches were clumsily and incompletely erased, and the names of Thutmose II were crudely carved over them. Most of the feminine endings and pronouns were attacked. South wall of the south chamber, upper terrace, Hatshepsut's temple at Deir el-Bahri

Rectangular roughening. A more thorough erasure was imposed on many of the raised representations in the inner Anubis chapel and the Hathor chapel at Deir el-Bahri (fig. 96) and on many sunk-relief representations on the walls of the Chapelle Rouge at Karnak (fig. 87). This technique involved roughening a rectangular patch of the surface to cover Hatshepsut's figure and names, obliterating almost all traces of the original relief—although the striding position of the feet is often discernible.

Smoothing. Sometimes the figure of Hatshepsut and the accompanying texts were smoothed away entirely and covered with a thin layer of plaster. This process was used most often on end walls of chapels at the Deir el-Bahri temple. Again, traces of separated feet indicate that the representations were masculine.

Replacement. Hatshepsut's figure was sometimes replaced by a depiction of an inanimate object, most often a table of offerings.[3] There is a single example of this on the upper terrace at Deir el-Bahri (fig. 97) and several others on the pyramidia of obelisks and at the small temple at Medinet Habu.[4] Elsewhere her cartouches were replaced, usually with those of Thutmose II (fig. 86) and more rarely with those of Thutmose I or Thutmose III, reassigning the accompanying image to these kings (fig. 98).

Patching. In a more radical form of replacement, most of the image of Hatshepsut was cut out of the wall and patching blocks were inserted and recarved. Reliefs on the facade of Thutmose III's temple in Buhen provide an example. There the underlying representations had apparently been feminine, since the male characteristics—the bull's tail and striding foot—that protrude beyond these patches were clearly carved into the blank background of originally narrower figural decoration (compare to fig. 2).[5] No royal names or titles survive on these patched walls,

since the upper courses are missing, and it is possible that these were alterations of Hatshepsut's images to make them masculine carried out during her reign. This may also be true of the recarving of what seem to be original feminine representations in the central sanctuary at Deir el-Bahri and of images of Hatshepsut's mother, Ahmose, in the same temple (fig. 99). Blocks were also removed in the sanctuary of the upper Anubis chapel at Deir el-Bahri, where a masculine figure of the queen had already been chipped away using the silhouette method. It is unclear whether these blocks were replaced with patches.

Covering. The walls around the central barque shrine at Karnak and the bases of Hatshepsut's obelisks were sheathed in new masonry. This extreme form of erasure may have been chosen because the walls in question occupied a space that was particularly sacred. So close to the sanctuary, the more extensive work required for other methods of erasure may have been impossible.

Dismantling. In what seems to have been the most radical suppression of Hatshepsut's existence, the Chapelle Rouge at Karnak was dismantled. It is possible, however, that it was dismantled to allow for the construction of a new barque shrine in the same space. Clearly, the partial erasure of Hatshepsut's name and image from the Chapelle Rouge took place after its dismantling.[6]

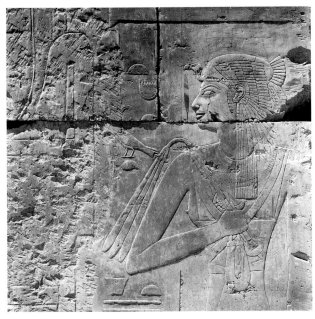

Fig. 99. This depiction of Hatshepsut's mother, Ahmose, presumably was altered during the construction of the temple at Deir el-Bahri. It originally showed her in her role as God's Wife of Amun, standing behind the large seated figure of Amun at the left. She now wears the queen's vulture headdress, but beneath this are traces of a short curled wig, and above the vulture's back is the faint outline of the pillbox-shaped modius worn by a God's Wife. The queen's original *hetes* scepter was recarved into a lotus flail. The ribbons that cross over her chest and tie around her waist are an archaic Libyan style of dress typical for Hathoric dancers. Left of the door, west wall of the upper terrace courtyard, Hatshepsut's temple at Deir el-Bahri

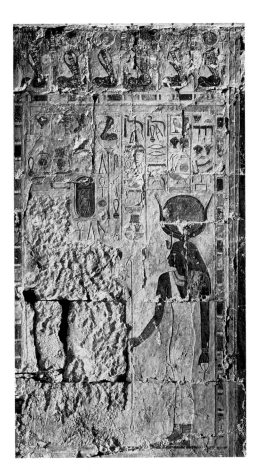

Fig. 100. Here, Hatshepsut was originally shown offering to Hathor. Her image was erased incompletely using a chipping technique that left some details of her kilt and crown and her rear arm and leg visible. The cartouche above her was altered to present the prenomen of Thutmose II. The monograms on the frieze along the top of the wall (raised ka arms on either side of a cobra with a sun disk and horns on its head) were left intact, preserving the spelling of Hatshepsut's prenomen, Maatkare. West wall of the entrance hall, Hathor chapel, Hatshepsut's temple at Deir el-Bahri

Fig. 101. In this now-blank rectangle, Hatshepsut originally stood at the left facing the Goddess of the West. Hatshepsut's figure was erased with a pointed tool, leaving a silhouette of fine scratches. Her cartouches on the doorway to the left were attacked in the same way, and some of the feminine gender markers in the inscriptions were also attacked. On the frieze above, the ka arms beneath the cobras were erased with a broader tool. The figure of the goddess was probably erased during the Amarna period, although erasure carefully following a silhouette is unusual for that time. (In this chapel, the divinities were apparently not restored post-Amarna.) West wall, Thutmose I chapel (north), upper terrace, Hatshepsut's temple at Deir el-Bahri

Multiple erasures. Some monuments were erased as well as covered (for example, the Hatshepsut rooms at Karnak) or patched (the back of the Anubis shrine at Deir el-Bahri is one). Others suffered multiple erasures, as evidenced by the variety of techniques found on the same wall, for example at Deir el-Bahri (figs. 100, 101). The fact that the relief decoration of Hatshepsut's monuments was attacked repeatedly and in differing degrees perhaps suggests that several programs of proscription with different goals were carried out at different times. However, there is no evident pattern in these erasures that allows their goals to be determined.

It is also possible that where the first five types of erasures occur in a single monument, they represent stages in a single unfinished process. Perhaps literate scribes marked the hieroglyphs that were to be deleted with scratching; the silhouettes were chipped in a first pass meant to level the raised relief; and the rectangular roughening blended the relief with the background surface, which was then smoothed and finally recarved. This

hypothesis would be consistent with Charles Nims's dating of all destruction of Hatshepsut's image to the latter half of Thutmose III's reign,[7] as it would imply a comparatively brief and rather disorganized campaign that was interrupted perhaps upon the accession of Amenhotep II. The principal argument against this theory is that the work would have been in different stages on a single scene—although a similarly random working method is seen in unfinished tombs.

INTERPRETATION OF THE ERASURES

The erasures of Hatshepsut's name and image raise two important questions. While some canonical images showing her as a male king were left intact and simply reidentified as Thutmose III or one of his forebears, more often they were completely erased or replaced with an image of an offering stand. Why most masculine images of Hatshepsut were erased rather than simply usurped is the first question, an intriquing one with important implications

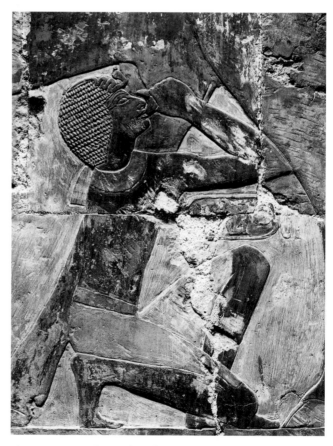

Fig. 102. An intact figure of Hatshepsut kneels to nurse from the udder of the Hathor cow. Here she appears to be shown with a feminine body and a woman's breast. Her cartouche was also left intact; all damage to the area appears to be accidental. South wall of the inner sanctuary, Hathor chapel, Hatshepsut's temple at Deir el-Bahri

for the nature of the images in Egyptian temple decoration. The answer may be that at least some images of Hatshepsut were identified with her not only by the presence of her name in the accompanying cartouche but also through a ritual, such as the Opening of the Mouth.[8] Perhaps an image identified through ritual could not easily be reassigned to another person.

More important historically is the question why Thutmose III attacked Hatshepsut's monuments at all. When Hatshepsut died he would have been a young adult, recognized as the junior king throughout Hatshepsut's reign. The transition was smooth, and many of Hatshepsut's officials continued to serve into the reign of Thutmose III. Nonetheless, he attacked her monuments.

There are three possible motives for such erasures. The first would be that Thutmose III hated Hatshepsut personally because she had assumed the kingship. This seems unlikely, given that some if not all of the erasures were effected at the end of Thutmose III's reign, almost two decades after Hatshepsut's death.[9] It is doubtful that Thutmose would wait twenty years to fulfill a personal vendetta, although the continuing influence of Hatshepsut's supporters might have contributed to a delay. That images of Hatshepsut as queen were never attacked makes it unlikely that the motive was personal hatred.

The erasures might have been meant as a rejection of the idea of female kingship in general. There were a number of other female kings in Egypt's history, and all of them seem to have been attacked after their deaths.[10] If the motive for the attack was Hatshepsut's feminine gender, however, one would expect the more completely erased images to be the most completely feminine. This does not seem to be the case: the wide male stride is visible in the most thoroughly erased scenes, and some quite feminine depictions of the queen were left intact,[11] perhaps because they are in sacred places (fig. 102).

Although no dynastic break occurred when Thutmose III assumed the throne, Hatshepsut was the last ruler of the Ahmoside line. This points to the third, and most likely, motivation for the erasures: the legitimization of Amenhotep II. The earlier kings of the Eighteenth Dynasty had had many daughters, and their progeny were more closely related to the founders of the dynasty than were Thutmose III and his son. Kingship derived its religious authority from the direct succession of rulers from one generation to the next, from Osiris to Horus. By attacking images of Hatshepsut as king and thus magically denying her kingship, Thutmose III disposed of a legitimate alternative to the Thutmoside line and facilitated his son's succession to the throne of Egypt. The fact that the erasures seem to have stopped suddenly, perhaps upon the coronation of Amenhotep II, suggests that the motive for the erasure disappeared once his kingship was assured.

1. See also "The Destruction of the Statues of Hatshepsut from Deir el-Bahri" by Dorothea Arnold in this volume. Although many of the same patterns of destruction can be seen in both two- and three-dimensional images, from a modern perspective there is a crucial difference. The original positions of destroyed statues have been lost, but their forms can be recovered, while the reverse is true of the erased reliefs: they remain in position, but their contents often cannot be restored.

2. The clearest example is the damage done to Hatshepsut's reliefs on the walls originally surrounding the barque sanctuary at Karnak temple, where several figures of the god and his name were left intact, while her nomen was still severely damaged.

3. Tawosret, a later female pharaoh, was similarly replaced in her own tomb.

4. Dorman 1995a, fig. 2.

5. Ricardo Caminos (1974, vol. 2) seems oddly reluctant to assign the underlying female figures to Hatshepsut, carefully reminding the reader that the identification is speculative. However, it is hard to imagine that another woman would have been represented taking the kingly role in rituals on a monument decorated during the reign of Thutmose III.

6. Dorman 1988, pp. 46–65.

7. Nims 1966.

8. Such rituals were clearly performed for statues and, in later periods, for entire temples, enabling them to function as living entities. See A. M. Roth 2001.

9. The argument for the year 42 date is based on the fact that the building that replaced Hatshepsut's Chapelle Rouge, the barque sanctuary of Karnak temple, cannot have been put up until after year 42 (Nims 1966; Dorman 1988).

10. See my "Models of Authority" in this volume.

11. Gilbert 1953, esp. fig. 17. Several of these intact portraits are more feminine than their erased counterparts.

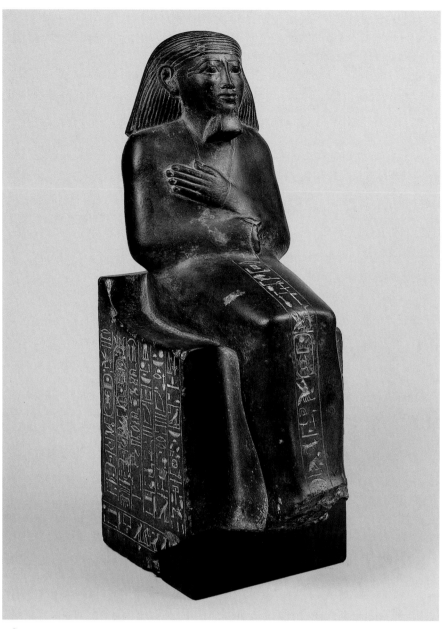

198

198. Ahmose, Called Ruru

Early 18th Dynasty, joint reign of Hatshepsut and
Thutmose III (1479–1458 B.C.)
Graywacke
H. 38.1 cm (15 in.)
Brooklyn Museum, Charles Edwin Wilbour Fund
61.196

The erasure of Hatshepsut's name was not lim-
ited to her temple walls but was also carried out
on statues of private individuals. An example of
such erasures may be found on this seated statue
of Ahmose, called Ruru. The statue must origi-
nally have stood in a temple, since Ruru claims
a share of the god's offerings; perhaps it was a
temple of Min of Coptos, where he was over-
seer of prophets.

Ruru is portrayed seated on a block throne
with a narrow back pillar. He wears a long cloak

that he holds closed with his right hand, and he
extends his left hand out from beneath it to lie flat
across his right breast. Both the cloak and the
somewhat oversize hands are typical of Middle
Kingdom statuary, but the head is carved in the
style of the early Eighteenth Dynasty, with a short
beard and raised eyebrows and cosmetic lines.
The hair, striated and tucked behind the ears, is
just long enough to fall behind his shoulders.

Hatshepsut's name was originally inscribed
on the statue in three places, while that of
Thutmose III appeared only once, following
hers. The most visible of the inscriptions, on the
front of the cloak, declares that Ruru is in the
king's heart. Here the throne name of
Hatshepsut, Maatkare, was replaced by that of
Thutmose III, Menkheperre. Despite the fact
that both throne names begin with the sun disk
hieroglyph, the entire cartouche seems to have
been cut back and recarved. In the inscription

on the back pillar, where Ruru is said to be in
the following of the Good God, the name
Aakheperkare Setepenre—the throne name of
Thutmose I—was substituted. The throne
name of Thutmose I was not often written with
the epithet Setepenre. It seems likely that the
original cartouche held Hatshepsut's personal
name and that when the substitution was made,
Setepenre was added to fill the long cartouche.
The same form of Thutmose I's name replaces
Hatshepsut's name on the left side of the
throne, where Ruru claims to have received a
silver stave with a gold handle from each of two
kings. An original cartouche of Thutmose III
occupies the secondary position. AMR

PROVENANCE: Unknown

BIBLIOGRAPHY Helck 1958, pp. 286–89, 434–35;
Bothmer 1966–67, pp. 55–61, figs. 1–4; Sauneron
1968, pp. 45–50; Ratié 1979, p. 285

199

199. Lintel of Hatshepsut and Thutmose III

Early 18th Dynasty, joint reign of Hatshepsut and
Thutmose III (1479–1458 B.C.)
Limestone
H. 50 cm (19⅛ in.), W. 115 cm (45¼ in.)
University of Pennsylvania Museum of Archaeology
and Anthropology, Philadelphia, Gift of the Egyptian
Research Account E 1823

This lintel was probably a part of Hatshepsut's
temple at Deir el-Bahri, although it was found
in a doorway of much later date.[1] It had probably
already been removed from its original posi-
tion by the time of the persecution of the name
of the god Amun by Akhenaten (r. 1349–
1336 B.C.), since Amun's name has been left
intact here.

The upper two of the four registers of
inscription are completely symmetrical. The
top register shows the winged sun disk and its
name, "the Behedite," while the next wishes life
to Thutmose III, identified by his Horus name.
The last two registers confer the same wish, but
upon two kings, Hatshepsut (on the left) and
Thutmose III (on the right). The former is said
to be beloved of Amun-Re, while the latter is
called beloved of the goddess Maat; otherwise,
the inscriptions are identical except for the car-
touches containing the kings' names.

Hatshepsut's two cartouches have been
completely erased and smoothed on the areas to
the left of the diagonal break, while the areas to
the right of the break seem to have been erased
using the chipped silhouette method (although
in this case leaving visible only the silhouettes
of the cartouches and not the individual hiero-
glyphs). The use of two techniques suggests
that the lintel had already been broken and sep-
arated by the time the erasures took place.
Alternatively, the erased area might have been
leveled with plaster that has fallen out to the
right of the break. In that case, the names of
Thutmose III might have been painted over the
cartouches. AMR

1. Quibell 1898, p. 5.

PROVENANCE: Found in western Thebes, the
Ramesseum; James Edward Quibell excavations for
the Egyptian Research Account, 1895

BIBLIOGRAPHY: Quibell 1898, pl. XIII, 1; Donald B.
Redford in Silverman 1997, pp. 162–63, no. 48

VI. THE AFTERMATH

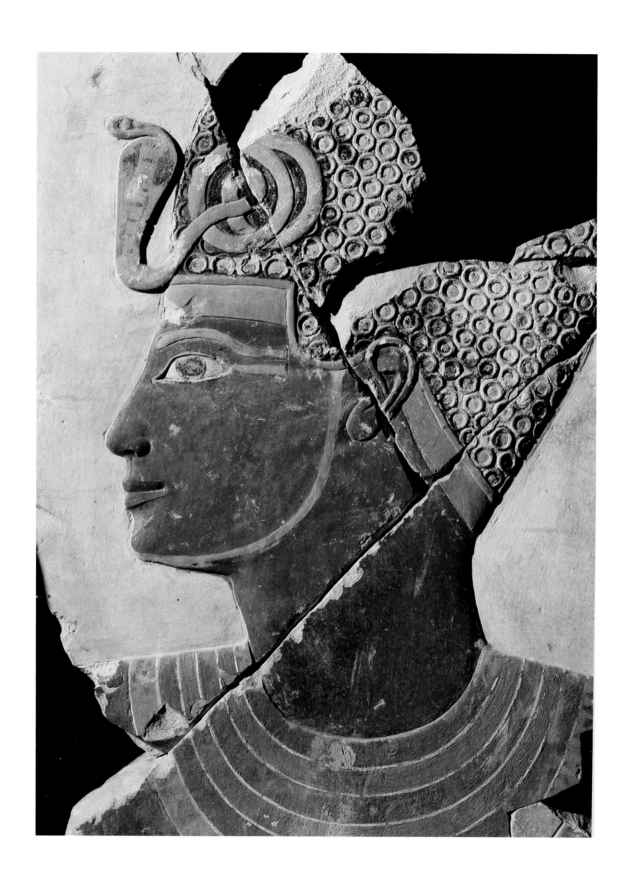

THE TEMPLE OF THUTMOSE III AT DEIR EL-BAHRI

Jadwiga Lipińska

One of the many structures erected by the great military leader and builder Thutmose III (r. 1479–1425 B.C.) was the temple of Djeser-Akhet (holy of horizon) at Deir el-Bahri, on the southern side of Hatshepsut's temple. Djeser-Akhet was constructed in the last decade of Thutmose's reign, from about 1435 B.C. to 1425 B.C., under the supervision of the vizier Rekhmire. The earliest written record of building activity on the temple dates from year 43 of Thutmose's reign, a date that coincides with the beginning of the proscription of Hatshepsut. The new structure was probably intended to overshadow Hatshepsut's temple.[1]

The site chosen—the space between the temple of Mentuhotep II and that of Hatshepsut (fig. 104)—consisted of a steep, rocky ridge. In order to make this site fit for use, it was necessary to cut into the rock face both vertically and horizontally. The resulting platform for the new building was irregular in shape, however, and too narrow, and it was enlarged by means of an artificial platform constructed using a stone frame filled with rock debris. The terrace thus created was about 11½ feet (3.5 meters) higher than the neighboring upper part of Hatshepsut's temple and about 46 feet (14 meters) higher than the platform of the temple of Mentuhotep II. Pavement slabs and huge sandstone blocks for column bases were laid on the terrace, and then the building was raised.

Like the temples of Mentuhotep II and Hatshepsut at Deir el-Bahri, Djeser-Akhet was made up of a sequence of terraces approached by ramps. (The temple on the upper platform constituted the principal part, but not the whole, of Djeser-Akhet.) Colonnades or pillared porticoes flanked the ramps and formed the facades of the three temples. These edifices, approached from the east along almost parallel processional avenues, made up a harmonious architectural complex of horizontal porticoes, vertical piers, and oblique ramps abutting a cliff about 300 feet (100 meters) high. The complex of temples at Deir el-Bahri was built, it appears, mainly for the reception of processions during the

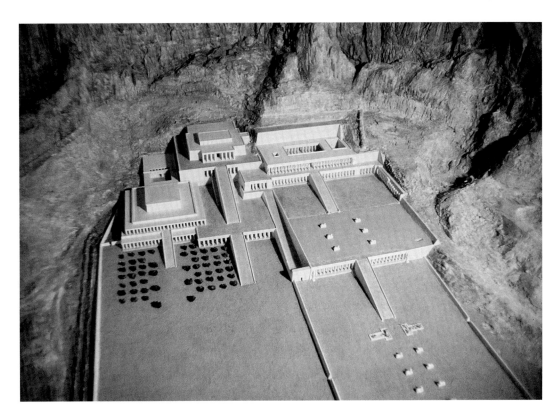

Opposite: Fig. 103. Head of Thutmose III, early 18th Dynasty. Painted relief fragments from the temple of Thutmose III, Deir el-Bahri

Fig. 104. Model re-creating the three royal temples at Deir el-Bahri. Left to right: the temple of Mentuhotep II; Djeser-Akhet, the temple of Thutmose III; Djeser-djeseru, the temple of Hatshepsut. Constructed by Stefan Miszczak

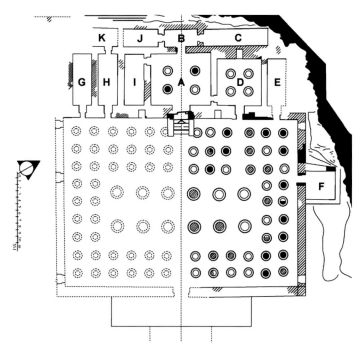

Fig. 105. Plan of the temple of Thutmose III at Deir el-Bahri: (A) barque hall, (B) vestibule or offering room, (C) sanctuary(?), (D) four-columned chamber with niche and representation of royal ka, (E–K) shrines of unknown function

Beautiful Festival of the Valley. For this purpose it was ideal—like a stage setting. It is a great pity that today two of the buildings—the temple of Mentuhotep II and that of Thutmose III—are almost totally destroyed. Remains of the lower end of a ramp to Thutmose's temple have been preserved, but there are only meager traces of the foundations of the porticoes. A number of decorated fragments of square pillars were found, and one part of the temple's middle level escaped destruction: the innermost shrine of the cow-goddess Hathor. This beautifully decorated shrine, discovered in 1906 behind the northwestern corner of the platform of Mentuhotep II's temple, was removed and taken to the Egyptian Museum in Cairo.

The upper, main part of the temple of Thutmose III was discovered in 1962 by a Polish-Egyptian archaeological mission led by Kazimierz Michałowski, and it was finally cleared in 1967. In recent decades the site has been partially restored. This area of the temple consisted of a great colonnaded hall with an entrance portico at the front and a row of shrines at the back (fig. 105). When the temple was destroyed, in a rock slide, the artificial platform gave way and everything that had been built on it disappeared. But structures that had been erected on the solid, rock platform survived in part (fig. 106): the lower drums of polygonal columns still stand on their bases; there are partially preserved pavements, wall foundations, and door jambs, or traces of them, as well as numerous scattered architectural elements. These remnants helped archaeologists to determine the original shape of the building, although some questions are still unanswered.

The great colonnaded hall is the most impressive part of Thutmose III's temple and the most important for the history of Egyptian architecture (fig. 105). Its dimensions—124⅔ x 87 feet (38 x 26.5 meters)—conform to those of the upper court in Hatshepsut's temple, and colonnades on all four sides frame its center, just as they do in Hatshepsut's court (fig. 57:9). Thutmose III's court was probably planned as an exact copy of Hatshepsut's court, but underwent modification. The central part of Hatshepsut's upper court, according to recent studies, was left uncovered and devoid of structures. In the temple of Thutmose III, however, seventy-six sixteen-sided polygonal columns, about 35½ inches (90 cm) in diameter and 18⅓ feet (5.6 meters) high, surrounded a double row of twelve larger thirty-two–faceted columns 43¼ inches (110 centimeters) in diameter, evidently supporting a roof on a level higher than the side aisles. Fragments of mullioned windows prove that the hall was lighted from above with a clerestory and constructed as a basilica—the second basilica in Egyptian temple architecture, after an earlier one in Karnak, in the jubilee temple Akh-Menu, which was also erected by Thutmose III. The architectural layout of the two basilicas is quite different, and the one at Deir el-Bahri seems to be a step forward, toward the hypostyle halls of the Nineteenth Dynasty.

Contrary to excavators' expectations, there was no rock-cut sanctuary in the temple of Thutmose III, and the temple's architect did not follow the example of Hatshepsut's temple in planning the shrines behind the hypostyle hall. To the north of the barque hall (fig. 105: A) there was a shrine with a roof supported by four columns and with a niche in the western wall (fig. 105: D); the royal ka was depicted at the rear, and the king receiving offerings from Iunmutef on the side walls. No traces of a sun altar were

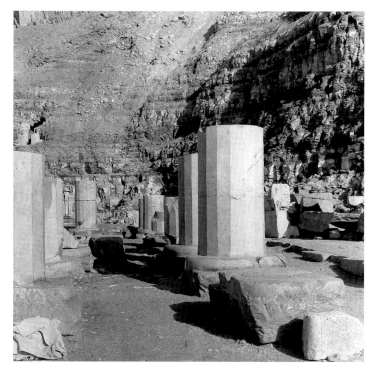

Fig. 106. Ruins of the colonnaded hall on the upper platform of the temple of Thutmose III at Deir el-Bahri

discovered, and scholars still dispute whether the long transverse shrine in the northwestern part of the temple (fig. 105: C) was used as the main sanctuary. It is possible that there were two sanctuaries, one for each form of Amun—Amun-Re and Amun-Kamutef—worshiped in the temple. (It should be mentioned that after the Eighteenth Dynasty the goddess Hathor was considered the mistress of the entire temple, as evidenced by numerous graffiti left by pilgrims on the walls and columns.)

In the debris covering the ruins, thousands of fragments of wall decoration were found, with admirably fresh polychromy preserved on delicate reliefs (fig. 103). This state of preservation is certainly due to the temple's comparatively short (for ancient Egypt) period of existence (from the fifteenth to the eleventh century B.C.) and to the limited time, after the temple's destruction, that the roofless shrines were exposed to the elements. As can now be established, the temple was partially ruined in a rock slide, after which stonecutters took over, dismantling the surviving walls and columns and cutting them into roughly uniform units. Misshapen and unfinished blocks left behind indicate that the stonecutters' order was for drums about 24 inches (60 centimeters) in diameter and for small blocks resembling oversized bricks. This activity seems to have been state-sponsored, as the scale of work was too large for any private enterprise (the ruined temple of Mentuhotep II met the same fate). It is not known what was done with the stone that was carted away. The decoration roughly hacked off the wall blocks, architraves, ceiling slabs, and other elements of the temple, and left behind by the stonecutters, can be fitted together, but this work is akin to assembling a gigantic jigsaw puzzle (fig. 107). Without costly re-creation of the missing blocks by restorers, any reconstruction of the temple decoration can be only theoretical—drawings on paper.

In 1978 a team of Polish archaeologists began to study some five thousand complete or only partly damaged limestone and sandstone blocks from the temple, which had been found together with innumerable smaller fragments and paper-thin flakes. Although this work is still not complete, the iconographic scheme for most of the temple walls has been firmly established.[2] Some walls were decorated with polychrome reliefs arranged in single registers, some in double ones. Their size was not dependent on the dimensions of the rooms, as it was in Hatshepsut's temple. The subjects of the decoration were typical for the period, as was the style of the reliefs—delicate but somewhat stiff and traditional. There were three main themes: the offering ritual, with the king offering alternately to two forms of Amun; scenes of the royal cult (for example, symbolic coronation, purification, the king led or embraced by a god or goddess, and the king suckled by Hathor); and the procession of the Beautiful Festival of the Valley, with the sacred barque of Amun carried by priests or resting on its stand. All images of the gods, except Atum, were destroyed

Fig. 107. Painted relief fragments showing the god Amun. From the temple of Thutmose III at Deir el-Bahri

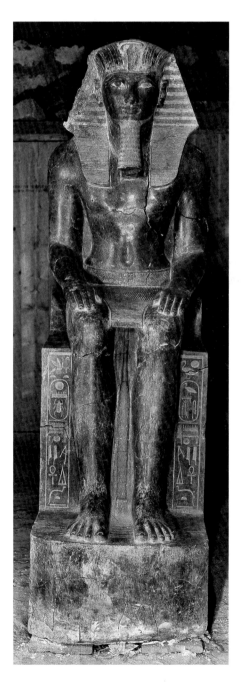

Fig. 108. Lifesize statue of Thutmose III discovered at his temple at Deir el-Bahri, early 18th Dynasty. Quartz-diorite

during the Amarna period (1349–1336 B.C.) and subsequently restored. In one place the sacred barque of Amun was hacked out; a layer of plaster was spread on the uneven surface of the defaced relief, and a new barque was painted, bearing the name of Haremhab (r. 1323–1295 B.C.), the last king of the Eighteenth Dynasty. (It is likely that all the restorations in the temple of Thutmose III were ordered by Haremhab.) All inscriptions concerning the gods were mutilated, then restored, and their original gray-blue background was whitewashed. All the untouched images of the king retained their original appearance and polychromy, however, and in some cases they are the only existing record of the colors of royal attire, for instance, of the red *shendyt* kilt worn together with the red crown in some scenes depicting the king running to a god. The materials brought to light in the ruined temple of Thutmose III are invaluable for studying the art of the first half of the Eighteenth Dynasty, for nothing similar is encountered in contemporary tombs or other temples, where such lively colors have vanished from representations.

Architectural fragments and pieces of decoration were not the only finds at the site of Thutmose III's temple; there were also a number of statues (royal, divine, and private), as well as votive stelae and offering basins and tables. Among the most important finds are a statue of Thutmose III enthroned (fig. 108), made of dark gray quartz-diorite and more than 6 feet (almost 2 meters) tall, and fragments of a lifesize white marble statue of a standing king, with traces of pigment. The faceless head and the upper torso of the latter were sent to The Metropolitan Museum of Art by Édouard Naville from his excavations at the temple of Mentuhotep II at the beginning of the twentieth century; the face and several other fragments of the statue were found in the ruined temple of Thutmose III; the face was taken to the Egyptian Museum in Cairo, and the other fragments, which suffice to partially restore the object, are still stored at Deir el-Bahri. Parts of four or five red

granite, headless statues of Thutmose III, in a better or worse state of preservation, and a head probably from a statue of Amenhotep III (r. 1390–1352 B.C.) were also found. When the temple of Thutmose III was destroyed, some of the statuary slid down to the temple of Mentuhotep II. But how did large stone fragments from the ruined temple of Mentuhotep climb up more than 55 feet (17 meters), to be left in the debris covering the site of Thutmose III's temple? Fragmentary reliefs from the temple of Hatshepsut were also found at the site, but they were most likely deposited there as a consequence of building activity in Hatshepsut's temple in the Ptolemaic Period (332–30 B.C.) or afterward, when Hatshepsut's temple housed a Coptic monastery. Once stonecutters ceased to quarry the ruined temple of Thutmose III, debris covered the site, which was later used as a burial ground. Later still, several naturally dried mummies of Coptic monks found their resting place there.

Most of the edifices in western Thebes were built as mortuary temples. Cult temples, like Medinet Habu, were extremely rare. Thutmose III already had a mortuary temple, and though some pharaohs had more than one, he evidently did not build his temple at Deir el-Bahri as a second one. There was no sun court, and evidence of the cult of his royal ancestors was limited to one narrow shrine in the southernmost part of the building, where images of Thutmose I and Thutmose II, enthroned in front of offering altars, decorated the longer walls. No fragments of false doors were ever found. The four-columned shrine (fig. 105: D) mentioned above, with a niche for the royal ka, seems to be the predecessor for the later temple of Amenhotep III in Luxor.

1. The account here is based on Lipińska 1977 and 1984 and Czerner and Medeksza 1992.
2. The results of this study are being prepared for publication.

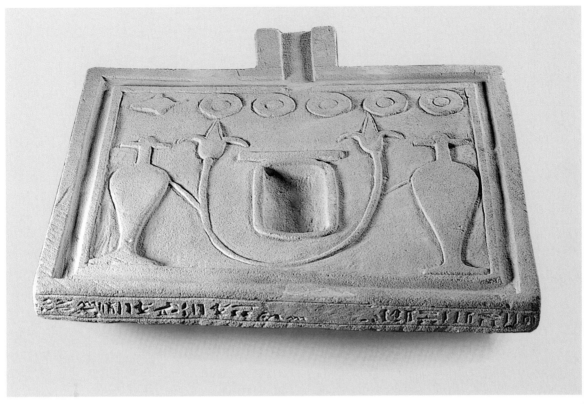

200

200. Offering Table of the Priest Aapekhti

Late Ptolemaic Period, 2nd–1st century B.C.
Whitish gray sandstone
H. 53 cm (20⅞ in.), W. 56 cm (22 in.)
Ägyptische Sammlung der Universität Tübingen 1692

In venerating deities and the dead, the ancient Egyptians used stone slab offering tables, on which they placed food offerings and over which they poured water libations. This offering table, which originally rested on a cylindrical support, carries decoration typical for its time. A groove running along the four sides of the tabletop is connected with a rectangular protruding spout. At the center is a receptacle for libations in the shape of a cartouche, the oblong device that usually framed a royal name. Two ewers carved in relief flank the cen-

tral basin, which is circled by a U-shaped stem with a lily blossom at each end. Above are the head of an ox (at the left) and five round loaves of bread, traditional offerings. The inscription on the narrow front edge invokes the deceased Aapekhti: "Oh Osiris, priest of Imhotep, priest and embalming priest of Aapekhti (the name of an otherwise unknown deity), second priest of (the god) Horus of Shent-Khentet, Aapekhti, the justified, son of Paheb, the justified, born of the lady of the house Meret, the justified!" The inscription thus refers to both a priest called Aapekhti and a deity of that name, as well as other deities.

The piece is not only a rare example of an offering table excavated in situ but also a demonstration that the temple of Hatshepsut was still a place of worship more than a millennium after the queen's demise. Originally the table faced the entrance to Aapekhti's tomb, which was located halfway between the area of

cultivation near the river and Hatshepsut's temple at Deir el-Bahri. In that temple, in Aapekhti's time, Imhotep—who some 2,500 years earlier had been an official and chief architect of King Djoser (r. 2630–2611 B.C.)—was worshiped as a wise man and deified healer. As a priest of Imhotep, Aapekhti himself was probably also a physician and knowledgeable in healing practices. He may well have treated suppliants suffering from illnesses who visited the temple. A person approaching this offering table was surely in search of healing from both the deceased Aapekhti and the deified Imhotep.

DOA

PROVENANCE: Western Thebes, Asasif, TT 411; excavations of the German Institute of Archaeology, 1965

BIBLIOGRAPHY: Dieter Arnold and Settgast 1966, pp. 81, 85, pls. XIV, b, xv, a, b, fig. 1 between pp. 72 and 73; Brunner-Traut and Brunner 1981, p. 30, pl. 146; Laskowska-Kusztal 1984

A CHRONOLOGY

The Later History and Excavations of the Temple of Hatshepsut at Deir el-Bahri

Dorothea Arnold

1425 B.C. on	After the death of Thutmose III, the temple continues to function as a place of worship. The architecture and relief decoration remain for the most part as modified by Thutmose III, except for such intrusions as the erasures of images of the god Amun and some other deities, carried out at the order of King Akhenaten during the Amarna period (1349–1336 B.C.), and the repair of this damage, principally by Ramesses II (r. 1279–1213 B.C.).
8th century B.C.	After damage to the temple during an earthquake, tombs for elite officials and priests are cut into the rock under the pavement of its courtyards and chapels. The main parts of the temple, however, continue to function as places of worship.
7th century B.C.	Many Eighteenth Dynasty reliefs are still visible, since numerous copies of them are made by artists decorating Twenty-sixth Dynasty tombs.
261–260 B.C.	A dated ostracon (found in the second court) thanks Amenhotep, son of Hapu, for a miraculous healing.
246–221 B.C.	A building of bricks and reused blocks is constructed in front of the southern middle colonnade; it may be a chapel for the Greek god Asklepios erected by Ptolemy III Euergetes I (r. 246–221 B.C.).
170–116 B.C.	The westernmost rock-cut chapel of the main sanctuary is altered: new reliefs make it a place of worship of the deified Amenhotep, son of Hapu; Imhotep, "architect" for the Third Dynasty king Djoser and "wise man"; and the Greek goddess Hygieia. Probably at the time of the alterations, a portico with six columns is built in front of the sanctuary. The portico contains cartouches of Ptolemy VIII Euergetes II (r. 170–116 B.C.).
until ca. A.D. 200	The temple is used as a place of healing.
4th century	The latest pagan inscriptions found on the site date to this time.
ca. 600–800	The Coptic monastery of Saint Phoibammon is built into the upper court and the northwestern part of the second court. (Coptic remains were found in the sun court, on 16 feet of accumulated debris.) In other places the monastery walls, of brick and reused stones, are built more or less on the level of the original pavement, and a brick tower (watchtower?) is a conspicuous element (fig. 109). Some of the Eighteenth Dynasty temple reliefs are painted over with figures of Christ and saints. The monastery is in use during these two centuries.[1]

1222–23	The last datable graffito left by a pilgrim is made.
1737	Richard Pococke, British traveler, visits the ruins.
1798–1802	Members of Napoleon Bonaparte's expedition visit and describe the ruins. They draw a plan of the visible remains showing the chapel of Hatshepsut, the upper court, the first ramp, and the avenue of sphinxes.
1809–22	*Description de l'Égypte*, with information from Napoleon's expedition, appears in print.
ca. 1817	The Italian explorer Giovanni Battista Belzoni and the Briton Henry William Beechley dig for objects for the collection of British consul Henry Salt.
1823–25	British traveler Henry Westcar visits the site; in his description the name Deir el-Bahri ("the northern monastery" in Arabic) appears in print for the first time.
1826	France acquires the false door of Thutmose I (cat. no. 87) from the Salt collection.
1827	British Egyptologist John Gardner Wilkinson clears some temple walls. He recognizes evidence of usurpations in the reliefs and wonders about feminine forms of the ruler's name in their inscriptions. He reads Hatshepsut's name as Amunneitgori.
1829	French Egyptologist Jean-François Champollion visits the ruins, recognizes Amun as the temple's main god, and transcribes Hatshepsut's name as Amenenthe. He hypothesizes about the use of the feminine form in the inscriptions, "as if a queen were in question." The Italian archaeologist Ippolito Baldassare Rosellini leads the Tuscan delegation in Champollion's expedition.
ca. 1832	Scottish anthropologist and artist Robert Hay sketches the remains of the Coptic monastery.
1845	German Egyptologist Karl Richard Lepsius and his Prussian expedition document the site and probably conduct some excavations. They draw a much-improved plan; they read Hatshepsut's name as Numt Amen. Fragments of statues are acquired for the Ägyptisches Museum, Berlin.
1855	John Baker Greene, British surgeon and barrister, undertakes some excavations and leaves his graffito in the sun court.
1858, 1862, 1866	François-Auguste Mariette, Director of Egyptian Antiquities, conducts the first large-scale excavations of the temple. He begins the destruction of the remains of the monastery and uncovers the chapels of Hathor and of Anubis and the middle level's southern colonnade, which contains the Punt expedition reliefs.
1867	Mariette shows finds from Deir el-Bahri in the Boulaq Museum (predecessor of the Egyptian Museum, Cairo) and at an exhibition in Paris.
1893–99	*In excavations conducted by the British Egypt Exploration Fund (EEF) under the Swiss Egyptologist Édouard Naville, the entire area of the temple is uncovered and all remaining Coptic walls are removed. Naville's assistant is the young British Egyptologist and artist Howard Carter, who is in charge of the*

Fig. 109. The ruins of Deir el-Bahri in 1893, before excavation by Édouard Naville for the Egypt Exploration Fund. The mud brick tower is part of the Coptic monastery that gave the site its name.

work for long periods while Naville is not present. The first restorations of temple architecture involve roofs over the middle colonnades, the reconstruction of the sun altar, and the consolidation of the sanctuary and upper colonnade walls, northwest chapel walls, Hathor shrine, and northern lower colonnade.

1894–95	Naville discovers foundation deposit A.
1895–1908	Under the auspices of the EEF, Naville publishes the temple reliefs in six volumes, with drawings mostly by Carter (see fig. 1).
1905–6 season	Naville finds the shrine to Hathor in the guise of a cow.
1909–11	*The British collector and excavator Lord Carnarvon and Howard Carter conduct excavations.*
1909–10	Work in the area of valley temples in Lower Asasif.
1910–11	Foundation deposits J and K are discovered.
1911–36	*Excavations are carried out by The Metropolitan Museum of Art, by Herbert E. Winlock, field director, with Lindsley F. Hall, Walter Hauser, William C. Hayes, Ambrose Lansing, Charles K. Wilkinson, and others; Harry Burton is the photographer.*
1912–13 season	Work in the valley temple area.
1921–22 season	Foundation deposit B and dumps of Hathor votives outside the courtyard gates of Mentuhotep's temple are discovered.
1922–23 season	The "Hatshepsut Hole" is excavated; it contains most of the small kneeling statues that have been found.
1923–24 season	Foundation deposits C, D, E, F are discovered; falcon panels are recognized on pillars of the lower colonnade; "priests' houses" north of temple and lower court are cleared.
1924–25 season	Stairway from the second court into the Eleventh Dynasty tomb of Neferu is discovered; a lion relief is uncovered at foot of lower ramp.
1926–27 season	Foundation deposits G and H are discovered; the westernmost part of the quarry and the section east of the expedition's "(Thomas) Cook's Resthouse" are cleared; many statuary fragments are found; the tomb of Senenmut (TT 353) is discovered.
1927–28 season	Cook's Resthouse is moved farther east to make room for digging; the quarry is fully excavated; many statuary fragments are found; the well is found; statues, including substantial parts of a large Osiride figure, are reassembled and later reconstructed at the north end of the lower colonnade by the Egyptian Antiquities Service (fig. 110).
1928–29 season	Excavation of the quarry is completed; the piecing together of statues continues (fig. 111); the tomb of Queen Meryetamun (fig. 72) is discovered.
1929–30	The reassembly of statues in the field is largely completed; exchanges of parts of statues take place between the Metropolitan Museum and the Ägyptisches Museum, Berlin.

Fig. 110. Colossal Osiride statue at the corner of the north colonnade on the lower level of Hatshepsut's temple at Deir el-Bahri

1930–31 season	The Metropolitan Museum excavates below the level of the second court; architectural elements found in a Ptolemaic trench are used in the restoration of the southern lower colonnade by the Egyptian Antiquities Service; a carved serpent and falcon are found on the upper ramp balustrade; further work on statues with restoration of missing parts is carried out; the remains of a sandstone statue in the field are examined; four Osiride statues are recognized in the sanctuary; work is conducted in the upper tomb of Senenmut (TT 71).
1931–32 season	Remains of the barque station at a halfway point on the causeway are discovered.
1935–36 season	The tombs of Senenmut's parents and other family members are discovered.
1925–52	Large parts of the temple, especially the lower and middle colonnades and the Hathor shrine, are reconstructed by a team led by the French architect Émile Baraize, Director of Works of the Egyptian Antiquities Service.
1961–present	*Work is conducted by Warsaw University's Polish Centre of Mediterranean Archaeology in Cairo, by Kazimierz Michałowski, Jadwiga Lipińska, Zygmunt Wysocki, Janusz Karkowski, Franciszek Pawlicki, Andrzej Kwaśnica, Krystyna Polaczek, Zbigniew E. Szafrański, and many others.*
1961	Restoration begins on the upper terrace of the temple in cooperation with the Gdańsk Office of the State Ateliers for the Conservation of Antiquities (PKZ).
1960s	A fourth, uppermost terrace is discovered and subsequently reconstructed as a high blank wall at the back of the temple and above it.
1962–67	The temple of Thutmose III is discovered and excavated.
ongoing	Relief decoration from Thutmose III's temple is reassembled.
1970s–90s	In Hatshepsut's temple, the upper terrace walls, upper ramp, and solar-cult complex are reconstructed.
1971–72	A possible foundation deposit pit is discovered in the northwest corner of a chapel to the "night sun," east of the sun court.
1973–74 season	The night-sun chapel is reconstructed.
1980s	The temple's upper colonnade is reconstructed, and fragments of seven Osiride statues are installed on pedestals (fig. 59).
1995	Restoration of the central solar-complex chapel is begun.
April 3, 2000	The upper terrace is officially opened for public viewing.
2003	Results of the excavation of the solar-cult complex are published (Karkowski 2003).

Fig. 111. Hatshepsut's statues being reconstructed in western Thebes in the late 1920s

1. I would like to thank Elisabeth R. O'Connell for informing me on the currently accepted dates for the use of the monastery and providing the reference to Lajtar 1991.

HATSHEPSUT'S REPUTATION IN HISTORY

Cathleen A. Keller

The officially sanctioned persecution of Hatshepsut's memory did not long outlast the reign of her successor, Thutmose III, but its effects were long-lasting. Thutmose omitted her from the list of Egypt's kings that he had inscribed in the Chamber of the Ancestors at Karnak.[1] Having been officially denied the status of "royal ancestor," Hatshepsut, along with the Amarna kings, was also absent from later king lists.[2] And while some kings of the Nineteenth Dynasty, chiefly Seti I (r. 1294–1279 B.C.)[3] and Ramesses II (r. 1279–1213 B.C.),[4] undertook restorations of Hatshepsut's monuments at Karnak, Deir el-Bahri, and elsewhere,[5] these were done as part of the general restoration of texts and images defaced during the reign of Akhenaten and did not constitute an official rehabilitation of her.

It is not known whether Hatshepsut's name was originally included in the Turin canon, since the end of this document is very fragmentary.[6] But the fact that even the Hyksos rulers were named on the list indicates its noncultic, more or less historical intent. If Hatshepsut's cartouche was omitted from the canon it cannot have been because she was a woman, since the cartouches of other rulers known to have been female, Neith-Iqerti (Sixth Dynasty, r. 2152–2150 B.C.) and Nefrusobek (Twelfth Dynasty, r. 1805–1802 B.C.), are present. Both these rulers, however, possessed something that Hatshepsut did not have: an independent reign.[7]

Still, memory of a female ruler who reigned early in the Eighteenth Dynasty must have survived, either in official archival documentation[8] or in folk memory.[9] For in the third-century B.C. history of Egypt written by the Egyptian priest Manetho, Hatshepsut makes a reappearance as "Amessis,"[10] a sister of Chebron (Thutmose II), who ruled after him for twenty-one years before being succeeded by Misphragmouthis (Thutmose III).[11]

But this renaissance of Hatshepsut was of short duration, for she is not mentioned in the later works of the classical historians. Several centuries after Manetho's time, writing in hieroglyphs was abandoned.[12] Although Coptic, the final direct descendant of ancient Egyptian, continued to be spoken in Egypt into medieval times, a crucial link to the past had been broken. No priest remained who could understand the inscriptions on the colossal pylons of ancient Thebes, let alone decipher the battered cartouches on Hatsheput's monuments.

Hatshepsut's reentry into modern history can be attributed to the individual also credited with the deciphering of Egyptian hieroglyphs, Jean-François Champollion (1790–1832). On his trip to Egypt in 1828–29 Champollion paid a visit to the great temple at Deir el-Bahri, still encumbered with the remains of the Coptic monastery that has given its name to the modern site.[13] He was surprised to note in the wall texts the occasional juxtaposition of female gender endings with depictions of a male king. Among the cartouches was one that he did not recognize but that he read tentatively as "Amenenthe."[14] Immediately suspecting that the female endings were connected with Manetho's Amessis, he posited that Thutmose II had been succeeded by his sister Amessis, who eventually married the regent Amenenthe, and that Amenenthe included her name in the cartouche with his own—thus explaining the occasional presence of female gender endings. Champollion called this composite ruler the *roi-reine*.

Now that documents of the ancient Egyptians could be read, the scholars who came after Champollion began to augment biblical and classical references to Egypt with "real" Egyptian documentation. While this information greatly expanded what was known, at times it appeared to contradict accepted accounts. Hatshepsut's chronological place in the Eighteenth Dynasty was a case in point. Because Thutmose III had destroyed her name and replaced it with his own as well as with those of his father and grandfather, historians attempting to reconstruct Egyptian chronology found it understandably difficult to determine precisely when she had reigned. How did the names of kings thought to have ruled before Hatshepsut come to be written over hers?

Seeking to impose order on these seemingly arbitrary alterations found on the monuments, the eminent German Egyptologist Kurt Sethe early in the twentieth century posited an epigraphic rule: in a usurped cartouche, the final name inscribed must be that of the usurper. When the variously reworked cartouche names were interpreted in this light, the vision they yielded

was of a series of palace coups and countercoups in which the first three Thutmoses and Hatshepsut engaged in a struggle for power, with Thutmose III emerging triumphant.[15] Sethe's scenario was accepted by most scholars of the early twentieth century[16] and was not seriously challenged until 1933.[17] It was from this story of cabal and intrigue that the image of Hatshepsut as palace schemer and manipulator emerged. The only female in the ménage, she was not thought to have had the power to contest openly for the crown: subterfuge must have been her only option.[18] After "usurping" the throne, the theory went, she cited her descent from Thutmose I and his Chief Royal Wife, Ahmose, to justify her claim.[19]

Unlike Thutmose III—who on the basis of his military prowess and short stature emerged in modern scholarship, possibly inaccurately, as "the Napoleon of ancient Egypt"[20]—Hatshepsut was perceived as lurking behind the scenes, waiting for her moment to strike and "suppress" Thutmose III, preventing him from achieving his glorious destiny.[21] Had he not attacked her monuments as soon as it was safe to do so? Could his motive have been anything other than revenge?[22] And indeed, beginning in 1858, excavations conducted at Hatshepsut's temple at Deir el-Bahri revealed a pattern of methodical destruction that appeared to support this theory. The Metropolitan Museum of Art Egyptian Expedition, directed by Herbert E. Winlock, had discovered, among much else, statuary of Hatshepsut that had been smashed and from which the royal uraeus had been systematically removed.[23] Surely no further evidence was needed to prove that Thutmose III had attempted to erase from history the kingship of his "detested stepmother."[24]

But how could one explain the extraordinary fact that a woman had occupied the throne during the early expansion of the empire, when Egypt was becoming a world power?[25] Surely Hatshepsut could not have accomplished such a feat alone; the actual maneuvering must have been done by powerful male courtiers who used the female king as a figurehead. Leading this supposed "palace camarilla,"[26] to judge from the number of his titles and magnificence of his monuments, was Senenmut, administrator in charge of the Amun temple at Karnak, tutor to Hatshepsut's daughter, Neferure, and steward of the king's own household. Only this "canny politician and brilliant administrator"[27] could have been the "evil genius"[28] behind her reign. Indeed, if Senenmut was actually what he claimed to be, "an intimate" of Hatshepsut, he must also have been her lover.[29] As this scenario of court intrigue and romance developed, modern parallels suggested themselves. Was Senenmut Lord Darnley to Hatshepsut's (supposedly) besotted Mary Queen of Scots? Was he the deluded Walter Raleigh to her astute and sexually repressed Elizabeth I?

Thus the "Hatshepsut problem"[30] became inextricably linked with the "Senenmut problem."[31] Scholarly works revealed intriguing connections between the two figures: they had been

close intimates, the fates of both were unknown, the monuments of both were attacked posthumously. In the 1960s, in an effort to turn away from reconstructions of ancient Egyptian history that read like soap operas, Egyptologists began to utilize analytical approaches derived from the social sciences. The search for patterns of behavior, as reflected in the archaeological record, was on. The monuments of Senenmut, in particular, were scrutinized by scholars seeking a single pattern that would reveal the reason for the destruction or survival of his memorials.[32] Senenmut was probably also a focus of attention during this period because every few years another monument depicting him was coming to light.[33]

Research on the side of the royals was equally active. In 1961 renewed study of Hatshepsut's temple at Deir el-Bahri was undertaken by a mission of the Polish Centre of Mediterranean Archaeology in Cairo, and major breakthroughs were made in understanding the overall decorative program of the temple.[34] In 1962 an entirely "new" temple, built by Thutmose III and called Djeser-Akhet, was discovered.[35] The 1960s also saw the beginning of a reassessment of the relationship between Hatshepsut and Thutmose III. It seemed that Thutmose III had not begun his *damnatio memoriae* of Hatshepsut until the final decade of his

Fig. 112. Crates containing statues of Hatshepsut being loaded onto a boat for transport to Cairo, 1931. Columns of Luxor temple, on the east bank of the Nile, are visible in the background.

reign,[36] and if this was the case, hatred and revenge were unlikely to have been his motives. For why would he have waited twenty years to launch his persecution of her memory?

By the 1970s, a reevaluation of Hatshepsut's reign was long overdue. Two major studies were published in 1979, Suzanne Ratié's *La reine Hatchepsout: Sources et problèmes* and Roland Tefnin's *La statuaire d'Hatshepsout: Portrait royal et politique sous la 18e Dynastie*. The former provides a summary of documentation through the 1970s; the latter is the first in-depth look at Hatshepsut's statuary since Winlock's excavations in the first half of the twentieth century.[37] In contrast to Winlock's negative assessment of Hatshepsut, both Ratié and Tefnin tend to take a decidedly positive view of her. In 1988 Peter Dorman published a study of Senenmut in which he largely discounts the idea of a romantic connection between Hatshepsut and her courtier Senenmut and rejects the suggestion that she was involved in the destruction of his memorials.[38]

An important reassessment of Hatshepsut's reign by Emily Teeter appeared in 1990;[39] 1993 saw the publication of an issue of *Les dossiers d'archéologie* devoted to the king and her monuments and drawing on recent discoveries;[40] and in 1999 an exhibition on the subject was organized by Alfred Grimm and Sylvia Schoske.[41] While archaeological research conducted in the mid-twentieth century focused on the recording and study of data gleaned from texts and monuments, the focus in much current research has been on establishing the political and religious motives for Hatshepsut's building and decoration programs.

Rather than finding fault with Hatshepsut's rule and attributing supposed failings to her female gender,[42] contemporary scholars have admired the facility with which she fused past and current styles and iconography to create a new royal rhetoric. Hatshepsut's titulary, images, and building programs all reflect innovative solutions to the problem of situating a female ruler in the predominantly male institution of the kingship. Although the themes of this discourse are not new, recent scholarship has combined new archaeological discoveries and increasingly precise techniques of art-historical analysis with in-depth studies of divinity, kingship, and cosmology to produce a view of the period more nuanced than those offered by earlier scholars. Hatshepsut's identity as Horus, the celestial falcon equated with the king; her intimate relationship with the national god Amun-Re; and her conversion of his city, Thebes, into the center of the cosmos[43] are all developed and inventively expressed in the art, architecture, and literature that flowered during her reign. Perhaps a modern reassessment of Hatshepsut as king should focus not on her personal reputation but on an appreciation of the dynamic presence that she brought to the throne and of the innovation and intellectual daring that characterized her reign.

1. The Karnak king list was transferred to the Musée du Louvre, Paris, by Prisse d'Avennes in 1843. See Redford 1986, pp. 29–34, and bibliography, p. 29, n. 101; for a pre-excavation photo of the room, see Barguet 1962, pl. XXVII.

2. The tradition of king lists is best documented on monuments of the Ramesside period, including the Abydos list, from the temple of Seti I (Redford 1986, pp. 18–20), and the Saqqara list, from the tomb of the official Tjuenroy (Redford 1986, pp. 21–24), which consisted of columns of cartouches belonging to those royal ancestors deemed worthy of continuing to receive offerings.

3. Barguet 1962, p. 100; Brand 2000, pp. 54–56, 59ff.

4. Porter and Moss 1972, pp. 341, no. 4, 348, no. 16, 356, no. 74.

5. Even some of Senenmut's monuments were restored, such as his stela from North Karnak (Helck 1960 and Murnane 1977, pp. 35–36) and British Museum statue 1513 (Eaton-Krauss 1998, p. 208).

6. The Turin canon, a scribal list on the back of an archival document, enumerates the kings of Egypt from the time that the gods ruled on earth to at least the end of the Seventeenth Dynasty. Although the end of the canon is destroyed, the kings of the Eighteenth Dynasty were likely listed in its column 23, according to Málek (1982, pp. 102–3). Probably a Nineteenth Dynasty document of the Ramesside period, the canon is now in the Museo Egizio, Turin. See Gardiner 1959; Redford 1986, pp. 2–18.

7. In other words, these two regnant queens were chronologically significant, while Hatshepsut was chronologically irrelevant. In addition, neither Neithiqeret nor Nefrusobek was, so far as we know, subjected to any systematic, officially sanctioned attempt to destroy her monuments. On Hatshepsut's use of the regnal years of Thutmose III, see Chappaz 1993a, pp. 93ff.

8. Official documentation would include contemporary royal correspondence, private documents, and historical king lists such as the Turin canon (Gardiner 1959).

9. The possible role of Theban folk memories of the original builder of the temple Djeser-djeseru is discussed in Redford (1986, pp. 246–47). Some scholars (Romer 1982, pp. 157–60; Wente 1984, p. 53) have suggested that a co-regency–period graffito above the Deir el-Bahri temple depicting a man and a woman engaged in anal intercourse (Romer 1982, p. 159) is to be identified as a political satire on the relationship between Hatshepsut and Senenmut; however, Bryan (1996, pp. 34–35) urges caution, particularly since no names or iconographic indicators of the couple's status are present.

10. The source of the name Amesse, the Egyptian equivalent of the Greek Amessis, remains uncertain. It may come from the name Ahmose, the mother of Hatshepsut, or Ahmose-Nefertari, who shared a cult with her son Amenhotep I in western Thebes, or it might derive from Hatshepsut; see Redford 1986, p. 247, for references. A corruption of Hatshepsut's nomen epithet Khenemet Amun is also possible.

11. Chebron is a corruption of Aakheperenre, the prenomen of Thutmose II. Misphragmouthis is a conflation of Menkheperre and Thutmose, the prenomen and nomen of Thutmose III. See Manetho 1940, pp. 100–101, 108–9.

12. The latest securely dated hieroglyphic text is dated to A.D. 394.

13. Champollion 1833. "Deir el-Bahri" is Arabic for "northern monastery."

14. Suzanne Ratié (1979, pp. 14–15) traces the early reading of Hatshepsut's name, from Manetho's Amessis to Auguste Mariette's Hatshepsitou. On Champollion's reading of Hatshepsut's name, see Ratié 1979, p. 14, n. 23.

15. Sethe 1896 and 1932.

16. See, for example, Breasted 1900, pp. 27–55, and Breasted 1912, pp. 269ff.

17. Edgerton 1933.

18. Breasted 1912, pp. 269–72; Gardiner 1961, pp. 183–84.

19. Given Hatshepsut's emphasis on her mother and daughter, Donald Redford (1967, pp. 71–72, 84–85) suggests that Hatshepsut's ultimate intention was to establish a royal matriarchy to supplant the succession rights of royal sons. Gay Robins's demonstration (1983) that royal power was not passed through the female line is an argument against Hatshepsut's having any such goal. Peter Dorman (2005), among others, has pointed out that Hatshepsut's stress on her royal descent from her father, Thutmose I, placed her squarely in the position of a royal son.

20. Thutmose III is described by Herbert Winlock (1942, p. 152) as a "short, stocky young man." However, Ann Macy Roth (personal communication,

e-mail, July 9, 2005) suggests that the measurements taken from his mummy were inaccurate, since the fact that his feet were missing was not taken into account. Still, the comparison between the Egyptian king and the French emperor continues to appeal and continues to be made in studies of royal mummies (J. E. Harris and Weeks 1973, p. 137, and Ikram and Dodson 1998, p. 323).

21. Typical of this hyperbole are William Hayes's description (1953, p. 82) of Hatshepsut springing into action following the death of Thutmose II: "It was not long . . . before this vain, ambitious, and unscrupulous woman showed herself in her true colors," and Winlock's reference (1942, p. 147) to her "devious politics."

22. John Wilson (1951, p. 176) cites the "vindictive fury" unleashed by Thutmose III on Hatshepsut's monuments following the period of his suppression.

23. Winlock 1942, p. 142.

24. Hayes 1959, p. 114.

25. On the assumption that a female ruler could not have taken an active role in military campaigns, it was suggested that Hatshepsut's "pacifist" coterie either cooperated or vied with an aggressive, militaristic party gathered around the young Thutmose III (Redford 1967, p. 63, citing Wilson 1951, pp. 174–76). It subsequently became apparent, however, that Hatshepsut may in fact have participated in military campaigns (Redford 1967, pp. 57ff.).

26. Winlock 1942, p. 212.

27. Hayes 1959, p. 106. See also Winlock 1942, p. 148: "Hers [Hatshepsut's] was a rule dominated by an architect."

28. Redford 1967, p. 85.

29. This assumption has long been a mainstay of historical fiction. A recent, and most unusual, variation on the theme is the suggestion that the Child of the Nursery, Maiherperi, was the natural son of the "Nubian" Senenmut and Hatshepsut (Desroches-Noblecourt 1986, pp. 152–53, and Desroches-Noblecourt 2002, pp. 270–71).

30. The term derives from the title of Sethe's 1932 publication *Das Hatschepsut-Problem noch einmal Untersucht.*

31. Lesko 1967.

32. Ibid.; Bothmer 1969–70; Schulman 1969–70; Meyer 1982; Schulman 1987–88; Dorman 1988.

33. The number of known extant statues of Senenmut is currently twenty-five; for a list and bibliography, see Hari 1984. For a bibliography of all his monuments, see Dorman 1988, pp. 189–202, and Dorman 1991.

34. Excavation by the Polish Centre of Mediterranean Archaeology in Cairo is still in progress, and new information continues to emerge.

35. See the essay by Jadwiga Lipińska at the beginning of this chapter.

36. Nims 1966. After analyzing the blocks from the disassembled Chapelle Rouge, a barque station built by Hatshepsut, Nims concluded that Thutmose III had actually completed most of the relief decoration of the chapel before dismantling the structure and replacing it with a chapel of his own. The apparently random distribution of erasures on the blocks seemed inexplicable if their defacement took place while the chapel was still intact; it was far more likely that the reliefs had not been attacked until the chapel had been disassembled and the blocks piled in one of the temple's blockyards for reuse. Surfaces facing out were then defaced, but those within remained intact. Although some of Nims's original analysis has been questioned, Peter Dorman (1988, pp. 46–65) has demonstrated convincingly that this later date for Hatshepsut's persecution is most likely correct. See also Dorman's essay "The Proscription of Hatshepsut" in the present volume.

37. Winlock 1942. See also the articles on the excavations published by Winlock in the *Bulletin of The Metropolitan Museum of Art* (cited in the bibliography of this volume).

38. Dorman also emphasizes the importance of close study of the Karnak monuments in tracing the historical trajectory of this period. See Dorman 1988, pp. 18–65. The ongoing excavations of the Franco-Egyptian team at Karnak continue to unearth new material and to offer new interpretations of the Thutmoside constructions; for the latest publication of their research, see *Cahiers de Karnak*, published annually by the Centre Franco-Égyptien d'Étude des Temples de Karnak.

39. Teeter 1990.

40. *Hatchepsout* 1993.

41. Grimm and Schoske 1999a.

42. Breasted (1912, p. 269) asserted that "the conventions of the court were all warped and distorted to suit the rule of a woman."

43. The last-named goal she accomplished by creating a web of ritual between cult centers of Amun at Karnak, Luxor, Deir el-Bahri, and Medinet Habu, intended to energize this universe-in-microcosm through a never-ending cycle of festal renewal; see "Architecture as Political Statement" by Ann Macy Roth in this volume.

Appendix: Inscriptions of Senenmut

Translation of the false-door inscription (cat. no. 73) by Peter F. Dorman. All other translations by Cathleen A. Keller.

[] Brackets enclose missing text that can be restored.
< > Angle brackets enclose a correction to a scribal error.
{ } Braces enclose Ramesside restorations.
() Parentheses enclose modern interpolations made for clarity.
(2) A number in parentheses indicates the beginning of the corresponding line in the inscription.

Block Statue of Senenmut (cat. no. 64)

British Museum, London, EA 1513

Across garment: (1) A royal offering (to) Amun Lord of the Thrones of the Two Lands, preeminent of all the gods. May he grant everything that goes forth (2) from upon the altar daily on the New Moon Festival, the Six-Day Festival, the Beginning-of-the-Month Festival, the Half-Month Festival, at every festival of Heaven and earth (3) and at every Beginning-of-the-Season Festival that occurs in this temple, as well as the sweet breeze that precedes him (4) to the ka of the Hereditary Noble and Headman, who has followed the king in his journeys since his (the king's) youth, King's Confidant who attends upon him, perceptive in the way of the palace, (5) who adorns the Horus who is in this land, pure of limbs whom his lord has purified, who has access to the marvelous character of the Lord of the Two Lands, (6) the Chamberlain who speaks in privacy, one vigilant concerning what is brought to his attention, one who finds a solution (literally, "thing") every single day, (7) Overseer of All Works of the King, the leader of one who works with his (own) two hands, skilled in every secret for guiding the (8) wise man toward that which he did not (yet) know, Overseer of the Council Chamber, High Steward, Tutor of the King's Daughter (Neferure), one praised of the Mistress of the Two Lands, Senenmut, justified.

On top of base: Hereditary [Noble], First-Rank [Courtier] and Royal [Seal Bearer], High Steward of the King's Daughter, Senenmut, he says: "My lady (?) repeated favors for me, the God's Wife, Hatshepsut, May she live! The king made me great; the king enhanced me, so that I was advanced before the (other) courtiers:

Around base: and, having realized my excellence in her heart, she appointed me Chief Spokesman (literally, "chief mouth") of her household. The King's House was under my charge, as well as judgment in this entire land." The Overseer of the Double Granary of Amun, Senenmut, he says: "O you God's Fathers, *wab*-priests, lector priests of Amun! As your noble god favors you, you shall hand over your offices to your children when you say: 'A Royal Offering (to) Amun-Re for the ka of Senenmut!'"

Senenmut Kneeling with Sistrum (cat. no. 66)

Egyptian Museum, Cairo, CG 579

Top of sistrum: (1) [Given] as a favor [of] the King's Gift to the Hereditary Noble and First-Rank Courtier and Steward of Amun, Sen[enmut, justified]. (2) [Con]fidant of the Female Horus, Wosretkaw (Hatshepsut), and one who is in the heart of the Horus, Khaemwaset (Thutmose III), who made efficient their monuments (3) forever and was enduring of their praise every day. (4) Overseer of Fields of Amun, Senenmut, justified; (5) Overseer of Gardens of Amun, Senenmut; (6) Overseer of Cows of (7) Amun, Senenmut, justified; (8) High Steward of (9) Amun, Senenmut, justified; (10) High Steward of the King, Senenmut, justified; (11) Chief of Retainers of Amun, Senenmut.

Back pillar: (12) [Given as a fav]or of the King's Gift, the King of Upper and Lower Egypt, Maatkare, given [life forever], (13) [to the Hereditary Noble, First-Rank Courtier], Royal Seal Bearer and Sole Companion and Steward of Amun, Senenmut, justified, in order to exist in the temple (14) [of Mut, Lady of I]sheru, to receive offerings that go forth in the presence of this great goddess and burial as a favor of the King's Gift to prolong lifetime in eternity and a fair memory with (15) [people] in the years to come for the Hereditary Noble, First-Rank Courtier and Overseer of the Double Granary of Amun, Senenmut, justified. (16) [It was commanded] to the High Steward, Senenmut, to control every work of the king in Ipet-Sut (Karnak), in Southern Heliopolis,[1] in (17) [the Temple of A]mun, Djeser-djeseru (at Deir el-Bahri), in the House of Mut in Isheru, and in the Southern Opet of Amun (Luxor temple) in [satisfying the heart (18) of the majesty] of this noble god, in making efficient the monuments of the Lord of the Two Lands and enlarging and making efficient . . . (19) the works without being neglectful, according to what was commanded in the palace, lively, prosperous, and healthy! It was commanded to him to be [in charge (20) of it] inasmuch as he is pleasing to the heart. It happened exceptionally well—just like what was commanded—he being efficient in acting in accordance with the desire of His Majesty about it, (21) [one precise and true], there is no one like him! Stout-hearted and unwearying with regard to the monuments of the Lord of the Gods (Amun), the Royal Seal Bearer and *Hem-netjer* priest of Amu[n, (22) Sen]enmut, he says: "I am the greatest of the greatest in the entire land, one who hears what is heard, alone and in privacy, the Steward of [Amun], (23) [Sen]enmut, justified. I am a true confidant of the king, one who does what his majesty praises daily, the Overseer of Cattle of Amun, Senenmut. I am (24) one who makes correct decisions[2] and is impartial, one with whose speech the Lord of the Two Lands is content, the 'Mouth' Nekhen,[3] the *Hem-netjer* priest of Maat, Senenmut. I am one who entered [loved] and (25) went forth praised, one who gladdened the heart of the king daily, the courtier and Controller of the Palace, Senenmut. I am one who provides (26) [allotments?] from the Granary of Divine Offerings at the beginning of each decade,[4] the Overseer of the Double Granary of Amun, Senenmut. I am the festival leader, (27) . . . the gods in the course of every day, on behalf

of the life, prosperity, and health of the lord, the Overseer of Cultivated Land[5] of Amun, Senenmut. I am the controller of controllers, preeminent of the courtiers, (28) [Controller of] all [works] of the King's House,[6] instructor of every craft, Overseer of *Hem-netjer* priests of Montu in Armant, Senenmut. For I am one to whom the affairs of the Two Lands were repeated (29); the administration[7] of Upper and Lower Egypt is under my seal; the obligatory production[8] of every foreign land is (30) under my supervision. I was one whose actions were known in the King's House, a True Royal Acquaintance, whom he loved, the Overseer of Gardens of Amun, Senenmut. (31) [O] you living ones on earth, the hourly-priesthood of the temple, who shall see my statue, my likeness,[9] [so that] (32) my memory might endure[10] in the necropolis. May this great goddess favor you as you say: 'A royal offering (to) Mut, Lady of I[sheru],

Left side of back pillar: (33) [that she might] give *hetepet* offerings that are in Upper Egypt to the ka of the Great One of the Tens of Upper and Lower Egypt, Senenmut. May she give (34) *djefau* offerings that are in Lower Egypt to the ka of the greatest of the great, the noblest of the nobles, (35) [Sen]enmut. May she give all that which goes forth from upon her offering table in Ipet-Sut (36) and [in] the temples of Upper and Lower Egypt to the ka of the Master of Secrets in the Tem- (37)[ples], Senenmut. May she grant invocation offerings of bread, beer, oxen, and fowl and drinking of (38) water from the eddy to the ka of the High Steward of Amun, (39) [Sen]enmut, justified. (40) The Overseer of Cows of (41) Amun, Senenmut. (42) The filler of storehouses (43) and enricher of granaries, (44) the Overseer of the Double Granary of (45) Amun, (46) Senenmut, (47) justified. (48) Overseer of Gardens of Amun, Senenmut, justified.

Right side of back pillar: (49) [Leader] of all the common people, preeminent in the entire land, Steward of Amun, Senenmut, justified. (50) High [Steward] of the King, Senenmut, revered with the Great God." (51) He supports Hathor, preeminent of Thebes, Mut, Lady (?) of Isheru. He causes her to appear and (52) displays her beauty on behalf of the life, prosperity, and health of the King of Upper and Lower Egypt, Maatkare, alive forever! (53) May she [grant] a fine burial in the western cemetery and (54) [just]ification with the Great God to the ka of the Master of Secrets of the Western Side, Senenmut; (55) and splendor in Heaven (56) and power on earth (57) to the ka of the Overseer of the Mansions (58) of the Red Crown, Senenmut, (59) begotten by Ramose and (60) born of Hat- (61)nefer. (62) The Overseer of Cultivated Land of Amun, Senenmut, justified.

Left side of base: (63) May she grant going forth and entering into the necropolis, in accordance with a follower of the righteous, to the ka of the one who repeats the speech of the king to the courtiers,

Front of base: (64) one who offers to the god, one without blame with people, the Steward of Amun, Senenmut. May she grant going forth (65) as a living *ba* and breathing the sweet breeze of the north wind to the ka of the Overseer of . . . of Amun, [Senenmut]; (66) and receiving loaves from upon the altar of Amun at every festival of Heaven and earth

Right side of base: (67) to the ka of the commoner, valiant of arm, follower of the king in southern, northern, eastern, and western foreign lands, pure of limbs between the bow,[11] one to whom the "gold of praise" is given

Around base: (68) . . . Senenmut. May he go forth as a living *ba* and follow god, Lord of the Gods. The one who will feed from the breasts of Horus, his name does not perish forever! The breath of the mouth is useful to the noble; this is not something to grow weary of. I am a noble to whom one listens. I have access to all writings of the *Hem-netjer*

priests. There was nothing that had happened since the First Occasion[12] that I did not know, for the sake of perpetuating my offerings. A (truly) praised one is one who exists . . .

Senenmut Kneeling with Sistrum (cat. no. 67)
The Metropolitan Museum of Art, New York, 48.149.7

Top of sistrum: (1) given as a favor of the King's Gift (2) to the Hereditary Noble and First-Rank Courtier, the confidant of the Female Horus, Wosretkaw (Hatshepsut), and (3) one who is in the heart of the Horus, Khaemwaset (Thutmose III), as one who made (4) their monuments effective forever and one enduring of favor with them (5) every day,

Right side of sistrum: (6) [the High Steward Senenmut, rever]ed (7) [with the Great God . . . gives] noble. (8) [He supports Hathor, preeminent of The]bes; he causes her to appear,

Left side of sistrum: (9) [he displays her beauty on behalf of the li]fe, prosperity, and health (10) of the King of Upper and Lower Egypt, Maatkare, and the King of Upper and Lower Egypt, (11) Menkheperre. May she grant a fine burial

Top of base: (12) to the ka of the Master of Secrets of the Western Side, Senenmut, justified.

At right hand: (13) Overseer of Works of Amun, Senenmut

At left hand: (14) Overseer of Cultivated Land of Amun, Senenmut

Back pillar: (15) May she grant splendor in Heaven and power on earth to the ka of the [High] Ste[ward of] the King, Senenmut, justified. May she give *hetepet* offerings that are in Upper Egypt to the ka of the Great [(16) One of the Tens of Upper and Lower Egypt], Senenmut. May [she] give [*djefau* offerings that are in Lower Egypt to the ka of the greatest of the great, noblest of the nobles], preeminent in the Mansion of the Red Crown, Senenmut. (17) May she give all that goes [forth] from upon her offer[ing table in Ipet-Sut (Karnak) and in the temples of the gods of Upper and Lower Egypt to the ka of the Master of Secrets] in the temples, (18) Senenmut. May she grant invocation offerings of bread, beer, oxen, and fowl and drinking at the eddy [to the ka of the High Stew]ard of Amun, Senenmut. The filler of storehouses and (19) [en]richer of granaries, the Overseer of the Double Granary of Amun, Senenmut, justified, begotten by Ramose, justified and born of Hatnefer. . . .

Senenmut Kneeling with Sistrum (cat. no. 68)
Staatliche Sammlung Ägyptischer Kunst, Munich, ÄS 6265

Right side of sistrum: (1) The leader of all of the common people, High Steward of (2) Amun, [Senenmut]. He supports the sistrum (3) of Iunyt who resides in Armant, (4) so that her place is elevated more than those of the (5) (other) gods. He causes her to appear. He displays her beauty.

Left side of sistrum: (6) For the ka of the Master of Secrets in the Temples, (7) Senenmut. May she give invocation offerings of bread, beer, oxen, and fowl, (8) the drinking of water at (9) the eddy for the ka of the Steward of (10) Amun, [Senenmut],

Back pillars: middle, left and right sides: (11) and vindication with the Great God for the ka of the Master of Secrets of the Western Side, [Senenmut]. May she give splendor in Heaven and power (12) on earth to the ka of the Overseer of the Mansions of the Red Crown, [Senenmut]. May she give *hetepet* offerings that are in Upper Egypt and *djefau* offerings (13) that are in Lower Egypt and everything that goes forth from upon her offering

table in Ipet-Sut and in the (14) temples of the gods of Upper and Lower Egypt to the ka of the High Steward of Amun, [Senenmut]. May she grant invocation offerings of bread, beer, oxen, and fowl (15) on behalf of the life, prosperity, and health of the King of Upper and Lower Egypt, Maatkare. May she grant a fine burial in the western cemetery
Around base: and the drinking of water at the eddy for the ka of the High Steward of Amun, [Senenmut]. The filler of storehouses and enricher of granaries, [Senenmut]: May she allow going forth and entering into the necropolis.
Top of sistrum: (1) the High Steward of Amun, [Senenmut]; (2) the Overseer of the Double Granary of Amun, [Senenmut]; (3) the Overseer of Cultivated Land of Amun, [Senenmut] (4) the High Steward of the King, [Senenmut].

Senenmut Kneeling with Hathor Emblem (cat. no. 69)
Egyptian Department of Antiquities Magazine, Luxor

Back pillar: (1) . . . by the Steward of Amun, Senenmut: He adores his (Amun's) manifestation daily; he propitiates his majesty forever. He gives (2) . . . He (Senenmut) . . . his beauty that his (Senenmut's) heart might live, and that he might receive the sweet breeze of the north wind. May he (Amun) grant a summoning to the daily offerings for the Sole Companion,
On left thigh and across knees: (3) and Steward of Amun, Senenmut. He adores (4) Amun-Re and Hathor, preeminent of Thebes, who resides in Kha-Akhet (5) on behalf of the life, prosperity, health, and favor every day of the ka of the steward Senenmut, like Re.
On right thigh: (6) Overseer of the Double Granary of Amun, Senenmut, justified;
On left side: (7) Steward of Amun, Senenmut; (8) Controller of Divine Offices, Senenmut, justified;
On right side: (9) Overseer of Cattle of Amun, Senenmut; (10) Overseer of Cultivated Land of Amun, Senenmut;
Beneath legs, both sides: (11)–(12) Steward of Amun, Senenmut.

Senenmut Kneeling with Uraeus Cryptogram (cat. no. 70)
Brooklyn Museum, 67.68

Back pillar: (1) The Steward [of Amun, Senenmut]: He supports Renenutet of the Granary of Divine (2) Offerings, to Montu, Lord of Armant. He causes her appearances, he lifts up her (3) beauty on behalf of the life, prosperity, and health of the King of Upper and Lower Egypt, (Maatkare), living forever. An offering (to) Renenutet,
Around base: (4) August Lady of Armant. May she grant *hetepet* offerings that are in (5) Upper Egypt to the High Steward of [Amun, Senenmut]. May she grant *djefau* provisions (6) that are in Lower Egypt to the Sole Companion and Overseer of the Double Granary of (7) Amun, [Senenmut]. May she grant splendor in Heaven and power on earth to the ka of the steward [Senenmut],
Top of base: (8) begotten by Ramose and born of the Lady of the House, Hatnefer, justified. (9) May she grant everything that comes forth from upon the offering table (10) of Montu in Armant for the Steward of Amun, [Senenmut].
Left side of back pillar: Overseer of All Works o[f] Am[un], Senenmut, justified.

Right side of back pillar: Overseer of Works of Mut in Isheru, Sen[enmut], justified.

Senenmut Kneeling with Uraeus Cryptogram (cat. no. 71)
Kimbell Art Museum, Fort Worth, AP 85.2

Back pillar: (1) High Steward of [Amun, Senenmut: He supports Renen]utet, foremost of Iuny (Armant); (2) He causes her to appear; he displays her beauty on behalf of the life, prosperity, and health of the King of Upper and Lower Egypt, Maatkare. (3) An offering (to) Renenutet, August Lady of Iuny, that she might give *hetepet* offerings that are in Upper Egypt
Rear of base: (4) and *djefau* offerings that are in Lower Egypt
Left side of base: (5) to the ka of the Overseer of the Double Granary of A[mun, Senenmut]. May she give all that which goes forth from upon her offering table to the Sole Companion
Front of base: (6) the confidant of the king in all affection [Senenmut].
Right side of base: (7) May she grant splendor in Heaven and power on earth to the Master of Secrets of the Western Side, [Senenmut]; (8) Overseer of all Works of Amun, Sen[enmut], justified; (9) Overseer of Works of Amun in Djeser-djeseru, [Senenmut], justified; (10) Royal Seal Bearer and Overseer of *Hem-netjet* priests of Montu in Iun[y, Senenmut], justified.

False-Door Stela from the Funerary Chapel of Senenmut (cat. no. 73)
Ägyptisches Museum und Papyrussammlung, Berlin, 2066

Above the wedjat eyes: The steward [Senenmut]; his father, Ramose; his mother, Hatnefer.
On the door frames: (1) Words spoken: greetings to you, O you who [sh]ines in [. . .], the Steward {of Amun} knows you, knows your name, and knows the names of these seven cows of yours, (2) as well as the [bull . . . O you who pro]vision the Westerners, may you give bread and beer to the steward {Senenmut}, may you provision the {Steward of Amun, Senenmut}, (3) may you give power to the steward [Senenmut], may {Senenmut} follow you, may the steward {Senenmut} be born under your buttocks. O shrine of souls, lady of all; O thundercloud (4) of Heaven, who raises the god; O you of the silent land (the necropolis), foremost of your place; O you of Khemmis, who ennobles the god; O you who are great of love, (5) of dappled hide; O you who are united with life, bright red one; (6) O you whose name prevails over your craft; O you bull, male consort of the cows: may you give bread and beer to the steward {Senenmut}, may you provision the stew{ard Senenmut}. O power of Heaven who opens the sun's disk, goodly rudder of the {eastern} sky; (7) O circler who {guides} the Two Lands, goodly rudder of the northern sky; O sunlight who resides in the abode of the divine images, goodly rudder of the {western} sky; (8) O you who presides over the red ones, goodly rudder of the southern sky: may you give to the steward {Senenmut} bread, beer, cattle, and fowl, may you provision the steward {Senenmut}, may y<ou> give to the steward {Senenmut} life, prosperity, health, and endurance (9) <upon earth>, may you give to the steward {Senenmut} Heaven, earth, the horizon [. . . for he kno]ws (them) all; and may you do the same (for me).

Text accompanying the bull and seven cows on the left:

The bull, ma[le consort of the cows]

Shrine of souls, lady of all

Thundercloud of Heaven, who raises the god

She of the silent land, foremost of her place

She of Khemmis, who ennobles the god

Great of love, red-haired one

United with life, of dappled hide

She whose name prevails over her craft

Text accompanying Anubis and four mummiform figures on the right:

He who is in the bandage (Anubis)

Power of Heaven who opens the sun's disk, goodly rudder of the eastern sky

Circler who guides the two lands, goodly rudder of the northern sky

Sunlight who resides in the abode of the divine images, goodly rudder of the western sky

He who presides over the red ones, goodly rudder of the southern sky

1. This is often understood as a reference to Armant; see Meyer 1982, p. 187. However, as indicated by Arne Eggebrecht (1975, cols. 435, 437), in texts of the Eighteenth Dynasty it may signify the Thebaid (greater Thebes) as the south's equivalent of Heliopolis.

2. *Jnk [wp?] m ꜣꜥ.t*, literally, "I am one who cuts *maat* (justice)."

3. This is an ancient title associated with the administration of Hierakonpolis, the emblematic capital of Upper Egypt and one of the earliest attested locations of the cult of the falcon-god Horus.

4. *R tp hrw 10 nb*, literally, "at the top of every ten days."

5. According to Barbotin 1987.

6. *Pr-nsw.t*, the royal palace administration. See Helck 1982 and Van den Boorn 1988, pp. 310ff.

7. *Ḫrp.t;* see Haring 1997, p. 332, n. 5.

8. *Bꜣk.t;* see ibid., pp. 15–16, 48.

9. If read as *snn=j*, the translation is "my likeness" (as Meyer 1982, p. 189). If read as *snn n=j*, the translation is "which was copied for me."

10. If *<mn>* is restored (there is no space for more).

11. *Pḏ.tj*, literally, "bowman," perhaps signifying one who is between a bow and a drawn bowstring.

12. *Sp tpj*, "the cosmos was created."

Glossary

a²a armlet — narrow gold band worn on the upper arm; element of the gold-of-honor jewelry set

Amarna period — sixteen-year period in the reign of the pharaoh Amenhotep IV / Akhenaten (crowned some seventy-five years after Hatshepsut's reign) when he ruled Egypt from a new capital at a site now called Amarna. During this time he tried to establish the Aten (the solar disk, which embodied the light of the sun) as the sole deity of Egypt, and the names and images of other gods, including Amun, were defaced or destroyed. Some of the destruction seen at Hatshepsut's temple at Deir el-Bahri and other monuments dates from this period.

Amun — god of Thebes, "the hidden one," usually shown in human form wearing a crown with two tall feathers. His main temple was at Karnak.

Amun-Re — fusion of the gods Amun and Re, combining in a single entity all the characteristics of the creator and the sustainer of the world; by the Eighteenth Dynasty, the preeminent Egyptian deity

ankh — hieroglyph meaning "to live" and "life"

Anubis — jackal-headed god of mummification, protector of the deceased

atef crown — elaborate crown that combines ram's horns, ostrich plumes, the sun disk, and uraeus cobras; worn by Osiris to symbolize his triumph over death and by the king in certain rituals

Aten — solar disk; under the pharaoh Akhenaten worshiped as the medium through which the divine power of light comes to the world

Atum — god of Heliopolis, "the undifferentiated one"; according to myth, the primeval being and creator of the world; also god of the setting sun

ba — manifestation of the power of a deity; a person's afterlife form of existence, which has the ability to move

barque of Amun — sacred boat in which the cult image of Amun was carried when it was transported from Karnak temple in festival processions

Beautiful Festival of the Residence — *see* Opet festival

Beautiful Festival of the Valley — annual religious festival during which sacred barques containing the images of Amun-Re, Mut, and Khonsu were transported from their temples on the east bank of the Nile across the river to western Thebes, where they visited the shrine of Hathor at Deir el-Bahri and some of the royal mortuary temples

bilbil — slender-necked juglet with specific characteristics based on imported vessels, probably from Syria. Bilbils may have been used to hold opium, and the form may be based on that of an inverted poppy pod.

block statue — type dating from the Middle Kingdom showing a man seated on the ground with knees drawn up to the chest, enveloped in a cloak; also called cuboid statue

blue crown — *see khepresh*

canopic jars — four jars used to store the mummified internal organs of the deceased; in the burial chamber, usually placed in a canopic box close to the mummy

cartonnage — layers of linen or papyrus soaked in plaster and shaped while still damp; used to make mummy masks and coffins

cartouche — oval frame, representing a knotted rope, that encloses the nomen and prenomen of the king

Chapelle Rouge — quartzite shrine, built by Hatshepsut, to shelter the barque of Amun at Karnak temple

coronation name — *see* prenomen

cryptogram — an emblem with hidden meaning

cult temple — temple for the celebration of the cult of a deity; often also a center of economic activity

damnatio memoriae — attempt to erase all traces of a person's existence

djed — hieroglyph meaning "stability"; sometimes described as a *djed* pillar

double crown — combination of the red crown and the white crown; symbolizes rule over a united Egypt

faience — nonclay ceramic material made of quartz paste which is molded or modeled and fired. It is either self-glazed or has a glaze that is applied before firing.

false door — carved or painted representation, in a tomb, of a doorway through which the deceased could communicate with the living and receive offerings

gold of honor	set of jewelry (including *shebiu* collars, *aʾa* armlets, and at least one *mesektu* bracelet) bestowed on high-ranking officials; also called gold of valor or award jewelry	Maat	goddess of truth, order, and justice; represented as a woman wearing a curled ostrich feather on her head and sometimes symbolized by the feather itself
Hathor	sky goddess, usually represented as a woman, sometimes as a cow. Her headdress is a sun disk between cow's horns, her name means "house of Horus," and her consort is Horus of Edfu. The site of Deir el-Bahri in western Thebes contained a shrine to Hathor long before Hatshepsut built a temple there.	Maatkare	Hatshepsut's prenomen: "the proper manifestation of the sun's life force" (literally, "Maat is the ka of Re")
		Maatkare cryptogram	cobra wearing a horned sun disk and perched on a pair of ka (raised) arms
hetep-di-nesut	standard offering formula found on many funerary objects. It magically provides all that a spirit needs to survive in the afterlife.	Medinet Habu	site in western Thebes best known for the mortuary temple of the Twentieth Dynasty pharaoh Ramesses III; also the location of a much earlier temple dedicated to Amun, built by Hatshepsut and Thutmose III on a site believed to be the burial place of Amun
Horus	sky god, represented as a falcon or a falcon-headed man; embodiment of the divine powers of the living king; protector of the king		
Horus name	one of several names of an Egyptian king's titulary; identifies the king as the representative of Horus	*menit* necklace	necklace made of many strands of small beads that could be used as a percussion instrument when shaken rhythmically during temple and festival ceremonies. Its sound was thought to appease the gods.
Hyksos	descendants of people from western Asia who had settled in the eastern Delta. They ruled northern Egypt during the Second Intermediate Period; their expulsion by Ahmose I, first king of the Eighteenth Dynasty, led to the reunification of Upper and Lower Egypt.	*mesektu* bracelet	wide curved gold cuff bracelet; element of the gold-of-honor jewelry set
		meskhetyu	implement used in the Opening of the Mouth ceremony
justified	literally, "true of voice"; epithet describing a deceased spirit who has been judged favorably in the next world	mortuary temple	temple for the celebration of the funerary or memorial cult of a deceased king, to ensure the survival of the king's spirit in the afterworld
ka	the life force of a deity or person, which continues to exist after the latter's death	Mut	consort of the god Amun and mother of Khonsu; depicted as a woman or as a vulture. Her Theban temple was just south of Karnak.
Karnak	principal temple of the god Amun of Thebes		
Keftiu	Egyptian name for the inhabitants of Crete	naophorous statue	statue depicting a kneeling man holding a naos, or shrine
khat	headdress of an Egyptian king, similar to a soft kerchief or wig cover and less formal than the *nemes*	Nebty name	one of the king's formal names; places the king under the protection of the goddesses Nekhbet and Wadjet; also called the Two Ladies name
khepresh	helmet-shaped crown worn by kings from the New Kingdom on; usually blue in color		
Khepri	divine manifestation of the rising sun	*nefer*	hieroglyph meaning "good," "beautiful," "perfect"
Khonsu	god of the moon; son of the god Amun and his consort, Mut	*nemes*	striped headcloth worn by kings
		nemset vessel	lustration vase
Lower Egypt	northern Egypt, including Memphis and the Nile Delta	nome	province or administrative unit in Upper and Lower Egypt
Luxor temple	Theban temple dedicated to Amun, located about two miles south of his principal cult center at Karnak	nomen	king's birth name; often accompanied by the epithet Son of Re
		nw jar	globular vessel generally containing a liquid offering to the gods; in sculpture, also used to imply other gifts
maat	order and justice established by the gods and personified by the goddess Maat	Opening of the Mouth ceremony	funerary ritual that allows the deceased, or a statue or other representation, to come to life

Opet festival	annual religious festival during which sacred barques containing the images of Amun-Re, Mut, and Khonsu were transported in processions from Karnak to Luxor temple, and back
Osiride statue	statue that presents the king as the god Osiris, ruler of the underworld
ostracon	limestone chip or pot shard used for writing and drawing
per-wer	shrine of Upper Egypt (literally, "Great House") or a shrine in imitation of it
prenomen	name taken by the king upon his accession to the throne; also called the coronation name or throne name; often accompanied by the title King of Upper and Lower Egypt
Re	"sun," the most important name of the sun god, who was later combined with many other gods, including Amun
red crown	the crown of Lower Egypt
Re-Harakhti	falcon-headed god, fusion of Re and Harakhti ("Horus of the horizon," a manifestation of the rising sun)
Retenu	Egyptian name for the area along the Mediterranean coast from modern Gaza to Syria; also applied to area's residents
rishi coffin	coffin decorated with a wing pattern
sa	hieroglyph meaning "protection"
scarab	amulet in the shape of a beetle and usually carved on its base with hieroglyphs, designs, or figures; Scarabs were powerful charms by association with the beetle hieroglyph, *kheper* ("to come into being," "to become"): the god Khepri, in the form of a beetle, was thought to push the sun into the sky at dawn.
Sed festival	rejuvenation ceremony for the reigning king, theoretically celebrated after thirty years of rule; also called the Heb Sed festival
serekh	simplified image of the royal residence surmounted by a falcon (symbol of the sky god Horus); encloses the Horus name of the king
shawabti	funerary figure that serves as a substitute for the deceased and performs certain kinds of labor for that person in the afterlife
shebiu collar	choker-style necklace traditionally made of gold ring beads; element of the gold-of-honor jewelry set
shen	hieroglyph meaning "to encircle"; symbolizes eternity
shendyt	tripartite kilt worn by the king
sistrophore	statue depicting a kneeling man holding a votive sistrum
sistrum	rattle used in religious ceremonies; the handle often depicts a woman with cow's ears, an image associated with the goddess Hathor
Son of Re name	*see* nomen
Theban triad	the gods Amun-Re, Mut, and Khonsu
titulary	list of titles
Two Ladies name	*see* Nebty name
Two Lands	Upper and Lower Egypt
uraeus	mythical fire-spitting cobra, a protector of kings and gods. An image of it rearing up with a dilated hood was worn on the front of a crown or a headdress such as the *nemes*.
Upper Egypt	the Nile valley south of the Delta
was	hieroglyph meaning "power," "dominion"; also called a *was* scepter
wedjat eye	"that which is made whole"; an eye with stylized falcon markings symbolizing the left eye of the god Horus; a powerful amulet for healing
white crown	the crown of Upper Egypt

Bibliography

Abbreviations used in the bibliography:

Ä&L	*Ägypten und Levante/Egypt and the Levant*
ASAE	*Annales du Service des Antiquités de l'Égypte*
BIFAO	*Bulletin de l'Institut Français d'Archéologie Orientale*
GM	*Göttinger Miszellen*
JARCE	*Journal of the American Research Center in Egypt*
JEA	*Journal of Egyptian Archaeology*
JNES	*Journal of Near Eastern Studies*
LÄ	*Lexikon der Ägyptologie*
MDAIK	*Mitteilungen des Deutschen Archäologischen Instituts, Abteilung Kairo*
SAK	*Studien zur altägyptischen Kultur*
S&N	*Sudan & Nubia*
ZÄS	*Zeitschrift für ägyptische Sprache und Altertumskunde*

Age of the Pyramids
1999 *Egyptian Art in the Age of the Pyramids.* Exh. cat. New York: The Metropolitan Museum of Art.

Ägyptens Aufstieg
1987 *Ägyptens Aufstieg zur Weltmacht.* Exh. cat., Roemer- und Pelizaeus-Museum, Hildesheim. Mainz am Rhein: Philipp von Zabern.

Ägyptische Kunst
1976 *Ägyptische Kunst aus dem Brooklyn Museum.* Exh. cat. Berlin: Staatliche Museen Preussischer Kulturbesitz, Ägyptisches Museum.

Aksamit, Joanna
1996 "Egyptian Faience Vessels from the Temple of Tuthmosis III at Deir el-Bahari." In *Cahiers de la céramique égyptienne* 4, pp. 1–17.

Aldred, Cyril
1961 *New Kingdom Art in Ancient Egypt during the Eighteenth Dynasty, 1570 to 1320 B.C.* 2nd ed. London: Tiranti.

1971 *Jewels of the Pharaohs: Egyptian Jewellery of the Dynastic Period.* London: Thames and Hudson.

1978 "Tradition and Revolution in the Art of the XVIIIth Dynasty." In *Immortal Egypt*, ed. Denise Schmandt-Besserat, pp. 51–62. Invited Lectures on the Middle East at the University of Texas at Austin 2. Malibu: Undena Publications.

Aldred, Cyril, et al.
1979 Cyril Aldred, Paul Barguet, Christiane Desroches-Noblecourt, Jean Leclant, and Hans Wolfgang Müller. *L'empire des conquérants: L'Égypte au Nouvel Empire (1560–1070).* Le monde égyptien: Les pharaons 2. L'univers des formes 27. Paris: Gallimard.

1980 Cyril Aldred, François Daumas, Christiane Desroches-Noblecourt, and Jean Leclant. *L'Égypte du crépuscule: De Tanis à Méroé, 1070 av. J.-C.–IVᵉ siècle apr. J.-C.* Le monde égyptien: Les pharaons 3. L'univers des formes 28. Paris: Gallimard.

Allen, James P.
2000 *Middle Egyptian: An Introduction to the Language and Culture of Hieroglyphs.* Cambridge: Cambridge University Press.

2001 "Taking of Joppa." In *The Oxford Encyclopedia of Ancient Egypt*, ed. Donald B. Redford, vol. 3, pp. 347–48. Oxford: Oxford University Press.

2002 "The Speos Artemidos Inscription of Hatshepsut." *Bulletin of the Egyptological Seminar* 16, pp. 1–17.

2005 *The Art of Medicine in Ancient Egypt.* Exh. cat. New York: The Metropolitan Museum of Art.

Allen, T. George
1927–28 "A Unique Statue of Senmut." *American Journal of Semitic Languages and Literatures* 44, pp. 49–55.

Altenmüller, Hartwig
1967 "Ein Opfertext der 5. Dynastie." *MDAIK* 22, pp. 9–18.

1983a "Bemerkungen zu den Königsgräbern des Neuen Reiches." *SAK* 10, pp. 25–61.

1983b "Das Grab der Königin Tausret im Tal der Könige von Theben." *SAK* 10, pp. 1–24.

Amiran, Ruth
1962 "The 'Arm-Shaped' Vessel and Its Family." *JNES* 21 (July), pp. 161–74.

1970 *Ancient Pottery of the Holy Land: From Its Beginnings in the Neolithic Period to the End of the Iron Age.* With the assistance of Pirhiya Beck and Uzza Zevulun. New Brunswick, N.J.: Rutgers University Press.

Ancient Egyptian Art
1922 *Catalogue of an Exhibition of Ancient Egyptian Art.* Exh. cat. London: Burlington Fine Arts Club.

Anderson, Julie R.
2004 Ed. *Treasures from Sudan.* Exh. cat., British Museum. London: British Museum Press.

Andreu, Guillemette, Marie-Hélène Rutschowscaya, and Christiane Ziegler
1997 *Ancient Egypt at the Louvre.* Trans. Lisa Davidson. Paris: Hachette.

Andrews, Carol
1990 *Ancient Egyptian Jewelry.* New York: Harry N. Abrams.

1994 *Amulets of Ancient Egypt.* Austin: University of Texas Press.

Arnold, Dieter
1975 "Deir el-Bahari III." In *LÄ*, vol. 1, cols. 1017–25. Wiesbaden: Otto Harrassowitz.

1982 "Per-wer II." In *LÄ*, vol. 4, cols. 934–35. Wiesbaden: Otto Harrassowitz.

1992 *Die Tempel Ägyptens: Götterwohnungen, Kultstätten, Baudenkmäler.* Zürich: Artemis & Winkler.

2002 *The Pyramid Complex of Senwosret III at Dahshur: Architectural Studies.* With contributions and an appendix by Adela Oppenheim and contributions by James P. Allen. Publications of the Metropolitan Museum of Art Egyptian Expedition 26. New York: The Metropolitan Museum of Art.

Arnold, Dieter, and Jürgen Settgast
1966 "Zweiter Vorbericht über die vom Deutschen Archäologischen Institut Kairo im Asasif unternommenen Arbeiten." *MDAIK* 21, pp. 72–94.

Arnold, Dieter, and Herbert E. Winlock
1979 *The Temple of Mentuhotep at Deir el-Bahari.* From the notes of Herbert Winlock. Publications of The Metropolitan Museum of Art Egyptian Expedition 21. New York: The Metropolitan Museum of Art.

Arnold, Dorothea
1984 "Reinigungsgefässe." In *LÄ*, vol. 5, cols. 213–20. Wiesbaden: Otto Harrassowitz.

1991 "Amenemhat I and the Early Twelfth Dynasty at Thebes." *Metropolitan Museum Journal* 26, pp. 5–48.

1993 *Techniques and Traditions of Manufacture in the Pottery of Ancient Egypt.* Pt. 1 of *An Introduction to Ancient Egyptian Pottery*, ed. Dorothea Arnold and Janine Bourriau. Sonderschrift (Deutsches Archäologisches Institut, Abteilung Kairo) 17. Mainz am Rhein: Philipp von Zabern.

1995 "An Egyptian Bestiary." *The Metropolitan Museum of Art Bulletin*, n.s., vol. 52, no. 4 (Spring).

1996 *The Royal Women of Amarna: Images of Beauty from Ancient Egypt.* With contributions by James P. Allen and L. Green. Exh. cat. New York: The Metropolitan Museum of Art.

forthcoming "The Statues of Hatshepsut from Deir el-Bahri According to the Excavation Records of Herbert E. Winlock."

Arnold, Dorothea, Felix Arnold, and Susan J. Allen

1995 "Canaanite Imports at Lisht, the Middle Kingdom Capital of Egypt." *Ä&L* 5, pp. 13–32.

Art and Afterlife in Ancient Egypt

1999 *Art and Afterlife in Ancient Egypt from the British Museum.* Exh. cat., Tokyo Metropolitan Art Museum; Kobe City Museum; Fukuoka City Museum; and Nagoya City Museum. Japan: Asahi Shinbun.

Arte nell'antico Egitto

1990 *Il senso dell'arte nell'antico Egitto.* Exh. cat. Bologna: Museo Civico Archeologico di Bologna.

Aruz, Joan

2003 Ed., with Ronald Wallenfels. *Art of the First Cities: The Third Millennium B.C. from the Mediterranean to the Indus.* Exh. cat. New York: The Metropolitan Museum of Art.

Assmann, Jan

1990 *Maʿat: Gerechtigkeit und Unsterblichkeit im alten Ägypten.* Munich: C. H. Beck.

1995 *Egyptian Solar Religion in the New Kingdom: Re, Amun and the Crisis of Polytheism.* Studies in Egyptology. London and New York: Kegan Paul International.

Assmann, Jan, et al.

1995 Jan Assmann, Eberhard Dziobek, Heike Guksch, Friederike Kampp, eds. *Thebanische Beamtennekropolen—neue Perspektiven archäologischer Forschung: Internationales Symposium, Heidelberg 9.–13.6. 1993.* Studien zur Archäologie und Geschichte Altägyptens 12. Heidelberg: Heidelberger Orientverlag.

Aston, Barbara G.

1994 *Ancient Egyptian Stone Vessels: Materials and Forms.* Studien zur Archäologie und Geschichte Altägyptens 5. Heidelberg: Heidelberger Orientverlag.

Aston, Barbara G., James A. Harrell, and Ian Shaw

2000 "Stone." In *Ancient Egyptian Materials and Technologies,* ed. Paul T. Nicholson and Ian Shaw, pp. 5–77. Cambridge: Cambridge University Press.

Athanasi, Giovanni d'

1836 *A Brief Account of the Researches and Discoveries in Upper Egypt, Made under the Direction of Henry Salt, to Which Is Added a . . . Catalogue and an Enumeration of Those Articles Purchased for the British Museum.* London.

Aubert, Jacques-F., and Liliane Aubert

1974 *Statuettes égyptiennes: Chaouabtis, Ouchebtis.* Paris: Librairie d'Amérique et d'Orient.

Aufrère, Sydney

1991 *L'univers minéral dans la pensée égyptienne.* 2 vols. Bibliothèque d'étude (Institut Français d'Archéologie Orientale du Caire) 105. Cairo: Institut Français d'Archéologie Orientale du Caire.

Ayrton, E. R., and W. L. S. Loat

1908–9 "Excavations at Abydos." In *Archaeological Report, 1908–1909,* pp. 2–5. London: Egypt Exploration Fund.

Bács, Tamás A.

2002 "A New Viceroy of Nubia." In *A Tribute to Excellence: Studies Offered in Honor of Ernő Gaál, Ulrich Luft, László Török,* ed. Tamás A. Bács, pp. 53–67. Studia Aegyptiaca 17. Budapest: ELTE.

Badawī, Ahmad Muhammad

1943 "Die neue historische Stele Amenophis' II." *ASAE* 42, pp. 1–23.

1948 *Memphis als zweite Landeshauptstadt im Neuen Reich.* Cairo: Institut Français d'Archéologie Orientale du Caire.

Badawy, Alexander, and Elizabeth Riefstahl

1972 "A Monumental Gateway for a Temple of King Sety I: An Ancient Model Restored." In *Miscellanea Wilbouriana,* ed. Bernard V. Bothmer, vol. 1, pp. 1–23. Brooklyn: Brooklyn Museum.

Bader, Bettina

2001 *Tell el-Dabʿa XIII: Typologie und Chronologie der Mergel C-Ton Keramik, Materialien zum Binnenhandel des Mittleren Reiches und der Zweiten Zwischenzeit.* Österreichische Akademie der Wissenschaften, Denkschriften der Gesamtakademie 22. Untersuchungen der Zweigstelle Kairo des Österreichischen Archäologischen Institutes 19. Vienna: Verlag der Österreichischen Akademie der Wissenschaften.

Baer, Klaus

1960 *Rank and Title in the Old Kingdom: The Structure of the Egyptian Administration in the Fifth and Sixth Dynasties.* Chicago: University of Chicago Press.

Bagnall, Roger S.

1993 *Egypt in Late Antiquity.* Princeton: Princeton University Press.

Baines, John

1986 "The Stela of Emhab: Innovation, Tradition, Hierarchy." *JEA* 72, pp. 41–53.

1989 "Ancient Egyptian Concepts and Uses of the Past: Third to Second Millennium BC Evidence." In *Who Needs the Past? Indigenous Values and Archaeology,* ed. Robert Layton, pp. 130–49. London: Unwin Hyman.

1996 "Contextualizing Egyptian Representations of Society and Ethnicity." In *The Study of the Ancient Near East in the Twenty-first Century: The William Foxwell Albright Centennial Conference,* ed. Jerrold S. Cooper and Glenn M. Schwartz, pp. 339–84. Winona Lake, Ind.: Eisenbrauns.

1997 "Temples as Symbols, Guarantors, and Participants in Egyptian Civilization." In *The Temple in Ancient Egypt: New Discoveries and Recent Research,* ed. Stephen Quirke, pp. 216–41. Papers from a colloquium held by the Department of Egyptian Antiquities, British Museum, July 21–22, 1994. London: British Museum Press for the Trustees of the British Museum.

2004 *Die Bedeutung des Reisens im alten Ägypten: 13. Siegfried-Morenz-Gedächtnis-Vorlesung 2002.* Leipzig: Ägyptisches Museum der Universität Leipzig.

Baker, Hollis S.

1966 *Furniture in the Ancient World: Origins and Evolution, 3100–475 B.C.* New York: Macmillan.

Barag, Dan

1962 "Mesopotamian Glass Vessels of the Second Millennium B.C.: Notes on the Origin of the Core Technique." *Journal of Glass Studies* 4, pp. 9–27.

Barbieri, M., Christine Lilyquist, and G. Testa

2002 "Provenancing Egyptian and Minoan Calcite: Alabaster Artifacts through ^{87}Sr/^{86}Sr Isotopic Ratios and Petrography." In *ASMOSIA VI—Interdisciplinary Studies on Ancient Stone: Proceedings of the Sixth International Conference of the "Association for the Study of Marble and Other Stones in Antiquity," Venice, June 15–18, 2000,* ed. Lorenzo Lazzarini, pp. 403–14. Padua: Bottega d'Erasmo.

Barbotin, Christophe

1987 "Aspects juridiques et économiques de l'offrande au Nouvel Empire." *Discussions in Egyptology* 9, pp. 69–78.

Barguet, Paul

1953a "Khnoum-Chou: Patron des arpenteurs." *Chronique d'Égypte,* no. 56 (July), pp. 223–27.

1953b "Une statuette de Senenmout au Musée du Louvre." *Chronique d'Égypte,* no. 55 (January), pp. 23–27.

1962 *Le temple d'Amon-Rê à Karnak: Essai d'exégèse.* Recherches d'archéologie, de philologie et d'histoire (Institut Français d'Archéologie Orientale du Caire) 21. Cairo: Institut Français d'Archéologie Orientale du Caire.

Becker, Lawrence, Lisa Pilosi, and Deborah Schorsch

1994 "An Egyptian Silver Statuette of the Saite Period: A Technical Study." *Metropolitan Museum Journal* 29, pp. 37–56.

von Beckerath, Jürgen

1990 "Nochmals zur Regierung Tuthmosis' II." *SAK* 17, pp. 65–74.

Beinlich-Seeber, Christine

1984 "Renenutet." In *LÄ,* vol. 5, cols. 232–36. Wiesbaden: Otto Harrassowitz.

Bell, Lanny

1985 "Luxor Temple and the Cult of the Royal *Ka.*" *JNES* 44 (October), pp. 251–94.

Bénédite, Georges

1908 "Un envoi de l'Institut Archéologique du Caire au Musée du Louvre." *Bulletin des musées de France,* p. 17.

1920 "La corne récipient dans l'ancienne Égypte." *Revue d'ethnographie et des traditions populaires* 1, pp. 81–86.

Bennett, Chris

2002 "A Genealogical Chronology of the Seventeenth Dynasty." *JARCE* 39, pp. 123–55.

Benson, Margaret, and Janet Gourlay

1899 *The Temple of Mut in Asher; an Account of the Excavation of the Temple and of the Religious Representations and Objects Found Therein, as Illustrating the History of Egypt and the Main Religious Ideas of the Egyptians.* London: John Murray.

Ben-Tor, Daphna

1989 *The Scarab: A Reflection of Ancient Egypt.* Exh. cat. Jerusalem: Israel Museum.

Berman, Lawrence M.

1999 With Kenneth J. Bohač. *Catalogue of Egyptian Art: The Cleveland Museum of Art.* Cleveland: Cleveland Museum of Art.

Berman, Lawrence M., and Bernadette Letellier

1996 *Pharaohs: Treasures of Egyptian Art from the Louvre.* Exh. cat. Cleveland: Cleveland Museum of Art.

Beylage, Peter

2002 *Aufbau der königlichen Stelentexte vom Beginn der 18. Dynastie bis zur Amarnazeit.* 2 vols. Ägypten und Altes Testament 54. Wiesbaden: Otto Harrassowitz.

Bickel, Susanne, and Jean-Luc Chappaz

1988 "Missions épigraphiques du Fonds de l'Égyptologie de Genève au Spéos Artémidos." *Bulletin* (Société d'Égyptologie, Geneva), no. 12, pp. 9–24.

1993 "Le Spéos Artémidos: Une temple de Pakhet en Moyenne-Égypte." In *Hatchepsout* 1993, pp. 94–101.

Bickerstaffe, Dylan

2002a "The Discovery of Hatshepsut's 'Throne.'" *KMT*, vol. 13, no. 1 (Spring), pp. 71–77.

2002b "Afterwords on Hatshepsut's 'Throne.'" Letter in Readers' Forum. *KMT*, vol. 13, no. 2 (Summer), p. 6.

Bietak, Manfred

1975 *Tell el-Dabᶜa II: Der Fundort im Rahmen einer archäologisch-geographischen Untersuchung über das ägyptische Ostdelta.* Österreichische Akademie der Wissenschaften, Denkschriften der Gesamtakademie 4. Untersuchungen der Zweigstelle Kairo des Österreichischen Archäologischen Institutes 1. Vienna: Verlag der Österreichischen Akademie der Wissenschaften.

1985 "Ein altägyptischer Weingarten in einem Tempelbezirk (Tell el-Dabᶜa 1. März bis 10. Juni 1985)." *Anzeiger* (Österreichische Akademie der Wissenschaften, Philosophisch-historische Klasse) 122, pp. 267–78.

1990 "Zur Herkunft des Seth von Avaris." *Ä&L* 1, pp. 9–16.

1994 "Die Wandmalereien aus Tell el-Dabᶜa/ᶜEzbet Helmi: Erste Eindrücke." Pt. 6 of Bietak et al. 1994, pp. 44–58.

1995 "Connections between Egypt and the Minoan World: New Results from Tell el-Dabᶜa/ Avaris." In *Egypt, the Aegean and the Levant: Interconnections in the Second Millennium BC*, ed. W. Vivian Davies and Louise Schofield, pp. 19–28. London: British Museum Press for the Trustees of the British Museum.

1996 *Avaris, the Capital of the Hyksos: Recent Excavations at Tell el-Dabᶜa.* London: British Museum Press for the Trustees of the British Museum.

1997 "The Center of Hyksos Rule: Avaris (Tell el-Dabᶜa)." In *The Hyksos: New Historical and Archaeological Perspectives*, ed. Eliezer D. Oren, pp. 87–139. University Museum Monograph 96. University Museum Symposium Series 8. Philadelphia: University Museum, University of Pennsylvania.

1998 "Gedanken zur Ursache der ägyptisierenden Einflüsse in Nordsyrien in der Zweiten Zwischenzeit." In *Stationen—Beiträge zur Kulturgeschichte Ägyptens: Rainer Stadelmann gewidmet*, ed. Heike Guksch and Daniel Polz, pp. 165–76. Mainz am Rhein: Philipp von Zabern.

2004a "Nahostpolitik: Fremdherrschaft und Expansion." In Petschel and von Falck 2004, pp. 140–44.

2004b "Seal Impressions from the Middle Till the New Kingdom: A Problem for Chronological Research." In *Scarabs of the Second Millennium BC from Egypt, Nubia, Crete and the Levant—Chronological and Historical Implications: Papers of a Symposium, Vienna, 10th–13th of January 2002*, ed. Manfred Bietak and Ernst Czerny, pp. 43–55. Österreichische Akademie der Wissenschaften, Denkschriften der Gesamtakademie 35. Contributions to the Chronology of the Eastern Mediterranean 8. Vienna: Verlag der Österreichischen Akademie der Wissenschaften.

2005 "The Tuthmoside Stronghold of Perunefer." *Egyptian Archaeology*, no. 26 (Spring), pp. 13–17.

forthcoming "Neue Paläste aus der 18. Dynastie." In *Structure and Significance/Bau und Bedeutung*, ed. Pieter Jánosi, pp. 131–68. Vienna.

Bietak, Manfred, Josef Dorner, and Pieter Jánosi

2001 "Ausgrabungen in dem Palastbezirk von Avaris: Vorbericht Tell el-Dabᶜa/ᶜEzbet Helmi, 1993–2000." *Ä&L* 11, pp. 27–119.

Bietak, Manfred, and Irene Forstner-Müller

2003 "Ausgrabungen im Palastbezirk von Avaris: Vorbericht Tell el-Dabᶜa/ᶜEzbet Helmi Frühjahr 2003." *Ä&L* 13, pp. 39–50.

Bietak, Manfred, and Nannó Marinatos

1995 "The Minoan Wall Paintings from Avaris." *Ä&L* 5, pp. 49–62.

Bietak, Manfred, and Clairy Palyvou

2000 "A Large Griffin from a Royal Citadel of the Early Eighteenth Dynasty at Tell el-Dabᶜa." In *Proceedings of the Eighth International Cretological Conference*, pp. 99–108. Heraklion.

Bietak, Manfred, et al.

1994 Manfred Bietak, Josef Dorner, Irmgard Hein, and Pieter Jánosi. "Neue Grabungsergebnisse aus Tell el-Dabᶜa und ᶜEzbet Helmi im östlichen Nildelta (1989–1991)." *Ä&L* 4, pp. 9–80.

Bisset, Norman G., Jan G. Bruhn, and Meinhart H. Zenk

1996 "The Presence of Opium in a 3,500 Year Old Cypriote Base-Ring Juglet." *Ä&L* 6, pp. 203–4.

Bisset, Norman G., et al.

1996 Norman G. Bisset, Jan G. Bruhn, Silvio Curto, Bo Holmstedt, Ulf Nyman, and Meinhart H. Zenk. "Was Opium Known in Eighteenth Dynasty Ancient Egypt? An Examination of Materials from the Tomb of the Chief Royal Architect Kha." *Ä&L* 6, pp. 199–201.

von Bissing, Friedrich W.

1898a "Eine Bronzeschale Mykenischer Zeit." *Jahrbuch des Kaiserlich Deutschen Archäologischen Instituts* 13, pp. 28–56.

1898b "Zu den Institutsschriften." *Archäologischer Anzeiger: Beiblatt zum Jahrbuch des Archäologischen Instituts*, vol. 13, no. 2, pp. 147–48.

1900 Ed. *Ein thebanischer Grabfund aus dem Anfang des Neuen Reichs.* Berlin: A. Duncker.

Bisson de la Roque, Fernand

1930 *Fouilles de l'Institut Français d'Archéologie Orientale du Caire (année 1929): Rapports préliminaires.* Pt. 1, *Rapport sur les fouilles de Médamoud (1929).* Fouilles de l'Institut Français d'Archéologie Orientale du Caire, vol. 7, pt. 1. Cairo: Institut Français d'Archéologie Orientale du Caire.

Blackman, Aylward Manley

1988 *The Story of King Kheops and the Magicians: Transcribed from Papyrus Westcar (Berlin Papyrus 3033).* Ed. W. Vivian Davies. Reading, Berkshire: J. V. Books.

Boehmer, Rainer Michael

1972 *Boğazköy-Ḥattuša: Ergebnisse der Ausgrabungen des Deutschen Archäologischen Instituts und der Deutschen Orient-Gesellschaft in den Jahren 1931–1939.* Vol. 7, *Die Kleinfunde von Boğazköy aus den Grabungskampagnen 1931–1939 und 1952–1969.* Wissenschaftliche Veröffentlichung der Deutschen Orient-Gesellschaft 87. Berlin: Gebr. Mann Verlag.

Bonnet, Charles

2004a "Kerma." In Welsby and Anderson 2004b, pp. 78–82.

2004b "The Kerma Culture." In Welsby and Anderson 2004b, pp. 70–77.

2004c With Dominique Valbelle. *Le temple principal de la ville de Kerma et son quartier religieux.* Paris: Errance.

Bonnet, Charles, and Dominique Valbelle

2004 "Kerma, Dokki Gel." In Welsby and Anderson 2004b, pp. 109–12.

Van den Boorn, G. P. F.

1988 *The Duties of the Vizier: Civil Administration in the Early New Kingdom.* Studies in Egyptology. London and New York: Kegan Paul International.

Borchardt, Ludwig

1896 "Zur Geschichte des Luqsortempels." *ZÄS* 34, pp. 122–38.

1905 "Statuen von Feldmessern." *ZÄS* 42, pp. 70–72.

1911–36 *Statuen und Statuetten von Königen und Privatleuten.* 5 vols. Catalogue général des antiquités égyptiennes du musée du Caire, nos. 1–1294. Berlin: Reichsdruckerei.

1937 *Die Entstehung des Generalkatalogs und seine Entwicklung in den Jahren 1897–1899.* Catalogue général des antiquités égyptiennes du musée du Caire. Berlin: Reichsdruckerei.

Borgeaud, Philippe, et al.

1994 Philippe Borgeaud, Françoise Bruschweiler, Enrico Norelli, and Albert de Pury, eds. *Le temple lieu de conflit: Actes du colloque de Cartigny, 1991.* Les cahiers du Centre d'Étude du Proche-Orient Ancien, Université de Genève 7. Louvain: Peeters.

Borghouts, Joris F.

1978 Trans. *Ancient Magical Texts.* Leiden: E. J. Brill.

1982 "Month." In *LÄ*, vol. 4, cols. 200–204. Wiesbaden: Otto Harrassowitz.

Bothmer, Bernard V.

1966–67 "Private Sculpture of Dynasty XVIII in Brooklyn." *Brooklyn Museum Annual* 8, pp. 55–89. Reprinted in *Egyptian Art: Selected Writings of Bernard V. Bothmer,* ed. Madeleine Cody, with Paul Edmund Stanwick and Marsha Hill, pp. 167–98. Oxford: Oxford University Press, 2004.

1969–70 "More Statues of Senenmut." *Brooklyn Museum Annual,* vol. 11, pt. 2, pp. 125–43. Reprinted in *Egyptian Art: Selected Writings of Bernard V. Bothmer,* ed. Madeleine Cody, with Paul Edmund Stanwick and Marsha Hill, pp. 217–36. Oxford: Oxford University Press, 2004.

Bourriau, Janine

1981a "Nubians in Egypt during the Second Inter-mediate Period: An Interpretation Based on the Egyptian Ceramic Evidence." In *Studien zur altägyptischen Keramik,* ed. Dorothea Arnold, pp. 25–41. Mainz am Rhein: Philipp von Zabern.

1981b *Umm el-Ga'ab: Pottery from the Nile Valley before the Arab Conquest.* Exh. cat. Cambridge: Cambridge University Press.

1982 "Clay Figure Vases." In *Egypt's Golden Age* 1982, pp. 101–2.

1984 "Salbgefässe." In *LÄ*, vol. 5, cols. 362–66. Wiesbaden: Otto Harrassowitz.

1987 "Pottery Figure Vases of the New Kingdom." *Cahiers de la céramique égyptienne* 1, pp. 81–96.

1988 *Pharaohs and Mortals: Egyptian Art in the Middle Kingdom.* Exh. cat. Cambridge: Fitzwilliam Museum.

1990 "Canaanite Jars from New Kingdom Deposits at Memphis, Kom Rabi'a." *Eretz-Israel* 21, pp. 18–26.

1991 "Relations between Egypt and Kerma during the Middle and New Kingdoms." In *Egypt and Africa: Nubia from Prehistory to Islam,* ed. W. Vivian Davies, pp. 129–44. London: British Museum Press for the Trustees of the British Museum and the Egypt Exploration Society.

1997 "Beyond Avaris: The Second Intermediate Period in Egypt Outside the Eastern Delta." In *The Hyksos: New Historical and Archaeological Perspectives,* ed. Eliezer D. Oren, pp. 159–82. University Museum Monograph 96. University Museum Symposium Series 8. Philadelphia: University Museum, University of Pennsylvania.

1999 "Some Archaeological Notes on the Kamose Texts." In *Studies on Ancient Egypt in Honour of H. S. Smith,* ed. Anthony Leahy and John Tait, pp. 43–48. Occasional Publications (Egypt Exploration Society) 13. London: Egypt Exploration Society.

2000 "The Second Intermediate Period (c. 1650–1550 BC)." In *The Oxford History of Ancient Egypt,* ed. Ian Shaw, pp. 184–217, 461–62. Oxford: Oxford University Press.

Bourriau, Janine, and Paul T. Nicholson

1992 "Marl Clay Pottery Fabrics of the New Kingdom from Memphis, Saqqara and Amarna." *JEA* 78, pp. 29–91.

Brand, Peter James

2000 *The Monuments of Seti I: Epigraphic, Historical, and Art Historical Analysis.* Probleme der Ägyptologie 16. Boston and Leiden: E. J. Brill.

Breasted, James Henry

1900 *A New Chapter in the Life of Thutmose III.* Untersuchungen zur Geschichte und Altertumskunde Aegyptens 2. Leipzig: J. C. Hinrichs.

1912 *A History of Egypt: From the Earliest Times to the Persian Conquest.* 2nd ed. New York: Charles Scribner's Sons.

Brewer, Douglas J., and Renée F. Friedman

1989 *Fish and Fishing in Ancient Egypt.* Natural History of Egypt 2. Warminster: Aris and Phillips.

Brier, Bob

1980 *Ancient Egyptian Magic.* New York: Morrow.

Van den Brink, Edwin C. M., and Thomas E. Levy

2002 Eds. *Egypt and the Levant: Interrelations from the Fourth through the Early Third Millennium BCE.* New Approaches to Anthropological Archaeology. London: Leicester University Press.

Broekhuis, Jan

1971 *De godin Renenwetet.* Assen: Van Gorcum.

Brovarski, Edward

1982 "Kohl and Kohl Containers." In *Egypt's Golden Age* 1982, pp. 216–18.

1986 "Tempelpersonal. I." In *LÄ*, vol. 6, cols. 387–401. Wiesbaden: Otto Harrassowitz.

1997 "Old Kingdom Beaded Collars." In *Ancient Egypt, the Aegean, and the Near East: Studies in Honour of Martha Rhoads Bell,* ed. Jacke Phillips, vol. 1, pp. 137–62. San Antonio: Van Siclen Books.

Brunner, Hellmut

1962 "Nochmals der König im Falkenkleid." *ZÄS* 87, pp. 76–77.

Brunner-Traut, Emma

1970a "Gravidenflasche: Das Salben des Mutterleibes." In *Archäologie und Altes Testament: Festschrift für Kurt Galling zum 8. Januar 1970,* ed. Arnulf Kuschke and Ernst Kutsch, pp. 35–48. Tübingen: J. C. B. Mohr.

1970b "Das Muttermilchkrüglein: Ammen mit Stillumhang und Mondamulett." *Die Welt des Orients* 5, pp. 145–64.

1971 "Nachlese zu zwei Arzneigefässen." *Die Welt des Orients* 6, pp. 4–6.

1972 "Letters to the Editor." *Israel Exploration Journal* 22, p. 192.

1977 "Giraffe." In *LÄ*, vol. 2, cols. 600–601. Wiesbaden: Otto Harrassowitz.

Brunner-Traut, Emma, and Hellmut Brunner

1981 *Die Ägyptische Sammlung der Universität Tübingen.* 2 vols. Mainz am Rhein: Philipp von Zabern.

Brunner-Traut, Emma, Hellmut Brunner, and Johanna Zick-Nissen

1984 *Osiris—Kreuz und Halbmond: Die drei Religionen Ägyptens.* Exh. cat., Kunstgebäude am Schlossplatz, Stuttgart, and Kestner-Museum, Hanover. Mainz am Rhein: Philipp von Zabern.

Brunton, Guy

1930 *Qau and Badari.* Vol. 3. Publications of the Egyptian Research Account and British School of Archaeology in Egypt 50. London: British School of Archaeology in Egypt and Bernard Quaritch.

Brunton, Guy, and Reginal Engelbach

1927 *Gurob.* Publications of the Egyptian Research Account and British School of Archaeology in Egypt 41. London: British School of Archaeology in Egypt and Bernard Quaritch.

Brussels, Musées Royaux d'Art et d'Histoire

1934 *Département égyptien: Album—édition de la Fondation Égyptologique Reine Élisabeth.* Preface by Marcelle Werbrouck. Brussels.

Bruyère, Bernard

1930 *Fouilles de l'Institut Français d'Archéologie Orientale du Caire (année 1929): Rapports préliminaires.* Pt. 2, *Rapport sur les fouilles de Deir el Médineh (1929).* Fouilles de l'Institut Français d'Archéologie Orientale du Caire, vol. 7, pt. 2. Cairo: Institut Français d'Archéologie Orientale du Caire.

1937 *Rapport sur les fouilles de Deir el Médineh (1934–1935).* Pt. 2, *La nécropole de l'est.* Fouilles de l'Institut Français d'Archéologie Orientale du Caire, vol. 15, pt. 2. Cairo: Institut Français d'Archéologie Orientale du Caire.

Bryan, Betsy M.

1991 *The Reign of Thutmose IV.* Baltimore and London: Johns Hopkins University Press.

1992 "Royal and Divine Statuary." In Kozloff and Bryan 1992, pp. 125–53.

1996 "In Women Good and Bad Fortune Are on Earth: Status and the Roles of Women in Egyptian Culture." In Capel and Markoe 1996, pp. 25–46.

1997 "The Statue Program for the Mortuary Temple of Amenhotep III." In *The Temple in Ancient Egypt: New Discoveries and Recent Research,* ed. Stephen Quirke, pp. 57–81. Papers from a colloquium held by the Department of Egyptian Antiquities, British Museum, July 21–22, 1994. London: British Museum Press for the Trustees of the British Museum.

2000 "The Eighteenth Dynasty before the Amarna Period (*c.* 1550–1352 BC)." In *The Oxford History of Ancient Egypt,* ed. Ian Shaw, pp. 218–71, 462–64. Oxford: Oxford University Press.

Brysbaert, Ann

2002 "Common Craftsmanship in the Aegean and East Mediterranean Bronze Age: Preliminary Technological Evidence with Emphasis on the Painted Plaster from Tell el-Dabʿa, Egypt." *Ä&L* 12, pp. 95–107.

Budge, E. A. Wallis

1925 *The Mummy: Chapters on Egyptian Funerary Archaeology.* 2nd ed. Cambridge: Cambridge University Press.

Busch, Ralf

2002 Ed. *Megiddo—Tell el-Mutesellim—Armageddon: Biblische Stadt zwischen Krieg und Frieden.* Exh. cat., Helms-Museum, Hamburg. Veröffentlichungen des Helms-Museums 88. Neumünster: Wachholtz.

Cabrol, Agnès

1995 "Une représentation de la tombe de Khâbekhenet et les dromos de Karnak-sud: Nouvelles hypothèses." *Cahiers de Karnak* 10, pp. 33–63.

Callender, Vivienne G.

2004 "Queen Tausret and the End of Dynasty 19." *SAK* 32, pp. 81–104.

Caminos, Ricardo Augustus

1968 *The Shrines and Rock-Inscriptions of Ibrim.* Archaeological Survey of Egypt, Thirty-second Memoir. London: Egypt Exploration Society.

1974 *The New-Kingdom Temples of Buhen.* 2 vols. Archaeological Survey of Egypt, Thirty-third and Thirty-fourth Memoir. London: Egypt Exploration Society.

1998 *Semna—Kumma.* Vol. 1, *The Temple of Semna.* Archaeological Survey of Egypt, Thirty-seventh Memoir. London: Egypt Exploration Society.

Caminos, Ricardo Augustus, and T. G. H. James

1963 *Gebel es-Silsilah.* Vol. 1, *The Shrines.* Archaeological Survey of Egypt, Thirty-first Memoir. London: Egypt Exploration Society.

Capart, Jean

1911 *Donation d'antiquités égyptiennes aux Musées Royaux de Bruxelles: Description et analyse.* Brussels: Vromant. Reprinted from the *Bulletin des Musées des Royaux des Art Décoratifs et Industriels,* 1908 and 1909.

1931 *Documents pour servir à l'étude de l'art égyptien.* Paris: Les Éditions du Pégase.

1947 *L'art égyptien: Choix de documents, accompagnés d'indications bibliographiques.* Vol. 4, *Les arts mineurs.* Brussels: Vromant.

Capel, Anne K., and Glenn E. Markoe

1996 Eds. *Mistress of the House, Mistress of Heaven: Women in Ancient Egypt.* With essays by Catharine H. Roehrig, Betsy M. Bryan, and Janet H. Johnson; catalogue by Anne K. Capel et al. Exh. cat., Cincinnati Art Museum. New York: Hudson Hills Press in association with the Cincinnati Art Museum.

Carlotti, Jean-François

1995 "Mise au point sur les dimensions et la localisation de la chapelle d'Hatchepsout à Karnak." *Cahiers de Karnak* 10, pp. 140–66.

Carnarvon, Earl of (George Edward Stanhope Molyneux Herbert), and Howard Carter

1912 *Five Years' Explorations at Thebes: A Record of Work Done 1907–1911.* London.

Carter, Howard

1903 "Report on General Work Done in the Southern Inspectorate." *ASAE* 4, pp. 43–50.

1916a "Report on the Tomb of Zeser-ka-ra Amenhetep I, Discovered by the Earl of Carnarvon in 1914." *JEA* 3, pp. 147–54.

1916b "A Tomb Prepared for Queen Hatshepsuit Discovered by the Earl of Carnarvon (October 1916)." *ASAE* 16, pp. 179–82.

1917 "A Tomb Prepared for Queen Hatshepsuit and Other Recent Discoveries at Thebes." *JEA* 4, pp. 107–18.

Casson, Lionel

1981 *The Pharaohs.* Treasures of the World. Chicago: Stonehenge Press.

Castiglioni, Alfredo, and Angelo Castiglioni

2003 "Pharaonic Inscriptions Along the Eastern Desert Routes in Sudan." *S&N,* no. 7, pp. 47–51.

Castiglioni, Alfredo, Angelo Castiglioni, and Jean Vercoutter

1995 *L'Eldorado dei faraoni: Alla scoperta di Berenice Pancrisia.* Novara: Istituto Geografico De Agostini.

Castiglioni, Angelo, and Alfredo Castiglioni

2004 "Gold in the Eastern Desert." In Welsby and Anderson 2004b, pp. 122–26.

Cauville, Sylvie

2002 *Dendara: Les fêtes d'Hathor.* Orientalia Lovaniensia Analecta 105. Louvain: Peeters.

Černý, Jaroslav

1969 "Stela of Emḥab from Tell Edfu." *MDAIK* 24, pp. 87–92.

Champollion, Jean-François

1833 *Lettres écrites d'Égypte et de Nubie, en 1828 et 1829: Collection complète, accompagnée de trois mémoires inédits.* Paris: Firmin Didot Frères.

Chappaz, Jean-Luc

1993a "Un cas particulier de corégence: Hatshepsout et Thoutmosis III." In *Individu, société et spiritualité dans l'Égypte pharaonique et copte: Mélanges égyptologiques offerts au Professeur Aristide Théodoridès,* ed. Christian Cannuyer and Jean-Marie Kruchten, pp. 87–110. Ath: Illustra.

1993b "Comment une femme put devenir roi." In *Hatchepsout* 1993, pp. 6–15.

Chassinat, Émile

1905–6 "Work of the Institut Français d'Archéologie Orientale du Caire, 1904–1906." In *Archaeological Report, 1905–1906,* pp. 81–85. London: Egypt Exploration Fund.

Chevrier, Henri

1934 "Rapport sur les travaux de Karnak (1933–1934)." *ASAE* 34, pp. 159–76.

1955 "Rapport sur les travaux de Karnak, 1953–1954." *ASAE* 53, pp. 21–42.

Christie's

2001 *Antiquities.* Sale cat., Christie's, New York, December 5 and 6, 2001.

Christophe, Louis-A.

1951 *Karnak-Nord.* Vol. 3, *1945–1949.* Fouilles de l'Institut Français d'Archéologie Orientale du Caire 23. Cairo: Institut Français d'Archéologie Orientale du Caire.

Clayton, Peter A.

1994 *Chronicle of the Pharaohs: The Reign-by-Reign Record of the Rulers and Dynasties of Ancient Egypt.* New York: Thames and Hudson.

Collecting Egyptian Art

1956 *Five Years of Collecting Egyptian Art, 1951–1956.* Exh. cat. Brooklyn: Brooklyn Museum.

Collection of Christos G. Bastis

1987 *Antiquities from the Collection of Christos G. Bastis.* Exh. cat., The Metropolitan Museum of Art, New York. New York and Mainz am Rhein: Philipp von Zabern.

Cooney, John D.

1953 "Egyptian Art in the Collection of Albert Gallatin." *JNES* 12 (January), pp. 1–19.

1976 *Catalogue of Egyptian Antiquities in the British Museum.* Vol. 4, *Glass.* London: British Museum Publications for the Trustees of the British Museum.

Corteggiani, Jean-Pierre

1987 *The Egypt of the Pharaohs at the Cairo Museum.* Trans. Anthony Roberts. London: Scala Books.

Cox, Warren E.

1944 *The Book of Pottery and Porcelain.* 2 vols. New York: Crown Publishers.

Cumming, Barbara

1984 *Egyptian Historical Records of the Later Eighteenth Dynasty.* Fasc. 2. Warminster: Aris and Phillips.

Curto, Silvio, and M. Mancini

1968 "News of Khaᶜ and Meryt." *JEA* 54, pp. 77–81.

Czerner, Rafal, and Stanisław Medeksza

1992 "The New Observations on the Architecture of the Temple of Tuthmosis III at Deir el-Bahari." In *Sesto Congresso Internazionale di Egittologia: Atti,* vol. 1, pp. 119–23. Turin: International Association of Egyptologists.

Damiano-Appia, M.

1999 "Inscriptions Along the Tracks from Kubban, Buhen and Kumma to 'Berenice Panchrysos' and to the South." In *Studien zum antiken Sudan: Akten der 7. Internationalen Tagung für Meroitische Forschungen von 14. bis 19. September 1992 in Gosen/bei Berlin,* ed. Steffen Wenig, pp. 511–42. Meroitica 15. Wiesbaden: Otto Harrassowitz.

Daressy, Georges

1902 *Fouilles de la Vallée des Rois (1898–1899).* Catalogue général des antiquités égyptiennes du musée du Caire, nos. 24001–24990. Cairo: Institut Français d'Archéologie Orientale du Caire.

1909 *Cercueils des cachettes royales.* Catalogue général des antiquités égyptiennes du musée du Caire, nos. 61001–61044. Cairo: Institut Français d'Archéologie Orientale du Caire.

1928–29 "Les branches du Nil sous la XVIIIᵉ Dynastie." *Bulletin de la Société de Géographie d'Égypte* 16, pp. 225–54, 293–329.

1929–31 "Les branches du Nil sous la XVIIIᵉ Dynastie." *Bulletin de la Société de Géographie d'Égypte* 17, pp. 81–115, 189–223.

Darnell, John Coleman

1995 "Hathor Returns to Medamûd." *SAK* 22, pp. 47–94.

2002a With Deborah Darnell. "Opening the Narrow Doors of the Desert: Discoveries of the Theban Desert Road Survey." In *Egypt and Nubia: Gifts of the Desert,* ed. Renée F. Friedman, pp. 132–55. London: British Museum Press.

2002b With Deborah Darnell. *Theban Desert Road Survey in the Egyptian Western Desert.* Vol. 1, *Gebel Tjauti Rock Inscriptions 1–45 and Wadi el-Ḥôl Rock Inscriptions 1–45.* With contributions by Deborah Darnell, Renée F. Friedman, and Stan Hendrickx. Oriental Institute Publications 119. Chicago: The Oriental Institute of the University of Chicago.

Daumas, François

1977 "Hathor." In *LÄ,* vol. 2, cols. 1024–33. Wiesbaden: Otto Harrassowitz.

Davies, Nina de Garis

1936 With Alan H. Gardiner. *Ancient Egyptian Paintings.* 3 vols. Chicago: University of Chicago Press.

1963 *Scenes from Some Theban Tombs (Nos. 38, 66, 162, with Excerpts from 81).* Private Tombs at Thebes 4. Oxford: Oxford University Press for the Griffith Institute.

Davies, Nina de Garis, and Alan H. Gardiner

1915 *The Tomb of Amenemhēt (No. 82).* The Theban Tombs Series 1. London: Egypt Exploration Fund.

Davies, Norman de Garis

1908 *The Rock Tombs of El Amarna.* Pt. 6, *Tombs of Parennefer, Tutu, and Aÿ.* Archaeological Survey of Egypt, Eighteenth Memoir. London: Egypt Exploration Fund.

1917 *The Tomb of Nakht at Thebes.* Publications of The Metropolitan Museum of Art Egyptian Expedition, Robb de Peyster Tytus Memorial Series 1. New York: The Metropolitan Museum of Art.

1922–23 *The Tomb of Puyemrê at Thebes.* 2 vols. Publications of The Metropolitan Museum of Art Egyptian Expedition, Robb de Peyster Tytus Memorial Series 2, 3. New York: The Metropolitan Museum of Art.

1923 *The Tombs of Two Officials of Tuthmosis the Fourth (Nos. 75 and 90).* The Theban Tomb Series 3. London: Egypt Exploration Society.

1925 *The Tomb of the Two Sculptors at Thebes.* Publications of The Metropolitan Museum of Art Egyptian Expedition, Robb de Peyster Tytus Memorial Series 4. New York: The Metropolitan Museum of Art.

1927 *Two Ramesside Tombs at Thebes.* Publications of The Metropolitan Museum of Art Egyptian Expedition, Robb de Peyster Tytus Memorial Series 5. New York: The Metropolitan Museum of Art.

1930 *The Tomb of Ḳen-Amūn at Thebes.* 2 vols. The Metropolitan Museum of Art Egyptian Expedition. New York.

1932 "Teḥuti: Owner of Tomb 110 at Thebes." In *Studies Presented to F. Ll. Griffith,* pp. 279–90. London: Egypt Exploration Society.

1933 *The Tomb of Nefer-hotep at Thebes.* 2 vols. Publications of The Metropolitan Museum of Art Egyptian Expedition 9. New York: The Metropolitan Museum of Art.

1935 *Paintings from the Tomb of Rekh-mi-Rē at Thebes.* Publications of The Metropolitan Museum of Art Egyptian Expedition 10. New York: The Metropolitan Museum of Art.

1943 *The Tomb of Rekh-mi-Rē at Thebes.* Publications of The Metropolitan Museum of Art Egyptian Expedition 11. New York: The Metropolitan Museum of Art.

1948 *Seven Private Tombs at Kurnah.* Ed. Alan H. Gardiner. Mond Excavations at Thebes 2. London: Egypt Exploration Society.

Davies, Norman de Garis, and Raymond Oliver Faulkner

1947 "A Syrian Trading Venture to Egypt." *JEA* 33, pp. 40–46.

Davies, W. Vivian

1981 *A Royal Statue Reattributed.* Occasional Paper (British Museum) 28. London: British Museum.

1982a "Razors." In *Egypt's Golden Age* 1982, pp. 189–91.

1982b "Thebes." In *Excavating in Egypt: The Egypt Exploration Society, 1882–1982,* ed. T. G. H. James, pp. 51–70. London: Trustees of the British Museum.

1987 *Catalogue of Egyptian Antiquities in the British Museum.* Vol. 7, *Tools and Weapons.* Pt. 1, *Axes.* London: British Museum Publications for the Trustees of the British Museum.

2001 "Kurgus 2000: The Egyptian Inscriptions." *S&N,* no. 5, pp. 46–58.

2003a "La frontière méridionale de l'empire: Les égyptiens à Kurgus." *Bulletin de la Société Française d'Égyptologie,* no. 157 (June), pp. 23–37.

2003b "Kouch en Égypte: Une nouvelle inscription historique à el-Kab." *Bulletin de la Société Française d'Égyptologie,* no. 157 (June), pp. 38–44.

2003c "Kurgus 2002: The Inscriptions and Rock-Drawings." *S&N,* no. 7, pp. 55–57.

2003d "Kush in Egypt: A New Historical Inscription." *S&N,* no. 7, pp. 52–54.

2003e "Sobeknakht of Elkab and the Coming of Kush." *Egyptian Archaeology,* no. 23, pp. 3–6.

2004 "The Rock Inscriptions at Kurgus in the Sudan." In *Séhel entre Égypte et Nubie— inscription rupestres et graffiti de l'époque pharaonique: Actes du colloque international (31 mai–1ᵉʳ juin 2002), Université Paul-Valéry, Montpellier,* ed. Annie Gasse and Vincent Rondot, pp. 149–60. Orientalia Monspeliensia. Montpellier: Université Paul-Valéry.

Davies, W. Vivian, and Renée F. Friedman

1998 *Egypt Uncovered.* New York: Stewart, Tabori and Chang.

Davis, Ellen N.

1986 "Youth and Age in the Thera Frescoes." *American Journal of Archaeology* 90 (October), pp. 399–406.

Delange, Elisabeth

1987 *Catalogue des statues égyptiennes du Moyen Empire, 2060–1560 avant J.-C.* Musée du Louvre. Paris: Éditions de la Réunion des Musées Nationaux.

1993 *Rites et beauté: Objets de toilette égyptiens,* Musée du Louvre. Paris: Éditions de la Réunion des Musées Nationaux.

Description de l'Égypte

1821–30 *Description de l'Égypte; ou, Recueil des observations et des recherches qui ont été faites en Égypte pendant l'expédition de l'armée française.* 2nd ed. 24 vols. Paris: C. L. F. Panckoucke.

Desroches-Noblecourt, Christiane

1952 "Pots anthropomorphes et recettes magico-

médicales dans l'Égypte ancienne." *Revue d'égyptologie* 9, pp. 49–67.

1986 *La femme au temps des pharaons*. Paris: Stock and Laurence Pernoud. Repr., 1993.

1995 *Amours et fureurs de La Lointaine: Clés pour la compréhension de symboles égyptiens*. Paris: Stock/Pernoud.

2002 *La reine mystérieuse: Hatshepsout*. Paris: Éditions Pygmalion.

Desroches-Noblecourt, Christiane, et al.

1986 *Sen-nefer: Die Grabkammer des Bürgermeisters von Theben*. Exh. cat., Römisch-Germanisches Museum, Cologne. Mainz am Rhein: Philipp von Zabern.

Devéria, Théodule

1896 "Notice de quelques antiquités relatives au basilicogrammate Thouth ou Teti, pour faire suite au mémoire de M. Samuel Birch sur une patère égyptienne du Musée du Louvre." In Théodule Devéria, *Mémoires et fragments*, pp. 35–53. Bibliothèque égyptologique 4. Paris: E. Leroux. Reprinted from *Mémoires de la Société Impériale des Antiquaires de France*, 3rd ser., 4 (1859), pp. 75–100.

Van Dijk, Jacobus

1988 "The Development of the Memphite Necropolis in the Post-Amarna Period." In *Memphis et ses nécropoles au Nouvel Empire— nouvelles données, nouvelles questions: Actes du colloque international CNRS, Paris, 9 au 11 octobre 1986*, ed. Alain-Pierre Zivie, pp. 37–46. Paris: Éditions du Centre National de la Recherche Scientifique.

Dixon, D. M.

2004 "Pharaonic Egypt and the Red Sea Arms Trade." In *Trade and Travel in the Red Sea Region: Proceedings of Red Sea Project I, Held in the British Museum October 2002*, ed. Paul Lunde and Alexandra Porter, pp. 33–41. Society for Arabian Studies Monographs 2. BAR International Series 1269. Oxford: Archaeopress.

Dodson, Aidan

1998 "On the Burial of Maihirpri and Certain Coffins of the Eighteenth Dynasty." In *Proceedings of the Seventh International Congress of Egyptologists, Cambridge, 3–9 September 1995*, ed. C. J. Eyre, pp. 331–38. Orientalia Lovaniensia Analecta 82. Louvain: Peeters.

Doll, Susan K.

1982 "Medicine." In *Egypt's Golden Age* 1982, pp. 290–91.

Donadoni Roveri, Anna Maria

1990 *Museo Egizio*. Turin: Barisone Editore.

2002 "The Funerary Equipment." In Ziegler 2002a, pp. 327–41.

Dorman, Peter F.

1980 "Recumbent Ibex." In The Metropolitan Museum of Art, *Notable Acquisitions, 1979– 1980*, pp. 11–12. New York: The Metropolitan Museum of Art.

1985 Review of Meyer 1982. *Bibliotheca Orientalis* 42 (May–July), cols. 295–302.

1988 *The Monuments of Senenmut: Problems in Historical Methodology*. London and New York: Kegan Paul International.

1991 *The Tombs of Senenmut: The Architecture and Decoration of Theban Tombs 71 and 353*. Publications of The Metropolitan Museum of Art Egyptian Expedition 24. New York: The Metropolitan Museum of Art.

1995a "The Epigraphic Survey." In *The Oriental Institute Annual Report, 1994–1995*. Chicago: University of Chicago.

1995b "Two Tombs and One Owner." In Assmann et al. 1995, pp. 141–54.

1997 "A Fragment of Relief from the Tomb of Senenmut (TT 71)." In *Iubilate Conlege: Studies in Memory of Abdel Aziz Sadek*, pt. 1, pp. 83–89. Special issue of *Varia Aegyptiaca* 10 (1995; pub. 1997).

2002 *Faces in Clay: Technique, Imagery, and Allusion in a Corpus of Ceramic Sculpture from Ancient Egypt*. Münchner ägyptologische Studien 52. Mainz am Rhein: Philipp von Zabern.

2003 "Family Burial and Commemoration in the Theban Necropolis." In *The Theban Necropolis: Past, Present and Future*, ed. Nigel Strudwick and John H. Taylor, pp. 30–41. London: British Museum Press.

2005 "The Early Reign of Thutmose III: An Unorthodox Mantle of Coregency." In *Thutmose III: A New Biography*, ed. Eric H. Cline and David B. O'Connor, pp. 39–68. Ann Arbor: University of Michigan Press.

Dorner, Josef, and Pieter Jánosi

2001 "Die Grabungsfläche H/V und andere Untersuchungen in ʿEzbet Helmi." Pt. 10 of Bietak, Dorner, and Jánosi 2001, pp. 105–19.

Drenkhahn, Rosemarie

1989 *Ägyptische Reliefs im Kestner-Museum Hannover*. Sammlungskatalog 5. Hanover: Kestner-Museum.

Dreyer, Günter

1984 "Eine Statue Thutmosis' II. aus Elephantine." *SAK* 11, pp. 489–99.

Drioton, Étienne

1927 *Rapport sur les fouilles de Médamoud (1926): Rapports préliminaires*. Pt. 2, *Les inscriptions*. Fouilles de l'Institut Français d'Archéologie Orientale du Caire, vol. 4, pt. 2. Cairo: Institut Français d'Archéologie Orientale du Caire.

1938 "Deux cryptogrammes de Senenmout." *ASAE* 38, pp. 231–46.

von Droste zu Hülshoff, Vera

1981 *Der Igel im alten Ägypten*. Hildesheimer ägyptologische Beiträge 11. Hildesheim: Gerstenberg.

Dunham, Dows

1970 *The Barkal Temples: Excavated by George Reisner*. Boston: Museum of Fine Arts.

Dunham, Dows, and Jozef M. A. Janssen

1960 *Second Cataract Forts*. Vol. 1, *Semna, Kumma*. Boston: Museum of Fine Arts.

Dunham, Dows, and William Kelly Simpson

1974 *The Mastaba of Queen Mersyankh III, G7530– 7540*. Giza Mastabas 1. Boston: Museum of Fine Arts, Department of Egyptian and Ancient Near Eastern Art.

Dupeux, Cécile, Peter Jezler, and Jean Wirth

2000 Eds. *Bildersturm: Wahnsinn oder Gottes Wille?* Exh. cat. Zürich: Neue Zürcher Zeitung; Bern: Bern Historisches Museum.

Dziobek, Eberhard

1992 *Das Grab des Ineni: Theben Nr. 81*. Archäologische Veröffentlichungen (Deutsches Archäologisches Institut, Abteilung Kairo) 68. Mainz am Rhein: Philipp von Zabern.

1993 "Some Kings' Sons Revisited." *GM*, no. 132, pp. 29–32.

1994 *Die Gräber des Vezirs User-Amun: Theben Nr. 61 und 131*. Archäologische Veröffentlichungen (Deutsches Archäologisches Institut, Abteilung Kairo) 84. Mainz am Rhein: Philipp von Zabern.

1995 "Theban Tombs as a Source for Historical and Biographical Evaluation: The Case of User-Amun." In Assmann et al. 1995, pp. 129–40.

1998 *Denkmäler des Vezirs User-Amun*. Studien zur Archäologie und Geschichte Altägyptens 18. Heidelberg: Heidelberger Orientverlag.

Eaton-Krauss, Marianne

1977 "The *Khat* Headdress to the End of the Amarna Period." *SAK* 5, pp. 21–39.

1982 "Earrings." In *Egypt's Golden Age* 1982, p. 227.

1998 "Four Notes on the Early Eighteenth Dynasty." *JEA* 84, pp. 205–10.

1999 "The Fate of Sennefer and Senetnay at Karnak Temple and in the Valley of the Kings." *JEA* 85, pp. 113–29.

Eder, Christian

2002 *Die Barkenkapelle des Königs Sobekhotep III. in Elkab: Beiträge zur Bautätigkeit der 13. und 17. Dynastie an den Göttertempeln Ägyptens*. Elkab 7 (Publications of the Comité des Fouilles Bèlges en Égypte). Brussels: Musées Royaux d'Art et d'Histoire; Turnhout: Brepols.

Edgerton, William F.

1933 *The Thutmosid Succession*. Studies in Ancient Oriental Civilization, The Oriental Institute of the University of Chicago 8. Chicago: University of Chicago Press.

Edwards, Amelia B.

1891 *Pharaohs, Fellahs and Explorers*. New York: Harper and Brothers. Repr., The Kegan Paul Library of Ancient Egypt. London: Kegan Paul, 2003.

Edwards, David N.

2004 *The Nubian Past: An Archaeology of the Sudan*. London and New York: Routledge.

Eggebrecht, Arne

1975 "Armant." In *LÄ*, vol. 1, cols. 435–41.
Wiesbaden: Otto Harrassowitz.

Egypt's Golden Age

1982 *Egypt's Golden Age: The Art of Living in the New Kingdom, 1558–1085 B.C.* Exh. cat. Boston: Museum of Fine Arts.

Elsasser, Albert B., and Vera-Mae Fredrickson

1966 *Ancient Egypt.* Exh. cat., Robert H. Lowie Museum of Anthropology, University of California, Berkeley. Berkeley and Los Angeles: University of California Press.

Emery, Walter B., Henry Sidney Smith, and Alan Millard

1979 *The Fortress of Buhen: The Archaeological Report.* With contributions by D. M. Dixon et al. Excavations at Buhen 1. London: Egypt Exploration Society.

Eremin, Katherine, et al.

2000 Katherine Eremin, Elizabeth Goring, Bill Manley, and Caroline Cartwright. "A Seventeenth Dynasty Egyptian Queen in Edinburgh?" *KMT*, vol. 11, no. 3 (Fall), pp. 32–40.

Eriksson, Kathryn O.

1993 *Red Lustrous Wheel-Made Ware.* Studies in Mediterranean Archaeology 103. Jonsered: Paul Åströms Förlag.

2001 "Cypriot Ceramics in Egypt during the Reign of Thutmosis III: The Evidence of Trade for Synchronizing the Late Cypriot Cultural Sequence with Egypt at the Beginning of the Late Bronze Age." In *The Chronology of Base-Ring Ware and Bichrome Wheel-Made Ware: Proceedings of a Colloquium Held in the Royal Academy of Letters, History and Antiquities, Stockholm, May 18–19, 2000*, ed. Paul Åström, pp. 51–68. Konferenser 54. Stockholm: Kungl. Vitterhets Historie och Antikvitets Akademien.

2004 "Using Cypriot Red Lustrous Wheel-Made Ware to Establish Cultural and Chronological Synchronisms during the Late Bronze Age." Paper presented at the conference "The Synchronization of Civilizations in the Eastern Mediterranean in the 2nd Millennium BC, 2000," held in Vienna, November 4–7, 2004.

Erman, Adolf

1894 *Life in Ancient Egypt.* Trans. H. M. Tirard. London and New York: Macmillan. Repr., New York: Dover Publications, 1971.

Evans, Arthur J.

1928 *The Palace of Minos; a Comparative Account of the Successive Stages of the Early Cretan Civilization as Illustrated by the Discoveries at Knossos.* Vol. 2. London: Macmillan.

Evers, Hans Gerhard

1929 *Staat aus dem Stein: Denkmäler, Geschichte und Bedeutung der ägyptischen Plastik während des Mittleren Reichs.* 2 vols. Munich: F. Bruckmann.

Fairman, H. W., and Bernhard Grdseloff

1947 "Texts of Hatshepsut and Sethos I inside Speos Artemidos." *JEA* 33, pp. 12–33.

Fakhry, Ahmed

1939 "A New Speos from the Reign of Hatshepsut and Tuthmosis III at Beni-Ḥasan." *ASAE* 39, pp. 709–23.

Fay, Biri

1988 "Amenemhat V—Vienna/Assuan." *MDAIK* 44, pp. 67–77.

1995 "Tuthmoside Studies." *MDAIK* 51, pp. 11–22.

1996 *The Louvre Sphinx and Royal Sculpture from the Reign of Amenemhat II.* Mainz am Rhein: Philipp von Zabern.

1998a "Egyptian Duck Flasks of Blue Anhydrite." *Metropolitan Museum Journal* 33, pp. 23–48.

1998b "Royal Women as Represented in Sculpture during the Old Kingdom." In *Les critères de datation stylistiques à l'Ancien Empire*, ed. Nicolas Grimal, pp. 159–86. Bibliothèque d'étude (Institut Français d'Archéologie Orientale du Caire) 120. Cairo: Institut Français d'Archéologie Orientale du Caire.

Fazzini, Richard A.

1975 *Images for Eternity: Egyptian Art from Berkeley and Brooklyn.* San Francisco: Fine Arts Museums of San Francisco; Brooklyn: Brooklyn Museum.

1984–85 "Report on the 1983 Season of Excavation at the Precinct of the Goddess Mut." *ASAE* 70, pp. 287–307.

1997 "Several Objects, and Some Aspects of the Art of the Third Intermediate Period." In *Chief of Seers: Egyptian Studies in Memory of Cyril Aldred*, ed. Elizabeth Goring, Nicholas Reeves, and John Ruffle, pp. 113–37. London and New York: Kegan Paul International.

2001 "Mut Precinct." In *The Oxford Encyclopedia of Ancient Egypt*, ed. Donald B. Redford, vol. 2, pp. 455–57. Oxford: Oxford University Press.

2002 "Some Aspects of the Precinct of the Goddess Mut in the New Kingdom." In *Leaving No Stones Unturned: Essays on the Ancient Near East and Egypt in Honor of Donald P. Hansen*, ed. Erica Ehrenberg, pp. 63–76. Winona Lake, Ind.: Eisenbrauns.

forthcoming "The Chapel of Osiris Ruler-of-Eternity and the Art of the Third Intermediate Period." In *The Twenty-third Dynasty Chapel of Osiris Ruler of Eternity at Karnak*, ed. Gerald Kadish and Donald B. Redford, chap. 5. Mississauga, Ontario: Society for the Study of Egyptian Antiquities Publications.

Fazzini, Richard A., and William H. Peck Jr.

1981 "The Precinct of Mut during Dynasty XXV and Early Dynasty XXVI: A Growing Picture." *Journal of the Society for the Study of Egyptian Antiquities* 11 (May), pp. 115–26.

1982 "The 1982 Season at Mut." *Newsletter* (American Research Center in Egypt), no. 120 (Winter), pp. 37–58.

1983 "Excavating the Temple of Mut." *Archaeology* 36, no. 2 (March–April), pp. 16–23.

Fazzini, Richard A., James F. Romano, and Madeleine E. Cody

1999 *Art for Eternity: Masterworks from Ancient Egypt.* Brooklyn: Brooklyn Museum of Art.

Fazzini, Richard A., et al.

1989 Richard A. Fazzini, Robert S. Bianchi, James F. Romano, and Donald B. Spanel. *Ancient Egyptian Art in the Brooklyn Museum.* Brooklyn: Brooklyn Museum; London: Thames and Hudson.

La femme dans l'Égypte des pharaons

1985 *La femme dans l'Égypte des pharaons.* Exh. cat., Musée d'Art et d'Histoire, Geneva. Mainz am Rhein: Philipp von Zabern; Cairo: Organisation des Antiquités Éyptiennes.

Feucht, Erika

1975 "Schmuck." In Vandersleyen 1975, pp. 384–91.

1977 "Gold, Verleihung des." In *LÄ*, vol. 2, cols. 731–33. Wiesbaden: Otto Harrassowitz.

1985 "The *ḥrdw n ḥ3p* Reconsidered." In *Pharaonic Egypt: The Bible and Christianity*, ed. Sarah Israelit-Groll, pp. 38–47. Jerusalem: Magnes Press, Hebrew University.

1995 *Das Kind im alten Ägypten: Die Stellung des Kindes in Familie und Gesellschaft nach altägyptischen Texten und Darstellungen.* Frankfurt and New York: Campus.

Firth, Cecil M.

1927 *The Archaeological Survey of Nubia: Report for 1910–1911.* Cairo: Government Press.

Firth, Cecil M., and Battiscombe Gunn

1926 *Teti Pyramid Cemeteries.* 2 vols. Excavations at Saqqara. Cairo: Institut Français d'Archéologie Orientale du Caire.

Fischer, Henry George

1962 "The Cult and Nome of the Goddess Bat." *JARCE* 1, pp. 7–23.

1968 "Egyptian Art." *The Metropolitan Museum of Art Bulletin*, n.s., 27 (October), pp. 89–91.

1974 "The Mark of a Second Hand on Ancient Egyptian Antiquities." *Metropolitan Museum Journal* 9, pp. 5–34.

1980 "Kopfstütze." In *LÄ*, vol. 3, cols. 686–93. Wiesbaden: Otto Harrassowitz.

1986 *L'écriture et l'art de l'Égypte ancienne: Quatre leçons sur la paléographie et l'épigraphie pharaoniques.* Paris: Presses Universitaires de France.

1996 *Varia Nova.* Egyptian Studies 3. New York: The Metropolitan Museum of Art.

2000 *Egyptian Women of the Old Kingdom and of the Heracleopolitan Period.* 2nd ed. New York: The Metropolitan Museum of Art.

Franco, Isabelle

2001 *Les grands pharaons et leur oeuvres: Dictionnaire.* Paris: Pygmalion.

Franke, Detlef

1994 *Das Heiligtum des Heqaib auf Elephantine: Geschichte eines Provinzheiligtums im Mittleren*

Reich. Studien zur Archäologie und Geschichte Altägyptens 9. Heidelberg: Heidelberg Orientverlag.

Frankfort, Henri, and J. D. S. Pendlebury

1933 *The City of Akhenaten*. Pt. 2, *The North Suburb and the Desert Altars: The Excavations at Tell el Amarna during the Seasons 1926–1932*. Fortieth Memoir of the Egypt Exploration Society. London: Egypt Exploration Society.

Freed, Rita E.

1982 "Cosmetic Arts." In *Egypt's Golden Age* 1982, pp. 199–200.

Freed, Rita E., Yvonne J. Markowitz, and Sue H. D'Auria

1999 Eds. *Pharaohs of the Sun: Akhenaten, Nefertiti, Tutankhamen*. Exh. cat. Boston: Museum of Fine Arts.

Friedman, Florence Dunn

1998 Ed., with Georgina Borromeo. *Gifts of the Nile: Ancient Egyptian Faience*. Exh. cat. London: Thames and Hudson; Providence: Museum of Art, Rhode Island School of Design.

Friedman, Renée F.

2001 "Nubians at Hierakonpolis: Excavations in the Nubian Cemeteries." *S&N*, no. 5, pp. 29–38.

2004a "The Nubian Cemetery at Hierakonpolis, Egypt: Results of the 2003 Season— Excavation of the C-Group Cemetery at HK27C." *S&N*, no. 8, pp. 47–52.

2004b "Seeking the C-Group: Excavations in the Nubian Cemetery, 2003." *Nekhen News* 16 (Fall), pp. 24–26.

Gabolde, Luc

1987a "À propos de deux obélisques de Thoutmosis II, dédiés à son père Thoutmosis I et érigés sous le règne d'Hatshepsout—pharaon à l'ouest du VIe pylône." *Cahiers de Karnak* 8 (1982–85; pub. 1987), pp. 143–58.

1987b "La chronologie du règne de Thoutmosis II, ses conséquences sur la datation des momies royales et leurs répercussions sur l'histoire du développe-ment de la Vallée des Rois." *SAK* 14, pp. 61–81.

1989 With Marc Gabolde. "Les temples 'mémoriaux' de Thoutmosis II et Toutânkhamon (un rituel destiné à des statues sur barques)." *BIFAO* 89, pp. 127–78.

1993 "La 'Cour de Fêtes' de Thoutmosis II à Karnak." *Cahiers de Karnak* 9, pp. 1–100.

1998 *Le "Grand Château d'Amon" de Sésostris Ier à Karnak: La décoration du temple d'Amon-Ré au Moyen Empire*. Mémoires de l'Académie des Inscriptions et Belles-Lettres, n.s., 17. Paris: Diff. de Boccard.

2003 "Compléments sur les obélisques et la 'Cour de Fêtes' de Thoutmosis II à Karnak." *Cahiers de Karnak*, vol. 11, fasc. 2, pp. 417–68.

2004 "La stèle de Thoutmosis II à Assouian, témoin historique et archétype littéraire." In *Séhel entre Égypte et Nubie—inscription rupestres et graffiti de l'époque pharaonique: Actes du colloque inter-national (31 mai–1er juin 2002), Université Paul-Valéry, Montpellier*, ed. Annie Gasse and Vincent Rondot, pp. 129–48. Orientalia Monspeliensia. Montpellier: Université Paul-Valéry.

Gabolde, Luc, and Vincent Rondot

1996 "Une chapelle d'Hatchepsout remployée à Karnak-Nord." *BIFAO* 96, pp. 177–227.

Galvin, Marianne

1981 "The Priestesses of Hathor in the Old Kingdom and the First Intermediate Period." Ph.D. diss., Brandeis University, Waltham, Mass.

Gardiner, Alan H.

1916 "The Defeat of the Hyksos by Kamōse: The Carnarvon Table, No. I." *JEA* 3, pp. 95–110.

1946 "Davies's Copy of the Great Speos Artemidos Inscription." *JEA* 32, pp. 43–56.

1947 *Ancient Egyptian Onomastica*. 3 vols. London: Oxford University Press. Repr., 1968.

1959 Ed. *The Royal Canon of Turin*. Oxford: Griffith Institute.

1961 *Egypt of the Pharaohs: An Introduction*. Oxford: Clarendon Press.

Gardiner, Alan H., T. Eric Peet, and Jaroslav Černý

1952–55 *The Inscriptions of Sinai*. 2 vols. 2nd ed. Forty-fifth Memoir of the Egypt Exploration Society. Oxford: Oxford University Press.

Garnot, Jean Sainte Fare

1949 "Deux vases égyptiens représentant une femme tenant un enfant sur ses genoux." In *Mélanges d'archéologie et d'histoire offerts à Charles Picard à l'occasion de son 65e anniversaire*, vol. 2, pp. 905–16. Paris: Presses Universitaires de France. Special issue of *Revue archéologique*, 6th ser., vols. 31–32.

Garstang, John

1901 *El Arábah: A Cemetery of the Middle Kingdom; Survey of the Old Kingdom Temenos; Graffiti from the Temple of Sety*. With notes by Percy E. Newberry and J. Grafton Milne. Publications of the Egyptian Research Account 6. London: Bernard Quaritch.

1909 "Excavations at Abydos, 1909: Preliminary Description of the Principal Finds." *Annals of Archaeology and Anthropology* (University of Liverpool) 2, pp. 125–29.

Gasse, Annie, and Vincent Rondot

2003 "The Egyptian Conquest and Administration of Nubia during the New Kingdom: The Testimony of the Sehel Rock-Inscriptions." *S&N*, no. 7, pp. 40–46.

Gauthier, Henri

1908 "Rapport sur une campagne de fouilles à Drah Abou'l Neggah en 1906." *BIFAO* 6, pp. 121–71.

Geheimnisvolle Königin Hatschepsut

1997 *Geheimnisvolle Königin Hatschepsut: Ägyptische Kunst des 15. Jahrhunderts v. Chr.* Exh. cat. Warsaw: National Museum.

Germer, Renate

1985 *Flora des pharaonischen Ägypten*. Sonderschrift (Deutsches Archäologisches Institut, Abteilung Kairo) 14. Mainz am Rhein: Philipp von Zabern.

Geus, Francis

2004 "Sai." In Welsby and Anderson 2004b, pp. 114–16.

Ghalioungui, Paul

1949 "Sur deux formes d'obésité représentées dans l'Égypte ancienne." *ASAE* 49, pp. 303–16.

Gilbert, P.

1953 "Les sens des portraits intacts d'Hatshepsout à Deir-el-Bahari." *Chronique d'Égypte*, no. 56 (July), pp. 219–22.

Gitton, Michel

1974 "Le palais de Karnak." *BIFAO* 74, pp. 63–73.

Glanville, S. R. K.

1928 "The Letters of Aaḥmōse of Peniati." *JEA* 14, pp. 294–312.

1931 "Records of a Royal Dockyard of the Time of Tuthmosis III: Papyrus British Museum 10056." *ZÄS* 66, pp. 105–21.

1932 "Records of a Royal Dockyard of the Time of Tuthmosis III: Papyrus British Museum 10056." *ZÄS* 68, pp. 7–41.

Godlewski, Włodzimierz

1986 *Le monastère de St. Phoibammon*. Deir el-Bahari 5. Warsaw: PWN—Éditions Scientifiques de Pologne.

Goebs, Katja

1995 "Untersuchungen zu Funktion und Symbolgehalt des *nms*." *ZÄS* 122, pp. 154–81.

2001 "Crowns." In *The Oxford Encyclopedia of Ancient Egypt*, ed. Donald B. Redford, vol. 1, pp. 321–26. Oxford: Oxford University Press.

Goedicke, Christian, and Rolf Krauss

1998 "Der Denkstein Berlin ÄGM 15699: Eine Ägyptologen-Fälschung." *Jahrbuch Preussischer Kulturbesitz* 35, pp. 203–20.

Goedicke, Hans

2004 *The Speos Artemidos Inscription of Hatshepsut and Related Discussions*. Oakville, Conn.: Halgo.

Goldstein, Sidney M.

1982 "Glass." In *Egypt's Golden Age* 1982, pp. 160–62.

Golénischeff, Vladimir Semenovich

1913 *Les papyrus hiératiques no. 1115A, 1116B de l'Ermitage Impérial à St.-Pétersbourg*. [Saint Petersburg].

Golvin, Jean-Claude

1987 "La restauration antique du passage du IIIe pylône." *Cahiers de Karnak* 8 (1982–85; pub. 1987), pp. 189–206.

1993 "Hatchepsout et les obélisques de Karnak." In *Hatchepsout* 1993, pp. 34–41.

Gourlay, Yvon J.-L.

1981 *Les sparteries de Deir el-Médineh: XVIIIe–XXe Dynasties*. Vol. 1, *Catalogues des techniques de sparterie*. Vol. 2, *Catalogue des objets de sparterie*. Documents de fouilles, vol. 17, pts. 1, 2. Cairo: Institut Français d'Archéologie Orientale du Caire.

Goyon, Jean-Claude

1983 "Inscriptions tardives du temple de Mout à Karnak." With an introduction by Richard A.

Fazzini and William H. Peck Jr. *JARCE* 20, pp. 47–63.

Goyon, Jean-Claude, and Christine Cardin

2004 Eds. *Trésors d'Égypte: La "cachette" de Karnak, 1904–2004*. With the collaboration of Michel Azim and Gihane Zaki. Grenoble: Conseil Général de l'Isère, ACPPA, Champollion.

Grace, Virginia R.

1956 "The Canaanite Jar." In *The Aegean and the Near East: Studies Presented to Hetty Goldman on the Occasion of Her Seventy-fifth Birthday*, ed. Saul S. Weinberg, pp. 80–109. Locust Valley, N.Y.: J. J. Augustin.

Graefe, Erhart

1973 "Amun-Re, 'Patron der Feldmesser.'" *Chronique d'Égypte*, no. 95 (January), pp. 36–46.

1980 "Das sogenannte Senenmut-Kryptogramm." *GM*, no. 38, pp. 45–51.

1981 *Untersuchungen zur Verwaltung und Geschichte der Institution der Gottesgemahlin des Amun vom Beginn des Neuen Reiches bis zur Spätzeit*. 2 vols. Ägyptologische Abhandlungen 37. Wiesbaden: Otto Harrassowitz.

1986 "Talfest." In *LÄ*, vol. 6, cols. 187–89. Wiesbaden: Otto Harrassowitz.

Graindorge, Catherine

1993 "Naissance d'une chapelle reposoir de barque." In *Hatchepsout* 1993, pp. 42–53.

Grajetzki, Wolfram

2005 "The Coffin of the 'King's Daughter' Neferuptah and the Sarcophagus of the 'Great King's Wife' Hatshepsut." *GM*, no. 205, pp. 55–65.

Gratien, Brigitte

1978 *Les cultures Kerma: Essai de classification*. Villeneuve-d'Ascq: Publications de l'Université de Lille III.

Griffith, Francis Llewellyn

1906–7 "Archaeology, Hieroglyphic Studies, etc." In *Archaeological Report, 1906–1907*, pp. 12–54. London: Egypt Exploration Fund.

1921 "Oxford Excavations in Nubia." *Annals of Archaeology and Anthropology* (University of Liverpool) 8, pp. 1–18, 65–104.

Griffiths, John G.

1982 "Osiris." In *LÄ*, vol. 4, cols. 623–33. Wiesbaden: Otto Harrassowitz.

Grimal, Nicolas, and François Larché

2003 "Karnak, 1999–1997." In *Cahiers de Karnak*, vol. 11, fasc. 1, pp. 7–64.

Grimm, Alfred, and Sylvia Schoske

1999a Eds. *Hatschepsut: Königin Ägyptens*. Exh. cat. Schriften aus der Ägyptischen Sammlung 8. Munich: Staatliche Sammlung Ägyptischer Kunst.

1999b *Im Zeichen des Mondes: Ägypten zu Beginn des Neuen Reiches*. Schriften aus der Ägyptischen Sammlung 7. Munich: Staatliche Sammlung Ägyptischer Kunst and Karl M. Lipp.

Guillevic, Jeanne C., and Pierre Ramond

1971 *Musée Georges Labit: Antiquités égyptiennes*. Toulouse: Musée Georges Labit.

Gutbub, Adolphe

1961 "Un emprunt aux textes des pyramides dans l'hymne à Hathor, dame de l'Ivresse." In *Mélanges Maspero*, vol. 1, *Orient ancien*, fasc. 4, pp. 31-72. Mémoires (Institut Français d'Archéologie Orientale du Caire) 66. Cairo: Institut Français d'Archéologie Orientale du Caire.

Habachi, Labib

1957 "Two Graffiti at Sehēl from the Reign of Queen Hatshepsut." *JNES* 16 (April), pp. 88–104.

1965 "The Triple Shrine of the Theban Triad in Luxor Temple." *MDAIK* 20, pp. 93–97.

1972 *The Second Stela of Kamose and His Struggle against the Hyksos Ruler and His Capital*. Abhandlungen des Deutschen Archäologischen Instituts Kairo, Ägyptologische Reihe 8. Glückstadt: J. J. Augustin.

1977 *The Obelisks of Egypt: Skyscrapers of the Past*. Ed. Charles C. Van Siclen III. New York: Charles Scribner's Sons.

1978 "The So-called Hyksos Monuments Reconsidered: Apropos of the Discovery of a Dyad of Sphinxes." *SAK* 6, pp. 79–92.

1980 "Königssohn von Kusch." In *LÄ*, vol. 3, cols. 630–40. Wiesbaden: Otto Harrassowitz.

2001 *Tell el-Dabʿa I: Tell el-Dabʿa and Qantir, the Site and Its Connection with Avaris and Piramesse*. Österreichische Akademie der Wissenschaften, Denkschriften der Gesamtakademie 23. Untersuchungen der Zweigstelle Kairo des Österreichischen Archäologischen Institutes 2. Vienna: Verlag der Österreichischen Akademie der Wissenschaften.

Hall, Harry Reginald

1928 "The Statues of Sennemut and Menkheperrēʿsenb in the British Museum." *JEA* 14, pp. 1–2.

1931 "The Oldest Representation of Horsemanship(?): An Egyptian Axe in the British Museum." *Annals of Archaeology and Anthropology* (University of Liverpool) 18, pp. 3–5.

Harden, Donald B.

1968 *Masterpieces of Glass: A Selection*. London: Trustees of the British Museum.

Hari, Robert

1984 "La vingt-cinquième statue de Senmout." *JEA* 70, pp. 141–44.

Haring, B. J. J.

1997 *Divine Households: Administrative and Economic Aspects of the New Kingdom Royal Memorial Temples in Western Thebes*. Egyptologische uitgaven 12. Leiden: Nederlands Instituut voor het Nabije Oosten.

Harper, Prudence O.

1995 Ed. *Assyrian Origins—Discoveries at Ashur on the Tigris: Antiquities in the Vorderasiatisches Museum, Berlin*. Exh. cat. New York: The Metropolitan Museum of Art.

Harris, James E., and Kent R. Weeks

1973 *X-Raying the Pharaohs*. New York: Charles Scribner's Sons.

Hartung, Ulrich

2002 *Umm el-Qaab*. Vol. 2, *Importkeramik aus dem Friedhof U in Abydos (Umm el-Qaab) und die Beziehungen Ägyptens zu Vorderasien im 4. Jahrtausend v. Chr.* Archäologische Veröffentlichungen (Deutsches Archäologisches Institut, Abteilung Kairo) 92. Mainz am Rhein: Philipp von Zabern.

Harvey, Stephen P.

1998 "The Cults of King Ahmose at Abydos." Ph.D. diss., University of Pennsylvania, Philadelphia.

2003 "Interpreting Punt: Geographic, Cultural and Artistic Landscapes." In *Mysterious Lands*, ed. David B. O'Connor and Stephen Quirke, pp. 81–91. London: UCL Press.

2004 "New Evidence at Abydos for Ahmose's Funerary Cult." *Egyptian Archaeology*, no. 24, pp. 1, 3–6.

Hassan, Ali

1976 *Stöcke und Stäbe im pharaonischen Ägypten bis zum Ende des Neuen Reiches*. Münchner ägyptologische Studien 33. Munich and Berlin: Deutscher Kunstverlag.

Hassanein, O., and N. Iskander

2003 "Shedding Light on the Functions of Some Unknown Objects in the Egyptian Museum, Cairo." *Egyptology at the Dawn of the Twenty-first Century: Proceedings of the Eighth International Congress of Egyptologists, Cairo, 2000*, ed. Zahi Hawass, with Lyla Pinch Brock, vol. 3, pp. 222–26. Cairo: American University in Cairo Press.

Hatchepsout

1993 *Hatchepsout: Femme pharaon. Les dossiers d'archéologie*, no. 187S (November).

Hayes, William C.

1935a *Royal Sarcophagi of the XVII Dynasty*. Princeton Monographs in Art and Archaeology, Quarto Series 19. Princeton: Princeton University Press.

1935b "The Tomb of Nefer-Khēwet and His Family." In *The Egyptian Expedition, 1934–1935*, pp. 17–36. *Bulletin of The Metropolitan Museum of Art* 30 (November), sect. 2.

1942 *Ostraka and Name Stones from the Tomb of Sen-Mūt (No. 71) at Thebes*. Publications of The Metropolitan Museum of Art Egyptian Expedition 15. New York: The Metropolitan Museum of Art.

1950 "The Sarcophagus of Sennemūt." *JEA* 36, pp. 19–23.

1951 "Inscriptions from the Palace of Amenhotep III." *JNES* 10 (January, April, July, October), pp. 35–56, 82–111, 156–83, 231–42.

1953 *The Scepter of Egypt: A Background for the Study of the Egyptian Antiquities in The Metropolitan Museum of Art*. Vol. 1, *From the Earliest Times*

to the End of the Middle Kingdom. Cambridge, Mass.: Harvard University Press for The Metropolitan Museum of Art.

1957 "Varia from the Time of Hatshepsut." *MDAIK* 15, pp. 78–90.

1959 *The Scepter of Egypt: A Background for the Study of the Egyptian Antiquities in The Metropolitan Museum of Art.* Vol. 2, *The Hyksos Period and the New Kingdom.* Cambridge, Mass.: Harvard University Press for The Metropolitan Museum of Art.

1960 "A Selection of Tuthmoside Ostraca from Dēr el-Baḥri." *JEA* 46, pp. 29–52.

1990 *The Scepter of Egypt: A Background for the Study of the Egyptian Antiquities in The Metropolitan Museum of Art.* Vol. 1, *From the Earliest Times to the End of the Middle Kingdom.* Vol. 2, *The Hyksos Period and the New Kingdom.* Rev. ed. New York: The Metropolitan Museum of Art.

Hegazy, el-Sayed, and Philippe Martinez

1993 "Le 'Palais de Maat' et la 'Place Favorite d'Amon.'" In *Hatchepsout* 1993, pp. 54–63.

Hein, Irmgard

2001 "Kerma in Auaris." In *Begegnungen—antike Kulturen im Niltal: Festgabe für Erika Endesfelder, Karl-Heinz Priese, Walter Friedrich Reineke, Steffen Wenig,* ed. Caris-Beatrice Arnst, Ingelore Hafemann, and Angelika Lohwasser, pp. 199–212. Leipzig: Helmar Wodtke und Katharina Stegbauer.

Hein, Irmgard, and Peter Jánosi

2004 *Tell el-Dabᶜa XI: Areal a/v Siedlungsrelikte der späten 2. Zwischenzeit.* Österreichische Akademie der Wissenschaften, Denkschriften der Gesamtakademie 25. Untersuchungen der Zweigstelle Kairo des Österreichischen Archäologischen Institutes 21. Vienna: Verlag der Österreichischen Akademie der Wissenschaften.

Helck, Wolfgang

1939 *Der Einfluss der Militärführer in der 18. ägyptischen Dynastie.* Untersuchungen zur Geschichte und Altertumskunde Aegyptens 14. Leipzig: J. C. Hinrichs.

1956 *Untersuchungen zu Manetho und den ägyptischen Königslisten.* Untersuchungen zur Geschichte und Altertumskunde Aegyptens 18. Berlin: Akademie-Verlag.

1958 *Zur Verwaltung des Mittleren und Neuen Reichs.* Probleme der Ägyptologie 3. Leiden: E. J. Brill.

1960 "Die Opferstiftung des *Śn-mwt.*" *ZÄS* 85, pp. 23–34.

1961–69 *Materialien zur Wirtschaftsgeschichte des Neuen Reiches.* Mainz am Rhein: Akademie der Wissenschaften und der Literatur.

1971 *Die Beziehungen Ägyptens zu Vorderasien im 3. und 2. Jahrtausend v. Chr.* 2nd ed. Ägyptologische Abhandlungen 5. Wiesbaden: Otto Harrassowitz.

1975a "Arbeitshaus." In *LÄ,* vol. 1, cols. 377–78. Wiesbaden: Otto Harrassowitz.

1975b *Historisch-biographische Texte der 2. Zwischenzeit und neue Texte der 18. Dynastie.* Kleine ägyptische Texte. Wiesbaden: Otto Harrassowitz.

1982 "Palastverwaltung." In *LÄ,* vol. 4, cols. 647–52. Wiesbaden: Otto Harrassowitz.

1983 *Historisch-biographische Texte der 2. Zwischenzeit und neue Texte der 18. Dynastie.* 2nd ed. Kleine ägyptische Texte. Wiesbaden: Otto Harrassowitz.

1988 *Die Lehre für König Merikare.* 2nd ed. Kleine ägyptische Texte. Wiesbaden: Otto Harrassowitz.

Hermann, Alfred

1932 "Das Motiv der Ente mit zurückgewendetem Kopfe im ägyptischen Kunstgewerbe." *ZÄS* 68, pp. 86–105.

1940 *Die Stelen der thebanischen Felsgräber der 18. Dynastie.* Ägyptologische Forschungen 11. Glückstadt: J. J. Augustin.

Hikade, Thomas

2001 *Das Expeditionswesen im ägyptischen Neuen Reich: Ein Beitrag zu Rohstoffversorgung und Aussenhandel.* Studien zur Archäologie und Geschichte Altägyptens 21. Heidelberg: Heidelberger Orientverlag.

Hintze, Fritz, and Walter F. Reineke

1989 Eds. *Felsinschriften aus dem sudanesischen Nubien.* 2 vols. Berlin: Akademie-Verlag.

Hoch, James E.

1994 *Semitic Words in Egyptian Texts of the New Kingdom and Third Intermediate Period.* Princeton: Princeton University Press.

Holladay, John S., Jr.

1997 "The Eastern Nile Delta during the Hyksos and Pre-Hyksos Periods: Towards a Systematic/Socioeconomic Understanding." In *The Hyksos: New Historical and Archaeological Perspectives,* ed. Eliezer D. Oren, pp. 183–252. University Museum Monograph 96. University Museum Symposium Series 8. Philadelphia: University Museum, University of Pennsylvania.

Hölscher, Uvo

1939 *The Excavation of Medinet Habu.* Vol. 2, *The Temples of the Eighteenth Dynasty.* The University of Chicago Oriental Institute Publications 41. Chicago: University of Chicago Press.

Holthoer, Rostislav

1977 *New Kingdom Pharaonic Sites.* Vol. 5, pt. 1, *The Pottery.* The Scandinavian Joint Expedition to Sudanese Nubia 5. Uppsala: Scandinavian Joint Expedition to Sudanese Nubia.

Hornblower, G. D.

1929 "Predynastic Figures of Women and Their Successors." *JEA* 15, pp. 29–47.

Horne, Lee

1985 Ed. *Introduction to the Collections of the University Museum.* Philadelphia: University Museum, University of Pennsylvania.

Hornemann, Bodil

1966 *Types of Ancient Egyptian Statuary.* Pts. 4 and 5. Copenhagen: Munksgaard.

Hornung, Erik

1990 *The Valley of the Kings: Horizons of Eternity.* Trans. David Warburton. New York: Timken.

Hornung, Erik, and Betsy M. Bryan

2002 Eds. *The Quest for Immortality: Treasures of Ancient Egypt.* Exh. cat. Washington, D.C.: National Gallery of Art.

Hornung, Erik, and Elisabeth Staehelin

1974 *Studien zum Sedfest.* Aegyptiaca Helvetica 1. Geneva: Belles-Lettres.

Houlihan, Patrick F.

1996 *The Animal World of the Pharaohs.* London and New York: Thames and Hudson.

Ikram, Salima, and Aidan Dodson

1998 *The Mummy in Ancient Egypt: Equipping the Dead for Eternity.* New York and London: Thames and Hudson.

Jacquet-Gordon, Helen

1972 "Concerning a Statue of Senenmut." *BIFAO* 71, pp. 139–50.

Jaeger, Bertrand

1982 *Essai de classification et datation des scarabées Menkhéperrê.* Orbis Biblicus et Orientalis, Series Archaeologia 2. Fribourg: Éditions Universitaires; Göttingen: Vandenhoeck & Ruprecht.

James, T. G. H.

1973 "Egypt: From the Expulsion of the Hyksos to Amenophis I." In *The Cambridge Ancient History,* vol. 2, pt. 1, *History of the Middle East and the Aegean Region, c. 1800–1380 B.C.,* ed. I. E. S. Edwards et al., pp. 289–312. 3rd ed. Cambridge: Cambridge University Press.

1974 *Corpus of Hieroglyphic Inscriptions in the Brooklyn Museum.* Vol. 1, *From Dynasty I to the End of Dynasty XVIII.* Wilbour Monographs 6. Brooklyn: Brooklyn Museum.

1976 "Le prétendu 'sanctuaire de Karnak' selon Budge." *Bulletin de la Société Française d'Égyptologie,* no. 75, pp. 7–30.

Jánosi, Pieter

1995 "Die stratigraphische Position und Verteilung der minoischen Wandfragmente in den Grabungsplätzen H/I und H/IV von Tell el-Dabᶜa." *Ä&L* 5, pp. 63–71.

1996 "Die Fundamentplattform eines Palastes (?) der späten Hyksoszeit in ᶜEzbet Helmi (Tell el-Dabᶜa)." In *Haus und Palast im alten Ägypten/House and Palace in Ancient Egypt,* ed. Manfred Bietak, pp. 93–98. International Symposium in Cairo, April 8–11, 1992. Österreichische Akademie der Wissenschaften, Denkschriften der Gesamtakademie 14. Vienna: Verlag der Österreichischen Akademie der Wissenschaften.

2002 "Bericht über die im Frühjahr 2001 erfolgten Sondagen im Dorf ᶜEzbet Helmi (Grabungsfläche H/I)." *Ä&L* 12, pp. 195–210.

Janssen, Jac. J., and Rosalind M. Janssen

1992 "A Cylindrical Amulet Case: Recent

Investigations." In *Gegengabe: Festschrift für Emma Brunner-Traut*, ed. by Ingrid Gamer-Wallert and Wolfgang Helck, pp. 157–65. Tübingen: Attempto Verlag.

Jéquier, Gustave

1921 *Les frises d'objets des sarcophages du Moyen Empire*. Mémoires (Institut Français d'Archéologie Orientale du Caire) 47. Cairo: Institut Français d'Archéologie Orientale du Caire.

1933 *Deux pyramides du Moyen Empire*. Fouilles à Saqqarah. Cairo: Institut Français d'Archéologie Orientale du Caire.

Johnson, W. Raymond

1999 "The *NFRW*-Collar Reconsidered." In *Gold of Praise: Studies on Ancient Egypt in Honor of Edward F. Wente*, ed. Emily Teeter and John A. Larson, pp. 223–33. Chicago: Oriental Institute of the University of Chicago.

Jones, Dilwyn

1988 *A Glossary of Ancient Egyptian Nautical Titles and Terms*. London and New York: Kegan Paul International.

Kaiser, Werner

1967 *Ägyptisches Museum Berlin*. Staatliche Museen Preussischer Kulturbesitz. Berlin.

1975 "Satettempel: Gesamtbereich." In Werner Kaiser, Günter Dreyer, Günter Grimm, Gerhard Haeny, Horst Jaritz, and Christa Müller, "Stadt und Tempel von Elephantine: Fünfter Grabungsbericht," *MDAIK* 31, pp. 40–51.

1977 "Satettempel: Gesamtbefund und geplante Dokumentation ausgewählter Entwicklungsphasen." In Werner Kaiser, Günter Dreyer, Robert Gempeler, Peter Grossmann, and Horst Jaritz, "Stadt und Tempel von Elephantine: Siebter Grabungsbericht," *MDAIK* 33, pp. 64–68.

1980 "Satettempel: Architektur und Wanddekor des Heiligtums der 18. Dynastie." In Werner Kaiser, Günter Dreyer, Peter Grossmann, Wolfgang Mayer, and Stephan Seidelmayer, "Stadt und Tempel von Elephantine: Achter Grabungsbericht," *MDAIK* 36, pp. 254–64.

1993 "Hatchepsout à Eléphantine." In *Hatchepsout* 1993, pp. 102–9.

Kaiser, Werner, et al.

1972 Werner Kaiser, Dino Bidoli, Peter Grossmann, Gerhard Haeny, Horst Jaritz, and Rainer Stadelmann. "Stadt und Tempel von Elephantine: Dritte Grabungsbericht." *MDAIK* 28, pp. 157–200.

Karageorghis, Vassos

2000 *Ancient Art from Cyprus: The Cesnola Collection in The Metropolitan Museum of Art*. With Joan R. Mertens and Marice E. Rose. New York: The Metropolitan Museum of Art.

Karetsou, Alexandra, and Maria Andreadaki-Blasaki

2000 *Krētē Aigyptos: Politismikoi desmoi triōn chilietiōn. Katálogos*. Exh. cat., Archaiologikon Mouseion, Heraklion. Heraklion: Hypourgeio Politismou.

Karkowski, Janusz

1976 "Studies on the Decoration of the Eastern Wall of the Vestibule of Re-Horakhty in Hatshepsut's Temple at Deir el-Bahari." In *Études et travaux* 9, pp. 67–80.

1981 *The Pharaonic Inscriptions from Faras*. Faras 5. Warsaw: PWN—Éditions Scientifiques de Pologne.

2003 *The Temple of Hatshepsut: The Solar Complex*. Deir el-Bahari 6. Warsaw: Neriton.

Kayser, Hans

1969 *Ägyptisches Kunsthandwerk: Ein Handbuch für Sammler und Liebhaber*. Bibliothek für Kunst- und Antiquitätenfreunde 26. Brunswick: Klinkhardt & Biermann.

Kees, Hermann

1949 "Ein Sonnenheiligtum im Amonstempel von Karnak." *Orientalia*, n.s., 18, pp. 427–42.

1953 *Das Priestertum im ägyptischen Staat vom Neuen Reich bis zur Spätzeit*. Probleme der Ägyptologie 1. Leiden and Cologne: E. J. Brill.

Keimer, Ludwig

1929 "Nouvelles recherches au sujet du *Potamogeton lucens* L. dans l'Égypte ancienne et remarques sur l'ornementation des hippopotames en faïence du Moyen Empire." *Revue de l'Égypte ancienne* 2, pp. 210–53.

Keller, Cathleen A.

1991 "Royal Painters: Deir el-Medina in Dynasty XIX." In *Fragments of a Shattered Visage: The Proceedings of the International Symposium of Ramesses the Great*, ed. Edward Bleiberg and Rita Freed, pp. 50–86. Monographs of the Institute of Egyptian Art and Archaeology 1. Memphis: Memphis State University.

Kelley, Allyn L.

1976 *The Pottery of Ancient Egypt: Dynasty 1 to Roman Times*. 4 vols. Toronto: Royal Ontario Museum.

Kemp, Barry J.

1978a "Imperialism and Empire in New Kingdom Egypt (c. 1575–1087 B.C.)." In *Imperialism in the Ancient World: The Cambridge University Research Seminar in Ancient History*, ed. Peter D. A. Garnsey and C. R. Whittaker, pp. 7–57, 284–97. Cambridge Classical Studies. Cambridge: Cambridge University Press.

1978b "The Harim-Palace at Medinet al-Ghurab." *ZÄS* 105, pp. 122–33.

1989 *Ancient Egypt: Anatomy of a Civilization*. London and New York: Routledge.

1997 "Why Empires Rise." *Cambridge Archaeological Journal* 7 (April), pp. 125–31.

Kendall, Timothy

1978 *Passing through the Netherworld: The Meaning and Play of Senet, an Ancient Egyptian Funerary Game*. Belmont, Mass.: Kirk Game Company.

1982 "Games." In *Egypt's Golden Age* 1982, pp. 263–66.

Kenyon, Kathleen M.

1965 *Excavations at Jericho*. Vol. 2, *The Tombs Excavated in 1955–8*. London: British School of Archaeology in Jerusalem.

Killen, Geoffrey

1980 *Ancient Egyptian Furniture*. Vol. 1, *4000–1300 BC*. Warminster: Aris and Phillips.

Kitchen, Kenneth A.

1982 "Punt." In *LÄ*, vol. 4, cols. 1198–1201. Wiesbaden: Otto Harrassowitz.

2004 "The Elusive Land of Punt Revisited." In *Trade and Travel in the Red Sea Region: Proceedings of Red Sea Project I, Held in the British Museum, October 2002*, ed. Paul Lunde and Alexandra Porter, pp. 25–31. Society for Arabian Studies Monographs 2. BAR International Series 1269. Oxford: Archaeopress.

Klemm, Dietrich D., Rosemarie Klemm, and Andreas Murr

2001 "Gold of the Pharaohs: 6000 Years of Gold Mining in Egypt and Nubia." *Journal of African Earth Sciences* 33, pp. 643–59.

2002 "Ancient Gold Mining in the Eastern Desert of Egypt and the Nubian Desert of Sudan." In *Egypt and Nubia: Gifts of the Desert*, ed. Renée F. Friedman, pp. 215–31. London: British Museum Press.

Klug, Andrea

2002 *Königliche Stelen in der Zeit von Ahmose bis Amenophis III*. Monumenta Aegyptiaca 8. Brussels: Fondation Égyptologique Reine Élisabeth.

Kołosowska, Elżbieta, Mahmoud el-Tayeb, and Henryk Paner

2003 "Old Kush in the Fourth Cataract Region." *S&N*, no. 7, pp. 21–25.

Der Königsweg

1987 *Der Königsweg: 9000 Jahre Kunst und Kultur in Jordanien und Palästina*. Exh. cat., Rautenstrauch-Joest-Museum für Völkerkunde, Cologne; Schloss Schallaburg, Lower Austria; and Prähistorische Staatssammlung, Munich. Mainz am Rhein: Philipp von Zabern.

Kozloff, Arielle P., and Betsy M. Bryan

1992 With Lawrence M. Berman. *Egypt's Dazzling Sun: Amenhotep III and His World*. Exh. cat. Cleveland: Cleveland Museum of Art.

Krauspe, Renate

1997a Ed. *Das Ägyptische Museum der Universität Leipzig*. Zaberns Bildbände zur Archäologie. Mainz am Rhein: Philipp von Zabern.

1997b *Katalog Ägyptischer Sammlungen in Leipzig*. Vol. 1, *Statuen und Statuetten*. Mainz am Rhein: Philipp von Zabern.

Kriéger, Paule

1960 "Une statuette de roi-faucon au Musée du Louvre." *Revue d'égyptologie* 12, pp. 37–58.

Krönig, Wolfgang

1934 "Ägyptische Fayence-Schalen des Neuen Reiches." *MDAIK* 5, pp. 144–66.

Kühnert-Eggebrecht, Eva

1969 *Die Axt als Waffe und Werkzeug im alten Ägypten.* Münchner ägyptologische Studien 15. Berlin: Bruno Hessling.

1975a "Axt." In *LÄ*, vol. 1, col. 587. Wiesbaden: Otto Harrassowitz.

1975b "Dolch." In *LÄ*, vol. 1, cols. 1113–16. Wiesbaden: Otto Harrassowitz.

Laboury, Dimitri

1998 *La statuaire de Thoutmosis III: Essai d'interprétation d'un portrait royal dans son contexte historique.* Aegyptiaca Leodiensia 5. Liège: Centre Informatique de Philosophie et Lettres.

2000 "Da la relation spatiale entre les personnages des groupes statuaires royaux dans l'art pharaonique." *Revue d'égyptologie* 51, pp. 83–101.

Lacau, Pierre

1909–57 *Stèles du Nouvel Empire.* 3 vols. Catalogue général des antiquités égyptiennes du musée du Caire, nos. 34001–34189. Cairo: Institut Français d'Archéologie Orientale du Caire.

1939 "Une stèle du roi 'Kamosis.'" *ASAE* 39, pp. 245–71.

Lacau, Pierre, and Henri Chevrier

1977–79 *Une chapelle d'Hatshepsout à Karnak.* 2 vols. Cairo: Service des Antiquités de l'Égypte and Institut Français d'Archéologie Orientale du Caire.

Lacovara, Peter

1981 "The Hearst Excavations at Deir el-Ballas: The Eighteenth Dynasty Town." In *Studies in Ancient Egypt, the Aegean, and the Sudan: Essays in Honor of Dows Dunham on the Occasion of His Ninetieth Birthday, June 1, 1980,* ed. William Kelly Simpson and Whitney M. Davis, pp. 120–24. Boston: Museum of Fine Arts, Department of Egyptian and Ancient Near Eastern Art.

1990 Ed. *Deir el-Ballas: Preliminary Report on the Deir el-Ballas Expedition, 1980–1986.* American Research Center in Egypt, Reports 12. Winona Lake, Ind.: Eisenbrauns.

1997a "Gurob and the New Kingdom 'Harim' Palace." In *Ancient Egypt, the Aegean, and the Near East: Studies in Honour of Martha Rhoads Bell,* ed. Jacke Phillips, vol. 2, pp. 297–306. San Antonio: Van Siclen Books.

1997b *The New Kingdom Royal City.* Studies in Egyptology. London and New York: Kegan Paul International.

1998 "Nubian Faience." In F. D. Friedman 1998, pp. 46–49.

2002 "Afterwords on Hatshepsut's 'Throne.'" Letter in Readers' Forum. *KMT,* vol. 13, no. 2 (Summer), pp. 6–7.

Lagarce, E., and Jean Leclant

1976 "Vase plastique en faïence, Kit. 1747: Une fiole pour eau de jouvence." In Gisèle Clerc, Vassos Karageorghis, E. Lagarce, and Jean Leclant, *Objets égyptiens et égyptisants: Scarabées, amulettes et figurines en pâte de verre et en faïence, vase plastique en faïence; sites I et II, 1959–1975,* pp. 183–290. Fouilles de Kition 2. Nicosia: Department of Antiquities, Cyprus, for the Republic of Cyprus.

Lajtar, Adam

1991 "*Proskynema* Inscriptions of a Corporation of Iron-workers from Hermonthis in the Temple of Hatshepsut in Deir el-Bahari: New Evidence for Pagan Cults in Egypt in the 4th Cent. A.D." *Journal of Juristic Papyrology* 21, pp. 53–70.

Lange, Hans Ostenfeldt, and Heinrich Schäfer

1908 *Grab- und Denksteine des Mittleren Reichs im Museum von Kairo.* Catalogue général des antiquités égyptiennes du musée du Caire, nos. 20400–20780. Berlin: Reichsdruckerei.

Lange, Kurt, and Max Hirmer

1961 *Egypt: Architecture, Sculpture, Painting in Three Thousand Years.* 3rd ed. London: Phaidon Press.

Lansing, Ambrose

1917 "Excavations in the Assasîf at Thebes." In *The Egyptian Expedition, 1915–16,* pp. 7–26. *Bulletin of The Metropolitan Museum of Art* 12 (May), suppl.

1920 "Excavations at Thebes, 1918–19." In *The Egyptian Expedition, 1918–1920,* pp. 4–12. *Bulletin of the Metropolitan Museum of Art* 15 (December), pt. 2.

1940 *Ancient Egyptian Jewelry: A Picture Book.* New York: The Metropolitan Museum of Art.

Lansing, Ambrose, and William C. Hayes

1937 "The Museum's Excavations at Thebes." In *The Egyptian Expedition, 1935–1936,* pp. 4–39. *Bulletin of The Metropolitan Museum of Art* 32 (January), sect. 2.

Larché, François

1999–2000 "The Reconstruction of the So-called 'Red Chapel' of Hatshepsut and Thutmose III in the Open Air Museum at Karnak." *KMT,* vol. 10, no. 4 (Winter), pp. 56–65.

Laskowska-Kusztal, Ewa

1984 *Le sanctuaire ptolémaïque de Deir el-Bahari.* Deir el-Bahari 3. Warsaw: PWN—Éditions Scientifiques de Pologne.

Leahy, Anthony

1995 "Ethnic Diversity in Ancient Egypt." In *Civilizations of the Ancient Near East,* ed. Jack M. Sasson, vol. 1, pp. 225–34. New York: Charles Scribner's Sons.

Leblanc, Christian

1980 "Piliers et colosses de type 'osiriaque' dans le contexte des temples de culte royal." *BIFAO* 80, pp. 69–89.

1982 "Le culte rendu aux colosses 'osiriaques' durant le Nouvel Empire." *BIFAO* 82, pp. 295–311.

Leclant, Jean

1960 "Astarté à cheval d'après les représentations égyptiennes." *Syria* 37, pp. 1–67.

1997 "Egypt in Sudan: The Old and Middle Kingdoms." In Wildung 1997b, pp. 73–77.

Lecuyot, Guy, and Anne-Marie Loyrette

1995 "La chapelle de Ouadjmès: Rapport préliminaire—I." *Memnonia* 6, pp. 85–93.

1996 "La chapelle de Ouadjmès: Rapport préliminaire—II." *Memnonia* 7, pp. 111–22.

Leemans, Conrad

1846 *Aegyptische monumenten van het Nederlandsche Museum van Oudheden te Leyden.* Vol. 2. Leiden: E. J. Brill.

Lefebvre, Gustave

1929 *Histoire des grands prêtres d'Amon de Karnak jus'qu'à la XXIᵉ Dynastie.* Paris: Paul Geuthner.

Legrain, Georges

1906–25 *Statues et statuettes de rois et de particuliers.* 4 vols. Indices by Henri Gauthier. Catalogue général des antiquités égyptiennes du musée du Caire, nos. 42001–42250. Cairo: Institut Français d'Archéologie Orientale du Caire.

Lehner, Mark

1997 *The Complete Pyramids.* London: Thames and Hudson.

Leiden, Rijksmuseum van Oudheden

1981 *Rijksmuseum van Oudheden/National Museum of Antiquities.* Nederlandse musea/Dutch Museums 6. Haarlem: Joh. Enchedé en Zonen Grafische Inrichting.

Lepsius, Karl Richard

1849–59 *Denkmaeler aus Aegypten und Aethiopien.* 12 vols. Berlin: Nicolai. Repr., Geneva: Belle-Lettres, 1972–73.

Lesko, Barbara Switalski

1967 "The Senmut Problem." *JARCE* 6, pp. 113–18.

Letellier, Bernadette

1981 Review of Tefnin 1979. *Bibliotheca Orientalis* 38 (May–July), cols. 305–8.

1991 "Thoutmosis IV à Karnak: Hommage tardif rendu à un bâtisseur malchanceux." *Bulletin de la Société Française d'Égyptologie,* no. 122 (October), pp. 36–52.

Lichtheim, Miriam

1976 *Ancient Egyptian Literature: A Book of Readings.* Vol. 2, *The New Kingdom.* Berkeley and Los Angeles: University of California Press.

Lilyquist, Christine

1975 "Egyptian Art." In The Metropolitan Museum of Art, *Notable Acquisitions, 1965–1975,* pp. 65–77. New York: The Metropolitan Museum of Art.

1979 *Ancient Egyptian Mirrors: From the Earliest Times through the Middle Kingdom.* Münchner ägyptologische Studien 27. Munich and Berlin: Deutscher Kunstverlag.

1988 "The Gold Bowl Naming General Djehuty: A Study of Objects and Early Egyptology." *Metropolitan Museum Journal* 23, pp. 5–68.

1993a "Granulation and Glass: Chronological and Stylistic Investigations at Selected Sites, ca. 2500–1400 B.C.E." *Bulletin of the American*

Schools of Oriental Research, nos. 290–91 (May–August), pp. 29–94.

1993b "On [Late] Middle Kingdom Style, with Reference to Hard Stone Scarabs, Inlaid Jewels, and Beni Hasan." *Discussions in Egyptology* 27, pp. 45–57.

1994 "Seven Objects Attributable to Kāmid el-Lōz and Comments on the Date of Some Objects in the 'Schatzhaus.'" In Wolfgang Adler, *Kāmid el-Lōz 11. Das 'Schatzhaus' im Palastbereich: Die Befunde des Königsgrabes*, pp. 207–20. Saarbrücker Beiträge zur Altertumskunde 47. Bonn: Rudolf Habelt.

1995 *Egyptian Stone Vessels: Khian through Tuthmosis IV*. New York: The Metropolitan Museum of Art.

1996 "Stone Vessels at Kāmid el-Lōz, Lebanon: Egyptian, Egyptianizing, or Non-Egyptian? A Question at Sites from the Sudan to Iraq to the Greek Mainland." In *Kāmid el-Lōz 16. 'Schatzhaus': Studien*, ed. Rolf Hachmann, pp. 133–73. Saarbrücker Beiträge zur Altertumskunde 59. Bonn: Rudolf Habelt.

1997 "A Foreign Vase Representation from a New Theban Tomb (The Chapel for MMA 5A P2)." In *Ancient Egypt, the Aegean, and the Near East: Studies in Honour of Martha Rhoads Bell*, ed. Jacke Phillips, vol. 2, pp. 307–43. San Antonio: Van Siclen Books.

1998 "The Use of Ivories as Interpreters of Political History." *Bulletin of the American Schools of Oriental Research*, no. 310 (May), pp. 25–33.

1999 "On the Amenhotep III Inscribed Faience Fragments from Mycenae." *Journal of the American Oriental Society* 119 (April–June), pp. 303–8.

2003 *The Tomb of Three Foreign Wives of Tuthmosis III*. With contributions by James E. Hoch and Alexander J. Peden. New York: The Metropolitan Museum of Art; New Haven and London: Yale University Press.

Lilyquist, Christine, and Robert H. Brill

1993 With Mark T. Wypyski. *Studies in Early Egyptian Glass*. With contributions by H. Shirahata, Robert J. Koestler, and R. D. Vocke Jr. New York: The Metropolitan Museum of Art.

Lindblad, Ingegerd

1984 *Royal Sculpture of the Early Eighteenth Dynasty in Egypt*. Memoir (Medelhavsmuseet) 5. Stockholm: Medelhavsmuseet.

1988 "An Unidentified Statue of Ahmose." *SAK* 15, pp. 197–201.

Lipińska, Jadwiga

1974 "Studies on Reconstruction of the Hatshepsut Temple at Deir el-Bahari: A Collection of the Temple Fragments in the Egyptian Museum." In *Festschrift zum 150 jährigen Bestehen des Berliner Ägyptischen Museums*, pp. 163–71. Staatliche Museen zu Berlin, Mitteilungen aus

der Ägyptischen Sammlung 8. Berlin: Akademie-Verlag.

1977 *The Temple of Tuthmosis III: Architecture*. Deir el-Bahari 2. Warsaw: PWN—Éditions Scientifiques de Pologne.

1984 *The Temple of Tuthmosis III: Statuary and Votive Monuments*. Deir el-Bahari 4. Warsaw: PWN—Éditions Scientifiques de Pologne.

Liverani, Mario

2001 *International Relations in the Ancient Near East, 1600–1100 BC*. Studies in Diplomacy. Houndmills, Basingstoke, Hampshire.

Lollio Barberi, Olga, Gabriele Parola, and M. Pamela Toti

1995 *Le antichità egiziane di Roma imperiale*. Rome: Istituto Poligrafico e Zecca dello Stato.

London, British Museum

1914 *Hieroglyphic Texts from Egyptian Stelae, &c., in the British Museum*. Pt. 5. London: British Museum.

1930 *A General Introductory Guide to the Egyptian Collections in the British Museum*. New ed. Preface by Harry Reginald Hall. London.

1975 *A General Introductory Guide to the Egyptian Collections in the British Museum*. New ed. London: British Museum Publications.

2004 "The Second Intermediate Period (13th–17th Dynasties): Current Research and Future Prospects." British Museum Annual International Egyptological Colloquium, July 14–16, 2004. Abstracts of papers. Archived at http://www.thebritishmuseum.ac.uk/aes/Sackler04.html.

Lucas, Alfred, and John Richard Harris

1989 *Ancient Egyptian Materials and Industries*. 4th ed. Rev. by John Richard Harris. London: Histories and Mysteries of Man.

Mackay, Ernest

1917 "Proportion Squares on Tomb Walls in the Theban Necropolis." *JEA* 4, pp. 74–85.

Málek, Jaromír

1982 "The Original Version of the Royal Canon of Turin." *JEA* 68, pp. 93–106.

1999 With Diana Magee and Elizabeth Miles. *Topographical Bibliography of Ancient Egyptian Hieroglypic Texts, Statues, Reliefs and Paintings*. Vol. 8, *Objects of Provenance Not Known*. Pt. 1, *Royal Statues; Private Statues (Predynastic to Dynasty XVIII)*. Series begun by Bertha Porter and Rosalind L. B. Moss, with Ethel W. Burney. Oxford: Griffith Institute, Ashmolean Museum.

Manetho

1940 *Manetho; with an English Translation*. Trans. William Gillan Waddell. Loeb Classical Library. Cambridge, Mass.: Harvard University Press.

Manniche, Lise

1989 *An Ancient Egyptian Herbal*. Austin: University of Texas Press.

1997 *Sexual Life in Ancient Egypt*. London and New York: Kegan Paul International.

1999 *Sacred Luxuries: Fragrance, Aromatherapy, and Cosmetics in Ancient Egypt*. Ithaca: Cornell University Press.

Der Manuelian, Peter

1981 "Notes on the So-called Turned Stools of the New Kingdom." In *Studies in Ancient Egypt, the Aegean, and the Sudan: Essays in Honor of Dows Dunham on the Occasion of His Ninetieth Birthday, June 1, 1980*, ed. Willliam Kelly Simpson and Whitney M. Davis, pp. 125–28. Boston: Museum of Fine Arts, Department of Egyptian and Ancient Near Eastern Art.

1987 *Studies in the Reign of Amenophis II*. Hildesheimer ägyptologische Beiträge 26. Hildesheim: Gerstenberg.

Der Manuelian, Peter, and Christian E. Loeben

1993 "New Light on the Recarved Sarcophagus of Hatshepsut and Thutmose I in the Museum of Fine Arts, Boston." *JEA* 79, pp. 121–55.

Manzo, Andrea

1999 *Échanges et contacts le long du Nil et de la Mer Rouge dans l'époque protohistorique (IIIe et IIe millénaires avant J.-C.): Une synthèse préliminaire*. Cambridge Monographs in African Archaeology 48. BAR International Series 782. Oxford: Archaeopress.

Marciniak, Marek

1965 "Une nouvelle statue de Senenmout récemment découverte à Deir el-Bahari." *BIFAO* 63, pp. 201–7.

Martin, Geoffrey Thorndike

1997 *The Tomb of Tia and Tia: A Royal Monument of the Ramesside Period in the Memphite Necropolis*. Fifth-eighth Excavation Memoir. London: Egypt Exploration Society.

Martin-Pardey, Eva

1986 "Tempelpersonal. II." In *LÄ*, vol. 6, cols. 401–7. Wiesbaden: Otto Harrassowitz.

Martinez, Philippe

1989 "À propos de la décoration du sanctuaire d'Alexandre à Karnak: Réflexions sur la politique architecturale et religieuse des premiers souverains lagides." *Bulletin* (Société d'Égyptologie, Geneva), no. 13, pp. 107–16.

1993 "Le VIIIe pylône et l'axe royal du domaine d'Amon." In *Hatchepsout 1993*, pp. 64–71.

Maspero, Gaston

1886 "Comment Thouth prit la ville de Joppé." In *Romans et poésies du Papyrus Harris no 500 conservé au British Museum*, pp. 49–72. Études égyptiennes, vol. 1, fasc. 1. Paris: Imprimerie Nationale.

1910 *Guide to the Cairo Museum*. 5th ed. Cairo.

Matthäus, Hartmut

1995 "Representations of Keftiu in Egyptian Tombs and the Absolute Chronology of the Aegean Late Bronze Age." *Bulletin of the Institute of Classical Studies* 40, pp. 177–94.

McGovern, Patrick E.

1985 *Late Bronze Age Palestinian Pendants: Innovation in a Cosmopolitan Age*. Journal for

the Study of the Old Testament/American Schools of Oriental Research Monograph Series 1. Sheffield: Journal for the Study of the Old Testament.

Meisterwerke altägyptischer Keramik
1978 *Meisterwerke altägyptischer Keramik: 5000 Jahre Kunst und Kunsthandwerk aus Ton und Fayence.* Exh. cat., Rastal-Haus, Höhr-Grenzhausen. Höhr-Grenzhausen: Keramikmuseum Westerwald.

Das Menschenbild im alten Ägypten
1982 *Das Menschenbild im alten Ägypten: Porträts aus vier Jahrtausenden.* Exh. cat. Hamburg: Interversa Gesellschaft für Beteiligungen.

Merrillees, Robert S.
1962 "Opium Trade in the Bronze Age Levant." *Antiquity* 36 (December), pp. 287–92.
1968 *The Cypriote Bronze Age Pottery Found in Egypt.* Studies in Mediterranean Archaeology 18. Lund: Paul Åström.
1970 "Evidence for the Bichrome Wheel-Made Ware in Egypt." *Australian Journal of Biblical Archaeology*, vol. 1, no. 3, pp. 3–27.
1974 *Trade and Transcendence in the Bronze Age Levant: Three Studies.* Studies in Mediterranean Archaeology 39. Göteborg: Paul Aström.
1982 "Metal Vases of Cypriot Type from the Sixteenth to the Thirteenth Centuries B.C." In *Early Metallurgy in Cyprus, 4000–500 BC: Acta of the International Archaeological Symposium, Larnaca, Cyprus, 1–6 June 1981*, ed. James D. Muhly, Robert Maddin, and Vassos Karageorghis, pp. 233–49. Larnaca: Pierides Foundation.

Meyer, Christine
1982 *Senenmut: Eine prosopographische Untersuchung.* Hamburger ägyptologische Studien 2. Hamburg: Borg.
1984 "Sistrophor." In *LÄ*, vol. 5, col. 802. Wiesbaden: Otto Harrassowitz.
1986 "Thutmosis I." In *LÄ*, vol. 6, cols. 536–39. Wiesbaden: Otto Harrassowitz.
1989 "Zur Verfolgung Hatschepsuts durch Thutmosis III." In *Miscellanea Aegyptologica: Wolfgang Helck zum 75. Geburtstag*, ed. Hartwig Altenmüller and Renate Germer, pp. 119–26. Hamburg: Archäologisches Institut der Universität Hamburg.

Milward, Angela J.
1982 "Bowls." In *Egypt's Golden Age* 1982, pp. 141–42.

Miron, Renate
1990 *Kāmid el-Lōz 10. Das 'Schatzhaus' im Palastbereich: Die Funde.* Saarbrücker Beiträge zur Altertumskunde 46. Bonn: Rudolf Habelt.

Mond, Robert
1905 "Report of Work in the Necropolis of Thebes during the Winter of 1903–1904." *ASAE* 6, pp. 65–96.

Mond, Robert, and Oliver H. Myers
1940 *Temples of Armant: A Preliminary Survey.*

2 vols. Forty-third Memoir of the Egypt Exploration Society. London: Egypt Exploration Society.

Montet, Pierre
1937 *Les reliques de l'art syrien dans l'Égypte du Nouvel Empire.* Publications de la Faculté des Lettres de l'Université de Strasbourg 76. Paris: Les Belles Lettres.
1951 *Les constructions et le tombeau de Psousennès à Tanis.* Fouilles de Tanis, La nécropole royale 2. Paris.

Moorey, Peter Roger Stuart
1983 *Ancient Egypt.* Rev. ed. Oxford: Ashmolean Museum.

Morenz, Siegfried
1984 *Gott und Mensch im alten Ägypten.* 2nd ed. Leipzig: Koehler & Amelang.

Morkot, Robert G.
1987 "Studies in New Kingdom Nubia, 1. Politics, Economics and Ideology: Egyptian Imperialism in Nubia." *Wepwawet* 3, pp. 29–49.
1991 "Nubia in the New Kingdom: The Limits of Egyptian Control." In *Egypt and Africa: Nubia from Prehistory to Islam*, ed. W. Vivian Davies, pp. 294–301. London: British Museum Press for the Trustees of the British Museum and the Egypt Exploration Society.
1995 "The Economy of Nubia in the New Kingdom." *Cahiers de recherches de l'Institut de Papyrologie et d'Égyptologie de Lille*, no. 17, pp. 175–89.
2000 *The Black Pharaohs: Egypt's Nubian Rulers.* London: Rubicon Press.

Muhammad, Abdul-Qader
1966 "Recent Finds." *ASAE* 59, pp. 143–55.

Müller, Hans Wolfgang
1989 *Der "Armreif" des Königs Ahmose und der Handgelenkschutz des Bogenschützen im alten Ägypten und Vorderasien.* Sonderschrift (Deutsches Archäologisches Institut, Abteilung Kairo) 25. Mainz am Rhein: Philipp von Zabern.

Müller, Hans Wolfgang, and Jürgen Settgast
1976 Eds. *Nofretete, Echnaton.* Exh. cat. Munich: Haus der Kunst.

Müller, Hans Wolfgang, and Eberhard Thiem
1999 *Gold of the Pharaohs.* Ithaca: Cornell University Press.

Müller, Marcus
2004 "Strategisches Vorfeld Levante: Diplomatie und Offensive." In Petschel and von Falck 2004, pp. 153–55.

Müller, Maya
1979 "Zum Bildnistypus Thutmosis' I." *GM*, no. 32, pp. 27–37.

Mummies and Magic
1988 *Mummies and Magic: The Funerary Arts of Ancient Egypt.* Exh. cat. Boston: Museum of Fine Arts.

Munro, Irmtraut
1988 *Untersuchungen zu den Totenbuch-Papyri der 18.*

Dynastie: Kriterien ihrer Datierung. Studies in Egyptology. London and New York: Kegan Paul International.

Murnane, William J.
1977 *Ancient Egyptian Coregencies.* Studies in Ancient Oriental Civilization, The Oriental Institute of the University of Chicago 40. Chicago: The Oriental Institute.
1982 "Opetfest." In *LÄ*, vol. 4, cols. 574–79. Wiesbaden: Otto Harrassowitz.

Murray, Margaret A.
1911 "Figure-Vases in Egypt." In Edward Ball Knobel, W. W. Midgley, Joseph Grafton Milne, Margaret A. Murray, and William Matthew Flinders Petrie, *Historical Studies*, pp. 40–46. British School of Archaeology in Egypt Studies 2. London: School of Archaeology in Egypt and Bernard Quaritch.

Muscarella, Oscar White
1974 Ed. *Ancient Art: The Norbert Schimmel Collection.* Mainz am Rhein: Philipp von Zabern.

Museo Civico Archeologico di Bologna
1994 *La collezione egiziana.* Bologna: Leonardo Arte.

Myśliwiec, Karol
1976 *Le portrait royal dans le bas-relief du Nouvel Empire.* Travaux du Centre d'Archéologie Méditerranéenne de l'Académie Polonaise des Sciences [19]. Warsaw: Éditions Scientifiques de Pologne.
1988 *Royal Portraiture of the Dynasties XXI–XXX.* Mainz am Rhein: Philipp von Zabern, 1988.

Nagel, G.
1949 "Le linceul de Thoutmès III. Caire, cat. n° 40.001." *ASAE* 49, pp. 317–35.

Naissance de l'écriture
1982 *Naissance de l'écriture: Cunéiformes et hiéroglyphes.* Exh. cat., Galeries Nationales du Grand Palais, Paris. Paris: Éditions de la Réunion des Musées Nationaux.

Naumann, Barbara, and Edgar Pankow
2004 Eds. *Bilder—Denken: Bildlichkeit und Argumentation.* Munich: Wilhelm Fink.

Naville, Édouard
1894–1908 *The Temple of Deir el-Bahari.* 7 vols. Egypt Exploration Fund, [Memoir] 12–14, 16, 19, 27, 29. London: Egypt Exploration Fund.
1899 "Figurines égyptiennes de l'époque archaïque." *Recueil de travaux* 21, pp. 212–16.
1907 *The XIth Dynasty Temple at Deir el-Bahari.* Pt. 1. Egypt Exploration Fund, Memoir 28. London: Egypt Exploration Fund.
1910 *The XIth Dynasty Temple at Deir el-Bahari.* Pt. 2. Egypt Exploration Fund, Memoir 30. London: Egypt Exploration Fund.

Naville, Édouard, and Howard Carter
1906 *The Tomb of Hâtshopsîtû.* London: A. Constable and Company.

Naville, Édouard, and Harry Reginald Hall
1913 *The XIth Dynasty Temple at Deir el-Bahari.* Pt. 3. With an appendix by Charles Trick

Currelly. Egypt Exploration Fund, Memoir 32. London: Egypt Exploration Fund.

Needler, Winifred

1983 Review of Pusch 1979. *JARCE* 20, pp. 115–18.

Nelson, Grace W.

1936 "A Faience Rhyton from Abydos in the Boston Museum of Fine Arts." *American Journal of Archaeology* 40, pp. 501–6.

Newberry, Percy E.

1893 *Beni Hasan.* Vol. 1. Archaeological Survey of Egypt, First Memoir. London: Egypt Exploration Fund.

1943 "Queen Nitocris of the Sixth Dynasty." *JEA* 29, pp. 51–54.

New York, Metropolitan Museum

1987 The Metropolitan Museum of Art. *Egypt and the Ancient Near East.* Introduction by Peter Dorman, Prudence Oliver Harper, and Holly Pittman. New York: The Metropolitan Museum of Art.

New-York Historical Society

1915 *Catalogue of the Egyptian Antiquities of the New York Historical Society.* New York: New-York Historical Society.

Nicholson, Paul T.

1993 *Egyptian Faience and Glass.* Shire Egyptology 18. Princes Risborough, Aylesbury, Buckinghamshire: Shire Publications.

2000 With Edgar Peltenburg. "Egyptian Faience." In *Ancient Egyptian Materials and Technologies*, ed. Paul T. Nicholson and Ian Shaw, pp. 177–94. Cambridge: Cambridge University Press.

Nicholson, Paul T., and Pamela J. Rose

1985 "Pottery Fabrics and Ware Groups at el-Amarna." In Barry J. Kemp, with contributions by A. Bomann et al., *Amarna Reports II*, pp. 133–74. Occasional Publications (Egypt Exploration Society) 2. London: Egypt Exploration Society.

Niemeier, Barbara, and Wolf-Dietrich Niemeier

1998 "Minoan Frescoes in the Eastern Mediterranean." In *The Aegean and the Orient in the Second Millennium: Proceedings of the Fiftieth Anniversary Symposium, Cincinnati, 18–20 April 1997*, ed. Eric H. Cline and Diane Harris-Cline, pp. 69–98. Aegaeum 18. Liège: Université de Liège, Histoire de l'Art et Archéologie de la Grèce Antique; Austin: University of Texas at Austin, Program in Aegean Scripts and Prehistory.

2000 "Aegean Frescoes in Syria-Palestine: Alalakh and Tel Kabri." In *The Wall Paintings of Thera: Proceedings of the First International Symposium, Petros M. Nomikos Conference Centre, Thera, Hellas, 30 August–4 September 1997*, ed. Susan Sherratt, vol. 2, pp. 763–802. Piraeus: Petros M. Nomikos and the Thera Foundation.

2002 "The Frescoes in the Middle Bronze Age Palace." In *Tel Kabri: The 1986–1993*

Excavation Seasons, ed. N. Scheftelowitz and Ronit Oren, pp. 254–85. Monograph Series, Tel Aviv University, Sonia and Marco Nadler Institute of Archaeology 20. Tel Aviv: Emery and Claire Yass Publications in Archaeology, Institute of Archaeology, Tel Aviv University.

Niemeier, Wolf-Dietrich

1991 "Minoan Artisans Travelling Overseas: The Alalakh Fresco and the Painted Plaster Floor at Tel Kabri (Western Galilee)." In *Thalassa, l'Égée préhistorique et la mer: Actes de la troisième Rencontre Égéenne Internationale de l'Université de Liège, Station de Recherches Sousmarines et Océanographiques (StaReSO), Calvi, Corse, 23–25 avril 1990*, ed. Robert Laffineur and Lucien Basch, pp. 189–201. Aegaeum 7. Liège: Université de Liège, Histoire de l'art et archéologie de la Grèce Antique.

Nims, Charles F.

1955 "Places about Thebes." *JNES* 14 (April), pp. 110–23.

1966 "The Date of the Dishonoring of Hatshepsut." *ZÄS* 93, pp. 97–100.

1971 "The Eastern Temple at Karnak." In *Aufsätze zum 70. Geburtstag von Herbert Ricke*, pp. 107–11. Beiträge zur ägyptischen Bauforschung und Altertumskunde 12. Wiesbaden: Franz Steiner in Komm.

Niwiński, Andrzej

2004 "Archaeological Secrets of the Cliff Ledge above the Temples at Deir el-Bahari and the Problem of the Tomb of Amenhotep I." In *IXᵉ Congrès International des Égyptologues, 6–12 septembre 2004, Grenoble-France: Résumés des communications*, p. 89. Grenoble: Conseil Général de l'Isère and Centre National de la Recherche Scientifique.

Nofret

1985 *Nofret—die Schöne: Die Frau im alten Ägypten.* Exh. cat., Haus der Kunst, Munich; Ägyptisches Museum, Berlin; and Roemer- und Pelizaeus-Museum, Hildesheim. Mainz am Rhein: Philipp von Zabern.

Nolte, Birgit

1968 *Die Glasgefässe im alten Ägypten.* Münchner ägyptologische Studien 14. Berlin: Bruno Hessling.

Northampton, 5th Marquis of (William George Spencer Scott Compton), Wilhelm Spiegelberg, and Percy E. Newberry

1908 *Report on Some Excavations in the Theban Necropolis during the Winter of 1888–9.* London.

Oates, David, John Oates, and Helen McDonald

1997 *Excavations at Tell Brak.* Vol. 1, *The Mitanni and Old Babylonian Periods.* Cambridge: McDonald Institute for Archaeological Research, University of Cambridge; London: British School of Archaeology in Iraq.

O'Connor, David B.

1983 "New Kingdom and Third Intermediate Period, 1552–664 BC." In *Ancient Egypt: A Social History*, ed. Bruce G. Trigger, Barry J. Kemp, David B. O'Connor, and A. B. Lloyd, pp. 183–278. Cambridge: Cambridge University Press.

1991 "Mirror of the Cosmos: The Palace of Merenptah." In *Fragments of a Shattered Visage: The Proceedings of the International Symposium of Ramesses the Great*, ed. Edward Bleiberg and Rita Freed, pp. 167–98. Monographs of the Institute of Egyptian Art and Archaeology 1. Memphis: Memphis State University.

1993 *Ancient Nubia: Egypt's Rival in Africa.* Philadelphia: University Museum, University of Pennsylvania.

1995 "Beloved of Maat, the Horizon of Re: The Royal Palace in New Kingdom Egypt." In *Ancient Egyptian Kingship*, ed. David B. O'Connor and David P. Silverman, pp. 263–300. Probleme der Ägyptologie 9. Leiden: E. J. Brill.

1997 "The Hyksos Period in Egypt." In *The Hyksos: New Historical and Archaeological Perspectives*, ed. Eliezer D. Oren, pp. 45–67. University Museum Monograph 96. University Museum Symposium Series 8. Philadelphia: University Museum, University of Pennsylvania.

Ogden, Jack

2000 "Metals." In *Ancient Egyptian Materials and Technology*, ed. Paul T. Nicholson and Ian Shaw, pp. 148–76. Cambridge: Cambridge University Press.

Otto, Eberhard

1952 *Topographie des thebanischen Gaues.* Untersuchungen zur Geschichte und Altertumskunde Aegyptens 16. Berlin: Akademie-Verlag.

1975a "Anuket." In *LÄ*, vol. 1, cols. 333–34. Wiesbaden: Otto Harrassowitz.

1975b "Chnum." In *LÄ*, vol. 1, cols. 950–54. Wiesbaden: Otto Harrassowitz.

Pamminger, Peter

1992 "Nochmals zum Problem der Vizekönige von Kusch unter Hatschepsut." *GM*, no. 131, pp. 97–100.

Paner, Henryk

2003 "Archaeological Survey on the Right Bank of the Nile between Kareima and Abu Hamed: A Brief Overview." *S&N*, no. 7, pp. 15–20.

Parkinson, Richard

1999 *Cracking Codes: The Rosetta Stone and Decipherment.* Berkeley and Los Angeles: University of California Press.

Patch, Diana Craig

1990 *Reflections of Greatness: Ancient Egypt at the Carnegie Museum of Natural History.* Pittsburgh: Carnegie Museum of Natural History.

1998 "By Necessity or Design: Faience Use in Ancient Egypt." In F. D. Friedman 1998, pp. 32–45.

Payne, Joan Crowfoot

1966 "Spectrographic Analysis of Some Egyptian Pottery of the Eighteenth Dynasty." *JEA* 52, pp. 176–78.

Peck, William H., Jr.

1978 *Egyptian Drawings*. New York: E. P. Dutton.

1997 *Splendors of Ancient Egypt*. Exh. cat. Detroit: Detroit Institute of Arts.

Pecoil, Jean-François

1993 "Les visages du pouvoir: Les métamorphoses iconographiques d'Hatchepsout." In *Hatchepsout* 1993, pp. 16–25.

Peet, T. Eric, and C. Leonard Woolley

1923 *The City of Akhenaten*. Pt. 1, *Excavations of 1921 and 1922 at el-ʿAmarneh*. Thirty-eighth Memoir of the Egypt Exploration Society. London: Egypt Exploration Society.

Petrie, William Matthew Flinders

1891 *Illahun, Kahun and Gurob, 1889–90*. London: David Nutt.

1894 *Tell el Amarna*. London: Methuen and Co. Repr., Warminster: Aris and Phillips, 1974.

1906 *Researches in Sinai*. With chapters by Charles Trick Currelly. New York: E. P. Dutton.

1909 *Qurneh*. London: School of Archaeology in Egypt and Bernard Quaritch.

1917 *Tools and Weapons: Illustrated by the Egyptian Collection in University College, London, and 2,000 Outlines from Other Sources*. Publications of the Egyptian Research Account and British School of Archaeology in Egypt 30. London: British School of Archaeology in Egypt. Repr., Warminster: Aris and Phillips, 1974.

1927 *Objects of Daily Use, with Over 1800 Figures from University College, London*. Publications of the Egyptian Research Account and British School of Archaeology in Egypt 42. London: British School of Archaeology in Egypt and Bernard Quaritch.

Petrie, William Matthew Flinders, and Guy Brunton

1924 *Sedment*. 2 vols. Publications of the Egyptian Research Account and British School of Archaeology in Egypt 34, 35. London: British School of Archaeology in Egypt and Bernard Quaritch.

Petrie, William Matthew Flinders, Gerald Averay Wainwright, and Ernest Mackay

1912 *The Labyrinth, Gerzeh and Mazghuneh*. Publications of the Egyptian Research Account and British School of Archaeology in Egypt 21. London: British School of Archaeology in Egypt and Bernard Quaritch.

Petschel, Susanne, and Martin von Falck

2004 *Pharao siegt immer: Krieg und Frieden im alten Ägypten*. Exh. cat., Gustav-Lübcke-Museum, Hamm. Bonn: Kettler.

Pharaonen und Fremde

1994 *Pharaonen und Fremde: Dynastien im Dunkel*. Exh. cat., Rathaus, Vienna. Sonderausstellung des Historischen Museums der Stadt Wien 194. Vienna: Eigenverlag der Museen der Stadt Wien.

Piacentini, Patrizia, and Christian Orsenigo

2004 *La Valle dei Re riscoperta: I giornali di scavo di Victor Loret, 1898–1899, e altri inedditi*. Milan: Università degli Studi di Milano.

Pierrat, Geneviève

2005 "La dame sans son enfant: À propos des vases sculptures de la XVIIIᵉ Dynastie." *Égypte, Afrique & Orient*, August, pp. 39–44.

von Pilgrim, Cornelius

2002 "Der Chnumtempel des Neuen Reiches." In Günter Dreyer, Hans-Werner Fischer-Elfert, Christian Heitz, Anne Klammt, Myriam Krutzsch, Cornelius von Pilgrim, Dietrich Raue, Simone Schönenberger, and Christian Ubertini, "Stadt und Tempel von Elephantine: 28./29./30. Grabungsbericht," *MDAIK* 58, pp. 184–92.

Pinch, Geraldine

1993 *Votive Offerings to Hathor*. Oxford: Griffith Institute and Ashmolean Museum.

1994 *Magic in Ancient Egypt*. London: British Museum Press.

Polz, Daniel

1998 "Theben und Avaris: Zur 'Vertreibung' der Hyksos." In *Stationen: Beiträge zur Kulturgeschichte Ägyptens—Rainer Stadelmann gewidmet*, ed. Heike Guksch and Daniel Polz, pp. 219–31. Mainz am Rhein: Philipp von Zabern.

Polz, Daniel, and Anne Seiler

2003 *Die Pyramidenanlage des Königs Nub-cheper-Re Intef in Draʾ Abu el-Naga*. Sonderschrift (Deutsches Archäologisches Institut, Abteilung Kairo) 24. Mainz am Rhein: Philipp von Zabern.

Porada, Edith

1947 *Seal Impressions of Nuzi*. Annual of the American Schools of Oriental Research 24. New Haven: American Schools of Oriental Research.

1984 "The Cylinder Seal from Tell el-Dabʿa." *American Journal of Archaeology* 88 (October), pp. 485–88.

Porat, Naomi, and Yuval Goren

2002a "Petrography of the Naqada IIIa Canaanite Pottery from Tomb U-j in Abydos." In Van den Brink and Levy 2002, pp. 252–70.

2002b "Petrography of the Naqada IIIa Canaanite Pottery from Tomb U-j in Abydos." In Hartung 2002, pp. 466–81.

Porter, Barbara A.

1986 "Egyptian Decorated Faience Bowls of Early Dynasty 18 from Thebes from the Excavations of The Metropolitan Museum of Art and Lord Carnarvon and Howard Carter." Ph.D. diss., Columbia University, New York.

Porter, Bertha, and Rosalind L. B. Moss

1934 *Topographical Bibliography of Ancient Egyptian Hieroglyphic Texts, Reliefs, and Paintings*. Vol. 4, *Lower and Middle Egypt (Delta and Cairo to Asyût)*. Oxford: Clarendon Press.

1937 *Topographical Bibliography of Ancient Egyptian Hieroglyphic Texts, Reliefs, and Paintings*. Vol. 5, *Upper Egypt: Sites (Deir Rîfa to Aswân, excluding Thebes and the Temples of Abydos, Dendera, Esna, Edfu, Kôm, Ombo and Philae)*. Oxford: Clarendon Press.

1951 With Ethel W. Burney. *Topographical Bibliography of Ancient Egyptian Hieroglyphic Texts, Reliefs, and Paintings*. Vol. 7, *Nubia, the Deserts, and Outside Egypt*. Oxford: Clarendon Press.

1960 With Ethel W. Burney. *Topographical Bibliography of Ancient Egyptian Hieroglyphic Texts, Reliefs, and Paintings*. Vol. 1, *The Theban Necropolis*. Pt. 1, *Private Tombs*. 2nd ed. Oxford: Clarendon Press.

1964 With Ethel W. Burney. *Topographical Bibliography of Ancient Egyptian Hieroglyphic Texts, Reliefs, and Paintings*. Vol. 1, *The Theban Necropolis*. Pt. 2, *Royal Tombs and Smaller Cemeteries*. 2nd ed. Oxford: Clarendon Press.

1972 With Ethel W. Burney. *Topographical Bibliography of Ancient Egyptian Hieroglyphic Texts, Reliefs, and Paintings*. Vol. 2, *Theban Temples*. 2nd ed. Oxford: Clarendon Press.

1974 With Ethel W. Burney. *Topographical Bibliography of Ancient Egyptian Hieroglyphic Texts, Reliefs, and Paintings*. Vol. 3, *Memphis*. Pt. 1, *Abû Rawâsh to Abûsîr*. 2nd ed. Rev. by Jaromír Málek. Oxford: Clarendon Press.

1978 *Topographical Bibliography of Ancient Egyptian Hieroglyphic Texts, Reliefs, and Paintings*. Vol. 3, *Memphis*. Pt. 2, *Ṣaqqâra to Dahshûr*. Fasc. 1. 2nd ed. Rev. by Jaromír Málek. Oxford: Griffith Institute, Ashmolean Museum.

Press, Ludwika

1967 *Architektura w ikonografii przedgreckiej*. Polskie Towarzystwo Archeologiczne, Biblioteka archeologiczna 20. Warsaw: Zakład Narodowy im. Ossolińskich.

Priese, Karl-Heinz

1991 Ed. *Ägyptisches Museum: Museumsinsel Berlin*. Mainz am Rhein: Philipp von Zabern; Berlin: Staatliche Museen zu Berlin, Stiftung Preussischer Kulturbesitz.

Pusch, Edgar B.

1979 *Das Senet-Brettspiel im alten Ägypten*. Pt. 1, *Das inschriftliche und archäologische Material*. Münchner ägyptologische Studien 38. Berlin: Deutscher Kunstverlag.

De Putter, Thierry, and Christina Karlhausen

1992 *Les pierres utilisées dans la sculpture et l'architecture de l'Égypte pharaonique: Guide pratique illustré*. Étude 4. Brussels: Connaissance de l'Égypte Ancienne.

Quaegebeur, Jan

1999 *La naine et le bouquetin; ou, L'énigme de la barque en albâtre de Toutankhamon.* Louvain: Peeters.

Quibell, James Edward

1898 *The Ramesseum.* Egyptian Research Account 2. London: Bernard Quaritch.

1908 *The Tomb of Yuaa and Thuiu.* Catalogue général des antiquités égyptiennes du musée du Caire, nos. 51001–51191. Cairo: Institut Français d'Archéologie Orientale du Caire.

1913 *Excavations at Saqqara (1911–12): The Tomb of Hesy.* Excavations at Saqqara 5. Cairo: Institut Français d'Archéologie Orientale du Caire.

Quirke, Stephen

1992 *Ancient Egyptian Religion.* London: British Museum Press for the Trustees of the British Museum.

Quirke, Stephen, and Jeffrey Spencer

1992 Eds. *The British Museum Book of Ancient Egypt.* London: British Museum Press for the Trustees of the British Museum.

Radwan, Ali

1983 *Die Kupfer- und Bronzegefässe Ägyptens von den Anfängen bis zum Beginn der Spätzeit.* Prähistorische Bronzefunde, sect. 2, vol. 2. Munich: C. H. Beck.

Rand, H.

1970 "Figure-Vases in Ancient Egypt and Hebrew Midwives." *Israel Exploration Journal* 20, pp. 209–12.

Randall-MacIver, David

1910 "The Eckley B. Coxe Junior Expedition." *Museum Journal* (University of Pennsylvania) 1, pp. 22–28.

Randall-MacIver, David, and Arthur Cruttenden Mace

1902 *El Amrah and Abydos, 1899–1901.* Egypt Exploration Fund, Memoir 23. London and Boston: Egypt Exploration Fund.

Randall-MacIver, David, and C. Leonard Woolley

1911 *Buhen.* 2 vols. Publications: Eckley B. Coxe Junior Expedition to Nubia 7, 8. Philadelphia: University Museum.

Ranke, Hermann

1940 "A Contemporary of Queen Hatshepsut." *University Museum Bulletin* (University of Pennsylvania), vol. 8, no. 1 (January), pp. 28–30.

1950 "The Egyptian Collections of the University Museum." *University Museum Bulletin* (University of Pennsylvania), vol. 15, nos. 2–3 (November), pp. 5–109.

Ratié, Suzanne

1979 *La reine Hatshepsout: Sources et problèmes.* Orientalia Monspeliensia 1. Leiden: E. J. Brill.

Raven, Maarten J.

1995 "Schmuck und Amulette." In Vogelsang-Eastwood 1995, pp. 113–25.

Redford, Donald B.

1967 *History and Chronology of the Eighteenth Dynasty of Egypt: Seven Studies.* Near and Middle East Series 3. Toronto: University of Toronto Press.

1981 "A Royal Speech from the Blocks of the Tenth Pylon." *Bulletin of the Egyptological Seminar* 3, pp. 87–102.

1986 *Pharaonic King-Lists, Annals and Day-Books: A Contribution to the Study of the Egyptian Sense of History.* Society for the Study of Egyptian Antiquities, Publication 4. Mississauga, Ontario: Benben Publications.

1992 *Egypt, Canaan, and Israel in Ancient Times.* Princeton: Princeton University Press.

1997 "Textual Sources for the Hyksos Period." In *The Hyksos: New Historical and Archaeological Perspectives,* ed. Eliezer D. Oren, pp. 1–44. University Museum Monograph 96. University Museum Symposium Series 8. Philadelphia: University Museum, University of Pennsylvania.

2003 *The Wars in Syria and Palestine of Thutmose III.* Culture and History of the Ancient Near East 16. Leiden and Boston: E. J. Brill.

2004 *From Slave to Pharaoh: The Black Experience of Ancient Egypt.* Baltimore and London: Johns Hopkins University Press.

Redmount, Carol A.

1995 "Ethnicity, Pottery, and the Hyksos at Tell el-Maskhuta in the Egyptian Delta." *Biblical Archaeologist* 58 (December), pp. 182–90.

Reeves, Nicholas

1990a *The Complete Tutankhamun: The King, the Tomb, the Royal Treasure.* London: Thames and Hudson.

1990b *Valley of the Kings: The Decline of a Royal Necropolis.* Studies in Egyptology. London and New York: Kegan Paul International.

1993 "The Ashburnham Ring and the Burial of General Djehuty." *JEA* 79, pp. 259–61.

2000 *Ancient Egypt, the Great Discoveries: A Year-by-Year Chronicle.* London: Thames and Hudson.

2003 "On Some Queens' Tombs of the Eighteenth Dynasty." In *The Theban Necropolis: Past, Present and Future,* ed. Nigel Strudwick and John H. Taylor, pp. 69–73. London: British Museum Press.

Reeves, Nicholas, and John H. Taylor

1992 *Howard Carter before Tutankhamun.* London: British Museum Press for the Trustees of the British Museum.

Reeves, Nicholas, and Richard H. Wilkinson

1996 *The Complete Valley of the Kings: Tombs and Treasures of Egypt's Greatest Pharaohs.* New York: Thames and Hudson.

Reisner, George A.

1905 *The Hearst Medical Papyrus.* University of California Publications, Egyptian Archaeology 1. Leipzig: J. C. Hinrichs.

1920 "The Viceroys of Ethiopia." *JEA* 6, pp. 73–88.

1923 *Excavations at Kerma, Parts IV–V.* Harvard African Studies 6. Cambridge, Mass.: Peabody Institute of Harvard University.

Reisner, George A., and William Stevenson Smith

1955 *The Tomb of Hetep-heres, the Mother of Cheops: A Study of Egyptian Civilization in the Old Kingdom.* Vol. 2 of *A History of the Giza Necropolis.* Completed and revised by William Stevenson Smith. Cambridge, Mass.: Harvard University Press.

Reynders, Marleen

1998 "Names and Types of the Egyptian Sistrum." In *Proceedings of the Seventh International Congress of Egyptologists, Cambridge, 3–9 September 1995,* ed. C. J. Eyre, pp. 945–55. Orientalia Lovaniensia Analecta 82. Louvain: Peeters.

Richardson, Elisha R.

1991 *Atlas of Craniofacial Growth in Americans of African Descent.* Craniofacial Growth Series 26. Ann Arbor: University of Michigan, Center for Human Growth and Development.

Ricke, Herbert

1939 *Der Totentempel Thutmoses' III.: Baugeschichtliche Untersuchung.* Beiträge zur ägyptischen Bauforschung und Altertumskunde 3. Cairo.

1954 *Das Kamutef-Heiligtum Hatschepsuts und Thutmoses' III in Karnak: Berichte über eine Ausgrabung vor dem Muttempelbezirk.* Beiträge zur ägyptischen Bauforschung und Altertumskunde 3, 2. Cairo: Schweizerisches Institut für Ägyptische Bauforschung und Altertumskunde in Kairo.

Ritner, Robert Kriech

1993 *The Mechanics of Ancient Egyptian Magical Practice.* Studies in Ancient Oriental Civilization, The Oriental Institute of the University of Chicago 54. Chicago: University of Chicago Press.

Robins, Gay

1983 "A Critical Examination of the Theory That the Right to the Throne of Ancient Egypt Passed through the Female Line in the Eighteenth Dynasty." *GM,* no. 62, pp. 67–77.

1993 *Women in Ancient Egypt.* Cambridge, Mass.: Harvard University Press.

1994a *Proportion and Style in Ancient Egyptian Art.* Austin: University of Texas Press.

1994b "Some Principles of Compositional Dominance and Gender Hierarchy in Egyptian Art." *JARCE* 31, pp. 33–40.

1995 *Reflections of Women in the New Kingdom: Ancient Egyptian Art from the British Museum.* Exh. cat. Organized by the Michael C. Carlos Museum, Emory University, Atlanta, Georgia. San Antonio: Van Siclen Books.

1999 "The Names of Hatshepsut as King." *JEA* 85, pp. 103–12.

Roeder, Günther

1924 *Aegyptische Inschriften aus den Königlichen Museen zu Berlin.* Vol. 2. Leipzig: J. C. Hinrichs.

Roehrig, Catharine H.

1990 "The Eighteenth Dynasty Titles Royal Nurse

(*mn³t nswt*), Royal Tutor (*mn³nswt*) and Foster Brother/Sister of the Lord of the Two Lands (*sn/snt mn³ n nb t³wy*)." Ph.D. diss., University of California, Berkeley.

2002 *Life Along the Nile: Three Egyptians of Ancient Thebes. The Metropolitan Museum of Art Bulletin*, n.s., vol. 60, no. 1 (Summer).

2005 "The Building Projects of Thutmose III in the Valley of the Kings." In *Thutmose III: A New Biography*, ed. Eric H. Cline and David B. O'Connor, pp. 238–59. Ann Arbor: University of Michigan Press.

forthcoming "Chamber Ja in Royal Tombs in the Valley of the Kings." In a volume to be published by the Oriental Institute of the University of Chicago.

Romano, James F.

1976 "Observations on Early Eighteenth Dynasty Royal Sculpture." *JARCE* 13, pp. 97–111.

1979 *The Luxor Museum of Ancient Egyptian Art: Catalogue*. Cairo: American Research Center in Egypt.

1998 "Sixth Dynasty Royal Sculpture." In *Les critères de datation stylistiques à l'Ancien Empire*, ed. Nicolas Grimal, pp. 235–303. Bibliothèque d'étude (Institut Français d'Archéologie Orientale du Caire) 120. Cairo: Institut Français d'Archéologie Orientale du Caire.

Romer, John

1974 "Tuthmosis I and the Bibân el-Molûk: Some Problems of Attribution." *JEA* 60, pp. 119–33.

1975 "The Tomb of Tuthmosis III." *MDAIK* 31, pp. 315–51.

1976 "Royal Tombs of the Early Eighteenth Dynasty." *MDAIK* 32, pp. 191–206.

1982 *Romer's Egypt: A New Light on the Civilization of Ancient Egypt*. London: Michael Joseph. Repr., *People of the Nile: A New Light on the Civilization of Ancient Egypt*. London: Michael Joseph, 1989.

Rosati, Gloria

1988 "Precious Ornaments: Jewels and Amulets." In *Egyptian Civilization: Daily Life*, ed. Anna Maria Donadoni Roveri, pp. 218–31. Museo Egizio, Turin. Milan: Electa.

Rose, Pamela J.

1984 "The Pottery Distribution Analysis." In Barry J. Kemp, with contributions by T. J. L. Alexander et al., *Amarna Reports I*, pp. 133–53. Occasional Publications (Egypt Exploration Society) 1. London: Egypt Exploration Society.

Rosellini, Ippolito

1832–44 *I monumenti dell'Egitto e della Nubia*. 3 vols. Pisa.

Rösing, Friedrich Wilhelm

1990 *Qubbet el Hawa und Elephantine: Zur Bevölkerungsgeschichte von Ägypten*. Stuttgart and New York: G. Fischer.

Roth, Ann Macy

1991 *Egyptian Phyles in the Old Kingdom: The Evolution of a System of Social Organization*. Studies in Ancient Oriental Civilization, The Oriental Institute of the University of Chicago 48. Chicago: University of Chicago Press.

1993 "Social Change in the Fourth Dynasty: The Spatial Organization of Pyramids, Tombs, and Cemeteries." *JARCE* 30, pp. 33–55.

2001 "Opening of the Mouth." In *The Oxford Encyclopedia of Ancient Egypt*, ed. Donald B. Redford, vol. 2, pp. 605–9. Oxford: Oxford University Press.

2002 "The Usurpation of Hem-Re: An Old Kingdom 'Sex-Change Operation.'" In *Egyptian Museum Collections around the World: Studies for the Centennial of the Egyptian Museum, Cairo*, ed. Mamdouh Eldamaty and Mai Trad, vol. 2, pp. 1011–23. Cairo: Supreme Council of Antiquities.

Roth, Silke

2001 *Die Königsmütter des alten Ägypten von der Frühzeit bis zum Ende der 12. Dynastie*. Ägypten und Altes Testament 46. Wiesbaden: Otto Harrassowitz.

2002 *Gebieterin aller Länder: Die Rolle der königlichen Frauen in der fiktiven und realen Aussenpolitik des ägyptischen Neuen Reiches*. Orbis Biblicus et Orientalis 185. Fribourg: Universitätsverlag; Göttingen: Vandenhoeck & Ruprecht.

Roullet, Anne

1972 *The Egyptian and Egyptianizing Monuments of Imperial Rome*. Leiden: E. J. Brill.

Russmann, Edna R.

1989 *Egyptian Sculpture: Cairo and Luxor*. Austin: University of Texas Press.

forthcoming "An Anonymous Image of a Great Queen." *Bulletin of the Egyptological Seminar* 17 (2005).

Russmann, Edna R., et al.

2001 Edna R. Russmann and T. G. H. James, with contributions by Carol Andrews et al. *Eternal Egypt: Masterworks of Ancient Art from the British Museum*. Exh. cat., Toledo Museum of Art; Wonders (Memphis International Cultural Series), Memphis; Brooklyn Museum; and other institutions. Berkeley and Los Angeles: University of California Press; New York: American Federation of Arts.

Ryholt, Kim S. B.

1997 *The Political Situation in Egypt during the Second Intermediate Period, c. 1800–1550 B.C.* Carsten Niebuhr Institute Publications 20. Copenhagen: Carsten Niebuhr Institute of Near Eastern Studies, University of Copenhagen, and Museum Tusculanum Press.

2000 "The Late Old Kingdom in the Turin King-List and the Identity of Nitocris." *ZÄS* 127, pp. 87–100.

el-Sabbahy, Abdul-Fattah

1992 "Kings' Sons of Kush under Hatshepsut." *GM*, no. 129, pp. 99–102.

el-Sadeek, Wafaa Taha, and J. M. Murphy

1983 "A Mud Sealing with Seth Vanquished (?)" *MDAIK* 39, pp. 159–75.

Saleh, Mohamed, and Hourig Sourouzian

1987 *The Egyptian Museum, Cairo: Official Catalogue*. Mainz am Rhein: Philipp von Zabern; [Cairo]: Organisation of Egyptian Antiquities, the Arabian Republic of Egypt.

Salje, Beate

1990 *Der 'Common Style' der Mitanni-Glyptik und die Glyptik der Levante und Zyperns in der Späten Bronzezeit*. Baghdader Forschungen 11. Mainz am Rhein: Philipp von Zabern.

Sauneron, Serge

1968 "La statue d'Ahmosé, dit Rourou au musée de Brooklyn." *Kêmi* 18, pp. 45–78.

Säve-Söderbergh, Torgny

1941 *Ägypten und Nubien: Ein Beitrag zur Geschichte altägyptischer Aussenpolitik*. Lund: Håkan Ohlssons Boktryckeri.

1946 *The Navy of the Eighteenth Egyptian Dynasty*. Uppsala: Lundequistska Bokhandeln.

1957 *Four Eighteenth Dynasty Tombs*. Private Tombs at Thebes 1. Oxford: Oxford University Press for the Griffith Institute.

1960 "The Paintings in the Tomb of Djehuty-hetep at Debeira." *Kush* 8, pp. 25–44.

1991 "Teh-khet: The Cultural and Sociopolitical Structure of a Nubian Princedom in Tuthmoside Times." In *Egypt and Africa: Nubia from Prehistory to Islam*, ed. W. Vivian Davies, pp. 186–94. London: British Museum Press for the Trustees of the British Museum and the Egypt Exploration Society.

Säve-Söderbergh, Torgny, and Lana Troy

1991 *New Kingdom Pharaonic Sites*. Vol. 5, pts. 2 and 3, *The Finds and the Sites*. Scandinavian Joint Expedition to Sudanese Nubia Publications 5. Uppsala: Scandinavian Joint Expedition to Sudanese Nubia.

el-Sayed, Rafed

2004 "*r³ n Md³.iw*—lingua blemmyica—*tu-bedawie*: Ein Sprachenkontinuum im Areal der nubischen Ostwüste und seine (sprach-) historischen Implikationen." *SAK* 32, pp. 351–62.

Scandone Matthiae, Gabriella

1995 "Ebla, la Siria e l'Egitto nel bronzo antico e medio." In *Ebla, alle origini della civiltà urbana: Trent'anni di scavi in Siria dell'Università di Roma "La Sapienza,"* ed. Paolo Matthiae, Frances Pinnock, and Gabriella Scandone Matthiae, pp. 234–41. Exh. cat., Palazzo Venezia, Rome. Milan: Electa.

1997 "The Relations between Ebla and Egypt." In *The Hyksos: New Historical and Archaeological Perspectives*, ed. Eliezer D. Oren, pp. 415–27. University Museum Monograph 96. University Museum Symposium Series 8. Philadelphia: University Museum, University of Pennsylvania.

Schäfer, Heinrich

1902 *Ein Bruchstück altägyptischer Annalen.* Berlin: Königliche Akademie der Wissenschaften.

Schenkel, Wolfgang

1977 "Harimszögling." In *LÄ*, vol. 2, cols. 991–92. Wiesbaden: Otto Harrassowitz.

1982a "Messchnur." In *LÄ*, vol. 4, col. 115. Wiesbaden: Otto Harrassowitz.

1982b "Onuris." In *LÄ*, vol. 4, cols. 573–74. Wiesbaden: Otto Harrassowitz.

Schiaparelli, Ernesto

1927 Ed. *Relazione sui lavori della Missione Archeologica Italiano in Egitto, anni 1903–1920.* Vol. 2, *La tomba intatta dell'architetto Cha.* Turin: R. Museo di Antichità.

Schneider, Hans D.

1987 *Kodai ejiputo ten, oranda Kokuritsu Raiden Kodai Hakubutsukan shozo/Art from Ancient Egypt, Chosen from the Collections of the National Museum of Antiquities at Leiden, the Netherlands.* Exh. cat., Odakyu Grand Gallery, Tokyo, and other locations. Leiden: Rijksmuseum van Oudheden.

1995 *Egyptisch kunsthandwerk.* Rijksmuseum van Oudheden, Leiden. Amsterdam: De Bataafsche Leeuw.

1997 With Maarten J. Raven. *Life and Death under the Pharaohs: Egyptian Art from the National Museum of Antiquities in Leiden, the Netherlands.* Exh. cat. Perth: Western Australian Museum; Leiden: Rijksmuseum van Oudheden.

Schneider, Hans D., and Maarten J. Raven

1981 *Die Egyptische oudheid: Een inleiding aan de hand van de Egyptische verzameling in het Rijksmuseum van Oudheden te Leiden.* Rijksmuseum van Oudheden. The Hague: Staatsuitgeverij.

Schneider, Thomas

1992 *Asiatische Personennamen in ägyptischen Quellen des Neuen Reiches.* Orbis Biblicus et Orientalis 114. Fribourg: Universitätsverlag; Göttingen: Vandenhoeck & Ruprecht.

1998 *Ausländer in Ägypten während des Mittleren Reiches und der Hyksoszeit.* Vol. 1, *Die ausländischen Könige.* Ägypten und Altes Testament 42. Wiesbaden: Otto Harrassowitz.

2003a *Ausländer in Ägypten während des Mittleren Reiches und der Hyksoszeit.* Vol. 2, *Die ausländische Bevölkerung.* Ägypten und Altes Testament 42. Wiesbaden: Otto Harrassowitz.

2003b "Foreign Egypt: Egyptology and the Concept of Cultural Appropriation." *Ä&L* 13, pp. 155–61.

2004 "Thebens Rückkehr zur Macht." In Petschel and von Falck 2004, p. 145.

Schoske, Sylvia

1990 *Schönheit—Abglanz der Göttlichkeit: Kosmetik im alten Ägypten.* Schriften aus der Ägyptischen Sammlung 5. Munich: Staatliche Sammlung Ägyptischer Kunst.

Schott, Siegfried

1955 *Zum Krönungstag der Königin Hatschepsût.*

Akademie der Wissenschaften, Göttingen, Philologisch-historische Klasse, Nachrichten, Jahre 1955, no. 6. Göttingen: Vandenhoeck & Ruprecht.

Schulman, Alan Richard

1957 "Egyptian Representations of Horsemen and Riding in the New Kingdom." *JNES* 16 (October), pp. 263–71.

1969–70 "Some Remarks on the Alleged 'Fall' of Senmūt." *JARCE* 8, pp. 29–48.

1987–88 "The Ubiquitous Senenmut." *Bulletin of the Egyptological Seminar* 9, pp. 61–81.

Schulz, Regine

1992 *Die Entwicklung und Bedeutung des kuboiden Statuentypus: Eine Untersuchung zu den sogenannten "Würfelhockern."* 2 vols. Hildesheimer ägyptologische Beiträge 33, 34. Hildesheim: Gerstenberg.

Schulz, Regine, and Matthias Seidel

1998 Eds. *Egypt: The World of the Pharaohs.* Cologne: Könemann.

Schweinfurth, Georg

1900 "Neue thebanische Gräberfunde." *Sphinx* 3, pp. 103–7.

Schweitzer, Ursula

1948 *Löwe und Sphinx im alten Ägypten.* Ägyptologische Forschungen 15. Glückstadt: J. J. Augustin.

Scott, George Richard, and Christy G. Turner II

1997 *The Anthropology of Modern Human Teeth: Dental Morphology and Its Variation in Recent Human Populations.* Cambridge Studies in Biological Anthropology. Cambridge: Cambridge University Press.

Scott, Nora Elizabeth

1947 *The Home Life of the Ancient Egyptians: A Picture Book.* New York: Plantin Press.

1964 "Egyptian Jewelry." *Bulletin of The Metropolitan Museum of Art,* n.s., vol. 22, no. 7 (March), pp. 223–34.

1973 "The Daily Life of the Ancient Egyptians." *The Metropolitan Museum of Art Bulletin,* n.s., vol. 31, no. 3 (Spring).

Seidel, Matthias

1996 *Die königlichen Statuengruppen.* Vol. 1, *Die Denkmäler vom Alten Reich bis zum Ende der 18. Dynastie.* Hildesheimer ägyptologische Beiträge 42. Hildesheim: Gerstenberg.

Seipel, Wilfried

1992 *Gott, Mensch, Pharao: Viertausend Jahre Menschenbild in der Skulptur des alten Ägypten.* Exh. cat. Vienna: Kunsthistorisches Museum.

2001 Ed. *Gold der Pharaonen.* Exh. cat., Kunsthistorisches Museum, Vienna. Milan: Skira; Vienna: Kunsthistorisches Museum.

Serpico, Margaret, and Raymond White

1998 "Chemical Analysis of Coniferous Resins from Ancient Egypt Using Gas Chromatography/ Mass Spectrometry (GC/MS)." In *Proceedings of the Seventh International Congress of Egyptologists, Cambridge, 3–9 September 1995,*

ed. C. J. Eyre, pp. 1037–48. Orientalia Lovaniensia Analecta 82. Louvain: Peeters.

2000 "Resins, Amber and Bitumen." In *Ancient Egyptian Materials and Technologies,* ed. Paul T. Nicholson and Ian Shaw, pp. 430–74. Cambridge: Cambridge University Press.

Sethe, Kurt

1896 *Die Thronwirren unter den Nachfolgern Königs Tuthmosis' I., ihr Verlauf und ihre Bedeutung; die Prinzenliste von Medinet Habu und die Reihenfolge der ersten Könige der Zwanzigsten Dynastie.* Untersuchungen zur Geschichte und Altertumskunde Aegyptens 1. Leipzig: J. C. Hinrichs.

1898 "Altes und Neues zur Geschichte der Thronstreitigkeiten unter den Nachfolgern Thutmosis' I." *ZÄS* 36, pp. 24–81.

1932 *Das Hatschepsut-Problem noch einmal Untersucht.* Abhandlungen der Preussischen Akademie der Wissenschaften, Philosophisch-historische Klasse 1932, no. 4. Berlin.

Settgast, Jürgen

1989 *Ägyptisches Museum Berlin.* 4th ed. Berlin: Staatliche Museen Preussischer Kulturbesitz, Ägyptisches Museum.

Shaw, Ian, and Paul Nicholson

1995 *The Dictionary of Ancient Egypt.* New York: Harry N. Abrams.

Shehata, Fathy I.

1982 "Bimaxillary Prognasthism in the Nubian People of Egypt." *Angle Orthodontist,* vol. 52, no. 1 (January), pp. 19–25.

Un siècle de fouilles françaises en Égypte

1981 *Un siècle de fouilles françaises en Égypte, 1880–1980: À l'occasion du centenaire de l'École du Caire (IFAO).* Exh. cat. Cairo: École du Caire; Paris: Musée du Louvre.

Silverman, David P.

1997 Ed. *Searching for Ancient Egypt: Art, Architecture, and Artifacts from the University of Pennsylvania Museum of Archaeology and Anthropology.* Essays by Edward Brovarski et al. Exh. cat. Dallas: Dallas Museum of Art; Philadelphia: University of Pennsylvania Museum; Ithaca: Cornell University Press.

Simpson, William Kelly

1963 *Heka-nefer and the Dynastic Material from Tashka and Arminna.* New Haven: Peabody Museum of Natural History of Yale University.

1973 Ed. *The Literature of Ancient Egypt: An Anthology of Stories, Instructions, and Poetry.* Trans. Raymond Oliver Faulkner, Edward F. Wente Jr., and William Kelly Simpson. New ed. New Haven and London: Yale University Press.

1977 *The Face of Egypt: Permanence and Change in Egyptian Art, from Museum and Private Collections.* Exh. cat. Katonah, N.Y.: Katonah Gallery.

Sist, Loredana

1996 *Museo Barracco: Arte egizia.* Quaderno 3. Rome: Istituto Poligrafico e Zecca dello Stato.

Smith, Grafton Elliot

1912 *The Royal Mummies.* Catalogue général des antiquités égyptiennes du musée du Caire, nos. 61051–61100. Cairo: Institut Français d'Archéologie Orientale du Caire.

Smith, Henry Sidney

1976 *The Fortress of Buhen: The Inscriptions.* Excavations at Buhen 2. Forty-eighth Excavation Memoir. London: Egypt Exploration Society.

Smith, Henry Sidney, and Alexandrina Smith

1976 "A Reconsideration of the Kamose Texts." *ZÄS* 103, pp. 48–76.

Smith, Mark

2004 With Mark Depauw. "Visions of Ecstasy: Cultic Revelry before the Goddess Ai / Nehemanit." In *Res severa verum gaudium: Festschrift für Karl-Theodor Zauzich zum 65. Geburtstag am 8. Juni 2004,* ed. Friedhelm Hoffmann and Heinz-Josef Thissen, pp. 67–93. Studia demotica 6. Louvain: Peeters.

Smith, Stuart Tyson

1992 "Intact Tombs of the Seventeenth and Eighteenth Dynasties from Thebes and the New Kingdom Burial System." *MDAIK* 48, pp. 193–231.

1995 *Askut in Nubia: The Economics and Ideology of Egyptian Imperialism in the Second Millennium B.C.* Studies in Egyptology. London: Kegan Paul International.

2003 *Wretched Kush: Ethnic Identities and Boundaries in Egypt's Nubian Empire.* London and New York: Routledge.

Smith, William Stevenson

1942 "Two Fragments from Hatshepshut's Karnak Obelisk." *Bulletin of the Museum of Fine Arts, Boston* 40 (June), pp. 45–48.

1952 *Ancient Egypt as Represented in the Museum of Fine Arts.* 3rd ed. Boston: Museum of Fine Arts.

1958 *The Art and Architecture of Ancient Egypt.* Pelican History of Art. Harmondsworth: Penguin Books.

1960 *Ancient Egypt as Represented in the Museum of Fine Arts, Boston.* 4th ed. Boston: Museum of Fine Arts.

1965a *The Art and Architecture of Ancient Egypt.* Rev. ed. Harmondsworth: Penguin Books.

1965b *Interconnnections in the Ancient Near-East: A Study of the Relationships between the Arts of Egypt, the Aegean, and Western Asia.* New Haven: Yale University Press.

Smith, William Stevenson, and William Kelly Simpson

1998 *The Art and Architecture of Ancient Egypt.* 3rd ed. Rev., with additions by William Kelly Simpson. Yale University Press Pelican History of Art. New Haven and London: Yale University Press.

Snape, Stephen Ralph

1986 "Mortuary Assemblages from Abydos." 2 vols. Ph.D. diss., University of Liverpool.

Sotheby's

1921 *Catalogue of the Amherst Collection of Egyptian and Oriental Antiquities.* Sale cat. Sotheby's, London, June 13–17, 1921.

2004 *Egyptian, Classical, and Western Asiatic Antiquities.* Sale cat. Sotheby's, New York, December 9, 2004.

Sourouzian, Hourig

1981 "Une tête de la reine Touy à Gourna." *MDAIK* 37, pp. 445–55.

1998 "Raccords Ramessides." *MDAIK* 54, pp. 279–92.

Spalinger, Anthony J.

1993a "A Chronological Analysis of the Feast of *thy.*" *SAK* 20, pp. 289–303.

1993b "A Religious Calendar Year in the Mut Temple at Karnak." *Revue d'égyptologie* 44, pp. 161–84.

2005 *War in Ancient Egypt: The New Kingdom.* Oxford: Blackwell.

Spalinger, Gretchen L.

1982 "Metal Vessels." In *Egypt's Golden Age* 1982, pp. 116–17.

Spencer, Patricia

1984 *The Egyptian Temple: A Lexicographical Study.* London and Boston: Kegan Paul International.

2004 "Digging Diary, 2003–2004." *Egyptian Archaeology,* no. 25 (Autumn), pp. 25–29.

Spiegelberg, Wilhelm

1897 "Varia." *Recueil de travaux* 19, pp. 86–101.

1927 "La ville de *Prw-nfr,* dans le delta." *Revue de l'Égypte ancienne* 1, pp. 215–17.

Spurr, Stephen, Nicholas Reeves, and Stephen Quirke

1999 *Egyptian Art at Eton College: Selections from the Myers Museum.* Exh. cat. New York: The Metropolitan Museum of Art; Windsor: Eton College.

Stadelmann, Rainer

1967 *Syrisch-palästinensische Gottheiten in Ägypten.* Probleme der Ägyptologie 5. Leiden: E. J. Brill.

1978 "Tempel und Tempelnamen in Theben-Ost und -West." *MDAIK* 34, pp. 171–80.

1979 "Totentempel und Millionenjahrhaus in Theben." *MDAIK* 35, pp. 303–21.

1980 "Medinet Habu." In *LÄ,* vol. 3, cols. 1255–71. Wiesbaden: Otto Harrassowitz.

2001 "Palaces." In *The Oxford Encyclopedia of Ancient Egypt,* ed. Donald B. Redford, vol. 3, pp. 13–17. Oxford: Oxford University Press.

Staehelin, Elisabeth

1982 "Menit." In *LÄ,* vol. 4, cols. 52–53. Wiesbaden: Otto Harrassowitz.

Starr, Richard F. S.

1939 *Nuzi: Report on the Excavation at Yorgan Tepa near Kirkuk, Iraq, Conducted by Harvard University in Conjunction with the American Schools of Oriental Research and the University Museum of Philadelphia, 1927–1931.* 2 vols. Cambridge, Mass.: Harvard University Press.

Steindorff, Georg

1900 *Die Blütezeit des Pharaonenreichs.* Monographien zur Weltgeschichte 10. Bielefeld: Velhagen & Klasing.

1901 Ed. *Grabfunde des Mittleren Reichs in den Königlichen Museen zu Berlin.* Vol. 2, *Der Sarg des Sebk-O.: Ein Grabfund aus Gebelén.* Berlin: W. Spemann.

1935–37 *Aniba.* 2 vols. in 3. Glückstadt: J. J. Augustin.

1937 "Ein bronzener Gefässuntersatz." *ZÄS* 73, pp. 122–23.

Strauss, Elisabeth-Christine

1974 *Die Nunschale: Eine Gefässgruppe des Neuen Reiches.* Münchner ägyptologische Studien 30. Berlin: Deutscher Kunstverlag.

Strudwick, Nigel

1985 *The Administration of Egypt in the Old Kingdom: The Highest Titles and Their Holders.* Studies in Egyptology. London and Boston: Kegan Paul International.

2001 *The Legacy of Lord Carnarvon: Miniatures from Ancient Egypt and the Valley of the Kings.* Exh. cat. Laramie: University of Wyoming Art Museum.

Strudwick, Nigel, and Helen Strudwick

1999 *Thebes in Egypt: A Guide to the Tombs and Temples of Ancient Luxor.* London: British Museum Press.

Szafrański, Zbigniew E.

1985 "Buried Statues of Mentuhotep II Nebhepetre and Amenophis I at Deir el-Bahari." *MDAIK* 41, pp. 257–63.

2001 Ed. *Królowa Hatszepsut i jej świątynia 3500 lat później / Queen Hatshepsut and Her Temple 3500 Years Later.* Warsaw: Agencja Reklamowo-Wydawnicza A. Grzegorczyk.

Teeter, Emily

1990 "Wearer of the Royal Uraeus: Hatshepsut." *KMT,* vol. 1, no. 1 (Spring 1990), pp. 4–13, 56–57.

1997 *The Presentation of Maat: Ritual and Legitimacy in Ancient Egypt.* Studies in Ancient Oriental Civilization, The Oriental Institute of the University of Chicago 57. Chicago: University of Chicago Press.

Tefnin, Roland

1973 "L'an 7 de Touthmosis III et d'Hatshepsout." *Chronique d'Égypte,* no. 96 (July), pp. 232–42.

1979 *La statuaire d'Hatshepsout: Portrait royal et politique sous la 18ᵉ Dynastie.* Monumenta Aegyptiaca 4. Brussels: Fondation Égyptologique Reine Élisabeth.

Terrace, Edward L. B.

1966 "'Blue Marble' Plastic Vessels and Other Figures." *JARCE* 5, pp. 57–63.

Terrace, Edward L. B., and Henry G. Fischer

1970 *Treasures of Egyptian Art from the Cairo Museum: A Centennial Exhibition, 1970–71.* Exh. cat. Boston: Museum of Fine Arts; New York: The Metropolitan Museum of Art.

Thomas, Elizabeth

1966 *The Royal Necropoleis of Thebes.* Princeton: Privately printed.

Thomas, Nancy

1995 *The American Discovery of Egypt*. With essays by Gerry D. Scott III and Bruce G. Trigger. Exh. cat. Los Angeles: Los Angeles County Museum of Art.

Tiradritti, Francesco

1999 Ed. *Egyptian Treasures from the Egyptian Museum in Cairo*. New York: Harry N. Abrams.

Török, László

1997 *The Kingdom of Kush: Handbook of the Napatan-Meroitic Civilization*. Handbook of Oriental Studies, The Near and Middle East 31. Leiden and New York: E. J. Brill.

Towry-White, E.

1902 "Types of Ancient Egyptian Draughtsmen." *Proceedings of the Society of Biblical Archaeology* (London), pp. 261–63.

Treasures of Tutankhamun

1976 *Treasures of Tutankhamun*. Exh. cat. New York: The Metropolitan Museum of Art.

Troy, Lana

1986 *Patterns of Queenship in Ancient Egyptian Myth and History*. Acta Universitatis Upsaliensis, Boreas 14. Uppsala: Universitetet; Stockholm: Almquist & Wiksell International.

1997 "Mut Enthroned." In *Essays on Ancient Egypt in Honour of Herman te Velde*, pp. 301–15. Groningen: Styx.

Tufnell, Olga

1984 *Studies on Scarab Seals*. Vol. 2, *Scarab Seals and Their Contribution to History in the Early Second Millennium B.C.* Warminster: Aris and Phillips.

Tyldesley, Joyce A.

1996 *Hatchepsut: The Female Pharaoh*. London and New York: Viking.

Uphill, E. P.

1961 "A Joint Sed-Festival of Thutmose III and Queen Hatshepsut." *JNES* 20 (October), pp. 248–51.

Urkunden 4

Urkunden der 18. Dynastie. Compiled by Kurt Sethe and Wolfgang Helck. Urkunden des ägyptischen Altertums, vol. 4, nos. 1–22. Leipzig: J. C. Hinrichs, 1906–58.

Valbelle, Dominique

1981 *Satis et Anoukis*. Mainz am Rhein: Philipp von Zabern.

1984 "Satet." In *LÄ*, vol. 5, cols. 487–88. Wiesbaden: Otto Harrassowitz.

2004 "Egyptians on the Middle Nile." In Welsby and Anderson 2004b, pp. 92–99.

Valbelle, Dominique, and Charles Bonnet

1996 *Le sanctuaire d'Hathor, maîtresse de la turquoise: Sérabit el-Khadim au Moyen Empire*. Paris: Picard.

Vandersleyen, Claude

1971 *Les guerres d'Amosis, fondateur de la XVIIIe Dynastie*. Monographies Reine Élisabeth 1. Brussels: Fondation Égyptologique Reine Élisabeth.

1975 *Das alte Ägypten*. With contributions by Hartwig Altenmüller et al. Propyläen Kunstgeschichte 15. Berlin: Propyläen Verlag.

1995 *L'Égypte et la vallée du Nil*. Vol. 2, *De la fin de l'Ancien Empire à la fin du Nouvel Empire*. Paris: Presses Universitaires de France.

Vandier, Jacques

1958 *Manuel d'archéologie égyptienne*. Vol. 3, *Les grandes époques: La statuaire*. Paris: A. et J. Picard.

1964 *Manuel d'archéologie égyptienne*. Vol. 4, *Bas-reliefs et peintures: Scènes de la vie quotidienne*. Paris: A. et J. Picard.

1969 *Manuel d'archéologie égyptienne*. Vol. 5, *Bas-reliefs et peintures: Scènes de la vie quotidienne*. Paris: A. et J. Picard.

Vandiver, Pamela B.

1986 "An Egyptian Faience Chalice." In W. David Kingery and Pamela B. Vandiver, *Ceramic Masterpieces: Art, Structure, and Technology*, pp. 51–67. New York: Free Press; London: Collier Macmillan.

Van Siclen, Charles Cornell, III

1980 "The Temple of Meniset at Thebes." *Serapis* 6, pp. 183–207.

1989 "New Data on the Date of the Defacement of Hatshepsut's Name and Image on the Chapelle Rouge." *GM*, no. 107, pp. 85–86.

Varner, Eric R.

2004 *Mutilation and Transformation: Damnatio Memoriae and Roman Imperial Portraiture*. Leiden and Boston: E. J. Brill.

Vassilika, Eleni

1995 *Egyptian Art*. With contributions by Janine Bourriau. Fitzwilliam Museum Handbooks. Cambridge: Cambridge University Press.

Velde, Herman te

1982 "The Cat as Sacred Animal of the Goddess Mut." In *Studies in Egyptian Religion: Dedicated to Professor Jan Zandee*, ed. Matthieu Heerma van Voss et al., pp. 127–37. Studies in the History of Religions 43. Leiden: E. J. Brill.

Verbovsek, Alexandra

2004 "Ägyptische Statuen im Ausland." In Petschel and von Falck 2004, p. 213.

Vercoutter, Jean

1956 *L'Égypte et le monde égéen préhellénique: Étude critique des sources égyptiennes (du début de la XVIIIe à la fin de la XIXe Dynastie)*. Bibliothèque d'étude (Institut Français d'Archéologie Orientale du Caire) 22. Cairo: Institut Français d'Archéologie Orientale du Caire.

Vermeule, Emily Townsend

1982 "Egyptian Imitations of Aegean Vases." In *Egypt's Golden Age* 1982, pp. 152–53.

La vie au bord du Nil

1980 *La vie au bord du Nil au temps des pharaons*. Exh. cat. Calais: Musée des Beaux-Arts et de la Dentelle.

Virey, Philippe

1889 *Mémoires publiés par les membres de la Mission Archéologique Française au Caire sous la direction de M. Bouriant, directeur de la Mission Archéologique Française au Caire*. Vol. 5, pt. 1, *Le tombeau de Rekhmara, préfet de Thèbes sous la XVIIIe Dynastie*. Ministère de l'Instruction Publique et des Beaux Arts. Paris: E. Leroux.

Vogel, Carola

2004 "Grenzschutz und Kolonisation." In Petschel and von Falck 2004, pp. 164–68.

Vogelsang-Eastwood, Gillian

1995 *Die Kleider des Pharaos: Die Verwendung von Stoffen im alten Ägypten*. With contributions by J. Fletcher, Maarten J. Raven, and W. Z. Wendrich. Exh. cat. Amsterdam: Batavian Lion; Hanover: Kestner-Museum.

1999 *Tutankhamun's Wardrobe: Garments from the Tomb of Tutankhamun*. Rotterdam: Barjesteh van Waalwijk van Doorn & Co.

Wachsmann, Shelley

1987 *Aegeans in the Theban Tombs*. Orientalia Lovaniensia Analecta 20. Louvain: Peeters.

Wainwright, Gerald Averay

1920 *Balabish*. Thirty-sixth Memoir of the Egypt Exploration Society. London: George Allen and Unwin.

1925 "A Dagger of the Early New Kingdom." *ASAE* 25, pp. 135–48.

Wallert, Ingrid

1962 *Die Palmen im alten Ägypten: Eine Untersuchung ihrer praktischen, symbolischen und religiösen Bedeutung*. Münchner ägyptologische Studien 1. Berlin: Bruno Hessling.

1967 *Der verzierte Löffel: Seine Formgeschichte und Verwendung im alten Ägypten*. Ägyptologische Abhandlungen 16. Wiesbaden: Otto Harrassowitz.

1970 [Ingrid Gamer-Wallert.] *Fische und Fischkulte im alten Ägypten*. Ägyptologische Abhandlungen 21. Wiesbaden: Otto Harrassowitz.

Wallet-Lebrun, Christiane

1994 "Contribution à l'étude de l'histoire de la construction à Karnak: La substitution du grès au calcaire comme matériau de construction dans le temple d'Amon-Rê." In *L'égyptologie et les Champollion*, ed. Michel Dewachter and Alain Fouchard, pp. 223–56. Grenoble: Presses Universitaires de Grenoble.

Waseda University

1993 Waseda University, Architectural Research Mission for the Study of Ancient Egyptian Architecture. *Studies on the Palace of Malqata— Investigations at the Palace of Malqata, 1985– 1988: Papers in Honor of Professor Watanabe Yasutada on the Occasion of His Seventieth Birthday*. [In Japanese.] Tokyo: Waseda University.

Weeks, Kent R.

1978 "The Berkeley Map of the Theban Necropolis."

Newsletter (American Research Center in Egypt), no. 105 (Summer), pp. 19–49.

2000 Ed. *Atlas of the Valley of the Kings.* Publications of the Theban Mapping Project 1. Cairo: American University in Cairo Press.

Weigall, Arthur E. P.

1908 "Upper Egyptian Notes." *ASAE* 9, pp. 105–12.

Weinstein, James Morris

1973 "Foundation Deposits in Ancient Egypt." Ph.D. diss., University of Pennsylvania, Philadelphia.

2001 "Joppa." In *The Oxford Encyclopedia of Ancient Egypt,* ed. Donald B. Redford, vol. 2, pp. 207–8. Oxford: Oxford University Press.

Wells, Ronald A.

1985 "Sothis and the Satet Temple on Elephantine: A Direct Connection." *SAK* 12, pp. 255–302.

1991 "Sothis and the Satet Temple on Elephantine: An Egyptian 'Stonehenge'?" In *Akten des vierten Internationalen Ägyptologen Kongresses, München 1985/IAE,* vol. 4, *Geschichte, Verwaltungs- und Wirtschaftsgeschichte, Rechtsgeschichte, Nachbarkulturen,* ed. Sylvia Schoske, pp. 105–15. Studien zur altägyptischen Kultur 4. Hamburg: Helmut Buske.

Welsby, Derek A.

2001 *Life on the Desert Edge: Seven Thousand Years of Settlement in the Northern Dongola Reach, Sudan.* With contributions by Carol Andrews et al. 2 vols. BAR International Series 980. Publication (Sudan Archaeological Research Society) 7. Oxford: Archaeopress.

2003 "The Amri to Kirbekan Survey: The 2002–2003 Season." *S&N,* no. 7, pp. 26–32.

2004 "The Northern Dongola Reach." In Welsby and Anderson 2004b, pp. 90–91.

Welsby, Derek A., and Julie R. Anderson

2004a "Sudan: Ancient Treasures." *Egyptian Archaeology,* no. 25, pp. 17–19.

2004b Eds. *Sudan—Ancient Treasures: An Exhibition of Recent Discoveries from the Sudan National Museum.* Exh. cat., British Museum. London: British Museum Press.

Wente, Edward F.

1980 "Genealogy of the Royal Family." In *An X-Ray Atlas of the Royal Mummies,* ed. James E. Harris and Edward F. Wente, pp. 122–62. Chicago: University of Chicago Press.

1984 "Some Graffiti from the Reign of Hatshepsut." *JNES* 43 (January), pp. 47–54.

Werbrouck, Marcelle

1949 *Le temple d'Hatshepsout à Deir el Bahari.* Brussels: Fondation Égyptologique Reine Élisabeth.

Westendorf, Wolfhart

1966 *Altägyptische Darstellungen des Sonnenlaufes auf der abschüssigen Himmelsbahn.* Münchner ägyptologische Studien 10. Berlin: Bruno Hessling.

1980 "Isisknoten A." In *LÄ,* vol. 3, col. 204. Wiesbaden: Otto Harrassowitz.

Wiebach, Silvia

1981 *Die ägyptische Scheintür: Morphologische Studien zur Entwicklung und Bedeutung der Hauptkultstelle in den Privat-Gräbern des Alten Reiches.* Hamburger ägyptologische Studien 1. Hamburg: Borg.

Wiener, Malcolm H., and James P. Allen

1998 "Separate Lives: The Ahmose Tempest Stela and the Theran Eruption." *JNES* 57 (January), pp. 1–28.

Wiese, André

2001 *Antikenmuseum Basel und Sammlung Ludwig: Die ägyptische Abteilung.* Sonderbände der Antiken Welt. Mainz am Rhein: Philipp von Zabern.

Wiese, André, and Andreas Brodbeck

2004 Eds. *Tutankhamun, the Golden Beyond: Tomb Treasures from the Valley of the Kings.* Exh. cat. Basel: Antikenmuseum Basel und Sammlung Ludwig.

Wildung, Dietrich

1969 *Die Rolle ägyptischer Könige im Bewusstsein ihrer Nachwelt.* Münchner ägyptologische Studien 17. Berlin: Bruno Hessling.

1974 "Zwei Stelen aus Hatschepsuts Frühzeit." In *Festschrift zum 150 jährigen bestehen des Berliner Ägyptischen Museum,* pp. 255–68. Staatliche Museen zu Berlin, Mitteilungen aus der Ägyptischen Sammlung 8. Berlin: Akademie-Verlag.

1977 "Falkenkleid." In *LÄ,* vol. 2, cols. 97–99. Wiesbaden: Otto Harrassowitz.

1980 *Fünf Jahre Neuerwerbungen der Staatlichen Sammlung Ägyptischer Kunst München, 1976–1980.* Mainz am Rhein: Philipp von Zabern.

1997a *Egypt: From Prehistory to the Romans.* Taschen's World Architecture. Cologne: Taschen.

1997b Ed. *Sudan: Ancient Kingdoms of the Nile.* Exh. cat., Kunsthalle der Hypo-Kulturstiftung, Munich; Institut du Monde Arabe, Paris; and other institutions. Paris and New York: Flammarion.

2000 Ed. *Ägypten 2000 v. Chr.: Die Geburt des Individuums.* With contributions by Günter Burkard et al. Exh. cat., Residenz Würzburg and Kunstforum of the GrundkreditBank, Berlin, arranged by the Staatliche Sammlung Ägyptischer Kunst, Munich, and the Ägyptische Museum und Papyrussammlung, Staatliche Museen zu Berlin—Preussischer Kulturbesitz. Munich: Hirmer.

Wilkinson, Alix

1971 *Ancient Egyptian Jewellery.* Methuen's Handbooks of Archaeology. London: Methuen.

Wilkinson, Charles K., and Marsha Hill

1983 *Egyptian Wall Paintings: The Metropolitan Museum of Art's Collection of Facsimiles.* New York: The Metropolitan Museum of Art.

Wilkinson, John Gardner

1830 *Topographical Survey of Thebes, Tápé, Thaba or Diospolis Magna.* London: Royal Geographical Society. Repr., Brockton, Mass.: John William Pye Rare Books, 1999.

1878 *The Manners and Customs of the Ancient Egyptians.* Rev. ed. 3 vols. London: John Murray.

Wilson, John Albert

1951 *The Burden of Egypt: An Interpretation of Ancient Egyptian Culture.* The Oriental Institute of the University of Chicago, An Oriental Institute Essay. Chicago: University of Chicago Press.

Winkler, Eike-Meinrad, and Harald Wilfing

1991 *Tell el-Dabʿa VI: Anthropologische Untersuchungen an den Skelettresten der Kampagnen 1966–69, 1975–8, 1985.* Österreichische Akademie der Wissenschaften, Denkschriften der Gesamtakademie 10. Untersuchungen der Zweigstelle Kairo Österreichischen Archäologischen Institutes 9. Vienna: Verlag der Österreichischen Akademie der Wissenschaften.

Winlock, Herbert E.

Notebook III. The Metropolitan Museum of Art Theban Expedition. Vol. 3, XI Dynasty Extramural Tombs. Compiled by Herbert Winlock, ca. 1920–32. Archives of the Department of Egyptian Art, The Metropolitan Museum of Art, New York.

Notebook VII. The Metropolitan Museum of Art Theban Expedition. Vol. 7, XVIII Dynasty Temple Architecture. Compiled by Herbert Winlock, ca. 1929–32. Archives of the Department of Egyptian Art, The Metropolitan Museum of Art, New York.

Notebook VIII. The Metropolitan Museum of Art Theban Expedition. Vol. 8, Hatshepsut Statues and Sphinxes. Compiled by Herbert Winlock, ca. 1929–32. Archives of the Department of Egyptian Art, The Metropolitan Museum of Art, New York.

Notebook IX. The Metropolitan Museum of Art Theban Expedition. Vol. 9, Hatshepsut Kiosk and Causeway Sphinxes, 1931–32 Season. Compiled by Herbert Winlock, ca. 1929–32, with contributions from Walter Hauser et al. Archives of the Department of Egyptian Art, The Metropolitan Museum of Art, New York.

1921 "Excavations at Thebes." In *Egyptian Expedition for MCMXX–MCMXXI,* pp. 29–53. *Bulletin of The Metropolitan Museum of Art* 16 (November), pt. 2.

1922 "Excavations at Thebes." In *The Egyptian Expedition, MCMXXI–MCMXXII,* pp. 19–48. *Bulletin of The Metropolitan Museum of Art* 17 (December), pt. 2.

1923 "The Museum's Excavations at Thebes." In *The Egyptian Expedition, 1922–1923,* pp. 11–39. *Bulletin of The Metropolitan Museum of Art* 18 (December), pt. 2.

1924 "The Tombs of the Kings of the Seventeenth Dynasty at Thebes." *JEA* 10, pp. 217–77.

1928a "The Museum's Excavations at Thebes." In *The Egyptian Expedition, 1925–1927*, pp. 3–58. *Bulletin of The Metropolitan Museum of Art* 23 (February), sect. 2.

1928b "The Museum's Excavations at Thebes." In *The Egyptian Expedition, 1927–1928*, pp. 3–28. *Bulletin of The Metropolitan Museum of Art* 23 (December), sect. 2.

1929a "The Museum's Excavations at Thebes." In *The Egyptian Expedition, 1928–1929*, pp. 3–34. *Bulletin of The Metropolitan Museum of Art* 24 (November), sect. 2.

1929b "Notes on the Reburial of Tuthmosis I." *JEA* 15, pp. 56–68.

1930 "The Museum's Excavations at Thebes." In *The Egyptian Expedition, 1929–1930*, pp. 3–28. *Bulletin of The Metropolitan Museum of Art* 25 (December), sect. 2.

1932a "The Museum's Excavations at Thebes: Excavations at the Temple of Ḥat-shepsūt." In *The Egyptian Expedition, 1930–1931*, pp. 4–37. *Bulletin of The Metropolitan Museum of Art* 27 (March), sect. 2.

1932b *The Tomb of Queen Mereyt-Ameun at Thebes*. Publications of The Metropolitan Museum of Art Egyptian Expedition 6. New York: The Metropolitan Museum of Art.

1933 "Three Egyptian Gold Circlets." *Bulletin of The Metropolitan Museum of Art* 28 (September), pp. 156–60.

1934 *The Treasure of El Lāhūn*. Publications of The Metropolitan Museum of Art, Department of Egyptian Art 4. New York: The Metropolitan Museum of Art.

1935a "A Granite Sphinx of Ḥat-shepsūt." *Bulletin of The Metropolitan Museum of Art* 30 (August), pp. 159–60.

1935b *The Private Life of the Ancient Egyptians*. New York: The Metropolitan Museum of Art.

1940 "The Mummy of Waḥ Unwrapped." *Bulletin of The Metropolitan Museum of Art* 35 (December), pp. 253–59.

1942 *Excavations at Deir el-Baḥri, 1911–1931*. New York: Macmillan.

1948 *The Treasure of Three Egyptian Princesses*. Publications of The Metropolitan Museum of Art, Department of Egyptian Art 10. New York: The Metropolitan Museum of Art.

Winterhalter, Silvia

1998 "Die Plastik der 17. Dynastie." In *Ein ägyptisches Glasperlenspiel: Ägyptologische Beiträge für Erik Hornung aus seinem Schülerkreis*, ed. Andreas Brodbeck, pp. 265–308. Berlin: Gebr. Mann.

Wit, Constant de

1951 *Le rôle et le sens du lion dans l'Égypte ancienne*. Leiden: E. J. Brill.

Woolley, C. Leonard

1955 *Alalakh: An Account of the Excavations at Tell Atchana in the Hatay, 1937–1949*. Society of Antiquaries, London, Research Committee, Reports 18. Oxford: Oxford University Press for the Society of Antiquaries.

World of Egypt

1995 *O kosmos tes Aigyptou sto Ethniko Archaiologiko Mouseio/The World of Egypt in the National Archaeological Museum*. Ed. Olga Tzachou-Alexandri. Exh. cat., Ethnikon Archaiologikon Mouseion, Athens. Athens: Greek Ministry of Culture, ICOM, and Hellenic National Committee.

Wreszinski, Walter

1936 *Atlas zur altägyptischen Kulturgeschichte*. Pt. 3, *Gräber des Alten Reiches*. Leipzig: J. C. Hinrichs.

Wysocki, Zygmunt

1986 "The Temple of Queen Hatshepsut at Deir el Bahari: Its Original Form." *MDAIK* 42, pp. 213–28.

1992 "The Temple of Queen Hatshepsut at Deir el Bahari: The Raising of the Structure in View of Architectural Studies." *MDAIK* 48, pp. 233–54.

Yadin, Yigael

1963 *The Art of Warfare in Biblical Lands in the Light of Archaeological Study*. 2 vols. London: Weidenfeld and Nicolson.

Yon, Marguerite

2003 "The Foreign Relations of Ugarit." In *Sea Routes—Interconnections in the Mediterranean, 16th–6th C. BC: Proceedings of the International Symposium held at Rethymnon, Crete, September 29th–October 2nd, 2002*, ed. Nicholas Chr. Stampolidis and Vassos Karageorghis, pp. 41–51. Athens: University of Crete and the A. G. Leventis Foundation.

Yoshimura, Sakuji

1995 Ed. *Painted Plaster from Kom el-Samak at Malqata-South*. [In Japanese.] Tokyo: Egyptian Cultural Center, Waseda University.

Zibelius-Chen, Karola

1988 *Die ägyptische Expansion nach Nubien: Eine Darlegung der Grundfaktoren*. Wiesbaden: L. Reichert.

2004 "Nubienpolitik." In Petschel and von Falck 2004, p. 163.

Ziegler, Christiane

1984 "Sistrum." In *LÄ*, vol. 5, cols. 959–63. Wiesbaden: Otto Harrassowitz.

2002a Ed. *The Pharaohs*. Exh. cat., Palazzo Grassi, Venice. Milan: Bompiani Arte.

2002b "The Queens of the New Kingdom." In Ziegler 2002a, pp. 237–67.

Ziegler, Christiane, and Marie-Hélène Rutschowscaya

2002 *Le Louvre: Les antiquités égyptiennes*. Paris: Scala.

Zivie-Coche, Christiane M.

1982 "Memphis." In *LÄ*, vol. 4, cols. 24–41. Wiesbaden: Otto Harrassowitz.

1984 "Sphinx." In *LÄ*, vol. 5, cols. 1139–47. Wiesbaden: Otto Harrassowitz.

Index

Page references for illustrations and illustration captions are in *italics*.

Photograph Credits

Dieter Arnold: fig. 58

Adapted from Dieter Arnold and Winlock 1979, pl. 41 (drawings by W. Hauser / G. M. Peek): fig. 60, top

Courtesy of the Phoebe Apperson Hearst Museum of Anthropology and the Regents of the University of California, Berkeley: cat. nos. 99, 185

Ägyptisches Museum und Papyrussammlung, Staatliche Museen zu Berlin: cat. no. 82b

From Bietak 2005, p 16: fig. 32

Museo Civico Archeologico di Bologna (photograph by Marcello Bertoni): cat. no. 25

From Borchardt 1911–36, CG 572: cat. no. 9

Photographs © 2005 Museum of Fine Arts, Boston: cat. nos. 36, 37, 51, 57, 78, 101, 108, 140, 146, 171, 177, fig. 27

Artur Brack: fig. 56

Brooklyn Museum: cat. nos. 15, 33, 40, 58, 190, 198, fig. 52. Archives of the Department of Egyptian, Classical, and Ancient Middle Eastern Art (photographs by Bernard V. Bothmer): cat. nos. 66, 68, 69, 70, figs. 7, 52, 53

Musées Royaux d'Art et d'Histoire, Brussels: cat. nos. 84, 173

Betsy M. Bryan: figs. 70, 71

© The Fitzwilliam Museum, University of Cambridge: cat. nos. 80, 102

From Carnarvon and Carter 1912: fig. 13

Adapted from Carter 1917: fig. 73 (drawing by Julia Jarrett)

From Chevrier 1934, p. 172, pl. IV: fig. 38

The Field Museum, Chicago (A114186c, photograph by Diane Alexandra White, background color changed; CSA49135–CSA49137, photographer unknown): cat. no. 61; (A107542c, photograph by Ron Testa; A86289, photographer unknown): cat. no. 178

Courtesy of the Epigraphic Survey, Oriental Institute, University of Chicago (drawing by Christina Di Cerbo and Margaret De Jong): fig. 86

Courtesy of the University of Chicago Press (from Habachi 1957, pp. 92–96): fig. 37

From Daressy 1902, CG 24071: fig. 25

W. Vivian Davies: figs. 17–19

Peter Dorman: fig. 88

Trustees of the National Museums of Scotland, Edinburgh (photographs by Leslie Florence): cat. nos. 2–6, fig. 8

© 2005 by Kimbell Art Museum, Fort Worth: cat. no. 71

Mohamed Gabr: cat. no. 193

From Geheimnisvolle Königin Hatschepsut 1997, pp. 74, 76: figs. 103 (photograph by George B. Johnson), 105

Kestner-Museum, Hannover, Germany (photographs by Christian Tepper): cat. nos. 17, 85, 184

© Roemer- und Pelizaeus-Museum Hildesheim: cat. no. 83

Antonio Idini studio fotografico: cat. no. 11

Drawings by Julia Jarrett: figs. 82, 83, 85

Rijksmuseum van Oudheden, Leiden (photographs by Peter Jan Bomhof and Anneke de Kemp): cat. nos. 95, 110b, 111, 112, 137, 149a, fig. 36

From Lacau 1909–57, CG 34002: cat. no. 10

From Legrain 1906–25, CG 42051, CG 42118: figs. 12, 43

© Jürgen Liepe: cat. nos. 35, 52, 54, 55, 73, 79, 82a, 82c, 162, 186, fig. 48

Ägyptisches Museum der Univeristät Leipzig: cat. nos. 27, 103, 179

Christine Lilyquist: fig. 24

Jadwiga Lipińska: figs. 104 (model by Stefan Miszczak), 107

Adapted from Lipińska 1977 (drawing by J. Lipińska / E. Falkowska, fig. 51, p. 5): fig. 60, bottom

From Lipińska 1984, p. 69 (photograph by Zbigniew Doliński): fig. 108

© The Trustees of the British Museum, London: figs. 9, 11, 22. Photographs by Sandra Marshall: cat. nos. 34, 64, 164, 169, 170, 180, 191, fig. 80. Photographs by Bruce Schwarz: cat. nos. 12, 26, 60, 166, 168

Courtesy of the Egypt Exploration Society, London: cat. no. 48, figs. 1, 2, 44, 46, 109

Courtesy of University College London (from Petrie 1909, pl. XXII): fig. 5

Sandra Marshall: figs. 16, 20

The Metropolitan Museum of Art, New York: cat. nos. 74, 113, 117, 147; figs. 66, 77, 78. Bruce Schwarz, the Photograph Studio, The Metropolitan Museum of Art: cat. nos. 1, 8, 13, 16, 18, 19, 20–24, 30–32, 40–47, 50, 56, 59, 62, 63, 67, 75–77, 81, 86, 88b, 89–94, 96, 97, 98a–e, 100, 104–7, 109, 110a, 114–16, 118–23, 125–36, 138–45, 148, 150–55, 159, 160, 175, 187, 189, 192, 194, 195,

197, figs. 40, 65, 67. Archives of the Department of Egyptian Art (photographs by Harry Burton): frontispiece, cat. nos. 41 base, 63 back, figs. 6, 10, 34, 35, 39, 45, 47, 50, 54, 55, 61, 64, 68, 72, 74, 84, 90–102, 110–12; fig. 14 (drawing by Lindsley Hall). Images by Anandaroop Roy: maps on pp. 2, 5, genealogy on p. 7 (after Ann Macy Roth), figs. 15, 21, 28, fig. 63 (adapted from Kemp 1991, fig. 71, p. 203, and Arnold 1992, p. 110)

Adela Oppenheim: cat. no. 38

The Visitors of the Ashmolean Museum, Oxford: cat. nos. 172, 182

Musée du Louvre, Paris (photographs by Bruce Schwarz): cat. nos. 7, 49, 65, 72, 87, 161, 163, 165, 167, 174, fig. 81

Reproduced with permission of the University of Pennsylvania Museum of Archaeology and Anthropology, Philadelphia, by which all rights are reserved (photographs by Tom Jenkins): cat. nos. 28, 29, 53, 124, 156–58, 188, 199

From Reisner 1905: cat. no. 196

Réunion des Musées Nationaux / Art Resource: cat. nos. 39, 176

Adapted from Ricke 1939, pl. 7 (drawing by H. Ricke): fig. 60, center

From Rossellini 1832–44, pl. XIX, 23, 24: fig. 79

Ann Macy Roth: figs. 4, 51

Pamlyn Smith: fig. 89

From Starr 1939, pls. 148–49: fig. 23

Isabel Stünkel: figs. 3, 41, 42, 87

From Szafrański 2001, p. 101 (photograph by Magdalena Grzegorczyk): fig. 59

From Terrace and Fischer 1970, p. 98 (photograph by Costa, Cairo): fig. 49

Adapted from E. Thomas 1966: fig. 76 (drawing by Julia Jarrett)

Eberhard Karls Universität Tübingen: Ägyptische Sammlung des Ägyptologischen Instituts: cat. no. 183; Institut für Ur- und Frühgeschichte und Archäologie des Mittelalters Jüngere Abteilung (photographer Hildegard Jensen): cat. no. 200

Museo delle Antichità Egizie, Turin: cat. nos. 14, 149b, 149c, 181

Adapted from Weeks 2000: figs. 26, 75 (drawings by Julia Jarrett)

Adapted from Weinstein 1973: fig. 62 (drawing by Julia Jarrett)

From Wildung 1997a, p. 132: fig. 57

932.014 Hatshepsut,
Hat from queen to
 Pharaoh

WITHDRAWN

L. E. SMOOT MEMORIAL LIBRARY
9533 KINGS HIGHWAY
KING GEORGE, VA 22485